THE SMITHSONIAN'S

HISTORY OF AMERICA IN 101 OBJECTS

THE SMITHSONIAN'S

HISTORY OF AMERICA IN 101 OBJECTS

RICHARD KURIN

THE PENGUIN PRESS

NEW YORK

2013

THE PENGUIN PRESS
Published by the Penguin Group
Penguin Group (USA) LLC
375 Hudson Street
New York, New York 10014

USA · Canada · UK · Ireland · Australia
New Zealand · India · South Africa · China

penguin.com
A Penguin Random House Company

First published by The Penguin Press, a member of Penguin Group (USA) LLC, 2013

Illustration credits appear on pages 705–18.

LIBRARY OF CONGRESS CATALOGING-IN-PUBLICATION DATA

Kurin, Richard, 1950–
The Smithsonian's History of America in 101 Objects / Richard Kurin.
pages cm
Includes bibliographical references and index.
ISBN 978-1-59420-529-3
1. United States—History—Sources—Exhibitions. 2. United States—Civilization—Sources—
Exhibitions. 3. Smithsonian Institution—Exhibitions. I. Title.
E173.K87 2013
973—dc23
2013017171

Printed in the United States of America
1 3 5 7 9 10 8 6 4 2

Designed by Gretchen Achilles

FOR MY TWO FAMILIES,

ALLYN, DANIELLE, JACLYN, AND KIPU AT HOME,

AND MY COLLEAGUES, FRIENDS, AND SUPPORTERS

AT THE SMITHSONIAN

CONTENTS

Foreword by G. Wayne Clough xi

Preface xiii

A Note on the Objects xix

Introduction 3

BEFORE COLUMBUS
(525 MILLION YEARS AGO TO 1492)

1. Burgess Shale Fossils 21

2. Bald Eagle 27

3. Clovis Stone Points 31

4. Mississippian Birdman Copper Plate 39

NEW WORLD
(1492 TO MID-EIGHTEENTH CENTURY)

5. Christopher Columbus's Portrait 45

6. Spanish Mission Hide Painting of Saint Anthony 51

7. Pocahontas's Portrait 56

8. Plymouth Rock Fragment 65

9. Slave Shackles 71

10. Americæ Nova Tabula (Map) 78

LET FREEDOM RING
(1760s TO 1820s)

11. Declaration of Independence 87

12. George Washington's Uniform and Sword 95

13. Benjamin Franklin's Walking Stick 99

14. Gilbert Stuart's Lansdowne Portrait of George Washington 105

15. Star-Spangled Banner 111

16. Thomas Jefferson's Bible 123

YOUNG NATION
(LATE EIGHTEENTH CENTURY TO 1850s)

17. Conestoga Wagon 131

18. Eli Whitney's Cotton Gin 134

19. John Deere's Steel Plow 141

20. Isaac Singer's Sewing Machine 145

21. Nauvoo Temple Sun Stone 153

SEA TO SHINING SEA
(1800 TO 1850s)

22. Lewis and Clark's Pocket Compass 159

23. John Bull Steam Locomotive *165*

24. Samuel Colt's Revolver *172*

25. Morse-Vail Telegraph *179*

26. Mexican Army Coat *186*

27. Gold Discovery Flake from
Sutter's Mill *193*

28. Martha, the last Passenger Pigeon *199*

A HOUSE DIVIDED (1850 TO 1865)

29. Frederick Douglass's Ambrotype
Portrait *207*

30. Harriet Tubman's Hymnal and Shawl *212*

31. Emancipation Proclamation
Pamphlet *217*

32. Christian Fleetwood's
Medal of Honor *224*

33. Appomattox Court House
Furnishings *231*

34. Abraham Lincoln's Hat *237*

MANIFEST DESTINY
(1845 TO EARLY TWENTIETH
CENTURY)

35. Albert Bierstadt's
Among the Sierra Nevada, California *247*

36. King Kamehameha III's
Feather Cape *252*

37. American Buffalo *259*

38. Sitting Bull's Drawing Book *267*

39. Bugle from the U.S.S. *Maine* *274*

INDUSTRIAL REVOLUTION
(1865 TO EARLY TWENTIETH
CENTURY)

40. Alexander Graham Bell's Telephone *283*

41. Thomas Edison's Lightbulb *289*

42. Frédéric Bartholdi's *Liberty* *295*

43. Andrew Carnegie's Mansion *301*

44. Ford Model T *311*

45. Wright Brothers' *Kitty Hawk Flyer* *317*

46. Bakelizer Plastic Maker *325*

MODERN NATION
(1870s TO 1929)

47. James Whistler's *Harmony in Blue and
Gold: The Peacock Room* *333*

48. Bernice Palmer's Kodak Brownie
Camera *339*

49. Helen Keller's Watch *346*

50. Suffragists' "Great Demand" Banner *353*

51. Ku Klux Klan Robe and Hood *361*

52. World War I Gas Mask *366*

53. Louis Armstrong's Trumpet *371*

54. Scopes "Monkey Trial" Photograph *379*

55. *Spirit of St. Louis* *384*

56. Babe Ruth Autographed Baseball *393*

GREAT DEPRESSION

(1929 TO 1940)

57. Franklin D. Roosevelt's "Fireside Chat" Microphone *401*

58. John L. Lewis's Union Badge *406*

59. Marian Anderson's Mink Coat *413*

60. Dorothy's Ruby Slippers *421*

61. Woody Guthrie's "This Land Is Your Land" *426*

GREATEST GENERATION

(1941 TO 1945)

62. U.S.S. *Oklahoma* Postal Hand Stamps *435*

63. *Spirit of Tuskegee* *439*

64. "We Can Do It!" Poster of Rosie the Riveter *445*

65. Japanese American World War II Internment Art *452*

66. Audie Murphy's Eisenhower Jacket *459*

67. *Enola Gay* *465*

COLD WAR

(1946 TO 1991)

68. Fallout Shelter *475*

69. Mercury *Friendship 7* *480*

70. Huey Helicopter *487*

71. Pandas from China *493*

72. Berlin Wall Fragment *501*

NEW FRONTIERS

(1950s TO 1980s)

73. Jonas Salk's Polio Vaccine *509*

74. Jacqueline Kennedy's Inaugural Ball Gown *513*

75. Julia Child's Kitchen *520*

76. The Pill and Its Dispenser *527*

77. Neil Armstrong's Space Suit *533*

78. "Mr. Cycle" PCR Machine *543*

79. Space Shuttle *Discovery* *546*

CIVIL RIGHTS

(1947 TO NOW)

80. Greensboro Lunch Counter *555*

81. Muhammad Ali's Boxing Gear *560*

82. Bob Dylan Poster by Milton Glaser *567*

83. Cesar Chavez's Union Jacket *573*

84. Gay Civil Rights Picket Signs *580*

85. AIDS Memorial Quilt Panel *587*

POP CULTURE

(MID-TWENTIETH CENTURY TO NOW)

86. Walt Disney's Mickey Mouse *595*

87. RCA Television Set *600*

88. Chuck Berry's Gibson Guitar *607*

89. Katharine Hepburn's Oscars *615*

90. Hope Diamond *620*

91. Andy Warhol's *Marilyn Monroe* *627*

92. McDonald's Golden Arches Sign *632*

93. Kermit the Frog *639*

94. *Star Wars'* R2-D2 and C-3PO *644*

DIGITAL AGE
(1945 TO NOW)

95. ENIAC *651*

96. Apple's Macintosh Computer *656*

97. Nam June Paik's
 Electronic Superhighway *663*

NEW MILLENNIUM
(2000 TO THE FUTURE)

98. New York Fire Department
 Engine Door from September 11 *671*

99. Shepard Fairey's *Barack Obama*
 "Hope" Portrait *678*

100. David Boxley's Tsimshian Totem Pole *685*

101. Giant Magellan Telescope *691*

What's Not Included? *697*

Old Things, New Studies *701*

*Object Specifications and Photographic
Credits* *705*

Time Line of American History *719*

Maps *727*

Notes *735*

Index *745*

In 1826, when English scientist James Smithson wrote his will and bequeathed his fortune to the United States to establish an institution dedicated to the "increase and diffusion of knowledge," he had high hopes that his gift was in good hands. I do not think the American people and the Smithsonian, as the trustees of that gift, have let him down. The Smithsonian stands for what is best about our country, through its research in science, history, art, and culture; through its care of the natural and cultural treasures of this planet; and through its work to educate tens of millions yearly during visits to its museums and every minute of the day via its digital outreach to the world.

FOREWORD

G. WAYNE CLOUGH,
Secretary,
Smithsonian Institution

Early on, the Smithsonian began acquiring the artifacts and artworks, the archives and documents, that represented America's national identity—its heritage and its accomplishments, its deep history and most creative aspirations. As the collections have grown, it has become a repository of who we are as a people.

The Smithsonian not only maintains our collective memory but also keeps alive, through research and education, an understanding of our accomplishments and ideals, our struggles and innovations, represented by the most comprehensive collection of objects in the world. Understanding our past is the only way to build a foundation for our future.

In this marvelous book, Richard Kurin, one of the Smithsonian's living treasures and my colleague, uses 101 key objects of American history in the Institution's collections to tell the story of our country in a robust, engaging, and entertaining fashion. His account shows us why these objects continue to attract some 30 million domestic and international visitors a year to our museums, and more than 100 million online—making it by far the most visited museum in the world and one cherished by generations of Americans and appreciated by people around the globe.

This book has been a joy to write, and I have learned so much in doing so.

The project was inspired by Neil MacGregor's outstanding *A History of the World in 100 Objects*, using the collection of the British Museum. That book proved to be enormously popular, and has provided an excellent introduction for many to appreciate the world's treasures, and the processes, societies, and people they represent. Scott Moyers, publisher of Penguin Press, publishing colleague Gail Ross, and I took up the idea of a book examining American history through the treasured objects of the Smithsonian Institution.

This book is written for a broad audience rather than for the professional historian or the scholar. I hope the stories about these 101 objects from the Smithsonian's collections will inspire readers to learn more of our nation's history. I also hope the book encourages acts of good citizenship—something so basic in the American experience.

No one could write this book alone—the scope of American history is too broad and the detailed knowledge required too deep. Furthermore, each of these objects has stories to tell not only about its place in history but also about how it came to the Smithsonian, and how it has been studied, displayed, and understood. Hence I have relied upon a stellar team of colleagues to help me.

Foremost has been a team of research scholars exceptionally well qualified and accomplished. Heather Ewing, a notable author with great knowledge of the Smithsonian, was a critical partner throughout the project. Helpful, supportive, and challenging, she coordinated the team. Laurie Ossman, an expert in architectural history and material culture, and Brian Daniels, an expert in American history and cultural heritage—both of them strong and experienced in museum studies—played major roles in guiding, researching, and shaping the book. Rounding out the research team, Ve-

PREFACE

RICHARD KURIN,

Under Secretary for

History, Art, and Culture,

Smithsonian Institution,

Washington, D.C.

ronica Conkling, a specialist in the history of decorative arts and museum studies, helped reference sources, track down objects, secure permissions for the use of photographs, and perform numerous other organizational tasks. Tatum Willis, a history student at Yale University who served as an intern, and my law school daughter Jaclyn Kurin helped develop the background material needed for the research.

The collections of the Smithsonian have dedicated stewards, curators, and fellows who study the objects, conservators who care for them physically, and managers and archivists who keep track of them and ensure their safety, security, and accessibility. Photographers document the objects, and Webmasters and technicians digitize and distribute information about them. Thanks to the cooperation of the Smithsonian's directors, with whom I am proud to serve, more than one hundred of these specialists were involved in the project and gave me and the research team information and access, wisdom and guidance, advice and more advice, about each and every object. Mostly I took it, though sometimes interpretations and approaches diverged. Among expert advisers are those listed below, by the museum or research center of the Smithsonian.

Anacostia Community Museum: Director, Camille Akeju; Joshua M. Gorman, Portia James, Gail Lowe;

Archives of American Art: Director, Katherine Haw; Acting Director, Liza Kirwin; Mary Savig;

Center for Folklife and Cultural Heritage: Director, Michael Mason; Director, Daniel Sheehy; Olivia Cadaval, Marjorie Hunt, Sojin Kim, Jeff Place, Arlene Reiniger, Stephanie Smith, D. A. Sonneborn;

Cooper-Hewitt, National Design Museum: Director, Caroline Baumann; Demian Cacciolo, Sarah Coffin, Caitlin Condell, Gail Davidson, Gregory Herringshaw, Cara McCarty, Matilda McQuaid, Janice Slivko, Stephen Van Dyk, Nate Wilcox;

Freer and Sackler Galleries: Director, Julian Raby; Lee Glazer, Cory Grace;

Hirshhorn Museum and Sculpture Garden: Acting Director, Kerry Brougher; Amy Giarmo, Evelyn Hankins, Susan Lake;

National Air and Space Museum: Director, John Dailey; Paul Ceruzzi, Tom Crouch, David Devorkin, Von Hardesty, Kate Igoe, Peter Jakab, Melissa Keiser, Roger Launius, Cathleen Lewis, Valerie Neal, Allan Needell, Michael Neufeld, Bob Van der Linden, Margaret A. Weitekamp;

National Museum of African American History and Culture: Director, Lonnie Bunch; Renee S. Anderson, Nancy Berkaw, Laura Coyle, Paul Gardullo, Jina Lee, Logan Metesh, Michèle Gates Moresi, William Pretzer, Dwandalyn R. Reece, Debora Scriber-Miller, Jacquelyn D. Serwer, Kevin Strait;

National Museum of African Art: Director, Johnnetta Cole; Bryna Freyer, Christine Kreamer, Sara Manco, Amy Staples;

National Museum of American History: Director, John Gray; Interim Director, Marc Pachter; David K. Allison, Jeanne Benas, William L. Bird, Melanie Blanchard, Joan Boudreau, Dwight Bowers, Doris Bowman, Roger Connor, Alicia Cutler, Nancy Davis, Janice Ellis, Lisa Kathleen Graddy, Rayna Green, Debra Hashim, John Edward Hasse, Kate Henderson, Valeska Hilbig, Eric Hintz, Eric Jentsch, Stacey Kluck, Paula Johnson, Paul Johnston, Jennifer Jones, Peter Liebhold, David Miller, Arthur Molella, Timothy Nolan, Katharine Ott, Vanessa Pares, Marvette Perez, Shannon Perich, Steve Prothero, Harry Rand, Jane Rogers, Harry Rubenstein, Noriko Sanefuji, Ann M. Seeger, Wendy Shay, Barbara Clark Smith, Carlene Stephens, Jeffrey Stine, Susan Tolbert, Steven Turner, Steve Velasquez, Hal Wallace, Mallory Warner, Diane Wendt, Roger White, William Withuhn, Raelene Worthington, Helena Wright, Cedric Yeh, William Yeingst;

National Museum of the American Indian: Director, Kevin Gover; Emil Her Many Horses, Ann McMullen, Patricia Nietfeld, David Penney, Heather A. Shannon, Gabrielle Tayac;

National Museum of Natural History: Director, Kirk Johnson; Laurie Burgess, James Dean, James DiLoreto, Doug Erwin, Candace Greene, Jake Homiak, Helen James, Adrienne Kaeppler, William Merrill, Chris Meyer,

Adam Minakowski, Daisy Njoku, Alicia Pickering, Jeffrey Post, Kristen Quarles, Daniel Rogers, Bruce Smith, Dennis Stanford, Barbara Stauffer, Scott Wing;

National Portrait Gallery: Director, Kim Sajet; Interim Director, Wendy Wick Reaves; Brandon Fortune, Anne Goodyear, Frank Goodyear, Mark Gulezian, Sidney Hart, Amy Henderson, John McMahon, Ellen Miles, Lizanne Reger, Deb Sisum, Linda Thrift;

National Postal Museum: Director, Allen Kane; Cheryl Ganz, Lynn Heidelbaugh, William Lommel, James O'Donnell, Nancy Pope;

National Zoological Park: Director, Dennis Kelly; Ed Bronikowski, Paul Marinari, Mehgan Murphy, Brandie Smith, Laurie Thompson, Vincent Rico;

Smithsonian American Art Museum: Director, Betsy Broun; Elizabeth Anderson, John Hanhardt, Eleanor Harvey, Karen Lemmey, Michael Mansfield, Richard Sorensen, William Truettner;

Smithsonian Astrophysical Observatory: Director, Charles Alcock; Jeffrey McClintock;

Smithsonian Institution Archives: Director, Anne van Camp; Ellen Alers, Pamela Henson; Marcel LaFollette, Marguerite I. Roby;

Smithsonian Institution Libraries: Director, Nancy Gwinn; Leslie K. Overstreet, Erin Rushing, Daria Wingreen-Mason, Conrad Ziyad.

In addition, former Smithsonian curators Jim Bruns of the Navy Museum and Franklin Odo of the Library of Congress contributed to particular object essays. Other family, friends, supporters, and colleagues also helped: Judy Bell, Christina Friberg, Nora Guthrie, Danielle Kurin, Clarie Miller, John Rogers, and Greg Wilson enhanced the content for specific items while Regent David Rubenstein and members of the Smithsonian National Board, particularly Sako Fisher, Judy Huret, Shelby Gans, Paul Neely, and other board members like Pat and Phillip Frost, Paul Peck, Pam Scott, and Tim Koogle, and my wife, Allyn Kurin, offered strong encouragement for the overall effort.

Colleagues in the Smithsonian's Material Culture Forum, led by its chair,

Mary Augusta Thomas, gave me important feedback and aided the progress of the project. My colleagues Betsy Broun, Lonnie Bunch, Tom Crouch, John Gray, Evelyn Lieberman, Marc Pachter, Nell Payne, Philip LoPiccolo, Harry Rubenstein, and Martin Sullivan, the former director of the National Portrait Gallery, kindly read the whole manuscript. Ivan Selin, the former chairman of the National Museum of American History board, offered superb guidance, insightful comments, and generous edits, as did Jim Dicke, the former chairman of the Smithsonian American Art Museum Commission.

All of the primary or featured objects come from the Smithsonian museums and organizations listed above. However, I have liberally used images of and written about objects from other museums, libraries, and archives that elucidate the Smithsonian items. The Library of Congress and the National Archives are vital repositories of our nation's heritage, as are numerous institutions across the United States, including more than 170 Smithsonian Affiliate museums.

An ace team of editorial assistants ably led by Lucy Harvey, now enmeshed in her second career, in museum studies at George Washington University, and including Ryan White and Evan Sarris Jr., read every word of the object essays and corrected many of them.

A special group helped with the Time Line of American History in the appendix. National History Day is a wonderful program supported by Ken Behring and others that encourages students and teachers from across the nation to research American history and publicly present their work through papers, displays, performances, and other products. Its director, Cathy Gorn, and staff members Kim Fortney and Adrienne Harkness arranged for some of the participants to help with this book. Among the teachers and students who contributed to the time line were Christine Park in Peter Porter's class at Montville Township High School in New Jersey; Spencer Otto in Mr. Wagner's class and Patrick Kennaly at Carlisle High School in Pennsylvania; Beth Desta in Cherie Redelings's class at Francis Parker High School in San Diego, California; and Laura Barnett, Andrea Betsill, Andrew Bu-

kowski, Daniel Crecca, Sami Ernst, Jordan Glider, Jonathan Healy, Katie Justice, Megan Leahy, Hope Meltser, Abby Schiela, Madison Shields, Prairie Wentworth-Nice, and Amanda Wolfgang, with their teachers, Lynne O'Hara, Brian Weaver, and Lynne O'Hara, at Central Bucks High School West in Doylestown, Pennsylvania.

Additionally, I thank Chris Liedel for his support and Carol LeBlanc for her leadership in coordinating the Smithsonian side of the partnership with Penguin Press on this project, and her staff members, including especially Brigid Ferraro as well as Beth Py-Lieberman, Ryan Reed, Brian Wolly, and Scott Stark. Lauryn Guttenplan of the Office of General Counsel successfully negotiated matters between the Smithsonian and Penguin Press. My trustworthy and incredibly talented assistant LeShawn Burrell-Jones provided crucial support keeping me on track through the writing and production of the book, and Roberta Walsdorf, always attendant to fiscal matters, paid the bills, for which I am thankful. Joanne Flores helped check sources for the text.

The team at Penguin Press led by Scott Moyers and including Mally Anderson, Tracy Locke, Claire Vaccaro, Gretchen Achilles, John Sharp, Sarah Hutson, and Randee Marullo have been thoroughly professional and helpful at every step of the way, and I am grateful for their excellent work.

Finally, I thank my family for their dependable and encouraging support, as always.

A NOTE ON THE OBJECTS

All of the 101 objects featured in this book are in the collections of the following Smithsonian museums, research centers, or programs:

Anacostia Community Museum

Archives of American Art

Center for Folklife and Cultural Heritage

Cooper-Hewitt, National Design Museum

Freer and Sackler Galleries

Hirshhorn Museum and Sculpture Garden

National Air and Space Museum

National Museum of African American History and Culture

National Museum of African Art

National Museum of American History

National Museum of the American Indian

National Museum of Natural History

National Portrait Gallery

National Postal Museum

National Zoological Park

Smithsonian American Art Museum

Smithsonian Astrophysical Observatory

Smithsonian Castle

Smithsonian Institution Archives
Smithsonian Institution Libraries

Images of objects from several other museums, archives, and libraries are included in the essays to supplement the stories told by the Smithsonian objects. These institutions are:

American Museum of Natural History

Autry National Center

British Museum

Cold War Museum

Computer History Museum

Crystal Bridges Museum of American Art

Honolulu Museum of Art

Indiana University, The Lilly Library and Image Archive

Library of Congress

Maryland Historical Society

Metropolitan Museum of Art

Museum of Fine Arts, Boston

National Air and Space Administration

National Archives

New-York Historical Society

Stanford University, Iris & B. Gerald Cantor Center for Visual Arts

University of Virginia, The Abraham Cowley Text and Image Archive

Woody Guthrie Archives

Yale University, Beinecke Rare Book & Manuscript Library

THE SMITHSONIAN'S

HISTORY OF AMERICA IN 101 OBJECTS

The Smithsonian Institution has the largest collection of museum objects anywhere in the world—137 million items plus some 19 million photographs; millions of books, recordings, film, and videotape; and tens of millions of archival documents accumulated over nearly two centuries. Increasingly, its collections are not only digitized but also "born digital" in the form of e-mails, graphics, and artwork. If one is looking for a treasure trove of Americana—as many have said—"it must be in the Smithsonian."

INTRODUCTION

In this book, I use the collections of the Smithsonian to tell the history of the United States.

The Smithsonian is not the only steward of the nation's treasures, but with millions of objects of American history, literally from "art" to "zoo," it has become the major repository of our collective memory. Over time, as the nation has changed its understanding of itself, its people, and what it means to be American, the Smithsonian too has changed. It has responded to public sentiment and, in some cases, spurred public discourse in a collective effort to assemble the artifacts of people, places, and events that matter to us. From the early years of accumulating the relics of our Founding Fathers and scientific curiosities to today's popular culture, politics, and technology, the Smithsonian collections do not define one single view of history, but rather provide us with the means to reconsider our past in light of what we value today.

If you want a comprehensive and visceral sense of American history, there's no place like the Smithsonian. That's what I've told many guests and visitors, colleagues and collaborators, from across the United States and around the world whom I have hosted at the Smithsonian during my decades-long career at the Institution. The Smithsonian's nineteen museums hold the "real stuff," the authentic touchstones of our history: George Washington's uniform, the Star-Spangled Banner, Abraham Lincoln's hat,

Harriet Tubman's hymnal, the Wright brothers' *Flyer*, Lindbergh's *Spirit of St. Louis,* Dorothy's ruby slippers, Jacqueline Kennedy's inaugural gown, Julia Child's kitchen, the Mercury and Apollo spacecraft, Cesar Chavez's union jacket, even Kermit the Frog. Some thirty million people a year make the pilgrimage to the Smithsonian to visit with these objects, many seeking to understand their own experiences in light of the struggles and triumphs that have collectively defined the nation.

At the Smithsonian, visitors find collections that span the range of time, from fossils of ancient life to modern inventions that have enabled us to analyze DNA and data from distant galaxies. We exhibit not only Gilbert Stuart's portraits of the Founding Fathers but also the work of artists such as Andy Warhol and Nam June Paik, which provide provocative commentaries on a more recent America. During the presidential campaign of 2008, the Smithsonian collected the Shepard Fairey collage portrait of Barack Obama that ubiquitously proclaimed "hope" and "change" for America on millions of posters. In 2010, the Smithsonian collected homemade signs made by Tea Party advocates, and a year later, totally different ones made by the Occupy Wall Street movement. Today's news is tomorrow's history— and the Smithsonian is there to cover and collect it.

The challenge posed by this book was to select a very limited number of objects from the Smithsonian's vast collections to tell the story of American history. This required making some difficult choices. The approach was to choose objects that could act as signposts for larger ideas, achievements, and issues that have defined us as Americans over time.

Physical objects are far from our only primary sources of information about American history, of course. We have all sorts of written records: diaries, autobiographies, letters, and newspapers, as well as documentary materials like photographs, recordings, film, video, and now even Facebook pages. But a well-chosen, authentic museum object is different: it not only bears witness to history, it is also part of it—it was *there*, at that time, at that place. Objects have the power to connect us in a direct, visceral, sensory

manner to other times and places in ways words do not. They put us next to key people or in the midst of an important event.

Just as one might write a biography of a person, one can write a biography of an object. In this book, you will find some key information and insights about each of the 101 objects—how and when they were made or formed, how they moved about, what they were used for or meant to be used for and by whom. As with museum exhibitions that use objects to illustrate a point, the objects in this book are here to tell a larger story. We cannot re-create the Civil War in a museum—there's no way to re-create the horrors of slavery, or put a battlefield into a gallery, fire real artillery, or treat wounded soldiers. But a museum has to illustrate these things. If it wants to do so with authentic objects, then it needs to choose carefully what it can use and then decide how, in order to represent that historical reality. A hand-drawn battle map of the time, a bullet or gunnery shell, a uniform bearing evidence of wounds, and broken metal shackles are all objects that, having been present at the event depicted, can speak to the larger story. The parts stand for the whole.

CHOOSING THINGS: WHAT THESE OBJECTS TEACH US ABOUT AMERICA'S HISTORY

About 90 percent of the Smithsonian's collections are specimens of natural history, but even so, choosing 101 from among the 10 to 12 million other objects to tell America's story is quite daunting. Making the job a bit easier is the fact that the Smithsonian has been around for more than 165 years, has had thousands of scholars and curators studying and displaying its collections, and thus has built up a tremendous reservoir of knowledge about what in its collections is especially important. We've also had the benefit of hundreds of millions of people visiting the museums and seeking out particular objects of interest to them. Using this pool of knowledge, I initially

cultural traditions. Now the digital age is upon us, with an explosion of national and global interconnectedness, the implications of which are still unclear. So we simultaneously live with personal computers, the AIDS quilt, McDonald's signs, contemporary American Indian totem poles, and the latest giant telescope—all of which are in the book.

While objects treated in the book are set in temporal periods, some basic thematic strands recur throughout American history. Among those I would identify are four key themes that have been the subject of scholarship and public debate and often crop up as titles or organizing principles for Smithsonian exhibitions:

- America, the beautiful and bountiful
- Life, liberty, and the pursuit of happiness
- Discovery, innovation, artistry, and creativity
- Diversity: a nation of nations

It is fair to say that in one way or another, the objects selected teach us about at least one of these themes in the American experience. The first theme represents the natural setting, the bounty of its land, the resources that fuel the country. Included in the book is a great depiction of the American landscape in a painting by Albert Bierstadt from the Smithsonian American Art Museum, as well as the American bison, or buffalo—an inhabitant in the Smithsonian's living collection at the National Zoo—which helps tell the story of resource exploitation and conservation.

"Life, liberty, and the pursuit of happiness," that wonderfully resonant phrase from the Declaration of Independence, speaks to the relationship of a government to its people and the realization of their rights and freedoms. Objects in the book like the plow, sewing machine, and Model T Ford represent the economic livelihood of the nation. Items such as slave shackles from the Middle Passage, Benjamin Franklin's staff of liberty, Frederick Douglass's portrait, the "Great Demand" banner of the women's suffrage movement, and a fragment of the Berlin Wall help tell the story of political

freedom and civil rights. Objects like the television and the Salk vaccine bear witness to the search for happiness and a better quality of life.

Discovery, innovation, and creativity have characterized America's cultures from its early Native inhabitants through European colonial settlements to the present. Discoveries like the shining yellow flake that started the gold rush are included, as are inventions such as Edison's lightbulb, the first plastic maker, and the space suit that enabled Neil Armstrong to walk on the Moon. American artistry and creativity is evidenced by Oscar statuettes, Warhol's *Marilyn Monroe,* an early drawing of Mickey Mouse, and the design of the Macintosh computer.

Diversity has always been a hallmark of the American experience, rooted in the peopling of the continent. Many Americans may think of migration, immigration, diaspora, and exile as recent political and social phenomena. But the fact that people of various nationalities, religions, ethnicities, and other groups can lay claim to different aspects of our shared territory and our cultural identity goes to the very core of the country's founding and subsequent development. From the copper-embossed birdman of Mississippian culture to the Spanish hide paintings of the Southwest, from the legendary Plymouth Rock to the sculpture model of the Statue of Liberty, from the art of Japanese Americans interred during World War II to a panel of the AIDS quilt, these objects illustrate the struggles and achievements of a nation conceived in the ideals of tolerance, respect, and equality.

THE "SECOND LIFE" OF OBJECTS IN THE MUSEUM

Collection objects arrive at the Smithsonian in various ways. Some come to us carried by hand, as when Muhammad Ali came to donate his boxing gloves. Some, like the Hope diamond, astonishingly enough, come through the U.S. mail. Stars of the Smithsonian's living collection—pandas at the National Zoo—came to us courtesy of Federal Express. In 2011, the space shuttle *Discovery*, our latest major addition at the National Air and

Space Museum, was flown into our Steven F. Udvar-Hazy Center at Dulles Airport. It was making its final flight after traveling almost 150 million miles over the past three decades. Another object—the Viking I spacecraft, donated to the Smithsonian by NASA, might never make it into the museum; it rests on the surface of Mars!

When an object is acquired by the Smithsonian it becomes a "museum object" and is given a unique number. Over the course of decades, these items are held and conserved, exhibited and reexhibited, sometimes in multiple ways. They often take on meanings that differ from their original historical roles—and have a kind of second life.

Curators decide that some objects are important because they "worked"; that is, like John Deere's plow or the cotton gin, they had a functional utility of considerable consequence. Others are thought to be important because they encode certain understandings, symbolizing or memorializing ideas and events—like the feather cape of a Hawaiian king, or the Medal of Honor of an African American soldier in the Civil War, or a contemporary American Indian totem pole. Yet others are valued because of their association with famous people and achievements—Andrew Carnegie's mansion, Louis Armstrong's trumpet, Julia Child's kitchen. Some are especially highly regarded because they document history in a direct way—an early map of America, Sitting Bull's drawings, a photograph of the iceberg that sank the *Titanic*. Often, the same object is important in a number of ways.

And sometimes its meaning as a museum object changes. The Mexican Army coat in this book, for example, was first accessioned as having belonged to General Santa Anna and exhibited as a trophy of the Mexican-American War. That changed when more information became available. In the early twentieth century, the Smithsonian displayed the steering wheel from the U.S.S. *Maine,* whose sinking in 1898 precipitated the Spanish-American War. It was put in a place of honor in the museum as a sacred, patriotic object. Over the years, the fervor that fueled its treatment subsided, and now it is relegated to distant storage.

Sometimes how an object is portrayed can generate considerable contro-

versy. In the mid-1990s, we planned to display the *Enola Gay*, the airplane that dropped the atom bomb on Hiroshima, in an exhibition marking the fiftieth anniversary of the end of World War II. The plans provoked such objections that the exhibition was drastically revised. It was not the first time a famous airplane was the subject of contention concerning its interpretation by the Smithsonian; decades earlier there had been a debate about the role of the Wright *Flyer* in aviation history.

All of this is to say that neither history nor museum display and presentation are obvious or natural. These are means of representation, mediated by human concerns and perspectives, failings and interests. History and the meaning of objects are to be deeply considered, argued, and debated. No doubt, my scholarly colleagues, members of the public, and even some officials may take issue with my interpretation of the objects I've chosen for this book. That's fine. Disagreement is a healthy intellectual impulse in a free country, and if it encourages future dialogue that can improve our understanding of American history, so be it.

HOW OBJECTS CAME TO THE SMITHSONIAN

The objects described in this book, along with the millions of others displayed and stored in the Smithsonian's museums and dozens of facilities, have accumulated over more than a century and a half. The Smithsonian Institution was first conceived by an English scientist, James Smithson (1765–1829). In 1826, he wrote a will, leaving his fortune to his nephew's future heirs, with the proviso that should his nephew die childless, his entire estate would go to the United States "to found at Washington, under the name of the Smithsonian Institution, an Establishment for the increase and diffusion of knowledge among men." It was a simple but startling statement of a gentleman of the Enlightenment that ultimately had an impact far beyond what he might have imagined.

The Oxford-educated Smithson, a chemist and geologist, never visited

the United States, but he likely admired Benjamin Franklin and Thomas Jefferson for the way they combined political ideals with scientific curiosity, acumen, and accomplishment. Smithson thought that the young United States might, more than any other nation, and with his help, combine its enthusiasm for democracy with the use of science and rationality to create a successful, prosperous, educated society—one whose benefits would be widely distributed to all.

With Smithson's death and that of his heirless nephew, the United States debated whether to accept, and what to do with, the money. In 1836, Richard Rush, President Andrew Jackson's envoy, sailed to England and secured the inheritance. In 1838, he returned to the United States with 104,960 newly minted British gold sovereigns. All of these were melted by the U.S. Mint and converted into $508,318 in U.S. currency, perhaps worth as much as $100 million in today's dollars. Almost a century later the Smithsonian acquired two gold sovereigns from the era.

The U.S. Congress then debated for another eight years what the Smithsonian should be and do. Some thought it should be a national library, others a national university, an agricultural research institute, a museum, or astronomical observatory. Finally, in 1846, an act was passed and signed into law by President James K. Polk. The Smithsonian would be managed by a Board of Regents comprised of the chief justice, the vice president, other officials, and private citizens; it would conduct research, operate a museum to house the national collections, host a library and art gallery, publish books, and perform other functions in order to increase and diffuse knowledge. Later, an area on the then-ill-defined "Mall" in Washington, D.C., was paced off for the building of the Smithsonian Castle and its gardens.

Joseph Henry (1797–1878), a professor of physics at the College of New Jersey (now Princeton University), was chosen by the Smithsonian Board of Regents to be secretary,

AN 1838 BRITISH GOLD SOVEREIGN

National Museum of American History

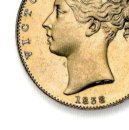

THE SMITHSONIAN'S HISTORY OF AMERICA IN 101 OBJECTS

the first head of the Institution. Henry, who studied and taught mathematics and natural philosophy, was one of the foremost scientists of the day. He had made discoveries in electromagnetism and his research was used by Samuel Morse in the development of the telegraph.

The Smithsonian's early collections came from a variety of sources and grew from various impulses. The first donation was the scientific apparatus of a university professor and the first purchase was of art and books from a regent. The founding legislation called for the Smithsonian to house collections of the federal government held in Washington. After some debate and time this led to the transfer of objects, like specimens collected from around the Pacific by the U.S.-sponsored Wilkes expedition, as well as those of the State and War departments held at the Patent Office Building and its National Gallery. A potpourri of artwork, historical relics, and curiosities came from John Varden's private Washington Museum, from the National Institute, a forerunner of the Smithsonian, and the Columbian Institute, a learned society based in the capital city. By the end of the Civil War, the Smithsonian had amassed enough natural history specimens, artwork, and historical items to have a well-visited, popular museum in its castle headquarters.

It was with considerable reticence that Henry endured the success of the museum, which was led by his assistant and eventual successor, Spencer Baird. Baird, a biologist and fanatic collector, embraced the idea of a U.S. National Museum and hit the mother lode in 1876. Philadelphia was home to the Centennial Exposition, the celebration of the one hundredth anniversary of the Declaration of Independence. This was the nation's first World's Fair and featured some two hundred pavilions that received more than ten million visitors over a six-month period. Eleven nations and twenty-six U.S. states as well as various industries organized pavilions, exhibitions, and displays. Through Baird's efforts, the Smithsonian became the de facto repository of the government exhibits once the centennial ended, and also inherited those items left behind by other nations and organizations. Those objects filled dozens of railroad cars and necessitated a new building for the U.S. National Museum—today known as the Arts and Industries Building.

Baird's collection dramatically increased the holdings of the Smithsonian and set it on the course of assembling the largest collection of objects on the planet. It also paid research dividends, as curators, scholars, and scientists had a heretofore unimaginable database of specimens, artifacts, and artwork to examine, explore, and test in an effort to understand natural, cultural, and historical processes.

The acquisition of collections at the Smithsonian went beyond inanimate objects to include living animals. Naturalists had collected animal skins and specimens, turning them over to taxidermists so they could be displayed in museum dioramas in the 1880s. That activity evolved into studying, conserving, and displaying live buffalo and other animals on the Mall—right behind the Smithsonian Castle—an effort that turned into the National Zoo.

Millions of objects were donated to the Smithsonian in the twentieth century. The Smithsonian became a massive collection of collections. A case in point was the creation of the new Freer Gallery. Charles Lang Freer was a great collector of Asian art, architecture, sculpture, and archaeological remains, as well as turn-of-the-century American artwork. He gave his fabulous collection to the nation and paid for a new museum bearing his name to be built on the Mall. His friend President Theodore Roosevelt helped facilitate the deal.

In 1908 and again in 1925 the Smithsonian received a selection of the collection of patent models from the U.S. Patent Office. These had generally been seen as documentary evidence for inventions—prototypes that represented the high value Americans placed on invention, innovation, and creativity and their commercial applications. At the Smithsonian these models served to document historical processes, U.S. industrialization, and the useful arts and industries of the country.

While the Smithsonian already had accumulated a collection of relics of American history—items used by the Founding Fathers and presidents, such as Lincoln—these collections also grew with transfers from the State Department and other donations in the early decades of the twentieth cen-

tury. The Smithsonian became the primary home to America's political and civic memorabilia.

The Smithsonian collection is far from static, as new collections and new museums have been built because of developments in American life. Baird's successor as secretary of the Smithsonian was Samuel Langley, who tried and failed to invent a piloted flying machine but whose interest in aviation inspired a collection that grew over the decades. A National Air Museum was established by law in 1946. I remember as a teenager in the early 1960s seeing some of the rockets displayed outdoors alongside the Arts and Industries Building. With the growth of the NASA space program, the impetus for a new building took a giant leap, as the nation needed a repository for the spacecraft of the era. In 1976, for the U.S. Bicentennial, the Smithsonian opened the National Air and Space Museum on the Mall.

Other museums also developed around new currents. The Anacostia Museum grew from an effort in the 1960s to send Smithsonian collections to an underserved community in Washington, D.C. The museum ended up collecting items in that community to document contemporary urban life.

S. Dillon Ripley, the eighth in a succession of Smithsonian secretaries, respectively courted Arthur Sackler to donate his outstanding collection of Asian art and Joseph Hirshhorn to donate his contemporary art collection. Aware of the emerging importance of Africa on the world scene and in American consciousness, the Smithsonian added an African art collection and museum as well. Government agencies too have followed suit over the years, with the U.S. Mint transferring coin collections to the Smithsonian and the U.S. postmaster general donating stamps.

Some museums and collections have grown from the Smithsonian's sense of national stewardship. The Cooper-Hewitt Museum in New York City was incorporated into the Institution when its vast collection of decorative art and design materials was orphaned in the 1960s. Similarly, in the 1980s, the Museum of the American Indian in New York City, with a world-class collection of some 800,000 objects collected by George Gustav Heye, was in jeopardy. The Smithsonian acquired the collection, which then formed the

basis of the new National Museum of the American Indian headquartered on the Mall in Washington, along with its Heye Center in New York.

The National Museum of African American History and Culture began not with a collection but rather with an idea—that the African American experience was not adequately represented in the Smithsonian. Legislation creating a museum and stipulating the acquisition of a collection followed a presidential commission report and was signed by President George W. Bush. When President Obama broke ground on the museum in 2012, the staff had already acquired some twelve thousand objects, among them Harriet Tubman's shawl, Nat Turner's Bible, letters from George Washington Carver, and a Tuskegee Airman training plane.

Just as the history of America continues to be made, so too do the collections of the Smithsonian. New museums are continually proposed to account for this. Currently, a presidential commission has recommended the establishment of a Smithsonian American Latino Museum to represent the experience of some fifty million Americans of Latino background. Additional museums have been suggested for women's history, finance, innovation, and immigration. These initiatives indicate a strong democratic impulse, the desire for representation in a national context, to acquire, save, and publicly display the objects of the American experience in all its diversity and poignancy. These initiatives can be politically challenging and budget busting, but socially they reflect a citizenry positively and constructively engaged in the civic life of the nation. I have little doubt that a century from now, a new edition of this book will have added a slew of new objects from the Smithsonian collections reflecting the continual development of our American history.

Still, if I were to pick one object that exemplifies the Smithsonian itself and connects it to America's history, it would be the crypt of James Smithson. When Smithson died in 1829, he was buried in the Protestant cemetery in Genoa, Italy, below a marble neoclassical sarcophagus-styled grave marker. Though he'd given his fortune and hopes to the United States, he had never set foot on its shore. That changed when the Smithsonian

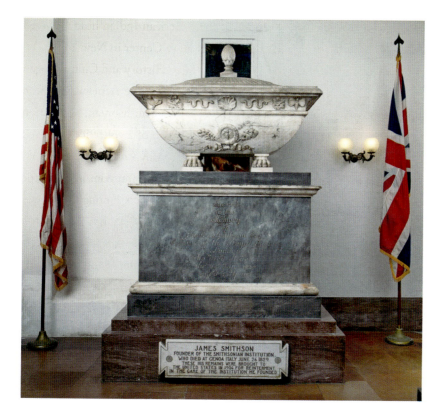

JAMES SMITHSON'S
CRYPT

Smithsonian Castle

was informed that the cemetery that housed its founder would have to be relocated. In 1903 long-term Smithsonian regent and inventor of the telephone, Alexander Graham Bell, and his wife, Mabel, went to Genoa to retrieve Smithson's remains. Bell was grateful for what Smithson had done for Americans, and for all humanity, by founding the institution bearing his name. Smithson's coffin received first a Navy and then a U.S. Cavalry escort to the Smithsonian Castle, where Bell delivered "the remains of this great benefactor of the United States" to lie in state. Subsequently, Smithson's sarcophagus was also retrieved. All sorts of official monuments were conceived for housing his remains in the nation's capital, though many people thought he already had one: the Smithsonian Institution.

BEFORE COLUMBUS

(525 MILLION YEARS AGO TO 1492)

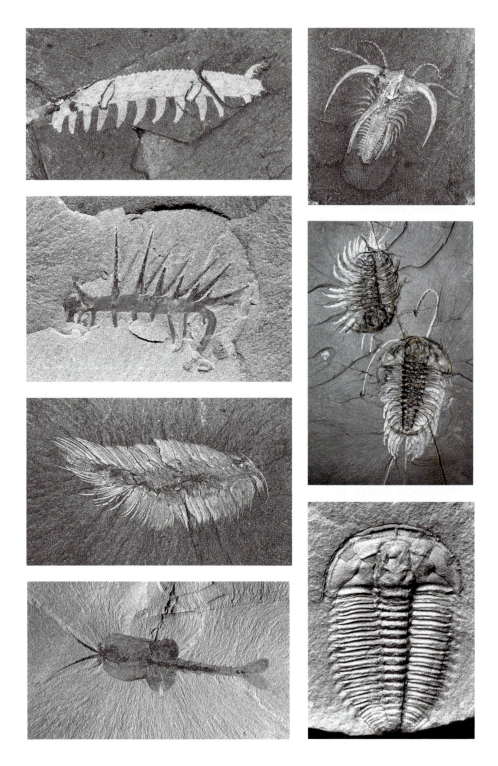

BURGESS SHALE FOSSILS *National Museum of Natural History*

How old is America and what did it look like in its earliest times? Planetary geologists now estimate that Earth was formed about 4.56 billion years ago. Three hundred million years ago, if you were looking at the planet from outer space it would have been very hard to identify what later became North America as it was a part of one massive supercontinent, Pangaea, in a vast ocean.

With geological evidence of plate tectonics, we now know that North America

BURGESS SHALE FOSSILS

formed when it broke away from a larger landmass incorporating Europe and Asia. To the south was Earth's other supercontinent, which included South America, Africa, and Australia. As the present-day continents separated and drifted on Earth's surface over billions of years, their positions relative to the planet's axis, its north and south poles, also shifted. This meant that parts of what became the United States once featured great seas. These geological formations hosted life, including plants and animals that lived and died hundreds of millions of years ago. The scale of both geological and biological change over this almost unimaginable length of time is difficult to comprehend. But just think, fossils found on New Hampshire's Mount Washington, the highest peak in New England, are those of trilobites, brachiopods, and other ocean creatures. Parts of North America, such as Montana, actually hosted subtropical forests.

ONE OF THE MOST IMPORTANT GEOLOGICAL DISCOVERIES OF THE TWENTIETH CENTURY OPENS A WINDOW ONTO LIFE IN AMERICA HALF A BILLION YEARS AGO.

National Museum of Natural History

Fossils, a term coined in the seventeenth century to mean something dug up from the earth, had long been viewed as curiosities. It was really only in the early nineteenth century that specialists in natural history, later to be called scientists, started examining such remains in a systematic way to understand the development of Earth and life upon it. Perhaps the most intriguing of such finds in North America came with the discovery in 1909 by Charles D. Walcott, then secretary of the Smithsonian Institution, of

what came to be known as the Burgess Shale fauna. These fossils, about 525 million years old, constitute one of the most important animal fossil finds in the world. They offer a remarkable window into what is known as the Cambrian explosion, the burst of diversification that gave rise to the lineages of life on Earth as we know it today.

Walcott was a pioneering paleontologist. While doing fieldwork with his family in the Burgess Pass of the Canadian Rockies one summer, he found fossils embedded in the black shale outcroppings above the town of Field, British Columbia. These turned out to be only the first specimens of an enormous trove of rare Cambrian era fossils, representing many animals new to science. He returned in 1910 to do more excavations, and again on and off for years to come. By 1924, he and his aides had discovered and excavated some sixty-five thousand fossil specimens, which are now housed in the Smithsonian's National Museum of Natural History.

Viewing the fraction of these thousands upon thousands of specimens that are on exhibit today at the museum, my mind strains to comprehend what my eyes see. These fossilized creatures are literally a snapshot of the past, a prehistorical menagerie, some recognizable, others truly mysterious as if from a science fiction movie. Walcott recognized their special significance, for while previous fossil finds typically depicted the hard parts of bodies like shell and bone, the Burgess Shale contained the fossilized traces of soft-bodied organisms—including the muscles, gills, digestive systems, antennae, and other body parts that are almost never preserved. These sea-dwelling animals had been captured in such an exceptionally complete form because their ecological community had been quickly buried in a series of underwater avalanches of silt and fine mud.

Walcott tried for almost two decades to connect the diverse early life forms to those species still living today. He showed how many of the fossilized organisms shared features that are recognizable in contemporary plants and animals. Among these were forms of algae and even primitive chordates—animals with a backbonelike structure. Ultimately, the Burgess

Shale fossils not only offered rare and striking evidence of early forms of animal life but also showcased a truly ancient moment in the process of evolution.

Preserving the Burgess Shale fossils at the National Museum of Natural History has provided millions of visitors the opportunity to peer back in time at the diversity of life that occupied North America some 500 million years ago and also served a strong research purpose. Walcott's specimens have allowed generations of scientists to reinterpret their significance.

In the 1960s, scientists began to reexamine the Burgess Shale, igniting debates that continue today. New expeditions and excavations near Walcott's site in the Canadian Rockies added even more diversity to the fossil finds. Similar finds were also made in Australia, China, Greenland, Siberia, Spain, and the United States, adding to scientists' ability to reassess the Burgess Shale classifications. Scientists challenged Walcott's idea that the fossilized organisms fit into groups of modern species. They focused their attention on how many of the creatures seemed to bear little resemblance to those of the modern day, such as *Opabinia*, with five eyes on stalks and a long snout that ended in a spiny claw, or *Hallucigenia*, whose name was coined to reflect its weird, dreamlike appearance.

Paleontologist Stephen Jay Gould brought the fascinating diversity of Burgess Shale fossils and the idea of the Cambrian big-bang explosion of life to a wide popular readership with his 1990 book, *Wonderful Life: The Burgess Shale and the Nature of History.* He argued that the Burgess Shale fossils demonstrated nature's evolutionary experiments, many of which yielded lineages that became extinct. Others have since questioned the lessons that Gould drew from the Burgess Shale and his emphasis on the role of chance in evolutionary history.

Cambridge University's Simon Conway Morris and the Royal Ontario Museum's Jean-Bernard Caron provided a dramatic case in point of these connections. One of the fossils, depicted on page 24, has the scientific name *Pikaia gracilens,* described by Walcott in 1911. *Pikaia* averaged about two

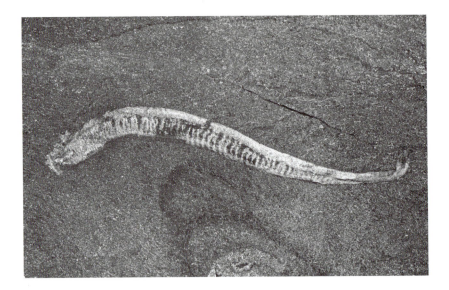

inches in length and swam above the seafloor using its body and an expanded tail fin. The animal's body is not rounded or earthwormlike. Given the extraordinary preservation of soft-tissue remains in the fossil, one can make out muscle blocks lying along a central notochord, or stiffening rod. This rod does not have vertebrae and is not a backbone as such, but it is the anatomical predecessor to such a feature. It makes *Pikaia* a cephalochordate, part of the group from which primates and eventually human beings evolved. No one can say if this particular type of creature is a direct predecessor of humans, though it is at least an ancestral cousin.

We know that humans arose in Africa and did not descend from any of the specific creatures found in the Burgess Shale, but these fossils continue to give us important clues as to the evolution, profusion, and extinction of life on the planet, and particularly in North America.

The fossils also remind us that American history is not really very old relative to the span of the natural history of the land and the life it hosts. Imagine that the time from the formation of the Burgess Shale fossils to the present were put on a one-day, twenty-four-hour clock. The time from

the fossils' formation until the migration of the first people into North America would constitute about twenty-three hours, fifty-nine minutes, and fifty-nine and a half seconds. Columbus would arrive with less than one-hundreth of one second left to go before midnight, and the whole of the history of the United States, from our Declaration of Independence in 1776 to our life today, would occur in much less than the blink of an eye!

BALD EAGLE *National Zoological Park*

Millions of years before human beings migrated to North America, as the Sierra Nevada and Cascade mountain ranges were still being formed, the first bald eagles soared across the boundless skies, maintaining a seemingly inalienable dominion over the bountiful landscape of what would eventually become the United States. By the time European settlers arrived, there might have been as many as half a million of these distinctive, uniquely American birds, revered by Native cultures for their majestic flight, fierce intelligence, and arresting appearance. The fateful—and ultimately hopeful—trajectory of their very existence is indicative of both the natural and the human history of America.

Despite the misnomer, the bald eagle is not bald. Its scientific name, *Haliaeetus leucocephalus* (white-headed), refers to the distinctive smooth white crown of the birds when they reach maturity at about six years old. The bald eagle is the only species of eagle unique to North America. Scientists believe that the species diverged from the Eurasian white-tailed eagle during the Miocene age, some ten to eighteen million years ago, somewhere in the northern Pacific—with the bald eagle heading east into North America.

Bald eagles typically occupy habitats near large bodies of water. They eat fish and small mammals and are renowned scavengers. Their fine "eagle eye" binocular and peripheral vision enables them to spot and then swoop down to catch prey in their talons. Bald eagles typically form monogamous pairs and construct their nests in tall trees or on cliffs; some nests are occupied by successive generations over time.

With a distinctive hooked, yellow beak and strong talons, a wing span of seven feet, and a normal flying speed of about thirty-five miles an hour, the bald eagle exudes power in the sky. Bald eagles live for about twenty years in the wild. In the late eighteenth century, it was thought that there were about 100,000 eagles in the continental United States.

2

BALD EAGLE

A MAJESTIC INDIGENOUS BIRD BECOMES A SYMBOL OF A NATION'S VITAL CONNECTION TO THE LAND.

National Zoological Park

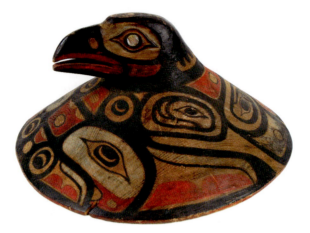

BALD EAGLE
DEPICTED IN
TLINGIT CREST
HAT

*National Museum of the
American Indian*

The bald eagle is sacred to a number of American Indian tribes, considered to be a messenger between humans and divine spirits. Eagle feathers are often part of traditional regalia like headdresses. Feathers and claws are used in traditional ceremonies. Plains Indians, for example, use eagle feathers as part of a medicine fan to help cure illness. Lakota present eagle feathers to those they honor; "a feather in the cap" is an expression deriving from this usage. Other Native tribes use representations of eagles to symbolize fertility and strength in their dances and prayers.

After the United States declared its independence, one of the Continental Congress's first acts was to commission a great seal. It took six years, three committees, and a good deal of debate. Finally, in 1782, with the American Revolutionary War coming to an end, it settled on a symbol of nationhood with the bald eagle at its center. Congress admired this distinctive American bird for its physical prowess and liked the parallels it suggested with the ancient Roman Republic, which also used the eagle in its symbolism. In the Great Seal of the United States, the eagle holds thirteen arrows and a thirteen-leaf olive branch in its talons, representing the thirteen original colonies.

Since then, and despite Benjamin Franklin's preference for the turkey,

the bald eagle has been used on the presidential seal, as part of the logo for many federal departments and agencies, and as a design element on U.S. coins and stamps. It has become a patriotic symbol used in political campaigns and to recruit soldiers.

Despite the visual ubiquity of its image, the bald eagle became an endangered species in nature because of habitat destruction, illegal shooting, and the presence of contaminants, particularly the insecticide DDT, in its prey. Though legal protection began with the Lacey Act of 1900, followed by the Migratory Bird Treaty of 1918, and then, more specifically, by the Bald Eagle Protection Act of 1940, fewer than one thousand bald eagles remained in the wild by 1963. Endangered species legislation in the 1960s and 1970s helped with restoration efforts, although the bald eagle was still listed as endangered or threatened in 1978 for almost all of the United States. The Bald Eagle Protection Act helped restrict hunting and limited the collection of bald and golden eagle feathers only to those legally recognized as Native American and for the purpose of religious and spiritual practice—criteria recently tightened. By 1995, the bald eagle population had increased dramatically to about nine thousand in the wild, a gain largely attributed to the banning of DDT decades earlier. The U.S. Fish and Wildlife Service designated bald eagles as threatened rather than endangered, and then removed them from the list in 2007. However, ongoing threats remain and include loss of wetland habitats, illegal shooting, poisoning from lead, and the ingestion of pesticide and chemical residues from eating prey.

The Smithsonian's National Zoological Park has a bald eagle named Tioga. A male, he came to the zoo from the American Eagle Foundation located at Dollywood in Pigeon Forge, Tennessee. He had been found as a fledgling near his nest in Pennsylvania in 1998 with a badly healed fracture of his left shoulder that made him incapable of flight. Sam, another male, originally from Alaska, came at the

same time. Curator Vincent Rico recalls how the two "absolutely gorgeous, feather-perfect birds," the smaller, more high-strung Tioga and the larger, calmer Sam, were introduced into the exhibition environment. For years the pair helped millions of visitors appreciate the importance of the species before Sam died in 2010.

At the National Zoo, a team of nutritionists and veterinarians keep Tioga healthy and active, enjoying a diet of fish, quail, chicken, and rats. Though Tioga is flightless and could not survive in the wild, other migrating eagles take advantage of the zoo's Bald Eagle Wildlife Refuge. Some five hundred pairs circulate in the Chesapeake Bay region. Smithsonian staff see every day how the presence of eagles in the zoo helps to increase awareness of the species and their fragility. Adopted as a national symbol more than two hundred years ago for its connotations of indomitable force, righteous dominion, and boundless resources, the eagle now also reminds us of our quest to achieve a more thoughtful balance between the natural and man-made environments in order to preserve the values of freedom and bounty that gave rise, centuries ago, to the promise of a new nation.

The stone tools in the Smithsonian's collection may at first glance look deceptively simple, but the stories they tell and the arguments they occasion are complex. Among the most interesting are those concerning the origins of the first Americans.

Native Americans have a wide variety of accounts, suggesting that humans emerged from underground, descended from the sky, or migrated from other lands. Following European settlement in the sixteenth century, priests, settlers, and scholars applied their own cultural assumptions and speculated that the Native people they found in North America might have originally been one of the lost tribes of Israel described in the Bible or even survivors from the vanished, mythical island of Atlantis. One Spanish Jesuit, José de Acosta, who lived in Peru, arrived at an explanation close to modern conventional scientific understanding. In 1590 he suggested that some of the Indians of the "New World" might have arrived by sea, but that mainly they had arrived by migrating overland near the "northern extremities" of North America—something he could only guess given the lack of empirical geographic knowledge about the Bering Strait at the time.

Key scientific evidence demonstrating the duration of human presence in the Americas came with an extraordinary discovery near Clovis, New Mexico, in 1929. There, nineteen-year-old Ridgely Whiteman found "warheads" and "extinct elephant bones" in the desert. Whiteman, active in the Boy Scouts, was interested in Indian lore and familiar with arrowheads from an extensive collection of artifacts his mother had accumulated in her native Ohio. Convinced of the significance of his discoveries, he sent a letter and a fluted flint spear point to Alexander Wetmore, the assistant secretary of the Smithsonian. Charles Gilmore, the Smithsonian's vertebrate paleontologist,

3

CLOVIS STONE POINTS

HUNTING TOOLS REVEAL AN EXTENSIVE HUMAN PRESENCE IN NORTH AMERICA 13,500 YEARS AGO.

National Museum of Natural History

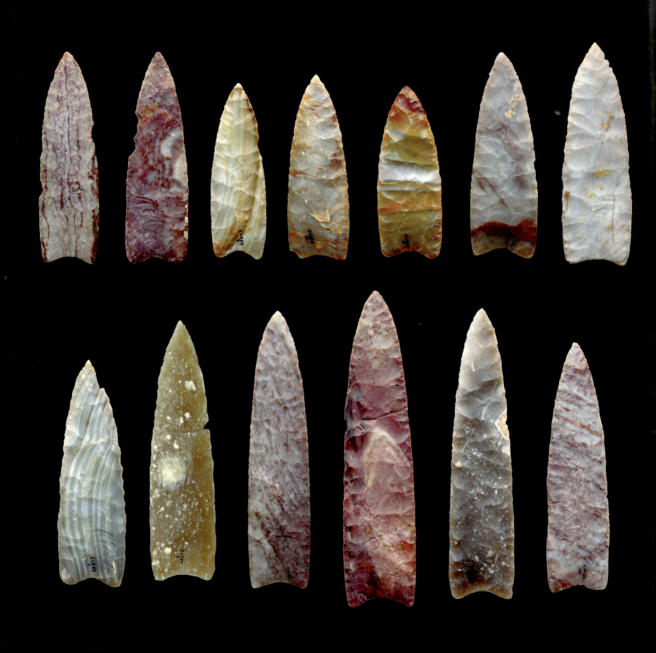

CLOVIS STONE POINTS *National Museum of Natural History*

went to Clovis to meet up with Whiteman and inspect the site. He found bison bones and a mammoth tooth, but no human artifacts.

Smithsonian anthropologists of the time were generally skeptical that the Americas had a Stone Age prehistory anything like that of Europe or the Middle East, where troves of stone tools had been found. But new finds in the American Southwest proved impossible to ignore. It would be an archaeologist from the University of Pennsylvania Museum of Anthropology and Archaeology, Edgar Howard, who joined with Whiteman to uncover the decisive artifacts in New Mexico. By 1933, Howard had accumulated evidence to support the existence of man-made artifacts—what years later came to be called Clovis points—in close association with the remains of mammoths and other extinct animal species. These points, Howard concluded, indicated the presence of a big-game hunting people in the American Southwest. Since mammoths were extinct, the existence of the man-made tools for hunting these beasts indicated that human habitation had occurred long ago. But how old were the Clovis points? Howard couldn't be sure, but he found Clovis points under a layer of earth replete with bison remains and another distinctive type of point, called Folsom. He concluded that the area had been occupied by at least two prehistoric cultures, Clovis being the more ancient.

Clovis became the generic name for similar finds, first in the West, but later in other parts of North America, and scores of them like those pictured came to the Smithsonian. Clovis points were made out of several different types of rock, typically flint, jasper, chalcedony, or chert. The point was made by flaking and chipping, a technique archaeologists call knapping. Basically the mother rock is held in one hand or on a horizontal surface, such as the maker's thigh. The maker wields another rock—the percussor— in his or her other hand and strikes, chips, and flakes off the mother stone, fashioning it into shape. Edges are made sharp by applying careful pressure to break off fine chips rather than striking. I have tried knapping, and it is a lot more difficult than it sounds.

The shape of the Clovis point likely arose through much trial and error. The sides of the stone taper from roughly parallel at the bottom to convex toward the tip. It is decidedly thicker in the midsection, which gives it weight, and is sharp at the side and tip edges so as to pierce and cut. The base is typically concave and dull-edged, and it is fluted—that is, a channel is chipped out on one or both surfaces at the bottom of the stone. This allows for hafting—the attaching of the point to, for example, a wooden shaft for use as a spear. Given that Clovis points range from about two to eight inches long, they were likely used at the tip of a number of different kinds of hunting, carving, and cutting tools—like spears, darts, or knives.

The age of Clovis points was not determined with any certainty until two decades after Whiteman's discovery. In 1949, University of Chicago chemist Willard Libby and his team invented a process called radiocarbon dating, which later won him a Nobel Prize. That technique is based on the fact that during their lifetimes, plants take in carbon-14 through photosynthesis. After they die, the isotope starts to decay at a fixed rate. By extrapolating the documented short-term decay rate, Libby calculated that the carbon isotope has a half-life of almost 5,600 years. In other words, half of the carbon-14 isotopes found in a certain substance would have decayed in that time, another half in another 5,600 years, and so on. With this chronologically fixed decay process established, Libby could then measure the amount of carbon-14 in a substance and essentially work backward to figure out when it died. Archaeologists collected burned or decayed organic remains found in proximity to stone points during their excavations, and by dating the remains could thus extrapolate the time the tool was used. Tests of material associated with Clovis points from different parts of the United States, Canada, and Mexico have now yielded dates up to about 13,500 years ago.

The identification of Clovis points and their age raised questions about the origins of their makers. Since the earliest archaeological discoveries were made in the western plains, most anthropologists believed that the

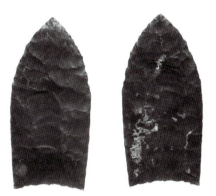

first Americans migrated over land bridges across the Bering Strait from northeastern Asia into Alaska about fourteen thousand years ago, when the sea levels were lower due to the last ice age. They would then have moved southward following ice-free corridors along the Pacific Coast and east of the Rocky Mountains, eventually moving south and eastward through Central and South America.

Questions about when and how the first Americans came are far from settled, however. In the late 1970s, archaeologist Tom Dillehay's discoveries in South America at Monte Verde, near Chile's west coast, included a human footprint, evidence of shelters, and stone tools. Carbon dating suggested human occupation almost fifteen thousand years ago. This finding was initially controversial, as many archaeologists were firmly convinced that Clovis culture had been America's first. But rigorous examination confirmed Dillehay's results and prompted archaeologists to speculate that there were probably multiple waves of migration from Asia, including at least one that predated Clovis. Many now believe that early migrants to the Americas did not generally follow large mammalian prey, such as mammoth, overland into the North American interior, but more likely moved southward along the West Coast by boat, surviving on fish, clams, and other

CAST OF RIDGLEY WHITMAN'S PROJECTILE POINT
National Museum of Natural History

seafood. The habitation sites of these early migrants, researchers reason, would now be underwater, off America's Pacific coastline, as sea levels have risen since then. Non-Clovis remains dating from about thirteen thousand years ago found on the Channel Islands just off the coast of Santa Barbara, California, might be evidence of one such migration.

Dennis Stanford, a colleague at the Smithsonian, has come to a very different and controversial conclusion. He has studied numerous Clovis finds in the eastern United States, including some from the Chesapeake Bay region, parts of Pennsylvania, and New England. Their dating is comparable to Clovis finds in western Canada, suggesting the technology may not have originated in the northwestern part of the continent, as previous scholars had thought. Stanford also points to the lack of extensive finds of Clovis-like points in northeastern Asia and instead thinks Clovis points bear a striking resemblance to, and seem to be made in the same way as, stone and bone artifacts identified with Solutrean culture from the Iberian Peninsula in Europe. From this resemblance, Stafford hypothesizes that twenty thousand years ago early Solutrean peoples hunted marine animals along the frozen edge of the North Atlantic ice shelf that connected Europe and North America during the last ice age. They may have used primitive boats to make their way across an Atlantic ice shelf from Europe through Iceland, Greenland, and northeastern Canada.

With the advent of DNA studies, scientists have been able to examine the connections between populations. Mitochondrial and Y-chromosome DNA analyses tend to link Native American populations to those of Siberia and eastern central Asia, and suggest a divergence of the two populations between fifteen thousand and twenty-two thousand years ago.

Linguistic evidence—another method for identifying long-lost links between peoples—is inconclusive, with no convincingly clear links between Native American languages and those of Asia or anywhere else. Depictions in rock art of such culturally distinctive symbols as large game animals, shamanistic drums, and turtles suggest linkage between America and Asia, though dating such evidence remains an issue.

As more evidence comes to light and archaeological and other methodologies evolve to interpret key pieces of evidence like the Smithsonian's collection of Clovis points, we will have new and different theories to address the question of who first came to America and when. Settling on an answer will undoubtedly provoke vigorous scientific debate.

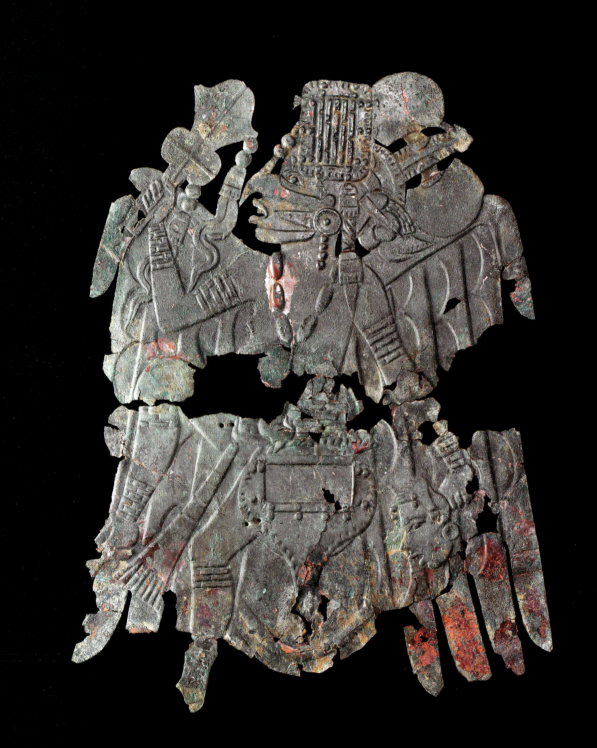

COPPER PLATE REPOUSSÉ OF A BIRDMAN *National Museum of Natural History*

Excavating an earthen works mound at Etowah, Georgia, on behalf of the Smithsonian's Bureau of American Ethnology in 1883, James P. Rogan came across stone sepulchers containing the skeletal remains of several adults and children. Among them were thin copper plates, two of which were exceptionally exquisite and depicted human birdlike characters. The workmanship startled anthropologists back at the Smithsonian, and—despite initial thoughts that the plates might have come



4

MISSISSIPPIAN BIRDMAN COPPER PLATE

from Mexican or Central American civilizations—challenged them to figure out who made them, how, and why. The embossed copper sheets, typically known as the Rogan plates, helped change the way scholars thought about the Native cultures of North America.

Questions about American Indian origins had long occupied explorers, settlers, and scholars who came upon enormous earthen works mounds in Ohio, Tennessee, Alabama, Georgia, and, most of all, Cahokia, Illinois, near present-day St. Louis, Missouri. French explorers traveling along the Mississippi River in the seventeenth century found more than one hundred mounds spread over an area of six square miles near Cahokia. The largest, now known as Monks Mound (named after European Trappist monks who established a monastery there in the late eighteenth century), was some one hundred feet high. The size of its base, measuring more than nine hundred feet long and more than eight hundred feet wide, rivals that of the Great Pyramid in Egypt. Other mounds, like Great Serpent Mound in Ohio, were designed and constructed in figurative shapes.

Even though sixteenth-century Spanish explorer Hernando de Soto had encountered Native Americans who built and used earthen works for defensive and ritual purposes, speculation abounded about the original

A FINELY EMBOSSED DECORATION FROM ABOUT A.D. 1300 DEMONSTRATES THE COMPLEXITY AND ARTISTRY OF NORTH AMERICAN NATIVE CIVILIZATION.

National Museum of Natural History

mound builders. Some Euro-American settlers, viewing Native Americans as lacking in "civilization," could not imagine them building such sophisticated structures. As a result, well into the nineteenth century the lost tribes of Israel, Egyptians, Greeks, Mesopotamians, and Hindus—basically, anyone but Native Americans—were suggested as the architects of the mounds.

Thomas Jefferson suspected otherwise when, in the 1780s, he excavated several skeletons and artifacts from a burial mound with a forty-foot circumference near his Monticello, Virginia, home. His conviction that the mounds were made by indigenous Americans was reinforced when he observed that local Monacan Indians periodically returned to the mound to perform mortuary rituals and venerate ancestors. In 1848, the Smithsonian published its first book in its *Contributions to Knowledge* series, *Ancient Monuments of the Mississippi Valley*, by Ephraim George Squier and Edwin Hamilton Davis. The work established the use of surveying as standard archaeological practice and illustrated how extensive mound building was.

Now, with the benefit of more than a century of research following Rogan's discovery, we know a lot more about the mounds, the societies that produced them, and the ceremonial practices and religious beliefs surrounding such figures as the birdman. Archaeological research has revealed that mound building is a tradition well over five thousand years old in America. By A.D. 1000 tens of thousands of mounds had proliferated in a region that stretched from west of the Mississippi River to the Atlantic Ocean and from the Gulf of Mexico to the Great Lakes.

Settlements of mound-building people were established on a scale comparable to the massive cities of the Aztecs of Mexico, the Maya of the Yucatán, and the Inca of the Andes. Cahokia, the largest urban center in North America, supported a population estimated at twenty to forty thousand people at its peak in the twelfth century—comparable to London at the time. Archaeological excavations have unearthed residential units near the mound composed of sod blocks, wooden posts, skins, and natural fibers, with hearths for cooking. Cahokia's economy depended upon planting and harvesting expansive fields of maize, supplemented by gardening, hunting,

and fishing. This midwestern metropolis was a bustling multiethnic hub populated by immigrants, pilgrims, and locals. Monks Mound included a huge plaza for large civic gatherings—perhaps for sports and religious rituals. Other structures included a stockade fence with watchtowers, a possible astronomical observatory, and earthen works where members of important lineages were likely buried. Artifacts found at the site indicate that Cahokia was trading goods and information with sites throughout the Great Lakes region, the Southeast, and near the Gulf of Mexico.

Cahokia was the major center for a culture, termed Mississippian by archaeologists, that spread over a large region of what later became the central and southeastern United States. It was characterized by large chiefdoms and an important spiritual and religious tradition called the Southeastern Ceremonial Complex. Mississippian people believed in the so-called birdman, depicted on stone tablets, pottery, shell pendants, and hammered copper plates that were worn as headdresses. Because of Cahokia's importance in shaping this tradition and some, though limited, evidence of a copper workshop there, several scholars believe that the repoussé plates found at Etowah originate from Cahokia.

This plate, about thirteen inches long and nine and a half inches wide, is made of sheet copper on which the birdman is carefully hammered out and its details tooled and finely chased, probably with a tool made of bone or antler. It depicts the large-winged birdman in an active stance, possibly dancing. His upraised arm holds a stone mace; his lowered arm holds a severed head. The birdman is richly costumed, wears an elaborate headdress, and possesses what seems to be a medicine bundle.

The plate was discovered in Mound C, which was built at Etowah during the period A.D. 1250–1400, though it could have been fabricated well before that. Etowah was the political and trade center of a regional Mississippian chiefdom, and the mound served as a burial site for the elite. Individuals were buried there with regalia and ornamentation like that illustrated in the repoussé plate.

Ethnohistoric documents and oral traditions indicate that the birdman

was a powerful deity who embodied several different incarnations represented by symbols on the copper plate. Archaeologists, art historians, and specialists in Native cultures have offered varied interpretations of the iconography. Part falcon, the birdman was associated with the upper world of the sun, moon, stars, and sky. As a bird of prey, the falcon appears to have been a spiritual guide for and representation of warfare. The mace and human head likely signify the birdman's prowess as a warrior. Yet the birdman is also associated with rebirth and fertility. For instance, his long nose and earrings may denote an avatar associated with fertility, whereas the bi-lobed arrow motif on his headdress has been interpreted as a symbol of death and rebirth. The birdman's ritual braid is a symbol of his incarnation as Red Horn, a mythic hero of high status and achievements who fought a supernatural war on behalf of humanity.

Some researchers believe that the copper plates were a means of not only representing the birdman's power, but also a way of imparting that power to those who wore them. Mississippian rulers would have prominently displayed these birdman plates to associate themselves with powerful gods and legitimize their power. People would see in their leader's connection to the spiritual realm enhanced powers to protect the community and fight off enemies. The symbolic association of a ruler with the falcon might also help him achieve his after-death journey to the heavens.

Through archaeological and related studies we continue to learn about how Cahokia, Etowah, and other mound settlements developed, as well as how and why they declined and were abandoned—possibly because of invasion by hostile groups, environmental degradation, and the spread of disease in the fourteenth and fifteenth centuries. But there is no doubt that Mississippian society, native to North America, was highly sophisticated and complex, defying later European expectations—and even those of some early anthropologists.

NEW WORLD

(1492 TO MID-EIGHTEENTH CENTURY)

CHRISTOFLE COLOMB, GENEVOIS

Chapitre 100.

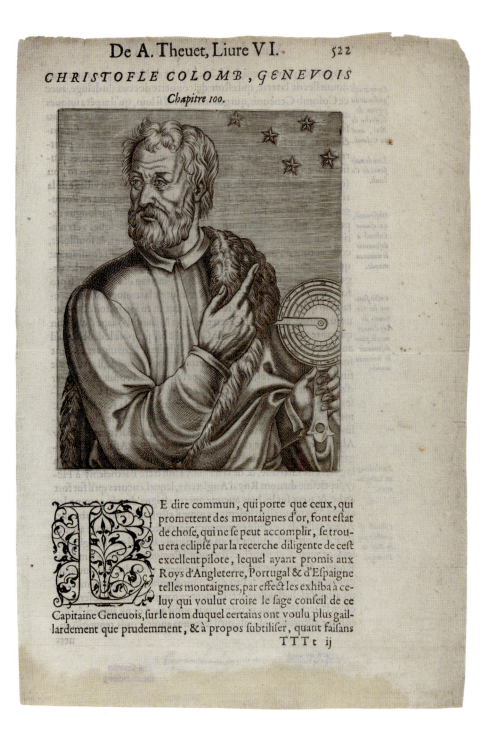

E dire commun, qui porte que ceux, qui promettent des montaignes d'or, font estat de chose, qui ne se peut accomplir, se trouuera eclipsé par la recerche diligente de cest excellent pilote, lequel ayant promis aux Roys d'Angleterre, Portugal & d'Espaigne telles montaignes, par effect les exhiba à celuy qui voulut croire le sage conseil de ce Capitaine Geneuois, sur le nom duquel certains ont voulu plus gaillardement que prudemment, & à propos subtiliser, quant faisans

TTTt ij

He was reported to be tall and strong, with light skin, light-colored eyes, and blond or reddish hair gone prematurely white. But aside from that general description, we don't know what Christopher Columbus (1451?–1506), the man who is often credited with "discovering" America in 1492, actually looked like. There are no known portraits of Columbus made while he was alive.

One of the earliest known images of Columbus is at the Smithsonian's National Portrait

CHRISTOPHER COLUMBUS'S PORTRAIT

Gallery in the form of an engraving from a book, *Les Vrais Pourtraits et Vies des Hommes Illustres* (*The True Portraits and Lives of Illustrious Men*), published in Paris in 1584. Its author, André Thevet, composed biographical essays of great men. He researched images for the book to accompany each essay and reportedly acquired an engraving of Columbus that was a copy of a copy. Thevet's image was made by an unknown artist who based his work on an oil painting by a Dutch artist who was living in Lisbon at the same time as Columbus.

In the portrait, Columbus points to the stars and is holding a navigational instrument. His gaze is distant, disconnected from the viewer, perhaps reflecting what some have speculated was his failing eyesight. His demeanor is unsettlingly pensive as he stares out intently toward the horizon. The pose captures Columbus, a stubborn and determined man whose vision of reaching Asia by sailing westward had many detractors, and whose success was disputed.

Columbus was not the first European to land in the Americas. Evidence from the archaeological site of L'Anse aux Meadows in Newfoundland, Canada, confirms that the account from the Icelandic sagas of Leif Ericson reaching North America is probably true. Ericson and his Norse

A HISTORICAL ENGRAVING DEPICTS THE EXPLORER WHOSE VOYAGE TO THE NEW WORLD PAVED THE WAY FOR EUROPEAN COLONIZATION OF AMERICA

National Portrait Gallery

compatriots likely landed in what they called *Vinland* and established and then abandoned a temporary settlement there. Numerous theories still being researched assert that other pre-Columbian visitors from afar reached the Americas, including Polynesians making landfall on South America's Pacific coast and a Malian king crossing the Atlantic in the fourteenth century. Whatever the truth, it was Columbus who ignited the great age of exploration.

Columbus was an experienced seafarer, probably born in Genoa, though others also claim him. From his studies of the writings of ancient travelers, geographers, and astronomers, he was convinced that ships could reach Asia from Europe, not only by traveling south and then eastward around Africa but by sailing westward. He, like many others of the time, accepted the idea that the world was spherical, but he believed Earth had a much smaller circumference than it actually does. He thought he had to journey only about twenty-four hundred miles westward from the Canary Islands, just off Africa's Atlantic coast, to land in Asia. There was no thought of an intervening continent.

The goal was to find a shorter, less expensive, and safer route to Asia for trade. For several hundred years, European merchants followed land and sea routes east, later dubbed the Silk Road, to trade with China, India, Persia, and Arabia. The route had been pioneered by Venetian adventurer Marco Polo and was protected by the rule of the Mongol Empire, which stretched from the Middle East through central Asia to India and China. But trade in silk, spices, precious metals, and rare goods was disrupted in 1453 with the fall of Constantinople (Istanbul) to the Ottoman Turks. European powers were forced to look for alternative sea routes to avoid the Middle East. For decades, Portuguese navigators made progress sailing their ships along Africa's coast, making new discoveries and bringing back new goods. Nevertheless, by the 1480s they had failed to reach the "Indies"—India and the Spice Islands.

Columbus was convinced that his westward route was faster and more direct. He spent years trying to convince Portuguese, Venetian, Genoan,

and English sponsors to support his plan. He was unsuccessful until Ferdinand and Isabella, king and queen of a newly united Spain, agreed. Hungry for advantage over their rivals in the spice trade and hoping to spread Christianity to India and beyond, the Spanish monarchs helped finance the voyage of Columbus's three ships, the *Santa María*, the *Pinta*, and the *Santa Clara*, which was nicknamed the *Niña* after her owner. They also agreed to make him the "Admiral of the Ocean Seas," governor of any lands he claimed, and give him a 10 percent share of any resulting revenue.

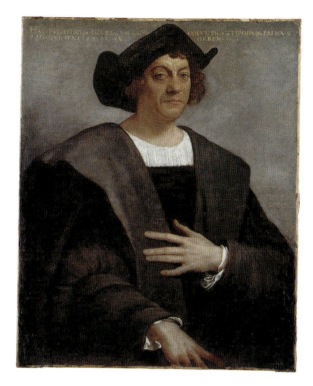

Columbus set sail from Spain in August 1492. He stopped at the Canary Islands for restocking and repairs, resuming the voyage in early September. On October 12, his crew sighted land and came ashore on an island he named *San Salvador*, which historians believe is in the Bahamas. According to his diary entry of that day, Columbus met peaceful natives whom he thought he could easily conquer and convert to Christianity. He called them Indios, or Indians, convinced he was in Asia, east of Japan. Subsequently, Columbus also landed on Cuba and on Hispaniola, which is the present-day Dominican Republic and Haiti, where he established a settlement and grounded and then lost the *Santa María*.

Columbus returned to Spain a hero, and was named the viceroy of the Indies. He would make three additional voyages, claiming land for the Spanish crown and souls for Christianity. Thousands of soldiers and settlers

PORTRAIT OF A MAN, SAID TO BE CHRISTOPHER COLUMBUS BY SEBASTIANO DEL PIOMBO

Metropolitan Museum of Art

accompanied him, establishing colonies on Caribbean islands and along the South American and Central American coasts. Never on any of these voyages did Columbus touch the shores of North America.

Columbus proved an inept governor of Hispaniola. He sought gold and other tributes from the native people. Under his orders and policies, native Tainos—numbering perhaps two hundred thousand—were enslaved, and, over the course of ensuing decades, almost exterminated. The Crown replaced Columbus as governor, and toward the end of his third voyage in 1500 he was arrested and brought back to Spain in chains. He was subsequently freed and had his wealth restored by King Ferdinand. Though he was able to make a fourth voyage, the Crown would not let him govern and reneged on payments. Columbus and his descendants contested claims against the Spanish court for decades.

Columbus died at age fifty-four in Valladolid, Spain. His remains were transferred decades later to colonial Santo Domingo, and then in 1795, when France took over the island, to Havana, Cuba. In 1898, following the Spanish-American War, they were sent back to Seville Cathedral in Spain. The Dominican Republic claims that some of Columbus's remains still reside in the Columbus Lighthouse in Santo Domingo.

Columbus was celebrated in the United States during revolutionary times as a symbol of the independent identity of the American people. In 1776, African American poet Phillis Wheatley turned "Columbia" into a mythical female personification of the nation in a letter sent to George Washington. The capital region became the District of Columbia; two state capitals, of South Carolina and Ohio, were named after Columbus; and a statue of the goddesslike Columbia was placed atop the Smithsonian's U.S. National Museum building, guarding science and industry.

In 1893, the four-hundredth anniversary of the explorer's voyages was marked by the World's Columbian Exposition, also known as the Chicago World's Fair. The U.S. Post Office issued the first-ever commemorative stamps—the Columbian issue, celebrating the explorer's accomplishments. They proved enormously popular. Numerous paintings and images of

Columbus were also exhibited and promulgated at the fair, and a good bit of scholarly care went into determining which images might be more plausible. Some were clearly fictional, others had Columbus in eighteenth-century garb, but none was thoroughly convincing.

Some one hundred years later, in 1992, there was much debate over the five-hundredth anniversary of Columbus's first voyage. Was it a celebration of a great achievement of discovery or the commemoration of a world-changing encounter between the people of the Eastern and Western hemispheres with immense positive and negative consequences? Researchers were more interested in the consequences of Columbus' actions than in depictions of his physical appearance.

Still, as different countries and cities competitively claim that Columbus is their native son, and as scientists try to piece together his origins using DNA tests, there is an abiding interest in knowing more about him. The most famous and most copied visual image is perhaps *Portrait of a Man, Said to be Christopher Columbus,* an oil-on-canvas work by the Italian Renaissance artist Sebastiano del Piombo, now in the collections of the Metropolitan Museum of Art in New York. The painting's inscription, which is old but not original, refers to the subject as Columbus. It was, however, painted in Rome, a city Columbus apparently never visited, and was completed in 1519, more than a decade after Columbus's death.

Is the engraved image in Thevet's book a better candidate? Maybe. According to Steven Turner, a Smithsonian curator specializing in the history

COLUMBUS COMMEMORATIVE STAMP

National Postal Museum

of scientific instrumentation, the engraving shows the explorer holding a nocturlabe, or nocturnal. This instrument is a relative of the astrolabe and was used by navigators of Columbus's era to help tell time by sighting the north star and typically one other in Ursa Major or Ursa Minor—to which the sailor is pointing. Columbus is known to have used a compass, a quadrant, and a sandglass, and taken with him some type of *astrolabo* for navigation. He needed to know his latitude to take advantage of the prevailing ocean winds that blew westward at certain latitudes, eastward at others. The nocturnal would have helped his calculations. That the nocturnal is depicted doesn't prove that the image is a true one of Columbus, but it does give some credence to Thevet's portrayal. In all likelihood, though, we will probably never know for certain how Columbus really looked.

Spanish explorers sought riches in America, but they also pursued a religious mission in their travels and conquests: the conversion of Indians to Christianity.

It was no wonder. Even if Spanish explorers in America failed to find gold or other riches, a mission to bring Christianity to Indians provided a convincing rationale for sponsors to continue to supply ships, men, and money. It also accorded well with religious politics back in Spain, where an Inquisition, begun in 1478, was accelerating. With the ascendency of a united Aragon and Castile under King Ferdinand and Queen Isabella, and the defeat of the last of the Muslim Moorish rulers in Andalusia, the kingdom became a bastion of Christendom. Expunging non-Catholic beliefs and behavior from the country became a royal, ecclesiastic, and civic duty.

The New World was the frontier of this effort. The early conquistadores made the eradication of Native spiritual leaders and the mass conversion of Native people part of their colonization program in the Americas.

Juan de Oñate y Salazar (1550–1626) was born in "New Spain," essentially colonial Mexico. Under orders of Spain's King Phillip II, he led an expedition to colonize the northern frontier "in the service of our Lord" by spreading the Holy Catholic faith and pacifying the Indians. Oñate crossed the Río del Norte, now the Rio Grande, near present-day El Paso in 1598 and claimed all the land beyond the river for New Spain. His party, which included seven Franciscan friars, continued north up the river valley and established a province he named Santa Fe de Nuevo México (though the town of that name was not established until more than a decade later). Oñate's trail from Mexico to the new province became known as the Camino Real, the King's Highway. Oñate established a small base for additional exploratory forays, bringing him into contact with Pueblo, Navajo, and Apache

6

SPANISH MISSION HIDE PAINTING OF SAINT ANTHONY

A RELIGIOUS PAINTING FROM A COLONIAL MISSION TO THE AMERICAN SOUTHWEST IS USED TO HELP CONVERT INDIANS TO CHRISTIANITY.

National Museum of American History

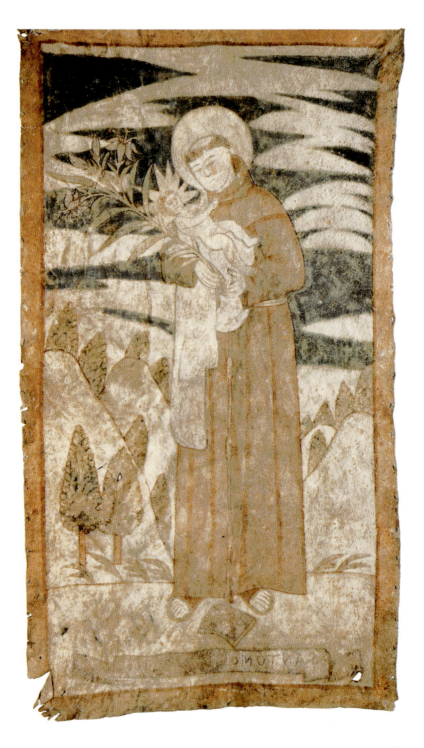

SPANISH MISSION HIDE PAINTING OF SAINT ANTHONY *National Museum of American History*

groups. Early on, he engaged in battles with the Acoma Pueblo, resulting in scores of deaths and brutal reprisals against the Native people, including slavery and amputation.

In 1598 the Franciscan friars founded the first Spanish mission, a religious outpost in New Mexico under Oñate's rule. A mission would usually consist of a chapel constructed of adobe brick and rough-hewn wood, though some were built of stone. The chapels would have no pews or seating; supplicants would stand or kneel on the earthen floor. Typically, chapels would have one or two towers, often several stories tall. A large wooden cross would top the tower, and some had bells installed to call people to prayer. The chapel would usually have a walled atrium or yard, which sometimes also served as a burial ground. The mission would include simple residences and fields. Some missions became rather fortresslike and grew to considerable size.

Mission iconography told the story of Christianity and encouraged conversions to the faith. Popular figures were Jesus, the Virgin Mary, Saint Joseph, and Saint Anthony. The Franciscans adorned the chapels with wooden crucifixes, wooden sculptures, and painted frescoes. Sometimes an ornate altar, or retablo, would be imported from Mexico. Walls were decorated with buffalo-, elk-, or deer-hide paintings featuring religious themes that were essentially teaching tools in the conversion process. They could be rolled up and easily transported.

The Spanish effort to convert the Indians of New Mexico to Christianity took decades and even then Indians retained many of their own religious and spiritual practices, and so sometimes conversions would be quite superficial. In 1680 the Pueblos revolted against the Spanish, expelled them from the region for more than a decade and in the process destroyed most of the missions and many of the hide paintings.

The hide-painting tradition continued after the Spanish reoccupation and the rebuilding of missions in the 1700s. For the Franciscans, the use of hides for visual representations of Christianity made sense—they were an easily available alternative to importing more expensive canvases for paintings. Elizabeth Boyd White, a noted curator of Spanish colonial art

at the New Mexico Museum of International Folk Art, identified this hide painting in the Smithsonian's collection as being painted in the early eighteenth century. Subsequent research identified the Mexico City–born Francisco Xavier Romero as the possible artist. Though he probably had little formal training, he sought to imitate studio techniques and drew as well upon woodcuttings and engravings from his home church for inspiration. His painting depicts Saint Anthony of Padua, Italy, in Franciscan tonsure, or shaved head, and habit, or robe. In his hands he holds an apparition of the baby Jesus, a common motif in the saint's representation. Saint Anthony was a well-respected contemporary of Saint Francis of Assisi, the founder of the Franciscan order, and among his most celebrated followers. He was canonized as a saint in 1232, less than a year after his death. He was acclaimed for his forceful, engaging preaching style.

Following Mexican independence in the early 1800s, Franciscan missionaries were withdrawn from New Mexico; the new supervising bishops, from the seat of the diocese in Durango, Mexico, learned of the paintings and did not find the rendering of sacred images on animal skins an appropriate form of religious expression, so they ordered their removal. The tradition of hide painting receded after New Mexico became part of the United States in 1848 and canvas became increasingly available for painting. And toward the latter part of the century, buffalo hides became increasingly rare as herds were hunted almost to extinction.

This hide came from the Tesuque Mission church in New Mexico, a building with a ceiling composed of thirty decorative carvings. By 1881, the church was in disrepair. The painting was collected by Jesse Walter Fewkes, who joined the Smithsonian's Bureau of American Ethnology in 1895 and became its director in 1918.

The missions of New Mexico were the oldest of the Spanish settlements in what became the American Southwest, contemporaneous with the British colonial settlements at Jamestown, Virginia, and Plymouth, Massachusetts. The Spanish built subsequent missions and outposts in Texas, Arizona, and California; San Francisco, San Diego, Santa Barbara, San Jose, Santa

Cruz, and other cities were built upon that heritage. The veneration of Saint Anthony is evident in thousands of churches in the region, and in the name of the seventh largest city in the United States: San Antonio, Texas. But hide paintings like the one at the Smithsonian also reflect something more. They are literal touchstones of the founding tradition of painting and santos carving in New Mexico—art forms that would emerge as vibrant aspects of Latino cultural identity in the American Southwest.

7

Simon van de Passe's engraving identifies her as Matoaka, the daughter of Prince Powhatan, emperor of the Virginia Algonquians, and notes her baptism to the Christian faith as Rebecca, currently wife to John Rolfe. The world knows her better by her nickname, Pocahontas (c. 1595–1617), the "playful one."

POCAHONTAS'S PORTRAIT

A 1616 IMAGE OF A FAMOUS NATIVE AMERICAN WOMAN PROMOTES THE JAMESTOWN COLONY IN VIRGINIA.

National Portrait Gallery

She is portrayed in the stylish dress of the English nobility of the time with an elaborate bodice, collar lace, and high hat. Her pose is firm and cool; her features suggest her Native Powhatan identity. The engraving, based on an oil painting, was included in *Baziliogia, a Booke of Kings*, which was not so much a book as a collection of prints or a catalog. Buyers could select their choices, which would then be compiled and bound with a made-to-order title page, into an individual volume. The title page of this compilation is dated 1618, a year after Pocahontas died.

The story of Pocahontas is closely entwined with the early history of Jamestown, the first permanent English settlement in America. In the opening years of the seventeenth century, England trailed the Spanish, Dutch, Portuguese, and French in the exploration and establishment of profitable colonies in the New World. Jamestown followed the failed attempt in the 1580s to maintain a colony at Roanoke along the Outer Banks of North Carolina.

In 1606, a group of English entrepreneurs gained a royal charter from King James I as the Virginia Company of London, granting them the exclusive right to settle colonies in the middle-Atlantic region of America. The company sold stock to raise funds to buy and equip ships. The enterprise was conceived as a profit-making venture; some seventeen hundred people purchased shares, becoming stockholders. The company then enticed skilled artisans to make the journey with promises of gold and riches.

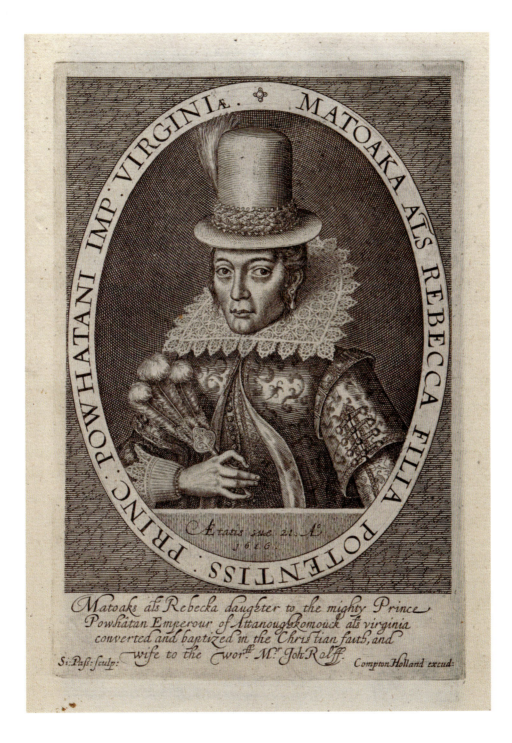

Matoaks als Rebecka daughter to the mighty Prince
Powhatan Emperour of Attanougskomouck als virginia
converted and baptized in the Christian faith, and
wife to the wor^{ll} M^r Joh Rolff.

S: Pass: sculp: Compton Holland excud:

POCAHONTAS BY SIMON VAN DE PASSE *National Portrait Gallery*

The company attracted a barber, a tailor, sailors, bricklayers, carpenters, and a preacher, as well as others simply listed as "gentlemen."

In December, three ships—the *Susan Constant,* the *Discovery,* and the *Godspeed*—set out from England with 144 men and boys aboard. In April 1607, under the command of Captain Christopher Newport, they made landfall, where they found plentiful strawberries, mussels, and oysters. Exploring an outlet of the Chesapeake Bay that they named the James River, they decided to establish their settlement upon an island surrounded by deep water, seemingly uninhabited by natives, and which appeared easy to defend. Unfortunately, it was also small, swampy, mosquito-ridden, and lacking in good drinking water.

Generally, the group was undermanned and ill prepared to form a viable settlement. Those who had expected to find gold or an easy life were sorely disappointed. Most were inexperienced at hard manual labor and lacked the skills needed to survive. They nonetheless felled trees and built a primitive fort with a stockade fence. Equipped with matchlock muskets, they had firepower to defend themselves against Indian attack. They were surrounded by some fourteen thousand Algonquian natives on the mainland, organized by chiefs into a confederation and headed by paramount leader Wahunsenacawh, or Chief Powhatan. The Algonquians, also called Powhatans, grew maize, beans, and squash; fished; hunted small game and deer; and lived in settled villages. Encounters with colonists varied from skirmishes to the Powhatans' provision of food and even lavish feasts.

Settlers had little incentive to do the longer-term work that would make the colony successful—they couldn't claim land ownership as individuals, and they received salaries from the Virginia Company no matter the quality of their performance. They failed to clear land and plant crops in time for harvest, leading to a food shortage later that year that resulted in the deaths of about one third of the settlers.

That first December, one of the more able settlers and a member of the governing council, twenty-eight-year-old John Smith, was captured by a

band of Indians while exploring a nearby river and was brought to Chief Powhatan. What happened next varied in Smith's own written accounts over the ensuing years. In the most elaborate account, there was a feast in the chief's village. Two large boulders were brought forth. Smith was beaten and dragged to the boulders, where the Indians were poised to bash his head in with their clubs until a teenage Pocahontas interceded. She ran over to Smith and put her head upon his to protect him from the expected blows. Powhatan relented in the face of his daughter's compassion, gave Smith his freedom, and had him escorted back to Jamestown. Myth or not, Smith's story of Pocahontas saving his life later became legendary.

Additional ships arrived in Jamestown in 1608 to reprovision the colony. New settlers included Dutch and Poles, who established glassmaking works, the first forms of manufacture in the colony. Given the region's plentiful forests, the Virginia Company saw the timber industry and pitch making as other potentially profitable export industries, along with wine and beer making.

Though he apparently was not well liked by other colonists, perhaps because of his "no work, no food" policy, Smith emerged as a leader in Jamestown. He proved a good negotiator, trader, and diplomat, improving relations with the Powhatan. Pocahontas would visit the fort, play with the children, and bring provisions for Smith to share with others. Nonetheless, despite Smith's best efforts, Jamestown still lacked a viable food sup-

NOVA BRITANNIA:

OFFERING MOST

Excellent fruites by Planting in
VIRGINIA.

Exciting all such as be well affected
to further the same.

LONDON
Printed for SAMVEL MACHAM, and are to be sold at
his Shop in Pauls Church-yard, at the
Signe of the Bul-head.
1 6 0 9.

ply. While away from Jamestown on a trading trip in 1609, Smith was severely injured in a gunpowder explosion and went back to England. Pocahontas heard he had died.

Leadership in the colony fell to George Percy, who proved incompetent. Colonists raided Powhatan villages seeking food. Powhatan retaliated, and armed conflict was the inevitable result. A massive food shortage ensued at Jamestown, a period that came to be known as the starving time. So many colonists died during the winter of 1609–10 that by the spring the survivors had abandoned Jamestown altogether, retreating downriver. When a relief ship, the *Deliverance,* arrived in 1610 with provisions and new settlers, it intercepted the survivors and found that only sixty-one of some five hundred colonists remained. Aboard was a new governor and one of the Virginia Company's largest shareholders, Lord De La Ware—the state of Delaware was later named after him—who persuaded the survivors to return to Jamestown. Among the new settlers was a planter, John Rolfe, who carried with him tobacco seeds from the Caribbean for planting in the colony.

Back in England, the Virginia Company knew it had a problem. Warfare with the Powhatan and a lack of organization continued to hamper Jamestown's ability to develop an economically successful export industry. Since it could not return a profit to its shareholders, the Virginia Company tried other ways of supporting its investment and servicing its rising debts. One strategy was to encourage investment for patriotic purposes. The company promoted the colony as an extension of England's might and pres-

tige among world powers. It presented to investors the idea that Jamestown would help them convert "heathen" Indians to the Christianity of the Church of England. And it claimed the colony would provide jobs to Englishmen, increasing the nation's wealth. This campaign resulted in increased investment for a few years, but as Jamestown failed to achieve any of its goals, its future remained in doubt.

Warfare between the settlers of Jamestown and the Powhatan continued. In 1613, in an attempt to compel Powhatan to return captured settlers, weapons, and tools, colonists took Pocahontas hostage. It took months to arrange an exchange, during which time Pocahontas was held in the nearby settlement of Henrico (about seventeen miles south of present-day Richmond), where she learned English, converted to Christianity, and was baptized as Rebecca by Alexander Whitaker, an English minister. She also met the pious John Rolfe, who was just starting to find success cultivating tobacco on his nearby farm. When peace came in 1614, Pocahontas decided to stay with the English and marry Rolfe, who loved her and wanted to save her soul. The marriage and peace between Powhatan and the settlers came in 1614. The newlywed gave birth the next January to a son, Thomas.

In an effort to show investors that Jamestown was a success, the Virginia Company had the Rolfes travel to England in 1616. Pocahontas was presented as the now-Christianized and civilized Indian princess, in line with the company's marketing strategy. She met King James I, attended important events, and was briefly reunited with John Smith, whom she was astonished to find still alive. His public show of respect to her, as well as the creation of the portrait from

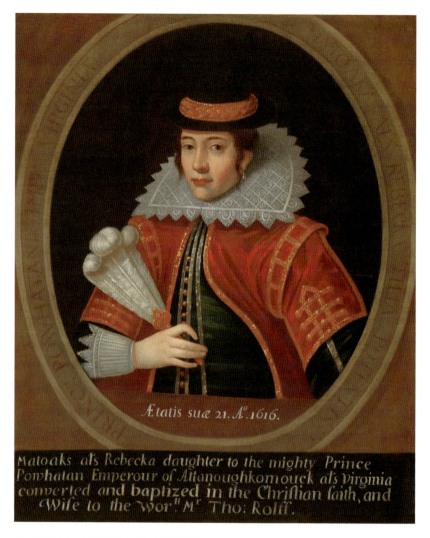

Ætatis suæ 21. Aº 1616.

Matoaks als Rebecka daughter to the mighty Prince
Powhatan Emperour of Attanoughkomouck als Virginia
converted and baptized in the Christian faith, and
Wife to the worll Mr Tho: Rolff.

PAINTING OF POCAHONTAS, UNKNOWN ARTIST *National Portrait Gallery*

which this engraving was made, served the company's needs. In 1617, as the
Rolfes began their voyage back to Virginia, Pocahontas took ill at Gravesend
in Kent, England, where she died and is buried.

That this engraving of Pocahontas in fashionable English garb was in-
cluded in a collection of images of British monarchs and notables conveyed

the idea that American Indians, even the daughter of an emperor, could become civilized and be incorporated into the English world. The portrait of Pocahontas's transformation indicated that Jamestown had succeeded as a British colony in America, a notion the Virginia Company promoted as a way of securing additional investments in its enterprise.

James Ring Adams, a historian at the Natural Museum of the American Indian, offers an alternative interpretation. His reading of the historical evidence is that Pocahontas was not a passive victim of the English but instead was headstrong, self-assured, and even acerbic. He notes that in the portrait Pocahontas fixes the viewer with a "penetrating, intelligent gaze." She was a smart, capable woman, well aware of her position bridging Native and European worlds.

Interestingly, the National Portrait Gallery also has a painting of Pocahontas by an unknown artist, based upon either the engraving for this 1618 printing or the original portrait. In this version, Pocahontas's skin tone is lightened and her features apparently anglicized. Looking closely at the painting, one finds a particularly telling mistake. The caption falsely notes that Pocahontas was wife to Thomas, not John Rolfe.

Contrary to many of the popular treatments, including the namesake Disney movie, there was no love affair between Pocahontas and John Smith. Her son, Thomas, is the ancestor of several prominent Americans, including first lady Edith Bolling Wilson. Ironically, while Rolfe's tobacco crop turned out to be a huge financial success, the colony failed commercially. Following another brutal war with the Powhatan, King James I revoked the Virginia Company charter in 1624, turning Jamestown from a private venture into a royal colony and sowing the seeds for Virginia's development as a colony, and ultimately a state in a new republic.

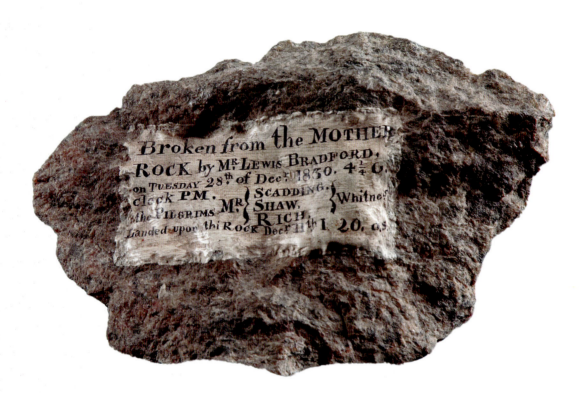

PLYMOUTH ROCK FRAGMENT *National Museum of American History*

T he two-by-four-inch stone has an inscription that reads "Broken from the Mother Rock by Mr. Lewis Bradford on Tuesday 28th of Dec. 1830 4¼ O'clock PM." It is a tiny fragment with a big story. According to legend, the Pilgrims, a group of Puritans who journeyed across the Atlantic Ocean aboard the *Mayflower,* landed at Plymouth Rock in what later became Massa-chusetts in December 1620. Plymouth Rock has become enshrined as their

PLYMOUTH ROCK FRAGMENT

literal and symbolic foothold on freedom and democracy in a new land.

Puritans have their roots in dissenting Protestant religious congregations in the late sixteenth century in the English Midlands. Some sought to re-form the Church of England, others sought to separate themselves from its traditions, practices, and authority. Dissenters were called Puritans by their enemies, originally as a term of spite. Their leaders faced imprison-ment for conducting their own services. They had hoped that when King James I took the throne, some religious reforms might follow, but other than authorizing an English version of the Bible, fines, imprisonments, and harassment continued. Some of the separatist Puritans fled persecution in England to Leiden in the Netherlands. Faced with issues of livelihood and assimilation, they considered forming a colony in the Americas, either in Guyana under Dutch auspices or under the Virginia Company charter. Al-though Jamestown was still struggling to survive, being close to another colony might offer some protection from Spanish and American Indian attacks and also have benefits for trade and commerce. Negotiations with the Virginia Company ensued for a colony near the Hudson River, but later collapsed.

The community had to secure a charter on its own and also persuade investors to put up the funds for the venture. Permission from the English

EARLY SETTLERS TURN THEIR LANDING POINT INTO A LEGENDARY SYMBOL OF THE JOURNEY TO RELIGIOUS FREEDOM AND LIBERTY.

National Museum of American History

court had to be obtained for the charter, and terms for the colonists' land and labor obligations to the investors settled, both complicated matters at the time. The Puritans selected a group of younger, stronger members of the community to settle the colony. They bought a small ship, the *Speedwell*, and rented a larger one, the *Mayflower*, for the voyage. The former ferried the Leiden group to England to join up with their fellow settlers as well as crew members and other colonists hired by investors to help ensure the venture's viability. When the ships began their voyage out of England, the *Speedwell* proved unseaworthy. Supplies and passengers were consolidated on the *Mayflower*, which set sail on September 6, 1620, with just over one hundred people aboard.

Land was sighted near Cape Cod on November 9, and the congregation's leader, William Brewster, led the group in prayer. The ship tried to head south toward the Hudson region, but shoals and currents proved difficult to negotiate. They turned around and anchored in what is now Provincetown Harbor. As the charter for the colony had still not been approved, the settlers discussed their obligations to the group, the colony, and investors.

The result, later called the Mayflower Compact, was agreed to by the forty-one adult males who signed. In it they pledged "for the general good of the Colony unto which we promise all due submission and obedience" to form a "civil body politic," through which issues would be decided by majority vote. John Carver was chosen as the first governor of the colony. The Mayflower Compact is often regarded as colonial America's first constitution, a commitment to lawful self-governance.

The *Mayflower*'s landing parties explored the coastal area for several weeks. They found remains of Indian mound burial sites, recently cultivated fields, and what looked like recently abandoned settlements. They found seeds they could plant for growing corn that proved useful, even "providential" in the Puritans' eyes, for their survival the next year. The local Wampanoag people of the region were familiar with and wary of the English, as previous fishing parties, slavers, and traders had visited, and there had been skirmishes between the two groups.

By December 11, the landing party entered Plymouth harbor and surveyed an area that eventually became the settlement. The area had been an Indian village known as Patuxet, abandoned by the Wampanoag a few years before because of an outbreak of disease—probably smallpox, likely introduced by European traders. Land for planting had already been cleared. Local hills offered good defense, and the Indians offered no immediate resistance.

The *Mayflower* colonists began to settle in. The first house was completed by mid-January. Families were assigned plots to build their own dwellings, and supplies were transferred off the ship. By March, the modest colony was up and running as the charter for the Plymouth Colony of New England had been approved while the *Mayflower* was still at sea. But the long journey and difficult conditions had taken their toll. Most of the colonists had scurvy and developed serious respiratory illnesses. Only forty-seven survived the winter.

William Bradford, who became governor in 1621, signed a peace treaty with at least some of the Wampanoag and Massasoit people and is often credited with celebrating the first Thanksgiving in America, though the precise history of this event is debated today. Bradford served in various offices until his death in 1657, and his account, *Of Plimoth Plantation*, provides an important record of the colony.

Plymouth Rock, however, is not mentioned in Bradford's or any other contemporaneous account of the colony's founding, though it may have been part of its oral history. The first written reference comes in 1741. The town wanted to build a wharf at the site of the colonists' landing at the bottom of Cole's Hill, a few hundred yards away from Leyden Street, the heart of the original settlement. The town historian, ninety-four-year-old Thomas Faunce, identified the precise boulder upon which he said his father had told him the settlers had set foot to found the colony. The granite boulder weighed about ten tons.

The rock became part of local lore. In 1774, the townspeople wanted to move the rock from the shore using a team of oxen and place it in the village

square next to their liberty pole—a flagstaff signaling their desire to be free of British rule—but the rock split in two. The top portion was removed to the town meetinghouse, with the bottom of the "mother rock" remaining in place at the wharf.

Over time, other pieces of the rock were taken as keepsakes and souvenirs—something described by French writer Alexis de Tocqueville during his visit to the United States in the early 1830s:

> This Rock has become an object of veneration in the United States. I have seen bits of it carefully preserved in towns in the Union. Does this sufficiently show that all human power and greatness is in the soul of man? Here is a stone which the feet of a few outcasts pressed for an instant; and the stone becomes famous; it is treasured by a great nation; its very dust is shared as a relic.

Tocqueville saw Plymouth Colony as the home of the Pilgrims—a term for the settlers that gained currency in the early nineteenth century. Plymouth Rock was becoming a divine beacon for Americans more generally. The rock was its material symbol, helping to shape a narrative of how English colonists, driven by their quest for freedom and religious liberty, had formed a new nation.

In Plymouth, the Pilgrim Society built a Victorian canopy over the wharf rock, and in 1880 the two pieces were reunited at the shore. They were cemented together, and the date of the landing—1620—was carved into the rock. By that time souvenir takers had broken off numerous pieces, reducing considerably the size of the mother rock. For its three-hundredth anniversary, the rock was set under a new canopy designed by the famed architectural firm McKim, Mead & White, whose projects included the renovation of the White House, the building of the Boston Public Library, and scores of other civic projects.

The Smithsonian has at least two pieces of Plymouth Rock. The tiny fragment shown here had been in the possession of Gustavus Vasa Fox, a

New England antiquarian, diplomat, and assistant secretary of the Navy. His family donated it to the Smithsonian in 1911. When curator William L. Bird rediscovered it recently, it was stored with Fox's cache of Russian photographs, illuminated manuscripts, and ornate state gifts. "Anyone looking at those would not necessarily be attuned, much less expecting, to find a little piece of Plymouth," he wryly noted.

The second piece of Plymouth Rock to come to the Smithsonian arrived in 1985 as a donation from the Plymouth Antiquarian Society. In 1920 the society purchased Plymouth's Sandwich Street Harlow House and discovered that their four-hundred-pound doorstep was made from part of Plymouth Rock. The society broke the rock into three pieces, offering a one-hundred-pound fragment to the Smithsonian because of what the Pilgrims meant to American history. Secretary S. Dillon Ripley went to Plymouth and brought the fragment back to the Smithsonian.

Over the centuries, Plymouth Rock has been celebrated by authors and artists, patriots and politicians, tourists and marketers, and, like other national icons, subject to numerous elaborations and tales. Some historians have raised questions about it, concerning not only its literal authenticity but also the role it has played in mythologizing the narrative of the Pilgrims, which has tended to crowd out the narratives of others—the women and non-Pilgrims of the colony, and the Native Americans of the region. Some have used its imagery to make a political point; for example, during the height of the civil rights movement, Malcolm X, riffing on a Cole Porter lyric, declared, "We didn't land on Plymouth Rock, the rock landed on us." Whether celebrated as a symbol of the quest for religious freedom and self-determination in the early years of European settlement in America or held up as a reminder of the many times since then that we have failed to fulfill that promise fairly and equally, Plymouth Rock remains a powerful reminder of the hard-won ideals upon which our nation was founded.

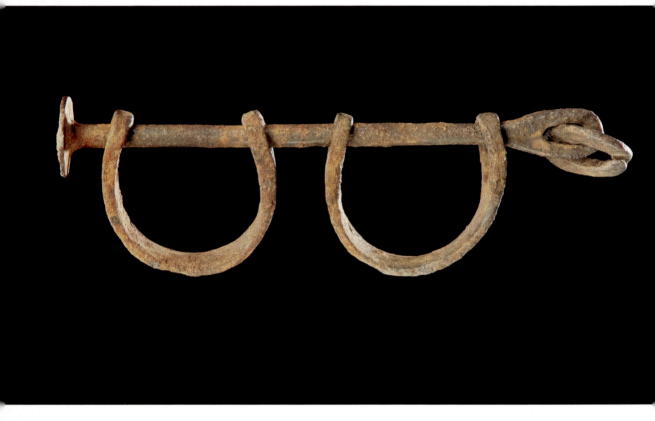

SLAVE SHACKLES *National Museum of African American History and Culture*

These are shackles that were used to control enslaved Africans as they were forcibly transported from their homes to America aboard ships specially modified to carry humans as cargo on the sea voyage known as the Middle Passage. Scholars estimate that approximately twelve million men, women, and children crossed the Atlantic Ocean in this way during the period from the early 1500s until the widespread abolition of slavery in the nineteenth century.

SLAVE SHACKLES

The Atlantic slave trade had its beginnings with the Portuguese and Spanish exploration of the West African coast and their commercial dealings with local rulers. These rulers, like some others in Africa, held slaves, though nowhere on the continent did slavery approach the permanent, widespread, and institutional form it took in the Americas.

In the fifteenth century, as Portuguese and Spanish navigators sought routes to Asia by sailing around Africa, they explored its Atlantic islands and coastal regions. The Spanish sought slaves in the Canary Islands while the Portuguese started a robust trade with African rulers, exchanging gold, peppers, ivory, copper, cowrie shells, textiles, luxury goods, and slaves. Much of the Portuguese trade was conducted in the West African coastal region from today's Senegal to Nigeria—part of which came to be known as the Slave Coast—and then later in the Angola region. The Portuguese brought the first African slaves back to Lisbon in the 1440s.

Among Portugal's trade partners were the rulers of Benin. Slaves were bought and sold in exchange for manillas, elaborate bracelets made from brass and bronze used as currency and depicted in some of the magnificent bronze sculptures for which the artists of Benin are renowned. An adult slave might have cost eleven manillas in the 1490s. The manillas, once

INSTRUMENTS OF BONDAGE ILLUSTRATE THE INHUMANITY OF A WORLDWIDE TRADE THAT ENSLAVED MILLIONS OF AFRICANS.

National Museum of African American History and Culture

it would generate for its European investors. In the 1700s, with the establishment of their American colonies, it was the English who dominated the slave trade.

In West Africa, the growth of the slave trade resulted in close alliances and cooperation with African rulers who supplied the European market by procuring large numbers of slaves through warfare, kidnapping, punishment, and internal trade. Their agents would force-march slaves to the coast in coffles—human caravans in which they would be bound with chains and ropes and Y-shaped branches around their necks. Slaves would be herded into barracoons, or pens, at coastal slave forts or depots, where their bodies would be washed, shaved, and oiled to give them a robust appearance. Prices were negotiated in currencies and kind.

The forts, compounds, and slave castles that developed along the Ghanaian, Gambian, and Senegalese shores gave rise to what have been called doors of no return—places where slaves looked out over an ocean that would forever separate them from their homes and families.

As slavery became a thriving international business, ship owners and captains economized the loading and transport of slaves, whom they considered cargo. Specialized ships were constructed and designed to hold hundreds of people, usually about 450, but sometimes many more. Captives, unwilling, desperate, and terrified, would be packed in. Slaves were stripped naked and often branded. Men were shackled, the right leg of one to the left leg of the next, lying in tight rows next to one another. Women and children were crowded together and suffered from poor sanitation, lack of fresh air and food, and devastating epidemics caused by the appalling conditions.

These shackles, similar to those found at the House of Slaves on Gorée Island—one of the slave compounds off the coast of Dakar—were once used in the Middle Passage. Examining them, chief curator Jacquelyn Serwer notes, "There's hardly enough room for a leg. They often walked around with the flesh of their legs raw because this metal would rub against their legs. . . . It was an instrument of torture."

Slaves were typically led up to the main deck to be fed one meal a day—

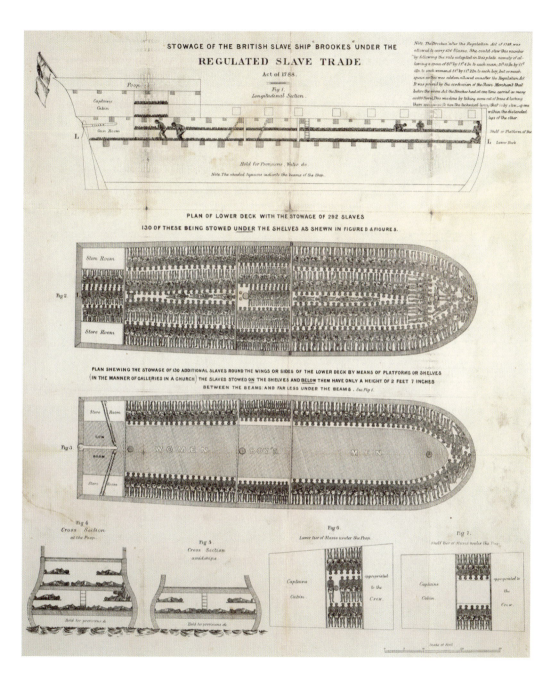

SLAVE SHIP TRANSPORT IN THE MIDDLE PASSAGE *Library of Congress*

beans, corn, yams, rice, and water—before being taken back to the hold. Conditions were foul and unsanitary. Scurvy, measles, smallpox, dysentery, and other infectious diseases were rampant and took the lives of an estimated one in six. Experiencing a five- to eight-week trip under these conditions led some slaves to commit suicide by jumping ship or starving themselves. Ship crews installed nets to prevent the former and would torture slaves into eating.

The vast numbers of slaves who were forced to endure shackles like these came to the Western Hemisphere on ships through the 1600s and 1700s; most were sent to the Caribbean, where they were condemned to lives of hard labor on plantations. The first enslaved Africans in British North America arrived in Jamestown in 1619. Though sold at market, they were initially regarded as indentured servants, a European custom in which a poor person—white or black—was bound for a fixed term of labor. But in practice, the distinction hardly mattered, as few people managed to outlive the term of their indenture, and those who did had little recourse to challenge owners who refused to free them. In 1654, the Virginia colony recognized slavery as an officially sanctioned condition that offered the enslaved person no legal protection, no human rights, nor any hope of liberation. Within a century, slavery was legal in all thirteen colonies.

As more slaves came to the Americas, some were able to escape to the Caribbean islands and join organized groups of Maroons. Some of these groups, in Jamaica and Suriname, hid out in inaccessible locales, learned guerrilla tactics, raided plantations, and encouraged others to escape or rebel against their European masters. To stem the possibility of full-blown slave uprisings, the British in Jamaica and the Dutch in Suriname signed treaties in the eighteenth century granting the Maroons freedom, land, and certain liberties, which allowed them to retain some aspects of their African cultures.

In 1992, for the Columbian Quincentenary, I hosted the descendants of these Maroon communities—which still exist—at the Smithsonian Folklife Festival. It was truly inspiring to hear how the Moore Town and Accom-

pang Maroons of Jamaica, the Ndyuka and Saramaka of Suriname, the Palenqueros of Columbia, and the Black Seminoles of Florida, Texas, and Mexico had escaped and resisted slavery.

When people came to America enslaved, they came in shackles that bound their bodies, limited their physical movements, and symbolized in the most personal of ways their lack of freedom. Lonnie Bunch, a noted historian and the director of the National Museum of African American History and Culture, says he makes a point of thinking about the shackles in the museum's collection every day. The experience, he says, "is the closest I come to understanding my slave ancestors." We do not know whose body was bound by these particular shackles, but we do know from the history of the Maroons that when shackles were smashed, broken, and removed, they served as a potent symbol of freedom.

10

Maps were crucial to European sailors in the age of exploration as they navigated far from familiar lands in hopes of exploring the New World, each staking his own country's claim to territory and natural resources. By the seventeenth century, European maps had evolved far beyond simple diagrams of landmasses, and the finest were embellished to showcase a range of geographical information, including people

AMERICÆ NOVA TABULA (MAP)

AN ELABORATELY ILLUSTRATED MAP OF THE AMERICAS FROM ABOUT 1648 PROVIDES INSIGHT INTO HOW EUROPEANS SEE THE NEW WORLD.

and places encountered, new flora and fauna, and sometimes the purely imaginary stuff of sailors' legends.

The Americæ Nova Tabula (America: New Map) by Willem Blaeu encapsulates European geographic and ethnographic knowledge as of about 1648, providing an excellent window into the moment when the North American British colonies that would later form the United States were just taking shape.

Dutch cartographers were leaders in the field, and the Netherlands was a primary center for the publication of maps—unsurprising given the important role maritime trade played in the development of that nation's economy. Although not accurate by today's standards Americæ Nova Tabula reflects the period's technical achievements in mapping—including lines of longitude and latitude, the equator, and the tropics of Capricorn and Cancer. In 1569, Flemish mapmaker Gerardus Mercator discovered a means of representing the spherical Earth on a flat surface through projection. In this case, each section of the map is bounded by lines that curve more the farther out they are from the center point.

The map shows and names America, bounded on the east by the Atlantic Ocean and on the west by the Pacific. The Caribbean and the Gulf of Mexico, areas explored by Columbus and others for Spain, seem to be the

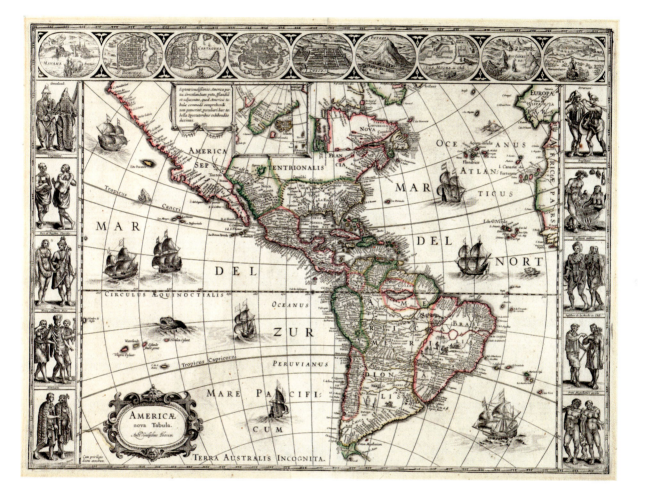

AMERICÆ NOVA TABULA OF WILLEM BLAEU *National Museum of American History*

most accurately charted and labeled. South America, or America Meridionalis, is presented with considerable detail, reflecting a number of previous European expeditions known to the mapmaker, while only the eastern and southern parts of North America, or America Septentrionalis, are remotely recognizable to us today.

In the north, Newfoundland and its coast are charted, but the Hudson Bay is attenuated and a series of lakes hardly suggests what will later be known as the Great Lakes. Nova Francia is labeled, indicating that French control over the territory had already been established. The Honguedo Strait and the Saint Lawrence River are named, but so too is Norem Bega, described as a fantastical settlement of either Native or Norse origins that eluded North American explorers in much the same way as did El Dorado, the legendary lost city of gold in South America.

Moving down the eastern seaboard, there are a few names that are familiar—the colony of Virginia is clearly decipherable, Jamestown having been established a few decades earlier. Florida is also recognizable, though its boundaries are misshapen. Croatan, an Indian settlement in North Carolina that might have hosted English settlers who disappeared from the Lost Colony of Roanoke after 1587, is indicated, as are the Appalachian and Catoctin mountains. The Chesapeake waterway is named—though it lacks any definition as a great bay.

The great, unexplored midsection of North America is a vast blank, as is the northwestern part of the continent. The Southwest, explored and documented by Spanish missionaries and conquistadores, features more information. California is named, as is a good part of Spain's Nova Granada, particularly the region that would become northern Mexico and the Rio Grande valley.

The map is particularly interesting for its decorative border, featuring renditions of American peoples and places. Among the former are represented the Virginian natives, the king and queen of Florida, Mexicans, Peruvians, and the Moche of South America. Vikings from Greenland appear in warm clothing and helmets, while Brazilians and those natives at the

southern end of Chile are represented in customary nakedness. In between, Native people appear in distinctive dress, wearing capes and draped apparel, with jewelry, headgear, and occasionally crowns made of local, natural materials. They brandish spears, shields, and clubs and display local plants, produce, and cooking implements. Sometimes even their offspring are pictured.

At the top of the map, illustrated medallions depict various key cities and sites of the Americas—among them the settlements of Havana, Cartagena, Santo Domingo, Rio de Janeiro, and Pernambuco, along with the silver mines at Potosí in what is now Bolivia. Mexico and Cuzco, capitals of Native empires, are depicted as well. Interestingly, all of the meticulously rendered "highlights" are in Central and South America—because North America remained a relatively unknown and undeveloped place in terms of both Native civilization and colonial settlement.

The contemporary race for political dominance is suggested in the seas, where the cartographer shows the many-masted sailing ships of the various European empires, including the caravels, carracks, and galleons of the era, flying their nations' colors and while those included the St. George's Cross of England, Blaeu was particularly partial to his home country, showing two types of flags of the Netherlands, the red, white, and blue ensign but also the double Princevlag, both used by the Dutch East India company.

There is a great deal of empirical knowledge reflected in the map's construction, but it also has many features of a long historical tradition extending back into antiquity, when sea exploration had many unknowns and was still shaped by ideas drawn from mythic and biblical sources. In both the Atlantic and Pacific oceans the mapmaker includes incredible creatures of the sea. When it comes to Native people, they are shown as human tribes in male-female pairs.

Many maps of America continued in this vein—half poetic, half scientific—through the end of the eighteenth century, when increased maritime and geographical knowledge eventually crowded out the space once

WALDSEEMÜLLER'S UNIVERSAL COSMOLOGY OF 1507 *Library of Congress*

occupied by the more fantastical representations of peoples and creatures. Nonetheless, open a detailed feature map drawn by National Geographic Society cartographers and designers and inserted into their magazine today, and you can find a similar formula of combining geographical information along with ethnological and architectural imagery to present a visual representation of a world region.

The naming of the continents, north and south, as America was firmly established by the time of this map. Columbus never declared unambiguously that the new continents were not extensions of Asia. That would await the results of four voyages made to South America from 1497 to 1504 by the Florentine explorer Amerigo Vespucci. Vespucci published his travel report, *Mundus Novus,* offering his evidence that explorers had indeed found a New World. Reading Vespucci's account, German cartographer Martin Waldseemüller, in 1507, a year after Columbus's death, published a world map that he titled *Universalis cosmographia secundum Ptholomaei traditionem et Americi Vespucii alioru[m]que lustrationes* (The Universal Cosmography According to the Tradition of Ptolemy and the Discoveries of Amerigo Vespucci and Others).

That map, lent to and exhibited at the Smithsonian from 1983 to 1985 and purchased by the Library of Congress in 2003, is eight feet wide and more than four feet high when fully assembled. It shows the whole world with the two "new" continents connected to each other by an isthmus, but clearly separated from Asia by an ocean. In a note, Waldseemüller gives Columbus credit for their discovery. The northern continent, called Parias following Vespucci's account, is malformed by today's standards—hardly recognizable. Below this, the vast continent to the south is designated with the first known occurrence of the Latinized form of Vespucci's name, "Americus." By the time Blaeu drew the Americæ Nova Tabula almost a century and a half later, North America and the future United States were taking recognizable geographic shape.

LET
FREEDOM
RING

(1760s TO 1820s)

We hold these truths to be self-evident, that all men are created equal, that they are endowed by their Creator with certain unalienable Rights, that among these are Life, Liberty, and the pursuit of Happiness.

The Declaration of Independence contains some of the best-known words in the English language, words that have inspired people all over the world to seek their freedom. The document was created to communicate the decision of the Continental Congress, adopted on July 2, 1776, that the United States of America had declared themselves independent from Great Britain and free from the rule of its monarch, King George III.

DECLARATION OF INDEPENDENCE

General George Washington had been leading an army against the British for almost a year by the time this Congress—an assembly of representatives from the various colonies—gathered in Philadelphia to discuss their future. Despite early no votes by Pennsylvania and South Carolina, a divided Delaware delegation, and New York's continued abstention, the adoption of the Declaration of Independence meant that on behalf of its countrymen, Congress had finally agreed to form an independent nation. The Declaration of Independence was written so that the Congress could explain to its own people, as well as to foreign governments, what it was doing and why.

The document was drafted by a committee composed of the colonies' elder statesmen, including Benjamin Franklin of Pennsylvania, John Adams of Massachusetts, Robert Livingston of New York, Roger Sherman of Connecticut, and the group's young intellectual firebrand, Thomas Jefferson of Virginia, the initial and primary drafter. Jefferson based the Declaration on his 1774 argument against British taxation, published as a *Summary View of the Rights of British America.* He worked on a portable, hinged,

A PROCLAMATION OF FREEDOM FOR A NEW NATION IS DRAFTED ON A PORTABLE DESK IN 1776 AND DECADES LATER COPIED FOR PRESERVATION AND WIDE DISSEMINATION.

National Museum of American History

mahogany desk that he designed himself and which Benjamin Randolph, an expert cabinetmaker in Philadelphia, crafted.

The Declaration gave a number of justifications for independence, among them the British king's refusal to pass laws necessary for the public good, the obstruction of local governance, the imposition of taxes without consent, the restriction of trade and commerce, and the deprivation of judicial process. Franklin improved Jefferson's initial "sacred and undeniable" truths to the more elegant "self-evident." The committee then presented the draft to the Continental Congress, which, to Jefferson's chagrin, reduced it by a quarter, improved grammar, and removed Jefferson's complaint that Britain had foisted the slave trade upon the colonies.

On July 4, 1776, the revised wording of the Declaration of Independence was approved and the document was sent to the nearby Philadelphia printer John Dunlap for publication. That night Dunlap set the Declaration in

type and printed some two hundred copies in broadside, a kind of one-sided bulletin or poster intended to be read aloud or displayed briefly and then discarded. These first copies of the Declaration of Independence were sent around the country, to England, and to General Washington in New York to be read to the troops to raise their spirits. Public readings occurred outside Independence Hall in Philadelphia as well as in other cities and towns of the colonies. Only twenty-six copies of this first printing are still known to exist. While some of Jefferson's earlier drafts have been preserved, the actual handwritten manuscript of the final draft—what was read and approved on July 4 as the Declaration of Independence—has disappeared from history.

Another copy, regarded as the original Declaration of Independence, is the so-called engrossed, or final, version. This document is the large sheet of parchment upon which the text of the Declaration of Independence was transcribed in handwritten calligraphy by the clerk of the Congress, Timothy Matlack. It was ordered by Congress on July 19 and took a few weeks to prepare. It was signed by most of the delegates in August and features the famous oversized John Hancock signature, as well as the signatures of Franklin, Adams, Jefferson, and others. At least one delegate did not add his signature to this unique copy until November.

The British government never gave an official response to the Declaration. George III gave a short speech about the American "trou-

DUNLAP'S PRINTED BROADSIDE OF THE DECLARATION OF INDEPENDENCE

Library of Congress

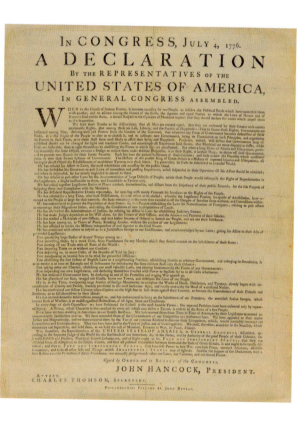

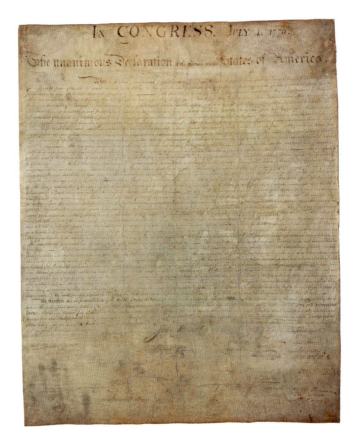

bles" later in the year and his troops continued fighting against Washington's army. Others commented on its behalf, charging that the signers were elite conspirators who had whipped up the sentiments of otherwise loyal colonists for their own private benefit. Some argued that the Declaration was hypocritical—how could the principle that "all men are created equal" be taken seriously when the signers persisted in holding, rather than freeing, their own slaves?

In 1777, Congress commissioned Baltimore publisher Mary Katherine Goddard to print a new broadside of the Declaration that listed the signers. Nine of these copies are known to have survived. Various individual states also printed their own versions.

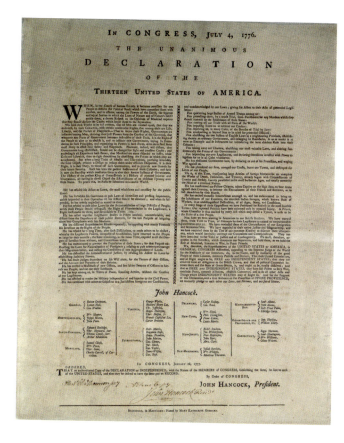

The Continental Congress carried the unique engrossed version with it when it shifted location during the Revolutionary War. After the war that document was turned over to the State Department.

The renown of the Declaration of Independence subsided soon after the Revolution only to reemerge during the campaign for the presidential election of 1800 between John Adams, a Federalist, and Thomas Jefferson, a Democrat-Republican. Each party vied to see its leader credited with a more important role in achieving independence. To Adams's surprise, July 4, not July 2, became the day celebrated by Americans as Independence Day. In the wake of the War of 1812, gripped with patriotic feelings, Americans embraced the Declaration and its signing with commemorative

artworks, public celebrations, and published accounts of the signers. July Fourth took on a somewhat mythic quality when Adams and Jefferson, reconciled, both died on July 4, 1826, the fiftieth anniversary of the original Declaration. The Declaration became, over time, the model for proclaiming the rights of women, workers, farmers, and others. Abraham Lincoln drew on the Declaration as a statement of principles that helped interpret the Constitution in light of the Civil War and the emancipation of those abandoned by the founders' promise of liberty for all. Independence movements in other countries also drew on the language of the Declaration.

By 1820, the ink on the engrossed version of the Declaration of Independence was fading. Secretary of State John Quincy Adams, a lifelong student and patron of American history, commissioned printer William Stone to create an engraving of the document so that accurate facsimiles could be printed and distributed throughout the country. To accomplish this, Stone apparently moistened the surface of the decades-old original so that some of its ink would be transferred onto a copper plate that was then etched and used as the master to print copies. It took Stone three years to do the etching. Congress then ordered Stone to print 200 copies on parchment. Stone actually printed 201, saving one for himself, and it is this one that was eventually donated to the Smithsonian by his wife in 1888.

The engrossed original, not surprisingly, lost some ink in Stone's process. It suffered additional fading when, from 1841 to 1876, it was publicly exhibited, in bright sunlight, in the Patent Office Building, along with other relics and treasures of the nation destined to come to the Smithsonian. It was sent to Philadelphia for the U.S. Centennial Exposition in 1876, but its fragile and faded condition led to its subsequent removal from public view and placement in storage at the Department of State. In 1921, custody of the engrossed version of the Declaration of Independence, as well as that of the United States Constitution, was transferred from the U.S. State Department to the Library of Congress. During World War II, it was removed from the capital and sent to Fort Knox along with other treasured historic documents. In 1952, the Declaration and Constitution were transferred to

the National Archives, where they have since been on public display. Addressing their continued decay conservators in 2011 placed these "charters of freedom" in titanium and aluminum cases filled with inert argon gas. Given the Declaration's condition, most facsimiles are based upon the Stone copies.

Jefferson's portable desk came to the Smithsonian in 1880, donated by his descendants. Jefferson himself attached a note to the desk in 1825, a year before his death, that read, "Politics as well as Religion has its superstitions. These, gaining strength with time, may, one day, give imaginary value to this relic, for its association with the birth of the Great Charter of our Independence." He gave the desk as a gift to his granddaughter Eleanora Wayles Randolph Coolidge's husband and wrote in a note to her that one day it might be "carried in the procession of our nation's birthday, as the relics of the Saints are in those of the Church." Her children gave the desk to the Smithsonian, where it now sits in the National Museum of American History for all to see, every day.

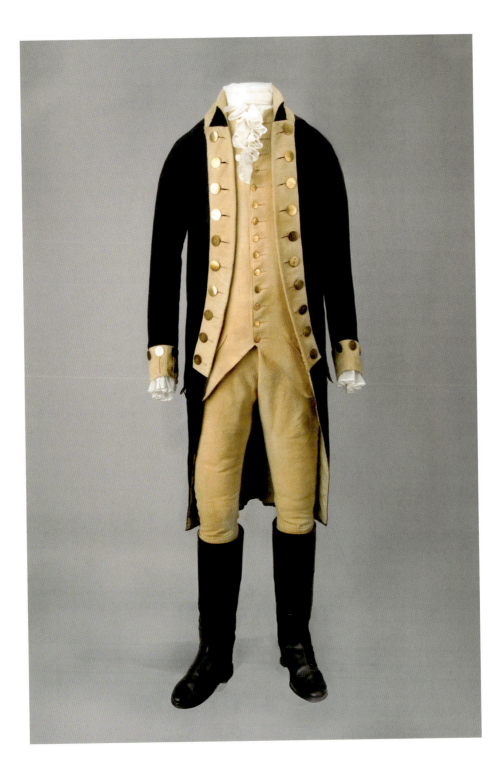

GEORGE WASHINGTON'S UNIFORM *National Museum of American History*

As the commander of the Continental Army, General George Washington was called upon not only to direct his troops, but also to forge an image of leadership for the new democratic nation. Washington was highly attuned to the importance of his military bearing and attire in asserting the rebellious Americans' inherent equality to the army of the British Empire, and in portraying the dignity of the cause of liberty to a worldwide audience of tottering empires and restive colonies. His uniform at the Smithsonian remains a potent emblem of the strength and authority Washington brought to the Continental Army and the fledgling nation.

GEORGE WASHINGTON'S UNIFORM AND SWORD

George Washington (1732–99) was born to a wealthy planter family of northern Virginia that raised tobacco with slave labor. He became a surveyor, gaining knowledge of the frontier regions of the colonies. He joined the Virginia Regiment and served as a twenty-three-year-old aide to British General Edward Braddock in the 1755 attempt to take Fort Duquesne during the French and Indian War. Washington was a keen student of the marks of command, noting the way a commanding officer conveyed his authority on the battlefield. Washington clearly had already formed expectations about the importance of uniforms; in a letter he described the sad state of the regiment's uniforms as "a suit of thin sleazy Cloth without lining, and without Waistcoats except of sorry Flannel." When Washington became a colonel and commander of the regiment, he ordered new uniforms from London and was very attentive to their colors and matters of style.

In June 1775, a few months after the Revolutionary War had begun, Washington accepted the commission from the Continental Congress to serve as the commander in chief of the newly created Continental Army, beating out the alternative candidate, John Hancock. Washington was re-

THE MILITARY REGALIA OF THE FIRST COMMANDER OF AMERICA'S MILITARY REFLECTS HIS LEADERSHIP AND VISION FOR THE NEW NATION.

National Museum of American History

garded as amiable and brave. Independently wealthy, he refused a salary for his service, asking only that his expenses be paid at war's end.

Washington insisted on proper uniforms, not only for himself and other officers but for the troops. Washington wanted his army to look like a unified, professional organization, a worthy opponent of the British troops. To contrast with the British redcoats, Washington chose the blue and buff colors of Virginia's Fairfax militia. Washington's design for the uniform was used by the U.S. Army until the beginning of the Civil War, and dress blues are still used by the Army today.

The pieces that make up Washington's uniform at the Smithsonian are indicative of a tall, thin commander. They were all worn by him, but made at different times. The waistcoat and breeches, made of buff wool, date from the Revolutionary War period. They were worn when he was the commander in chief of the Continental Army, and they are represented in Charles Willson Peale's 1779 painting of Washington after the Battle of Princeton. The regimental blue wool coat is part of a uniform made for Washington in 1789, well after the war ended. The coat has a buff wool rise-and-fall wide collar, buff cuffs and lapels, and buff lining; there is a row of distinctive yellow tombac buttons made of a copper and zinc alloy on each lapel as well as on each cuff. Records reveal that Washington wore this uniform when he visited Philadelphia on Provisional Army duty in 1789. It may have been depicted in John Ramage's watercolor of the same year. Washington periodically wore the uniform until his death in 1799.

Washington used several swords during the Revolutionary War. His service sword was a simple hunting hanger, also called a *couteau*, meant to hang from a belt. It has a slightly curved, grooved steel blade, a silver-mounted cross guard and pommel, and a green ivory grip.

Washington used this sword after 1777. On its scabbard is etched "J Bailey, Fish Kill," as the sword was remounted with a new hilt and silver cross guard in Fishkill, New York, by John Bailey, an immigrant cutler from Sheffield, England. It was used by Washington as his battle sword when commanding the Continental Army for much of the Revolutionary War.

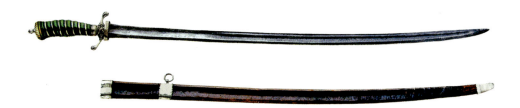

He might have also used it as president and commander in chief when he last reviewed the troops in Cumberland, Maryland, and Bedford, Pennsylvania, in 1794 during the Whiskey Rebellion.

Washington bequeathed five swords to his five nephews. He wrote them instructions to draw the swords only in self-defense or "in the defense of [the] country and its rights." Samuel Washington, who served in the army and was among the troops reviewed by his uncle in 1794, got to choose first, and chose the sword Washington wielded in battle, the simple sword with the green grip. When Samuel passed away in 1831, he left the sword to his son, Samuel T. Washington, who donated it to the United States; decades later it was transferred to the Smithsonian.

The uniform was initially donated to the Columbian Institute, and then, in 1841, it was transferred to the National Institute and housed in the Patent Office Building. It came to the Smithsonian in 1883 with a Patent Office collection, and has been on display almost continuously since then. From 1942 to 1944, during World War II, the Smithsonian packed up many of its treasured artifacts, including this uniform, and sent them to the Shenandoah Valley for safekeeping. It is perennially one of the most popular of the Smithsonian's holdings, seen by millions of people every year, and still, as ever, making an impression.

WASHINGTON'S SWORD AND SCABBARD

National Museum of American History

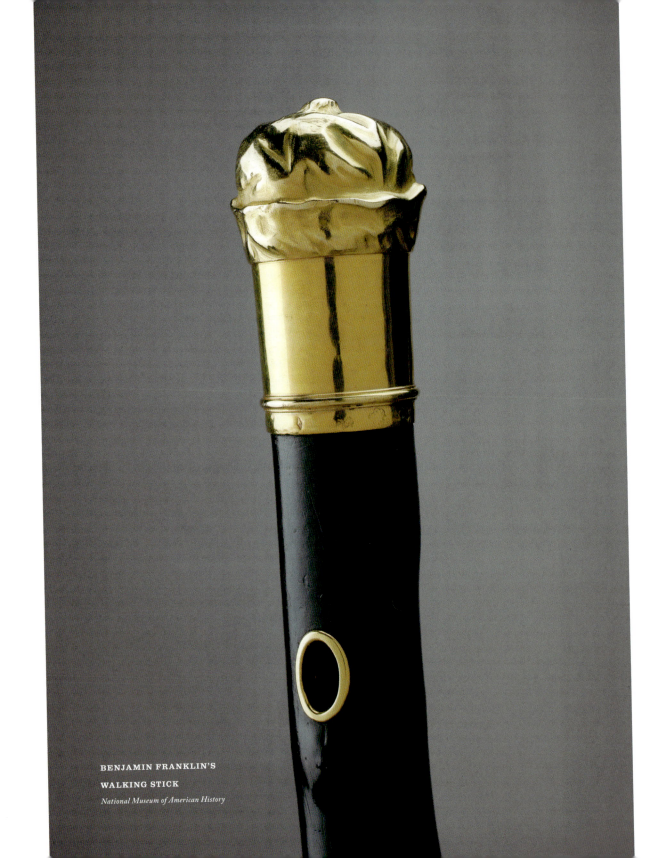

BENJAMIN FRANKLIN'S
WALKING STICK

National Museum of American History

W hile General George Washington was fighting for independence from the British on American soil, Benjamin Franklin was doing the same in France. After participating in the Continental Congress and signing the Declaration of Independence in Philadelphia, Franklin became the American commissioner to France, essentially acting as the first ambassador.

Benjamin Franklin (1706–90) truly was an American hero. He was born in Boston to Puritan parents and had only a few years of elementary schooling before apprenticing in his brother's printing shop. He ran off to Philadelphia and was then sent to London where he worked as a typesetter. (A printing press he may have used there is now in the collections of the Smithsonian.) Returning to Philadelphia, he took up a number of other jobs before becoming a newspaper publisher and advocate for American independence.

Franklin was an amazingly innovative civic leader, helping to found the country's first postal system as well as a public library, volunteer fire department, college, hospital, and America's most prominent scholarly and scientific society of the time. He wrote and published *Poor Richard's Almanack,* offering useful information and sensible advice in an unpretentious manner; widely read, it made Franklin rich.

Franklin pursued a range of scientific experiments and endeavors, from research proving that lightning is electricity (he is credited with inventing the lightning rod) to the charting of the Gulf Stream. These accomplishments earned him honorary degrees from Harvard, Yale, and Oxford as well as friendships with leading intellectuals of the day.

Franklin arrived in France as a celebrity less than six months after helping to draft the Declaration of Independence. He was America's most renowned personality; a statesman and scientist, and a man of cultural and

BENJAMIN FRANKLIN'S WALKING STICK

A STAFF GIVEN TO A BELOVED AND RESPECTED SCIENTIST-STATESMAN MAKES A POWERFUL STATEMENT ABOUT AMERICAN DEMOCRACY.

National Museum of American History

BENJAMIN FRANKLIN.
Né à Boston, dans la nouvelle Angleterre le 17. Janvier 1706.

civic accomplishment who was widely respected at home and abroad. The French were fascinated by his erudition and lack of pretension, and they literally came out in droves to see him. The humble Franklin was taken aback by the attention, noting to his daughter: "My picture is everywhere, on the lids of snuff boxes, on rings, busts. The numbers sold are incredible. My portrait is a best seller, you have prints, and copies of prints and copies of copies spread everywhere. Your father's face is now as well known as the man in the moon."

Contributing to Franklin's popularity was the fur cap he wore to keep warm. To the French, this embodied the frontier spirit of America and confirmed their belief that Americans were somehow closer to nature than Europeans were. As French intellectuals questioned ideas of human nature, natural rights, and the state, Franklin obliged their curiosity with his fur-capped appearance as well as the ideas embedded in his work and the Declaration of Independence. Franklin's cap—in contrast to the notoriously elaborate wigs and hats worn by the French queen, Marie Antoinette—became a "cap of liberty," a symbol of freedom.

Franklin's mission in Paris was to secure French support for the Revolutionary War effort. France and Britain had concluded the Seven Years' War in the previous decade and were constantly competing powers. French aid to Washington's troops, particularly at sea, was essential for an American victory. Britain's naval force was the strongest in the world. Its ships could

blockade American ports, quickly transport soldiers along the East Coast, and bombard Washington's military positions with impunity. Only France, if it was willing, could provide a counterweight to this British strength.

Franklin succeeded. In 1778, he secured a military and trade alliance between the United States and France under King Louis XVI to help the war effort. The military partnership was spelled out in a Treaty of Alliance, and trade provisions in a related Franco-American Treaty of Amity and Commerce. The treaty stated that if France was attacked by Britain or its commerce and navigation hindered, the United States and France, and indeed other nations (such as Spain), would join together in fighting Britain. The French would lend the United States money, carry on trade, provide military support and supplies, and encourage other nations to help. Franklin was the key person to convince the French and shepherd the treaty negotiations. When France recognized the United States by signing the treaty, Britain declared war on France and the alliance was set.

The French supplied loans, arms, ammunition, and uniforms to Washington's army. French movements in the Caribbean forced the British to redeploy troops away from North America, helping the American cause. In 1777, Franklin prevailed upon George Washington to employ the Marquis de Lafayette, an outspoken French supporter of American independence and its ideals, as his aide-de-camp. Franklin thought this would help to secure French support for the war effort. He was right. In 1780, Franklin worked with Lafayette to prevail upon Louis XVI to send an additional six thousand French troops to aid Washington's army.

Franklin's diplomatic work was conjoined with his social life. An accomplished musician, Franklin played several instruments, invented another (the glass armonica), and was a regular feature in Paris's many salons and theaters. Among his many admirers was Maria Anna, the Countess of Forbach and an unabashed supporter of the American cause. From humble beginnings, she had risen in society to become a patron of the arts. She and Franklin dined together, shared a passion for chess, and corresponded

often. The countess relished her relationship with the American and sought his help in obtaining a commission for her nephew to fight and serve in Washington's army. She was also friendly with Lafayette, who served as a conduit of information on the war's progress. Indeed, her two sons, Christian and William, served with Lafayette toward the war's end; they were known to George Washington and both were key officers under General Rochambeau's command at Yorktown.

French participation proved decisive in the Battle of Yorktown. Coordinating strategy with Washington, France sent twenty-nine warships and more than ten thousand troops, ultimately forcing the surrender of British General Cornwallis, which effectively ended the war. When it came time to negotiate a peace treaty, Britain sought to separate the Franco-American alliance in order to gain better terms, but Franklin helped hold it together.

After the success at Yorktown and Lafayette's return to Paris, the marquis, the countess, and Franklin celebrated together. The countess gave Franklin a special gift of a fine, well-crafted, four-foot-long walking stick. It had a unique top: instead of the standard orb, it took the form of Franklin's fur liberty cap. Franklin cherished the walking stick, and would keep it for the rest of his life.

In 1783, Franklin, along with John Adams and John Jay, successfully negotiated the Treaty of Paris, officially ending the Revolutionary War. His celebrated mission came to an end in 1785 when Thomas Jefferson was appointed the next emissary of the United States to France. When he arrived, the foreign minister, Charles Gravier, the Comte de Vergennes, asked: "It is you who replace Dr. Franklin?" Jefferson replied, "No one can replace him, Sir; I am only his successor." When Franklin returned from France, perhaps inspired by Forbach's friend, philosopher Denis Diderot, and his vehement arguments against slavery, he freed his two slaves, published a call for abolition, and became president of the Pennsylvania Abolitionist Society. He was also elected president (governor) of Pennsylvania and signed the U.S. Constitution while serving as a delegate to the Constitutional Convention.

In 1789, Franklin wrote a codicil to his will. When he contemplated his life and role in the New Republic, he thought of his beloved walking stick. He made his final bequest:

> My fine crab-tree walking stick, with a gold head curiously wrought in the form of the cap of liberty, I give to my friend, and the friend of mankind, General Washington. If it were a Sceptre, he has merited it, and would become it. It was a present to me from that excellent woman, Madame de Forbach, the dowager Duchess of Deux-Ponts, connected with some verses which should go with it.

Franklin's term "cap of liberty" referred to the fur cap he had worn in Paris that made him appear so overtly American at the time. It also could have melded that reference with Masonic symbolism. Both Franklin and Washington were Freemasons, and to members of that fraternity the cap represented support for liberty and republican government and opposition to forms of monarchy. That Franklin bequeathed his friend Washington a walking stick topped with the cap of liberty, instead of what it could have been—a scepter topped with a crown—symbolized the accomplishment of the new, democratic republic they'd both helped to create.

Franklin's cane, like Washington's sword, was eventually inherited by Washington's nephew, Samuel. In 1843, his son, Samuel T. Washington, sent the cane and sword to Virginia Congressman George Summers with a note asking him to present the relics to the nation "to keep in memory the character and services of those two illustrious founders of our republic." Summers proclaimed to the assembled House of Representatives, "Let the sword of the hero and the staff of the philosopher go together. Let them have a place among the proudest trophies and most hon-

FRENCH MEDALLION OF BENJAMIN FRANKLIN BY JEAN-BAPTISTE NINI

National Portrait Gallery

ored memorials of our national achievements." As the House erupted into thunderous applause, former president John Quincy Adams rose to thank the family and move that Congress accept them. The sword and staff were deposited with the State Department (which had a small exhibit of relics of the Founding Fathers in its library) and, then, in 1922, they were turned over to the Smithsonian so they could be displayed to the nation. Although the Smithsonian had long borrowed from the Massachusetts Historical Society a three-piece silk suit that Benjamin Franklin wore in Paris during his treaty negotiations, it wasn't until 2012 that the costume was permanently transferred to the Institution. We still do not, however, have the fur cap.

G ilbert Stuart (1755–1828) was a Rhode Island–born artist who moved to England as a young man to make his name. He returned to his country as a mature artist to paint the portraits of many noteworthy and historically important Americans. His most famous sitter was George Washington; his paintings of the first president have become our most widely recognized representations of the father of our country, gracing museums, official buildings, courtrooms, schoolhouses, and the one-dollar bill.

GILBERT STUART'S LANSDOWNE PORTRAIT OF GEORGE WASHINGTON

THE GREAT PORTRAITIST PAINTS THE ICONIC IMAGE OF THE FIRST PRESIDENT AND FATHER OF THE COUNTRY.

National Portrait Gallery

While living in New York in 1794, Stuart painted a portrait of prominent New York patriot John Jay, then the chief justice of the Supreme Court. Jay liked the painting and wrote a letter for Stuart introducing him to George Washington. That November, Stuart went to Philadelphia, the temporary capital of the United States, to meet Washington and arrange for sittings for a portrait. Washington, then in his second term as president, would sit for Stuart at least three times in 1795 and 1796. Two of these sessions resulted in two waist-length portraits, including the unfinished painting known today as the *Athenaeum* portrait because of its later ownership by the Boston Athenaeum. Stuart repainted that image on commission more than seventy-five times, referring to it as his one-hundred-dollar bill, its price per copy. This is the image that appears today on the one-dollar bill.

In the spring of 1796, Senator William Bingham, then one of America's wealthiest men, and his wife, Anne, commissioned Stuart to paint a third portrait of the president. The painting was a gift for the Marquis of Lansdowne (William Petty, Lord Shelburne) in London, in recognition of his support for the American cause during the Revolution. Bingham had become friends with Shelburne in England during the 1780s, when Shel-

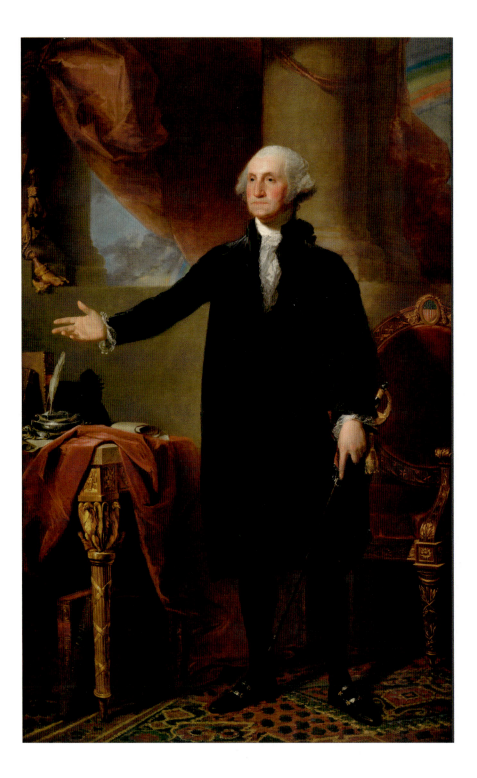

GILBERT STUART'S LANSDOWNE PORTRAIT OF GEORGE WASHINGTON *National Portrait Gallery*

burne was prime minister and had helped bring about the end of the Revolutionary War. Bingham called him "a warm friend of the United States," and they both shared a great admiration for Washington.

Timing provided an important context for the portrait for Lansdowne. The painting was undertaken in April 1796, shortly after the February 1796 ratification of the Treaty of Amity, Commerce, and Navigation, Between His Britannic Majesty and the United States of America, which is known as the Jay Treaty after John Jay, its negotiator. This treaty brought the two countries closer together by resolving issues that had remained since the signing of the Treaty of Paris of 1783 at the end of the Revolutionary War. The Jay Treaty, negotiated in 1794 and opposed by Jefferson, averted another war between Britain and the newly independent United States.

The new painting was the first life-size full-length portrait to depict George Washington as president and civic leader of the nation, rather than as a general in his military uniform, as Charles Willson Peale and John Trumbull had done. In the painting, Washington is clothed in the black velvet suit he wore for public appearances as president, demonstrating his citizen status in an age dominated by royal rule and military conflict. The setting is entirely fictional. This was not Washington at his desk in his President's House office in Philadelphia. Rather, Washington is presented in a scene that symbolizes the civic republic that the United States aspired to be.

Washington is portrayed in an oratorical stance, though his audience is unseen. The gesture and pose allude to his annual address to Congress, delivered the previous December, which included references to the Jay Treaty. His visage is serious, his jaw rigid—and there's been speculation that he might have even been pained at the time by a new set of false teeth.

George Washington's left hand rests on the hilt of a ceremonial sword while his right hand is poised near an inkwell. The books on top of the desk refer to the Federalist Papers and the Journals of Congress, and those under the table are titled *General Orders, American Revolution,* and *Constitution & Laws of the United States,* referring to his past roles as general and president

of the Constitutional Convention of 1787. The papers on the desk may represent the Jay Treaty—no writing is visible on them. The black cockade on his black hat, also on the table, may indicate loyalty to the Federalist Party, which supported the Jay Treaty. The columns and ornate table leg allude to the Roman Republic, a model of sorts for the United States government. The armchair is elaborately decorated but is not a throne, and hence befitting a president, not a king. In the distance is the sky; on the left the clouds signify the turbulence of the American Revolution, while the rainbow is a sign of a positive future for the young republic.

Overall, as National Portrait Gallery curator and scholar Ellen Miles notes, the portrait speaks to post–Revolutionary War optimism. It reinforces the idea that the United States under the leadership of George Washington faced a bright future.

The completed painting was shipped to London in the fall of 1796, and was displayed there in Lansdowne House. After the marquis died in 1805, the painting was acquired at auction by American merchant Samuel Williams, who lived in London. He owned it until 1827, and the next owner, also in London, was an English merchant, John Delaware Lewis. It was acquired in 1889 from Lewis's descendant by Archibald Philip Primrose, fifth Earl of Rosebery. The painting remained in Britain for the next eighty years, save when it was lent to important American exhibitions. In 1876 it came to the U.S. Centennial Exhibition in Philadelphia, and in 1932 to the George Washington Bicentennial Historical Exhibition at the Corcoran Gallery of Art in Washington, D.C. The painting came back to the United States in 1968 on long-term loan when the Smithsonian's National Portrait Gallery opened to the public. The portrait stayed on public view at the gallery until 2000, when the building closed for a major renovation.

The seventh Earl of Rosebery gave the painting to his son, Lord Harry Dalmeny, in 1992, and eight years later Dalmeny informed the Smithsonian that he had decided to sell the painting for $20 million. Realizing that the American people would take the loss of this painting as a national tragedy,

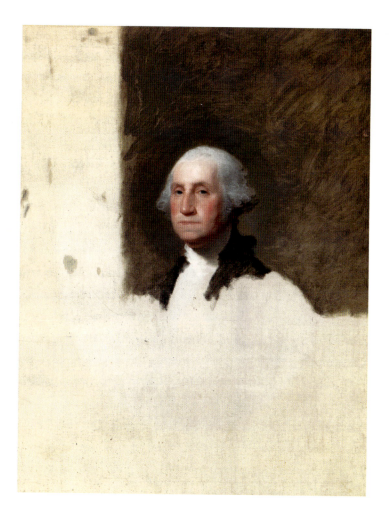

the Smithsonian sought a patron to buy the painting and donate it to the museum.

Marc Pachter, the director of the National Portrait Gallery at the time, took to the airwaves, appearing on the *Today* show with Matt Lauer. Pachter called the pending loss of the painting "a patriotic emergency" and explained its significance to some nine million viewers. Fred W. Smith, chair of the Donald W. Reynolds Foundation, was impressed by Pachter's determina-

tion to save the painting for the nation. The Reynolds Foundation made a generous donation to purchase the painting for the American people and present it to the National Portrait Gallery. At that time, the gallery and its sister American Art Museum were renovating their home, the historic Patent Office Building, and the Reynolds Foundation also made a large gift toward the renovation project and for the display of the portrait. When the building reopened in 2006, the Lansdowne portrait of George Washington was installed in a spectacular new setting.

Gilbert Stuart was commissioned to paint additional versions of this portrait. Miles, research historian Margaret Christman, and gallery conservator Cindy Lou Molnar have carried out historical research and technical examinations of the several paintings. One version was painted for Bingham himself, and is now owned by the Pennsylvania Academy of the Fine Arts. Another, commissioned by William Constable, belongs to the Brooklyn Museum in New York. There is a healthy debate over whether Stuart or another artist in his studio painted the version that has hung in the White House since 1800; and there are several derivative paintings in the halls of the U.S. Congress and other public buildings. But Miles and her team have determined that the National Portrait Gallery's Lansdowne portrait is indeed the original. In fact, Stuart himself identified it as such in 1823 when annotating a letter from Washington that arranged for the sittings in April 1796.

A ttend a sporting event in the United States, amateur or professional, and it's bound to begin with the crowd rising to its feet to join in singing, "Oh, say can you see . . . ," a song known as "The Star-Spangled Banner," America's national anthem. Many do not realize that the song refers to an actual flag, nor do they realize that its lyrics were penned when the fledgling nation's existence was in doubt.

This inspiring ensign flew over Baltimore's Fort

STAR-SPANGLED BANNER

McHenry during a crucial battle with the British in 1814. The flag now resides at the Smithsonian in a special gallery at the National Museum of American History.

America's War of 1812, our so-called second war of independence against the British, grew out of a complicated set of conflicts in Europe and North America. After the Revolutionary War, in violation of the terms of the peace treaty, Britain continued to occupy forts in the Northwest Territory on the American frontier. The British wanted to use Indians as a buffer between the United States and their colonies in Canada. They formed alliances with Native American tribes who sought to stop American settlers from encroaching on their traditional lands. In Europe, Britain was defending itself against Napoleon and his armies of conquest on the Continent. Britain and France sought to cripple each other's trade and commerce through naval battles, seizure of commercial ships, and blockades. The United States tried desperately to remain neutral in this conflict.

The British Navy needed 140,000 sailors to man its vast fleet. Facing a shortage of seafarers due to disease and defection, the British detained U.S. merchant vessels, capturing British citizens—including those who had become naturalized Americans—and impressing them into service on their ships. The British also blocked U.S. trade with France. Outraged, the U.S.

A FLAG SEWN IN BALTIMORE INSPIRES THE NATIONAL ANTHEM AND BECOMES A TREASURED ICON.

National Museum of American History

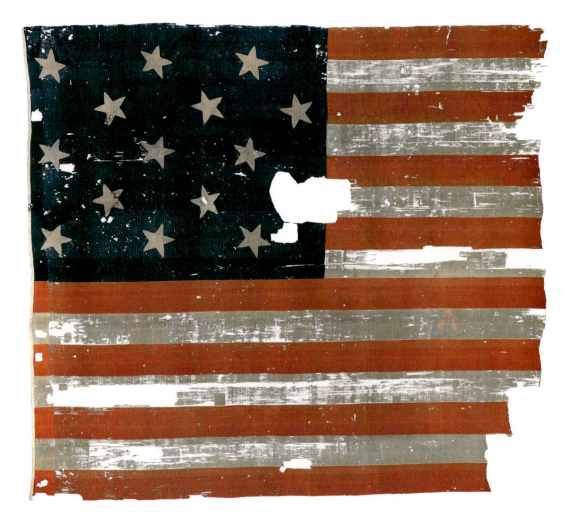

STAR-SPANGLED BANNER *National Museum of American History*

government deemed the British actions illegal and disrespectful of its national sovereignty, but with tiny armed forces and a weak navy, the United States was powerless to do very much.

President Thomas Jefferson and his successor, James Madison, resisted war, not wanting to raise a large navy or the government debt it would require, and instead opted for a trade embargo against the British. They hoped that denial of American raw materials would persuade the British to stop the impressments. But New Englanders depended on Britain for half their trade; they, along with Canadian colonists, undermined the embargo. Western war hawks in Congress advocated for the U.S. invasion of Canada as an alternative way of pressuring the British. For their part, the British were upset with the Americans for trading with the French and for making enormous profits off the war trade. By 1812, finding no other solution to British harassment, Madison successfully urged Congress to declare war. American troops engaged with British troops and their Native American allies, led by such figures as Tecumseh, in a series of nondecisive battles in southern Canada and the Great Lakes region.

The British developed a multipronged strategy for defeating the United States: blockade the eastern seaboard, invade New York State, and capture New Orleans. The effort picked up steam after the British defeated Napoleon in Europe in early 1814.

The Chesapeake Bay was a hub of the eastern seaboard trade. While British ships controlled much of the bay, Baltimore, the United States' fourth largest city, was a center of shipping, a staunchly anti-British city, and it harbored hundreds of privateers—independent ship owners granted the right by Madison to attack and take British ships. If British troops captured Baltimore, they could stop the privateers and strangle much of the United States' international commerce. If Baltimore fell, the United States would have to make concessions to Great Britain; its independence could be compromised.

Before British forces turned their attention to Baltimore, they first struck a dramatic political blow. In August 1814, British General Robert Ross led

forty-five hundred disciplined troops toward Washington, D.C. At Bladensburg, Maryland, they routed a larger force of American regulars and untrained local militia who ran from battle—to the chagrin of Madison, who witnessed the debacle. The city of Washington was now defenseless. First Lady Dolley Madison, servants, and slaves packed up valuables from the president's mansion, including its version of the Gilbert Stuart painting of George Washington, and fled along with the rest of the government.

British troops systematically torched the city, setting fire to the Capitol building, looting and burning the Presidential Mansion, and ransacking the Treasury and other government buildings before a massive thunderstorm dampened their work. Though they left the city, shock reverberated throughout the nation.

Madison returned to a devastated Washington. Repairs on the Presidential Mansion had to wait until war's end, when heavy coats of white paint covered the scorched sandstone and popularized the building's earlier though infrequent designation as the White House.

Now the British attack turned northward to Baltimore. Only Fort McHenry, guarding the city's harbor, stood in the way of British victory. British Admiral Alexander Cochrane and General Ross had a simple plan—pound Fort McHenry from ships anchored in the bay, and send in troops by land to surround and take the fort. Then the British could clear out the city's defenders.

Baltimoreans were determined to defend themselves. Fifteen thousand militiamen protected the land route into the city. The Americans sank junked boats to form a barrier preventing British ships from easily sailing directly into the inner harbor—they'd have to take the fort. At Fort McHenry, American Major George Armistead had fifty-seven artillery pieces and one thousand troops to face three British frigates, five bomb vessels, and one rocket-launching ship anchored two miles away, just beyond the range of his guns.

A VIEW of the BOMBARDMENT of Fort McHenry, near Baltimore, by the British fleet taken from the Observatory under the Command of Admirals Cochrane & Cockburn, in the morning of the 13th of Sept. 1814 which lasted 24 hours, & thrown from 1500 to 1800 shells, in the Night attempted to land by forcing a passage up the ferry branch but were repulsed with great loss.

The British salvo began on September 13, 1814. Spherical bombs burst deadly shrapnel over Fort McHenry. Whooshing Congreve rockets rained fire. After the daylong bombardment, British ships moved in for the kill. But as they came into range, the American gunners finally unleashed their response, knocking the rocket ship out of commission and forcing the bombers to retreat. The British continued the aerial onslaught; bombs and rockets lit up a tempestuous night sky filled with lightning and torrential rain.

Meanwhile, British land troops, seeking to invade the city, were stalled by the American defenders. Ross was killed in the battle. The naval bombardment continued until just before dawn, when it started to tail off.

Francis Scott Key, a thirty-five-year-old Washington lawyer and amateur poet, observed the onslaught from a boat in the harbor. He was temporar-

A VIEW OF THE BOMBARDMENT OF FORT McHENRY BY JOHN BOWER

Maryland Historical Society

ily in British custody, having negotiated the release of an American civilian prisoner, and was kept at sea during the battle. Key had originally opposed the war and the idea of the United States invading Canada. He had written to a friend that he would rather see "the American flag lowered in disgrace than have it stand for persecution and dishonor." Nonetheless, he dutifully served in the militia and sadly witnessed Washington's burning.

Through that night, Key wondered whether the fort would stand or fall. As dawn approached, what flag would he see over the fort—the American Stars and Stripes or the British Union Jack? The answer would signal the fate of the nation.

A year earlier, when Major Armistead took command, he had written, "We have no suitable ensign to display over the Fort, and it is my desire to have a flag so large that the British will have no difficulty in seeing it from a distance."

Two flags were ordered from Baltimore seamstress Mary Pickersgill, whose family had a long history of serving the young country. Pickersgill had learned her craft from her mother, who had sewn flags and uniforms for George Washington's Continental Army. The large, thirty-by-forty-two-foot garrison flag was made from worsted-wool bunting, with fifteen stars against an indigo background, eight red stripes, and seven white ones, as stipulated by the 1794 Flag Act. The cotton stars were two feet across, and each stripe was twenty-three inches wide. Pickersgill's teenage daughter, two nieces, and an African American indentured servant helped with the sewing. The flag cost $405.90.

As dawn broke, Francis Scott Key saw this large garrison flag flying over Fort McHenry. The republic's defenders had stood their ground. The attack fleet sailed in retreat. Overcome by emotion, Key penned a four-stanza poem on the back of a letter. The first stanza is the best known and poignantly ends in a question mark:

O say can you see, by the dawn's early light,
What so proudly we hail'd at the twilight's last gleaming,

Whose broad stripes and bright stars through the perilous fight

O'er the ramparts we watch'd were so gallantly streaming?

And the rocket's red glare, the bombs bursting in air,

Gave proof through the night that our flag was still there,

O say does that star-spangled banner yet wave

O'er the land of the free and the home of the brave?

Days later, Key's poem was published as "The Defense of Fort McHenry," with instructions that it be sung to the tune of "To Anacreon in Heaven," a British popular song Key had in mind when composing the poem. Weeks later it got a new title, "The Star-Spangled Banner."

The war formally ended with the Christmastime Treaty of Ghent, but because of the slow pace of communications, the war's deadliest battle, Andrew Jackson's defense of New Orleans, was fought weeks later. After the war's end, prisoners were exchanged and impressment activities ended. The U.S. northern borders were settled, and Canada emerged with a stronger sense of national identity. Native Americans were the biggest losers, with the frontier more open than ever for settlement and westward expansion.

"The Star-Spangled Banner" became the standard patriotic song for national celebrations, banquets, and public performances and was widely published in songbooks. Abolitionists questioned the irony of the lyrics—particularly the line "the land of the free" because Key was a slaveholder. Interestingly enough, it was Key's law

POEM
HANDWRITTEN
BY FRANCIS
SCOTT KEY

Maryland Historical Society

partner and brother-in-law, Roger B. Taney, who helped popularize the account of the song's writing. Taney went on to become chief justice of the United States and the author of the infamous Dred Scott decision in 1857, which solidified the legal status of slavery. Nonetheless, the song grew in popularity during the Civil War. By the 1890s, the Army and Navy played "The Star-Spangled Banner" for the daily raising and lowering of the flag; a decade later soldiers and sailors came to attention during its playing and civilian audiences adopted the practice—standing for the song at theaters and baseball games. Congress followed the armed services in designating it the national anthem in 1931.

But what of the flag itself?

Armistead acquired the flag after the war, and it was passed down in his family, first to his widow, Louisa, then to his daughter, Georgina, and finally to his grandson Eben Appleton. It was reflown over Fort McHenry to salute the Marquis de Lafayette when the Revolutionary War hero visited Baltimore in 1824. For decades it was carried and displayed during parades and patriotic events. According to newspapers, it was regarded as "a holy relic never disgraced, and receiving now the homage of friends."

The Armistead family allowed war veterans and prominent people to take snippings from the flag. Historians of the time noted that viewing or possessing a relic of something connected to great men and great deeds could inspire awe and "moral sensitivity and reflection." One official supposedly got a star. Others were buried with swatches. Over time, some two hundred square feet had been cut out of the flag.

The flag was hidden during the Civil War. In 1876 it was sent to the U.S. Centennial Exhibition in Philadelphia, but it was not displayed because of its fragility, even though a canvas backing had been added to shore it up. In 1907, to avoid continual requests to display the flag, Armistead's reclusive grandson lent it to the Smithsonian, and five years later he donated it outright, declaring the national museum the obvious choice to serve as the home of the Star-Spangled Banner. In 1914, with officials pressing the Smithsonian to lend it to Baltimore for the upcoming centennial celebra-

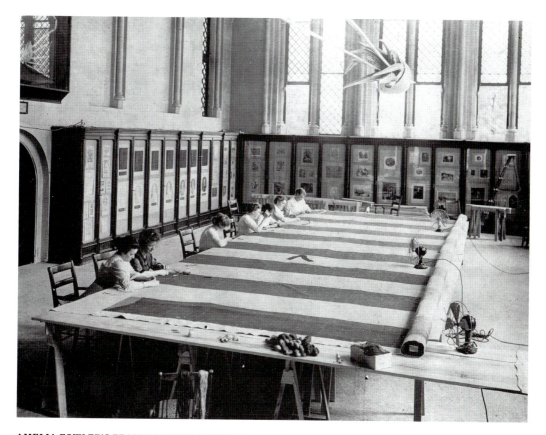

AMELIA FOWLER'S TEAM WORKING ON THE FLAG IN 1914 *Smithsonian Institution Archives*

tions, Appleton added a condition—the flag had to remain at the national museum "forever."

The former garrison flag was in a sorry state. The Smithsonian hired conservator Amelia Bold Fowler and her team of ten skilled seamstresses to save it for $1,243. They set up in the Smithsonian Castle and removed the canvas, replacing it with a linen backing, which was attached to the flag by an interlocking mesh of some 1.7 million stitches. The flag was then exhibited vertically in a giant glass display case in the Arts and Industries Building, where it was seen by millions over the next half century. The only time it was removed was during World War II, from 1942 to 1944, when

President Franklin D. Roosevelt feared Germany might bomb the National Mall. The flag was packed up and sent for safekeeping, along with other important national collections, to Shenandoah National Park near Luray, Virginia.

In 1964, the Star-Spangled Banner became the centerpiece of the new Museum of History and Technology, later renamed the National Museum of American History, where it was dramatically displayed as a symbol of American freedom. It hung vertically on a specially constructed frame, soaring fifty feet high in a monumental open space known as Flag Hall, and was unveiled several times a day as the national anthem played. Over the years, museum conservators realized that the flag was being stretched out of shape; changes in temperature and humidity, as well as dust and pollutants, were harming the fibers. Bright light was fading its colors. By the mid-1990s, a plan was devised to preserve the nearly two-hundred-year-old textile born in war and lovingly maltreated as a relic and an icon.

Major funding was needed. Enter First Lady Hillary Rodham Clinton and her Save America's Treasures program. The Star-Spangled Banner was number one on the list. Clinton inspired a major donation from clothing manufacturer Ralph Lauren. The flag was taken down and treated in a temporary laboratory. Museum visitors could watch conservators working on a scaffold suspended over the flag as, inch by inch, they vacuumed and cleaned the flag of oil, mold, dust, and other detritus. Their most painstaking task? Carefully removing every one of the 1.7 million stitches sewn in 1914 and replacing the old backing with Stabiltex—a strong, stable, and sheer material.

The conservation process took six years. Funds from the government, philanthropist Kenneth Behring, and others enabled us to construct a new home for the flag in the museum's central core. I am proud to have played a role in overseeing the final arrangements for this renovation. The flag would rest in a special climate- and light-controlled, low-oxygen chamber, displayed on an adjustable table that was tilted at an angle so it could be seen by the public without stressing the fabric. By the time President George W.

Bush, General Colin Powell, and others ceremonially opened the renovated museum, we'd spent nearly $58 million caring for the flag.

The installation is striking. You walk along a darkened hallway, seeing painted images of the War of 1812, passing a charred timber from the Presidential Mansion, burned during the invasion of Washington, as well as an actual rocket and bomb from the attack on Fort McHenry. Imagining Francis Scott Key in the dark out on Chesapeake Bay, his eyes straining to see the fort and the flag flying above it, you turn a corner and, with the light simulating the early dawn, through a wall of glass you see the Star-Spangled Banner. Every time I see it I get chills. The threadbare fragility of the physical flag is evident—but it speaks proudly nonetheless. The words of Key's poem are projected on a back wall, the question mark about the endurance

of the country answered by the flag's very presence. It is as awe-inspiring as a museum experience can be.

The allure of the Star-Spangled Banner in America's memory has fueled displays of the flag during poignant moments of collective national experience—Marines raising it at Iwo Jima, astronauts planting it on the moon, heroic athletes receiving their Olympic gold medals under its gaze, first responders hoisting it over the remnants of the World Trade Center after the attacks of September 11.

And, as the exhibition reminds us, the flag is also used as a symbol of protest, a call to do better and to realize the highest ideals of our national purpose.

Among the millions who annually see the flag is a special group. Just outside the Star-Spangled Banner chamber, the museum periodically holds public swearing-in ceremonies for new naturalized citizens. When it does, there is not a dry eye in the house. Previously naturalized citizens, like former Secretary of State Madeleine Albright, have sworn in children from Bosnia, refugees from Afghanistan, a serviceman originally from Ghana, and others. The ceremony is an affirmation of citizenship and the promise of America as home to those who make the commitment to belong. That affirmation is precisely the act that the British refused to recognize, the very reason for the War of 1812 that led to the Star-Spangled Banner becoming the embodiment of the American ideal.

O f his many accomplishments, Thomas Jefferson wanted to be remembered for three deeds: authoring the Declaration of Independence, founding the University of Virginia, and writing religious freedom into the Statute of Virginia.

Jefferson typically avoided discussing his religious beliefs publicly, and, as a result, was sometimes accused of being anti-Christian and anti-religious, especially

THOMAS JEFFERSON'S BIBLE

during his presidential campaigns of 1800 and 1804. He believed profoundly that the relationship between man and God was a matter of individual belief, faith, or reflection and that the government had no business being involved in such an intimate activity. He was suspicious of what he called priestcraft, and in Virginia he worked on the disestablishment of any official ties between organized religious institutions, particularly the Episcopal Church (which had been the Anglican Church, or Church of England) and the government. He disavowed the thought of any official or state religion, believing that Presbyterians, Baptists, and others should practice their religions freely. Joining religion to the state, he believed, would cause dissent and foment division among the people and contribute little to civic life and institutions. Jefferson celebrated the Constitution's first amendment for putting "a wall of separation of church and state."

A UNIQUE WORK EXPRESSES THE STILL-CONTROVERSIAL BELIEFS OF THE PRESIDENT AND PATRIOT WHO DEFINED RELIGIOUS LIBERTY FOR THE NATION.

National Museum of American History

Jefferson nonetheless thought of himself as a Christian, though he wrote that "I am a sect by myself, as far as I know." Jefferson was a Deist; he believed in God as the creator, even the endower of human and natural gifts. Though Jefferson thought deeply about the life of Jesus and his moral teaching, he did not believe in Christ's divinity. Jefferson corresponded with a number of colleagues, like Benjamin Rush, Thomas Paine, and Joseph Priestley, on the subject.

THOMAS JEFFERSON'S BIBLE *National Museum of American History*

As president, Jefferson read and contemplated the teaching of the Bible. He composed a tract, *Syllabus of an Estimate of the Merit of the Doctrines of Jesus, Compared with Those of Others,* which he then distributed to a close circle of friends. This led to another project even closer to his heart. In the Presidential Mansion at night, Jefferson would literally cut out selected passages from the Four Gospels of the New Testament and paste them down on blank sheets of paper. The result was the forty-six-page volume *The Philosophy of Jesus of Nazareth extracted from the account of his life and doctrines as given by Matthew, Mark, Luke and John.* Jefferson would read passages from the volume before sleep to gain inspiration.

When he retired to his beloved Monticello estate after the presidency, Jefferson resumed his passion and meticulously cut up passages from New Testament Bibles in four different languages—English, French, Latin, and Greek—rearranged them, and pasted them onto blank pages, each about five inches wide and eight inches long. He needed two Bibles of each language so that he could use both the front and back sides of their pages. The English versions had a larger print size than the others. In the occasional cases where Jefferson accidentally omitted a verse, he would turn a passage on its side and paste it down near the paper's edge. He would line up the extracted verses in columns by languages, so that when he put two pages side by side, he could read and compare, from left to right, the Greek version in the first column, the Latin in the second, the French in the third, and the English in the fourth. Having studied these languages since his youth, Jefferson was well equipped to make comparisons, though what insight he obtained from doing so remains a mystery.

By about 1820, he was finished; the document now extended to eighty-four double-page spreads. His title page read: "The Life and Morals of Jesus of Nazareth, Extracted textually from the Gospels in Greek, Latin, French, & English." He then sent the pages to Frederick Mayo, a bookbinder in Richmond, who stitched the pages together, inserting stubs of paper between them to enlarge the spine. Mayo lined the spine with layers of paper to comply with Jefferson's instruction that the book be able to be closed fully

and completely and covered the book in a red leather binding adorned with gold lettering. The short title *Morals of Jesus* was tooled in gold on the spine. Jefferson handwrote "A Table of the Texts from the Evangelists employed in this narrative and of the order of their arrangement" to provide a table of contents of sorts and likely glued this into the book after its binding.

The selections and organization of the book are noteworthy for what they reveal about Jefferson's beliefs. He thought that the Bible's Gospels had been tainted, not by Jesus' word but by his followers; that the main teachings of Jesus' life had suffered from misunderstandings, historical accretions, and elaborations of extraneous material, supposition, and even superstition. Jefferson purged the material he judged "contrary to reason" and omitted passages that referred to miracles and to Jesus' divinity. He was convinced that Christ was a great teacher of moral truths that universally applied to all of humanity. It was unnecessary and an affront to reason to have to clothe those truths in the miraculous, especially when, in Jefferson's view, Jesus never claimed to be divine. Jefferson's arrangement of the extracts provides a chronological narrative of Christ's life, from his birth on the very first page to his death on the last. Indeed, the book ends with the passage "There laid they Jesus, and rolled a great stone to the door of the sepulchre, and departed." Jefferson did not include the resurrection.

Jefferson kept the book at his Monticello home, read it before bed, and drew lessons and wisdom from it. He had no plans to publish it or distribute it broadly, knowing that many would take exception to his approach. Various clergymen had previously declared that Jefferson would bring down God's wrath on the new republic; revealing this work would only fan such sentiments. After Jefferson died, the book stayed in his family. Jefferson biographer Henry Randall was shown the index by the former president's grandson, Thomas Jefferson Randolph, and included information about it in his 1858 biography, but it remained a private document.

The Life and Morals of Jesus of Nazareth came to the Smithsonian through the efforts of the Institution's librarian, Cyrus Adler. In 1886, as a student of Semitic studies at Johns Hopkins University, Adler had cataloged the

library of Joshua Cohen in Baltimore. In this library of Judaica were two English-language copies of New Testament Bibles from which passages had been cut out. A note made clear they'd been purchased from Dr. Macaulay's medical library, which in turn had obtained them from the sale of Jefferson's library. Intrigued by the idea that Jefferson had edited a Bible, Adler tried to locate the volume. By 1895, having joined the Smithsonian staff, he had determined that it was still in the hands of the family. He purchased it from Jefferson's great-granddaughter Carolina Randolph for $400. Adler quickly put it on display as "Thomas Jefferson's Bible" in an exhibition of other Bibles and antiquities the Smithsonian organized for the Cotton States International Exposition in Atlanta.

Jefferson's Bible came to the attention of Congress in 1902 when both houses agreed to print the volume, including an introduction by Adler. Clergy lodged a complaint that the work was an assault on Christ's divinity and should not be published. Congress went ahead, and the Government Printing Office, working with the Smithsonian, photographed each page of the original and in 1904 published the book. Congress received nine thousand copies, and distributed them between the two chambers. The House gave away all their copies in 1904. The Senate held on to more books, and for many years presented a copy to new members on the day they were sworn in. That tradition lasted until the 1950s, when the supply of books ran out. In the meantime, other publishers reprinted the book in numerous formats for broader public distribution. They used as its title *The Jefferson Bible*, a term that its compiler would no doubt question.

Jefferson's Bible had already suffered some damage by 1904—many pages had torn edges and others had darkened with exposure to light. Over the next century, the book became increasingly fragile, making its continued display problematic. Extensive conservation treatment would be needed. The National Museum of American History's paper conservator Janice Ellis and curator Harry Rubenstein consulted with conservators from across the Smithsonian, as well as with those from the Library of Congress, the National Archives, Winterthur, and the University of Virginia. Led by Ellis,

museum conservators tested, analyzed, and photographed the book, painstakingly documenting every page.

The team confirmed that six Bibles had been used as sources—the Greek and Latin had come from one edition—and established the exact editions. They found marks on the volumes' pages indicating how Jefferson plotted out the pasting. They documented each and every handwritten notation, mistake, and correction he made. They identified the twelve types of paper, two types of glue, and various inks used. They also determined a host of problems: the glues had dried out, papers had become brittle, and the binding and stubs made the book impossible to open fully without cracking pages.

Conservation involved taking the volume apart page by page, cleaning and repairing each leaf, replacing the stubs, and resewing the book into its original covers using as much original material as possible while keeping the methods and materials sympathetic to the original.

The result was a marvelous success, and the Jefferson Bible went back on display in 2011 in the museum's new Albert H. Small Documents Gallery. A fully digitized version and two new print editions, including a leatherbound facsimile of the original, were also made available for viewing, and they continue to provide the public with an opportunity to deepen its understanding of Jefferson's views and his handiwork.

YOUNG NATION

(LATE EIGHTEENTH CENTURY TO 1850s)

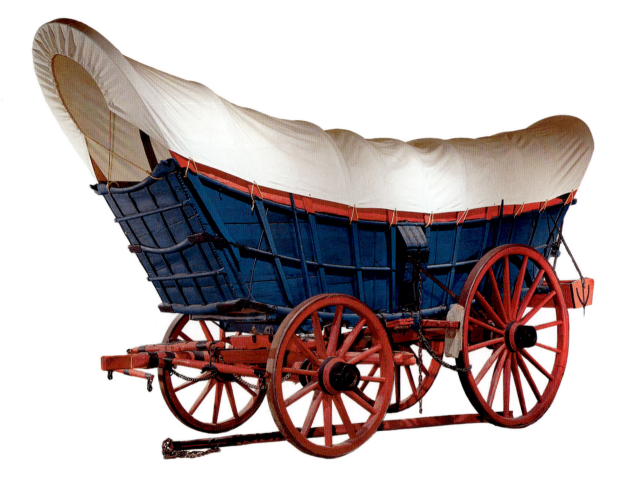

CONESTOGA WAGON *National Museum of American History*

Although covered wagons are associated primarily with westward expansion across the prairies, their forerunners, Conestoga wagons, originated in the mid-1700s, if not before, in southeastern Pennsylvania. They likely developed in German settlements near Lancaster and the Conestoga River. These wagons were the freight carriers of colonial America and the young United States. They transported supplies and finished goods from eastern towns to settlers along the Ohio River Valley and returned with flour, whiskey, tobacco, furs, coal, iron, and other marketable products.

17

CONESTOGA WAGON

A HORSE-DRAWN COVERED WAGON MOVES GOODS BETWEEN CITIES AND THE FRONTIER OF A YOUNG NATION.

National Museum of American History

Originally, the wagons were used along the "Great Wagon Road," which followed ancient pathways of the Iroquois through the Shenandoah Valley from Philadelphia to Augusta, Georgia.

The Great Wagon Road also carried German and Scots-Irish immigrant settlers southward from Pennsylvania into Virginia, the Carolinas, and Georgia. Settlers sought new, cheap land on the western frontier to establish their farms. More than 100,000 immigrants moved along this route, which today runs along Interstate 81 through the Shenandoah Valley and then through North Carolina and South Carolina to Georgia. Along the way, settlements grew like a strand of beads on the roadway.

After the American Revolution, the United States gained formal possession of the Northwest Territory from Britain, and settlers were lured westward. Roads were essential for the increased wagon traffic. Upgraded roads linked Philadelphia to Pittsburgh and Baltimore to Wheeling (now in West Virginia, but then in Virginia). The first federally funded road, known as the National Road, was built in several segments between 1811 and 1838. It stretched from Cumberland, Maryland, to Wheeling, then through Ohio and Indiana to Vandalia, Illinois. Much of the National Road still exists today as U.S. Route 40. The road provided opportunities for people with

horse-drawn Conestoga wagons to thrive on freight traffic between East Coast cities and the new settlements in the Ohio River region. When New York State's Erie Canal threatened to render the National Road obsolete and put Pennsylvania's economy at risk, Pennsylvania invested heavily in railroads and canals. Plans were devised to extend the National Road all the way to St. Louis, but Congress cut off funds in 1837, and by then it was too late to complete the project. After railroads reached Pittsburgh and Wheeling in the mid-1850s, the slow wagon trip was not competitive with freight trains, and Conestoga wagons disappeared from long-distance service.

Wagons needed to be sturdy as they had to cross streams and shallow rivers, navigate steep mountain passes, and deal with rutted roads and deep mud. The Conestoga wagon's frame and suspension were made of wood, while the wheels were typically iron-rimmed for greater durability; a stretched tough white canvas cover provided protection from the weather. Wagons combined utility with Pennsylvania German folk art, as indicated in this example, with a blue body, red running gear, and decorative ironwork. The curved shape shifted cargo toward the center and prevented items from sliding as the wagon traversed trails on hills and mountain slopes.

The Smithsonian's Conestoga wagon was acquired from a Pennsylvania collector. Although its provenance is largely unknown, according to museum curator Roger White it was probably built and in service from about 1840 to 1850. He believes it to be among the largest Conestoga wagons made, eighteen feet long and almost eight feet wide, indicating its intended use—hauling large, heavy consignments of freight.

Six horses pulled the wagon. Rarely did passengers ride in it. The wagoner, or driver, typically rode on the horse nearest the wagon on the left side, or sat on the "lazy board," which extended from the wagon, or walked alongside it. In good weather, the wagon would travel about ten to fifteen miles a day, making a trip across Pennsylvania a three- or four-week journey. The wagon carried a feed box for the horses. The wagoner would usually sleep on a rolled-up mattress in the wagon or outdoors, except in cold weather, when a roadside inn with a roaring fireplace might make an attractive stop.

As settlers and traders moved westward along the Santa Fe Trail, they adopted the Conestoga wagon. But since the wagons had to cover much longer distances than in the East, and because water was scarce, they found it better to use oxen or mules than horses. Teams of oxen, sometimes as many as two dozen, would haul the heaviest loads. Wagon drivers on the Oregon Trail found that the Conestoga wagons were too big and heavy for their needs: hauling the huge wagons killed even the sturdiest oxen before the journey was done. Their answer to the problem was dubbed the prairie schooner, a smaller version of the Conestoga that typically measured four feet wide and ten to twelve feet in length. The wagon's tongue and neck yoke almost doubled the length. It often lacked the cantilevered canvas top, or bonnet, that extended over the front and back of the Conestoga. The sturdy little wagons were built by the Studebaker brothers or any of a dozen other wagon builders, known as wainwrights. Teams of four to six oxen or six to ten mules were sufficient to get the wagons and their occupants to Oregon.

Prairie schooners inevitably broke down, and parts wore out during the rough overland journeys. Tools, supplies, and wagon parts—iron bolts, linchpins, skeins, nails, a hoop iron, a variety of tools, and a jack—for making repairs en route were carried in a jockey box attached to one end or side of the wagon. Water barrels, a butter churn, a shovel, an ax, a tar bucket, a feed trough for the livestock, and even chicken coops were hung on the outside of the wagon as well. With only one set of springs, the wagon ride was so rough that it was said a churn filled with cream at dawn would turn to butter after half a day's journey.

Rides were also dangerous. On longer wagon journeys, threats abounded from raiding parties or thieves, lethal diseases, and other mishaps. Nonetheless, the Conestoga wagon and its successor, the prairie schooner, came to symbolize opportunity and new frontiers for Americans. These wagons enabled hundreds of thousands of easterners and new immigrants from Europe to head west, settle new lands, and make a fresh start in an expanding American nation.

This artifact appears to be among the more modest of items within the vast Smithsonian collections. It features a narrow hand crank that turns a spinning drum with four simple pulleys and is encased within a plain cherrywood box measuring fourteen inches long by ten inches high. However, its simplicity belies its impact. This is Eli Whitney's cotton gin—not the original model, as that was destroyed in a Patent Office fire in 1836, but rather a demonstration

ELI WHITNEY'S COTTON GIN

A MACHINE
IMPROVES THE
PROCESSING
OF COTTON
AND EXPANDS
A SLAVERY-
DRIVEN
AGRICULTURAL
ECONOMY.

National Museum of American History

model that was used in Whitney's early court cases. It came to the Smithsonian in 1908. This straightforward-looking device helped make cotton "king" and inadvertently contributed to America's most costly war.

Its history begins with the agricultural economy of the American South. The Southern colonial economy developed in the seventeenth and eighteenth centuries around the cultivation of tobacco. Intensive tobacco cultivation, however, depleted soils fairly quickly, and Southern growers increasingly faced competition from other world regions anxious to provide supplies to Europe. Planters began looking for an alternative cash crop. Rice, indigo, and sugarcane were cultivated in the semitropical lowcountry regions of South Carolina and Georgia, but faced strong competition from widespread Caribbean plantations enjoying more favorable land and climatic conditions. Growers in the upland South desired a crop that would thrive in the hot, dry summers and in relatively poor soil with limited rainfall.

Cotton was a possible answer. Grown natively in India and Mexico for thousands of years, cotton first became known to Europeans in the fourteenth century as a kind of wool that grew on trees or shrubs. It produced pods, known as bolls, of fiber that when processed could be turned into yarn and threads and woven into textiles and clothing. By the eighteenth century,

ELI WHITNEY'S COTTON GIN *National Museum of American History*

England's developing textile mills began using Indian cotton, employing considerable labor, and turning out new cloth for domestic consumption and export.

In the American colonies, cotton was planted at Jamestown. Short-staple Mexican cotton was a good horticultural fit with the American South. Unlike long-staple cotton, it did not need a semitropical environment and could be widely planted. There was, however, one huge problem: it required too much labor to be economically profitable. Harvesting cotton—that is, removing the bolls from the shrubs, known as picking cotton—took a lot of time and labor in the fields. Adding to this, the short-staple cotton bolls were full of seeds intricately attached to fibers. A technology—the roller gin—had long before been developed to remove the seeds from long-staple cotton, but it was ineffective for the short-staple variety. The seeds had to be removed by hand so that the fibers could be processed. This was a slow, tedious procedure. One person working all day could perhaps separate out about four to eight pounds of usable cotton fiber from the seeds.

A number of inventors attempted to tackle the problem by trying to develop a workable and efficient cotton "engine" to separate the fiber from the unwanted seeds. Several found varying degrees of success, but it was Eli Whitney (1765–1825) who trumpeted the leading design.

Whitney was a New Englander who as a recent Yale graduate moved to Georgia in 1792 in search of a teaching job. He ended up living at the Mulberry Grove plantation of Catharine Greene, the widow of Continental Army General Nathanael Greene. Whitney's background in farming and penchant for mechanical tinkering primed his interest in the challenge of processing cotton on the plantation and led to his construction of a small device in a wooden housing. It had at its core a hand-turned wooden cylinder, or drum. Attached to the drum were wire hooks, or teeth, to catch onto the boll and pull the fibrous material through a slatted screen. The seeds would not fit through the slats and thus dropped out, leaving the seeded cotton fiber to pass through. Brushes then removed the fiber from the teeth, and moved the cotton along to be collected. Using the device, one could

process fifty to sixty pounds of cotton a day, about a tenfold increase over the previous hand-removal method, dramatically increasing efficiency. The only drawback was that many more of the fibers were cut in the process than would have been by hand processing. This resulted in an inferior yarn when spun—as it had more knots and was rougher to the touch. Nonetheless, the vast increase in the quantity of cotton processed provided for considerable economic gain. Whitney sought to patent his cotton gin in a March 14, 1794, application to the federal government.

The idea of a patent was enshrined in the U.S. Constitution, then still a very young document. Article I gave Congress the authority "to promote the progress of science and useful arts by securing for limited times to authors and inventors the exclusive right to their respective writings and inventions." Basically, inventors would have the right to benefit economically from their innovations for a period of years. They could either manufacture or publish their works and make money from selling such products, or they could license their work to others, who would then pay for the right to use or manufacture the invention. Others could not use the invention or creation without permission and, presumably, payment. The government could also refuse to grant patents if the invention was deemed unoriginal or did not work as described.

Whitney submitted his application, with a description, drawing, and model of the cotton gin, to Secretary of State Thomas Jefferson. Jefferson himself was not a strong supporter of the concept of patents, believing they created a monopoly on knowledge and innovation. He advocated the free and open distribution of scientific and technical innovations. And the newness of the patent process and the small number of employees dedicated to it meant that patents were not easily obtained.

Nonetheless, Whitney pressed forward and took on Greene's plantation manager, Phineas Miller, as his business partner. Miller was a fellow Yale graduate and would later marry Greene. Whitney and Miller first tried a system of charging growers to gin their cotton—much like a sawmill or gristmill. They would seed the cotton for an in-kind fee of 40 percent of the

cotton cleaned. Growers resented the steep fee—it was a lot to pay for what seemed to be a very simple process, and the idea never got off the ground. Additionally, it was impractical, as the demand for cotton gins was very high and geographically widespread. Whitney and Miller instead went into the manufacturing business back in New Haven, Connecticut, but could not meet demand. They also faced fierce competition, as other mechanics easily made their own cotton gins. Some copied Whitney's invention while others made modifications and improvements on his design. Whitney improved the gin over the years, and claims have also been made that Greene made crucial improvements to the original design.

The proliferation of copied, modified, and improved versions of the cotton gin kept Whitney busy filing some two dozen patent-infringement lawsuits over the next decade, which drained his profits. It was not until 1807 that Whitney's patent was firmly established, and though it made him famous it did not make him wealthy.

The consequences of Whitney's invention went far beyond the mechanical seeding of cotton. Because cotton processing could now proceed on a scale heretofore impossible, much more land could be devoted to cotton cultivation. As cotton was easy to transport and did not spoil, it could be sent afar to textile mills in Europe. In 1793, before the cotton gin, the United States exported 500,000 pounds of cotton. This grew to 93 million pounds by 1810. In the ensuing decades cotton became the chief export of the United States, accounting for more than half of all exported goods. Cotton also headed to New England, where immigrant British entrepreneur Samuel Slater had developed a machine to spin cotton thread, which led to the establishment of textile mills in Rhode Island and Massachusetts. As mechanical textile looms developed in the following decades, they acquired almost unlimited capacity to turn raw materials into finished textiles, stoking increasing demand for Southern cotton.

Paradoxically, Whitney's labor-saving invention helped to preserve and expand slavery through the South. Other forms of Southern slave-based agriculture were of declining or limited profitability before the expansion

of cotton growing. Cotton agriculture required an increased labor force for planting and picking. King cotton became the dominant product of the Southern economy, supported by slave labor. In 1790, just under 700,000 slaves were reported in the first U.S. census. That number grew to almost 900,000 in 1800, and even though the importation of slaves was abolished in 1808, there were about 2 million slaves in 1830 and 4 million in 1860— as cotton production reached a staggering almost 2 billion pounds. Profits from the enterprise fueled large plantations, with their Greek Revival mansions, as well as the lavish, almost aristocratic lifestyles of the antebellum South's white, landowning elite. Cotton cultivation also supported small-farm owners and slavery for their operations as well. The desire to acquire more and more land for cotton cultivation contributed to the forced removal of Cherokee, Choctaw, and Seminole Indians from their Southern homelands to Oklahoma in the 1830s—resulting in the infamous Trail of Tears. The costs and stakes of managing and controlling the huge slave population led to increasing regulations and harsher treatments as well as Southern attempts to buttress slavery's legal standing in the nation. The tension between Southern slave owners and Northern abolitionists would percolate for decades, ultimately culminating in the Civil War.

JOHN DEERE'S STEEL PLOW *National Museum of American History*

The young United States was an agricultural country. Its populace depended upon farming for its daily meals and for bountiful surpluses that could be traded and sold off in markets and towns.

While the vast Midwest—historically known as the Northwest Territory—had long beckoned American colonists seeking land to farm and settle, the British had reserved the region for American Indians, forbidding colonists to migrate beyond the Appalachian Mountains. But following the Revolutionary War, the Treaty of Paris in 1783 formalized American government control of the region, and the westward movement, with its promise of agricultural plenty, began. The number of free white male settlers reached five thousand by 1798. Settlements grew. Ohio became a state in 1803, with the territories of Indiana, Illinois, Michigan, Wisconsin, and Minnesota on a similar path. British forays from Canada and their alliances with threatened American Indian tribes destabilized the region through the War of 1812, but were finally brought to an end with the Treaty of Ghent in 1814. Indiana and Illinois soon became states, and with stable property rights established and land bought and sold, the development of prairie agriculture could proceed.

Plows were at the heart of agriculture and had been so for thousands of years. A plow was needed to prepare the soil for large-field agricultural plantings, typically cereal grains. Many of the leaders of the American Revolution owned farms and, like George Washington and Thomas Jefferson, sought to bring scientific principles to the enterprise. Jefferson even invented a plow especially adapted to the hilly fields of Monticello.

The plow's function is to cut into the soil, turning over the upper layer to bring fresh nutrients to the surface, while burying weeds and the remains of previous crops. Plowing breaks up compacted earth, aiding in plant growth.

19

JOHN DEERE'S STEEL PLOW

A MODEST INNOVATION OPENS UP THE MIDWEST TO AGRICULTURE AND HELPS FEED A NATION AND EVENTUALLY THE WORLD.

National Museum of American History

It typically creates furrows for the planting of new seed. While plows could be pulled by men, they were often animal-powered—pulled by horses, oxen, and mules. In the American colonies, the first plows were made of wood and came in various sizes and shapes. Plows generally have three basic, connected parts—a beam, which is held by a man or attaches to an animal or machine; a plowshare, the ground-cutting edge of the implement; and the moldboard, or weighted body attached to the plowshare, which turns over the soil. Some plows have a chisel attached to the plowshare and a coulter, or vertical cutting surface, hanging down from the beam that precedes the plowshare and precuts a channel in the ground.

Wooden plows can work both light and sandy and heavily irrigated soils. In Britain in the eighteenth century, inventors and mechanics started to experiment with the shape of the moldboards, and with attaching or covering them with iron. A one-piece iron moldboard and plowshare was manufactured in Britain and came to America. Combined with animal power, these iron plows were very effective in preparing relatively small fields east of the Appalachians. But prairie soils were another matter. They were heavier and covered with tougher grasses. The cast-iron plow would retain the heavier-cut midwestern clay soil on its plowshare rather than flipping it over. Sometimes iron plowshares would bend or even break in especially resistant soil.

Working as a blacksmith, John Deere (1804–86) was well aware of the problem with the iron plows. Deere, born to a tailor in Vermont and apprenticed as a blacksmith, had gone into the trade as a young man, moving to Grand Detour, Illinois. There are several versions of how he came to arrive at steel as a solution to the problem. In one, he was inspired to use polished steel for the moldboard and plowshare by recalling the smooth, sharp, polished needles used by his father for sewing through soft leather. In another, he was inspired by thinking of the steel tines of a pitchfork working hay. In yet another, he improvised, fashioning a moldboard from a broken but reusable secondhand steel sawmill blade, figuring the clay soil would easily slide off the highly polished steel surface.

Whatever the inspiration, in 1837 Deere developed a steel plowshare that farmers found exceedingly useful. He also started to experiment with the shape of the moldboard, figuring he could make it turn over the sticky soil more efficiently. By 1838 the moldboard took shape as a parallelogram, curved in a concave fashion with a specific contour that would maximize the turning of soil, like this Smithsonian version. He sold the plow to a local farmer who had great success with it. More neighbors placed orders, and within a few years Deere was selling close to one hundred plows annually. The steel plow was becoming a commercial success; Deere partnered with Leonard Andrus to produce more plows to satisfy demand. He experimented with a steel coulter and a steel-covered iron moldboard to achieve greater efficiency. But the two men had a falling out, and Deere relocated to Moline, Illinois, where he established a factory and set up his own company. By 1855, Deere was selling more than ten thousand steel plows a year, and his plow was known as "the plow that broke the Plains." He continued to innovate, developing nine different models.

As Deere was developing the plow, others were pursuing similar types of innovations in agriculture to increase efficiency and productivity. Among the more notable was the development of reapers by Obed Hussey of Ohio and Cyrus McCormick of Virginia in the 1830s. Harvesting grain was tedious work, largely done by hand and requiring a great deal of labor to cut and pile and bundle the produce. The early Hussey and McCormick reapers both required a team of horses to pull a machine, one man to operate a crank-driven blade to cut and rake the grain into swaths, and another to drive. While hand labor was still required to follow along and tie the grain into bundles, the reaper reduced labor significantly. Subsequent inventions, such as the Marsh harvester, improved efficiency even more.

The Deere plow, the reapers, and related inventions allowed U.S. farms to produce more crops to feed larger city and town populations with less labor. In 1800, about 80 percent of the labor force was involved with agriculture. Only fifty years later, it was just over 50 percent. This freed up the American population for other pursuits, such as trade, manufacturing,

and service industries. Agricultural productivity, on the other hand, was up. Farmers had to invest more in implements, tools, and machines than in labor—especially in the Midwest, with its big grain-producing enterprises. The need to borrow money to buy machines outweighed more traditional reservations about going into debt. It also meant that farmers required ready access to cheap credit from banks—a persistent concern in the late nineteenth and early twentieth centuries. That there was money to be made in agricultural business activities motivated innovators like McCormick and Hussey to battle for years over patent infringement and market share before concluding a financial settlement. Other competitors had emerged by the 1870s, notably Warder, Bushnell, and Glessner, and the Gammon (later Deering) Harvester Company.

John Deere continued to do very well financially. He left running operations to his son and incorporated the business as Deere & Company. The company introduced various plows in the ensuing years, including those pulled by steam tractor. Mechanized plowing could be done faster and more efficiently with larger fields, but also with increased capital expense.

With the rise of the internal combustion engine in the twentieth century, the company went on to manufacture a plethora of tractors, combines, and harvesters and became one of the largest companies in the world. It enabled industrial-scale agriculture scarcely imaginable in Deere's time. Indeed, today, less than 1 percent of the American population is engaged in farming, and productivity has increased exponentially. The company, justly proud of its legacy, donated the 1838 steel moldboard plow to the Smithsonian in 1938, one hundred years after its invention.

Since prehistoric times, sewing has been a time-consuming hand skill required to make not only clothing, hats, and shoes but also quilts, tents, saddles, bags, sails, and a host of other goods. In Europe and colonial America, domestic hand sewing of cloth was typically regarded as "women's work" to be done at home, while the heavier-duty tasks of cutting cloth, commercial tailoring, and making leather goods fell traditionally to men in workshops.

A variety of machines changed both work routines and the scale of textile production. Thread and yarn making had been industrialized in England in the eighteenth century with the development of the fly-shuttle loom and spinning jenny. These machines led to greater output and productivity, the growth of the textile industry, and the early industrial revolution. The industry advanced in England in the early decades of the nineteenth century—the number of steam-powered mechanical looms increased from about 5,000 in 1818 to more than 250,000 by 1850. A huge amount of cloth was being produced for worldwide consumption at ever-lower prices, generating new opportunities to assemble it into finished goods.

From the mid-eighteenth century onward, numerous European inventors tried to make headway in developing a sewing machine, but none proved workable. High-end customers still went to tailors for custom-made items, but early producers of ready-made items, such as men's shirts, typically farmed out hand sewing to women to assemble finished goods at home and get paid by the piece, or they engaged middlemen, called sweaters in England, to run arduous and gruesome sweatshops for hand sewers. In 1830, a French tailor, Barthélemy Thimonnier, designed a functioning machine that used only one thread and a hooked needle that made a chain stitch of the type used primarily in embroidery. Although this machine was

20

ISAAC SINGER'S SEWING MACHINE

A PRACTICAL MECHANICAL INVENTION TRANSFORMS INDUSTRY AS WELL AS THE ROLE OF WOMEN IN THE WORKFORCE AND AT HOME.

National Museum of American History

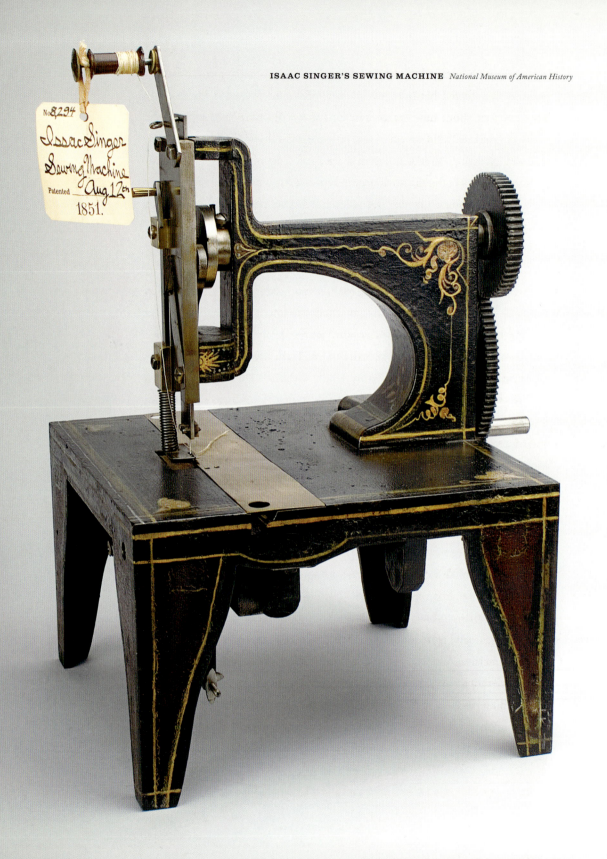

quite primitive, enraged tailors burned down Thimonnier's garment factory because they feared his new invention would render their skills obsolete. This concern about new technology might explain why Walter Hunt, an American who in 1834 invented a machine that could perform a more practical straight stitch, failed to pursue a patent for his invention, stating that he feared the loss of jobs its widespread use would cause.

The race to mechanize sewing accelerated through the mid-nineteenth century with the increased production of cotton, the burgeoning of populations in cities, and a growing demand in the United States and Europe for ready-made clothing. The first sewing machines were intended for factories and tailors' shops, not home production. Starting in the 1840s in the United States, in an explosion of inventive creativity, numerous patents were issued for machines of various shapes and types. The Smithsonian's collections have more than a dozen of these patent models, all transferred to the Institution in 1908.

Elias Howe (1819–67) made major headway in 1846 when he patented the first two-thread machine that, like machines today, used a threaded-eye pointed needle to push one looped thread through a tiny hole in the fabric, where it caught another thread on the underside of the machine, producing a lockstitch that attached two pieces of fabric together.

Howe's innovation was eclipsed by Isaac Merritt Singer (1811–75), who successfully brought an improved invention to market. Singer, the eighth child of poor German Jewish immigrants, had worked as a mechanic and cabinetmaker in New York and then for a print-type maker in Ohio. There he developed an improved type-carving machine, which he took to Boston seeking financial backing. Singer befriended Orson Phelps, who was developing a sewing machine based on Howe's advance but seeking increased precision and efficiency. Singer improved on Phelps's design with a forward-moving shuttle that tightened stitches, a friction pad that controlled the tension of the thread from the spool, and an adjustable arm that permitted the spooled thread to be changed as needed. This allowed for more reliable and continuous stitching than Howe's machine.

 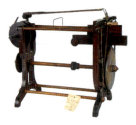 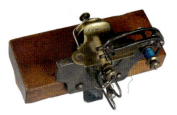

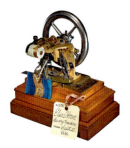 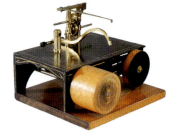 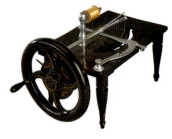

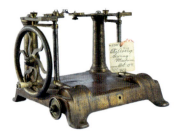 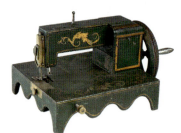

 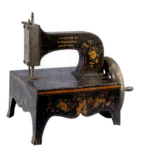

Phelps produced the machines in his shop for heavy-duty commercial use, making the head, base cams, and gear wheels out of cast iron. The machine was transported in its packing crate, which served as a stand. Singer proved a good showman in demonstrating that even petite women seamstresses could easily use the machine.

Indeed, a worker using Singer's machine could sew nine hundred stitches per minute, more than twenty times as many as a skilled seamstress. Singer's business with Phelps was on the road to success, with one hitch: Howe legally contested their use of his lockstitch mechanism. Even though Singer banded together with other sewing machine inventors and manufacturers in a consortium called the Sewing Machine Combination to reduce licensing and litigation overhead, Howe won. Singer and the others agreed to pay him royalties on each machine sold. By 1856, I. M. Singer and Co. began to mass-produce sewing machines, making more than twenty-five hundred units the first year, and expanding to thirteen thousand in 1860. While the machine could be powered by a hand wheel, Singer added a foot-powered wooden treadle to free both hands to guide cloth while stitching. Singer also developed a cheaper home version.

Machine-sewn clothing could be made much faster and more cheaply than hand-sewn apparel. Mass production encouraged a division of labor between workers and managers, and led to further labor efficiencies in packing and shipping of material and finished goods. Women could now be paid salaries and their productivity could be closely monitored. Levels of production skyrocketed and costs plummeted. During the Civil War, both the Union and the Confederacy had a need for hundreds of thousands of mass-manufactured uniforms and tents, providing a boon to Singer's business, and to numerous clothing manufacturers.

After the Civil War immigration and domestic migration increased, cit-

Left to right, top row to bottom row: **SEWING MACHINE PATENT MODELS OF GREENOUGH, 1842; BEAN, 1843; CORLISS, 1843; HOWE, 1846; BACHELDER, 1849; ROBINSON, 1850; WILSON, 1850; GROVER AND BAKER, 1851; WILSON, 1851; AVERY, 1852; HODGKIN, 1852; BRADEEN, 1852; MILLER, 1852; WILSON, 1852; WICKERSHAM, 1853** *National Museum of American History*

ies grew even more rapidly, and the national need for manufactured clothing expanded across the continent. Some clothing developed in tandem with sewing machines. One popular article was heavy-duty pants manufactured by San Francisco clothing merchant Levi Strauss and his partner, Bavarian immigrant Jacob Davis. The pair strengthened men's trousers by riveting their pockets. Made with a brown cotton material called duck, and more popularly with blue denim, these pants were well worn in the West. Over the course of the next century those pants, called Levi's and jeans, became a symbol of American identity.

Back east, apparel factories grew in size and number, as did their workforce. Immigrant women and children found work in sweatshops and garment shops. Manufacturers could pay low wages and impose tough conditions on workers. In the 1880s, weekly wages for sewing machine operators in Baltimore, Boston, and New York ranged from about $3.50 to $7.00. Working conditions were unsafe and hours long. "If you don't come in Sunday, don't come in Monday" was the famous admonition affixed to many sweatshop walls. Reformers worried about bad factory conditions—poor light, bad air, overcrowding, and work tasks that endangered women's health.

By the turn of the twentieth century, virtually all Americans were buying ready-made clothing in shops and through catalogs like Sears, Roebuck and Company. New York City was a center of clothing manufacture. Baltimore was big for men's suits, and Los Angeles was emerging as a center for sportswear. The garment industry became a magnet for new immigrant labor, particularly among Italian and Jewish immigrants—both my grandfathers included. The growing industry led to calls for increased rights for workers. In 1900 the International Ladies' Garment Workers' Union (ILGWU) was formed in New York City to protect the rights and improve the conditions of garment workers—largely women working at sewing machines in hot, dusty, fetid tenement shops on East Broadway or Clinton Street. Exposés of the horrific living conditions of the working poor were published by reformers like Jacob Riis and prompted widespread public outcry and a call for public policy to protect people, especially children, from exploitation and squalor.

The ILGWU galvanized support for a walkout at the Triangle Shirt-waist factory in New York in November 1909, which eventually led to a fourteen-week-long strike called the Uprising of the 20,000. Women's suffrage advocates drew public and political attention to the plight of garment workers as part of an overall movement for women's rights. The nation was shocked the next year, as a fire at the unsafe Triangle factory led to the deaths of 129 female and 17 male workers; bystanders watched in horror as 62 women jumped to their deaths from the upper floors of the ten-story structure. The exits had been locked by the owners, allegedly to prevent theft, and as a result many women could not escape. While the owners avoided conviction for manslaughter and a civil suit yielded victims' families only paltry settlements of seventy-five dollars per fatality, the public was outraged and legislation followed. However, minimum-wage laws and other protections were not enacted for decades.

Sewing machine sweatshops continued to be operated by the garment industry in New York's Chinatown and other U.S. cities, although American manufacturers increasingly set up such operations in other nations where labor costs were cheaper and standards less exacting. Today, millions of workers use a variety of sewing machines in China, Vietnam, India, Bangladesh, the Philippines, Mexico, Central America, and parts of Africa to fulfill the needs of a global market. Some economists see this as a natural part of a developing economy while others see it as a form of abuse and related to other ills, such as human trafficking, indentured servitude, and child labor. In addition, the environmental toll from harsh chemical fixatives and artificial dyes used in clothing manufacturing has raised concern.

Meanwhile, in America, sewing machines became a product increasingly marketed, by the Singer Sewing Company and others, for noncommercial use, mainly by women to advance their creative talents and homemaking skills at home through the textile arts. That trend continues today, as many sewing machines are now sold to immigrant women from developing countries who choose to maintain their tradition of home sewing or who prefer noncommercial clothing.

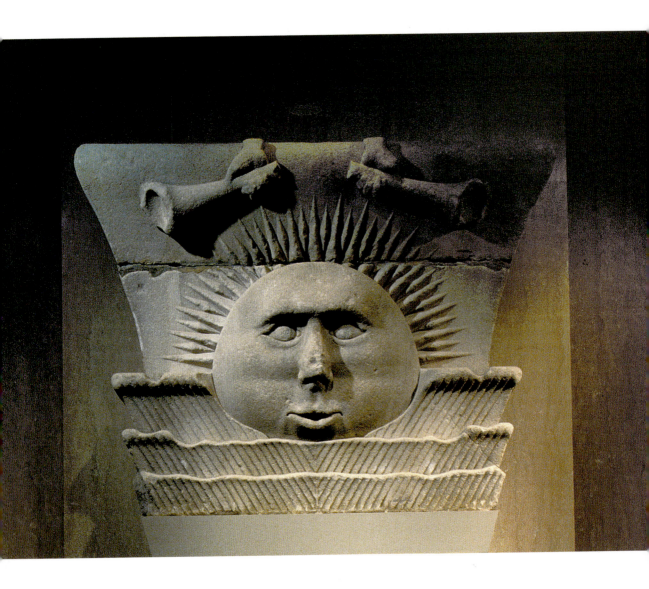

SUN STONE FROM THE NAUVOO MORMON TEMPLE *National Museum of American History*

The design for this radiating sun stone came in a vision to the Mormon prophet Joseph Smith. One of only three still in existence and by far the most complete, it is among the most important relics to survive from the Nauvoo Temple, a site that played an important role in the development of the religion of the Latter-day Saints.

The Church of Jesus Christ of Latter-day Saints (known as Mormonism to outsiders) is perhaps the best known of American-born religious traditions, springing forth during the Second Great Awakening, a period of heightened attention to religion in the early nineteenth century. The first Great Awakening occurred in British colonial America in the 1730s. The so-called Burned-over District—the towns, cities, and villages that developed along the Erie Canal and stretched westward across central New York State to the shores of the Great Lakes—was a hotbed of Protestant evangelical revival. In addition to reforming and Americanizing religious practices, this Second Great Awakening gave rise to strong abolitionist and women's suffrage movements in the region.

By the 1820s, the popular belief in America as a nation built on shared democratic principles had become linked to the notion that these founding principles were divinely ordained. In the 1830s and 1840s, visitors such as Alexis de Tocqueville, Frances Trollope, and Charles Dickens remarked in their widely read accounts on the fiercely pious faith professed by many Americans they met in their travels. Though the nation's founding documents specifically promised religious tolerance, most equated religion with established European Protestantism. Thus new native-born religious movements, such as Mormonism, were viewed somewhat suspiciously as a threat to the established order.

The Church of Jesus Christ of Latter-day Saints grew from the reports of Joseph Smith Jr. (1805–44), who said he'd had a vision of the divine. He

NAUVOO TEMPLE SUN STONE

SYMBOLIC CARVINGS REFLECT A RELIGIOUS TRADITION FOUNDED AND PERSECUTED ON AMERICAN SOIL.

National Museum of American History

drew some early converts and dictated its scripture, the Book of Mormon, which he asserted was a translation of buried ancient golden plates that he had uncovered through the guidance of an angel. Among other things, this testament offered an account of ancient American civilizations. Native Americans, for example, were cast as Lamanites, connecting them to the ancient Holy Land. Smith embraced what he took as God's instructions to reestablish the true Church of Christ; its adherents became known as Latter-day Saints, or Mormons.

To avoid persecution by his neighbors in upstate New York, Smith called upon his followers to gather together. He led them west in 1831 to establish a communalistic American Zion, or New Jerusalem. They initially settled in Kirtland, Ohio, where they built their first temple, and established an outpost in Jackson County, Missouri. But their beliefs were anathema to the conventional Protestant Christianity of their neighbors. Both settlements faced local bias and ridicule and sometimes violent opposition; Smith and most of his followers were forced out of Missouri and fled Ohio.

In 1839 they settled in western Illinois, in a town called Commerce that they renamed Nauvoo, which means "beautiful" in Hebrew and, according to Joseph Smith's own translation, also implies "the idea of rest." The town grew from about twenty-four hundred settlers in 1840 to some eleven thousand five years later, and more in surrounding environs. The community chose as the site for a temple the high point on the bluff overlooking the city and the Mississippi River. Smith himself laid the cornerstone on April 6, 1841, and the building rose quickly—to 165 feet tall and with a rectangular footprint of 128 feet by 88 feet, a much larger scale than their first temple in Kirtland. Its clock tower featured a trumpeting angel weathervane. A traveler described it as a crowning "noble marble edifice, whose high tapering spire was radiant with white and gold." Its purpose was to hold the special rituals of marriage and baptism that came to characterize the religious movement.

Drawn from a dream vision of Joseph Smith's, the Nauvoo temple was designed by architect William Weeks in a Greek Revival style and elaborately

adorned. His design was based on celestial themes, with star stones, sun stones, and moon stones. Thirty hand-carved two-and-a-half-ton limestone capitals with a sun stone motif crowned pilasters that defined the temple's perimeter. These stones had a radiant sun face rising out of a bank of clouds, with a pair of handheld trumpets above them. The foreman for the work explained it as "a representation of the Church, the Bride, the Lamb's wife," citing Revelation 12:1, concerning the "woman clothed with the sun, and the moon under her feet, and upon her head a crown of twelve stars." Thus the star stones were at the top of the temple as crown, the moon stones below as feet, and the sun stones in the middle. The interior of the temple was designed progressively, from basement to attic, in terms of life's spiritual journey from baptism through terrestrial and celestial rooms to a sealing room for marriages.

Construction of the temple proceeded under Smith's leadership. He was not only a religious leader but also Nauvoo's mayor. He ran for president of the United States as an independent in 1844, arguing aggressively for the country's western expansion and for ending slavery by selling public land to compensate slave owners for their losses. As Smith's political voice became more radical, so did some of his theological revelations. Most notably, he began encouraging polygamy among the hierarchy of the Latter-day Saints Church.

In June 1844, a dissident group of Mormons published the one and only edition of a newspaper they named the *Nauvoo Expositor*. They accused Smith of promoting polygamy and soliciting women already married to others. They also accused him of setting himself up as a theocratic ruler and consolidating too much power as both church president and town mayor. Smith met with the city council and declared the paper a public nuisance, ordering its printing press to be destroyed. Complaints, fueled by anti-Mormon sentiment, came from surrounding towns alleging that Smith had violated freedom of the press and wrongfully destroyed others' property. Smith declared martial law and called out the Nauvoo militia to defend the town. This was regarded as a treasonable offense, and Illinois Governor Thomas Ford had Smith arrested and then jailed in nearby Carthage. Days later, a mob led by an anti-Mormon group stormed the jail and killed Smith and his brother Hyrum.

Though there was some doubt and disagreement over succession, Brigham Young took over as the leader of the main body of the community. He ordered some alterations to the half-completed temple and began to use it for worship and rituals at the end of 1845 and the early months of 1846. But the Mormons faced increasing violence. Young led much of the community west yet again, eventually settling in the Salt Lake Valley, then part of Mexico. By the fall, mobs had run the remaining Mormons out of Nauvoo and vandalized the temple. Those who remained tried to sell the temple over the next two years; in 1848 it was set afire and badly gutted—its finely carved wooden interior furnishings destroyed. Damage from a tornado two years later rendered the structure unsafe and unsound.

In 1865 what remained of the temple was demolished and stones were salvaged for other buildings—including the town jail and a school. A century later, two moon stones were retrieved from Nauvoo and sent to Salt Lake City, Utah, which had become the seat of the church. The sun stone that eventually came to the Smithsonian was one of two that had been sent downstream by riverboat to be used at the entrance of a Methodist college. One of these was later sent to Springfield for the new state capitol building, but was subsequently transferred to the state fairgrounds. It now rests in Nauvoo State Park, where a breakaway offshoot from the mainstream Mormon church helps to pay for its upkeep. The other one became the property of the Historical Society of Quincy and Adams County. It was displayed in Quincy on the grounds of the mansion belonging to John Wood, Illinois's twelfth governor. The Smithsonian had the opportunity to acquire the sun stone in the late 1980s. Curator Richard Ahlborn thought it reflected the complexity of our nation's spiritual origins. "Perhaps no other faith founded in America represents aspects of our nation as well as the Mormons," he said. Clearly it provides an important chapter in America's religious life—relating to both the flourishing of the country's diverse communal faiths and the persecution and intolerance many faced.

SEA
TO SHINING
SEA

(1800 TO 1850s)

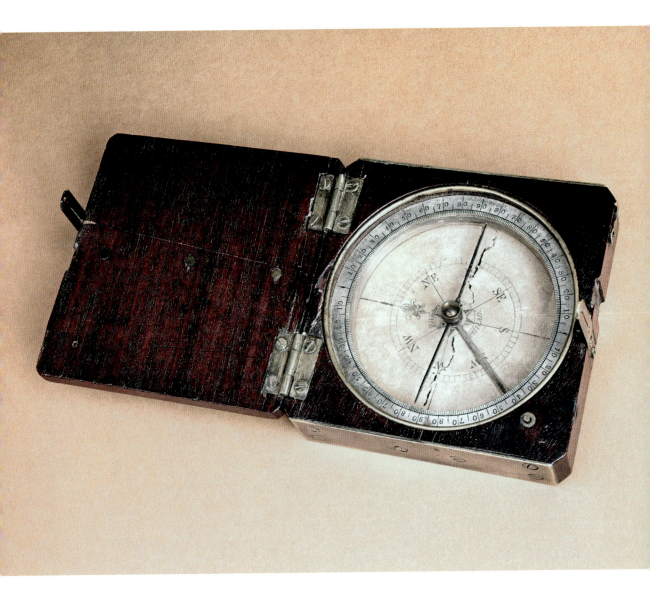

LEWIS AND CLARK'S COMPASS *National Museum of American History*

T his is the compass that helped Meriwether Lewis and his partner, William Clark, to chart and navigate their way across the North American continent to the Pacific coast.

Though it might appear modest to us today, this silver-plated compass was an important navigational instrument. Mounted with screws in a small, square mahogany case, it features a silver-plated brass rim that is graduated to degrees, and eight numbered sections, or octants, that stretch from north to south. A paper dial is recessed within the case, and two small brass sight vanes pro-

LEWIS AND CLARK'S POCKET COMPASS

trude from either side of it. The device, which fits well in the palm of the hand, boasts a leather carrying case and a securing strap. Made in Philadelphia by craftsman Thomas Whitney, it cost Meriwether Lewis five dollars. Lewis also purchased three other, cheaper compasses as he prepared for a daunting transcontinental journey at the request of President Thomas Jefferson.

French, then Spanish, and then French again, the so-called Louisiana Territory comprised a region of more than 800,000 square miles, consisting of what is now Arkansas, Missouri, Iowa, Oklahoma, Kansas, Nebraska, almost all of South Dakota, most of Montana, Wyoming, Colorado, Louisiana, Minnesota, and parts of Texas and New Mexico—essentially the entire midsection of the current United States.

Napoleon Bonaparte had seen an important role for the territory in the French empire in the New World, but he gave up the idea after the successful slave revolts in Haiti, France's bountiful Caribbean colony. Without the income from Haiti's lucrative sugar plantations to fund his overseas armies and colonial possessions, to say nothing of the stable naval presence in the Caribbean, the Louisiana Territory was indefensible from British attack. Thus Napoleon concluded that it was better to sell it off to the United

A SMALL HANDHELD INSTRUMENT ENABLES A LEGENDARY EXPEDITION TO GUIDE ITSELF ACROSS THE CONTINENT.

National Museum of American History

States. The young country was at first seeking to buy only New Orleans—necessary as a port to anchor American trade up and down the Mississippi River—and Napoleon's offer startled the American government.

Jefferson knew that the region was important for his country's future, and as head of the American Philosophical Society he had already been planning to send an expedition, led by his trusted aide Meriwether Lewis, to explore it. As president of the United States, Jefferson debated in his mind the constitutionality of making the purchase, but the strategic boost it would give the young nation trumped his reservation. And the price was right—about $15 million, or a mere $.03 per acre. With the purchase in 1803, the size of the United States doubled, and its westward expansion was assured. Now Lewis's expedition would take on added importance as it mapped the new territory, explored its resources, and met with Indian leaders.

Meriwether Lewis (1774–1809) worked and lived for several years in the Presidential Mansion. He was born in the president's native Albemarle County, Virginia, and had served in the militia and then the U.S. Army, where he was a commissioned lieutenant. Raised in Georgia, he was a naturalist of sorts, adept at survival in the wild, and also somewhat knowledgeable about and sensitive to American Indians. Lewis chose a fellow soldier, William Clark (1770–1838), to help share command of the expedition. Clark, also born in Virginia, was raised in Kentucky. He had joined the militia as a teenager to fight against Indians on the frontier after the Revolutionary War and rose to become an officer.

Jefferson charged the pair with leading a group of almost three dozen men, called the Corps of Discovery. The Corps' mission was to explore the new territory, establish trade and sovereign relationships with American Indian tribes, and find a route to the Pacific Ocean so the United States could lay claim to the Oregon Territory. Jefferson also encouraged the expedition to make maps, observe natural phenomena, and chart the geology, flora, fauna, and other resources of the region.

The compass was but one of many scientific instruments Lewis procured for the trip. At Jefferson's direction, he started buying items in the

late spring of 1803, among them thermometers, a portable microscope, a brass scale, and hydrometers for testing liquid density. There were also navigation instruments, including Hadley's quadrant to ascertain the position of certain celestial bodies, a set of plotting instruments to make maps, a theodolite for measuring angles, a set of planispheres to identify stars and constellations, and artificial horizons to measure distances. Jefferson personally tutored Lewis in making celestial observations and had Lewis study with the leading mathematicians and scientists of the day in Philadelphia, learning astronomical calculations from mathematics professor Robert Patterson and surveying from the prominent Andrew Ellicott. Jefferson's instructions to Lewis were as follows:

> Beginning at the mouth of the Missouri, you will take observations of latitude and longitude, at all remarkable points on the river, and especially at the mouths of rivers, at rapids, at islands, and other places and objects distinguished by such natural marks and characters of a durable kind, as that they may with certainty be recognized hereafter. The courses of the river between these points of observation may be supplied by the compass, the log-line and by time, corrected by the observations themselves. The variations of the compass too, in different places should be noticed.

The Corps, composed of thirty-three soldiers and William Clark's lifelong slave, an African American named York, was also equipped with rifles, ammunition, gunpowder, knives, medicine, mosquito netting, tools and nails, writing implements, kettles and cooking implements, lamps, axes, saws, adzes, fish hooks, and other survival goods, as well as Peace Medals to give to Indian leaders. After staging in Illinois Territory, the Corps embarked on May 14, 1804, from outside St. Louis on their expedition up the Missouri River. They had a large fifty-five-foot keelboat equipped with sail, oars, and poles, and two smaller craft.

They possessed copies of roughly drawn, incomplete, and inaccurate

maps and accounts composed by previous travelers, but these were inadequate to the task. The Corps used the compass and other instruments to chart their course, using a technique called dead reckoning. Lewis and Clark were aware that their compass pointed not to true geographic north but rather twenty-three degrees south of magnetic north, and they compensated accordingly in their calculations. They would take compass readings and head west two thousand miles along the river. Following Jefferson's instructions, they would take note of particular landmarks and river confluences. Clark was more of a mapmaker than Lewis, and probably used the compass the most.

This type of mapping required one first to determine geographic position in terms of latitude and longitude. Latitude was most easily determined by using the sextant to locate the North Star at night and then, by determining angles, calculating a distance from the pole on the globe. Computing longitude was more complex, requiring use of an accurately wound clock, observing the position of the sun at noon, determining the plane of the horizon, and calculating the difference from Greenwich Mean Time. Local time was also calculated by observing the Moon's position in the sky relative to other stars and then comparing that to readings in a nautical almanac.

Every day, several times a day, Lewis and Clark would read their compass, take a bearing or heading from some landmark, and record their direction—for example, as "28° west of south to a rock looking like a tower" on the river. They would then have to determine the distance they traveled to the next bearing. This they sometimes did with a surveyor's chain on land—measuring thirty-three–foot lengths as "two pole chain," or with log line reels on the river. They would let out line attached to a buoy, determine the distance traveled over a set time to calculate speed, and from that interpolate overall distance on a particular leg of their journey. Clark charted the course on field sheets, like graph paper, with preset one-inch squares. In all, the use of the compass and other navigational devices required skill, patience, calculating acumen, and time.

Over the summer of 1804, the Corps journeyed westward up against

LEWIS AND CLARK FIELD SHEET MAP

Beinecke Rare Book and Manuscript Library, Yale University

the current of the Missouri, passing what is now Kansas City and Omaha. They built Fort Mandan to winter in what is now North Dakota, and met the French Canadian fur trapper Toussaint Charbonneau and his Shoshone wife, Sacagawea. She then helped translate and guide them through parts of their journey. The Corps crossed the Continental Divide at Lemhi Pass in the Rockies, and followed the Clearwater River to the Snake River and then to the Columbia River, and passed what is now Portland to the Pacific Ocean. They wintered in Oregon and then headed back east. The group split up at the Continental Divide and reunited in August 1806 at the confluence of the Yellowstone and Missouri rivers. They made it back to St. Louis by September 23.

Amazingly for the time, only one member of the Corps died during the

journey. The knowledge they returned with was immense. Lewis came back with detailed descriptions of flora, fauna, and geology—having discovered some two hundred species unknown at the time. The Corps interacted with leaders from about two dozen American Indian tribes, and described dozens more. The many accurate maps—some 140 of them—facilitated subsequent discoveries and settlement in the new territory.

When Lewis and Clark arrived in St. Louis in September 1806, few of the instruments that were purchased for the trip had survived the journey. This pocket compass, however, was one of them. It would be kept by Clark as a memento. Years later Clark gave it to his friend and fellow veteran of the War of 1812 Captain Robert A. McCabe.

The compass that helped chart the continent came to the Smithsonian more than a century later through the McCabe family. Much of the expedition's surviving manuscript material is at the American Philosophical Society, while the field notes and most of the original manuscript maps are at Yale University's Beinecke Rare Book & Manuscript Library. The Academy of Natural Sciences in Philadelphia and the Royal Botanic Gardens in Kew, London, have some of the expedition's specimen sheets. Besides the compass, none of the other scientific equipment used by the expedition is known to exist. Says National Museum of American History curator Harry Rubenstein about this small, exquisite, though well-worn, compass, it "has taken on a symbolic importance far beyond its actual usefulness; it is one of the treasures of our collection." What's more, "it still works."

Starting in 1833, for more than three decades, the steam locomotive John Bull pulled passengers and cargo trains on the route between America's two largest cities at the time, New York and Philadelphia. Railroad travel was new in the 1830s; the locomotive was already an engineering marvel, and the John Bull helped make it a business success. This locomotive heralded the new form of transporta-

JOHN BULL STEAM LOCOMOTIVE

tion that would within decades stretch across the continent.

The history of the railroad begins in England, with the development of stationary steam engines by James Watt and his contemporaries in the mid-eighteenth century. The underlying principle of the steam engine is rather simple. Water, heated by a coal- or wood-burning fire, creates steam. If the steam is contained within an enclosed container, pressure builds. If the release of pressure is channeled and controlled, the steam can push pistons back and forth to power pumps, wheels, gears, blowers in mills, and other mechanical devices to move and turn things. The earliest steam engines ran at extremely low pressures and were terribly wasteful of fuel. The pursuit of higher working pressures became the path to improvement in both fuel economy and in gaining more power in a more compact space—something needed to move things like boats and trains.

In America, the impact of steam-powered transportation was dramatically demonstrated in 1807 when Robert Fulton sailed his steamboat *Clermont* up the Hudson River from New York City. Fulton's success led to a widely shared vision of interconnecting the young country through a network of navigable waterways and canals. Both public works and private entrepreneurs raced to construct the waterways that held the promise of unparalleled riches. Before long, steamboats were plying the Mississippi,

AN ENGINE INITIATES LONG-DISTANCE RAILROAD SERVICE BINDING THE COUNTRY TOGETHER AND SPURRING THE NATION'S INDUSTRIAL DEVELOPMENT.

National Museum of American History

23

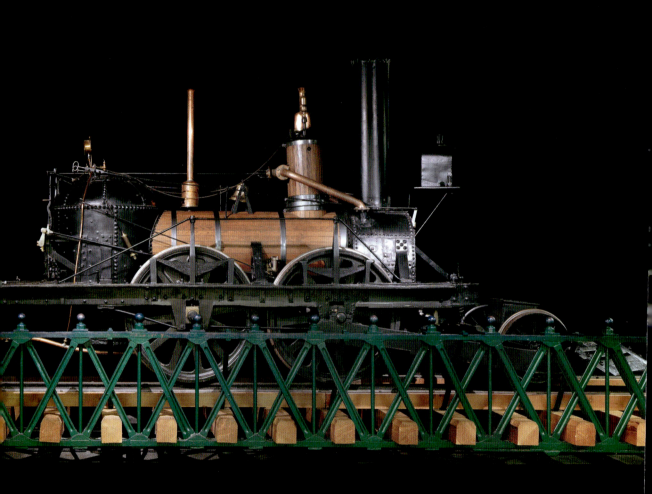

JOHN BULL STEAM LOCOMOTIVE *National Museum of American History*

the Ohio, the Hudson, the Mohawk, the Erie Canal, and the Great Lakes, bringing lumber, furs, coal, minerals, and foodstuffs from the interior to the coastal cities and returning to the hinterlands with manufactured goods. New settlements and cities grew on the western rivers. The steam engine and its applications for trade and transport became patriotic enterprises for the burgeoning young country, particularly after the War of 1812.

Meanwhile, the development of the steam-powered railroad was well under way in England. In 1804, Cornishman Richard Trevithick took a working locomotive on an experimental journey, hauling about ten tons of iron almost ten miles in just over four hours. Others developed twin-cylinder and rack-and-pinion locomotives, looking for the most efficient design. Then in 1825, George Stephenson built the Stockton & Darlington Railway in the north of England—the first steam-powered railroad—and established himself as the world's leading engineer in the planning and building of railways. His son, Robert, became the premier designer and manufacturer of locomotives. It was his company that built the John Bull.

In the United States, engineer and New Jersey entrepreneur Robert Stevens envisioned building a rail line along the roughly seventy-six-mile route between two busy New Jersey transit points, Camden and South Amboy. Camden was a short ferry ride across the Delaware River from Philadelphia, while South Amboy was a longer, though much-traveled, ferry ride to and from Manhattan across the lower Hudson River. Stevens saw this route as an important and lucrative one for the nation. The fact that he could locate the railway entirely within one state was a huge boon politically and economically; he successfully cultivated New Jersey legislators and investors to pave the way for his rail line. Next, he needed a dependable, high-quality steam locomotive. He sailed to England, studied locomotives there, and ultimately ordered the John Bull from Robert Stephenson's company.

The John Bull was designed and built in Britain, then taken apart and shipped to the United States. After arriving in Bordentown, New Jersey, it was reassembled by a team led by a young mechanic named Isaac Dripps.

where we were un-boated and stowed away in the Rail Road Cars, — and I you know, for the first time.

I give you a view of what is called a *Train of Cars*, all chained together

my Car

Baggage Car. — Rear Deck Car — { 6 Cars for all who pay 3 dollars for the passage } — { Second Deck Cars (for Stragglers) } — { Engine Car (8 wheels) }

The Deck Cars carry those who wish to go cheap, they are more open and more corsely made than those in the middle; and those forward are subject to more noise and smoke and to greater danger in case the Boiler bursts. — The 6 small Cars are very neatly and comfortably made, and each one carries 24 Passengers without the least crowding! — The other 3 Cars will carry nearly double that number. So when this Train is full they will take about 150 persons; — and if there are more they can hitch

He had never seen a locomotive before, but he had experience working with steamboats. In eleven days, he and his crew put the locomotive back together on a short length of track. A fire was lit, steam rose, and the locomotive moved. Two years later, in 1833, once money had been raised, a route surveyed, and tracks laid, the railway got under way and began service.

The locomotive had a tendency to derail over the Camden & Amboy Railroad's hastily laid, uneven track, and so Stevens and Dripps added an extra pair of guide wheels carried in a frame out in front, which helped steer the locomotive into curves and over poorly aligned rails. This innovation became an American hallmark.

John Frazee, one of America's first professional sculptors, rode on the John Bull and described his trip in an illustrated letter to his wife: "A few minutes and we were off like a shot, at the rate of 15 miles an hour." The sensation of "high speed train travel [was] at first quite disagreeable, [and for] several miles I was chuck full of fears, fits, and starts!" Frazee never got

used to "the eternal and deafening roar" of the train's locomotive, which bombarded his ears like a "continual thunder" and gave him a headache.

Camden & Amboy eventually built its own locomotive workshops and bought fifteen additional American-made copies of the locomotive, all with the added guide wheels. It was by far the most prosperous of all the railroad lines in America between the 1830s and the 1850s. The C&A Railroad inspired the development of other railroads, as well as American locomotive and railway car manufacture. By the end of the 1830s, American manufacturers were building locomotives and exporting them to other countries, including Russia.

Railways soon began to transform the country. Land had to be purchased and cleared for rail routes and rail yards; bridges and tunnels had to be constructed. Railroad construction stimulated waves of new immigration by hiring hundreds of thousands of people coming from Ireland, Italy, and Eastern Europe.

Railroads in the East extended westward, stimulating new agriculture—especially wheat-growing in the upper Midwest. Mining, heavy industry, and manufacturing boomed. A big stimulus to industry was supplying the ore and finished iron needed to manufacture millions of rails and supplying the wood and coal needed to operate fleets of locomotives, which were increasing in number every decade. Locomotive manufacturing became a leading U.S. industry. Railcars transported massive amounts of timber, ore, cattle, and grain to mills and stockyards; delivered finished metals and component parts to manufacturing plants; and carried produce, dressed meat, and consumer goods of all kinds to markets across the nation.

These developments led to the dream of a true transcontinental railroad, an accomplishment that took shape during the Civil War. Construction of the transcontinental railroad line—America's Pacific Railroad—brought thousands of workers from China. Two companies, congressionally chartered during the height of the war to achieve the Union's war aim of keeping California in the Union, built the line. Historian Stephen Ambrose called it "the greatest achievement in the world" during the nineteenth century.

The Central Pacific Railroad built eastward from Sacramento, and the Union Pacific Railroad built westward from Council Bluffs, Iowa. The two met at Promontory Summit, an arid spot north of Salt Lake in Utah Territory, on May 10, 1869, to ceremonially drive the Last Spike, which was made of California gold. Bells rang in celebration all across the country.

Railways generated subsidiary industries, and spawned towns as hubs of commerce. Railroads encouraged internal migration and tourism, reduced the perils of overland travel, and allowed for the rapid movement of troops, treasure seekers, and reporters. Rails carried money and mail and connected people and communities across the continent. Rail travel changed conceptions of distance and time—journeys became predictable, with schedules, timetables, and even standard time calculations. Throughout the nineteenth century and the first half of the twentieth, railways reflected different levels of comfort and treatment depending upon economic class and race. And during that long era, as Smithsonian transportation history curator John H. White so well expressed it, "railroads carried everything and everybody everywhere."

Amid these changes, the John Bull ended active use in 1866, just after the end of the Civil War. Its historical importance was recognized at the U.S. Centennial Exhibition in 1876, where it was featured in an exhibit organized by J. Elfreth Watkins, who would later become the Smithsonian's first curator of industry and technology. John Bull appeared at the National Railway Appliance Exhibition in Chicago in 1883; two years later, curator Watkins acquired the locomotive as the Smithsonian's engineering artifact No. 1.

In 1893, Watkins and the Smithsonian agreed to lend John Bull for display at the World's Columbian Exposition. A train crew took the little engine—under its own steam—from Washington, D.C., to Chicago. It was a great public relations success; brass bands greeted the locomotive and its two-car train at stops all along the way. Thousands of visitors to the ex-

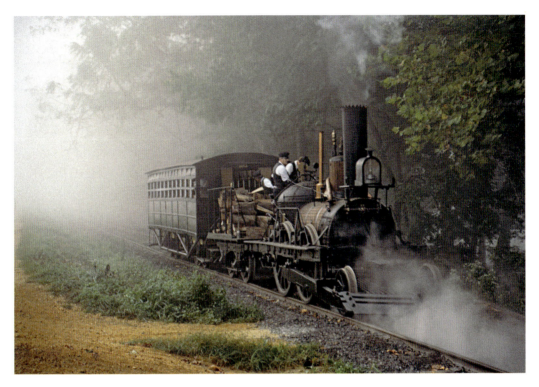

position rode in cars pulled by the antique engine. John Bull appeared at other public exhibitions from 1927 to 1940.

Then on September 15, 1981, for the 150th anniversary of its first test run in America, the Smithsonian's John White, John Stine, and Bill Withuhn took John Bull to the old Georgetown Branch rails beside the Chesapeake and Ohio Canal in Washington, D.C., fired her up, and went for a once-in-a-lifetime excursion. In 1985, John Bull was flown to Dallas for an exhibition. John Bull now rests in the National Museum of American History on the National Mall, where it is seen by some five million visitors annually.

24

In the Smithsonian's collection of firearms, of the approximately seven thousand different weapons, none played a more central role in America's westward expansion and conflict than the Colt revolver.

As a boy growing up in Hartford, Connecticut, Samuel Colt (1814–62) was enamored of inventions and was given the latitude to experiment with gunpowder and fireworks. Familiar with the one-shot pistols of the time, he, like others, mused about a multishot firearm. One such pistol, called the pepperbox, was gaining in popularity. It consisted of four or more barrels that mechanically rotated around an axis and were fired in turn by the hammer.

SAMUEL COLT'S REVOLVER

A COMMER-CIALLY MANU-FACTURED HANDGUN PLAYS A PIV-OTAL ROLE IN THE HISTORY OF THE WEST.

National Museum of American History

Sent by his father to learn seamanship, the teenage Colt found inspiration while aboard the brig *Corvo* on the way to Calcutta. He noticed that the ship's wheel would rotate while steering, but in any position, its spokes would always lock into a clutch to hold it in place. On the ship, using scrap wood, Colt built a model pepperbox with a cylinder that would rotate when the shooter activated the hammer and would lock the chamber into alignment with a single barrel by means of a pawl, or ratchet.

Returning from sea, Colt, financed by his father, tried making a rifle and a gun, initially with little success. Stimulated by Robert Fulton, Eli Whitney, and other great inventors of the period, Colt saw himself as an inventor too—but he needed money to support his continued experiments, and so, chancing upon nitrous oxide, or laughing gas, he took to the road with a portable lab as "the celebrated Dr. Coult of New York, London, and Calcutta." Colt demonstrated the gas's effects on street corners and then in lecture halls, learning how to be an effective public speaker, audience charmer, and marketer.

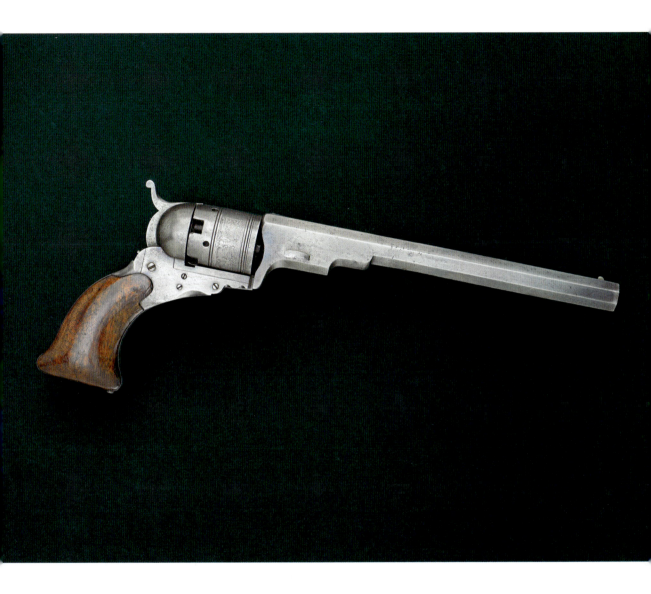

COLT REVOLVER *National Museum of American History*

Colt earned enough money to hire gunsmiths and perfect his design. He seized on the idea of a single-barrel gun with a revolving cylinder that would lock into place, automatically aligning lead balls with the barrel. He sought and secured a patent for the gun, first in England in 1835 and then in the United States the following year.

Commonly called the Colt Paterson, the gun was manufactured in Paterson, New Jersey, at a short-lived plant operated by Colt until 1842. It was the first commercial repeating firearm with a revolving cylinder with multiple chambers that align to a single barrel. It originally held five lead balls, at first of .28 caliber, but then, as in the example pictured here, increased to .36 caliber so as to have greater impact. The gun was successful because of the percussion ignition system, in use since the 1820s. Percussion caps ignite the gunpowder in each chamber, which propels the lead ball toward the target. The gun has a formidable seven-inch barrel, often rifled. Early models, such as the one shown here, had no mechanism for easy reloading; a shooter would have to stop, disassemble the gun, reload the cylinder, and put it back together. Indeed, the gun was bought with a whole kit of tools and parts. Often, gunmen would keep spare preloaded cylinders with them for easy reassembly. That rather awkward procedure was corrected with an attachable loading lever incorporated into the revolver by 1840. Also, in this case, the gun had a folding trigger that retracted into the frame until the hammer was cocked.

A multishot firearm that did not require immediate reloading after each shot proved a great advantage to gunmen, whether in military battle, fighting enemies, killing wildlife, or in personal disputes. The holster version of the revolver could hit a standing target at about fifty yards. Kit Carson was a famous early user along the Santa Fe Trail. Though Colt sold some of his manufactured Paterson revolvers to the Army and Marines, they thought the gun too fragile and unreliable for field operations. Colt had better luck selling to the Republic of Texas. The Texas Rangers used them to dramatic effect in their fights with the Comanches. As a consequence, the gun is often called the Texas Paterson. All told, Colt sold some

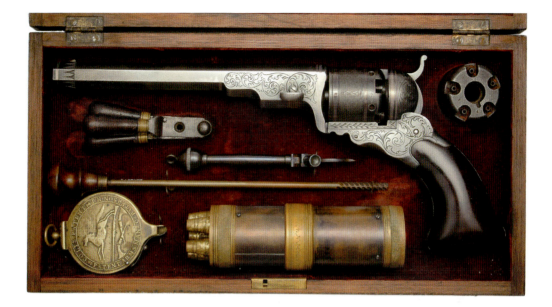

one thousand guns at about fifty dollars each before his Paterson plant closed.

COLT REVOLVER KIT

Autry National Center

Success in Texas led to further improvements in the pistol. Samuel Hamilton Walker, a captain in the Texas Rangers, had become an advocate of the revolvers. When the United States went to war with Mexico in 1846, Walker became a captain in the U.S. Mounted Rifles. He visited Colt, seeking to adapt the basic design into a new, more powerful weapon that could be used by horse-mounted troops. The result was the Colt Walker, a long, heavy six-shooter that could stop a horse. The Mounted Rifles ordered a thousand for use in battle.

To meet the order, Colt rented an existing manufacturing plant in Whitneyville, Connecticut, from Eli Whitney Jr., son of the inventor. Colt enlisted Whitney's expertise to refine his concept of interchangeable parts and mass production. This was a major innovation in American manufacturing, dramatically improving the efficiency of production. No gun was unique—the parts of any particular model could replace those of any other,

bringing down the cost of both the product and its repair. By the end of the Mexican-American War, Colt was prosperous and confident enough to build his own plant—Colt's Patent Firearms Manufacturing Company, in Hartford, Connecticut. The factory expanded in 1855, and the following year, Colt built himself a mansion nearby, which overlooked a worker housing development. Colt introduced ten-hour workdays, lunch hours, sanitary inspections, and a clubhouse to discourage carousing after hours.

Colt always had a gift for advertising and marketing. He paid artist George Catlin to include Colt revolvers in his western paintings. He personally toured the country and the world to demonstrate his products, giving "presentation" guns, sometimes elaborately engraved to show off the company's artistry, to prominent individuals as a promotional gambit. He also aggressively protected the rights to his invention, pursuing litigation against imitators, renewing his patent in 1849, and maintaining a monopoly on revolving-cylinder technology up to the Civil War. He also became one of the wealthiest men in America.

By the mid-1800s, Colt revolvers were used by soldiers, settlers, family members, cowboys, and Indians. The gun provided personal protection against acts of lawlessness, but was also used by outlaws and gunslingers. Colt revolvers were used by soldiers on both sides of the Civil War. The Colt Single Action Army Model revolver was incredibly popular among all elements of the population—lawman and soldier, cattle rancher and homesteader—and is sometimes called the gun that won the West. Owners included Teddy Roosevelt, Buffalo Bill Cody, Wyatt Earp, Pat Garrett, and Billy the Kid, among others, giving the Colt revolver an iconic association with the Wild West. The revolver was also successfully marketed and sold abroad, becoming America's most exportable manufactured item.

This Colt Paterson revolver came to the Smithsonian in 1908 in a transfer of patent models from the Department of the Interior. It was part of what museum curators hoped would become a larger and more significant collection of firearms. The National Museum was often barraged with offers of collections for sale, although it seldom had the money to follow

through. For example, in 1908, the Smithsonian disappointed the collector Nathan Spearing when it turned down, for lack of funds, a 533-piece collection of fifteenth-, sixteenth-, and seventeenth-century arbalests, harquebuses, wheel locks, a flintlock musket and pistol, and other early Colt revolvers. More usually, curators tried to convince a single collector to gift a significant collection, as for example in 1913 when it sought the U.S. Cartridge Company's collection. That effort continues to the present as the market for historical pieces has soared. A Colt Paterson recently sold at auction for almost $1 million.

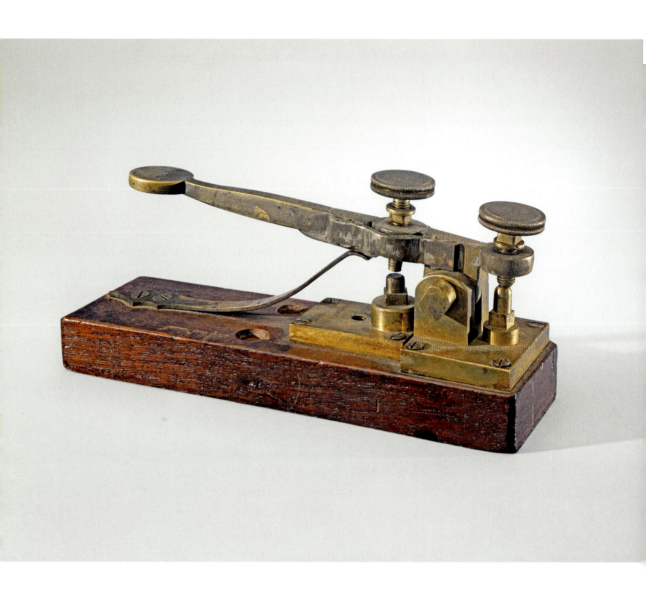

MORSE-VAIL TELEGRAPH KEY *National Museum of American History*

"W hat hath God wrought?" With that simple sentence taken from the Bible, Numbers 23:23, and exchanged between Samuel Morse and his partner, Alfred Vail, Americans and the world entered a new age of widespread rapid communication—the telegraph. Before that, communication in America was by post: hand-carried letters conveyed on foot, by boat, or by wagon, or on horseback.

On May 24, 1844, Morse sat in the Supreme Court

MORSE-VAIL TELEGRAPH

Chamber of the U.S. Capitol, while Vail waited at the Mount Clare depot in Baltimore. Morse tapped out the message on his key—short quick taps and slower long ones. The taps closed an electric circuit, sending pulses of electric current from a battery down a wire that ran north along railroad tracks to the receiving machine some forty miles away. Electric relays along the course helped send the pulses along. When received by Vail, the pulses activated an electromagnet that caused a stylus to indent a paper tape. Short pulses made dots, long pulses made dashes. The paper tape moved forward powered by a clockwork mechanism. When interrupted, the stylus retracted, creating space on the tape as the device waited for the next pulse to indent the next coded letters. The code used binary elements—the dots and dashes. Developed largely by Vail but popularized as the Morse code, each letter of the alphabet had a unique pattern of dots and dashes formed by short and long key taps. In that first message, *W* was dot-dash-dash, *H* four dots, *A* a dot-dash, and *T* a single dash, for example. When Vail then sent the message back down the line as confirmation, the two men had successfully demonstrated that instantaneous long-range communication was possible and practical. The telegraph quickly grew in popularity and importance in the years that followed, supplanting other forms of communication and making Morse rich.

AN INVENTION REVOLUTIONIZES COMMUNICATIONS, BRINGING THE NATION CLOSER TOGETHER.

National Museum of American History

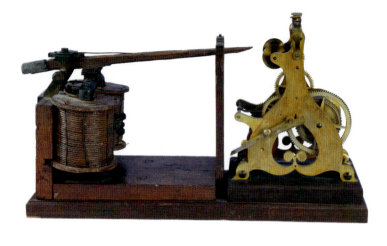

(TOP) TELEGRAPH
REGISTER FOR
TURNING PULSES
INTO PAPER
MESSAGES;
(BOTTOM)
ORIGINAL
PAPER TAPE OF
TELEGRAPHIC
MESSAGE FROM
VAIL TO MORSE

*National Museum of
American History*

Morse and Vail's device was not, in fact, the first electric telegraph. A number of inventors had been working at it for years, experimenting with systems of transmission and ways of communicating messages. The science of electricity had quickened its pace in the late eighteenth century as a result of many insights and experiments, including those of Benjamin Franklin, who demonstrated the electrical nature of lightning. By the early nineteenth century, the Italian Alessandro Volta had developed the battery, and Dane Hans Christian Ørsted and Frenchman André-Marie Ampère had connected electricity and magnetism. In 1821, Englishman Michael Faraday invented the electric motor. A few years later, William Sturgeon developed the electromagnet and Bavarian Georg Ohm analyzed the electric circuit. The use of electricity to send pulses that could then be read as messages took many experimental forms. One European invention featured dozens of wires leading into glass tubes of acid, each representing a letter of the alphabet or a number. When current was transmitted along one of

the wires it caused a reaction in the tube, creating bubbles, and wire by wire, bubble by bubble, a message could be tediously sent and read. An electric relay invented in 1835 by physicist Joseph Henry allowed current to be sent through wires longer than a mile.

About the same time Morse worked to find a solution to the problems of wires, distances, and codes, British inventors William Cooke and Charles Wheatstone developed an electrical telegraph in Britain. It consisted of multiple lines and ran for thirteen miles along a railroad. Pulses of electricity made needles point to different letters. Later, they used wheels of typescript to decode messages. Their system failed to catch on commercially.

Morse's success lay in his system's simplicity. He used one wire to transmit a message over great lengths using the earth as a ground to complete the circuit. The encoding technology—the keying or tapping device—allowed an easily transmitted and read pulse code. Given Morse's early career as an artist, he seemed an unlikely inventor of a new technology, but it was a time when artistic and scientific pursuits overlapped and were often conjoined in explorations and understandings of the natural world.

Morse, born in Massachusetts to a Calvinist minister, began his adult life as a painter. After graduating from Yale, he took up residence in England, and then returned to the United States, painting portraits of such leaders as John Adams. Morse founded the National Academy of Design in New York in 1826 to promote the study and teaching of the fine arts in the United States. In 1832, on the voyage home from a trip to Europe, Morse met Charles Thomas Jackson of Boston, a recent Harvard medical graduate and brother-in-law of Ralph Waldo Emerson. Jackson was enamored of geology, chemistry, and recent developments in electromagnetism. As they talked, Morse grew fascinated with electromagnetism; back in New York, he continued to paint, and taught at New York University, but now he also dabbled as an inventor.

By this time, Henry had demonstrated how electric current and electromagnets could be used to ring a bell over a considerable distance, and suggested a signaling device. In 1837 Morse had developed a prototype of

a recording telegraph (also today in the Smithsonian) that printed messages on a ribbon of paper. He partnered with a fellow New York University professor and inventor, Leonard Gale, to use relays to transmit a current over ten miles of wire wrapped around Gale's classroom. They joined forces with Alfred Vail, whose family owned an ironworks, to produce model telegraphs. Morse thought that he would encode words as numbers, send pulses indicating numbers over the electric line, and then decode the numbers at the receiving end. He filed for a patent on September 28, 1837—the same day Britons Cooke and Wheatstone filed their patent in England. A few months later, they switched from the numerical to the dots-and-dashes system.

In 1838, Morse sent a telegraph message (also now in the Smithsonian collections)—"Attention the universe, by kingdom's right wheel"—over a distance of two miles. Morse traveled around the United States demonstrating his device to scientists and politicians, and lobbying for federal funding to build the first telegraph line. Unsuccessful, he traveled back to Europe to file patents for his device in England, France, and Russia. On the trip he met Louis Daguerre, inventor of the daguerreotype process of photography. Morse brought this method back to the United States and taught it to Mathew Brady, among others.

In 1843, Congress allotted thirty thousand dollars for Morse to build an electric telegraph line between Washington, D.C., and Baltimore. He started working with Ezra Cornell to lay the line in special trenches, but obstacles such as poorly insulated wires forced a switch to poles that carried the line overhead. Months later, he was ready for the famous transmission. Annie Ellsworth of Lafayette, Indiana, the daughter of Patent Office Commissioner Henry Leavitt Ellsworth, chose the message.

Following the Baltimore-Washington transmission, Morse hired an agent, former Postmaster General Amos Kendall, to develop commercial telegraph companies and license his patent. Investors rapidly recognized and embraced the economic potential. The telegraph line was extended to Philadelphia and New York, with Boston and Buffalo following soon af-

ter. By 1850, dozens of different telegraph companies operated more than twenty thousand miles of line across the United States. Many competing systems and companies grew during the decade, leading to efforts at consolidation, which, among other things, produced Western Union. By 1861, telegraph lines stretched from the Atlantic to the Pacific. Interestingly, in practice, the technology worked aurally, not visually: Morse and Vail's early telegraph made noise as its electromagnet clicked on and off, and telegraph operators were easily able to distinguish the clicks of dots and dashes by ear, making it unnecessary to read the printout from a register.

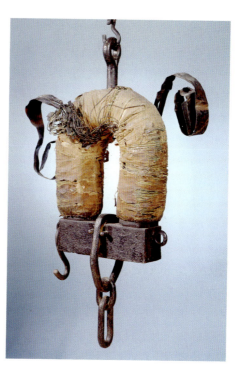

JOSEPH HENRY'S ELECTROMAGNET

National Museum of American History

Uses of the telegraph proliferated. Police departments used it to convey information to catch criminals, fueling early popular interest in the new medium. Railroad companies could send information about schedules and delays in arrivals and departures. The telegraph allowed correspondents to rapidly convey information. The "news" was really new, and print newspapers flourished. Reporters flocked to the Mexican-American War and filed reports every few hours, engaging the public as never before in world events. In 1848, six newspapers in New York established the Associated Press to help defray the costs of long-distance telegraphy. Starting in the late 1840s, Joseph Henry, who had become the secretary of the Smithsonian, developed a system of some six hundred volunteer "citizen scientists" across the United States who would daily record their observations of the

weather and mail their reports to the Institution. By the late 1850s, weather reports were telegraphed in from a few key cities, allowing Henry to make a daily weather map in the Smithsonian Castle, creating what was essentially the first storm warning system. The Smithsonian map was reprinted in newspapers, and the whole project eventually turned into what became the National Weather Service.

The telegraph quickly proliferated internationally. In 1852, a wire under the English Channel successfully connected London and Paris. Because a number of people worked on developing different telegraph systems, Morse had to fight various claims to secure his patent. His fellow sea voyager Charles Jackson claimed Morse stole his idea and threatened to sue. In 1854, the Supreme Court upheld Morse's patent, and all telegraph companies were required to pay him royalties for the use of their devices, making him very wealthy. Vail left the partnership before the telegraph became lucrative, and died in 1859.

During the Civil War, President Abraham Lincoln frequently used the telegraph to communicate with his battlefield generals while the public closely followed the war's progress. After the Civil War, a cable laid under the Atlantic connected the United States to Europe. In ensuing decades, telegraph lines were established across the planet.

Morse died in 1872. In 1900, his youngest son, Edward Lind Morse, came to the Smithsonian's U.S. National Museum and offered the original message recorded by the Morse register in the Capitol during the May 25, 1844, test. The strip of paper, twenty-eight inches long and one and a half inches wide, is embossed in three parallel lines of Morse characters that read "What hath God wrought?" Above the message is written, in Morse's handwriting, "Sent from the lower depot at Baltimore to Washington Saturday May 25th. 1844. Sam. F. B. Morse, Superintendent of Elec. Mag. Telegraphs." Below the characters, Morse transcribed the message. The Library of Congress has the paper message sent from Washington to the Baltimore telegraph register.

Morse failed to keep the original Washington device from the famous

transmission. Vail kept the Baltimore register and willed it to Morse on the condition that it be turned over to the New Jersey Historical Society. But his son, Stephen, broke the will and, after a failed attempt to get Congress to appropriate funds for the Smithsonian to purchase it from him, sent it to Sibley College of Cornell University, where it remains today. The device in the Smithsonian's collection was donated by Western Union. It was Vail's improvement on Morse's original device and may have been used on the Washington-Baltimore line in the fall of 1844, at the beginning of the revolution in communications that eventually connected people across the globe.

26

When this blue wool coat was first put on exhibition, the Smithsonian thought it had a grand trophy of "manifest destiny." Trimmed with red edging and facings, gilt buttons, and a gold on red-colored collar, it was a spoil of the U.S. victory in the Mexican-American War: ostensibly the military uniform of the great Mexican General Antonio López de Santa Anna. The story of the coat is closely tied to the history of Texas and the western expansion of the United States.

MEXICAN ARMY COAT

A MISIDENTIFIED TROPHY FROM THE MEXICAN-AMERICAN WAR TELLS A STORY OF A PIVOTAL MOMENT IN THE WESTERN EXPANSION OF THE UNITED STATES.

National Museum of American History

Since the days of early Spanish exploration and colonization, much of the West—present-day Texas, New Mexico, Arizona, Nevada, Colorado, Utah, and California—was part of what was known as New Spain or Greater Mexico. Explorers, hunters, prospectors, settlers, and presidents eyed this territory for its natural resources, trade routes, and strategic importance, and, especially after the Louisiana Purchase, envisioned either buying or obtaining it for the United States. Not everyone agreed. As a senator, New England's Daniel Webster supposedly asked, "What do we want with this vast worthless area, this region of savages and wild beasts, of desert, of shifting sands and whirlwinds of dust, of cactus and prairie dogs?"

Texas, or *Tejas*, was to provide the answer and set large-scale western expansion in motion. As part of colonial Spain, Texas was a sparsely populated frontier territory. After Mexico won its independence in 1821, it encouraged Americans to immigrate to Texas—and hundreds of English-speaking citizens from the United States came, sowing good farmland, establishing trade and other enterprises, and attracting more settlers. For the Mexican authorities, the presence of these Anglo-Americans provided stability on their northern frontier, also home to independence-minded Comanche, Navajo, and Apache communities. By 1830, American immigrants vastly outnumbered Mexican natives in the region. The Americans had slaves,

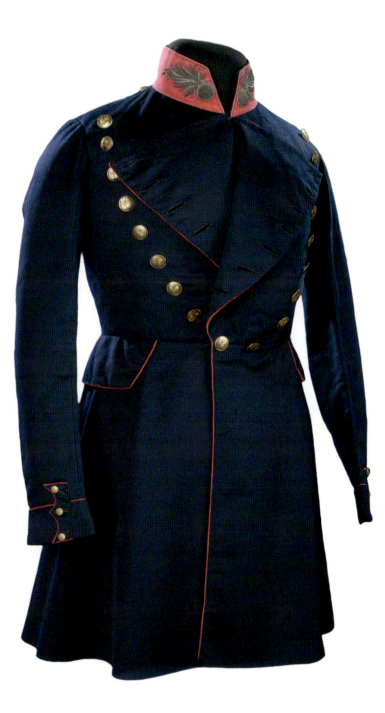

MEXICAN ARMY COAT *National Museum of American History*

and paid little in taxes and other duties. The Mexican government closed off immigration, instituted customs duties, and reinforced its prohibitions of slavery, but American settlers rebuffed these efforts.

In 1834, General Santa Anna (1794–1876) became president of Mexico and sought to tighten control over Texas. American Texans rebelled, took up arms, and, in 1836, declared their independence, establishing the Republic of Texas. Santa Anna responded by leading an army against them. At the Battle of the Alamo, a mission-fort (now in downtown San Antonio), his far larger Mexican force overwhelmed the Texans. All but a few of the defenders were killed. Texans took up the rally cry of "Remember the Alamo," and their army, under the command of Sam Houston, later defeated and captured Santa Anna at the Battle of San Jacinto. In exchange for his life and his release, Santa Anna signed a treaty recognizing an independent Texas.

The Republic of Texas gained recognition from the United States and other nations. Though many Texans wanted Texas to become a U.S. state, the Congress was divided on the issue.

James Polk, running for president in 1844, supported the annexation of Texas to the United States as a slave state in accord with the Missouri Compromise. He also wanted to buy New Mexico and California from Mexico, and settle the border of Oregon with the British. Polk won the election in part on his grand vision of extending the United States across the continent to the Pacific Ocean. Journalist John L. Sullivan echoed this vision in an 1845 essay urging the annexation of Texas. He justified it because "it is our manifest destiny to overspread the continent allotted by Providence for the free development of our yearly multiplying millions." It was the first usage of the term. Later in the year, Sullivan claimed it was the United States' manifest destiny to claim all of Oregon "for the development of the great experiment of liberty and federated self-government entrusted to us."

In 1845, the United States annexed Texas, making it the twenty-eighth state. Mexicans disputed the claim, and a manufactured border skirmish led Polk to send U.S. forces into war against Mexico in 1846.

Whigs in the U.S. Congress, like Webster, opposed Polk's actions. Another congressman, Abraham Lincoln, thought the war was suspiciously provoked. Abolitionists resented the expansion of slavery. Henry David Thoreau refused to pay his taxes for what he considered an unjust war; jailed for his protest, he wrote his landmark essay entitled *Civil Disobedience*.

Polk's war strategy was to position General Zachary Taylor's army on the northern frontier and send General Winfield Scott's army through the port of Veracruz in the Gulf of Mexico and on to an invasion of Mexico's central valley and its capital. Scott's twelve-thousand-man army included military leaders such as Ulysses S. Grant, Robert E. Lee, George Meade, Stonewall Jackson, and Commodore Matthew Perry. Perry's naval forces pounded Veracruz until it fell, and Scott's army marched toward the capital and met Santa Anna's forces about halfway there. The Mexican Army was quickly routed, paving the way for Scott to continue on and occupy Mexico City in September 1847. New telegraph-aided communications allowed news of Scott's victory to spread far and wide, quickly making him an American hero. Santa Anna tried to fight on, but failed.

In 1848, Mexico and the United States signed the Treaty of Guadalupe Hidalgo, which granted America possession of Texas, established the Rio Grande as the international border, and ceded California, Nevada, Utah, New Mexico, most of Arizona and Colorado, and parts of Oklahoma, Kansas, and Wyoming to the United States. Mexicans living in this territory were eligible to become U.S. citizens. The United States was now a much larger country geographically, and the size and diversity of its population increased considerably. In return, the United States paid Mexico a little

over $18 million, assumed about $3 million of Mexican government debts owed to U.S. citizens, and promised to suppress Indian "lawlessness" on the frontier.

To Americans, Santa Anna was not only a vanquished general but also, in his defeat, a symbol of the United States' newfound power to achieve continental domination. Not everyone agreed, but the idea found particular resonance with those who believed in manifest destiny for its religious overtones and those with decidedly racist ideas about American rule over so-called inferior peoples of the hemisphere.

Among them was one of General Scott's lieutenants, Chatham Roberdeau Wheat. Wheat was born in Alexandria, Virginia, grew up in Louisiana, and went to college in Nashville, Tennessee, before joining the Tennessee Volunteer Infantry to fight in Mexico. He faced Santa Anna's army and was part of the force occupying Mexico City.

When Wheat returned home he was elected to the Louisiana state legislature and became involved in something called the Knights of the Golden Circle. This was a group promoting the idea of a new slave-holding society circling the Gulf of Mexico that would help support the South. Wheat strongly supported efforts to Americanize Mexico and Anglicize its institutions. He later fought for the Confederacy during the Civil War and died in Virginia in 1862. Following his death, his mother donated a coat her son had acquired during the war with Mexico to the Alexandria Masonic Lodge in his memory. An accompanying note read:

Gen'l Santa Anna's Dress Coat. Captured by Captain Roberdeau Wheat while on Gen'l Winfield Scott's staff after one of Santa Anna's hasty retreats. Capt Wheat's mother presents this relic of the Mexican War to "The Alexandria Masonic Lodge" in memory of her son who was native of Alex. and also his Mother.

Alexandria, Virginia, was a Union-occupied town at that time, and the Masonic Lodge was housed in rooms of the old city hall. In those rooms

was a public exhibit of artifacts associated with George Washington, who had been a prominent member of the lodge. The display became a community shrine to aristocratic Southern and Confederate patriots. By making the donation, Mrs. Wheat tied her son to George Washington and to Confederate "resistance" in the occupied South. The uniform was also a war trophy from a well-known American enemy, and a symbol of a victory of U.S. expansionism.

When Alexandria's old city hall burned to the ground in 1871, the Masons lost their museum and transferred the Washington relics and the Santa Anna coat to the Patent Office Building. The items were part of a U.S. centennial exhibit in 1876, and then accessioned into the Smithsonian's collections in 1883. The coat retained a sign indicating it had been Santa Anna's.

In April 1884, Matías Romero, Mexico's ambassador in Washington, who had seen the coat on exhibit, wrote to U.S. Secretary of State Frederick T. Frelinghuysen. He had been suspicious about the assertion that the coat had been Santa Anna's because it did not seem elaborate enough to have been the uniform of a Mexican Army general. He sent off a very detailed description to Mexican officials back home. Their response was that the uniform was that of a second lieutenant of the artillery. Additionally, the ambassador was informed that "a grandson of Gen. Santa Anna, who was recently in the city and saw the said coat, thought that, owing to its size, it could never have belonged to his grandfather."

Romero did not want his country depicted in defeat, and noted that the "United States Government may have been deceived" by the donor in thinking the coat was Santa Anna's. He asked the secretary of state to take "proper" action. Frelinghuysen accepted Romero's contention and passed the note to Smithsonian Secretary Spencer F. Baird.

The Smithsonian changed the explanatory sign, and the coat is now displayed in the Price of Freedom exhibition at the National Museum of American History, not as the war trophy it was once taken to be, but rather as a symbol of the lives lost in the conflicts waged to expand the territorial boundaries of the United States.

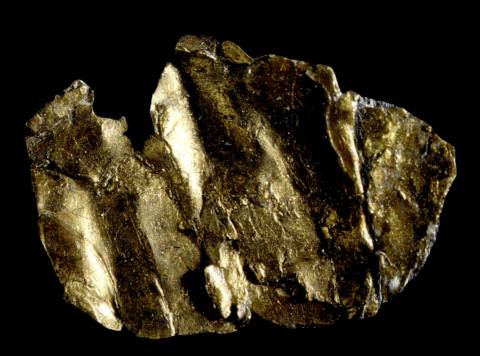

SUTTER'S MILL DISCOVERY FLAKE *National Museum of American History*

I t is incredible that something weighing less than one thousandth of an ounce and smaller than a fingernail could have such an impact upon America's history. But that was true in the case of the find in January 1848 along the South Fork of the American River at Coloma, California, that ignited the Gold Rush.

GOLD DISCOVERY FLAKE FROM SUTTER'S MILL

California was at that moment, officially, Mexican territory, because the Treaty of Guadalupe Hidalgo ending the Mexican-American War had not yet been signed. That changed within a fortnight when the region was ceded to the United States. The discovery would fuel a massive migration, opening up the Pacific west coast to new settlement and unprecedented commerce.

That January morning, carpenter James Marshall was overseeing the construction of a sawmill for Colonel John Sutter. He noticed something glittering in the water of the mill's tailrace, and bent down to pick it up. According to Sutter's diary, Marshall "found that it was a thin scale of what appeared to be pure gold." Marshall and Sutter tested the flake and were confident it was gold.

In the summer of 1848, Colonel Sutter presented Marshall's gold flake to Captain Joseph L. Folsom, U.S. Army assistant quartermaster at Monterey. Folsom was in northern California to verify the gold claim for the U.S. government. Folsom noted that Marshall had hammered the nugget into a flattened flake for easier identification. He gave its weight at 0.0855 gram.

After Marshall's first find, other nuggets were discovered, and Folsom estimated that some four thousand men were mining gold by the time he arrived. Folsom acquired and noted a number of these discoveries and took samples, entrusting U.S. Army Lieutenant Lucien Loeser to take the gold specimens back to Washington for delivery to President James Polk.

27

A SMALL PIECE OF YELLOW METAL FOUND IN 1848 STARTS THE CALIFORNIA GOLD RUSH.

National Museum of American History

Loeser took a ship to Panama's Pacific coast, traveled by horseback across the isthmus to the Atlantic coast, boarded a ship to New Orleans, and then continued overland to Washington. A letter of transmittal from Folsom that accompanied the packet listed this flake, "Specimen #1," as "the first piece of gold ever discovered in this Northern part of Upper California found by J. W. Marshall at the Saw Mill of John A. Sutter."

Within weeks Polk formally informed Congress that gold had been discovered in California. In his State of the Union address on December 5, 1848, Polk noted that it had been previously known that California had precious metals, but the discovery of gold signaled that such riches were probably much more extensive than had been thought. Polk described how people were flocking to California to find gold. Indeed, he lamented that almost all the men in the territory were consumed with the search. Crews were abandoning their ships and soldiers deserting their posts to become prospectors. Prices were skyrocketing. Polk called for the establishment of a mint in California and argued that the discovery of gold would be good for everyone in the country—propelling commerce and trade forward and making the United States a power rivaling those of Europe. He closed by asserting that "the acquisition of California and New Mexico, the settlement of the Oregon boundary, and the annexation of Texas, extending to the Rio Grande, are results which, combined, are of greater consequence and will add more to the strength and wealth of the nation than any which have preceded them since the adoption of the Constitution."

The gold flake was deposited with the National Institute for the Promotion of Science at the Patent Office Building in 1849, with Smithsonian Secretary Joseph Henry presiding at the event. Some then commented that the flake's specific gravity was lower than expected.

As the discovery of gold in California became widely known, it set off what is commonly called the Gold Rush. Some 300,000 Americans from the East and the Midwest headed to California. So did many immigrants from Latin America, Europe, China, and even Australia. They became known as 49ers, ready to prospect for gold and gain boundless wealth. While some

did indeed grow wealthy, many either left in despair or simply stayed in the region setting up farms or working as menial laborers. This established the foundations for a culturally diverse though not necessarily harmonious California populace. In fact, the Native population dropped drastically, from about 150,000 in 1848 to about 30,000 a dozen years later. Most died of disease, many were killed, others were displaced from their land.

California was quickly organized as a U.S. territory and admitted to the Union as a "free" state in 1850 consonant with the terms of the Missouri Compromise. Because of the fear that the Gold Rush was bringing in free blacks and other immigrants, the state constitution denied the right to vote to all except white male inhabitants. The legislature passed the Foreign Miner's License law, imposing a tax of twenty dollars a month on all foreign miners. As many could not pay, they looked for other work, competing with white workers. Chinese prospectors and laborers became targets of systematic discrimination. An 1852 law levied a fifty-dollars-per-person tax on Chinese immigrants, with the governor claiming they undercut other laborers, resisted assimilation, and sent their pay home to China, thus failing to contribute to the economy.

The 49ers were mainly individual prospectors and entrepreneurs carrying only their tin pans, and the easily accessible gold was quickly tapped out. Increasingly, more capital and more sophisticated machinery were needed to strike it rich. Mining operations started to be concentrated among wealthy individuals and their growing companies. Many people worked in the trades or in services, like transport, that served the gold mines. Others sought unrelated jobs in the growing towns and their developing commercial life. San Francisco grew from 1,000 people in 1848 to 25,000 in 1850 and then 150,000 in 1870. Its mint was established in 1854 and quickly outgrew initial expectations, relocating to a new building in the 1870s. Land ownership, speculation, and prices increased. Churches and civic institutions grew, with law enforcement and civil government often lagging slightly behind. Within decades, the rapidly modernizing West fueled a desire for better links with the rest of the country. The transcontinental railroad was in part

a result, providing for the transport of western resources to the cities of the East, which in return provided manufactured products and luxury goods. The link and the trade spurred the growth of midwestern centers like Chicago, St. Louis, and Kansas City, Missouri, as railroad hubs. Later in the century, the need would help drive the demand for the Panama Canal.

Back in Washington, the Sutter Mill gold flake faced its own developments. By 1862, it and other collections of the National Institute were turned over to the Smithsonian. Decades later, when George Merrill, the Smithsonian's curator of geology, examined what he called the discovery flake under a microscope, he found numerous minute white quartz and iron or manganese particles embedded in it.

The Smithsonian received many requests to send the flake back to California, either for temporary display or more permanently. In 1925, the Pioneer Society of California requested that the Smithsonian return the gold nugget to California so that it could be displayed at the California state museum. Merrill protested the very idea of the Smithsonian acceding to the repatriation requests of states, writing, "How long would a museum last if each and every city or state were to withdraw choice materials?" As Smithsonian Secretary Charles Walcott explained to California's Senator Samuel M. Shortridge, Marshall's discovery of the flake had national significance and a national audience at the national museum. "The discovery of this gold was of such far reaching historical interest that its importance as a state exhibit is far outweighed by the effect which its discovery had on our national history. It seems to me therefore that its location in the National Museum is very appropriate."

That didn't stop the Department of Mines and Mining of the Sacramento Chamber of Commerce from requesting that the discovery flake be lent to them for exhibit at the 1927 California State Fair two years later. The Smithsonian refused, citing concerns about the piece's fragility as well as security. A replica or facsimile of the flake was suggested, and the Smithsonian made a mold, cast a gold facsimile, and sent it to California at the chamber's expense. It was a big hit at the fair. The Smithsonian later made

a duplicate mold for President Herbert Hoover, a trained mining engineer and mineral collector. In 1938, the Sacramento chamber asked for another replica for the Golden Empire Centennial, and the Smithsonian complied. In 1947 it sent a plaster replica to the California Centennial Commission for its inclusion in a Historical Caravan exhibition, visited by one million visitors throughout the state. The next year, California's U.S. Senator William Knowland asked once again that the discovery flake be returned to California.

Secretary Alexander Wetmore explained to the senator that the item was absolutely unique, a symbol of the opening of the West and of continuing interest to all Americans. It would not be given back. Reinforcing its importance, when the Smithsonian's new Museum of History and Technology opened in 1964, the discovery flake was displayed in the Growth of the United States exhibition. Finally, in 1998 on the 150th anniversary of its original discovery, this tiny gold nugget returned to California, loaned by the Smithsonian to and exhibited at the Gold Discovery Museum. Governor Pete Wilson noted how the little flake had started it all—meaning the Gold Rush and the State of California. Currently, it is included in the On the Water exhibition, illustrating the role it played in changing transportation patterns and resources in the United States.

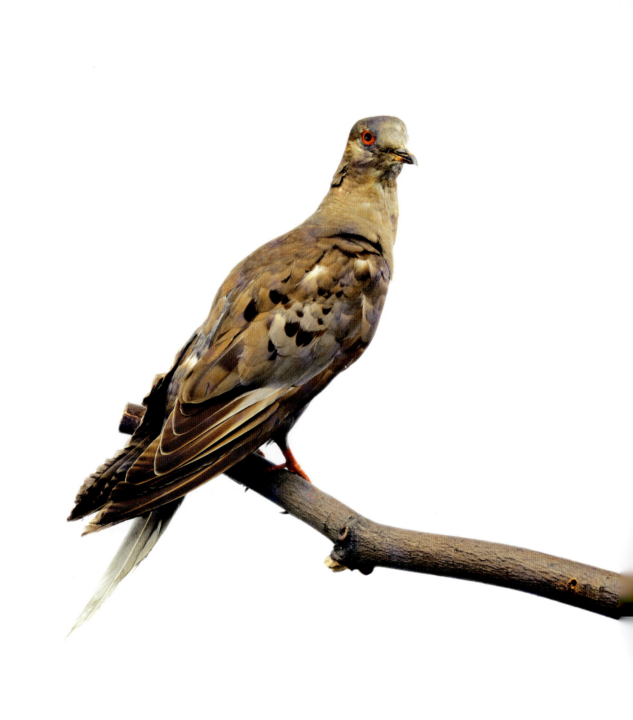

PASSENGER PIGEON MARTHA *National Museum of Natural History*

MARTHA Last of her species, died at 1 p.m., 1 September 1914, age 29, in the Cincinnati Zoological Garden. EXTINCT

So read the Smithsonian museum label.

The passenger pigeon, *Ectopistes migratorius*, was once the most common bird in the United States, numbering in the billions. In 1534, French explorer Jacques Cartier noted in his ship's log a seemingly infinite flock of wild pigeons off the shore of Prince Edward Island. Samuel de Champlain reported "countless numbers," and Cotton Mather described a flight as being about a mile in width and taking several hours to pass overhead. These descriptions established the spectacle of the birds' migration as one of the signature wonders of the New World, a metaphor for its seemingly limitless natural abundance.

In 1813, John James Audubon was awestruck by a single, thundering migratory mass that blackened the sky over his head throughout a fifty-five-mile journey in Kentucky:

MARTHA, THE LAST PASSENGER PIGEON

THE EXTINCTION OF A BIRD SPECIES FAMOUSLY DOCUMENTED BY JOHN JAMES AUDUBON MARKS THE VAST CHANGES IN AMERICA'S ECOLOGY.

National Museum of Natural History

The air was literally filled with Pigeons; the light of noon-day was obscured as by an eclipse; the dung fell in spots, not unlike melting flakes of snow; and the continued buzz of wings had a tendency to lull my senses to repose. I cannot describe to you the extreme beauty of their aerial evolutions, when a Hawk chanced to press upon the rear of a flock. At once, like a torrent, and with a noise like thunder, they rushed into a compact mass. In these almost solid masses, they darted forward in undulating and angular lines, descended and swept close over the earth with inconceivable velocity, mounted perpendicularly so as to resemble a vast column, and, when high were

seen wheeling and twisting within their continued lines, which then resembled the coils of a gigantic serpent . . . the noise which they made, though yet distant, reminded me of a hard gale at sea, passing through the rigging of a close-reefed vessel.

John James (born Jean-Jacques) Audubon (1785–1851), a native of the Caribbean island of Saint Domingue—modern-day Haiti—became a legendary ornithologist and painter who not only studied and documented most known species of birds but also discovered new ones. His novel, life-size and scientifically accurate illustrations of birds and mammals in their natural habitats set a standard for almost two centuries. His major works were *Birds of America,* 435 hand-colored plates published between 1827 and 1838, accompanied by a five-volume text entitled *Ornithological Biography (1831–39)* and *The Viviparous Quadrupeds of North America* (150 plates, published 1845–48, with accompanying text in three volumes, 1846–53).

Audubon had an enormous impact upon America's knowledge of birds, and was particularly influential with Spencer Fullerton Baird and, through him, the Smithsonian.

Baird was a teenage self-taught ornithologist when he met Audubon in 1840 and worked under his tutelage, studying his collections and learning to illustrate birds. In 1844 Audubon named a sparrow Baird's Bunting, or *Ammodramus bairdii,* after his young student. Audubon inscribed a copy (now at the Smithsonian) of his *Ornithological Biography* to Baird, "with the affectionate regard and best wishes of his sincere friend." Baird went on to become one of the Smithsonian's assistant secretaries and its second secretary. He built and expanded the Smithsonian's bird collection, which would grow into one of the world's largest, with some 625,000 specimens. Baird's early interest in Audubon's work would later lead to the acquisition of seven engraved copper plates from the folio edition of *Birds of America.* The Institution also acquired a number of texts, paintings, and individual prints over the years.

Audubon saw the wonder of America's natural bounty in its numerous

bird species, as well as the importance of native habitats to their survival. The passenger pigeon's habitat was large mixed-hardwood forests, as it migrated from Canada in the summer to the American South in winter. The pigeons' diet relied on beechnuts, acorns, chestnut seeds, berries, worms, and insects.

As Americans cleared eastern forests for farming or timber, the pigeon's migratory route was forced westward, and soon the birds adapted to the deforested landscape by shifting their diet from foraged nuts and insects to grain from farmers' painstakingly cultivated fields. The devastation to crops and livelihoods caused by the birds was huge, comparable to a prairie fire or bison stampede. One pigeon flock was documented as covering more than one hundred miles in length and between six and eight miles in width, and consumed an estimated six million bushels of grain a day.

To protect their crops, farmers shot at passenger pigeon flocks. They promoted pigeon shooting as sport, and they sold pigeon meat to cities as a cheap food source for the poor. By 1857, people began to notice fewer passenger pigeons. A bill was proposed in the Ohio legislature to limit the number of passenger pigeons that could be killed, but opponents derided the idea that there was any potential threat to the species. One of the last large nestings—and slaughters—of passenger pigeons occurred in Michigan in 1878. Some seven million birds were hunted and killed. Professional hunters used bait and traps to net and shoot the birds to sell to city markets at fifty cents a dozen. Hunters would attack nests, kill young birds, and disable older roosting ones with fumes from burning sulfur.

Few people could imagine that the ravenous passenger pigeon that darkened the skies in massive numbers was truly endangered, and fewer still found the prospect of extinction unwelcome. Audubon was one who had recognized the possible threats to the species he documented, and his name was invoked by conservationists in calls to protect them. That did not help the passenger pigeon. Overhunting, habitat loss, and possibly infectious diseases that spread through their colonies made the passenger pigeon increasingly rare by the late nineteenth century. The last confirmed

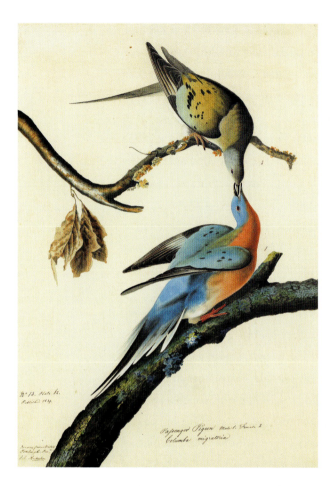

sighting of a wild passenger pigeon was in 1900. From 1909 to 1912, the American Ornithologists' Union offered $1,500 to anyone finding a nesting colony of passenger pigeons, but all efforts were futile. Never again would man witness the magnificent spring and fall migratory flights of this swift and graceful bird. A few survived in captivity, but attempts to save the species by breeding them were unsuccessful. The small captive flocks weakened and died.

Martha, a passenger pigeon named after George Washington's wife, who lived her whole twenty-nine-year life in the Cincinnati Zoo, was apparently the last surviving member of the species. Immediately following Martha's death in 1914, the Cincinnati Zoological Garden packed her in an enormous three-hundred-pound block of ice and shipped her to the Smithsonian. Following her arrival in Washington, Martha's skin was mounted for display by Smithsonian taxidermist Nelson Wood. Her internal organs were preserved as part of the fluid, or "wet," collections of the National Museum of Natural History.

Martha's widely reported death had a sobering public impact. Americans had long held the idea that the continent's natural resources were boundless; now they realized that progress and civilization could have irreparable and undesirable consequences. Congressman John F. Lacey of Iowa had been

prescient about the loss of the passenger pigeon in advocating in 1900 for a law seeking to preserve wild birds and game. In 1916 the United States and Great Britain, on behalf of Canada, agreed to the Migratory Bird Treaty in order to protect migratory birds. Two years later, Congress passed legislation to implement the treaty, which has subsequently been amended to include agreements with Mexico, Japan, and Russia. The Lacey Act of 1900 and the Migratory Bird Treaty established precedents for a host of other wildlife and habitat protection measures in the twentieth century, culminating in the Endangered Species Act of 1973.

Martha was displayed in the National Museum's Bird Hall from the 1920s through the early 1950s, and in the Birds of the World exhibit that ran from 1956 until 1999. She is slated to be exhibited again on the centennial of her death in 2014. Martha left the Smithsonian Institution twice. In 1966 the San Diego Zoological Society wrote to Smithsonian Secretary S. Dillon Ripley, himself an ornithologist, seeking the loan of Martha for its Golden Jubilee as part of a focus on conservation. "With the blessing of the Smithsonian, Martha is flying again," announced the *Washington Star*. And in June 1974, Martha returned to the Cincinnati Zoo for the dedication of a new building named in her honor. Both times she was insured by Lloyd's of London and flown first class, with an airline flight attendant escort.

Martha continues to inspire. Recently, artist Rachel Berwick won a Smithsonian Artist Research Fellowship, took up residence at the Institution, worked with ornithologist James Dean, the Natural History Museum collections, and the Audubon materials, and produced an exhibition called A Vanishing; Martha. The exhibit consisted of hundreds of cast amber passenger pigeons suspended on a series of thin brass rods in a large, room-sized installation. The rods toward the perimeter of the room have more birds, and the number per rod decreases toward the center, where there is only one left . . . Martha, the last of her kind.

A
HOUSE
DIVIDED

(1850 TO 1865)

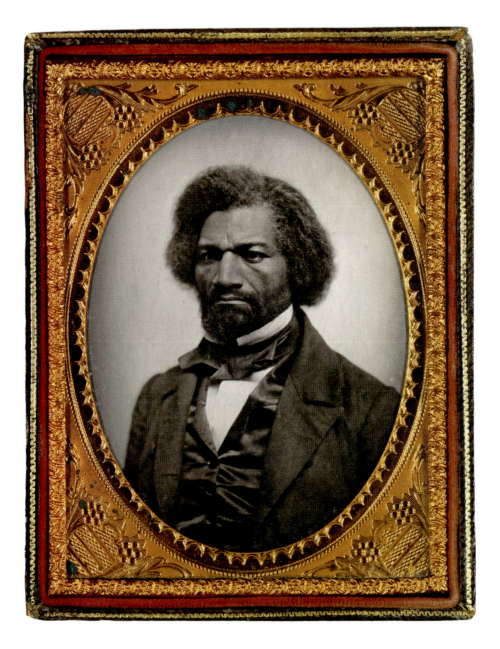

FREDERICK DOUGLASS, UNKNOWN PHOTOGRAPHER *National Portrait Gallery*

Handsome, distinguished, intense. All apply to the man in this portrait, a dedicated American social reformer, brilliant orator, insightful author, savvy statesman, and talented leader of the abolitionist movement, and himself a former slave. He was a living testament to the abilities of African Americans at a time in the United States when racial theories embodied in legalized slavery and social prejudices promoted the inferiority of blacks. In this portrait, as in others throughout his life, he is impeccably and formally dressed, on par with the most distinguished Americans of the day. This was no accident. Douglass was perhaps the most photographed African American of the nineteenth century. He was keenly aware of the power of photography not only to make a picture but also to craft an image of himself and his people.

29

FREDERICK DOUGLASS'S AMBROTYPE PORTRAIT

A FORMER SLAVE WHO BECAME AN ELOQUENT CHAMPION FOR HUMAN RIGHTS SHAPES HIS OWN IMAGE AND THAT OF AFRICAN AMERICANS.

National Portrait Gallery

Douglass (1818–95) was born Frederick Augustus Washington Bailey, a slave in Talbot County, on Maryland's Eastern Shore. He barely knew his mother, and his father was rumored to be her white master. Raised by his grandmother, he was essentially rented out to other masters, ending up in Baltimore as a young teen, where his master's wife taught him the alphabet. Though teaching slaves to read was strongly discouraged, the young boy took to it with a hunger, learning from white children and picking up newspapers when he had the chance. He realized early on that reading and education provided the mental pathway from slavery to freedom.

As a teenager, he read Bible passages to other slaves and tried to teach them to read, occasioning beatings and punishments. In 1838, with the help of a free black woman named Anna Murray, he escaped Maryland and slavery, and made his way to New York City. Describing his experience, he

wrote, "A new world had opened upon me. I lived more in one day than in a year of my slave life."

Murray joined him, and with the support of the abolitionist network the couple married and moved to New Bedford, Massachusetts, adopting "Douglass" as their last name. Douglass became active in the church-based abolitionist movement, lecturing with William Lloyd Garrison, the publisher of the *Liberator,* an antislavery newspaper. Whereas Garrison thought the U.S. Constitution fundamentally flawed because it allowed slavery, Douglass thought it an unfinished work that could evolve by bringing to fruition the aspirations of the Declaration of Independence that "all men are created equal." Douglass's speeches offered audiences direct, first-person, compelling narratives of slavery and its immorality. His first autobiography, *Narrative of the Life of Frederick Douglass, an American Slave,* published in 1845, received great critical acclaim. Many readers were surprised that a former slave could be so articulate. It sold more than ten thousand copies and was translated into French and Dutch.

Douglass visited Ireland and England, and was amazed that he was treated not "as a color, but as a man," equal to whites. While in Great Britain, Douglass's friends and admirers raised enough money to purchase his freedom from his former owner. Douglass returned to the United States and set out in earnest as a publisher of abolitionist newsletters and pamphlets. The motto of one, the *North Star,* was "Right is of no Sex—Truth is of no Color—God is the Father of us all, and we are all brethren"—a simple statement explaining where Douglass stood on human rights.

Douglass witnessed the early development of photography and commented on its ability to shape and reshape images of black men and women. In a *North Star* article, he advised blacks to present themselves carefully and with good, strong character, so that they could overcome white prejudices. Douglass criticized the way African Americans were visually portrayed in the newspapers and books of the day. He attacked depictions of blacks "with features distorted, lips exaggerated—forehead low and depressed—and the

whole countenance made to harmonize with the popular idea of Negro ignorance, degradation and imbecility."

Douglass was also conscious of his own image. Reviewing Wilson Armistead's *A Tribute for the Negro,* a book arguing for the capabilities of blacks, Douglass noted that his own engraved image bore a "much more kindly and amiable expression, than is generally thought to characterize the face of a fugitive slave." Douglass's second autobiography, *My Bondage and My Freedom,* written a few years later, corrected that impression with an engraving, drawn from an earlier daguerreotype photograph, in which Douglass looks much more serious and defiant.

Such is the case in this rare ambrotype from about 1856, in the collections of the National Portrait Gallery. The ambrotype likely derives its name from James Ambrose Cutting, who just a few years earlier acquired patents for a new photographic process that briefly replaced the older, more expensive way of making daguerreotypes. Ambrotypes are made by coating a glass plate with an emulsion, exposing the wet plate for somewhere between five and fifteen seconds, fixing the image, varnishing the back surface, attaching another glass over it, and typically securing it in a frame.

Ambrotypes are very fragile, and each was unique, so you could not make multiple copies from a single image. This method lost out to tintypes and other innovations in photography in the 1860s. Douglass believed that with these advances in technology, photography could be a widely democratizing medium. "The humblest servant girl may now possess a picture of herself such as the wealth of kings could not purchase fifty years ago," he wrote. Photography, he saw, could be used to improve the perceptions and treatment of African Americans. Just as he conceived of speeches and even ballads as changing opinions about slavery and freedom, he saw photography as a means of "swaying the heart by the eye."

Douglass was dedicated to the art of persuasion. He interpreted the aim of the Civil War as the abolition of slavery, and in newspapers, speeches, and personal meetings he urged President Abraham Lincoln to enlist blacks in

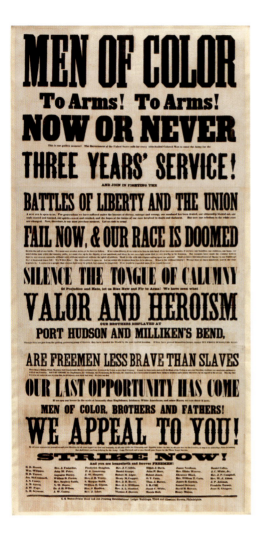

the Union Army, eliminate slavery, and guarantee black suffrage throughout the nation. For Lincoln, this abolitionist stance was too sweeping a program too soon in the war; the president feared he'd lose the crucial support of slave-holding border states that he needed to hold the Union together.

In 1861, the Washington Lecture Association held a series of abolitionist lectures at the Smithsonian Castle, against the wishes of Secretary Joseph Henry. The castle's auditorium was the biggest and finest in the nation's capital, capable of seating more than two thousand people. The aim of the series was to persuade President Lincoln to abolish slavery. Wendell Phillips, Horace Greeley, Ralph Waldo Emerson, Henry Ward Beecher, and others offered weekly lectures. President Lincoln, members of Congress, and other senior leaders attended. The series was so popular that more lectures were added through the spring of 1862, adding to the ever-mounting pressure on Lincoln. The last and culminating speaker was to be Frederick Douglass. But Secretary Henry declared, "I would not permit the lecture of the colored man to be given in the room of the Institution," and Douglass was denied.

Mere weeks later, though, Douglass's spirits were lifted when Lincoln freed all slaves in the District of Columbia and then went on to issue the Emancipation Proclamation in January 1863. Douglass pressed for more, urging Lincoln to support universal black abolition and suffrage, particularly as blacks were serving as soldiers fighting for the Union. Douglass

played a critical role in the creation of the Fifty-fourth Massachusetts Infantry in which two of his sons served. He worked with Lincoln to recruit freed slaves from the South to join Union forces. Douglass spoke often and widely to recruit black soldiers, helping to sponsor large recruitment posters directed toward "Men of Color."

After the Civil War and Lincoln's assassination, Douglass was ambivalent about Lincoln. He called him "the White man's president," and blamed him for moving slowly for abolition. Yet he also declared, "Though Mr. Lincoln shared the prejudices of his white fellow-countrymen against the Negro, it is hardly necessary to say that in his heart of hearts he loathed and hated slavery."

Douglass continued lecturing and writing after the Civil War; he served as the president of the Freedman's Savings Bank and then as emissary to the Dominican Republic. After moving from Rochester, New York, to Washington, D.C.'s Anacostia neighborhood, he held several official positions in the District of Columbia. He continued to be active in the women's suffrage movement. Suffrage pioneer Elizabeth Cady Stanton called Douglass "an African prince . . . majestic in his wrath."

Douglass's legacy continues to inspire those in the civil rights, women's rights, and human rights movements. This holds true for the Smithsonian as well. On February 22, 2012, the Smithsonian and the nation celebrated the groundbreaking for the new National Museum of African American History and Culture. Museum Director Lonnie Bunch led the ceremony, which featured speeches by President Barack Obama, former First Lady Laura Bush, civil rights hero and Congressman John Lewis, Smithsonian Secretary Wayne Clough, and others. I was honored to speak, and noted, recollecting Joseph Henry's denial 150 years ago, "We can't change what Henry said—but we can correct it. With this building, we can proudly say Frederick Douglass's words will certainly be heard in the rooms of the Smithsonian."

30

Harriet Tubman (c. 1822–1913) was an unlikely heroine. Petite, sickly, and enslaved for the first quarter of her life, she found her way to freedom and then dedicated herself to saving countless others.

Tubman earned her renown as a "conductor" for the Underground Railroad, helping African Americans escape slavery during the Civil War era. Her hymnal speaks to the connection between her religious faith and her actions—reflected in her unofficial title, "the Moses of her people," and

HARRIET TUBMAN'S HYMNAL AND SHAWL

ARTIFACTS ASSOCIATED WITH AN AMERICAN HERO REFLECT THE DEPTH OF HER FAITH AND THE BREADTH OF THE ACCLAIM FOR HER ACCOMPLISH- MENTS.

National Museum of African American History and Culture

the shawl, a gift from Britain's Queen Victoria, to acclaim for her good works.

Born into slavery as Araminta Ross on Maryland's Eastern Shore, she worked first as a house servant and then as a field hand. As a teen, she suffered a severe head injury at the hands of a brutal overseer when she tried to help a fellow slave. This abuse might have caused subsequent spells of unconsciousness, seizures, and vivid dreams throughout her lifetime. In 1844, she married a free black man, John Tubman, and in 1849, she escaped to Philadelphia to gain her own freedom. The city, with its large Quaker and free black population, was a center of abolitionist sentiment. It had an active Underground Railroad led by William Still and the Vigilance Society. Despite a one-hundred-dollar reward advertised for her capture (she was known as "Minty"), Tubman returned to Maryland's Eastern Shore in secret and began to guide enslaved people to their freedom via the series of safe houses known as the Underground Railroad, beginning with her niece and other family members.

As an aspect of the Congressional Compromise of 1850, which sought to balance power between slave-holding and non-slave-holding states, the

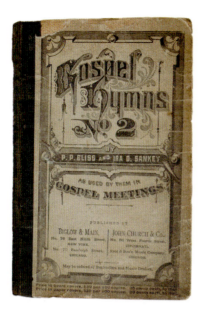

HARRIET TUBMAN'S HYMNAL AND SHAWL *National Museum of African American History and Culture*

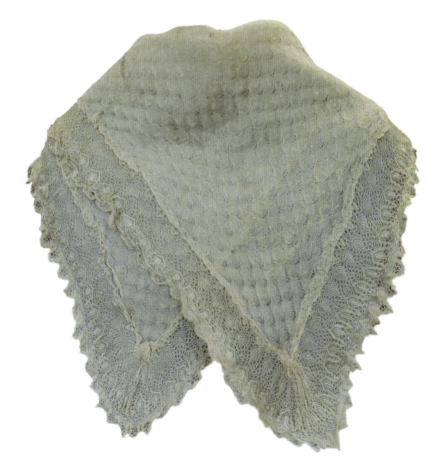

Fugitive Slave Act was strengthened. Not only were slave catchers granted federal powers to reclaim slaves in any state, federal officials in free states were required to assist slave catchers operating in their jurisdictions. The law also required people of color to prove their free status, even in the North, while rescinding their legal right to a trial in cases of dispute.

The Underground Railroad developed as an illegal network of people who assisted and sheltered escaped slaves along routes to Canada, Mexico, or Spanish Florida, where they would be free under law and exempt from extradition. The network expanded rapidly after 1850, in spite of the greater legal risk for those assisting escaped slaves. An estimated one thousand enslaved people a year made it to freedom along the Underground Railroad. While this was a statistically small percentage, it nonetheless gave people hope and helped dramatize the terrible injustice of the federal laws that supported slavery.

Undeterred by the Fugitive Slave Act, Tubman ventured into Maryland at least a dozen times in the 1850s; most historians believe she conducted thirteen missions. She helped rescue scores of people, guiding them to safe houses in the North and to freedom in Canada. Frederick Douglass hailed her work, and insurrectionist John Brown called her "General Tubman." She developed a friendship with abolitionist William Seward, later President Lincoln's secretary of state, who helped her relocate to Auburn, New York. During the Civil War, Tubman served as a cook, a nurse, and possibly a spy, and scout for the Union Army. In 1863, she accompanied Union troops on gunboat raids on plantations along the Combahee River near Beaufort, South Carolina—raids that rescued more than seven hundred fleeing slaves. Tubman is reputed to have calmed and encouraged many of them by singing:

Of all the whole creation in the east
or in the west
The glorious Yankee nation is the
greatest and the best

Come along! Come along!
don't be alarmed.

After the war, Tubman settled in Auburn and, having long been estranged from her first husband, married a younger black man, Nelson Davis, a Union Army veteran. She befriended upstate New York neighbor Susan B. Anthony and became an advocate for women's rights and suffrage, as well as being active in her church, with the Salvation Army, and with freedmen's schools. Following the death of her second husband, she helped establish an African American nursing home for herself and other aged and indigent people. When she died, she was buried with military honors at Auburn's Fort Hill Cemetery.

Tubman was a determined individual who, in an age that enshrined passivity as a virtue in women and slaves, took on a leading role in helping people seek their freedom. She was a devout Christian and throughout her life was inspired by divine visions. Although she could not read, she loved singing; an annotation in the hymnal in the Smithsonian's collection, the P. P. Bliss and Ira D. Sankey's *Gospel Hymns No. 2*, indicates that it was a treasured volume. The 112-page book with paper-wrapped board covers and cloth spine naturally falls open to the hymns read to her or that she sang, among them "Swing Low, Sweet Chariot," which was sung at her funeral. As Tubman did not write, her name was most likely inscribed in the hymnal by a friend or relative.

Tubman cherished the silk lace and linen shawl sent to her by Queen Victoria in 1897, on the occasion of the queen's Diamond Jubilee—the sixtieth year of her rule. Queen Victoria was perhaps the world's most powerful leader at the time. Invitations were sent to rulers and prominent people around the world, including Tubman, to join in the celebration in England. Although Tubman could not attend, Queen Victoria sent her the shawl as well as a silver medal.

The shawl, hymnal, and other items documenting Tubman's life, including numerous family photographs, were donated to the Smithsonian

by Charles L. Blockson in 2011. Blockson is the founder and curator of the Charles L. Blockson Afro-American Collection at Temple University, which includes rare texts, slave narratives, art, and other significant artifacts of African American history. The items had passed from Tubman to her grand-niece Eva Stewart Northrup, whom the childless Tubman had raised in Auburn, and then to Northrup's daughter, Mariline Wilkins. Wilkins had used the items to teach school groups about Harriet Tubman and willed them to Blockson upon her death. Blockson's family history was intertwined with Tubman's, as his own ancestor Jacob Blockson escaped slavery on Maryland's Eastern Shore with her. Blockson noted that Tubman was "one of the most important women in American history" and "her story needs to be heard by generations to come." Upon receipt of Blockson's gift, National Museum of African American History and Culture's Director Lonnie Bunch declared, "There is something both humbling and sacred found in the personal items of such an iconic person. It is an honor to be able to show the private side of a very public person, a woman whose very work for many years put her in service to countless others."

From the outset of the Civil War, abolitionists urged President Abraham Lincoln to free the people who remained in bondage throughout the Confederate states. He hesitated, believing that doing so would undermine important support for the Union cause in the border states—Delaware, Maryland, Kentucky, and Missouri—which allowed slavery but did not join the Confederacy. If these states became estranged from the Union, the prospects for military victory on the battlefield would be dealt a major blow.

31

EMANCIPATION PROCLAMATION PAMPHLET

By mid-1862, Lincoln had become increasingly convinced of the moral need to end slavery. Emancipation also had strategic advantages.

The promise of freedom in the South for enslaved African Americans could seriously undermine Confederate power. In hope of liberation, slaves might actively sabotage the Southern war effort or weaken its fragile economy by withholding their labor. In fact, thousands of slaves had already escaped to sanctuary in Union territory, to places like Fort Monroe in Virginia, where they were still not eligible for protection under the law as refugees, but instead were classified as contraband—enemy property subject to seizure under martial law. These refugees were aiding the Army's military effort, providing information on Confederate movements and supply lines, which helped provide a practical rationale for emancipation. Lincoln hoped that in the North emancipation would give African Americans a reason to enlist in the Union Army and aid the military effort. Internationally, an abolitionist course would dissuade Britain and France, both of which had ended slavery in their own countries but retained purely economic interests in Southern manufactured goods and plantation crops, from lending their considerable military support to the Confederate states.

As a first step, on April 16, 1862, Lincoln signed the District of Co-

THE HISTORIC ORDER BY PRESIDENT ABRAHAM LINCOLN, FREEING SLAVES IN THE CONFEDERACY, IS WIDELY DISSEMINATED.

National Museum of African American History and Culture

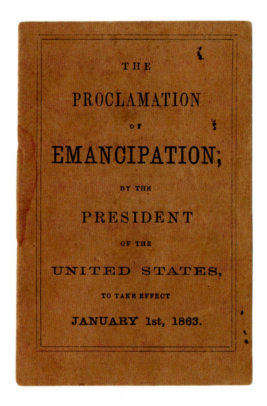

EMANCIPATION PROCLAMATION, PRINTED PAMPHLET

National Museum of African American History and Culture

lumbia Compensated Emancipation Act. About three thousand enslaved people who had been living in the shadows of the Capitol and the White House throughout the war were freed. To ensure minimal resistance, their former masters were generously compensated—at rates up to $300 per enslaved person—from a government fund. In addition, Lincoln finally, fifty-eight years after its independence, extended official recognition to the black Republic of Haiti in July 1862.

During the summer of 1862, Lincoln visited the War Department's telegraph office almost daily, exchanging messages with his Union generals. As summer faded into autumn, the president sat at the desk of Major Thomas Eckert, and, using the officer's pen and the ornate brass inkstand shown on page 221, drafted the Emancipation Proclamation. Then he waited for good news from the battlefields, so as to issue it from strength, not weakness.

On September 22, 1862, five days after Union troops turned back the northern charge of the Confederate Army at Antietam, Maryland, Lincoln issued the Emancipation Proclamation. Relying on the constitutional powers of the president as commander in chief of the Army and Navy, Lincoln presented the proclamation as an executive order, not a law, so it did not require congressional approval or review. It proclaimed as free the enslaved people in states and regions that remained in the Confederacy as of January 1, 1863. The proclamation did not abolish slavery throughout the United States, but it did make the abolition of slavery a war aim. It did not free the remaining slaves in northern or border states or end slavery, nor did it free enslaved people in Tennessee, parts of Virginia, or parts of Louisiana (including New Orleans) where Union forces had assumed control. Abolition would not come until 1865, after war's end, with the ratification of the Thirteenth Amendment to the Constitution. But the Emancipation Proclamation gave hope to African Americans across the country, who now saw their dreams of freedom clearly linked to a Union victory, and thus it provided a seminal turning point in the struggle from slavery to freedom.

Lincoln's proclamation was widely publicized and reproduced in the

months leading up to the New Year 1863. Throughout the autumn some items in the proclamation changed. Lincoln's idea of compensating slave states for the loss of their "property" was dropped, as was reference to having newly manumitted people of color, many of whom were fourth-generation or more Americans, sent abroad to establish new colonies in either Central America or Africa. The preliminary draft said nothing about African Americans' potential role as soldiers, but in the final proclamation, former slaves were to be accepted into the United States armed forces.

On December 30, 1862, a final draft of the Emancipation Proclamation circulated among the cabinet. It combined the Preliminary Proclamation, some pro forma sections, and a final closing added by a State Department clerk. Secretary of State William Seward brought this version of the Emancipation Proclamation to the White House for the president to sign on the morning of January 1, 1863. Lincoln signed it, but then noticed an error. The superscription read, "In testimony whereof I have hereunto set my name and caused the seal of the United States to be affixed." Lincoln preferred to use "hand" rather than "name," and asked Seward to have it changed. Later that day Lincoln signed the corrected final copy, saying as he did, "I never, in my life, felt more certain that I was doing right than I do in signing this paper."

It was Lincoln's corrected version that by day's end was distributed to the press and brought to the telegraph office for transmission across the nation. Four copies were made of the original final draft. A "clean" official document was kept by the State Department, and that copy is now in the National Archives. Later in the year, Lincoln presented his original copy to the women in charge of the Northwestern Sanitary Fair in Chicago, in recognition of their support of the Union Army. He told them that he had some desire to retain the paper, "but if it shall contribute to the relief and comfort of the soldiers, that will be better." They sold it to Thomas Bryan, a prominent citizen and member of the wartime Union Defense Committee, who purchased it for the Soldiers' Home in Chicago, of which he was presi-

TELEGRAPH OFFICE INKSTAND USED BY PRESIDENT LINCOLN FOR DRAFTING THE EMANCIPATION PROCLAMATION *National Museum of American History*

dent. The home and the document were destroyed in the Great Chicago Fire of 1871.

Among the various versions of the Emancipation Proclamation produced and promulgated was a miniature printed booklet published in Boston in December 1862 by abolitionist John Murray Forbes. We don't know how many copies were printed, but booklets such as this one in the Smithsonian were distributed by Union soldiers to blacks at the front lines of the war. They were read aloud in the field by Union officers in Confederate territory, allowing former slaves to hear for themselves the official words of the president, words that transformed their hopes and prayers for freedom into reality.

Eyewitness accounts describe celebrations on January 1, 1863, as thousands of blacks in the Confederate states of North Carolina, South Carolina, Florida, and other locales were informed of their new legal status as freedmen. The proclamation was read in the Mississippi Valley, Alabama,

parts of Arkansas, and the Georgia Sea Islands. Booker T. Washington, who was just a boy at the time, recalled the event:

> Some man who seemed to be a stranger (a United States officer, I presume) made a little speech and then read a rather long paper— the Emancipation Proclamation, I think. After the reading we were told that we were all free, and could go when and where we pleased. My mother, who was standing by my side, leaned over and kissed her children, while tears of joy ran down her cheeks. She explained to us what it all meant, that this was the day for which she had been so long praying, but fearing that she would never live to see.

The effect of reading these cheaply printed "pocket" copies of the Emancipation Proclamation was stunning. Colonel Thomas Wentworth Higginson, a Massachusetts minister and antislavery activist who was in command of the First South Carolina Volunteers—the first federally authorized regiment of freedmen—at Port Royal, South Carolina, on January 1, 1863, the Day of Jubilee, reported what took place following the reading:

> Just as I took and waved the flag, which now for the first time meant anything to these poor people, there suddenly arose, close beside the platform, a strong male voice (but rather cracked and elderly), into which two women's voices instantly blended, singing, as if by an impulse that could no more be repressed than the morning note of the song-sparrow—
>
> *"My Country, 'tis of thee,*
> *Sweet land of liberty,*
> *Of thee I sing!"*
>
> Firmly and irrepressibly the quavering voices sang on, verse after verse; others of the colored people joined in. . . . I never saw anything

so electric; it made all other words cheap; art could not have dreamed of a tribute to the day of Jubilee that should be so affective. History will not believe it . . . it seemed the choked voice of a race at last unloosed.

After it was ended, tears were everywhere. . . . Just think of it!—the first day they had ever had a country, the first flag they had ever seen which promised anything to their people. . . . When they stopped, there was nothing to do for it but to speak, and I went on; but the life of the whole day was in those unknown people's song.

Read countless times, these unassuming little booklets, as Smithsonian curator Paul Gardullo notes, communicated a new spirit of freedom for heretofore enslaved people. One hundred fifty years later, the National Museum of African American History and Culture acquired one of these rare remaining booklets for its opening exhibitions on the National Mall, a reminder to all of the struggle for freedom, the power of the words, and the first steps in a journey toward equality that continues to shape the American experiment.

Every Medal of Honor awarded by the U.S. government is extraordinary, but this one is especially so. It tells a poignant story of an African American soldier's bravery during the Civil War and an equally compelling tale of how his descendants battled for justice long after his death.

The recipient was Sergeant Major Christian A. Fleetwood (1840–1914). Fleetwood was born a free man in Baltimore, Maryland. He received an excellent early education and later served as the secretary of the Maryland Colonization Society, an organization promoting the emigration of free blacks in the United States to Liberia. Fleetwood visited Liberia as a teenager and returned to the United States to attend Ashmun Institute (later renamed Lincoln University) in Oxford, Pennsylvania, one of the first colleges in the nation dedicated to educating African Americans. He then founded and published with others the *Lyceum Observer* newspaper in Baltimore during the beginning of the Civil War.

African Americans had fought in the Revolutionary War and the War of 1812, but by the mid-nineteenth century, that service was often publicly ignored. Since 1820, the U.S. Army had prohibited "Negroes or Mulattoes" from serving in uniform. When the Civil War broke out in April 1861, President Lincoln called for seventy-five thousand volunteers to join the army; a number of Northern blacks offered their services but were rebuffed. The War Department was opposed to arming blacks for fear it would induce the loyal slave-holding border states to join the Confederacy. By the fall of 1862, the situation had changed. The Union faced heavy battlefield losses. Enrollments were declining, and it was clear that winning the war

32

CHRISTIAN FLEETWOOD'S MEDAL OF HONOR

THE NATION'S HIGHEST MILITARY HONOR IS AWARDED TO AN AFRICAN AMERICAN SOLDIER DURING THE CIVIL WAR AND HELPS INTEGRATE THE U.S. NATIONAL MUSEUM DECADES LATER.

National Museum of American History

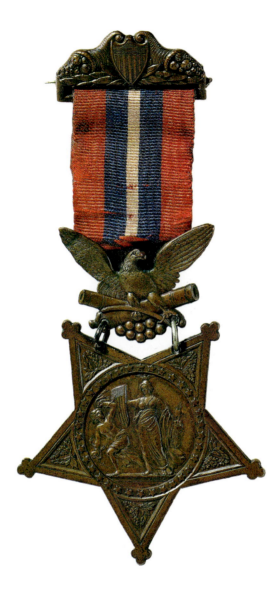

MEDAL OF HONOR AWARDED TO CHRISTIAN FLEETWOOD

National Museum of American History

would take longer than had been expected. Abolitionists advocated for black military service as a resource to help the Union effort. The Emancipation Proclamation included the provision that freed slaves could serve in the U.S armed forces.

Thereafter, in January 1863, Secretary of War Edwin M. Stanton gave John A. Andrew, the abolitionist governor of Massachusetts, authorization to form regiments that could include persons of African descent. The Fifty-fourth Massachusetts Infantry was born. Frederick Douglass was buoyed by the new policy and encouraged two of his sons to serve. Other black regiments designated U.S. Colored Troops (USCT) were quickly raised with help from Douglass and others who issued the call "Men of Color, to Arms!" Douglass knew military service provided a route to freedom, opining:

> Once let the Black man get upon his person the brass letters "U.S.,"
> let him get an eagle on his button, and a musket on his shoulder and
> bullets in his pocket, and there is no power on earth which can deny
> that he has earned the right to citizenship in the United States.

Approximately 180,000 men answered the call; African Americans made up about 10 percent of all Union forces.

The twenty-three-year-old Fleetwood was among those joining in August 1863. "A double purpose induced me and most others to enlist, to assist in abolishing slavery and to save the country from ruin," he later wrote. Fleetwood enlisted in Company G of the Fourth Regiment, U.S. Colored Infantry. Given his education, he was assigned the rank of sergeant and was promoted to sergeant major days later. His unit was assigned to campaigns in North Carolina and Virginia.

In September 1864, Fleetwood's unit was part of the massive siege of Petersburg, Virginia, a pivotal campaign that would help lead to the end of the war. Union troops under General Ulysses S. Grant were trying to break the network of trenches and garrisons protecting the route between the southern Virginia supply center and Richmond, the capital of the Confederacy.

On September 29, 1864, Fleetwood's Fourth Regiment participated in the Battle of Chaffin's (or Chapin's) Farm on the outskirts of Richmond, south of the James River. Some twenty-six thousand Union troops faced about fifteen thousand Confederate troops. Several thousand black troops led the charge, traversing rough forested and swampy terrain against the Confederate defenses. Fleetwood led one flank of his unit's attack. Fighting was fierce. More than half of the black soldiers were killed or wounded. During his unit's charge, all save one of the flag-bearing color guards were killed. Fleetwood grabbed the American flag from a soldier who had been hit and continued forward, leading his men into heavy fire. Though they could not breach the defense line, the flag-brandishing Fleetwood again rallied the troops to continue the fight.

Fleetwood and two of his fellow flag bearers were issued Medals of Honor on April 6, 1865, three days before Confederate General Robert E. Lee surrendered to Grant. Fleetwood's official citation reads: "Seized the colors, after 2 color bearers had been shot down, and bore them nobly through the fight."

Congress had approved such Medals of Honor in 1861 for the Navy and a year later for the Army. Secretary of the Navy Gideon Welles directed the Philadelphia mint to develop a design, which they did with the aid of silversmiths William Wilson & Son. Fleetwood's medal is made of bronze and depicts an inverted gold star featuring a central motif of the ax- and shield-bearing Roman goddess of war and wisdom, Minerva, repulsing a male snake-clutching figure of discord. Thirty-four stars encircle the central figures and represent the states, both Union and Confederate. The star points are formed by laurel leaves and a cluster of oak to represent victory and strength. The star hangs from an eagle, which signifies the nation. The eagle, in turn, is attached to a simple silk ribbon mirroring the flag's own red, white, and blue hues. The solemn medal symbolizes the victory of the United States over a brutal conflict threatening the country.

Fleetwood was photographed wearing the Medal of Honor and other honors he received. Although all the white officers of the regiment peti-

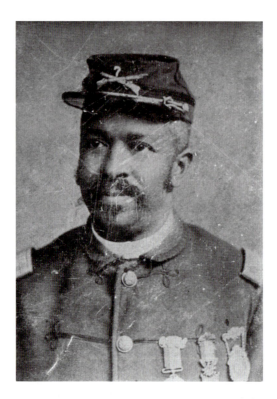

SERGEANT
CHRISTIAN
FLEETWOOD

Library of Congress

tioned for Fleetwood to be commissioned an officer, Secretary of War Stanton refused.

Fleetwood was one of twenty-four African Americans to receive the Medal of Honor during the Civil War—fourteen of which were awarded in the bloody Battle of Chaffin's Farm. After the war, Fleetwood worked in several government positions in the Freedman's Savings and Trust Company and in the War Department in Washington, D.C. He organized a battalion of D.C. National Guardsmen as well as the Colored High School Cadet Corps of the District of Columbia, which established a high standard of military service for African American soldiers. Christian Fleetwood died in 1914.

In 1947, Fleetwood's elderly daughter, Edith, offered his Medal of Honor to the U.S. National Museum, noting that this would be a first as

the museum did not have or display any African American collections. She also said it was important because of the "nation's renewed and determined emphasis upon true democracy," referring to President Harry S. Truman's recent integration of the armed forces. At the same time she offered the medal to the Smithsonian, she was donating her father's papers to the Library of Congress.

In principle, her gift to the museum fit within the collecting framework espoused by Theodore Belote, then the Smithsonian's curator of historical collections. Belote focused on what he described as "eminent Americans," by which he generally meant men who served some capacity in government or the military. Although the associate curator, Charles Casey (who handled military medals), recommended that the material be accessioned to the permanent collection, Belote objected.

Belote disingenuously argued that the collection lacked adequate storage and display space—a patently false claim given his own recent acquisition activities. Belote was more concerned with the inclusion of African American artifacts in the historical collections and the political statement that such an acquisition would make. While he said he would be "the last one to recommend that relics of colored soldiers should be excluded from a national military museum," he maintained that the U.S. National Museum's collection was not the proper place.

Cognizant of the impact of this rejection, the secretary of the Smithsonian, Alexander Wetmore, overrode Belote and accepted the donation. But when Belote put the medal on display, he omitted any reference on the label to Fleetwood's membership in the Fourth Colored Troops. Edith Fleetwood protested, saying that no one would ever know her heroic father was black. She argued that one day she hoped such identification would be superfluous, but for the present, it was necessary to achieve a "true democracy." This time the head of the museum, Remington Kellogg, overruled Belote, and Fleetwood's service was accurately recognized, as it is today in the Price of Freedom exhibition in the National Museum of American History.

APPOMATTOX COURT HOUSE FURNISHINGS *National Museum of American History*

On Palm Sunday, April 9, 1865, Confederate General Robert E. Lee (1807–70), commander of the Army of Northern Virginia, entered the home of Wilmer McLean in the village of Appomattox Court House, Virginia, to discuss the terms of surrender that would effectively end the Civil War. The generals assigned to organize the surrender had chosen McLean's parlor as more suitable than the grim local tavern.

A few hours earlier, as the Confederate forces faced certain defeat against Union General Ulysses S. Grant's Army of the Potomac, Lee had told General James Longstreet, "There is nothing left for me to do but to go and see General Grant, and I would rather die a thousand deaths."

The son of a Revolutionary War general, Lee had served as an engineer in the U.S. Army in the Mexican-American War, as superintendent of the U.S. Military Academy at West Point, and had put down John Brown's uprising at Harpers Ferry. Lee had married into the family of George Washington, and though he supported the preservation of the Union, he'd resigned his commission to remain loyal to his home state of Virginia—even though President Lincoln had asked him to lead the Union Army. Instead, he became the military adviser to Jefferson Davis and head of the Confederate Army of Northern Virginia, and ultimately the leader of all Confederate forces.

By 1865, with his army boxed in, cut off from supply lines, and exhausted from the Siege of Petersburg and the Appomattox Campaign, Lee had no choice but to surrender. Dressed in a notably clean dress uniform with sword, Lee arrived first in the McLean parlor and took the more comfortable high-backed cane chair. He reportedly waited about a half hour.

Ulysses S. Grant (1822–85), in contrast with Lee, entered the parlor clad

33

APPOMATTOX COURT HOUSE FURNISHINGS

GENERALS LEE AND GRANT NEGOTIATE THE END OF AMERICA'S MOST DEVASTATING WAR.

National Museum of American History

in a mud-spattered battle uniform with no sword. Grant, also a West Point graduate, had met Lee when both helped secure the U.S. victory over Mexico in Winfield Scott's march from Veracruz to Mexico City in 1848. He had retired from the military and failed at farming, bill collecting, and the tannery business before rejoining the Army at the outset of the Civil War. He rose in rank and command, eventually becoming head of the Union forces. He took the lower-backed leather chair.

Lee was joined by just one aide while Grant brought with him more than a dozen, including Robert Todd Lincoln, the son of the president.

After a brief exchange of personal reminiscences about their past acquaintance at West Point and in the Mexican-American War, Lee and Grant got down to business. Lee objected to the surrender provision that the troops' horses and arms be confiscated, noting that the soldiers often supplied their own weapons and mounts and would need those horses to help till the fields upon their return to civilian life. Grant agreed to this, and added the stipulation that all troops agree not to take up arms against the government again. Leaning over the small, oval, spool-legged table between them, Grant drafted the final terms of surrender. Lee leaned on a marble table and wrote his surrender letter:

> *We, the undersigned Prisoners of War, belonging to the Army of Virginia, having been this day surrendered by General Robert E. Lee, C.S.A., Commanding said Army to Lieut. Genl. U. S. Grant, Commanding Armies of United States, do hereby give our solemn parole of honor that we will not hereafter serve in the armies of the Confederate States or in any military capacity whatever, against the United States of America or under aid to the enemies of the latter, until properly exchanged in such manner as shall be mutually approved by the respective authorities.*

While there were still Confederate troops in the field under other commanders, Lee's surrender assured the freedom of his key military leaders

and effectively marked the end of the Civil War. Great cities like Atlanta and Richmond lay in ruins. Millions of lives had been disrupted; homes and crops destroyed; and families devastated by the loss of sons, fathers, and husbands: some 700,000 Americans dead in total. Though the Emancipation Proclamation freed enslaved people in the South, slavery remained the law of the land in the border states, and a handful of unfortunate people remained enslaved in the North, trapped under decades-old "gradual abolition" provisions.

Grant's aide Orville E. Babcock emerged from the parlor and informed the waiting officers and civilians, "The surrender has taken place—you can come in again."

Shortly thereafter, Union officers, recognizing the significance of the event, took pieces of furniture as souvenirs, which McLean later claimed they had done without permission. These became increasingly valuable relics of American history in the decades that followed.

Grant would go on to become president of the United States for two terms. Lee would gain ever more respect as a university president, reconciler between North and South, and, in retrospect, a brilliant general who had loyally served the "Lost Cause of the Confederacy." Both men would be celebrated with statues and other memorials, Lee throughout the South and Grant throughout the North. Despite Grant's success in following through on civil rights and suppressing Confederate nationalism and the Ku Klux Klan, celebrations of Lee obscured the causes of the war and the plight and conditions of African Americans, both before and well after the conflict. This was especially true with regard to the racial persecution of the post-Reconstruction period, which laid a foundation for Jim Crow laws in the South that mandated racial segregation and restricted the civil rights and civil liberties of blacks for nearly a century afterward.

As for the relics from Appomattox, a Union officer, General Henry Capehart, claimed Grant's chair. He held it for almost three decades before giving it in 1893 to his fellow General Wilmont Blackmore, who bequeathed it to the Smithsonian. The chair bears an inscription: "this is the chair in

which Genl. U.S. Grant sat when he signed the Articles of Capitulation resulting in the surrender of the Confederate Army by Genl. R. E. Lee at Appomattox Court House, Virginia, April 9th, 1865."

Major General Philip Sheridan reportedly bought the spool table for twenty dollars in gold—though McLean claimed it was taken. In 1876 Sheridan presented it to Elizabeth Custer after her husband, George Armstrong Custer, Sheridan's aide at Appomattox, was killed at the Battle of Little Bighorn. Elizabeth Custer stored it in a fireproof warehouse in New York City and had it brought out only for special occasions. One was a meeting of the Union League Club in 1896, where General Porter, who was raising funds for Grant's Tomb, delivered an address on the Civil War surrender. The small and humble-looking table stood in front of him. There were many veterans in the audience listening to Porter's address, and their interest intensified when they learned of the table's significance. One declared it "the Ark of the Covenant to all survivors of the Civil War." Custer wanted to sell the table to the Smithsonian, but the museum lacked the funds. In 1912, she lent it to the Smithsonian, and in 1936, according to her will, the loan became a bequest.

Union General E. W. Whitaker took Lee's chair, and it remained in his possession until 1871, when he presented it to the Nathaniel Lyon Post of the Grand Army of the Republic, an organization for Union veterans, to be awarded to the person selling the most tickets for a benefit performance. Captain Patrick O'Farrell, by virtue of having sold ninety-six tickets, became the new owner. O'Farrell displayed it at the Connecticut Historical Society, where he encouraged "every veteran and the son of every veteran" not only to look at it but also to sit in it. According to O'Farrell, everyone owned a share in it. In 1915, his widow, Bridget O'Farrell, donated the chair to the Smithsonian.

There were other pieces of furniture in the McLeans' parlor as well. Union General Edward Ord is supposed to have bought the marble table from the McLeans for forty dollars. It ended up at the Chicago Historical Society. A secretary desk also eventually came to the Smithsonian.

The McLean house itself, which the family left in 1867, was purchased in 1891 by a New York investor who hoped to dismantle and reconstruct it as an exhibit at the 1893 World's Columbian Exposition. This effort failed for lack of enthusiasm. A subsequent scheme to move the McLean house to Washington, D.C., as the "Surrender" centerpiece of a Civil War museum progressed far enough that the building was completely disassembled; but as plans once again fell apart, materials fell prey to scavengers. In 1941, an act of Congress created the Appomattox Court House National Monument to reconstruct the McLean House and to preserve the surrounding landscape.

In 1950, the Commonwealth of Virginia began a campaign to have the Smithsonian's Appomattox furniture returned. The state legislature went so far as to ask Virginia's congressional representatives to introduce a bill to force the removal of the furniture from the Smithsonian to the Appomattox Court House National Monument. The Smithsonian's congressional regents blocked passage of the bill, and a compromise was reached, with the U.S. National Museum agreeing to lend the furniture in order to have replicas produced. Since then, the furnishings have stayed in Washington, D.C., where they have been used in a number of exhibitions at the Smithsonian relating to the Civil War and the presidency. While some curators have occasionally questioned their value as mere souvenirs, others point to their continuing ability to connect museum visitors to a poignant moment in our nation's history.

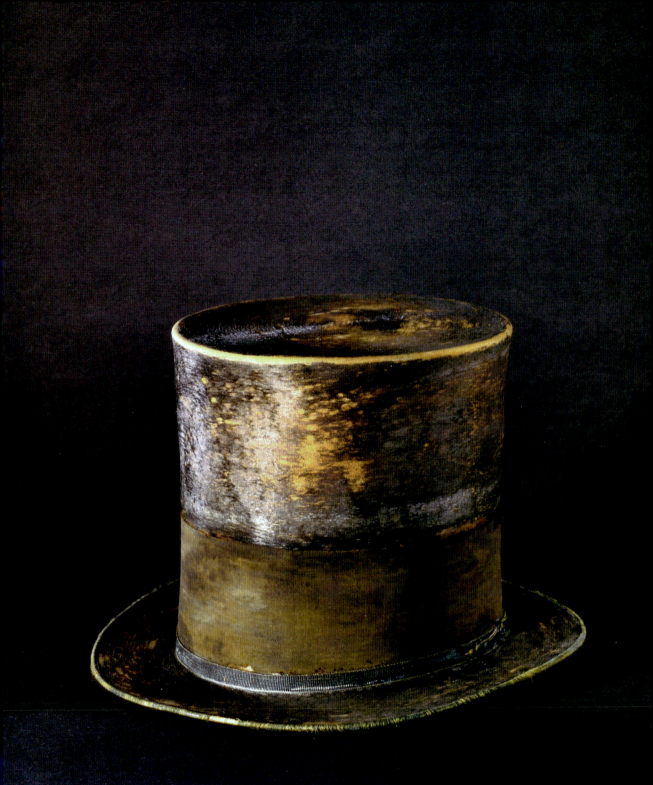

LINCOLN'S HAT *National Museum of American History*

T hough he was six feet four inches tall and towered over most of his contemporaries, President Abraham Lincoln chose to stand out even more by wearing high stovepipe hats. Lincoln was quite aware of how he appeared both to the public and to military and political leaders, having grown a beard just after his first election, perhaps to project a more mature bearing as he took on the role of commander in chief.

Lincoln acquired this top hat from J. Y. Davis, a

34

ABRAHAM LINCOLN'S HAT

Washington, D.C., hatmaker. It is made of silk fibers over a paper base and fabric lining, decorated with a 3/8-inch silk ribbon and a small metal buckle. After its purchase, Lincoln added a 3-inch silk grosgrain ribbon mourning band in memory of his deceased son, Willie.

Stylish silk hats were popular in the 1860s. Silk had been replacing beaver fur as the preferred hat material in America for several decades. British Queen Victoria's husband, Prince Albert, wore a top hat, and it became a symbol of upper-class respectability. In America, silk hats signaled a somewhat more urbane presence than the backwoodsman-like fur cap delightfully celebrated by Benjamin Franklin during his French residency decades earlier. While frontier values of honesty and hard work might have helped get Lincoln elected president, he would need to project sophistication and an elevated stature to meet the nation's challenges during the Civil War.

Lincoln's hat, typical of clothing of the time, is not marked for size. Most clothing in preindustrial America, Lincoln's hat included, was custom-made for a particular individual, either at home or by a tailor or dressmaker. Army uniforms were one of the exceptions, and the huge numbers of uniforms needed for the Civil War sparked the development of standard sizes for men. Other exceptions were garments from so-called slop shops, which produced and sold cheap ready-made clothing for unmarried laborers, sailors

THE SIGNATURE HAT OF THE PRESIDENT WHO FACED THE NATION'S GREATEST CHALLENGE BECOMES A NATIONAL TREASURE.

National Museum of American History

on long voyages, and, increasingly after the 1810s, Southern slaves. It wasn't until well after the Civil War, with the expanding industrial use of the sewing machine, that a full range of ready-to-wear garments for men became popular. A shift in popular taste to looser-fitting fashions that required less precision tailoring and the rise of mail-order catalogs contributed to the social acceptability of ready-made clothing. For women, save for commercially manufactured cloaks, corsets, and hoop skirts, widespread acceptance and use of ready-made standard-sized clothing did not occur until after the turn of the century.

Like shoes, hats were made on wooden forms called lasts. A specific hatmaker would have a series of lasts, but one maker's lasts were not necessarily the same size as another's. A customer would try a hat on for fit rather than look for a specific size. While Lincoln's hat was not labeled as such, it would correspond to a size 7⅛ today.

Lincoln might have worn this hat on April 3, 1865, when he visited Richmond, Virginia, after the Confederate capital had finally fallen to Union troops. Several days later, General Robert E. Lee surrendered to General Ulysses S. Grant at Appomattox Court House.

The Civil War was over. Lincoln had preserved the Union and freed the slaves. He had established land grant colleges, encouraged the development of the railroads, and advanced the nation's scientific work. He had recently celebrated his second inaugural and had every reason to enjoy a welcome break. On the night of Friday, April 14, 1865, Lincoln planned to take in a performance of *Our American Cousin* at Ford's Theatre with his wife, Mary Todd. They were originally to be accompanied by General Grant and his wife, but a change of plan substituted Major Henry Rathbone and his fiancée, Clara Harris, instead.

On that Good Friday morning, Confederate loyalist John Wilkes Booth, learning that the president would attend the play, joined with other conspirators to put in place a bold plan to kidnap and assassinate key Union leaders.

In the evening, Lincoln donned this hat for the last time when he took

a carriage ride from the White House to the nearby theater. He arrived late—the play was already in progress, but the action stopped as the audience greeted the president. He took his chair in the presidential box, his hat on the floor beside him.

During the third act of the play, Booth made his way to the presidential box and shot Lincoln in the back of the head. Leaping down onto the stage, Booth shouted, *"Sic semper tyrannis!"* (the motto of the Commonwealth of Virginia—"Thus always to tyrants!") and "The South is avenged!" The mortally wounded Lincoln was taken to the Petersens' boardinghouse across the street. Treatment by physicians proved futile, and he died shortly after seven o'clock the next morning.

After Lincoln's assassination, the War Department preserved his hat and other material left at Ford's Theatre. With the permission of Lincoln's widow, the department transferred the hat to the Patent Office and then, in 1867, sent it, along with many other collections, to the Smithsonian.

Smithsonian Secretary Joseph Henry had worked with Lincoln. He helped the president by recommending the use of observation balloons in

CONSPIRATORS' HOODS

National Museum of American History

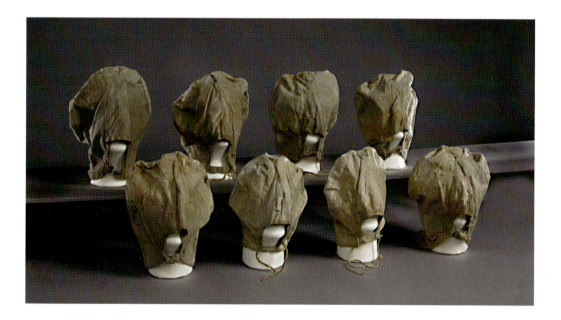

the Civil War, reviewing proposals for war technology, setting up a lantern light warning signaling system from the Smithsonian's Castle tower, exploring the repatriation of free blacks to Liberia, and even exposing a phony medium who had conducted séances in the White House. Henry ordered his staff not to exhibit the hat "under any circumstance, and not to mention the matter to any one, on account of there being so much excitement at the time." Part of that excitement was driven by the uncertainties about the reconciliation of North and South in light of the assassination. Would it spark Southern resistance and Northern punishment?

Lincoln, immediately upon his death, was treated by many as a Christian martyr. Just as with saints and other religious figures, the "relics" associated with Lincoln not only took on historical significance but also carried spiritual power as emblems of his sanctity. Just after Lincoln's death, mourners descended on Ford's Theatre and the Petersens' house. They sought items associated with Lincoln's martyrdom—bloodied bandages and linens from his deathbed, locks of his hair, moldings from the theater's box. Henry was worried that the hat would become a relic of what he regarded as irrational veneration. He had it stored in the castle's basement.

The American public did not see the hat again until 1893—well after Henry's death—when the Smithsonian lent it to an exhibition hosted by the Lincoln Memorial Association near Ford's Theatre. This hat was implicated in a lawsuit, apparently confused with another Lincoln stovepipe hat, which the family of the pastor who had ministered to Lincoln on his deathbed tried to retrieve decades later. Through the twentieth century, Lincoln's hat was often on public view and became an iconic visual symbol of the sixteenth president. It is one of the most treasured and popular items on display at the Smithsonian.

This hat is not the only headwear in the Smithsonian's collections associated with the conspiracy against Lincoln and his assassination. More gruesome are the canvas hoods that Secretary of War Edwin Stanton made the conspirators wear during their imprisonment.

Lincoln's hat is joined at the Smithsonian by other personal artifacts of

the beloved president, like an iron wedge he used for splitting wood, his office suit, and the famed Gardner "cracked" photograph.

GARDNER'S
CRACKED-PLATE
PHOTOGRAPH OF
LINCOLN

National Portrait Gallery

This photograph was taken by Alexander Gardner on February 5, 1865, at his studio at Seventh and D streets. Gardner was a Scottish immigrant who had worked in New York for Mathew Brady, America's most prominent photographer of the time, and later ran Brady's Washington shop before establishing his own studio in 1863. Gardner had already photographed Lincoln half a dozen times, and the two men had great respect for each other. The photo session was to provide the public with images of Lincoln for his second term. The plan was to supply them to *Harper's Weekly* and other publications for engraving and distribution.

The cracked portrait was shot on an imperial-size glass-plate negative, sixteen by twenty inches. If you wanted a big picture, you needed a big camera and a large glass plate. Gardner was a photographic artist. For the shot, he focused the camera and set the aperture to a very shallow depth of field. This created an effect where Lincoln's eyes and the front of his face are in very intense focus while the ears and back of his head are fuzzy. The image is a soulful one, staged to reveal the man Gardner knew well. It shows Lincoln tired—exhausted by the war effort—but with the hint of a smile, perhaps signaling his forthcoming second term and optimism about ending the conflict and rebuilding the Union.

After exposing the glass plate Gardner probably followed his usual procedure, using a flame to apply a varnish to finish it. Somehow a crack emerged. It did not break the plate, but it made the image unusable. Gardner made one albumen silver print—this one—and then, seeing it as a failure, likely destroyed the plate. The session turned out to be Lincoln's last formal photographic sitting—though not the last photograph of Lincoln—and it is unknown if anyone saw this print in 1865.

The photograph was acquired directly from Gardner by a great Lincoln admirer, Truman Bartlett, in the 1870s. Around the turn of the century it passed to Frederick Hill Meserve, a New York businessman whose father had been a Union soldier and who spent a lifetime building a collection of Civil War images. His daughter, Dorothy Meserve Kunhardt, carried on his work, and after she died the family approached the Smithsonian. The Institution acquired fifty-four hundred glass-plate negatives from Mathew Brady's studio, along with one print, this cracked portrait of Lincoln. Though the portrait is quite sensitive to exposure to light and only rarely exhibited, it quickly became one of the iconic images of the sixteenth president. Some imputed supernatural meaning to the crack running across the top of Lincoln's head, claiming it foreshadowed his assassination two months later.

All sorts of stories abound about Lincoln artifacts at the Smithsonian. One concerns Lincoln's gold pocket watch. When Smithsonian curator

Harry Rubenstein heard a tale about a secret inscription made on its inner parts, he became curious. In 2009 he had the watch opened up. Sure enough, inside the watch were several engravings made by repairmen over the Civil War years. One was a prayer for national success, but another was particularly astonishing. One of the people who had serviced the watch had engraved in cursive style the name "Jeff Davis," almost as though it were a signature. Unknown to Lincoln, and indicative of the divided nation and underlying secret loyalties rampant even in the nation's capital, he'd carried hidden within his beloved timepiece the name of the president of the Confederacy.

LINCOLN'S
POCKET WATCH
AND ITS INTERIOR

National Museum of
American History

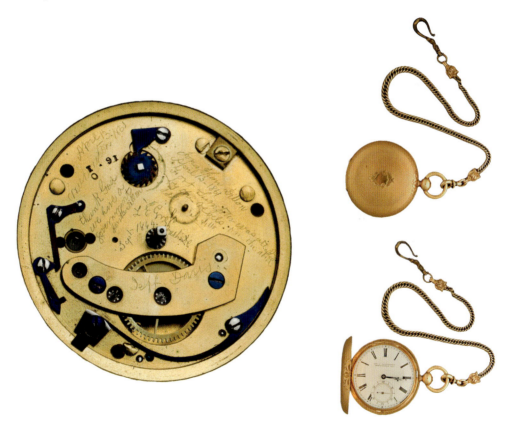

MANIFEST DESTINY

(1845 TO EARLY TWENTIETH CENTURY)

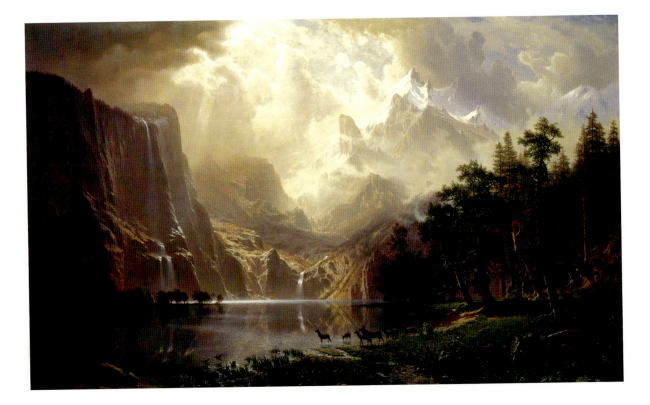

AMONG THE SIERRA NEVADA, CALIFORNIA BY ALBERT BIERSTADT *Smithsonian American Art Museum*

The painting is huge—ten feet wide—to match the grandeur of the scene it depicts. It is a majestic, glowing, panoramic vision of the American West, painted in 1868 by Albert Bierstadt (1830–1902). Paintings by Bierstadt, Thomas Moran, and others inspired Americans to imagine the West as an almost biblical "promised land," endowed by its creator with abundant resources and destined to be occupied and settled by intrepid white pioneers. Bierstadt's painting gave full visual form to the developing national ideology of manifest destiny.

ALBERT BIERSTADT'S AMONG THE SIERRA NEVADA, CALIFORNIA

Bierstadt had come to the United States as an infant when his parents, German immigrants, settled in New Bedford, Massachusetts, a whaling community with a mix of ethnic neighborhoods that was featured in Herman Melville's *Moby-Dick*. Following the lead of prominent figures who found spiritual comfort in New World scenery, Bierstadt gravitated toward visual art. As a young man he studied in Germany, where he mastered a dramatic style of landscape painting that he practiced first in Europe and later among Hudson River School artists in the East.

A PAINTING OF THE WESTERN LANDSCAPE GIVES AMERICANS A VISUAL SENSE OF MANIFEST DESTINY.

Smithsonian American Art Museum

Bierstadt traveled to the Rockies in 1859 with a land-surveying party after the Gold Rush had aroused the interest of the entire nation. The leader of the party, Frederick W. Lander, was scouting a route across the Rockies for the first continental railroad. Along the way, the group encountered brutal trail conditions and Indian attacks—a difficult introduction for Bierstadt to the West, who was nonetheless taken by the landscape's visual beauty and grandeur. The artist made several such trips over the next decade, paid for by the Union Pacific Railroad, to paint scenes of California that would lure tourists and eventually investors to the West. In 1863 Bierstadt approached the Sierra Nevada along a route his companion described as

the most horrible desert conceivable by the mind of man . . . alkali, white as the driven snow. . . . I look back on that desert as the most frightful nightmare of my existence. . . . Just across the boundary we sat down on the brink of glorious Lake Tahoe . . . a crystal sheet of water. Here, virtually at the end of our overland journey, since our feet pressed the borders of the Golden State, we sat down to rest, feeling that one short hour, one little league, had translated us . . . into heaven.

In a studio in Rome four years later, Bierstadt would reenvision that moment, transferring it to the canvas now called *Among the Sierra Nevada, California.* In the process, he represented the serene, luminous landscape with a range of emotions—awe-inspiring mountain scenery, a theatrical sky, small fragile flowers in the foreground. Bierstadt painted not what he actually saw but an imaginative, all-purpose California mountain landscape. He altered colors, and dramatized and romanticized flora, fauna, topography, and sky to create a transcendent image. Most striking of all is the celestial light that falls on the spectacular mountain peaks, whose pinnacles and crags are rendered with brushstrokes so fine they are barely discernible. The overall effect is that of a national anthem whose visual form evokes the grand scenery of the American West.

Bierstadt exhibited the painting in Europe in 1869, winning accolades in Berlin, Moscow, Saint Petersburg, and London. He sought to sell the painting back in America along with others of the West, recognizing its appeal to those on the East Coast. Many had seen attractively composed black-and-white photographs of the West, but these were only moderately successful in leading the public to a new appreciation of their nation's natural wonders. Bierstadt had an acute sense of the market, and knew that if he had a better product—well-painted great panoramic pictures of the West—easterners would pay good money to see and buy them.

Bierstadt was also a natural showman and self-promoter. He unveiled his canvases as if they were theatrical events, selling tickets and planting

news stories—strategies that one critic described as a "vast machinery of advertisement and puffery." But it was also a time when P. T. Barnum used his museum to demonstrate how close "high" and "popular" culture actually were. For some events, a Bierstadt canvas, elaborately framed, might be installed in a darkened room and hidden behind luxurious drapes. At the appointed time, the work would be revealed to thunderous applause. The theatrics typified other spectacles of artistic and historical display, such as large-size cycloramas. As Smithsonian curator Eleanor Harvey points out, Bierstadt "probably did more to introduce east coast Americans to the topography of the western third of the country than any other artist. And when you stand in front of this piece, bear in mind your ancestors paid what is now five dollars . . . [to] marvel at it. It's like an IMAX theater experience for the nineteenth century."

Among the Sierra Nevada, California was acquired by William Brown Dinsmore, the head of a shipping and railroad company, in 1873 for the Locusts, his ninety-two-room Italianate villa in Dutchess County, New York. It passed in his family to his great-granddaughter Helen Huntington Astor. After a divorce, she married Lytle Hull. Helen Hull helped found the New York Opera Company and served on the boards of the Metropolitan Opera, the New York City Ballet, Lincoln Center, and the New York Philharmonic. She razed the Locusts and built a smaller, more modern home on the same site in 1941. Among her interior decorating schemes, she had the Bierstadt canvas (absent the frame) glued directly onto a curved wall on the second-floor stairway landing. She died in 1976—with the painting bequeathed to the Smithsonian.

Smithsonian curator William Truettner went to the house with a conservator to take possession of the painting. They also discovered the original ornate gilded frame in a barn on the estate. It was in four pieces—but in almost perfect condition. Smithsonian conservators spent some six hundred hours of work to treat the surface of the painting and to remove the glue from the back of the canvas. The painting was then lined on an aluminum mount and set into the original frame. In 1985 it was rehung in the Smith-

sonian's American Art Museum, where it became the centerpiece of the nineteenth-century-landscape collection.

In 1991 Truettner curated an extraordinary exhibition at the museum, The West as America, which offered a new interpretation of the imagery of the American West. Though this particular Bierstadt was not in the show,

others were. Labels and signage for the show noted how many of the romantic paintings of the period were "contrived" and "staged fictions" that reinforced notions of "white privilege" and "racist" attitudes. A number of conservative historians and political leaders criticized the show, the curators, and the museum for taking a heavy-handed "politically correct" revisionist view of American history, which denigrated the popular vision that characterized the West as a land of unbridled opportunity. Faced with a barrage of criticism, including newspaper editorials and congressional threats of budget cuts, and also recognizing the overstatement in the signage, the museum's director agreed to rewrite the labels. But beyond debates of the so-called culture wars, it is more important to understand the paintings in their historical context. In Bierstadt's day and age, especially in the decade following the Civil War, these imaginative, aggressively American landscapes were seen as redemptive. They represented a new West, an unbelievably rich and beautiful Eden where the nation might start over in an effort to obviate and ultimately heal the wounds of a terrible Civil War.

As the new century dawned, Bierstadt and other landscape painters passed the torch to a remarkable group of nature photographers, Carleton Watkins among them, and later to Ansel Adams, whose focus became conservation. It was Adams, among others, who worked hard to reclaim what was left of the incredible world that Bierstadt had seen and recorded during the years he painted in the far West.

36

A little more than a century ago, Hawaii was an independent kingdom, as this feathered cape from one of its former monarchs reminds us. Hawaii's annexation to the United States reflects the culmination of America's dream of manifest destiny.

Hawaii, a chain of hundreds of volcanic islands at the northernmost end of the Polynesian archipelago, was unknown to Americans and Europeans until it was visited by British Captain James Cook in 1778. Cook called the islands the Sandwich Islands after the patron of his voyages, the fourth Earl of Sandwich. At the time of Cook's visit, about 450,000 natives survived largely on the cultivation of the starchy root vegetable taro, fishing, raising pigs, gardening, and gathering seaweed. After Cook's "discovery," European ships found the islands a good source of supplies and an attractive rest stop in the immense Pacific Ocean.

Traditional Hawaiian society was hierarchical, with *ali'i*, or hereditary chiefly families, and their kahuna, or religious specialists, at the top. *Kapu*, or sacred prohibitions, guided interactions between chiefs and commoners and between men and women. A number of chiefdoms competed for power on Oahu, the big island of Hawaii, Maui, Kauai, and other islands. In 1795, one warrior chief, named Kamehameha, gained control of the big island and started bringing the chiefs of the other islands into a larger, unified confederation. He was aided by English and American advisers who supplied his warriors with muskets, ammunition, and training. By 1810, Kamehameha had established himself as the ruler of the Kingdom of Hawaii, a monarchy loosely modeled upon European principles.

In addition to—or perhaps because of—the adoption of European political ideas, the islands were increasingly home to American and European

KING KAMEHAMEHA III'S FEATHER CAPE

A HAWAIIAN KING BESTOWS A GIFT TO A PEOPLE WHO WOULD LATER DISMANTLE HIS KINGDOM.

National Museum of Natural History

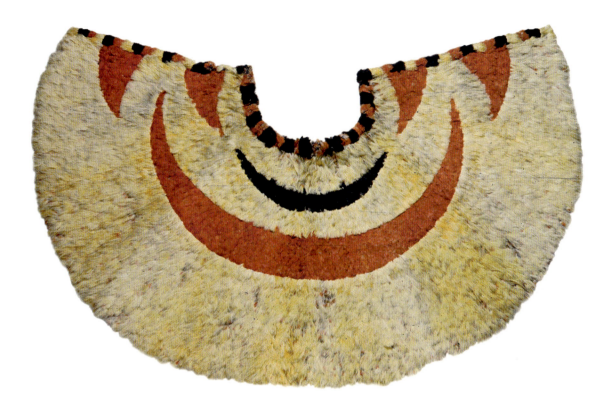

KING KAMEHAMEHA III'S BIRD FEATHER CAPE *National Museum of Natural History*

traders, whalers, visitors, and settlers. Disease became endemic, and the Hawaiian native population, lacking immune resistance, was drastically reduced. Protestant missionaries from the United States, particularly from New England, also came to the islands. To their way of thinking, the Hawaiians were heathens who needed to be converted to Christianity and civilized.

Upon Kamehameha's death in 1819, the kingship passed to Liholiho, the eldest son of his highest-ranking wife, and he became Kamehameha II. Under American and European influence, he ended the *kapu* system of sacred prohibitions, and the traditional social boundaries crumbled. He died in 1825, and his younger brother, twelve-year-old Kauikeaouli, became King Kamehameha III. This boy king had been brought up as a Christian by his puritanical stepmother, Queen Regent Ka'ahumanu.

In 1829, the U.S.S. *Vincennes,* an American ship commanded by naval officer William Bolton Finch, stopped in Hawaii during its around-the-world exploration. Finch met the teenage King Kamehameha III while witnessing what he called "a very high ceremonial occasion" having to do with the schooling of Hawaiian children. The king was apparently impressed with the concern expressed by Finch and his officers for the progress of Hawaiian youth, and presented Finch with this feathered cape.

That was an extraordinary gesture, because *'ahu'ula,* or feathered capes and cloaks, were among the most valuable items in traditional Hawaiian society. They were worn with feathered helmets and were a sign of royal or chiefly status. Made of tens of thousands—in some cases hundreds of thousands—of intricately woven *hulu manu,* or bird feathers, the longer cloaks and shorter capes were both aesthetically exquisite and symbolically indicative of importance and rank. The cloaks were constructed using a woven netting of *olona,* or native hemp, decorated with different-colored feathers obtained from local birds.

This cape's yellow base comes from the *'ō'ō (Moho nobilis)*. These feathers were carefully harvested by skilled bird catchers who plucked a feather or two from a live bird and then released it. The red and black feathers

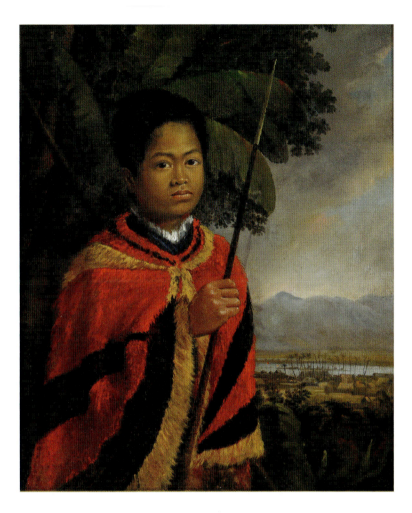

come from the *'i'iwi* (*Vestiaria coccinea*). Bundles of feathers were tied close together to form a uniform surface for the cape. On the back are two crescents, one of black feathers and a red one below it. The front also features two half-crescents of red on each side of the chest, which form full crescents when the cape is closed. The inner surface has no lining, and thus shows the *olona* netting and the quill ends of the feathers. The cord on the upper border is extended to allow fastening at the throat.

As an adult, Kamehameha III would suffer through a series of personal

KING KAMEHAMEHA III BY ROBERT DAMPIER

Honolulu Museum of Art

disappointments and misfortunes as a ruler. He signed a constitution in 1840 and wrestled with the influence of European and American advisers who tried to shape Hawaiian law and society to their own liking and political advantage. He greeted the U.S.S. *Vincennes* for a second time when it arrived in 1841 carrying Charles Wilkes, the commander of the U.S. Exploratory Expedition, charged by the U.S. Congress with carrying out scientific surveys in the Pacific and around the world. Wilkes was a former member of Washington, D.C.'s learned Columbian Institute, and the specimens and artifacts he acquired in Hawaii and other places over the course of the expedition would ultimately form the basis of the Smithsonian collections.

Through the 1840s, the Hawaiian government became increasingly westernized, following American and British models. Although Hawaiian chiefs participated in policy decisions as a House of Nobles, most cabinet and official positions were held by Americans and Englishmen rather than by native people. The Hawaiian system of laws and courts was rationalized, based on European ideas, as were land titles. In 1848, reforms—known as the Great Mahele—allowed for the redistribution of land ownership, which had previously been almost entirely restricted to the noble class, but more foreigners rather than Hawaiian commoners secured the property rights. Such steps permitted the development of American- and European-owned plantations for growing and processing sugarcane. As Hawaiians were losing political control of their land and society with a second constitution in 1852, disease was continuing to take a physical toll on their population; by the 1850s it was down to about seventy-five thousand, one sixth of its size at Cook's arrival less than a century before.

The impact of this economic and cultural assault on Hawaii's native peoples was further exacerbated by the California Gold Rush, which brought more Americans to the West Coast and then on to Hawaii to explore opportunities. Smallpox ran rampant, killing even more Hawaiians. American settlers started to talk about U.S. annexation of the islands, in spite of objections from the British and the French.

Kamehameha III died in 1854, and the kingdom continued under the Kamehameha line until 1872, when Kamehameha V died without a designated heir. Turmoil over the succession followed, resulting in an election and, finally, the selection of David Kalakaua as king in 1874. In time, missionaries, businessmen, wealthy Americans, and Europeans found problems with Kalakaua's spending, and his royal Hawaiian ways, and in 1887 forced him at gunpoint to sign a new constitution, stripping away most of his powers, entrusting future voting to large landholders exclusively, and denying rights to Chinese and Japanese settlers as well as to native Hawaiians. Kalakaua's sister Lili'uokalani succeeded him in 1891 and tried to recover native Hawaiian rule, but failed. Americans in Hawaii, aided by U.S. Marines, overthrew Queen Lili'uokalani and ended the sovereignty of the Kingdom of Hawaii in 1893, establishing their own provisional government. Seeking annexation to the United States, they negotiated first with the administration of President Benjamin Harrison and then with that of President Grover Cleveland. They failed in both attempts and formed the short-lived Republic of Hawaii, with Sanford Dole as president.

When William McKinley became president in 1897, he started flexing America's emerging muscle. Envisioning the Panama Canal soon joining the Atlantic and Pacific oceans, he, Theodore Roosevelt, and others believed that business across the Pacific—even to China—would boom. To control the seas, the United States would need a great navy. There would be a need for secure supply stations in the Pacific for ships fired by coal, making Hawaii an ideal location. So by mid-1898, McKinley proclaimed, "We need Hawaii just as much and a good deal more than we did California. It is manifest destiny." McKinley pushed annexation through Congress, making the former independent kingdom a U.S. territory. No ruler would ever wear a royal feathered cape again.

Although the U.S. Congress issued a formal apology for the forced takeover of the Hawaiian Kingdom in 1993, by that time its native chiefdoms and many of its traditions had already receded into history. Some aspects of the islands' natural heritage, like the very bird species used for the Kame-

hameha cloak, are now extinct. Other native Hawaiian traditions, however, such as the floral art of lei making, taro cultivation, hula kahiko dancing and chanting, the use of the Hawaiian language, and knowledge of Polynesian navigation, not only survived but were revitalized in a Hawaiian renaissance during the 1970s and 1980s. Collections at Hawaii's Bishop Museum and at the Smithsonian became resources for Hawaiians to reclaim their culture. Scholars like Smithsonian curator Adrienne Kaeppler helped provide important historical and ethnographic knowledge. I was able to work with John Waihee, the first native Hawaiian to become governor of the state, and with local Hawaiian researchers, cultural specialists, and Smithsonian colleagues to produce a Folklife Festival on the National Mall in 1989. The summer showcase celebrated the state and helped to encourage the traditions that previous generations of Americans had helped to eradicate. This magnificent feather cape serves as a haunting reminder of what was lost.

T he buffalo at the National Zoo have an amazing history, connecting them not only with America's prehistory but also with the history of our efforts to save endangered species.

The buffalo's ancestry goes back to the Asian steppe bison that migrated across the land bridge from Asia to North America probably hundreds of thousands of years ago. It evolved over time into the giant bison, and was eventually hunted by early Native Americans, who became increasingly proficient in the use of stone-pointed weapons. Scientists believe that the smaller American bison, or buffalo, evolved into its current form about ten thousand years ago.

The buffalo lived in and off of the vast American grassland prairies, historically found in the midsection of the continent. Though smaller than their precursors, buffalo are nonetheless large animals—adult males may weigh up to two thousand pounds, females a bit less. They are herbivores, grazing during the day, slowly roaming to different foraging sites, though they can gallop at more than thirty miles an hour and jump up to six feet in the air.

Buffalo congregate in small herds of about twenty animals, with males and females in separate herds except when mating. Sometimes herds clustered in groups, numbering in the thousands; it was these groups, roaming to feeding grounds and salt licks, that tamped down pathways and cleared the "traces" across the continent that were later developed by American Indians, settlers, and railroad builders into the trails, routes, and rail beds that eventually traversed the United States.

Native Americans valued and revered the buffalo as a source of food, clothing, and shelter, as well as for social and ritual needs. Ancient rock drawings depict buffalo as a symbol of power, freedom, and plenty. Buffalo had an enormous impact upon the prairie's ecology. Conversely, rain pat-

37

AMERICAN BUFFALO

AN ANIMAL VITALLY IMPORTANT TO NATIVE PEOPLES IS COMMERCIALLY HUNTED— ALMOST TO EXTINCTION— BEFORE INSPIRING THE CONSERVATION MOVEMENT.

National Zoological Park

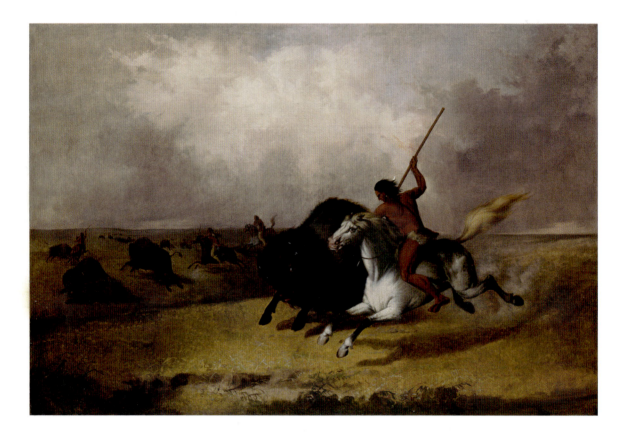

DEPICTION OF THE AMERICAN BUFFALO IN *BUFFALO HUNT ON THE SOUTHWESTERN PRAIRIES*
BY **JOHN MIX STANLEY** *Smithsonian American Art Museum*

terns and periodic prairie fires affected the expansion of grasslands and thus the buffalo population. Scholars now believe that Plains Indians actually managed the grasslands upon which buffalo depended through selective and deliberate fire burns.

Even before the widespread introduction of the horse, American Indians learned to stampede herds of buffalo over cliffs for mass slaughter. Butchery was perfected so as to remove the meat and make maximum use of body parts. The more tender hump meat, as well as the organs, were removed for eating and trade; tough meat was dried into pemmican; sinews were used for bows; fat provided grease; hooves were boiled for glue; horns, head, and wool were used for regalia and ritual purposes; and hides were turned into leather for apparel and shelter, and for recording "winter counts," pictorial depictions of community events.

By the time European explorers and settlers started to reach the plains, experts estimate there were perhaps fifty million buffalo in North America, making them one of the most populous species of large mammal on the planet. The near eradication of the buffalo occurred within only a few decades in the latter half of the nineteenth century.

While most American Indian buffalo hunts were relatively modest and controlled—as depicted in the contemporaneous paintings of John Mix Stanley and George Catlin in the Smithsonian collections—some tribes were, by the 1830s, engaged in mass exploitation. The Comanche, for example, were by then killing hundreds of thousands of buffalo annually and selling their meat and skins. After the Civil War, in the 1870s, buffalo killing went into even higher gear.

The combination of guns, railroads, commercial activity, and war with American Indians proved deadly to the species. Horses provided greater mobility in tracking down and reaching herds, and improved arms allowed for increased killing efficiency. Railroads allowed easier access to the herds and supported the mass shipment of hides and skins to consumer markets in the East and beyond. There was a huge market for buffalo skins and hides to be processed into leather apparel, coats, and rugs for customers in

the Northeast and Europe. A good buffalo skin would sell for three dollars in Kansas, and a finished buffalo-hide winter coat for fifty dollars. Buffalo leather was also well suited and highly in demand for the belts used with pulleys and steam engines in the factories of the time.

Commercial hunters spread across the country and turned their techniques for slaughtering and processing buffalo into a highly organized business enterprise. Teams of professional hunters were accompanied by congeries of wranglers, gun loaders and cleaners, skinners, cooks, blacksmiths, guards, and teamsters with their horses and wagons. A hunter could kill a hundred buffalo in one session, and there were hundreds of such teams operating daily. Historians have estimated that sometimes more than 100,000 buffalo were slaughtered in a single day, their hides taken, cleaned, stacked, and shipped eastward by wagon and railroad.

**LONE DOG
WINGER COUNT**

*National Museum of the
American Indian*

Given the scope of the carnage, some hunters, including Buffalo Bill Cody, spoke out in favor of protecting the species, but President Ulysses S. Grant refused to sign legislation to that effect. The U.S. Army encouraged the excessive killing of buffalo as a way of eliminating food supplies for Indian communities—starving Indians off their land and onto reservations. Realizing there was a real prospect of true extinction, some ranchers in Montana, South Dakota, Oklahoma, and Texas started to preserve very small herds of surviving buffalo.

One of the people most responsible for saving the buffalo from extinction was William Temple Hornaday (1854–1937), the chief taxidermist at the Smithsonian. Hornaday was a pioneer of realistic, lifelike museum displays; his work helped define modern taxidermy. He wanted to create at the Smithsonian the world's first display of an entire family group of buffalo—which would serve to represent the species were it to become extinct. In the spring of 1886, Hornaday and a team headed to Montana to collect specimens for the museum, but they were stunned to find no live buffalo on the plains, only thousands of skeletons bleaching in the sun. While there had been perhaps as many as fifteen million buffalo living at the end of the Civil War, by the 1880s they were on the very verge of extinction. It took a second trip and three months of hunting in the fall of 1886 for Hornaday to find the specimens he needed for his museum group. The impact of killing some of the last buffalo was not lost on Hornaday, and he began to think about how to save the species.

Hornaday brought back with him from Montana a buffalo calf, named Sandy on account of his wavy, yellowish-brown hair. Sandy, who was kept tied to a stake outside the National Museum during the day, was a big hit with visitors. To Hornaday's devastation, Sandy died suddenly, only a few weeks after his arrival in Washington, from pasture bloat, a result of eating damp clover. Hornaday skinned and mounted the animal to add to the buffalo family group display.

Sandy inspired Hornaday to initiate the Smithsonian's Department of

Living Animals, as part of a plan to establish a breeding program to help save the buffalo. Housed in pens on the south lawn of the Smithsonian Castle, the popular living animal exhibition soon grew to 172 mammals and birds and drew many visitors. Hornaday advocated for a national zoological park, for the conservation and study of wild animals sacred to the national heritage. He wanted to preserve buffalo not only in museum exhibits but as a living herd in captivity to educate Americans and, as he said, help atone for America's extermination of the species. He was successful on both counts. The Smithsonian acquired six buffalo, the first to ever become the property of the U.S. government, and in 1889 Congress passed legislation creating the National Zoo.

Smithsonian Secretary Samuel Langley appointed Hornaday the acting superintendent and enlisted America's most noted landscape architect, Frederick Law Olmsted, to design the zoological park. Hornaday and Langley had a falling-out, however, and, in 1891, when the animals were marched from the National Mall to their new home in Rock Creek Park, Hornaday was not with them. He had left to become the head of the New York Zoological Society and its Bronx Zoo, a position he held for three decades. To spread his message, Hornaday published *The Extermination of the American Bison,* considered today the first important book of the American conservation movement. He cofounded the National Bison Society with President Theodore Roosevelt, sent fifteen of the zoo's buffalo west to seed a herd, and established National Bison Ranges in Kansas and Montana to ensure the survival of the American buffalo. These efforts inspired the use of the buffalo and the American Indian on the "buffalo nickel," first minted by the U.S. government in 1913. Subsequently, numerous universities and organizations and several states adopted the buffalo as a symbol for their official seal.

Thanks to Hornaday's efforts, western herds were slowly built up. Today there are perhaps five hundred thousand American buffalo, though only about thirty thousand are in the wild in national parks.

Hornaday's decision to bring live buffalo to the National Mall was re-
prised one hundred years later in 1989, when Mandan and Hidatsa tribes
from South Dakota participated in the annual Smithsonian Folklife Festival.
During the festival, they tanned buffalo hides, performed buffalo songs and
dances, and made buffalo hide boats and buffalo regalia—all to demonstrate
the importance of the buffalo in their culture and the fact that their herds
were being regenerated. A female among the live buffalo unexpectedly gave
birth to a baby calf just after midnight on June 24, within a stone's throw of
the Washington Monument. The calf was given the Mandan name Nasca

**BUFFALO ON
THE MALL,
BEHIND THE
SMITHSONIAN
CASTLE**

*Smithsonian Institution
Archives*

Nacasire, or "Summer Calf." The Indian elders wrote to Smithsonian Secretary Robert McCormick Adams and Senator Daniel Inouye, connecting the calf's birth to the legislative process—then moving forward—to "give birth" to another Native American presence on the Mall, the National Museum of the American Indian. Both would signal the resurgent vitality of America's oldest cultures.

S itting Bull (1831–90) was among American history's greatest Native American leaders, fighting for the independence of his people at a time when the U.S. government was expanding its control throughout the West. His unique book of drawings is an amazing document—twenty-two pencil and watercolor sketches that record, in his own terms, his exploits as a warrior and the deeds that established him as a leader. He made these drawings in 1882 while a prisoner at Fort Randall, Dakota Territory.

Sitting Bull was a Lakota Sioux warrior, a holy man and tribal chief who led Native people of the Dakota Territory to resist the encroachment of the U.S. government in the northern plains of the American West. He fought against intruders to Lakota territory—both Indians and non-Indians. In the 1860s Sitting Bull participated in raids against U.S. Army forts and small settlements in the region. When other tribal leaders, such as Red Cloud, agreed to settlement on reservations, Sitting Bull persevered, pursuing a largely guerrilla-style fight against intruders. He targeted railroad survey parties intent on establishing a Northern Pacific Railway line through the Dakotas.

In 1874, U.S. Army Lieutenant Colonel George Armstrong Custer, an officer with a reputation for recklessness who had risen to prominence as a Union commander during the Civil War, led military escorts into the Black Hills—Lakota Sioux territory—to look for gold. When Custer announced the discovery of the precious ore, it led to a mini–gold rush, which in turn attracted more white speculators and inflamed tensions with the local Sioux. To ensure unrestricted access to the gold, the U.S. government ordered all resident tribes to move from these lands onto reservations, where they lived in poverty, dependent for survival upon promised federal rations that were often late or of poor quality. Those who resisted were declared "hostiles," and that included Sitting Bull and his band of warriors.

38

SITTING BULL'S DRAWING BOOK

A NATIVE AMERICAN LEADER DOCUMENTS HIS BATTLES AND EXPLOITS.

National Museum of Natural History

SITTING BULL'S DRAWING BOOK *National Museum of Natural History*

To fight against U.S. troops and resist pacification, Sitting Bull made alliances with other tribal groups, including the Northern Cheyenne. Sitting Bull was thought to have "strong medicine" as a warrior, meaning he had extraordinary powers in battle. His camp welcomed other bands of Indians and fighters seeking refuge, and by mid-1876 is believed to have grown to about ten thousand people. When Custer's Seventh Cavalry sought out the camp and attacked, Sitting Bull and several thousand Sioux, Cheyenne, and Arapaho warriors fought back, forcing Custer's retreat. On June 25, 1876, at the Battle of the Little Bighorn, Indian warriors, inspired by Sitting Bull's vision, utterly defeated the Army, killing Custer and more than 260 under his command.

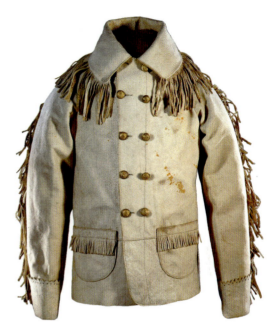

CUSTER'S JACKET

National Museum of American History

Custer's defeat shocked many Americans who were convinced of white racial superiority to Indians and of the inevitability of bringing all of U.S. continental territory under their control. The federal government sent more troops into the Dakotas and began a counterattack against Sitting Bull and his allies. Not strong enough to engage the U.S. Army directly, the Indians broke up into smaller bands and retreated to isolated areas. Sitting Bull withdrew into Canada, established a camp there, and refused offers of a federal pardon if he turned himself in and agreed to live on the reservation. But after years of holding out, when the scarcity of buffalo pushed his people to the brink of starvation, Sitting Bull returned to the United States and surrendered. Presenting himself at Fort Buford in Montana in 1881 with about two hundred others, the proud chief directed his son to hand over his gun to authorities, supposedly stating, "I wish it to be remembered that I was the last man of my tribe to surrender my rifle." Sitting Bull and

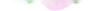

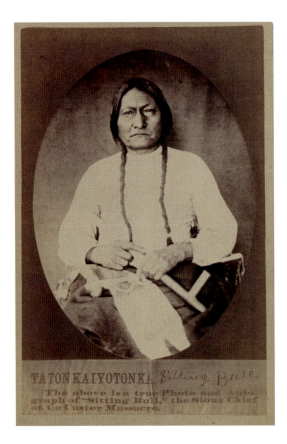

TATONKAIYOTONKA *Sitting Bull*
The above is a true Photo and Auto-
graph of "Sitting Bull," the Sioux Chief
at the Custer Massacre.

SITTING BULL

National Portrait Gallery

his group were transferred to the Stand-
ing Rock Agency at Fort Yates in North
Dakota, but fears that his presence would
stir up rebellious feelings among others
at Standing Rock prompted the Army
to move him down the Missouri River to
Fort Randall in South Dakota, where he
and his band were imprisoned for the next
year and a half.

While at Fort Randall, Sitting Bull
used the pages of a blank ledger book
to draw scenes from his life as a warrior.
Having learned to write his name in En-
glish while in Canada, Sitting Bull signed
each of the drawings. He also dictated ex-
planations of each of the episodes in his
native language, which were then trans-
lated into English and written down. The
book came to the Smithsonian's Bureau
of American Ethnology in 1923 from the
son of General John C. Smith, who had
received the book from Lieutenant Wallace Tear, an Army officer who was
posted at Fort Randall.

The tradition of recording events pictorially had a long history among
Plains Indians. At one time drawings were made on buffalo and other hides
with natural pigments. Once trade items became available, Indians eagerly
adopted new materials, producing many drawings in pencil and watercol-
ors on paper, often in ledger books. Sometimes, in winter counts, the im-
ages documented the history of a tribe or band, with one picture for each
year (a year, or winter, being measured from first snowfall to first snowfall).
Other drawings memorialized exploits of individuals. Sitting Bull was not
the only warrior to adapt this tradition to drawing with new materials. An-

other Lakota, Red Horse, made extraordinary pictographs of the Battle of the Little Bighorn. They provide a rare glimpse of an Indian perspective on this engagement.

Sitting Bull's drawings done at Fort Randall do not represent any of his many battles against the U.S. Army. Instead, they tell of his exploits against other Indian tribes, such as the Assiniboine and Crow. The drawings are revealing in both style and detail. Sitting Bull portrays himself and other human figures as flat, lacking dimension. They have little facial detail. The horses, on the other hand, are drawn with a greater eye to three-dimensional perspective. Their volume and musculature are evident, and many of his horse depictions have distinctive hide patterns and coloring so that they are individually identifiable.

Sitting Bull depicts himself in seven or eight different headdresses in the 1882 paintings. They signal his status, power, and accomplishments. In his rendering of himself as a youthful warrior, he wears a horned headdress. In others, where he is shown as a more mature chief, he wears elaborate eagle-feathered headdresses. In one of the pictures he wears a long sash— which was used by accomplished warriors to stake themselves to the ground during a fight and not retreat unless released by a comrade. Also evident

SITTING BULL'S DEPICTION OF BATTLE WITH THE ASSINIBOINE

National Anthropological Archives, National Museum of Natural History

is Sitting Bull's spiritual protection, or medicine, represented by a shield, headdress, as well as paint on his body or his horse.

In the drawing of his fighting the Assiniboine, Sitting Bull reveals the spiritual powers that protected him in battle. Buffalo hooves appear on his hands and at his ankles. The horse he rides is painted to embody a bird of prey, perhaps a hawk. The eye and beak of the bird overlap with the eye of the horse, and the talon of the bird is painted on the hind quarter. With only a coup stick—a blow from which served as a ritual gesture of conquest—Sitting Bull vanquishes his opponent with his extraordinary power.

In 1883, Sitting Bull and his band were allowed to return to Standing Rock and rejoin their people. He maintained his dignity, refusing to adopt Christianity as his religion, living with two wives, and rejecting federal entreaties to embrace white settlement in the area. He did send his children to reservation schools to learn to read and write. Surprisingly, in 1885, Sitting Bull joined Buffalo Bill's Wild West Show, where he was paid fifty dollars per week to parade before packed arenas of largely white audiences in the Great Lakes region, across the Northern Plains and Canada, and, finally, in Washington, D.C. He may have joined in order to get away from the reservation, or perhaps he sought to project the dignity and standing of his people and himself as a chief. In either case, he found the circuslike spectacle intolerable and left after four months, returning to the reservation.

By 1890, the Ghost Dance movement began to take hold among the Lakota, a spiritual ceremony that represented a new resistance to white control, a way for Indians to summon spiritual powers to help them reclaim their freedom and independence. Sitting Bull was asked to lead a Ghost Dance at Standing Rock. Fearing that Sitting Bull's participation would ignite the simmering resentment into full-scale rebellion on the reservation, a federal agent sent Lakota police to Sitting Bull's cabin to "arrest" him, ensuring that white hands would remain distant from any bloodshed. When they dragged Sitting Bull outside, the Lakota police met with the chief's defenders and a battle ensued; Sitting Bull was shot and killed.

Government officials continued to fear the power of the Ghost Dance

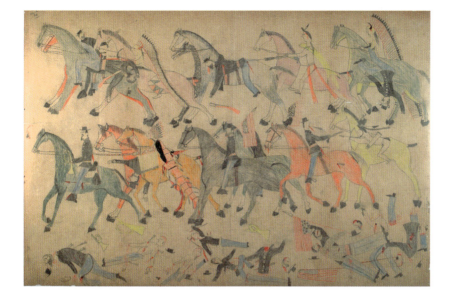

and demanded that bands surrender their weapons. In one horrendous confrontation, the Seventh Cavalry attacked the band of Big Foot, a Lakota Ghost Dance leader, at Wounded Knee Creek on December 29, 1890, killing several hundred Lakota men, women, and children. While official accounts claimed that this prevented a potential rebellion, many, particularly Native Americans, viewed it as a massacre perpetrated to avenge Custer's defeat at Little Bighorn.

Wounded Knee became a rallying point for the American Indian Movement in the 1970s, and Sitting Bull did as well—a leader respected by both Indians and whites for his fierce determination to remain free. In 2010, the Smithsonian's National Museum of the American Indian projected the image of Sitting Bull, among other elders, onto the façade of its building on the National Mall, located in the shadow of the U.S. Capitol. It was a dramatic juxtaposition and a statement of how far the country has come in recognizing and honoring the rights of Native Americans in the face of historical injustice.

RED HORSE'S
DEPICTION OF
THE BATTLE OF
LITTLE BIGHORN

National Anthropological Archives, National Museum of Natural History

39

The U.S. political position on Cuba has always been complicated. It still is.

This bugle was recovered in 1912 from the wreck of the battleship U.S.S. *Maine*, which blew up in the harbor of Havana, Cuba, on February 15, 1898, killing 266 American sailors and precipitating the Spanish-American War. What sent the

BUGLE FROM THE U.S.S. *MAINE*

ship to its watery grave is still a mystery, but its destruc-

A POIGNANT RELIC IS RECOVERED FROM A DESTROYED SHIP THAT BECAME A BATTLE CRY FOR EXPANDED U.S. INFLUENCE IN THE CARIBBEAN AND BEYOND.

National Museum of American History

tion ushered in geopolitical shifts that saw the end of the Spanish empire and a new era of American expansionism.

In 1823, President James Monroe enunciated what came to be called the Monroe Doctrine, asserting that the United States would not tolerate further European efforts to colonize land or interfere with the newly independent nations of the Americas—a policy that didn't apply to Cuba at the time because it was firmly under Spanish rule. John Quincy Adams thought that Cuba was a natural part of North America and would revert to the United States after Spanish rule came to an end. After the Mexican-American War, the United States sought to buy Cuba from Spain, but was rebuffed. Some Southerners envisioned Cuba as aligned with proslave states. Others saw it as a way station for freed slaves being repatriated to Liberia.

From 1868 to 1878, Cubans mounted an independence movement that was suppressed by Spanish authorities. In 1891, Cuban independence leader José Martí established a U.S. headquarters for a Cuba libre movement in Florida and New York and gave speeches to stir popular sentiment for the United States to help Cuban forces expel Spain from the island. Martí led an armed force into Cuba and lost. Though Martí was killed during the conflict, the independence movement continued as a series of guerrilla actions, which were brutally suppressed by the Spanish authorities.

BUGLE FROM THE MAINE *National Museum of American History*

In the 1890s, various U.S. interests debated policies toward Cuba. President Grover Cleveland estimated U.S. commercial investment in Cuba—largely in sugar plantations, mining, and railroads—at about $100 million and recognized that such an investment had to be protected. America's agricultural and industrial might was growing quickly: the United States had become the second largest economy in the world after Great Britain. The country needed markets for its steel, oil, cotton, and manufactured products. American big business sought an open-door policy so that it could sell products, generate profits for its massive expansion, and employ a growing labor force. If it wasn't able to grow, its workers would be idled, fomenting strikes, civil unrest, and radical labor movements—as became evident in the recession of 1893. New markets in Cuba, China, and Japan were all viewed by American business as targets of economic opportunity.

Others saw additional geopolitical dimensions to American expansion. Assistant Navy Secretary Theodore Roosevelt, Massachusetts Senator Henry Cabot Lodge, publishers William Randolph Hearst and Joseph Pulitzer, and President William McKinley, among others, saw a world being carved up by European imperial powers. They were convinced it was the United States' manifest destiny to acquire control over territory and colonies even beyond the nation's continental boundaries. Gaining concessions in China and taking over Hawaii, the Philippines, Panama, Nicaragua, Cuba, and other holdings would give the United States commercial markets, military bases, canals, and facilities so that it could compete with other major powers and take its place in the world as a great nation. Some added a racially based moral component—seeing the intervention of a superior white race as a duty in order to bring their ideal of a more advanced way of life to supposedly inferior peoples of the world. Socialists, labor leaders, unionists, and populists like William Jennings Bryan opposed military adventurism and U.S. imperial expansion, even though they sympathized with the Cuban fight for freedom.

Nonetheless, Roosevelt and others itched for war with the Spanish over

Cuba. Hearst's *New York Journal* and Pulitzer's *New York World* inflamed American passions with their propagandistic yellow journalism. Newspaper articles fueled outrage over Spanish excesses against Cuban freedom fighters and included an undertone of anti-Catholicism—implying the Vatican was acting through Spain. While the accounts of the use of slave labor in Cuba upset some U.S. progressive groups, the fact that Cuba—where slavery had remained legal until 1886—was a racially divided nation and that Afro Cubans were largely among the insurgents convinced many, particularly in the business community, that supporting only the independence-minded rebels would not aid their interests. The last thing militarists and businessmen wanted was "another Haiti," an unstable, black-controlled country suspicious of U.S. intentions.

The McKinley administration was negotiating with Spain to try to reach some arrangement about Cuba's future even as the United States built up its naval presence in the Caribbean to show the flag and pressure the Spanish. When a pro-Spanish riot broke out in Cuba's capital city of Havana in January 1898, the Navy sent the battleship *Maine* into the city's harbor without first properly informing Spanish authorities. It was viewed locally as a provocation.

On the night of February 15, the bugle sounded "Taps" aboard the *Maine*. The ship's captain, Charles Dwight Sigsbee, who had been writing a letter to his wife, described what happened next:

> I laid down my pen and listened to the notes of the bugle, which were singularly beautiful in the oppressive stillness of the night. . . . I was enclosing my letter in its envelope when the explosion came. It was a bursting, rending, and crashing roar of immense volume, largely metallic in character. It was followed by heavy, ominous metallic sounds. There was a trembling and lurching motion of the vessel, a list to port. The electric lights went out. Then there was intense blackness and smoke.

Of the 354-man crew, only 88, including the captain, survived. The ship was destroyed, sinking into the harbor.

Hearst and Pulitzer quickly blamed the sinking of the *Maine* and the deaths of the sailors on the Spanish and called for war. "Remember the *Maine*, to hell with Spain," they proclaimed, echoing what had become a widely circulated slogan. The cause for the explosion was thought to be a mine or a torpedo. Day after day, they and other propagandists screamed for war, publishing phony photographs and even producing war-inciting films. The U.S. Navy conducted an investigation and concluded that the ship's stocks of ammunition had been set afire by an external mine. Over the next month or so, the business community increasingly saw military action as the only viable course. President McKinley concluded the same, giving Spain an ultimatum to give up their rule—to the United States, not the rebels—or face war.

The sinking of the *Maine* served as a rallying cry for action. On April 11, McKinley asked Congress to declare war on Spain, which it did. The war did not last long—about four months. The U.S. Navy was far superior, and the Spanish military forces had been weakened by internal rebellion in Cuba and an independence movement in the Philippines. By December, the United States and Spain had signed the Treaty of Paris. Spain relinquished its sovereignty over Cuba, ceding temporary control of the island to the United States. It also gave up its colonies of Puerto Rico, Guam, and the Philippines to the United States.

In 1899, the U.S. Navy retrieved some of the human remains and other items from the *Maine*. The Smithsonian sought and received the ship's steering wheel. The damaged wheel was regarded as a patriotic treasure and was prominently displayed in the National Museum alongside the nation's most prized relics.

In the following decade, pressure grew to bring up the *Maine* and retrieve the rest of the human remains. In 1910, Congress provided funds

for a salvage operation and for conducting another investigation into the explosion. The Army Corps of Engineers supervised the operation. They refloated the hull, removed the remains of about seventy individuals, and salvaged dozens of items from the ship and the harbor floor. On March 16, 1912, the ship's intact wreckage was floated out to sea near Havana and, with somber, patriotic ceremony, sunk. The human remains were buried at Arlington National Cemetery and the ship's mast was installed there as a memorial. An official inquiry again concluded that the explosion was caused by an external source, though subsequent investigations, including one in 1976, proved inconclusive and found no evidence of mine or torpedo damage.

Following the salvage and final sinking of the *Maine,* the artifacts from the ship—anchors, bells, life preservers, guns—were distributed to the Naval Academy, naval yards, parks, courthouses, and museums. This bugle, possibly the one heard by Captain Sigsbee just before the explosion, the one playing "Taps" that fateful night, now encrusted with shell, coral, and other marine detritus, came to the Smithsonian, a potent reminder of the United States' tumultuous relationship with Cuba.

INDUSTRIAL REVOLUTION

(1865 TO EARLY TWENTIETH CENTURY)

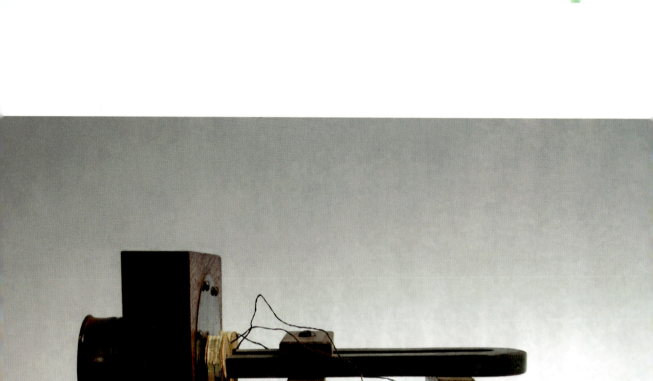

BELL'S BOX TELEPHONE *National Museum of American History*

M r. Watson, come here. I want to see you!"

So declared Alexander Graham Bell, speaking into a tin mouthpiece on March 10, 1876. His voice was turned into electric current and transmitted to his assistant, who heard it on a receiver. It was a seminal moment, one of many on the long road to develop a working telephone.

The development of the telegraph in the 1840s opened up a variety of possibilities for using electromagnetism to convey information. Many inventors experimented with the transformation of sound into electric current, vibrations, or visual images. These experiments led to the microphone, phonograph, and telephone.

ALEXANDER GRAHAM BELL'S TELEPHONE

A MACHINE FOR PRODUCING "ELECTRIC SPEECH" REVOLUTIONIZES WORLDWIDE TELECOMMUNICATIONS.

National Museum of American History

Alexander Graham Bell (1847–1922) was a key figure among these inventors. He was born in Scotland, the son of a professor of elocution who created a method of "visible speech" in order to teach the deaf to speak. Bell learned the technique as a child and grew up interested in the nature of sound, voice, and speech—doubly so because his mother started to go deaf as he became a teenager.

Seeing a primitive "speaking machine" in London, Bell's father challenged him to produce a better one. As a young man, he studied developments in acoustic theory and conducted his own experiments. He learned German and Sanskrit and became a speech and elocution teacher. Family illness motivated Bell's move to Canada with his parents, where he continued to pursue his interests. Bell learned the Mohawk language, taught the deaf, and experimented with sound and electricity.

Bell worked on a phonautograph, a device that translated sound waves into patterns on a smoked-glass plate. He began to think about a telegraph-like device that could somehow transmit the human voice—what he called

PROTOTYPES
OF BELL'S
TELEPHONE
EXHIBITED AT
PHILADELPHIA'S
CENTENNIAL
EXHIBITION

*National Museum of
American History*

electric speech. In the summer of 1874, he sketched out the idea of a harplike apparatus composed of a series of steel reeds. A voice projected at the reeds would cause them to vibrate over a magnet, inducing a variable current in the coils of an electromagnet. That current would then be transmitted over a wire to a receiver that would turn the variable current back into sound. Bell termed this proposed device an articulating telephone.

Several months later Bell traveled to Washington to see Smithsonian Secretary Joseph Henry, seeking advice. Bell knew of Henry's scientific preeminence and his work in electricity and acoustics. Henry, enthused by Bell's work, strongly encouraged him and advised further study into electricity and electromagnetism. The meeting at the Smithsonian proved inspirational for Bell.

Working with mechanic and electrician Thomas Watson, Bell developed a primitive mechanism for acoustic telegraphy, a device to convey the hu-

man voice over an electric line. He and competitor Elisha Gray both filed papers at the U.S. Patent Office on February 14, 1876, for a similarly designed telegraphy device that used liquid to help turn sound waves into electric current. However, Bell had built a prototype, whereas Gray submitted only a concept. Three weeks later, Bell received Patent No. 174,465 for an "improvement in telegraphy."

A few days later, Bell made his famous transmission to his assistant, Watson. Sound waves from Bell's voice caused a membrane stretched across the narrow end of the mouthpiece to vibrate. A needle attached to the center of that membrane had electric current running through it. As the membrane vibrated, the needle moved up and down in a cup of slightly acidic water, and as it did, the electrical resistance between the needle's current and the water varied. The varying vibrations, or fluctuations—which Bell called an undulatory current—traveled through a wire to a receiver, which translated them back into sound.

The device could barely convey a conversation, so Bell and Watson continued to experiment, seeking a viable and efficient design. They developed several models that Bell then showed in Philadelphia at the 1876 U.S. Centennial Exhibition. Bell demonstrated several experimental telephones at the fair, including a pair of units that proved exceedingly popular.

The units worked as transmitter and receiver. Vibrations from the speaker's voice, directed into a tube, moved a membrane that, in turn, vibrated a steel armature near an electromagnet. That vibration caused a fluctuating current in the coil that was transmitted by wire to the other unit. The receiver reversed the process so that the current caused a membrane to vibrate, generating sound waves. Joseph Henry, a judge for the event, did not see Bell's telephone there but later invited Bell to the Smithsonian to demonstrate the invention. Henry opined that Bell's telephone was "the greatest marvel hitherto achieved by the telegraph."

Bell continued to experiment through the summer and fall, and developed what came to be called the box telephone. The object depicted is the original, one of a pair used by Bell and Watson in a demonstration be-

tween Boston and Salem, Massachusetts, on November 26, 1876. Critical features are the iron diaphragm (seen as a circular disk mounted on the vertical wooden support), two electromagnets (light brown disks facing the diaphragm), and a horseshoe-shaped permanent magnet (lying horizontally) pressed against the electromagnets. When used as a transmitter, sound waves at the mouthpiece caused the diaphragm to move, inducing the fluctuating current in the electromagnets. That current was conducted over wires to a similar instrument that acted as a receiver. There, the current in the electromagnets caused the diaphragm to move, producing air vibrations that could be heard by the listener.

Bell, in Boston, and Watson, sixteen miles away in his native Salem, connected two telephones to the telegraph wires of the Eastern Railroad Company. Their voices, even when whispered, were clearly heard, and the press described the conversation as "free and easy."

Watson also identified voices other than Bell's. They routed the circuit not only directly between Boston and Salem but also through Portland, Maine, and North Conway, New Hampshire, demonstrating the ability to transmit voices over longer distances.

TOP VIEW OF
BELL'S BOX
TELEPHONE

National Museum of
American History

THE SMITHSONIAN'S HISTORY OF AMERICA IN 101 OBJECTS

With its viability proven, the game was on to develop this version into a commercial product, and Bell, Watson, and others formed the Bell Telephone Company in July 1877. They added a wooden cover to the device, giving it a finished look, and soon replaced the electromagnetic converter with a carbon variable-resistance device designed by Francis Blake, based on a principle patented by Thomas Edison.

The telephone proved immediately popular in offering businesses, and later households, instantaneous vocal communications. This time-saving, convenient improvement on the telegraph did away with trips to a station, intermediaries for transcribing and transmitting messages, and waiting for a response. Civic services benefited, as people gained the ability to call police and fire departments. Household users gained closer communication with doctors, merchants, relatives, and friends. Switchboard operators, typically unmarried young women (thought to be more patient and accommodating than men by the Bell company), learned how to recognize ring patterns for signaling different "party line" customers who shared telephone connections. Telephone engineers developed systems of exchanges to identify local telephone circuits, telephone numbers, and private lines in subsequent decades. The number of users went from five million in 1910 to virtually all households and businesses by the year 2000.

Bell Telephone would become the American Telephone and Telegraph Company (AT&T). A lucrative enterprise, "Ma Bell" came to embody America's industrial expansion and prowess in the twentieth century, as well as the pitfalls of a monopoly enterprise. Ultimately, the company was deemed too powerful and anticompetitive, and the U.S. government broke it up in 1982.

After starting his telephone company, Bell moved to Washington, D.C., and continued to work on a device for recording sound. Although several years behind Edison, who demonstrated his phonograph in 1876, Bell nonetheless conducted innovative experiments. He formed Volta Laboratory Associates and deposited a sealed box of his early recordings at the Smithsonian in an attempt to protect his invention in case of a future patent

dispute. During four terms as a Smithsonian regent, from 1898 until shortly before his death in 1922, Bell added immeasurably to the Institution. He funded the aerodynamics work that helped establish the Smithsonian Astrophysical Observatory and supported Smithsonian Secretary Samuel Langley's efforts to achieve the first manned flight.

On a more sentimental mission, in 1903, Bell traveled to Genoa, Italy, to personally supervise the exhumation of Smithsonian founder James Smithson and brought the remains to the National Mall for reburial in a place of honor in the Institution's castle building. He also donated a number of important objects, and shortly after his death his company donated originals and models of early experimental telephones.

The two hundred recordings Bell left to the Smithsonian remained inaccessible for decades, due to the lack of a technology to play them back. In 2011, scientists and scholars from the Lawrence Berkeley National Laboratory, the Library of Congress, and the Smithsonian cooperated on a project to optically read the grooves in Bell's early recording disks. At a meeting that year, the regents, Secretary Wayne Clough, and senior staff listened to the first of those deciphered recordings. Straining, I could hear Alexander Graham Bell's electric speech coming to me from the 1880s, reciting "Mary Had a Little Lamb." As Smithsonian curator Carlene Stephens, who ran the project for us, aptly said, "This stuff makes the hair stand up on the back of my neck. It's the past speaking directly to us in a way we haven't heard before."

O n New Year's Eve 1879, as night fell over Christie Street in Menlo Park, New Jersey, a block north of Thomas Edison's laboratory, the darkness was broken by pools of amber light pouring from dozens of incandescent bulbs of fragile glass. Crowds chattered, reporters scribbled, and neighbors peered from their windows at the glorious spectacle. Since October, Edison had been producing bulbs that lasted up to forty hours

THOMAS EDISON'S LIGHTBULB

at a time, and here, for the first time anywhere, electricity powered by Edison's own power plant would shatter the darkness of an entire neighborhood with light that was brighter and safer than the gaslights used in major cities in the United States and Europe.

THE INCANDESCENT LAMP LIGHTS A NATION.

National Museum of American History

The Smithsonian owns several of Edison's experimental bulbs. This one was used in his New Year's Eve 1879 display on Christie Street, the demonstration that showed Americans that electricity would be an effective way to light up the night. Within a decade, Edison's bulbs would illuminate homes, streets, and cities, granting millions of people freedom to live, play, and work on a man-made schedule, independent of the natural rhythm of the sun and seasons. The transformation had tremendous consequences.

Before Edison's light, Americans and people around the world depended upon candlelight, oil lamps, and gaslight, which had become the dominant light source in U.S. and European cities earlier in the century. People still largely organized their lives around the daylight hours. In rural areas, work started at dawn and proceeded until dusk. A full moon in a clear sky offered enough illumination for people to venture out for a few hours to meet in churches, at dances, and for other gatherings. In cities, most factories, offices, markets, and schools depended on the daylight for their activities. The darkness of night served as a cloak for crime. Walking city streets was

EDISON'S INCANDESCENT LAMP *National Museum of American History*

dangerous, but so too was horse-and-carriage travel for the more well-to-do. City streets were replete with hard-to-see, uneven surfaces, dark ditches, and other hazards that could overturn and damage buggies and disable travelers. Burning candles and lamps provided some illumination in homes, although they could be expensive and dangerous. A tipped candle or spilled whale oil, gas, or kerosene could ignite and destroy a room, home, or neighborhood. The elite had wider access to gaslights at home for dinner and reading, and for the theater, receptions, balls, and other entertainment. However, the light was dim. A typical gaslight gave off only a few foot-candles, equivalent to the light of a few wax candles from a foot away. And if unattended or poorly serviced, gaslights could explode or start a disastrous fire.

A number of inventors had been at work since the beginning of the century trying to develop an artificial source of light through the use of electricity. In 1802, British scientist Humphry Davy used a large battery to pass current through a platinum strip to create light. Platinum was considered a promising material because it has a high melting point and oxidizes slowly. Another British scientist, Warren De la Rue, put a coil of platinum in a vacuum tube and passed a current through it, creating what might arguably be considered the first incandescent lightbulb in 1840. Other inventors succeeded as well, but none without problems—the materials burned too quickly, gave off too little light, were too expensive, or required so much current as to be impractical for commercial purposes. Then, in 1878, thirty-one-year-old Thomas Alva Edison announced, somewhat prematurely, that he had the answer. Gas stocks around the world plummeted.

Edison, born in Ohio and home-schooled in Michigan, became a telegraph operator and then a self-taught inventor. He received patents for improving the telegraph and developing a stock ticker. His earnings allowed him to set up an industrial research lab in Menlo Park, New Jersey. In 1876, Edison startled the world with his invention of the phonograph, earning him royalties, great acclaim, and a newspaper-bestowed title, "the Wizard of Menlo Park."

Edison next set out to conquer the problem of electric lighting. His initial

idea was to follow earlier precedents and produce a lamp with a platinum filament that would not burn out in the presence of oxygen. To keep the filament from overheating and melting, Edison designed a complex regulating mechanism. The regulator would occasionally shunt current away from the filament, allowing it to cool off. This mechanism proved complicated to make and operate, and a lightbulb that shut itself off every few minutes was hardly practical. Additionally, platinum was too rare and costly for commercial production.

Experiments with platinum served a purpose, however. Edison discovered that heat released gases trapped in the metal filament. The creation of a better vacuum pump allowed Edison and his team to produce the high vacuum needed to remove the gases and reduce the problematic heat. While filament experiments progressed through late 1878 and into 1879, Edison initiated work on other components needed for a practical lighting system, including meters, cables, and generators. He also began an economic survey of gas lighting, the technology against which he would have to compete. Always the savvy businessman, Edison also used the time to find financial backing. He formed the Edison Electric Light Company with several investors, including J. P. Morgan and members of the Vanderbilt family.

The lightbulb effort benefited from other projects at Menlo Park. At the same time as he was working on the lightbulb, Edison was also attempting to produce a competitor to Alexander Graham Bell's telephone. While working on its carbon resistors, Edison realized that carbon could be made into a thin filament of high electrical resistance—just what he needed for his lightbulb. That realization changed the course of his lighting research.

Edison, like many other inventors, had tried carbon as a lamp filament, but was discouraged by the material because it burned out quickly when exposed to oxygen. In the fall of 1879, he resumed experiments with carbonized filaments making use of the new vacuum pump. In October 1879, one of Edison's assistants recorded a series of experiments with filaments made from a variety of materials. Much mythology surrounds these experiments, but according to the lab's notebooks, a carbonized filament of

uncoated cotton thread burned for a total of fourteen and a half hours from October 22 to the next day. This breakthrough led the Menlo Park team to believe that they were on the right track. Soon Edison made bulbs that lasted an astounding forty hours. Edison and his men recorded designs and experiments in notebooks all around the lab. He knew these books would be invaluable for backing patent claims, especially given that other inventors, like Joseph Swann in Britain, had been proceeding along a similar track, perfecting vacuum pumps and experimenting with carbon filaments. Based on his research and the cumulative documented evidence, that November Edison filed for a patent.

By the end of the year, Edison was ready for a public demonstration. He stamped out small horseshoe patterns in cardboard and carbonized them, producing filaments. He mounted these in hand-blown glass bulbs made by an expert from Europe. The bulb slid into a wooden socket. The lead-in wires were soldered to metallic strips laid parallel to the glass stem of the lamp and bound with thread. In this way, the lamp sat in the socket where the metallic strip made contact with terminals, so that electric current could pass through the filament.

The Pennsylvania Railroad ran special trains at reduced rates so that spectators could see Edison's New Year's Eve demonstration. Edison lit up dozens of lamps along Christie Street in Menlo Park, placing bulbs in globes atop slender wooden posts. As a newspaper described it, visitors were astonished and delighted at the display, which included "burners," or bulbs, lighting up his laboratory and residence, and the boardinghouse across the street as well. Edison's company stock went from $100 to $4,000 a share in the wake of the demonstration, which continued through the first week of January 1880.

A few months later, Edison's team discovered that a carbonized bamboo filament could last longer than six hundred hours, adding to the viability of his incandescent bulb. Edison also patented a system of direct current electrical distribution, which his company used to hook up and light lower Manhattan two years later. In 1889, Edison General Electric was formed.

In 1892 it became the General Electric Company. It and other companies began lighting city streets, buildings, homes, and factories with electricity all across the country. As a newspaper of the time proclaimed, the "problem is solved"; Americans had convenient light.

Edison's invention and development of an affordable, universal lighting system based on electricity grew beyond a matter of convenience and became a necessary ingredient for America's entrance into what we often consider the modern world. Factories, for better or worse, could more easily operate around the clock, leading to expanded hours for factory workers and more profits for owners. Offices could stay open past sunset, further increasing productivity. And managers could flee the cities for the suburban hamlets that developed along commuter railroad and streetcar lines, following well-lit streets back to well-lit homes, far from the increasing squalor of overpopulated urban neighborhoods.

Restaurants, theaters, symphonies, and social organizations proliferated in cities and towns as daylight no longer limited activity. Many people could work a full day and still go out at night for leisure, especially when lightbulbs for signs, headlamps, and streetlamps turned night into day. Magazines and newspaper publishing expanded, as more people gained access to usable light for evening reading. With more illuminated hours available to do things, the demand for entertainment and leisure gave rise to the development of more playhouses, concert halls, and something new, also invented by Edison: the movies.

Beyond the many practical transformations, Edison's invention gave Americans and the world a sense of a resounding triumph over nature, and faith that human intelligence, perseverance, and business acumen could transcend the limitations of the past.

What is the Statue of Liberty doing in a book about objects in the collections of the Smithsonian?

The Statue of Liberty stands 151 feet tall at the entry of New York's harbor. The sculpture *Liberty Enlightening the World* stands close to four feet tall and greets visitors on the second floor of the Smithsonian's American Art Museum in Washington, D.C. Both were created by Frédéric Auguste Bartholdi; the latter to help build and make possible the installation of the former.

42

FRÉDÉRIC BARTHOLDI'S *LIBERTY*

The history starts in Egypt in 1855 with a young French sculptor, Bartholdi, visiting Luxor along the Nile and seeing the colossal statues of ancient Thebes. He fell in love with the large stone sculptures, whose "kindly and impassable glance," he said, seems "to disregard the present and to be fixed upon the unlimited future."

Back in France, Bartholdi attended a dinner party in 1865 hosted by Édouard René Lefebvre de Laboulaye, a lawyer, professor, and chairman of the French antislavery society. Laboulaye was completing his work on a three-volume *Political History of the United States*. He was an outspoken critic of the repressive policies of France's Second Empire and its leader, Emperor Louis-Napoléon Bonaparte. The emperor had supported the Confederacy in the Civil War. With the American conflict having just ended, Laboulaye rejoiced at the defeat of slavery and the restoration of liberty in the United States. Though he had never visited America, Laboulaye waxed rhapsodic about the historic connections between France and the United States, recalling Benjamin Franklin, Thomas Jefferson, the Marquis de Lafayette, and the ideals of both nations. He proposed that some type of grand monument to liberty should be built for the American Centennial in 1876 for the whole world to see.

THE MODEL FOR A MONUMENT TO INTERNATIONAL FRIENDSHIP THAT BECOMES A WELCOME SIGN TO MILLIONS OF IMMIGRANTS.

Smithsonian American Art Museum

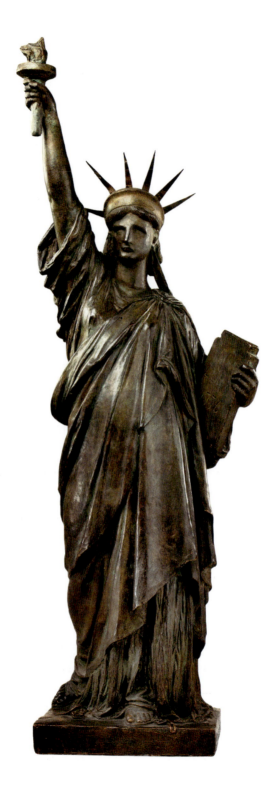

FRÉDÉRIC BARTHOLDI'S MODEL OF LIBERTY *Smithsonian American Art Museum*

The idea of a monument struck a chord with Bartholdi, and when he returned to Egypt in 1869, he came up with the idea of a massive statue at the entrance of the newly constructed Suez Canal. Bartholdi conceived of the statue as a robed woman with a headdress standing on a large pedestal holding a torch. She would double as a lighthouse. He did some initial design sketches and called his proposed monument *Egypt Bringing Light to Asia.*

The Egyptians were neither interested in Bartholdi's idea nor willing to pay for it, so Bartholdi changed course. He made his way to America in 1871, visiting a number of U.S. cities. Sailing into New York Harbor, Bartholdi was struck by its beauty and grandeur; to him, it signaled the gateway to America, and he was inspired to locate his grand statue there. Bedloe's Island, a tiny islet off Manhattan that was owned by the federal government, seemed the perfect spot.

Bartholdi compared his project to the building of the Colossus of Rhodes, one of the great wonders of the ancient world. Fashioned of bronze, that gigantic statue was reputed to stand astride two islands, with ships sailing into the harbor between its legs. The Colossus of Rhodes was a symbol of power; Bartholdi's lady would be a symbol of liberty.

Bartholdi returned to France and, with the leadership of Laboulaye, formed the Franco-American Union in 1875 to raise money for the project. The idea was that the French committee would raise the funds from citizens—not the government—for the statue's construction and shipment; the American government would provide the land, and an American committee would raise the funds to build the rather large pedestal that was needed for mounting the statue. Laboulaye urged President Grant to support the project.

The French committee immediately succeeded in raising enough funds to start on the fabrication. Bartholdi's design was accepted; it featured a robed lady liberty wearing a spiked crown, lifting a torch in her right hand and clutching a tablet inscribed "July 4, 1776" in her left arm, while standing atop broken chains and shackles.

Bartholdi needed a first-class engineer for the project, as he knew the

massive outdoor statue would be buffeted by rain, wind, snow, and storms. He enlisted Eugène Viollet-le-Duc, who came up with the idea of using the *repoussé* method to hammer more than three hundred thin sheets of copper piecemeal into the form of the statue's outer skin and a system of iron bar armature to connect the sheets together.

Bartholdi sculpted and built progressively larger scale models of the statue—four-, nine-, and thirty-six-foot versions—in order to develop plaster casts and the wooden forms over which the copper would be placed and hammered into shape. With a construction team working away in Paris, he made a good deal of progress. So in 1876, he was able to send the fabricated right arm and torch to Philadelphia to be shown at the Centennial Exposition of the United States, after which it was displayed at Madison Square Garden in New York. Bartholdi hoped this would stimulate Americans to take the project seriously and raise the funds necessary for building the pedestal. The American fund-raising had gotten off to a slow start; many wondered whether the French would come through on their part of the project, and many also saw the endeavor as a local New York City project rather than a national one. Even though the fund-raising did not gain the expected momentum from the torch arm's display, President Grant signed a bill allowing the statue to be built on Bedloe Island before he left office in 1877.

Bartholdi's team completed the head and shoulders in 1878 and displayed the completed sections at the Paris Exposition. Viollet-le-Duc died in 1879, and Bartholdi hired Alexandre Gustave Eiffel to take his place. Eiffel accepted and even praised Viollet-le-Duc's plans for the *repoussé* and armature work on the statue, but substituted his own plans for securing the structure. Instead of relying upon support from the outer shell, Eiffel designed a 120-ton inner skeletal structure that would be anchored by a central 98-foot pylon composed of four huge iron posts. That structure would be tied into a similarly configured structure sunk into the 154-foot-high pedestal. The skeleton would be a marvel of lightweight truss work. Flat metal bars would be bolted at one end to the pylon and at the other to a

section of the copper skin. The bars would hold the statue together, but also create a flexible suspension system, allowing the statue to adjust to weather conditions. Visitors would be able to walk up to the top of the statue using an interior staircase. Eiffel's ideas, cutting-edge at the time, would be put to full use a decade later, with the building of the Eiffel Tower in Paris.

By 1882, the French committee had raised all the money—$250,000— needed for the statue, and though Laboulaye had died, Bartholdi and Eiffel were on track to complete the work the following year. But American efforts to raise a similar amount for the pedestal construction were lagging, and so Bartholdi had to slow down the work. Project supporters appealed to New York City, the New York State Assembly, and the U.S. Congress. Bartholdi shipped one of the working models of the statue—the four-foot version—from Paris to the Capitol in Washington, D.C.

If Bartholdi sent this model to persuade Congress to provide funds for the project, it didn't work, at least not immediately. But this terra-cotta model, painted to look like bronze with a touch of tin in the crown, was used by architect Richard Morris Hunt to help design the pedestal. Hunt, the son of a congressman, had worked on the building of the Capitol's dome. He had a great affinity for the French, having been the first American to study architecture at the École des Beaux-Arts in Paris; he had just helped design a new façade for the Louvre.

Bartholdi's model was displayed in the rotunda of the Capitol, where it attracted its fair share of attention, including that of Jewish Hungarian immigrant and newspaper owner Joseph Pulitzer.

The idea and reality of the statue as a monument to freedom impressed Pulitzer, and he exhorted Americans to donate money, using his newspaper the *New York World* to promote the cause. Pulitzer criticized the wealthy for failing to contribute. Other cities—Philadelphia, Boston, San Francisco, Cleveland, Baltimore, and Minneapolis—made a play for erecting the statue in their locales. Pulitzer argued that the statue was of national significance. After months of what amounted to a crusade, citizens came around. Groups held sports events, plays, and performances to benefit the statue. Working

people and schoolchildren contributed from as far away as Florida, Louisiana, Colorado, and California. Artists and writers like Mark Twain donated items for auction, with proceeds going to the project. By 1885, Pulitzer had helped the American committee raise the last $100,000 of the $300,000 needed to complete the pedestal and its anchoring structure.

The statue, which had been assembled in Paris, was disassembled and shipped to New York for reconstruction. Given Thomas Edison's recent triumph, the decision was made to light the statue's torch with electric bulbs. Finally, on October 28, 1886, with President Grover Cleveland presiding, Bartholdi, perched in the raised torch, unveiled the statue by pulling a rope that released a French tricolor flag covering Lady Liberty's face. Following the dedication, Bartholdi's model was transferred from the Capitol rotunda to the Smithsonian.

In 1903, words from a poem, "The New Colossus," were added on a tablet to the base of the statue. The poem was written by Emma Lazarus in 1883 and donated to the Bartholdi Pedestal Fund for the Statue of Liberty as part of the fund-raising effort. Lazarus had died in 1889, but her friend Georgina Schuyler, a New York philanthropist and descendant of the Dutch settlers of New York, rediscovered it and donated the tablet in "loving memory" of her friend. Lazarus's poem had originally addressed anti-Semitism toward Jews who had fled pogroms in Russia to come to the United States in the early 1880s. But with the opening of nearby Ellis Island in 1892 as the processing station for more than twelve million immigrants from Europe, the sight of the Statue of Liberty and the last verse of Lazarus's poem took on special meaning for the waves of immigrants who came to America in the early twentieth century and ever since:

Give me your tired, your poor,
Your huddled masses yearning to breathe free,
The wretched refuse of your teeming shore.
Send these, the homeless, tempest-tost to me,
I lift my lamp beside the golden door!

T he Smithsonian's collection is more than artifacts, artworks, and documents housed in buildings; it also, in some cases, includes the buildings themselves. One of them, the Cooper-Hewitt, National Design Museum in New York, exemplifies the rise of American industrial might and the man behind it. This huge mansion on Fifth Avenue was the home of Andrew Carnegie and one of the first residences in the city to use steel in its construction. Given that steel was the source of the fortune that earned Carnegie the distinction of being one of the richest men in the

ANDREW CARNEGIE'S MANSION

world, the mansion, when completed in 1902, was an apt advertisement for American success, for the so-called Gilded Age, and for the industry that produced it.

Andrew Carnegie (1835–1917) was a self-made, self-educated man. He was born in Scotland and immigrated with his parents to western Pennsylvania in search of economic opportunity. As a teenager, Carnegie worked first in a textile factory, then as a messenger, and later as an operator in a telegraph office. He went to work for the Pennsylvania Railroad Company, where he rose up through the ranks. He was able to invest early, though modestly, in iron, rail, and bridge building connected to the development of the railroad. He also learned the ins and outs of the business, brokering a deal for Pullman sleeping cars that enabled relatively comfortable long-distance travel. During the Civil War, his boss and mentor became a high official in the War Department, and Carnegie aided the Union in using and securing rail and telegraph lines for the movement of troops. He bought property and made a small fortune with the discovery of oil. He also bought ironworks, establishing companies that were supplying the needed metal and rolled steel for the great industrial expansion after the end of the Civil War.

THE GILDED AGE NEW YORK HOME OF AMERICA'S RICHEST INDUSTRIALIST LITERALLY EMBODIES ITS ERA.

Cooper-Hewitt, National Design Museum

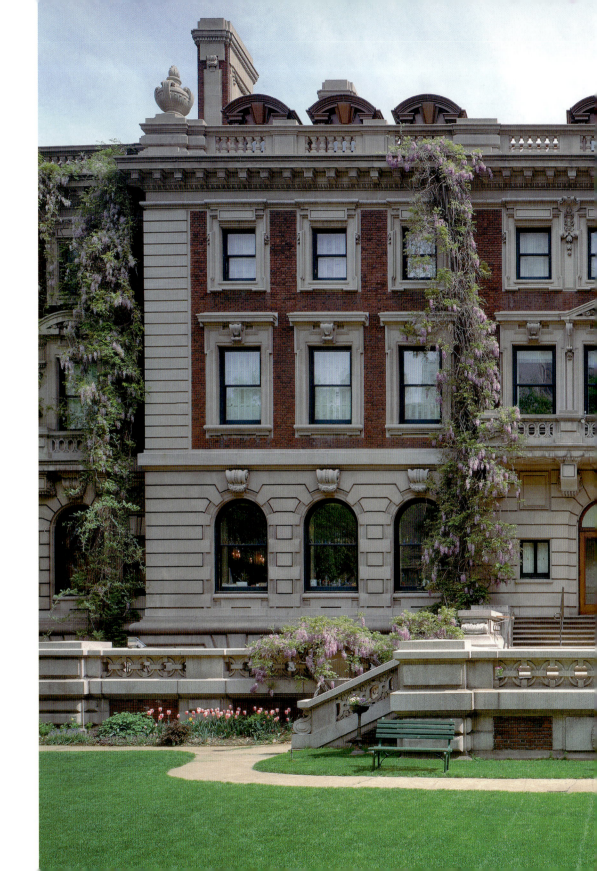

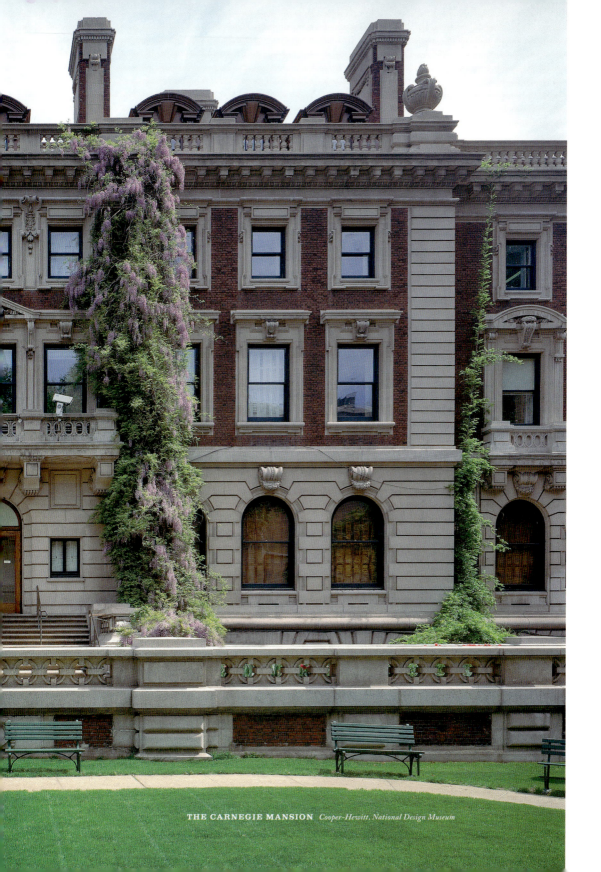

THE CARNEGIE MANSION *Cooper–Hewitt, National Design Museum*

Pittsburgh was a hub of industrial manufacturing, in part because of the plentiful coal and iron deposits in the region. Railroads, bridges, and buildings at the time typically were constructed of cast iron. Though steel items had been manufactured since antiquity in Africa, Asia, and Europe, there was no effective mass industrial method for doing so until the development of the Bessemer process. Steel is stronger, harder, and more durable than iron. It also does not rust as quickly or extensively as iron does. In the 1850s, Englishman Henry Bessemer invented a furnace that could burn off the high carbon content of pig iron—a product of iron ore—in a rapid and predictable way using oxidation in order to turn it into molten steel for final shaping. Carnegie equipped his company with the new furnaces, adapted work practices, and produced steel in large quantity so that it replaced iron as the material of choice in America's industrialization.

Much of Carnegie's success can be attributed to his control of the steel supply chain; he not only owned iron- and steelworks but also acquired the sources for the raw materials, like deposits of iron ore and coke, and the railroads and ships that transported them. At its height, in the 1880s, the operation was turning out two thousand tons of steel per day. His company was efficient and productive, and he bought out other companies until Carnegie Steel Company stood as the world's leading industrial giant in the 1890s. By the turn of the century, Carnegie was ready to turn to the next stage of his life, and in 1901, he sold his company to banker John Pierpont Morgan for $480 million, earning as his share more than $200 million. Morgan, who bought other steel companies as well, then consolidated them into U.S. Steel, the nation's first billion-dollar company.

In 1887, the fifty-one-year-old Carnegie married thirty-year-old Louise Whitfield, a New Yorker. A decade later they had a daughter. Social practice at the time dictated that she have a proper Manhattan upbringing, and Louise Carnegie also wanted a large garden and fresh air for her child, so Carnegie directed his architects to build the "most modest, plainest, and most roomy house in New York."

Families made wealthy in America's industrial boom of the latter half of the nineteenth century included the Astors, Goulds, Rockefellers, and Vanderbilts. They built palatial homes in New York, Chicago, Cleveland, St. Louis, and Buffalo as well as mansions—euphemistically called cottages—in Newport, Palm Beach, and Long Island. Playing off the classical notion of the golden age, writer and humorist Mark Twain coined the term "the Gilded Age" to signal the enormous excess of wealth and splendor exhibited by this new class of Americans and point out how their materialism provided a veneer over serious social and economic problems. In 1899, sociologist Thorstein Veblen published his *The Theory of the Leisure Class,* noting the "conspicuous consumption" of the wealthy elite. Mansions were essentially architectural billboards. They showed American workers the stunning power of the men who controlled their livelihoods—the nation's railroads, ships, banks, coal, steel, and oil industries. These men were titled "robber barons," a new aristocracy that some believed had unfairly amassed huge wealth. These homes and other properties illustrated their success and served as means of elite competition for status and recognition.

These mansions and estates also symbolized American economic ascendancy in the world. The United States was becoming an industrial powerhouse with an economy rapidly racing ahead of those of European countries. There long existed a feeling, even among Americans, that the young, wild frontier nation was culturally inferior to the more sophisticated Europe. These exorbitant mansions, with all their appurtenances, galleries of art, and industrial conveniences, positioned their owners, however humble their origins, to be modern-day nobility, successors to Europe's fading aristocracy.

Carnegie, while publicly lumped into this group, considered his status as distinct from other multimillionaires of the time. He had a very strong philanthropic, pragmatic bent and eschewed pointless ostentation. Beginning in the 1880s, he donated money to build public libraries in the United States and Scotland. Over his lifetime, he established and supported some three thousand libraries across the United States and Canada. He supported

museums and a music hall in his Allegheny and Pittsburgh communities and gave millions of dollars to establish the Carnegie Institute of Technology in Pittsburgh and the Carnegie Institution in Washington. His charity was consistent with the vision he outlined in his 1889 manifesto, *The Gospel of Wealth,* to foster the improvement of mankind.

For his Manhattan home, Carnegie chose a location more than a mile north of what was considered the socially acceptable northern end of town—which was then located around modern-day Seventieth Street. High society in New York used the size of wealthy socialite Caroline Astor's ballroom—which could hold four hundred people—as a measure of status. Carnegie was adamant that his house would never contain a ballroom and called the home's largest room a picture gallery.

Carnegie enlisted the firm of Babb, Cook and Willard to design the mansion. They were known primarily as commercial architects and for having built the tallest building in Montreal—the New York Life Insurance Building. Carnegie's choice was suggestive of his preference for people familiar with technological innovations that had been developed in commercial practice.

The exterior of the mansion was designed in Georgian Revival style, perhaps to resemble the baronial estates to which Carnegie aspired as a boy in Scotland. While Americans had always sought European grandeur in architecture, the practice of copying European palaces with such historical fidelity and opulence was new to the industrial age in America.

The mansion was built with a steel frame structure. The steel consisted of so-called I or H beams, which have a central section of steel with flanges at ninety degrees coming off both of its edges. The beams are particularly efficient in carrying both bending and shear loads, making Carnegie's mansion particularly sturdy. The mansion had innovative central heating and cooling with extensive boilers and an elaborate coal delivery system, as well as an Otis elevator—then quite rare for residences. Other flourishes included a teak parlor room designed by Lockwood de Forest and an Aeolian

organ in the front hall that was played every morning while Carnegie rose and dressed. About twenty servants maintained the household and the large outdoor garden.

The mansion had an enormous impact on its neighborhood, which was renamed Carnegie Hill from its former name, Prospect Hill. Carnegie acquired other adjacent and nearby lots and sold them to people he knew in order to control development around his home, among them the Sloanes and Otto Kahn, who built elegant homes.

Ironically, it was the steel I or H beams, so prominent in the Carnegie Mansion, that in ensuing years were refined and improved by Bethlehem Steel and used to erect what Carnegie sought to keep out of his neighborhood: tall buildings. Steel-framed skyscrapers, like the Woolworth Building in 1913 and the mammoth Empire State Building in 1931, came to characterize the modern city and the New York skyline. After Carnegie died, Louise gave nearby properties to the Spence School and to the Church of the Heavenly Rest in order to prevent a large apartment building from going up that would have literally overshadowed her beloved garden. Over the years, however, luxurious homes within or at the tops of skyscrapers would supplant the imitative European-style mansions as a symbol of New York's power and prestige.

Louise Carnegie lived in the mansion until her death in 1946. The new

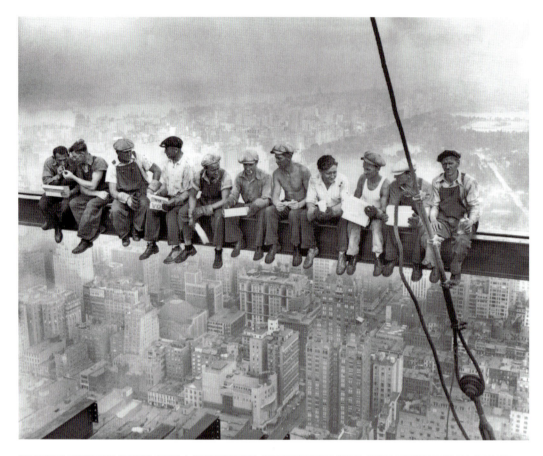

CHARLES EBBETS'S *LUNCH ATOP A SKYSCRAPER*, WORKERS PERCHED OVER ROCKEFELLER CENTER

Bettmann Archives/CORBIS

owner, the Carnegie Corporation, leased it to Columbia University's School of Social Work in 1949 for twenty-one years. Toward the end of that term, the Cooper Union, a famed New York college dedicated to providing free education to working people—a cause that Carnegie supported—was selling off its historic collections of decorative art, art history, and design materials. Public outcry and a grassroots campaign ensued to save those collections, leading to the Smithsonian's involvement. The Carnegie Corporation offered to rent the mansion to the Smithsonian for one dollar a year, and

then donated the property to the institution outright in 1972. The Cooper-Hewitt Museum opened its Carnegie Mansion doors to the public in 1976 during the celebration of the bicentennial of the United States. I suspect that timing, and the building's use as a museum with its emphases on creativity, innovation, and design, would likely have appealed to its owner, steel magnate and civic-minded philanthropist Andrew Carnegie.

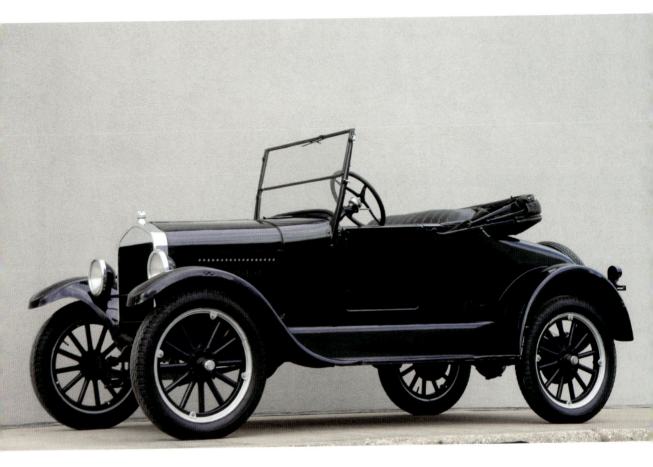

1926 **FORD MODEL T ROADSTER** *National Museum of American History*

By the end of the nineteenth century, the success of railroads in moving masses of people and goods across the United States led to the pursuit of another, even more ambitious technology, the development of mechanical, engine-powered vehicles to replace the horse- and mule-drawn wagons, buggies, and carriages that individuals and families had long used.

A number of German, French, British, and American inventors made progress toward such a self-propelled vehicle in the 1870s. Karl Benz, a German engineer, won a patent in 1879 for an internal-combustion two-stroke gasoline engine. In 1886, he built a "Motorwagen," arguably the first automobile. It had three wire wheels and looked like a huge mechanical tricycle. It was equipped with a water-cooled, one-cylinder, four-stroke gasoline engine mounted horizontally in the rear of a tubular steel-frame body. A driver, sitting in a seat with his feet resting on a buckboard, operated a tiller connected by a rack-and-pinion mechanism to a single front wheel. The back wheels were rotated by chains that connected them to the engine with a differential gear mechanism—similar to that of a bicycle. Benz's vehicle could go about eight miles an hour. Over the next few years, Benz and his partners built and sold several dozen of these motorcars.

In upstate New York, at about the same time, George Selden designed a "road engine" to propel a light vehicle. But aside from a patent model, he never built a practical, workable prototype. By the 1890s, many other inventors were hard at work experimenting with vehicles powered by electricity, steam, and petrol, most with two axles and four wheels.

Steam-powered vehicles needed large, heavy boilers and a lot of time to build up sufficient pressure to propel motion, and would prove the least successful option. The real competition was between electric cars, powered by batteries that had to be frequently recharged, and engines powered by petroleum-based fuels—kerosene, alcohol, benzene, and gasoline.

44

FORD MODEL T

THE AUTOMOBILE THAT PUTS AMERICANS ON THE ROAD AND DRIVES ITS TWENTIETH-CENTURY MANUFACTURING ECONOMY.

National Museum of American History

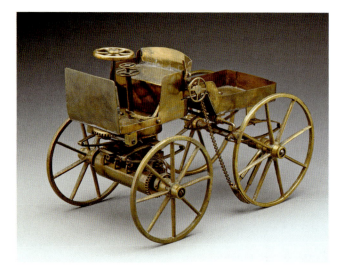

The Duryea brothers, designer Charles and machinist Frank, built their first successful road-tested gasoline-engine motorcar in 1893. It is now in the Smithsonian. Basically, it added a four-horsepower single-cylinder engine to an adapted two-axle, four-wheel, horse-drawn buggy. With a spray carburetor, it could burn gasoline with some efficiency. The Duryea brothers' second vehicle won America's first motorcar race, which was sponsored by the *Chicago Times-Herald* on Thanksgiving Day, 1895. The next year, the brothers organized the first American automobile manufacturing company—the Duryea Motor Wagon Company—in Springfield, Massachusetts. There they hand-assembled thirteen identical vehicles.

That same year, in a home workshop in Detroit, Michigan, thirty-two-year-old Henry Ford built a gasoline-powered motorcar he called the Quadricycle. It had a simple steel frame with two axles riding on four bicycle tires, a simple box seat with metal arms, and a wooden dash with an electric bicycle bell. Ford, like other entrepreneurs, sought to produce commercially successful motorcars. Ransom Olds, for example, sold more than four hundred cars in 1901, the first large-scale gasoline automobile enterprise. Ford started and failed in his first business forays before putting together a group of partners to form the Ford Motor Company in 1903. The company produced the Model A, and in ensuing years, the models K, N, and S.

The Model K was known as the Gentleman's Roadster and sold for about $2,800, making it accessible to only very wealthy customers. By con-

trast, Ransom Olds's least-expensive cars were selling for less than a quarter of that price, thanks to his use of a stationary assembly line. Instead of a team of workers assembling one vehicle at a time from beginning to end, specialized groups would concentrate on performing specific sets of tasks to install particular components of the automobile, and then repeat those procedures when they moved on to the next unit.

In 1908, Ford adopted this manufacturing strategy to produce the Model T, selling it for $850. It turned out to be a roaring success, as he later wrote:

> I will build a car for the great multitude. It will be large enough for the family, but small enough for the individual to run and care for. It will be constructed of the best materials, by the best men to be hired, after the simplest designs that modern engineering can devise. But it will be so low in price that no man making a good salary will be unable to own one—and enjoy with his family the blessing of hours of pleasure in God's great open spaces.

1893 DURYEA MOTOR CARRIAGE

National Museum of American History

Ford produced about ten thousand Model Ts in the first year of production. The car was popularly known as the Tin Lizzie.

Ford had three key factors working in his favor. First was the product itself. The Model T had a front-mounted, rear-wheel-drive, four-cylinder engine, manufactured in a block rather than as separately cast cylinders. This gave it a twenty-horsepower performance and allowed speeds of more than forty miles an hour. The engine had to be cranked by hand to start. It had a steering wheel with a throttle lever and three

foot pedals to control the engagement of gears in high, low, and reverse, and a brake for the transmission. Mounted on the wooden wheels were pneumatic rubber tires with inner tubes. The Model T had stylish bodies and seating variations that could accommodate two people or a whole family.

Second was the cost to produce the Model T. Ford's assembly line method depended upon using interchangeable parts, which increased efficiency and lowered costs. Specializing tasks increased the quality and speed of the work effort. Teams at the various assembly stations could work at a steady pace without waiting for others.

Third was the fact that the Model T engine could run on just about anything—kerosene, gasoline, or ethanol. Car owners could even distill their own fuel. Kerosene was available at almost every hardware store.

The development of large, commercially viable oil wells in Texas, and decreasing prices for gasoline, meant lower operating costs for car owners. Electric cars with batteries, which outsold gasoline-powered cars until 1910, cost two to three times as much as the Model T. They had limited range before they needed recharging, and electric power was found only in cities and larger towns. Gasoline pumps could be located anywhere. Although gasoline cars generated noxious, smelly fumes and noisy knocking sounds, gasoline's lower price and greater distance range proved decisive.

Ford produced a number of variations of the Model T, among them a two-seat runabout, a five-seat touring car, and a seven-seat town car. While in the earliest years they came in a variety of colors, from 1914 to 1926 they were available only in black. In 1913, Ford further improved production by introducing the moving assembly line. The Model T parts would be on a track and move along the production process as different teams added various components. A newly assembled car came off the line every three minutes. The increased labor efficiency meant lower production costs and allowed Ford to lower the price even further—a new Model T went for as little as $260 in 1925.

Its production methods also made Ford products viable in international markets, as the company expanded its activities into Europe. Quality im-

provements were also made along the way. For example, an optional battery-ignition start-up system was available by 1919, replacing the hand crank.

Although it dominated the U.S. market in the 1910s, Ford began losing sales to General Motors in the mid-1920s. GM had introduced the idea of yearly model changes for their cars, which proved wildly successful. In 1927, Ford discontinued Model T production. By that time, fifteen million Model Ts had been sold, making it one of the best-selling cars of all time.

The success of the Model T was also connected to good labor policies and practices. Ford's plants in Detroit and Highland Park, Michigan, employed large numbers of African Americans and attracted thousands of immigrant laborers and actively promoted their Americanization. Ford's production methods encouraged worker safety, and in the early years, Henry Ford had a strong reputation with labor. Thousands left farm work behind for the five dollars a day he offered factory workers. Immigrants found good gainful employment. But positive relations with labor soured over time and especially after the formation of the United Auto Workers union in 1935 and the Flint sit-down strike at General Motors the next year. While General Motors and Chrysler settled with the union, Henry Ford held out, bringing in his own strike busters and enforcers. Workers started to unionize at Ford's River Rouge plant. The firing of some of the union members in 1941 led to a mass walkout. The strike closed down car production, and while Ford paid strikebreakers, he finally capitulated, making concessions beyond union demands. He agreed that the Ford Motor Company would be a closed shop, meaning all employees had to be union members. He agreed to initiate a workers' dues check-off provision that would allow union dues to be deducted from payroll and sent directly to the union—a policy now being reversed in some states, including Michigan, through right-to-work laws.

The company's economic success bred broad prosperity and fortunes for the Ford family and other top executives, who in turn helped build Detroit mansions and civic institutions. Ford's wealth and the family's philanthropy led to the creation of the Ford Foundation, which in subsequent decades

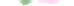

played a major role in expanding economic opportunity, improving health care, and supporting important educational and cultural initiatives in the United States and around the world.

This 1926 Ford Model T Roadster came to the Smithsonian in the early 1970s, a gift from John T. Sickler of Burtonsville, Maryland, a personal friend of museum transportation curator Don H. Berkebile. It was restored with new tires, a new interior and dashboard paint job, and a new exterior paint coating. On display, the Model T reminds millions of visitors of how Henry Ford democratized personal mobility by making an exceedingly popular product affordable to millions. People could live in one place and drive to work in another, expanding the development of city suburbs. They could visit relatives, go on Sunday drives, or extend their tourism to far-flung locations. Businesspeople could transport their goods and services to distant places and markets.

The dramatic expansion of Model T use stimulated Ford's competitors and fueled the growth of the massive U.S. automobile industry. Hundreds of thousands of jobs were created directly, and millions more through auto-supply manufacturers, gas stations, the oil and gas industry, and road building and repairs. The creation of roads and motor transport expanded truck manufacturing and the whole trucking industry, which had a huge impact upon the movement of American raw produce and finished goods around the country, growing the economy directly and through secondary occupations and services.

The ubiquitous use of the automobile also had enormous cultural consequences from the development of drive-in theaters and fast-food restaurants to its celebration in song and film, often as an expression of personal freedom.

O n May 30, 1899, the proprietor of a Dayton, Ohio, bicycle shop sent a letter to the Smithsonian:

Dear Sirs:

I am an enthusiast, but not a crank in the sense that I have some pet theories as to the proper construction of a flying machine. I wish to avail myself of all that is already known and then if possible add my mite to help on the future workers who will attain final success.

Wilbur Wright

Between 1899 and 1905, Wilbur Wright and his brother, Orville, carried out aeronautical research and experimentation that led to the first successful man-carrying powered airplane in 1903 and a refined, practical flying machine two years later. All successful airplanes since have incorporated the basic design elements of the 1903 Wright *Flyer.*

WRIGHT BROTHERS' KITTY HAWK FLYER

The Smithsonian sent the Wrights the material they requested—indeed, at that time, the secretary of the Smithsonian, Samuel Langley, was deeply involved in his own aeronautical experiments. This initial spirit of cooperation would later turn disputatious.

Langley was a self-taught but brilliant astronomer and physicist. He had directed the Allegheny Observatory in Pittsburgh and been instrumental in using measurements of the solar day to help establish standard time zones for the nation's railroads, a huge accomplishment that unified travel and communication schedules. He had been experimenting with flying models and gliders since 1887, when he came to the Smithsonian to take up the post of secretary, and a few years later he established the Smithsonian Astrophysical Observatory. In 1896, working in a shed located behind the Smithsonian Castle, he developed two unpiloted heavier-than-air steam-

A BENCHMARK ACHIEVEMENT BORN OF CAREFUL RESEARCH BROADENS HUMAN HORIZONS AND THE IMAGINATION.

National Air and Space Museum

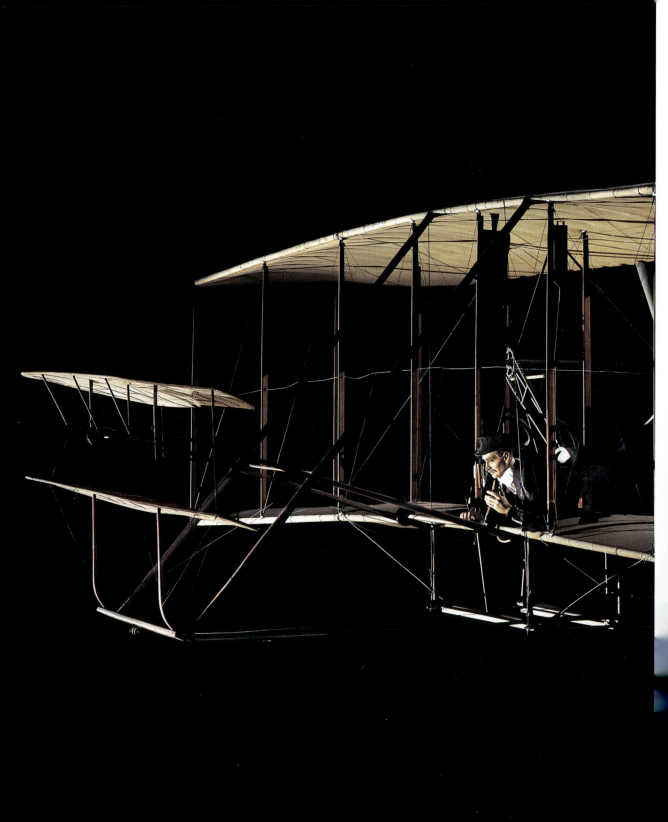

KITTY HAWK FLYER *National Air and Space Museum*

powered flying machines that were launched from a catapult on a houseboat in the Potomac River and flew about three-quarters of a mile. By 1898, at the urging of Theodore Roosevelt, then assistant secretary of the Navy, Langley received funds from President McKinley's War Department to develop a piloted version of his experimental craft.

The Wrights studied Langley's research and the reports of others, experimented with hang gliders, and realized that a successful airplane would feature three systems: a set of lifting surfaces, or wings; a method of balancing and controlling the aircraft; and a means of propulsion.

All were important, but they first concentrated on how to maintain balance and control because they thought that was the toughest problem. Given the Wrights' experience with the bicycle—a highly unstable but controllable machine—they insightfully surmised that a flying machine would be fundamentally unstable as it traveled through air, yet could, like a bicycle, be controlled.

The Wrights realized that if the wing on one side of a craft met the oncoming flow of air at a greater angle than the opposite wing, it would generate more lift on that side, causing the wing to rise and the aircraft to bank. If pilots could manipulate the wings using this principle, they could maintain balance and turn the aircraft as well. The brothers considered but rejected using a system of gears and pivoting shafts to change the angles of the wings because it would be too heavy and complex. Instead they came up with the idea of twisting, or warping, the wing structure in controlled ways using interconnected wire cables.

In building their first experimental aircraft in 1899, a kite with a five-foot wingspan, the Wrights combined their wing-warping innovation with braced biplane wings inspired by the 1896 glider made by aviation pioneers Octave Chanute and Augustus Herring. That glider used steel wires crisscrossed between vertical wooden struts to support the upper and lower wings. Wilbur flew the test kite and the wing-warping controls worked well.

The brothers next turned their attention to testing the curve of the wing

profile, the wing area necessary to lift a pilot, and the type of materials best suited to construct a glider. For their tests they needed wide-open spaces with strong, steady winds; they settled on Kitty Hawk, North Carolina, in 1900. They built their glider for about fifteen dollars and repeatedly tested it by flying it as a kite, and recording and analyzing the results. The glider was something of a disappointment, producing less lift than predicted.

To increase lift they increased the wing size of their 1901 glider to a twenty-two-foot span and added a different curvature to the airfoil. Rather than continuing to use French cotton sateen fabric for covering the wing, they switched to Pride of the West brand unbleached cotton muslin. For the first time, the brothers could make real flights, which revealed serious control problems.

Returning home to Dayton, they suspected that the information used to compute lift and drag might be wrong. During the fall of 1901 they built their own primitive wind tunnel for testing the aerodynamics of different wing shapes. They increased lift efficiency with a thinner and longer wing and an improved airfoil for a new glider. Testing their third glider at Kitty Hawk in 1902, they decided on a movable rudder and integrated its controls with a hip harness or cradle that controlled the wing warping. The brothers made somewhere between seven hundred and one thousand glides; flights of five hundred feet were common.

Now they could add a propulsion system. They designed a single twelve-horsepower gasoline-powered internal combustion engine to turn two propellers rotating in opposite directions behind the wings. Wind-tunnel tests led them to further increase wing area to get the lift to carry the added weight of the engine, the two propellers, and structural reinforcement. The wind-tunnel data were also crucial to the design of the very efficient propellers. The Wrights then returned to Kitty Hawk in 1903 with what they simply called the *Flyer*.

Meanwhile back along the Potomac, Langley thought he was on the verge of manned flight. But when he launched what he called the *Aerodrome* on October 7, 1903, the craft plunged directly into the river. He tried again

on December 8. This time the craft broke apart upon launch. Langley was ridiculed in the newspapers and excoriated in Congress.

Six days later, on December 14, the Wrights were finally ready. They tossed a coin to see who would make the first attempt. Wilbur won and climbed into the pilot's position. The *Flyer* powered down forty feet of rail, lurched up, stalled, and smashed into the sand after a three-second flight. But Wilbur was confident.

The plane was repaired and readied for the next try on December 17. With Orville controlling the plane using a wooden hand lever and a padded hip cradle, the *Flyer* darted up, sailed slowly over the sand, and came to rest with a thud twelve seconds later, about 120 feet from where it had taken off. A man had flown.

The Wright brothers made three more flights that day. Wilbur flew 175 feet; Orville then covered more than 200 feet in fifteen seconds. Then, with Wilbur at the controls, the *Flyer* flew 852 feet in fifty-nine seconds, clearly demonstrating that the plane was capable of sustained controlled flight.

Just after the fourth flight, a gust of wind overturned the airplane and sent it tumbling across the sand. Severely damaged, the 1903 *Flyer* never flew again.

The Wrights tested two more machines in an Ohio pasture in 1904 and 1905. By October 1905 they had transformed the experimental success of 1903 into the reality of a practical airplane capable of remaining aloft under the full control of the pilot for extended periods of time. Before revealing their triumph to the public, however, the brothers wanted to secure a patent and contracts for the sale of their invention. Finally, in the summer of 1908, Wilbur flew in public for the first time in France while Orville flew for the U.S. Army at Fort Myer in Virginia.

In 1910, Smithsonian curator George Maynard noted that visitors to the U.S. National Museum wanted to see the Wright airplane they had heard so much about. The secretary of the Smithsonian, Charles Walcott, wrote to Wilbur asking for a model and an actual aircraft. The Wrights were receptive but noted that they didn't have a craft in adequate condition for exhibit.

In 1911 the U.S. Army donated the 1909 Wright Military Flyer, which the brothers had produced as a demonstration craft, but this was not the original craft that visitors longed to see.

By 1914, two years after Wilbur Wright's death, Secretary Walcott reassessed the historical role of the *Aerodrome*, largely to bolster Langley's legacy. Walcott paid Glenn H. Curtiss $2,000 to rebuild and test the *Aerodrome*. Curtiss had just lost a lawsuit with the Wrights' company for his refusal to pay license fees to them for violating the brothers' patent. Curtiss rebuilt the old craft incorporating a great many fundamental changes, after which the craft made several short, straight-line flights. Langley's plane was then restored to its failed 1903 configuration and placed on display in the museum with a label identifying it as the "first man-carrying aeroplane in the history of the world capable of sustained free flight."

This declaration understandably angered Orville Wright. He refused to donate the *Kitty Hawk Flyer* to the Smithsonian until the Institution admitted that the 1914 test of the rebuilt Langley craft did not prove that it had been capable of flight in 1903. Walcott refused to alter his position. So over the next decade, Orville exhibited the restored *Flyer* at the Massachusetts Institute of Technology in Cambridge and at aeronautical and automotive expositions in New York and Dayton while the controversy with the Smithsonian festered.

Orville genuinely hoped that the airplane would one day go to the U.S. National Museum, but the Smithsonian dug in its heels and refused to change the label of the Langley *Aerodrome*. Wright responded by shipping the *Flyer* to the London Science Museum in 1928, and he altered his will to ensure that it would remain there permanently in the event that the Smithsonian did not change course.

In 1934, the famed Charles Lindbergh wrote to Walcott's successor, Smithsonian Secretary Charles G. Abbot, offering to mediate the dispute with Orville Wright. Abbot met with Lindbergh and Wright, but to no avail.

The London Science Museum expected the Smithsonian to eventually

correct its mistake, but it also knew that if Orville died without changing his will, the *Flyer* would stay with the museum. The museum took very good care of the plane, and during the blitz of London in World War II, the *Flyer* was evacuated with other important collections to a cave outside the city.

In 1942, Abbot finally agreed to publish a full account of the alterations made to Langley's plane and remove the contested *Aerodrome* label. This was enough for Orville, who then decided that the *Flyer* would return to the United States and be displayed at the Smithsonian once World War II ended. The London Science Museum asked for and received permission to make a duplicate flyer for display. The *Flyer* came back to Washington after Orville Wright passed away in 1948. It was exhibited in the Arts and Industries Building and then transferred to the National Air and Space Museum when it opened in 1976. It remains there today as one of the Smithsonian's most popular and beloved displays. People generally marvel at the seeming simplicity of this rough-hewn machine that initiated the age of flight.

The National Air and Space Museum is not the only Smithsonian museum to house aeronautical treasures from the early days of flight. The U.S. Postal Service inaugurated airmail service in 1918, and issued an exorbitantly priced airmail stamp featuring a Curtiss Jenny biplane. A few were printed with the plane inverted (though, depending upon the production sequence, the border might have been printed upside down). One of the world's most valuable stamps, the famous misprint can be seen at the Smithsonian's National Postal Museum.

T he Bakelizer is probably the most important artifact in the Smithsonian's collections never to be exhibited. It is a large, heavy, ugly-looking egg-shaped industrial device that sits on a four-legged support. Its significance, in a word, is plastics. Smithsonian curator Jon Eklund has called the fourteen-hundred-pound cast-iron vessel "the birthplace of the polyester kingdom."

BAKELIZER PLASTIC MAKER

For most of human history, the only substances that could be molded were clays—as pottery and glass. Hardened clay and glass were used for storage, but they were heavy and brittle. Some natural substances, like tree gums, resins, and rubber, were sticky and moldable but of limited practical use. In 1836, Charles Goodyear developed the process now known as vulcanization, which made rubber more durable. The industrial revolution, with its new inventions and technologies, created a demand for more durable, heat-resistant, lightweight materials. This was particularly true for the growing number of industrial and consumer products using electricity, which required the manufacture of casings, insulation, coatings, and other parts. Inventors sought to develop inorganic substitutes for natural materials to meet these new needs.

In 1838 French chemist Anselme Payen isolated and identified cellulose as the primary material in plants, wood, and fibers like cotton. Experiments using cellulose with nitrates, diluents, and solvents led to the development of collodion—a clear, glutinous liquid that Englishman Frederick Scott Archer later found could be used as an alternative to albumen, or egg white, as an emulsion for coating glass plates in the making of photographs. In the mid-1850s, Alexander Parkes realized that collodion left a residue after evaporating, and he started to treat the substance. Mixing cellulose nitrate with camphor, he produced a hard, flexible, and transparent material—

arguably the first semisynthetic plastic. It could be molded when heated and retain its shape when cooled. He immodestly called the material Parksine and demonstrated its properties at the 1862 Great International Exhibition in London.

American John Wesley Hyatt acquired Parkes's patent and continued experimentation with cellulose nitrate and camphor in order to find a practical substitute for the ivory used to make billiard balls, which his Albany company manufactured. His brother coined the term "celluloid." In ensuing decades, celluloid was adapted in a strip format and used for movie film, but it proved too brittle and flammable for many industrial uses.

Other scientists and inventors continued the quest for a viable, practical plastic material. In 1872, German scientist Adolf von Baeyer, who was later to win the Nobel Prize, discovered a tarlike substance formed by a reaction between phenol and formaldehyde. He disparagingly called it *"schmiere,"* or goo. Others followed his experiments, and in 1899 Englishman Arthur Smith patented a phenol-formaldehyde resin for use as an ebonite substitute in electrical insulation. However, his substance needed several days for hardening, and it deformed during the cooling process. Others in England, Germany, Austria, and the United States pursued the idea of using phenol-formaldehyde resins, experimenting with different solvents and processes for developing useful, synthetic materials that could meet the needs of new products. There was a large demand for heat-resistant insulators then typically made of shellac—a natural resin secreted from an insect, the female lac bug of India and Thailand.

Enter Leo Baekeland, a Belgian chemist transplanted to New York. In the 1890s he invented a form of photographic paper, Velox, which he sold to George Eastman of Kodak for a reported $1 million. Though he received somewhat less, it allowed Baekeland to establish his own laboratory in Yonkers, New York, where he worked on the development of synthetic resins. He wanted to make a substitute for shellac, and more money as well.

Baekeland built on the previous thirty years of experimentation with phenol-formaldehyde reactions. He found that adding caustic soda and

other bases resulted in a solid body that was resistant to heat and solvents. The problem was the dangerous, uncontrolled off-gassing produced by the reactions. He first tried to slow the reaction with low temperatures until he eventually hit upon the idea of increasing the temperature while extricating the gas by-product. In his Yonkers garage he built the Bakelizer, this monstrous-looking, solidly fabricated, steam-heated, air-sealed kettle in which pressure and temperature could be adjusted exactly. By using a catalyst, he found that he could control the reactions of phenol and formaldehyde under heat and pressure to produce a new phenolic polymer—a synthetic thermosetting resin with remarkable characteristics. The new chemical compound was technically called polyoxybenzylmethylenglycolanhydride. Baekeland just called it Bakelite.

The Bakelizer made about nine pounds of brownish Bakelite at a time. The product was an extremely malleable substance, readily moldable and shaped, and quite strong when combined with fillers such as cellulose. In 1907 Baekeland applied for a patent, which was later granted, for his heat and pressure process. Baekeland announced the invention at a meeting of the New York section of the American Chemical Society in 1909, with the *New York Times* reporting on a "new chemical substance." Bakelite proved to be the first commercially viable plastic. Intended as a replacement for shellac and hard rubber, it was initially used for making molded electrical insulation. But Bakelite turned out to be an astonishingly versatile material and was quickly adapted for other uses, from billiard balls to the casing for telephones and radios.

Baekeland established a Bakelite factory in Germany, and then the General Bakelite Company in Perth Amboy, New Jersey, after his own garage lab burned down. He successfully set up licensees and partnerships in foreign countries, supplying the electrical industry and branching out to other industries as well. Bakelite was used for electrical insulators, machinery, shell casings, and even airplane propellers in World War I. By the end of the war, there were Bakelite factories in the United States, Canada, parts of South America, throughout Europe, and in South Africa, Japan, and Australia.

The use of this plastic and other related types created a revolution in product design and development. Bakelite had its imitators and competitors, and Baekeland took them to court for infringing upon his patent. He hit on the marketing slogan "The Material of a Thousand Uses," which turned out to be an understatement. Plastics found immediate application in the automobile, electrical, and machine-building industries. Manufacturers found increasing use for them to make consumer goods. A rising middle class in cities throughout the world required a huge increase in manufactured, rather than artisan-crafted, goods. Traditional and luxury items relied on the availability of limited and generally expensive natural materials like wood, hides, metals, ivory, porcelain, and gemstones. However, plastics allowed for the creation of affordable appliances, furniture, sporting goods, footwear, and even costume jewelry. By the 1920s the first entirely synthetic plastic had become indispensable to most industries and manufacturers. The age of plastics had begun. *Time* magazine featured Baekeland on its cover.

Plastics had a tremendous impact on the design community. Famous industrial designers, like Paul T. Frankl, Raymond Loewy, Norman Bel Geddes, Henry Dreyfuss, and Walter Dorwin Teage, took advantage of the properties of Bakelite and made it synonymous with Art Deco "streamline" forms. Products had curved and sleek lines; dynamic shapes visually suggesting the movement, speed, and elegance of automobiles and trains; and the power of industrial might. While the European Bauhaus movement had used more natural materials in developing its aesthetic, Americans could experiment with the new material. Art Deco designs for plastic emerged for a wide array of consumer products. Plastic could be fashionable, associated with modern and even futuristic lifestyles. But as competitors to Bakelite came on the market and as plastics developed in a wide range of vibrant colors, especially by the 1960s, the material came to be seen as too democratic, too ubiquitous, associated with the artificial, cheap, tacky, and insignificant.

This original Bakelizer, affectionately called Old Faithful by its first operators, was kept by Baekeland's Bakelite Corporation. Union Carbide

acquired Baekeland's company in the late 1930s and kept the reaction vessel. Given its historical significance, the Smithsonian's Jon Eklund tried to obtain the device beginning in 1971, to no avail. Then, in 1983, with the American Institute of Chemical Engineers having recently marked its Diamond Jubilee, Union Carbide donated it to the Smithsonian. The Institution also acquired Baekeland's diaries, lab notes, and photographs as a donation from Baekeland's granddaughter Celine Karraker.

This Bakelizer, also referred to as a "still," a word best known for its association with a moonshining apparatus, had provided the model for larger and more sophisticated devices to make plastic in the years after its invention. By the time of Baekeland's death in 1944, annual production of plastics had reached 175,000 tons—quite a leap from the lump of material first produced in the original Bakelizer.

MODERN NATION

(1870S TO 1929)

HARMONY IN BLUE AND GOLD: THE PEACOCK ROOM BY JAMES WHISTLER

Freer Gallery of Art

The Peacock Room, one of the most fanciful and beautiful of decorative interiors, installed now in the Smithsonian's Freer Gallery of Art for almost a century, tells at least three stories. The first is of American aesthetic creativity in the late nineteenth century. The second is of the Gilded Age in America and how private wealth prompted connoisseurship, private collecting, and display. The third is of how this appreciation took a public turn and became a government responsibility.

JAMES WHISTLER'S HARMONY IN BLUE AND GOLD: THE PEACOCK ROOM

The Peacock Room was originally the dining room in the London home of Frederick Richards Leyland (1831–92). Based in Liverpool, Leyland was a wealthy shipping magnate who had worked his way up from apprentice to manager to owner. He became a collector, most notably of Renaissance art, Chinese blue-and-white porcelain, and William Morris furnishings, which he displayed in his London mansion at 49 Prince's Gate in the Kensington neighborhood.

In 1876, Leyland commissioned the architect Thomas Jeckyll (1827–81) to redesign his dining room to display his collection of Chinese Kangxi porcelain. Jeckyll constructed beautiful shelving and composed other decorative elements, including hanging antique Dutch gilt leather on the walls and placing a painting by James McNeill Whistler, *The Princess from the Land of Porcelain*, in the place of honor above the fireplace.

Whistler, who was decorating the entrance hall of Leyland's house at the time, offered some modest suggestions for the dining room. When Jeckyll's health failed that summer, Leyland was happy to have Whistler take over the project.

Whistler (1834–1903) had been born to a wealthy American family in Lowell, Massachusetts. They relocated to Saint Petersburg, Russia, when he

A MAGNIFICENTLY DECORATED ROOM DEMONSTRATES CREATIVITY AND AN APPRECIATION OF CROSS-CULTURAL ARTISTIC INFLUENCES.

Freer Gallery of Art

was nine years old, and lived and traveled around Europe as he came of age. He developed a passion for art. Returning to the United States, Whistler attended the U.S. Military Academy at West Point, served as a draftsman with the U.S. Coast Survey, and painted. Whistler, like other American artists of the time, decamped to Paris to study, and there met many of the influential artists of mid-nineteenth-century Europe.

Whistler is now best known for his 1871 portrait, *Arrangement in Grey and Black: Portrait of the Artist's Mother,* typically referred to as *Whistler's Mother.* He rose to prominence as an expatriate American artist, becoming a leading proponent of aestheticism, or "art for art's sake," the idea of creating pure beauty, unencumbered by moral or narrative concerns—whether in music, literature, or painting. Interestingly, many artists and critics of the movement drew inspiration from Japanese art, which was newly available to Europeans as a result of the expeditions of the British and of the American Commodore Matthew Perry. Whistler's interest in both contemporary art and Japanese aesthetics accorded well with Leyland's own sensibility and taste.

In taking over Jeckyll's redesign of the dining room, Whistler had some suggestions about minor alterations, to which Leyland agreed. The owner then departed to his Liverpool home. During his absence, Whistler grew bolder with his revisions. He covered the ceiling with squares of Dutch metal (imitation gold leaf) and painted a lush pattern of peacock feathers, gilded the spindle shelving, and embellished the inside panels of the shutters with an array of magnificent peacocks.

When Leyland returned to London in the fall of 1876, he was surprised by the changes to his dining room. Whistler asked for payment, and Leyland, angry at the sum the artist requested, finally agreed to pay half. Leyland wrote a check for one thousand pounds. Pounds were the currency of tradesmen; gentlemen and professionals were paid in guineas. Guineas were worth a bit more in monetary value, but also signaled higher status. Whistler, seeing himself foremost as an artist rather than as the hired hand of a wealthy businessman, was insulted and set out to exact his revenge.

With Leyland away again, Whistler coated the costly leather wall with Prussian-blue paint, and painted a mural featuring a pair of fighting peacocks. Titled *Art and Money; or, the Story of the Room,* the painting is an allegorical portrait of artist and patron. The angry bird on the right has silver feathers on his throat symbolizing Leyland's habit of wearing white ruffled shirts. The docile peacock on the left is crowned with a silver crest feather, suggesting the single white lock that rose artfully above Whistler's forehead. At the feet of the Leyland peacock are the silver shillings the patron refused to pay the artist.

As his decorations of the room grew more elaborate, Whistler audaciously entertained visitors and the press in Leyland's home. Whistler regarded the room as a three-dimensional painting and a musical composition; he titled it *Harmony in Blue and Gold: The Peacock Room,* and literally signed the walls several times with his butterfly emblem. When Leyland returned to his London home and saw the new mural, he immediately threw Whistler out. The artist never saw the room again.

Whistler, like a number of other accomplished American artists and

THE FIGHTING PEACOCKS IN THE PEACOCK ROOM

Freer Gallery of Art

writers, continued to live as an expatriate in Europe. Many of his most important collectors, though, were Americans, and they brought his work back to the United States

For Americans who made outsized fortunes in the Gilded Age, art became a means not only to display their wealth but to demonstrate their cultural sophistication. By buying and encouraging Whistler's work, this emergent patron class could keep abreast of the latest artistic trends as well as foster pride in an American at the forefront.

Despite Leyland's displeasure with the artist, the Peacock Room remained intact as Whistler left it, and fully furnished with the Chinese porcelain, until Leyland's death in 1892. Twelve years later the Peacock Room was dismantled, removed from the house, and exhibited at Obach's, a London art gallery. Wealthy American industrialist Charles Lang Freer, having recently acquired *The Princess from the Land of Porcelain*, purchased it. Freer (1854–1919) was a wealthy art collector who had made his fortune manufacturing railroad cars. The room was again taken apart, and reinstalled in an addition to Freer's house in Detroit, where he displayed his own collection of ceramics on Whistler's gilded shelves.

Freer recognized the importance of the Peacock Room in understanding Whistler's style and its Japanese influence; he believed it to exemplify the spirit of universal beauty that informed his philosophy of collecting and united his holdings of Asian and American art. The acquisition of the room by Freer represented the cultural aspirations of Americans at a time when the nation's economic and political prestige was growing on the international stage, but its artistic and cultural standing still lagged far behind Europe. Here was a creation of an American artist, celebrated in Europe and now brought back home.

While the Gilded Age produced no shortage of wealthy people with frivolous pursuits, Freer was a civic-minded citizen, an idealistic and active proponent of the City Beautiful movement, exemplified by the grand, neoclassical architecture at the 1893 Chicago World's Fair. He believed urban architecture and landscaping could shape growing American cities,

and through them civic behavior. He was close friends with fellow Michigander Senator James McMillan, who led the U.S. Senate Park Commission, which in 1902 developed a plan for Washington, D.C.'s core of monuments and public buildings as well as a park system. Known as the McMillan Plan, it created the National Mall and returned D.C. to the classical ideals of the first plan for the federal city, created by French engineer Pierre Charles L'Enfant for George Washington in 1791.

Freer wanted his collections to grace the capital and uplift the nation. He offered to donate his art to the Smithsonian and also finance the building of a museum to hold it.

In 1904, Freer first proposed to donate 2,250 artworks—though that number quadrupled over a decade. While an art gallery had been proposed in the Smithsonian's founding legislation, and even though the Institution had a substantial collection of art, no separate museum had yet been created. The Smithsonian's Board of Regents debated for more than a year about whether to accept Freer's offer. They were concerned about restrictions imposed by Freer, the focus on Asian art, and possible conflicts with proposals for a National Gallery of Art. But President Theodore Roosevelt, a strong supporter of the Smithsonian, urged moving forward, and the gift was accepted in 1906.

Freer put up the funds and commissioned architect Charles A. Platt to design the museum in an elegant Italian Renaissance palazzo style that well accorded with the McMillan Plan. Construction started in 1916; the building opened to the public in 1923, after Freer's death, with the Peacock Room installed as its treasured feature. Freer's philanthropy—his beloved collection, the building, and a large endowment—turned private wealth toward public purpose in an effort to educate and inspire the nation's citizenry. It represented a distinctly American proclivity to "give something back to society."

Having been dismantled, moved, and reassembled three times, the room's physical structure needed refurbishment by the middle of the twentieth century. Between 1947 and 1950 the museum hired Boston restor-

ers John and Richard Finlayson to carry out an extensive renovation. They fixed the damaged ceiling, restored the cracked leather, retouched and repainted many surfaces, and remounted wall hangings, but they neglected the wainscoting and in their work lost some of the more subtle harmonies Whistler had incorporated into the room's decoration.

More recent treatment, between 1989 and 1993, corrected that. A team of conservators gradually removed an accumulation of darkened varnish, dirt, and overpaint, leaving the original surfaces of the room untouched. The wooden wainscoting was revealed to be greenish gold, and the ceiling became vibrant with feather patterns on a shimmering golden background. Once the conservation was complete, the color scheme became apparent: the coppery golds as well as the brilliant blues and greens of Whistler's decoration resemble the iridescent markings of peacock feathers. The curators then installed Chinese blue-and-white porcelain similar to Leyland's original collection on the elaborate walnut framework originally designed by Jeckyll. That installation changed in 2011 when curator Lee Glazer led the effort to present the room as it looked in Freer's Detroit home, filled with more than 250 ceramics from all over Asia. The room remains what the artist intended it to be, a beautiful, whimsical land of porcelain ruled by the princess in his painting—as well as a wonderful tale of American creativity as our nation emerged proudly onto the world stage.

Sometime around her seventeenth birthday on January 10, 1912, or for Christmas a few weeks before, Canadian Bernice Palmer received a Kodak Brownie box camera. It was a No. 2 Brownie Model B, manufactured by the Eastman Kodak Company in Rochester, New York, in the fall of 1911. It used roll film and retailed for three dollars. Just the year before, as an advertising gimmick, Kodak had introduced the public to the "Kodak girl"—a confident young woman in a blue-and-white-striped dress, ready to go anywhere with her Brownie camera. Bernice, like many teenagers, was a perfect target consumer. She asked her parents to get her the handheld Brownie as a gift.

BERNICE PALMER'S KODAK BROWNIE CAMERA

A NEW DEVICE ENABLES PEOPLE, INCLUDING A SEVENTEEN-YEAR-OLD EYEWITNESS TO THE *TITANIC* DISASTER, TO DOCUMENT THEIR EXPERIENCES.

National Museum of American History

When the Brownie originally came out in 1900 it was a huge hit, selling more than 100,000 units in the first year. It helped democratize photography, enabling many to use the simple, relatively inexpensive device to take their own pictures for the first time. The Brownie, marketed specifically to women and children, was the latest in a line of cameras that encouraged widespread mobile amateur photography. Before, in the early mid-nineteenth-century days of photography, taking pictures involved transporting heavy, cumbersome equipment, applying emulsions to temperamental glass plates in the dark, loading them one by one into a camera, and processing exposures with toxic chemicals. The highly technical process required a good deal of expertise and a great deal of time, making it either a professional pursuit or a very expensive hobby.

That changed as a result of efforts by inventors such as Rochester's George Eastman (1854–1932). His father's early death forced Eastman to drop out of school at fourteen in order to work and support his family. Jobs with insurance companies and then a bank provided money and brought

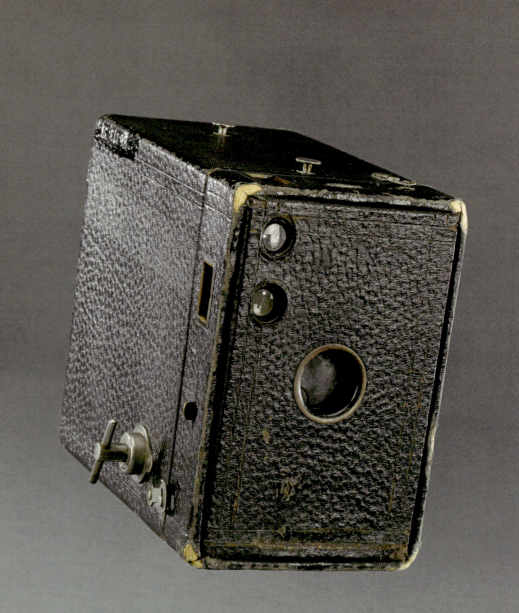

BROWNIE CAMERA *National Museum of American History*

out his entrepreneurial talents. He developed an interest in photography and sought to simplify the expensive equipment, supplies, and complicated processes it required. The quest led him to revolutionize the way ordinary people documented and shared their life experiences.

Within a decade of starting out, Eastman, reading about British advances, developed a technique that made feasible the commercial production of prepared "dry coated" photographic plates. This made photography more convenient by eliminating the messy chemical step of preparing negatives. Eastman essentially separated the act of picture taking from picture making and went into business supplying these plates to a growing number of photographers. He continued to experiment, and in 1885 introduced the first lightweight roll film precoated with emulsions—simplifying the photographic process further. Eastman made up the brand name Kodak in 1888—he thought it sounded good—advertised his product vigorously, and wrote his own copy: "You press the button—we do the rest." People could now take their own snapshots, and Kodak would develop the pictures.

Eastman and his research chemist then perfected transparent roll film, which allowed a several-hundred-foot-long strip of sequential negatives to be spooled onto a portable reel. This facilitated Thomas Edison's development of the motion picture camera in 1891. That same year Kodak introduced its first daylight-loading camera, which meant that a photographer could now reload the camera without having to retreat to a darkroom. This enabled people to snap more images, which in turn meant increased sales of Kodak film. In 1895, Kodak introduced its Pocket camera, which used roll film and incorporated a small window through which the numbers of exposures could be read (whereas previously you had to keep track in your head of the numbers of pictures taken). Three years later Eastman came out with the Folding Pocket Kodak camera, the ancestor of all modern roll-film cameras. It produced a 2¼-by-3¼-inch negative, which remained the standard size for decades. In 1900 Kodak marketed the first Brownie camera. It sold for one dollar and used Kodak film that sold for fifteen cents a

roll. For the first time, the hobby of photography was within the financial reach of virtually everyone.

The Brownie was named after the fictional mischievous, fun-loving fairy goblins created by Canadian writer and illustrator Palmer Cox. The name resonated with the fun and magic of picture taking. The early Brownie camera was basically a cardboard box, coated and stamped to resemble leather, with a simple meniscus lens that took pictures on roll film. The No. 2 model allowed users to snap six images of 2¼ inches by 3¼ inches per roll. After the film was exposed, the owner had to remove the film cartridge from the camera, wrap it in provided protective paper, and deliver it to a Kodak film developer. This was much simpler than either sending in the whole camera or developing the negatives on one's own.

The Brownie attracted an audience of people who were not interested in the technical side of the photographic process but wanted to memorialize their own life's events. Kodak provided a detailed instruction book to purchasers, offering guidance on when during the day to take pictures, how far to stand from the object photographed, and how long to allow for film exposures given the lighting conditions—either indoors or outside.

The portability of the Brownie meant that spontaneous, informal snapshots were increasingly popular, and inevitably, a Brownie sometimes happened to be there when major world events occurred. While photojournalism boomed with the development of increasingly portable professional equipment, everyone with a Brownie camera was now a potential reporter, creating a stunning new expectation of immediacy in the public representation of historic events. Few had foreseen how the Brownie would usher in a new age of citizen eyewitnesses to history. This created new opportunities to share visual information broadly through newspapers and magazines, but it also created challenges for authorities, which sought to manage the flow of information and control what the public knew. For example, the proliferation of unauthorized combat images would lead to a ban on Brownie cameras among enlisted men and officers in World War I.

Teenager Bernice Palmer's use of the Brownie exemplified the idea of

citizen-documentarian in a most dramatic way. In April 1912, just months after receiving the camera, Bernice and her mother boarded the Cunard liner R.M.S. *Carpathia* in New York for a Mediterranean cruise. *Carpathia* had barely begun its journey when it received a distress call just after midnight on April 15 from the White Star ocean liner R.M.S. *Titanic*.

Ocean liners were the technological marvel of the times. Ships had become larger, faster, and more luxurious with every passing year. They were works of art and sources of national pride, carrying world leaders, the wealthy, and celebrities in expansive first-class accommodations as well as poor immigrants belowdecks. The *Titanic* was White Star's new flagship, built in Belfast and regarded as unsinkable. On its maiden transatlantic trip it carried over twenty-two hundred passengers, including, among the wealthy and famous Americans on board, John Jacob Astor IV and Benjamin Guggenheim. It had departed Southampton, England, on April 10, and days later struck an iceberg in the north Atlantic and sank in less than three hours.

The *Carpathia* sped to the scene of the sinking ship. Its crew managed to rescue more than seven hundred survivors from the icy ocean. Equipped with her new camera, Bernice took pictures of the iceberg that probably sank the *Titanic*. She also took snapshots of some of the *Titanic* survivors on the decks of the *Carpathia*.

Carpathia lacked the food to feed and resources to care for both the paying passengers and *Titanic* survivors. It reversed course and headed back to New York. When it arrived three days later, the ship was met by tens of thousands hankering for news of survivors and reports of the disaster. Bernice sold publication rights to her film to Underwood & Underwood, a photographic news service, for ten dollars—which must have seemed like a lot, given that a roll of film cost just twenty-five cents. No one knew whether her snapshots would actually turn out. Bernice, though, must have read the Brownie camera instruction booklet thoroughly, for her photographs were well composed and properly exposed, no small feat given the extraordinary shock and chaos surrounding the rescue. Her pictures appeared

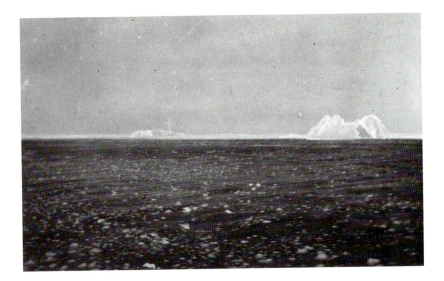

PHOTOGRAPHS
OF THE ICEBERG
AND *TITANIC*
SURVIVORS

*National Museum of
American History*

in newspapers around the world and provided the best documentation of the aftermath of a tragedy that immediately assumed mythic proportions. Underwood returned the developed pictures to her, as they'd promised.

For many, the news of the sinking brought disbelief and then profound grief and doubt. The *Titanic* was a marvel of the industrial era; its luxury spoke of social privilege in the Gilded Age; its very name smacked of pride. If the *Titanic* could go down, was anything in the modern world safe and certain? The loss of the *Titanic* undermined people's faith in technology and progress and came to be regarded as a cautionary tale about the limits of human achievement. In subsequent decades it became the most famous shipwreck of all time.

In 1986, Bernice Palmer Ellis, then in her nineties, donated her camera to the Smithsonian, where it has been on display for several exhibitions. For a meeting of the Smithsonian Board of Regents in April 2012, we featured the museum's collections concerning the *Titanic*, given that it was the one-hundredth anniversary of its sinking. I asked that the camera be taken off display for a day or two and brought to the meeting. Curator Paul Johnston did that, and as he was showing off the Brownie, he offhandedly mentioned

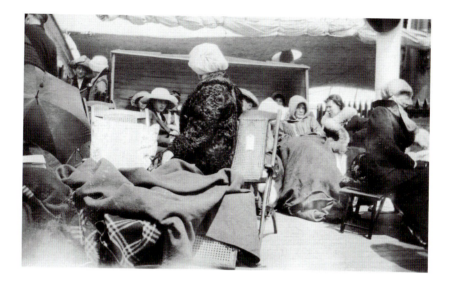

that there was still undeveloped film in the camera. Regents and staff were startled and amazed. While Johnston explained that the film likely contained images snapped by Bernice Palmer long after she'd returned on the *Carpathia*, everyone was eager to have it developed. It took some time to do so given the historical nature of the process, and sadly, the film turned out to be unexposed; but our curiosity signaled the lure of a simple device through which anyone—including a teenage girl—could capture a poignant moment in our nation's history.

49

This unassuming but elegant watch barely hints at the revolution its owner would lead on behalf of millions of vision-impaired people left behind in the centuries of struggle to achieve equality in American life and society. The gold and brass timepiece was manufactured in Switzerland about 1865. Its face is rather normal, with hour and minute hands and a smaller inner circle and indicator for seconds. There's a small stem for winding the watch and a loop called a bow for attach-

HELEN KELLER'S WATCH

A TIMEPIECE WITH A SIMPLE BUT SPECIAL FEATURE HELPS A REMARKABLE WOMAN LEAD THE WAY TOWARD WORLDWIDE RECOGNITION FOR THE DISABLED.

National Museum of American History

ing it to a chain. What is unusual—and might be mistaken for a simple decorative feature—are pinlike studs protruding from the case surrounding the dial. There are twelve, corresponding to each of the twelve hours. Even more interesting, attached to the back side of the case is a revolving hand in the shape of an elaborately decorated arrow. This hand is connected to the watch movement inside. Called a touch watch, the device was designed to enable a person to tell the time by feeling the watch instead of looking at it. The person would tactiley line up the back arrow with the pins to determine the hour and estimate the minutes.

John Hitz, a Swiss diplomat, the watch's first owner, used it to tell time discreetly while engaged in meetings or discussions. He retired as the Swiss consul general to the United States, and by 1892 he was superintendent of the Volta Bureau, an organization serving the deaf and hearing-impaired established by Alexander Graham Bell in Washington, D.C. There Hitz gave the watch to a young blind and deaf girl named Helen Keller. She treasured the watch for the rest of her life.

Helen Keller (1880–1968) was born on an Alabama plantation to a veteran Confederate officer and gentleman farmer and his second wife, a Southern socialite. The blond-haired, blue-eyed toddler lost both her sight

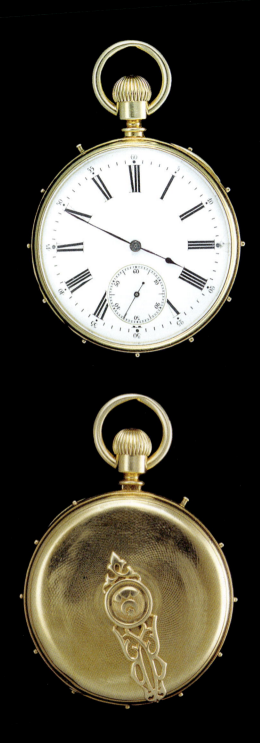

HELEN KELLER'S WATCH *National Museum of American History*

and her hearing when at nineteen months old she suffered brain fever—what we now understand to have been either scarlet fever or meningitis.

Following her illness, the young child grew up in a very protected household environment. She was a difficult child, prone to throwing tantrums, smashing things, kicking, biting, and scratching. Her parents felt pressure to give up on the prospect of Helen having anything like a fulfilling life until her mother read an article about Laura Bridgman, another deaf and blind girl, who learned to write and communicate through sign language. A physician put Helen's mother in touch with Alexander Graham Bell, who had developed new ways of teaching the deaf to read lips and speak. Bell suggested the Perkins School for the Blind, where Bridgman had studied. The school's director, Michael Anagnos, arranged for a former student and young teacher named Anne Sullivan, herself vision-impaired, to go to Alabama and tutor Keller.

Sullivan assumed a powerful role in the Keller home, moving into a small cottage on the property alone with the seven-year-old child. Helen had devised some gestures to communicate with family members, but she could not understand Sullivan's attempts at finger spelling—whereby Sullivan used different configurations of fingers pressed into her student's palm to spell the names of various objects. The communication system that Keller had created for herself made it difficult for her to grasp the connection between those movements and the words and ideas that Sullivan was trying to teach her.

Suddenly, one day, after a fruitless month of tutelage, Sullivan spelled out "w-a-t-e-r" as she ran pump water over Keller's hand. Helen caught on in a breakthrough moment and spelled the word back to Sullivan. That opened the floodgates for Helen, who became a quick and obsessive learner, absorbing the names of all sorts of things and people—including Anne Sullivan, whom she called "Teacher" from that time on.

Within the year, Keller and Sullivan relocated to Boston to attend the Perkins School. It was during her school years that she and Sullivan traveled to Washington, D.C., and received this watch from Hitz. Keller learned to

read Braille, use a typewriter, and lip-read, following Bell's method of placing her finger on Sullivan's lips and throat. With Sullivan always at her side, Keller then attended the Wright-Humason School for the Deaf in New York and the Cambridge School for Young Ladies in Boston before gaining entrance to Radcliffe College, where admirer Mark Twain had helped arrange payment for her tuition. In 1904, she became the first deaf and blind person to receive a college degree in the United States.

Keller learned to speak and became a popular lecturer as well as the prolific author of more than a dozen books. She was an inspirational advocate for those with disabilities, raising public consciousness as well as funds. Keller's eloquence, insight, and warmth not only challenged but exploded preconceptions of the disabled as limited human beings. With Sullivan's collaboration, Keller learned to communicate with mainstream audiences, who discovered that she had a lot to say.

Keller's social justice work extended well beyond disability issues. She advocated for unions, became a member of the Socialist Party, and joined the radical Industrial Workers of the World, better known as the Wobblies. She was a suffragist, speaking out for equal rights for women. Keller participated in suffragist rallies and marches, and opposed Woodrow Wilson's reluctance to endorse women's rights. She was a friend of birth control advocate Margaret Sanger. She believed strongly in justice for African Americans and supported the National Association for the Advancement of Colored People. She was also a founding member of the American Civil Liberties Union.

Once, in 1952, Keller accidentally left her beloved watch behind in a New York City taxi. She feared it was lost forever. With ads in newspaper lost-and-found columns and the help of the city's pawnbrokers, she recovered her prized possession from a pawnshop. After her death in 1968, her niece and nephew inherited the watch.

On December 8, 1974, Helen's nephew's wife, Elizabeth Keller, wrote to the Smithsonian on behalf of the family, offering the watch as a donation. She wrote, "We felt that [Helen] would have wished the watch exhibited

or placed where it would make the maximum impact in acquainting persons with the problems of the blind."

The Smithsonian responded that it was indeed interested, and asked for pictures and additional information in order to verify its provenance and authenticity. The donation and exhibition of the watch tell a wonderful story of how such a relatively simple invention could help one young girl, and presumably others, surmount life's obstacles to achieve fulfillment and success in modern society if given the opportunity to do so.

The cause of providing opportunities for Americans with disabilities grew through the twentieth century thanks to Keller's work and that of many others. Over the years, the Smithsonian acquired other donations that represented adaptations of technology—typewriter keyboards for the sight impaired, both makeshift and high-tech artificial limbs, and a variety of other devices. In 1990, President George H. W. Bush signed the Americans with Disabilities Act, modeled partially on the Civil Rights Act, which was the most sweeping disability rights legislation in history. It mandated that local, state, and federal governments and programs be accessible, that businesses make "reasonable accommodations" for disabled workers, and that public accommodations such as restaurants and stores make "reasonable modifications" to ensure access for disabled members of the public. The act also mandated access in public transportation, communication, and other areas of public life.

Among those who fought for the legislation was Ed Roberts. Roberts had been paralyzed by polio, but in 1962 fought for his right to attend the University of California at Berkeley.

ED ROBERTS'S WHEELCHAIR

National Museum of American History

He became an activist and helped establish independent-living centers for people with disabilities. He used a jury-rigged wheelchair—it was motorized, with a Porsche-like seat cushion and a large headlight for nighttime travel. It was customized for controls held on by duct tape and with various additions for Roberts's convenience and use. Roberts died in 1995, and after a memorial service for him in Washington, D.C., his friends took his wheelchair to the Smithsonian Castle and left it there with a note: "This is an important story." They were right—and the wheelchair is now part of the national collections.

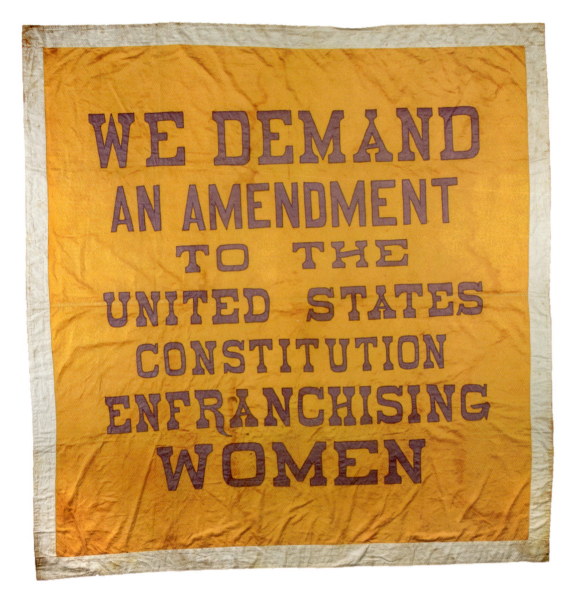

"GREAT DEMAND" BANNER *National Museum of American History*

In 1917, more than one thousand women stood before the White House in a cold, pouring rain, holding silent vigil to demand a constitutional amendment to extend the vote to them. Their quest to be enfranchised by law was known at the time as the Great Demand.

The Smithsonian's Great Demand banner, as it came to be called, declares in bold words and style the determination of the women who made and carried it. Their campaign on behalf of women sought to move America one step closer to fulfilling the nation's long-deferred promise of equality under the law.

From colonial times to the American independence movement and the writing of the U.S. Constitution, voting rights had been restricted. Each colony had made its own rules about who could vote, and this practice continued once they became states. Requirements generally called for a certain age of maturity, generally twenty-one, and ownership of property, among other qualifications. Younger adults, Indians, African Americans, and women were typically disqualified from voting. While there were stirrings for the right of women to vote in the early nineteenth century, the cause took on a new seriousness with the Seneca Falls Convention of 1848. There, Elizabeth Cady Stanton proposed that the convention's Declaration of Sentiments— modeled on the aspirations of the Declaration of Independence—include the demand for women's suffrage.

The effort picked up steam after the Civil War, when debate over the Fifteenth Amendment to the U.S. Constitution, which extended the vote to African American men, split the movement. Some leaders, like Susan B. Anthony, Elizabeth Cady Stanton, and Sojourner Truth, refused to endorse the amendment, believing it should also give women the vote. Others, such as Julia Ward Howe, Lucy Stone, and long-term women's rights ally

50

SUFFRAGISTS' "GREAT DEMAND" BANNER

A PROTEST BANNER IS UNFURLED BY WOMEN TO ASSERT THEIR RIGHT TO VOTE.

National Museum of American History

Frederick Douglass, argued that if black men were enfranchised, their support would help women achieve their goal. The conflict fractured the women's movement, with some focusing on obtaining women's suffrage state by state, others aiming at achieving universal suffrage at the federal level. Congress held hearings on women's suffrage just about every year; a bill was introduced in 1878, but nothing came of it. Women's suffrage efforts were also active overseas, particularly in Great Britain and Scandinavia.

In 1887, the American suffrage movement overcame internal disagreements over strategy, forming the National American Woman Suffrage Association (NAWSA), led by Susan B. Anthony. Efforts at the state level in the United States produced results, particularly in the Rockies and the West, with Wyoming, Colorado, Utah, and Idaho all granting women's suffrage in state elections before 1900. Following suit in the following decades were Washington, California, Arizona, Kansas, Oregon, Montana, Nevada, and New York.

NAWSA expanded under the leadership of Anthony's successor, Carrie Chapman Catt, who was first elected in 1900. Progressive Era activists like Jane Addams at Hull-House in Chicago, labor unionists, the antialcohol temperance movement, and other reform efforts allied themselves with the suffragists. Also supporting the suffrage movement were activists in education, the professions, and even sports and physical fitness. The concept of the "New Woman"—intelligent, independent, accomplished, and capable—became a staple of literature.

In 1913, NAWSA's Alice Paul organized a women's suffrage parade in Washington, D.C., the day before Woodrow Wilson's inauguration as president. Paul, a Quaker graduate of Swarthmore College, had gone to Great Britain while working toward her PhD from the University of Pennsylvania. There she was schooled in the militant tactics of the British suffrage movement. When she returned to the United States she became very active in guiding the women's movement to more aggressive actions, and to shifting attention away from state to federal suffrage efforts. Paul decided to put

direct pressure on the newly elected president, who opposed a constitutional amendment granting women the right to vote.

Banners like the Smithsonian's were used at many suffrage marches, demonstrations, and vigils. Archival photographs show a sign from a Delaware rally in 1914 with the wording and style of the Smithsonian banner; there's another image of a similar banner at a National Woman's Party office in 1916. Currently, there are two banners of this type known to exist, one at the Sewall-Belmont House in Washington, D.C., a museum devoted to the history of U.S. women's suffrage, and the other at the Smithsonian. They both have the same lettering style, leading one to believe that there was probably a guide or template for their creation. Both are very large banners, and probably required two people to carry them. The Sewall-Belmont House banner is seventy-one inches wide and seventy-four inches long, and the Smithsonian banner is a few inches smaller. The former is made of cotton, the latter of silk.

We don't know for sure whether this particular banner was used in January 1917 when Paul organized the picketing of the White House, with members of the National Woman's Party carrying signs intended to challenge and embarrass Wilson. Photographs of the time depict banners asking, "Mr. President what will you do for woman suffrage?" and "Mr. President how long must women wait for liberty?"

The picketing was amplified on Sunday, March 4, 1917, the day of Wilson's second inaugural, when the Congressional Union for Woman Suffrage and the National Woman's Party organized a demonstration to "encircle the President's Mansion with a chain of purple, white and gold." In spite of a drenching rain, more than one thousand people came out to stand in silent vigil for several hours. A mile or so away, Jeannette Rankin of Montana took her seat in the House of Representatives as the first woman to be elected to the U.S. Congress.

Paul continued the picketing after the inauguration. While Wilson might have been somewhat amused at first, his attitude changed with the

picketers' persistence. The silent sentinels, as the women called themselves, were increasingly seen as an embarrassment to the administration. Wilson was moving the United States toward war against Germany, and on April 2 told Congress that war was necessary in order that the world "be made safe for democracy." The picketers' banners pointed out the hypocrisy of fighting for democracy and freedom in Europe while denying it to women at home.

In June 1917, the District of Columbia police began arresting picketers for obstructing sidewalk traffic. The women would be sentenced to serve in the Occoquan Workhouse Prison in Lorton, Virginia. In August, scuffles broke out at the gates of the White House as angry spectators assaulted suffragists while city police stood by. The picketing continued. On October 20, Alice Paul was arrested and sentenced to seven months in jail. She and her companions were held in solitary confinement and denied counsel. Paul went on a hunger strike and was violently force-fed. Authorities confined her to a psychiatric ward in an effort to discredit her. On November 14, thirty women in the Workhouse Prison were beaten, threatened, and mistreated in what came to be known as the Night of Terror. The subsequent storm of critical publicity was such that the administration itself soon called for the release of all suffragist prisoners.

ALICE PAUL
"JAILED FOR
FREEDOM" PIN

National Museum of
American History

As soon as Alice Paul got out of jail, she went back to work. She also had commemorative pins made for the women who went to prison for the cause. In December 1917, at a meeting in their honor, the picketers who had been jailed were presented with small silver pins in the shape of prison doors with heart-shaped locks. The National Museum of American History now holds three of these "Jailed for Freedom" pins, including the one that belonged to Alice Paul.

While Wilson had been repelled by the militancy of the suffragists, finding their methods insulting, unfeminine, and unpatriotic, he was embarrassed by their treatment. He was better disposed to Carrie Chapman Catt's more moderate approach. Catt, who distanced herself and others from Paul's picketing, appealed to Wilson to support a congressional vote

on the women's suffrage amendment, and he did. The Senate rejected the amendment by two votes in 1918, but the following year finally passed the Nineteenth Amendment, which stated, "The right of citizens of the United States to vote shall not be denied or abridged by the United States or by any State on account of sex." It was ratified in 1920.

The desire to document the women's suffrage movement at the Smithsonian began in 1918 when the members of NAWSA offered to donate a portrait of Susan B. Anthony by Sarah J. Eddy. The Smithsonian's art gallery passed on it; the history division opined that it wasn't interested. In 1919, with the passage of the Nineteenth Amendment, the Smithsonian accepted the portrait, along with other items belonging to Anthony and the

suffrage movement. The gallery director wrote, "There can be no question of the historical importance of the movement initiated by Miss Anthony now carried out to a successful ending." Among the trove of artifacts that found a home in the National Museum were Susan Anthony's signature red Indian crepe shawl, material from the Seneca Falls Convention, and numerous documents and photographs.

With the passage of the Nineteenth Amendment, the right to active participation in American representative democracy had legally reached all adult citizens over twenty-one. In the wake of this success, in 1923 Alice Paul drafted and began campaigning for the ratification of an Equal Rights Amendment (ERA) to guarantee federal protection under the law for both sexes. Although a few states ratified the ERA, the momentum of the suffrage movement slowed, and soon the Depression and World War II led Congress and the public to focus on more immediate and pressing concerns. In 1958, President Eisenhower, the first president to endorse the ERA, asked Congress to ratify it, but opponents added language that made the amendment unacceptable to its sponsors in the National Woman's Party. With the upheaval of the Vietnam War in the 1960s, youth called to serve in the military at age eighteen demanded the right to vote. The expansion of the fundamental democratic principle of universal suffrage came in 1971, when the Twenty-sixth Amendment was ratified, granting eighteen-year-olds the vote. The Equal Rights Amendment for gender equality remained—and remains to this day—unratified.

The Smithsonian banner was donated to the Institution by Martin Gilmer Louthan of Konawa, Oklahoma, in honor of his mother, Marie Gilmer Louthan (1891–1954). Louthan came to Washington to stay with her in-laws when her husband was sent overseas to serve in the war. Her father-in-law was the chief of U.S. Capitol Police during the years of Woodrow Wilson's presidency. According to Smithsonian curator Lisa Kathleen Graddy, "The family's history has always been that Marie carried this banner in a women's suffrage march during the years she was in D.C."

She could have carried it with a partner in the effort to surround the White House with a chain of purple, white, and gold banners, or it could have been a headquarters decoration—there's simply no historical documentation. Graddy can't help but wonder about the dinner-table conversations that might have occurred between the young suffragist and her father-in-law, who, in his job as police chief, might have been arresting her fellow protesters.

KU KLUX KLAN ROBE AND HOOD

National Museum of American History

After the Civil War, the policies that were put in place by the federal government, collectively known as Reconstruction, led to vast changes in the South between 1865 and 1877. Blacks won Southern seats in Congress, and interracial governments composed of black freedmen and Northerners were installed in several states to ensure that elected state and local governments didn't countermand the postwar amendments to the Constitution and new civil rights laws, or take reprisals against former enslaved blacks. Voting rights were temporarily suspended for prominent Confederate leaders and established for black men.

KU KLUX KLAN ROBE AND HOOD

Civic improvements like public schools and railroad lines were regarded as impositions by some white Southerners, particularly when funded through taxation that targeted the planter class struggling to reestablish their prosperity without slave labor on land devastated by war. Lucrative government contracts were awarded to Northern companies and to political supporters of the Grant administration, not a few of whom were former Union officers. Martial law enforced federal policies. In rural areas, in particular, federal troops faced a difficult time maintaining any kind of order.

DISGUISES THAT WROUGHT TERROR UPON GENERATIONS SERVE AS REMINDERS OF THE NATION'S LEGACY OF INTOLERANCE.

National Museum of American History

Angry planters and former Confederates banded together to form a number of secret groups to lash out against the Northerners and the freedmen whom they blamed for disempowering them. They burned farms and murdered African Americans in horrific public displays of intimidation. One of the most notorious of these groups was the Ku Klux Klan, founded by Confederate veterans in Pulaski, Tennessee, in late 1865. The name came from the Greek word *kyklos,* meaning "circle," and the Scotch-Gaelic word "clan," with its connotations of antiquity, kinship, and militant unity. They adopted the white pointed hoods and robes to hide their identities, and some also claimed they represented the ghosts of slain Confederates seeking revenge. The Klan grew to perhaps 500,000 members, all white men.

Attempts were made to organize the Klan around a codified dogma with a quasimilitary structure, under the leadership of a Grand Wizard, the first of whom was former Confederate General Nathan Bedford Forrest. However, local groups remained largely independent and uncontrollable.

By 1870, the federal government intervened. Congress passed several Force Acts, which enabled district attorneys to prosecute Klan violence as federal crimes, and the movement went dormant. This worked for a while, but within a few years an underground network began to reemerge. The so-called Compromise of 1877 gave Rutherford Hayes the U.S. presidency over Samuel Tilden after a disputed election, in return for effectively ending federal intervention in the South. With the return of segregationist, white Democrats to power in the South, ongoing violence against blacks continued, often with local government support. More than three thousand blacks were lynched by the Klan and other similar groups in the United States between 1882 and 1920.

In 1915, a new version of the Klan was founded in Atlanta, Georgia, inspired in no small part by the widespread popularity of D. W. Griffith's epic silent film *The Clansman,* later retitled *The Birth of a Nation,* which offered a heroic depiction of the Reconstruction-era Klan and their white supremacist agenda. The new Klan organized more formally than the old one, recruiting members throughout the country and in cities as if it were another fraternal organization. It gave recruiters a share of the initiation fee and the charge paid by each member for his white robe and hood. It had a formal national and state organizational structure and produced a constitution for its "knights," or members. The Klan grew to perhaps five million members by the time of its grand parade down Pennsylvania Avenue in Washington, D.C., on September 13, 1926. Though it expanded during a time of national prosperity, the Klan reflected the various regional tensions of the times. In the South, it was fueled by racism. It also found a home in the cities of the North and the Midwest, feeding off the social tensions of urban industrialization and vastly increased immigration. It even made its way to Canada.

THE SMITHSONIAN'S HISTORY OF AMERICA IN 101 OBJECTS

This Klan preached "One Hundred Percent Americanism"; its agenda was largely anti-immigrant, anti-Semitic, and anti-Catholic, and also attacked southern and Eastern European immigrants who had fled war and poverty at home and found factory jobs in America. In the South, in particular, violence against African American individuals and communities once again escalated. This new Klan promulgated a nostalgic view of a racist past. Allied with white Protestant fundamentalism, the Klan also supported Prohibition and capitalized on fears about the perceived loosening of public morals in the so-called Jazz Age by recruiting members for a women's auxiliary. It adopted a burning wooden Latin cross as an emblem of its alleged Christian mandate and used it as a means of intimidation.

KLANSMEN ALBUM COVER, 1923

The Lilly Library, University of Indiana

The Klan's archetypal regalia, sometimes known as the glory suit by Klansmen, is distinctive and now widely recognized. It consists of a floor-length solid-white robe, sometimes decorated with a round badge bearing an insignia with a cross, and a white, sharply pointed hat that includes a full-faced cloth mask with eyeholes. The basic costume, which has some rank-based and regional variations, was designed both to disguise and to intimidate.

The origins of the costume are unclear. Similar types of garments have been traditionally used in Spanish festivities such as Holy Week, symbolizing the act of penance. In New Mexico, lay priests of the early 1800s

formed religious fraternities and became known as Los Penitentes, wearing robes and pointed hats. Some have suggested that the design of the robes was based upon the costumes of the Reconstruction-era Klan depicted in Griffith's *The Birth of a Nation* film. But the film shows the Klansmen wearing a variety of costumes, and there is far less standardization than one might expect.

While the twentieth-century Klan adopted white as the standard color for its robes and hoods, some groups used different colors to distinguish differences in status—purple, for example, for the high-ranking Imperial Dragon, and black for Knight Hawks, who functioned as enforcers.

The Smithsonian's white robe, cape, and hood, dating to the early-twentieth-century Klan, were donated in 1969 by Kenton Broyles, a collector of political memorabilia from Waynesboro, Pennsylvania. The material is lightweight cotton cloth. A red tassel tops the cone-shaped head gear. It is in the collection of the National Museum of American History. Nothing is really known of its historical provenance. More is known about a black robe in the collections of the National Museum of African American History and Culture. That robe came from the family of noted Florida writer and folklorist Stetson Kennedy. He had worked with anthropologist and writer Zora Neale Hurston on a Works Progress Administration (WPA) project documenting folk traditions in Florida, and in the 1940s infiltrated the Klan. By that time, scandals, criminal behavior, internal divisions, and determined opposition from the National Association for the Advancement of Colored People had eroded membership and residual public sympathies toward the Klan. Stetson Kennedy helped write the brief that the state of Georgia used to revoke the Klan's national corporate charter in 1947.

Another, much smaller version of the Klan arose after World War II and became active during the civil rights movement, largely in the South, engaging in acts of intimidation and violence directed against African Americans and their supporters. Klan violence did not cease with the passage of the Civil Rights Act in 1964. As recently as 1981, racially motivated murders have been attributed to Klan members. Klan groups still exist today,

aligned with other white supremacist organizations in opposition to illegal immigration, civil rights for same-sex marriage partners, and reproductive choice for women. Despite their characterization by federal law enforcement standards as a terrorist organization, the Klan and its members have sought and received affirmation of their right to public assembly and free speech under the First Amendment of the Constitution.

While not treasured by museum curators or visitors, the Klan robe and hood in the Smithsonian's collection provide poignant and necessary reminders of a history of intolerance and persecution, now much overcome.

KU KLUX KLAN MARCH DOWN PENNSYLVANIA AVENUE IN 1926

Library of Congress

52

WORLD WAR I GAS MASK

World War I started in Europe in 1914 and pitted allies Britain, France, and Russia against the Central Powers—Germany, the Austro-Hungarian Empire, and its partner states. The United States under President Woodrow Wilson had tried to stay out of the war and even broker peace, but the death of 128 Americans with the German sinking of the British passenger ship R.M.S. *Lusitania,* the sinking of U.S. merchant ships by German submarines, and a proposed German alliance with Mexico forced Wilson's hand. The United States entered the war in 1917.

The war saw some seventy million men in uniform, and the use of increasingly lethal weapons resulted in the deaths of some nine million combatants. This was the first war to use "weapons of mass destruction." It has been called by some historians the chemists' war because of the applications of modern chemistry to create and unleash on a large scale gases whose aim was to kill and maim, to render the enemy helpless and demoralized.

The Hague Convention of 1899 prohibited the launching of projectiles that contained poisonous or asphyxiating gases. But when the war began in 1914, neither the French, with their use of tear-gas-filled grenades, nor the Germans, with their use of irritants in fragmentation shells, considered themselves to be bound by the treaty. Besides, their effects were negligible, even as irritants.

Everything changed in early 1915 when the German military successfully weaponized chlorine. German chemical companies had been developing stocks of chlorine as a by-product of manufacturing dyes. Near Ypres, Belgium, that April, German troops released more than 160 tons of chlorine contained in nearly six thousand gas canisters into an easterly breeze. The gray-green noxious cloud drifted over French colonial troops, who fled their

A NECESSARY COUNTERMEASURE IS DEVELOPED TO DEFEND AGAINST A HORRIFIC MILITARY INNOVATION.

National Museum of American History

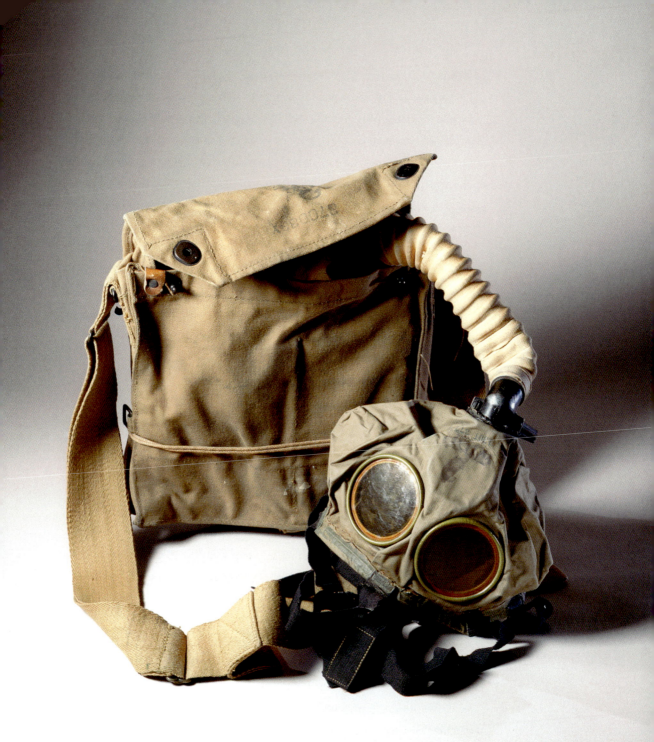

GAS MASK *National Museum of American History*

positions. German troops, themselves wary of the deadly gas, could not take full advantage of the chemical attack.

While the Allies protested the attack as a violation of the Hague Convention, Germany argued that the treaty prohibited the use of deadly chemicals only in shelling—not the projection of gas into the open air. The German army continued such attacks at Ypres, though their most dramatic use was in an attack on Russian troops south of Warsaw, resulting in about a thousand fatalities and some nine thousand casualties. The Russians started to build stockpiles of chemical weapons, the British deployed chlorine against German troops, and the French used deadly phosgene, as did the Germans.

Just as chemistry and engineering produced new chemical weapons, so too did it produce increasingly sophisticated measures to counter them. Gas goggles were typically used to protect the eyes of soldiers from tear gas. The Germans had issued breathing masks to those handling the gas at Ypres. When a Canadian medic there identified the gas used as chlorine, he urged troops to urinate in a cloth and hold it over their mouth and nose to neutralize the chemical's effect. Pads of material impregnated with chemicals tied around nose and mouth were a typical response to gas attacks. Primitive gas helmets—basically fabric bags saturated with chemical neutralizing agents—followed, to be donned when makeshift warning bells rang out signaling that an attack was under way. The British Hypo helmet, fabric soaked with sodium hyposulfite, was an example. The P-gas helmet, which was impregnated with sodium phenolate, was partially effective against phosgene, while the PH-gas helmet, impregnated with phenate hexamine, issued in 1916, was an improvement. Problems persisted. When masks got wet or rained upon, the chemicals washed out and into soldiers' eyes. Experiments with eyepieces followed. Breathing under a mask caused carbon dioxide buildup, and so mouthpieces for exhaling were developed to provide a partial solution.

By the time the United States entered the war in 1917, the Germans had already started to use mustard gas in shells. Though not immediately

fatal, mustard gas was used to disable the enemy and pollute the battlefield. Its effects lingered for weeks, making it well suited to the trench warfare of the time, as it froze troops in place. The gas blistered exposed skin, irritated eyes, and induced severe nausea. As soldiers breathed in the gas, it would strip off the mucous membrane, causing great pain, internal bleeding, and eventually death. Without countermeasures, the gas could be decisive in determining the war's outcome.

The United States developed two such countermeasures as it entered the war. One was to build its own stockpiles of chemical weapons with which to attack the German army and its allies. The other was the development and production of gas masks to negate the most serious effects of a chemical attack.

The Bureau of Mines set up a War Gas Investigations program, and the National Academy of Sciences led by Smithsonian Secretary Charles D. Walcott established the National Research Council and a committee to coordinate research into noxious gases at various universities and in private industry. The NRC also established an experimental station at American University. This unit later moved to what became known as Gunpowder Neck, on farmland requisitioned by the government in Harford County, near Aberdeen, Maryland. There, in an area designated the Edgewood Arsenal, the United States researched, tested, developed, and manufactured its first chemical weapons—chloropicrin, phosgene, and mustard gas.

At Edgewood, the U.S. government also began the manufacture of gas masks—a mere twenty-five thousand in 1917, but some three million improved versions, called the RFK (the Richardson-Flory-Kops), the next year. The Smithsonian has a number of World War I gas masks from the Edgewood Arsenal, the site of the U.S. response to chemical warfare in Europe. This mask, like millions of others, was used to protect Americans from the awful effects of these noxious chemicals. It has more than a dozen separate pieces, all playing a role in ameliorating the impact of a chemical gas attack. Importantly, the mask relies on rubber in its construction and would not have been possible without the development of an extant rubber

industry in the United States prior to the war. Now almost all of that rubber in the masks in the Smithsonian collection has disintegrated.

The gas masks produced at Edgewood were a version of the self-contained small box respirator developed by the Allies so that soldiers would not have to breathe in the chemical-filled air. The box respirator used a two-piece design: a mouthpiece connected via a hose to a metal box filter. The filter contained activated coconut charcoal, soda lime, and cotton pads that neutralized chemical gas and allowed the delivery of clean air back to the wearer. The filter could be removed and upgraded as necessary. The respirator featured a single-piece, close-fitting rubberized mask, adjustable head straps, and yellow eyepieces. The box filter was compact and could be worn around the neck with a strapped carrier.

The gas masks were supplied to U.S. soldiers in what were called the American Expeditionary Forces in Europe under the command of General John Pershing. More than one million Americans served in France at the height of the fighting in 1918, and they were instrumental in bringing the war to an end. More than one hundred thousand died—almost half from the influenza epidemic, and relatively few from poisonous gas.

The gas mask became an icon of sorts of World War I, or the Great War, as it was widely known before World War II. Leaders became increasingly aware of how modern science and industry could turn warfare into a lethal mass industrial process. The prevention of the use of poisonous gas in warfare took on added urgency after peace was secured, resulting in commitments in ensuing years by world leaders not to use chemical weapons save for defensive purposes. Just a few decades after World War I, though, people the world over recoiled at the news of the use of gas by the Nazis in concentration camps to kill innocent Jewish civilians and others. More recently, the use of chemical gases by authoritarian regimes such as those of Hafez al-Assad in Syria and Saddam Hussein in Iraq, and the use of noxious substances by terrorists, such as the sarin gas attack in the Tokyo subway in 1995, shock us anew and remind us, sadly, that the use of gas masks cannot yet be consigned to history.

THE SMITHSONIAN'S HISTORY OF AMERICA IN 101 OBJECTS

J azz began as a uniquely American form of music, and the impor-
tance of Louis Armstrong (1901–71) in its development, techni-
cally and culturally, is perhaps unequaled. While musicians lauded
and emulated his scat-style sing-
ing, improvisational techniques,
and virtuoso trumpet playing, his
charismatic stage presence and
distinctive gravelly voice popular-

LOUIS ARMSTRONG'S TRUMPET

ized jazz widely in the United States and around the world. He was long
associated with Selmer brass trumpets, made in France, saying they had "the
purest, finest tone of any trumpets I know about." So identified with the
instrument was Armstrong that he called his Selmer trumpet Satchmo, a
nickname—shortened from Satchel Mouth—that he'd picked up for him-
self on a visit to London in 1932.

That spirit of New Orleans not only forged Armstrong and jazz, it also
informed a period of early-twentieth-century American cultural life—the
Jazz Age—the post–World War I and pre-Depression 1920s, known for
its boundary-breaking, improvisational exuberance. New Orleans is a city
historically defined by its unconventional blending of French, Caribbean,
African American, Southern, and other traditions into a unique and in-
novative social and cultural brew. It is, as one geographer called it, "the in-
evitable city on an impossible site," built on a low-lying swampy landscape
to serve as a strategic port for trade up and down the Mississippi River and
through the Gulf of Mexico. As a port of call owned by Spain, France, and
then the United States, it brought waves of immigrants as managers, specu-
lators, and laborers to join Native American Choctaw and Natchez, dis-
located Acadians/Cajuns from Canada, enslaved Africans, Haitian rebels,
Filipinos, Chinese, Malays, Germans, Sicilians, Irish, and a host of people
from the Dalmatian Coast. The diversity of the city is staggering. Yet what
sets New Orleans apart has been the degree to which the traditions of its

THE INSTRUMENT OF A LEGENDARY MUSICIAN HELPS DEVELOP A UNIQUELY AMERICAN MUSIC.

National Museum of African American History and Culture

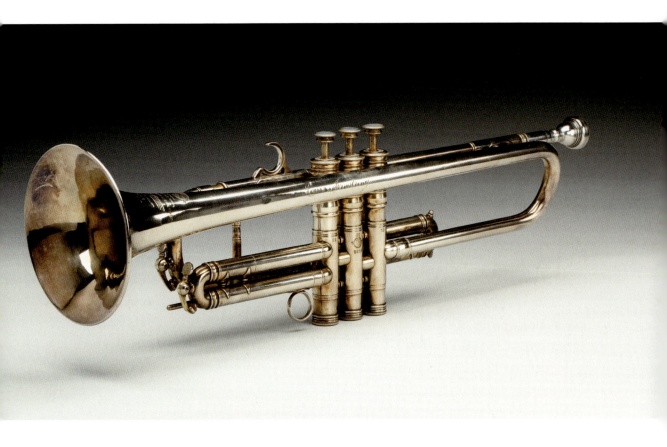

LOUIS ARMSTRONG'S TRUMPET *National Museum of African American History and Culture*

varied communities have mixed, creolizing or combining indigenous, African, and European customs into a mélange of new cultural forms.

This was most evident in music. New Orleans was a center of the slave trade. In the early nineteenth century, "slave dances" became regular events in Congo Square, a place where the remnants of different African traditions were shared. Variations on Spanish musical traditions from the Caribbean; instruments, tunes, and dances from French settlements along the Mississippi; and Scots-Irish instruments and rhythms from Appalachia came to town. Creoles of color, descendants of French colonists and African and Native American wives or mistresses, collectively constituted the largest free black community in the South and provided musicians to play for dances and balls with a repertoire that included everything from central European polkas and schottisches to formal French quadrilles and their folksier variant, the contra dance; from Celtic reels to syncopated Spanish habaneras. As if that weren't enough, the city's legacy of having been ruled by different governments with their armed presences left a tradition of military marches, marching bands, and brass instrumentation. When mixed with Baptist church music and African traditions of dance, the marching band tradition gave rise at the end of the nineteenth century to the legendary New Orleans funeral parade.

By the mid-1890s, several new styles of music had begun to filter into the city. One was ragtime, an outgrowth of an African American improvisational practice of "ragging"—syncopating and rearranging everything from spirituals and minstrel tunes to European folk melodies, operatic arias, and military marches on the piano and turning them into livelier, more danceable versions. A second new music was the blues, coming in with itinerant musicians from the Mississippi Delta, who composed guitar tunes based on three chords and arranged typically in twelve-bar sequences, and sang deeply and often irreverently of the challenges of life. A third, more sacred influence came with black refugees from the Delta, who—escaping the hard labor of harvesting cotton or cutting cane for the promise of a better life in the city—brought with them the hymns and call-and-response shouts of

the Baptist church. Another influence came from black Holiness churches. These were new, urban congregations that used the loud sound of tambourines, drums, pianos, cornets, and trombones to celebrate the joy they felt in the Lord's embrace.

New Orleans musicians, many of them Creole, took these sacred and secular elements—the instruments like piano and horns, the improvisational and call-and-response qualities, the emotion of musical expression—and started melding them into a new form. It didn't have a name, until someone called it jazz.

Armstrong was born in New Orleans at about the same time this new music, still unnamed, was starting to gel. Poor and often abandoned, he survived as a child with the help of relatives and by singing on street corners, scrubbing graves, scavenging food scraps, and selling coal to prostitutes. He loved music, from the blues played in the Storyville district's honky-tonk dance halls and brothels to the brass bands accompanying the New Orleans parades and funerals. A Lithuanian Jewish immigrant family gave him odd jobs and lent him the money to buy his first instrument, a cornet, which he taught himself to play. He received his first formal music instruction while in the Colored Waifs' Home for Boys, where he had been sent for a minor infraction. Upon his release, Armstrong performed with pickup bands in small clubs and played funerals and parades around town with the Tuxedo Brass Band and others, drawing the notice of trumpet player Joe "King" Oliver, a member of Kid Ory's band. Armstrong joined the band and Oliver became his mentor. When Oliver, like many New Orleans jazz musicians, moved to Chicago, Armstrong became the band's leader; he then went on to perform on Mississippi riverboats and subsequently joined Oliver in Chicago.

Chicago in the early 1920s was one of the centers of the Jazz Age. With the prohibition of alcohol, speakeasies—clubs illegally serving drinks—proliferated. Music provided the entertainment, and the musicians from New Orleans were playing the new jazz music that audiences found modern, attractive, and engaging. The music inspired new dances, such as the

Charleston. Women dancers, called flappers, displayed new fashion styles and exhibited a newfound freedom born of the women's suffrage movement. The association of drink, music, dance, clubbing, and a comparatively freer expression of sexuality gave jazz a risqué reputation as a somewhat immoral music—it put the "sin in syncopation," said one critic. Playing with King Oliver's Creole Jazz Band, Armstrong was in the middle of it all.

In 1924, Armstrong moved to New York City to play in Fletcher Henderson's Orchestra at the prestigious Roseland Ballroom. New York was replacing Chicago as the epicenter of jazz, though other centers had sprouted in Kansas City and back in New Orleans. Armstrong's New Orleans style influenced other New York musicians, and impressed such jazz talents as Coleman Hawkins and Duke Ellington. Jazz was in clubs, on Broadway, and in Harlem—at the famed Cotton Club—crossing over from black to white audiences. George Gershwin wrote *Rhapsody in Blue*. The musical elite praised jazz, and Irving Berlin called it the "rhythmic beat of our everyday lives." Such songs as "Dinah" and "Sweet Georgia Brown" became hugely popular. Armstrong made his first recordings as a band leader with his Hot Five (later his Hot Seven), and had his big hit with "Muskrat Ramble." By 1928, Armstrong recorded "Heebie Jeebies," which introduced scat singing to a broad audience, as well as "West End Blues," one of the more famous recordings in jazz. Armstrong, promoted as "the world's greatest jazz cornetist," also became well known for his powerful trumpet, rhythmic swing, and unique vocal style.

Armstrong's 1929 recording of "Ain't Misbehavin'" built on the audience's familiarity with jazz musician Fats Waller's version and reinterpreted it to widespread acclaim. Armstrong had become a star, popularizing "black music" among white audiences. He appeared on Broadway, and the following year made his film and radio debuts.

While the Depression provided a sobering end of sorts to the exuberance of the seemingly carefree Jazz Age, the music continued to develop. Armstrong was busy as a recording artist and as a music headliner on a virtually nonstop tour. The Depression-ravaged country loved his charming patter

and his seemingly carefree, reassuring style. He toured internationally as well as domestically, spending time in England in the early 1930s. It was during this time that Armstrong is reputed to have received his first Selmer B-flat trumpet as a gift from England's King George V. That trumpet is in the collection of the Louis Armstrong House Museum, located in the former long-term residence of the musician in Queens, New York. Armstrong found it a joy to play, and Selmer-made trumpets became his instrument of choice. The Selmer family had a long history of making high-quality instruments, particularly saxophones. With Armstrong's approval and endorsement, they even developed a specifically named Armstrong trumpet. The Selmer trumpet in the Smithsonian's collection was manufactured in 1946 and came to the Institution by way of Armstrong's close friend and former manager, Joe Glaser. The trumpet is engraved "Henri Selmer, Rue D'Ancourt, Paris and Louis Armstrong."

DIZZY GILLESPIE'S TRUMPET

National Museum of American History

Armstrong went on to record scores of albums, play thousands of concerts, grace several dozen films, and appear on television numerous times. His many hits included "When the Saints Go Marching In," "Stardust," "What a Wonderful World," and "Dream a Little Dream of Me." At the age of sixty-three, Armstrong knocked the Beatles out of the number-one position on the music charts with "Hello, Dolly!" He was enthusiastically greeted as a jazz artist and cultural ambassador for the United States when he toured Asia, Europe, and Africa. Though Armstrong sometimes faced criticism from others involved in the civil rights movement for not being more vocal, he spoke up publicly in 1957 about President Dwight D. Eisenhower's inaction in desegregating schools in Little Rock, Arkansas. He also canceled a planned State Department tour of the Soviet

Union, pointing out the hypocrisy of representing America abroad when its government so mistreated its people at home.

Armstrong's musical influence was huge, shaping artists ranging from Bing Crosby to Johnny Cash. Generations of trumpet players took inspiration from Armstrong's mastery. As Dizzy Gillespie said, "If it weren't for him, there wouldn't be any of us." Gillespie's own uniquely modified "silver flair" bent B-flat trumpet—illustrating in physical form the remarkable improvisational quality of jazz—is now with Armstrong's at the Smithsonian.

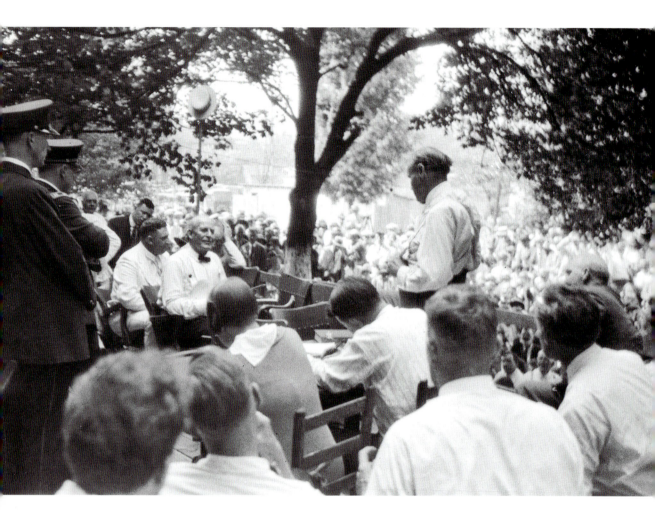

SCOPES TRIAL PHOTOGRAPH BY WATSON DAVIS *Smithsonian Institution Archives*

Letters, papers, and photographs documenting one's family history are often rediscovered in boxes and trunks stored away in basements, closets, and attics across the country. Sometimes this happens at the Smithsonian, where new discoveries enable us to reexamine historical events. Such was the case in 2005 when historian Marcel Chotkowski LaFollette uncovered a cache of rare, unpublished nitrate negatives and photographs of the famous 1925 Scopes trial in the collections of the

SCOPES "MONKEY TRIAL" PHOTOGRAPH

Smithsonian Institution Archives. They had been donated to the Smithsonian, along with other materials, by the Washington, D.C.–based Science Service, which had been founded in 1921 for the promotion of science writing and information. Its managing editor, Watson Davis, had covered the trial and taken the photographs. The Smithsonian developed the negatives; among them was this photograph of William Jennings Bryan and Clarence Darrow on the last day of testimony.

Looking at the photograph, you can sense the spectacle and drama amid the summer heat in rural Tennessee. The attention of the huge crowd is focused on a raised platform, where the seated, bow-tied Bryan, called as a witness, is being interrogated by the standing, suspended Darrow. Spectators strain to see and hear what looks like a performance. Indeed, it was. Baltimore journalist H. L. Mencken had called it the Monkey Trial, not only because it contested the idea of man's evolution from the apes but also because of its circuslike atmosphere. The trial was attended by hundreds of reporters, and portions of it were broadcast live on radio to many parts of the United States.

On trial was physics teacher John Thomas Scopes, who admitted that he had violated Tennessee law by discussing evolution in the county high

TWO OF AMERICA'S FOREMOST LEGAL ADVOCATES FACE OFF IN COURT OVER THE TEACHING OF EVOLUTION IN PUBLIC SCHOOLS.

Smithsonian Institution Archives

school. Bryan, a former presidential candidate, gifted orator, defender of American farmers, and ardent evangelical Presbyterian, was helping the prosecution. Darrow, the Chicago-based labor lawyer, free speech advocate, and modern agnostic, was heading the teacher's defense. The trial took on special significance as a contemporary measure of how strong currents of American thought—religious faith and scientific reason—were opposed or reconciled.

Although the idea of the evolution of natural, physical, and social phenomena had existed as a scientific concept for some time, English naturalist Charles Darwin amplified its meaning. Darwin's theory, published in *The Origin of Species* in 1859, was grounded in an empirically based understanding of the processes by which species develop. The subsequent application of evolutionary thought to the development of humans occasioned considerable religious, scholarly, and public debate, not only in Britain and Europe but in the United States as well. Some leading scientists, such as Harvard's Louis Agassiz, believed species to be fixed, with natural, unchanging characteristics over time. Those who took this view generally assumed humans to have immutable, inherent, natural features that could not be changed. This harmonized with the belief, based in a fundamentalist reading of Judeo-Christian Scripture, that man was made, complete and perfect, on the sixth day of creation. However, other mid-nineteenth-century scientists, like Smithsonian Secretary Joseph Henry, accepted Darwin's thesis and promoted his theory, even as they maintained their religious faith. Outside the academic community, evolution had both liberal and conservative sociopolitical interpretations. Reformers could argue for the benefits of striving to improve peoples and races through education and work. Elites could counter that processes such as "survival of the fittest" and "natural selection" justified the hierarchy of the rich, powerful, and industrious over the poor, weak, or lethargic.

Museums, books, and schools in the United States found no clear consensus on the teaching of evolution in the late nineteenth and early twentieth centuries. Tennessee's high school science textbook *Civic Biol-*

ogy included evolution, but the state's Butler Act, passed in 1925, prohibited public school instructors from teaching that humans evolved "from the lower orders of animals." It also prohibited any denial that the biblical account of creation, as stated in the book of Genesis, was the sole authoritative explanation of human origins.

Only a few states at the time had such a law, and the American Civil Liberties Union (ACLU), then in its infancy, wanted a test case to challenge it. Fatefully, a group of local businessmen in tiny Dayton, Tennessee, with a population of about eighteen hundred, thought that a challenge in their village might bring it publicity, business, and renewed growth. Confident that the ACLU would provide the defense, they needed to find a teacher who would state that he or she had violated the law (school classes had already concluded for the year). A young John Scopes fit the bill. The recent University of Kentucky graduate had spent a quiet year teaching high school science and coaching football at Rhea County High School in Dayton. He'd been planning to sell automobiles that summer to earn extra money. In early May 1925, he met with the group, agreed with the plan, and three weeks later was indicted by a grand jury for violating the Butler Act. In his own autobiography, he wrote that he had not taught the theory in the classroom, but he did believe in evolution and in free speech. The trial, *State of Tennessee v. John Thomas Scopes,* started on July 10 in the Rhea County Courthouse with Judge John T. Raulston presiding.

The sixty-five-year-old Bryan had sought the invitation of Rhea County prosecutors to participate. Bryan was a well-known figure, having waged and lost three campaigns for president. As Democratic nominee for president in 1896, he captivated the nominating convention with his "Cross of Gold" speech, advocating easier credit for farmers, small businessmen, and rural folks. Known as the Great Commoner, Bryan was a populist, opposing the growth of big banks, trusts, corporations, and monopolies—seeking instead benefits for "ordinary" Americans. A compelling and captivating orator, he had a strong moralistic streak based upon his Christian beliefs.

Darrow, three years younger, was a friend of Bryan, having run for an

Illinois seat in Congress on Bryan's 1896 presidential ticket. Darrow started out as a corporate railway attorney, but switched to defending labor causes, including union leader Eugene Debs for his role in the 1894 Pullman strike. Darrow took on numerous cases, arguing against the death penalty and for free speech. He was on the National Committee of the ACLU, and was not afraid to represent unpopular clients. Darrow strongly disagreed with Bryan's emphasis on religion as the basis for civic morality.

A number of themes ran through the short trial. On July 13, Darrow made his big pitch, arguing that the Butler Act should be declared unconstitutional because it violated the separation of church and state. Judge Raulston was not convinced. A week later, on July 20, the overcrowded courtroom and Tennessee summer heat persuaded the judge to move the proceedings outside on the courthouse lawn, under the shade of trees. Darrow called Bryan to the stand as an "expert" on the Bible. The photographs preserved in the Smithsonian Institution Archives captured this historic moment as the two great persuaders faced off, pitting scientific evidence against religious faith.

Darrow pushed Bryan to explain how various biblical facts could be true. His mocking, aggressive questioning confused Bryan, who was the master of campaign, Chautauqua lecture and tent revival speeches—not cross-examination. "You insult every man of science and learning in the world because he does not believe in your fool religion," said Darrow. When Bryan complained that Darrow's purpose was "to cast ridicule on everybody who believes in the Bible," Darrow vehemently retorted, "We have the purpose of preventing bigots and ignoramuses from controlling the education of the United States." Darrow and Bryan went at it for some two hours until Judge Raulston gaveled the court to adjournment. Some believed Darrow gave a vigorous defense of evolution; others felt Darrow had pushed too hard, making Bryan sound foolish. The next day, after only nine minutes of deliberation, the jury returned a verdict of guilty against Scopes. The judge fined him one hundred dollars.

Five days later, Bryan died in his sleep, probably due to a stroke. He was

buried at Arlington National Cemetery. Darrow went into semiretirement soon after, occasionally taking on a high-profile case. Two years later, the Tennessee Supreme Court heard Scopes's appeal and overturned his conviction on a technicality; the jury and not the judge should have determined the fine to be paid. Instead of sending the case back for retrial, however, the court dismissed it. The ACLU was thus denied a constitutional challenge. In the ensuing years, dozens of states proposed and adopted legislation to disallow the teaching of evolution.

During the Scopes trial, the newspapers urged the Smithsonian to comment. Secretary Charles D. Walcott, a geologist and paleontologist who was also a devout Christian, responded that the facts of evolution "are too obvious to be resisted by any fair-minded person who will study them." Walcott was typical of the many scientists who did not see a dichotomy between science and religion, and who both accepted the Bible as religious text and accepted the theory of evolution as good science.

More than fifty years later, in 1979, the Smithsonian opened a landmark exhibition on evolution. This exhibition provoked a lawsuit, *Crowley v. Smithsonian,* which charged that the Institution was violating the First Amendment; but the Smithsonian won the case and all subsequent appeals, establishing a precedent useful to museums around the country seeking to mount exhibitions on evolution.

Nonetheless, nearly a century after the Scopes trial, many Americans continue to reject the theory of evolution, though most do accept it, and many who do find ways of reconciling its scientific findings with the beliefs of their religious faiths.

55

SPIRIT OF ST. LOUIS

THE AIRPLANE
MAKES THE
FIRST SOLO
NONSTOP
FLIGHT ACROSS
THE ATLANTIC
OCEAN,
ENTHRALLING
THE WORLD.

*National Air and Space
Museum*

On May 21, 1927, Charles A. Lindbergh (1902–74) completed the first solo nonstop transoceanic flight in history, flying his *Spirit of St. Louis* 3,610 miles, from Roosevelt Field on Long Island, New York, to Paris, France, in thirty-three hours and thirty minutes. With this flight, Lindbergh claimed a $25,000 prize and became a world hero.

The plane was named in honor of Lindbergh's supporters in St. Louis, Missouri, who helped pay for the aircraft.

Lindbergh was an underdog in the competition for the prize. He hailed from a broken home in Detroit, Michigan. His father, a congressman, and mother, a high school chemistry teacher, had separated when he was seven, and he was bounced between parents and schools. Fascinated by mechanics and aviation, he studied aeronautics. He took his first flight as a passenger in 1922, and became a wing walker, parachutist, and mechanic on barnstorming tours across the Midwest and West. Barnstorming was a kind of traveling circus of stunt flying and related acrobatic tricks staged in open fields, enabling civilian pilots to hone their skills and earn money in the post–World War I years. Lindbergh bought a surplus Army Curtiss Jenny biplane, and with little training made his first solo flight in May 1923, and from there barnstormed as "Daredevil Lindbergh." He enrolled in Army flight-training school, earning a commission as a Second Lieutenant in the Air Service Reserve Corps. He served as a flight instructor and went to work for Robertson Aircraft Corporation flying the airmail route between St. Louis and Chicago.

Inevitably, Lindbergh also became interested in the Orteig Prize. In 1919, New York hotel owner Raymond Orteig, an immigrant from France interested in aviation and promoting Franco-American goodwill, made a pledge to pay an aviator $25,000 (equivalent to more than $1 million today) for making the first direct flight between Paris and New York. The

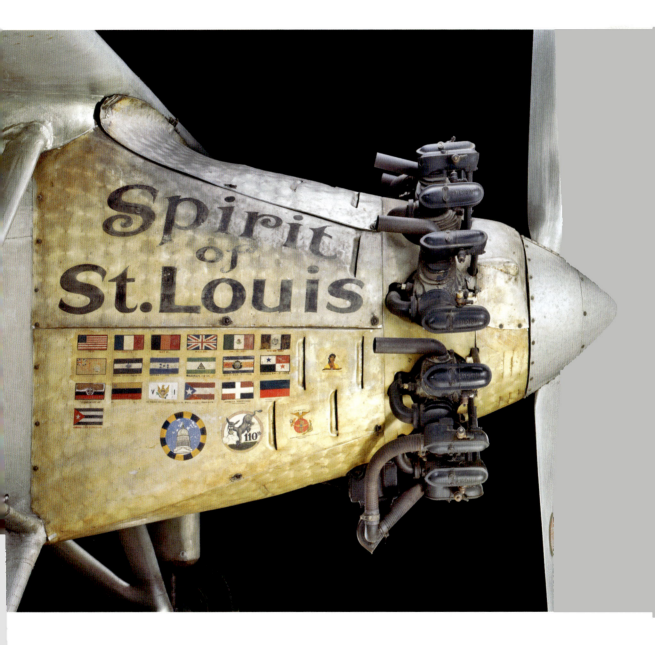

SPIRIT OF ST. LOUIS *National Air and Space Museum*

initial term of the prize was five years, which Orteig extended in 1924. As aircraft technology advanced, more and more famous American and French pilots took up the challenge. Lindbergh, a virtually unknown twenty-five-year-old pilot with relatively little experience, was not the most likely contender.

Undaunted, Lindbergh put up a few thousand dollars of his own savings, money from Robertson Aircraft, and a bank loan backed by sponsors from St. Louis to purchase a plane from B. F. Mahoney's Ryan Aircraft Corporation in San Diego with the specifications needed to make the flight. The main issue was carrying the 450 gallons of gasoline needed for a direct flight. This required larger fuel tanks than normal, and accommodating that additional weight—2,700 pounds—necessitated balancing lift, safety, and other design modifications. Designer Donald Hall modified several Ryan aircraft, reaching a final design that improved upon the conventional Ryan M-2 high-wing strut-braced monoplane by increasing the wingspan by ten feet and lengthening the fuselage by two feet, as well as adding support to the fuselage and wing to accommodate the load. They added plywood to the wings' leading edges. The engine was moved forward to balance the fuel tanks and the cockpit moved more toward the rear for safety. Because of this, Lindbergh could not see directly ahead. He had to use a periscope on the left side to see ahead, or turn the airplane and look out a side window. Lindbergh made a risky decision to depend on just a single Wright J-5C, 223-horsepower engine. He also equipped the plane with just a single seat. Lindbergh would fly solo even though it was not a requirement for the prize.

The plane was painted silver and carried registration number N-X-211. The "NYP" on the tail designates "New York to Paris." Lindbergh first flew the aircraft from San Diego to New York with one stop, at St. Louis, setting a new transcontinental record. On the morning of May 20, 1927, after waiting for favorable weather, Lindbergh took off alone on a muddy runway, clearing telephone lines at the far end of the field and headed for Paris.

During the flight Lindbergh, who always jointly referred to himself and the *Spirit of St. Louis* as "we," encountered terrifying obstacles, including storm clouds at ten thousand feet and whitecap waves as he skimmed the ocean at ten feet, plus ice and fog that left him flying blind for several hours. But finally, he landed at Le Bourget Airport at 10:22 P.M. on Saturday, May 21, where he was greeted by a wildly enthusiastic crowd of more than 100,000 people. Storming the field, they pulled Lindbergh out of the cockpit and carried him around above their heads, while souvenir hunters attacked the *Spirit of St. Louis*, tearing scraps from the fabric covering on the fuselage, until both pilot and plane were rescued from the mob by French officials.

Lindbergh flew around Europe in the patched *Spirit* and received the Légion d'Honneur from the president of France before returning to the United States aboard a Navy cruiser. He was escorted home by a fleet of warships and aircraft that ended with a trip up the Potomac River to Washington, D.C., where President Calvin Coolidge awarded him the Distinguished Flying Cross. A ticker-tape parade down Fifth Avenue in New York City followed.

Lindbergh subsequently toured the United States with the *Spirit of St. Louis*, visiting all forty-eight states. Seen by more than a quarter of the U.S. population, the plane generated such massive publicity that it boosted the aviation industry and led to an explosion of air travel. People trusted "Lucky Lindy" and began to see airplanes as a safe and reliable means of transport. Lindy flew from Washington to Mexico City, making stops through Central America and the Caribbean; flags of the countries he visited were painted on the *Spirit*'s cowling.

Smithsonian Secretary Charles Abbot, mindful of the troubled story of the donation of the Wright *Flyer*, sent Lindbergh a congratulatory telegram upon his arrival in Paris and requested the donation of the aircraft. Lindbergh was flattered, but noted that his financial backers had a claim on the aircraft. People across the country wrote letters to the Smithsonian and to

editors of newspapers hankering for the plane to be donated to the national collections. Lindbergh's backers agreed. On April 30, 1928, the *Spirit of St. Louis* made its final flight—from St. Louis to Washington, D.C., where Lindbergh presented the aircraft to the Smithsonian.

If Lindbergh was America's flying hero, its heroine was Amelia Earhart (1897–c. 1937). Beginning with the scrapbook of accomplished women that she kept as a child in Kansas, Earhart exhibited no shortage of independence and a determination not to let her horizons be limited by gender. She took a course in auto repair and attended college; she worked a variety of jobs throughout her early years, among them nurse, social worker, telephone company clerk, truck driver, and photographer. She took her first flight in California in December 1920, and afterward declared, "As soon as I left the ground, I knew I myself had to fly." Her first instructor was a woman, Mary Neta Snook, who gave her lessons in a Curtiss Jenny. She purchased a plane and began flying in various competitions along with

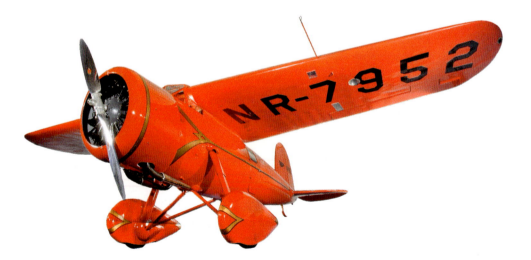

other women pilots. As a result of the efforts of publisher George Putnam, she flew across the Atlantic as a passenger in 1928. Putnam became her manager and companion, and a few years later her husband. He promoted her heavily in the 1929 Women's Air Derby, the first all-female "transcontinental" (from Santa Monica, California, to Cleveland, Ohio), which caused a sensation among the press. She finished third. That same year she helped to found the Women Pilots Association.

Earhart was determined to then replicate Lindbergh's solo flight across

the Atlantic. In 1930 she bought this Vega 5B and called it her Little Red Bus. Introduced in 1927, the Vega was the first product of designer Jack Northrop and Allan Loughead's Lockheed Aircraft Company. Sturdy and fast, the Vega was innovative at its time and was used by pilots trying to set speed and distance records. The plane had an internally braced one-piece spruce wing and a spruce veneer molded fuselage that strengthened the craft and reduced its weight. The cowling and wheel pants reduced drag and gave it a streamlined style.

On May 20–21, 1932, Earhart, flying this red Lockheed Vega 5B, left Harbour Grace, Newfoundland, Canada, headed for France. Flying solo, Earhart fought a number of obstacles, including fatigue, a leaky fuel tank, and a cracked manifold that spewed flames out the side of the engine cowling. Ice formed on the Vega's wings and caused a sudden three-thousand-foot descent. Realizing she was on a course far north of France, she landed in a farmer's field in Northern Ireland. Acclaimed in London, Paris, and Rome, she returned home to a ticker-tape parade in New York City and honors in Washington, D.C.

Later, in August 1932, Earhart made the first solo nonstop flight by a woman across the United States—also in this plane. She flew 2,447 miles from Los Angeles to Newark, New Jersey, establishing a women's record of nineteen hours and five minutes.

Earhart set her sights on an around-the-world flight in 1937. She flew from California to Hawaii in a twin-engine Lockheed 10E Electra on the first leg. Suffering a crash on takeoff from Hawaii, Earhart shipped her damaged plane back to California for repairs, with plans to resume her around-the-world attempt, this time traveling east. On May 20, 1937, she took off from Oakland, California, with Fred Noonan as her navigator. By June 29, they had flown across Africa, the Middle East, South Asia, and Australia to a landing at Lae, Papua New Guinea. On July 2 they took off for tiny Howland Island for refueling before continuing on to Hawaii and the West Coast. A U.S. Coast Guard cutter heard her radio transmissions as she approached the area, but she never arrived. Despite a massive search, the

plane was never found, and Earhart and Noonan were declared lost at sea. Americans, and indeed people around the world, were shocked by her loss. Earhart's unsolved disappearance has continued to spawn a wide variety of theories that sometimes overshadow her true contributions as a pioneer of aviation.

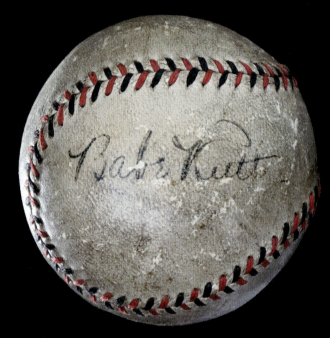

"BABE RUTH" AUTOGRAPHED BASEBALL *National Museum of American History*

G od, we liked that big S.O.B. He was a constant source of joy," said former Yankee teammate Waite Hoyt, capturing the sentiment of many Americans at the funeral of Babe Ruth.

George Herman "Babe" Ruth (1895–1948) was a legend on and off the baseball diamond. An athlete of tremendous accomplishment, a fan favorite who was always getting into trouble, he almost singlehandedly made baseball the national pastime in the 1920s.

BABE RUTH AUTOGRAPHED BASEBALL

This particular baseball, autographed by Babe Ruth, came to the Smithsonian as a gift from Juliana C. and Robert M. Jones, in memory of their late father, Thomas J. Jones of Scranton, Pennsylvania. Thomas Jones received it from his father, Evan Jones, who had asked Ruth to sign it for him during one of Ruth's visits to Scranton in the 1920s. Ruth signed a lot of baseballs and other mementos. It was one of the things he did that endeared him to fans and helped connect millions to the game.

Ruth grew up in Baltimore, a poor, neglected, and delinquent child. As a boy living at the St. Mary's Industrial School for Boys, he discovered his love and talent for baseball. Ruth joined the local minor league team, the Orioles, in 1914. The Boston Red Sox bought Ruth's contract, and he pitched for their local minor league club, the Providence Grays, for most of the season. In 1915, he was on the Red Sox squad. He won 18 games, lost 8, and batted .315, helping the team get to the World Series. The next year, he emerged as one of the best left-handed pitchers in the league. He could also hit, breaking the major league home run record with 29 home runs in 1918. As a Red Sox player, Ruth not only struck out Ty Cobb, one of the best hitters to ever play the game, but also hit 10 home runs off and outpitched Walter Johnson, one of the league's all-time best pitchers. But to

A SOUVENIR MARKS AMERICA'S EMBRACE OF A SUPREMELY TALENTED SPORTS HERO.

National Museum of American History

the dismay of Red Sox fans ever since, after leading the Sox to two World Series titles, Ruth's contract was sold to the New York Yankees following the 1919 season.

Ruth anchored the Yankees teams of the 1920s, becoming baseball's most exciting player and transcending sports to become a well-known American celebrity. His astonishing prowess and showmanship proved a great uplift to professional baseball when it needed it most. Ruth's career took off in the wake of the infamous 1919 Black Sox scandal, in which several Chicago White Sox players conspired to intentionally lose the World Series to the Cincinnati Reds for money. The scandal badly damaged the game's wholesome public image.

The Yankees converted Ruth from a pitcher to a right fielder. He excelled as a crowd-pleasing slugger, setting a number of long-standing records, including those for home runs in a season (60), lifetime home runs (714), and runs batted in (2,213). As the nation sank into the collective despair of the Great Depression, Babe Ruth's seemingly unstoppable talent provided a welcome diversion as he led the Yankees to seven pennants and four World Series titles. After a final season playing for the Boston Braves, Ruth retired in 1935, and was one of five initial players inducted into baseball's Hall of Fame the following year.

Nicknamed "the Bambino" and "the Sultan of Swat," Ruth dominated the game like no player before or since. He made baseball immensely popular, both with his on-field performance and off-field mixture of high-profile rowdiness and good charitable works, which included visiting children in hospitals, schools, and orphanages as well as donating money to these and other worthy causes.

Baseball was a different game after Ruth came on the scene. Until 1920, games had been slow-paced lower-scoring matchups, dependent on good pitching and fast base running. They were slow-paced. Ruth turned baseball into an exciting slugfest, hitting 54 homers in 1920, 59 in 1921, 35 in a shortened 1922 season, and 41 in 1923, when the Yankees moved from the Polo Grounds—home of the rival New York Giants—to their new Yan-

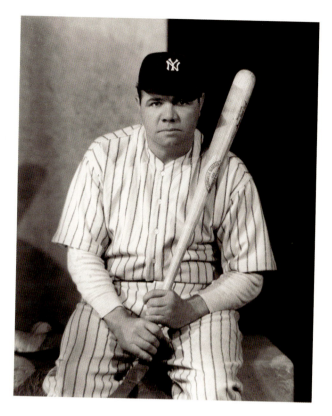

kee Stadium. Ruth packed in the fans and kept them on the edge of their seats waiting expectantly for his next towering shot into the stands. Indeed, sparkling new Yankee Stadium was called The House That Ruth Built, because of his popularity with the fans and success in bringing paying customers to the game. That year, 1923, the Yankees finally beat the Giants in the World Series.

Ruth is associated with what has come to be known as the live-ball era. Baseballs in Ruth's time had a cushioned wooden or cork core around which more than a mile of yarn was wrapped and sewn into a horse-hide leather finish or covering, leaving a large stitched seam around the exterior. Balls were about 9 to 9¼ inches in circumference and 2⅞ to 3 inches in diameter. Prior to 1920, with relatively few home runs hit, the ball was retrospectively

BABE RUTH BY

NICKOLAS MURAY

National Portrait Gallery

termed a "dead ball." After Ruth, it became live. Some baseball historians have attributed this to actual changes in the making and construction of baseballs. Owners of the teams wanted more home runs and a livelier game because they generated fan excitement and sold tickets. Some believe baseballs were wound tighter after 1920, producing a "juiced" ball that would take off when hit and go a longer distance. Others attribute the post-1920 live-ball era to Ruth and his influence on other players. Ruth took a bigger swing with an upward trajectory and was successful in connecting for the long ball; other players started imitating his swing and also met with success. Still other analysts attribute the reasons for the increase in home runs in the 1920s to the banning of the spitball and the more frequent replacement of dirt-covered balls. Whatever the reason, the 1920s saw more home runs, exciting more fans and increasing attendance at games.

Ruth was equally flamboyant off the field. He could be effusively friendly, making exorbitant gifts. Following the pattern of his youth, Ruth was always doing reckless things—carousing, drinking, overeating, and pushing the boundaries of acceptable conduct. On the field, he'd hurl dirt at opposing players, curse umpires, and even threaten hecklers in the stands. Still, players and fans forgave him, and his reputation for impulsive behavior became part and parcel of his larger-than-life persona.

Less readily excusable was Ruth's violation of the league rules set by baseball commissioner Judge Kenesaw Mountain Landis. Landis had forbidden players in the World Series from playing in barnstorming games after the series. He thought the barnstorming (informal off-season exhibition games usually played in small towns and rural locations) took away from the dignity of the game and also posed the possibility that the league's proprietary championship games could be unofficially repeated after the season ended. Looking to earn a little extra income, Ruth and other players started a barnstorming tour in the 1921 postseason, openly defying Landis. The tour ended in Scranton, where Ruth was supposedly so popular that the coal mines shut down operations and the schools closed early so fans could see him play. Nevertheless, Commissioner Landis fined Ruth an amount equal

to his World Series winnings, and suspended him from playing the first seven weeks of the next season. Landis, apparently more agitated by Ruth's open defiance than by the principle of the matter, subsequently rescinded the no-barnstorming policy.

Evan Jones most likely obtained the Smithsonian's ball during another of Ruth's visits to Scranton and nearby Wilkes-Barre a few years later. The baseball has black and red stutching, colors used for National League balls from the late 1920s until the early 1930s.

In 1926, Ruth visited the region just after the Yankees lost the World Series to the St. Louis Cardinals. He played in a widely advertised afternoon exhibition game that drew hundreds of youngsters hankering to see the Babe up close. Many had him sign autographs before the game; some even ran on the field, interrupting the game, to get his handshake. After the game ended, Ruth stayed on the field, challenging four pitchers to a contest to see if they could best him. They each threw their pitches, trying to strike him out, and he smacked a few over the fences. The last pitcher threw him a fastball that he belted out a reported distance of more than six hundred feet—possibly the longest a baseball has ever been hit. Perhaps Evan Jones got his ball autographed that day.

While Babe Ruth was arguably the dominant sports figure of the 1920s, he was hardly alone. Professional athletes were coming into their own in a variety of sports where amateur athletics had previously prevailed. Indeed, the star athlete of the previous decade was Jim Thorpe, a Native American athlete who had won gold medals for the pentathlon and decathlon at the 1912 Olympics in Stockholm. After being declared the greatest athlete in the world by King Gustav of Sweden, he was stripped of his medals because he had been paid as a semiprofessional baseball player. (This act, tinged with the racism of the time, was overturned in 1983, thirty years after Thorpe's death.) In the 1920s, Jack Dempsey was the highly regarded heavyweight boxing champion. Red Grange had gone from the University of Illinois to the National Football League's Chicago Bears, and made professional football as exciting and popular as the more established college

version. Bill Tilden was winning professional tennis championships, and even the amateur Bobby Jones was besting professionals in every major golf championship. It was a time when outstanding talent and performance in sports made star athletes into national heroes. Women athletes like Helen Wills, who dominated in tennis, and Gertrude Ederle, who bravely swam the English Channel, were also becoming well-known and respected. Some two million New Yorkers turned out to cheer Ederle in a ticker-tape parade after her feat in 1926.

But none among these remains as well-known today as Babe Ruth, even sixty-five years after his death. And while many of his records have since been broken, no player has ever surpassed the devotion that the Babe elicited from his fans. Evan Jones was one such fan, and his baseball allows the Smithsonian to pay tribute to the man teammate Waite Hoyt called "the greatest crowd pleaser of them all."

GREAT

DEPRESSION

(1929 TO 1940)

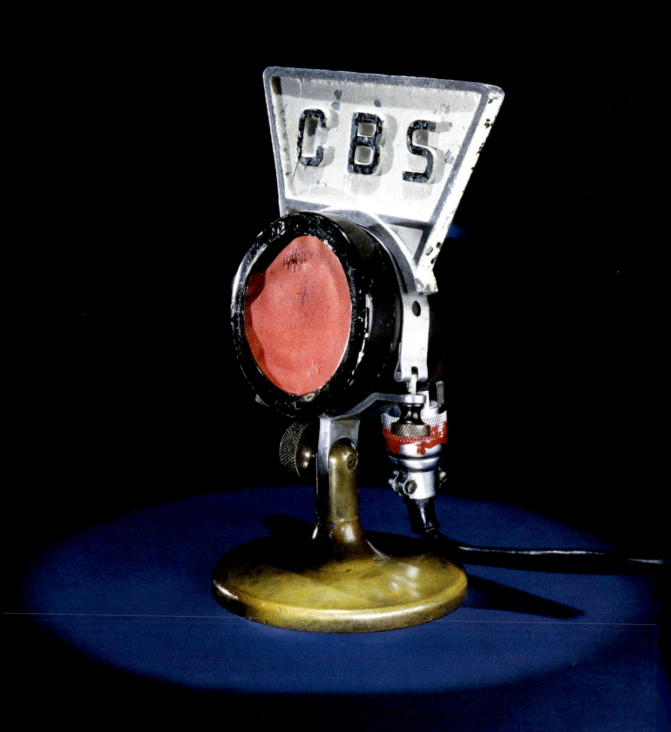

CBS RADIO MICROPHONE *National Museum of American History*

M y friends, I want to talk for a few minutes with the people of the United States about banking."

So it began, on Sunday night, March 12, 1933, the first of thirty-one informal "Fireside Chat" radio addresses that President Franklin Delano Roosevelt would deliver through a bevy of microphones from different stations and networks to an audience of millions of Americans brought together by the new technology of radio.

FRANKLIN D. ROOSEVELT'S "FIRESIDE CHAT" MICROPHONE

Just over a week before, on March 4, Roosevelt had been sworn in as the thirty-second president of the United States. The nation was in the throes of the worst economic depression in its history. Unemployment was at about 25 percent. Industrial production was down by about a third from precrash levels. The banking system was collapsing. No president with the exception of Abraham Lincoln entered the White House with as severe a crisis as that which confronted Roosevelt.

The Roosevelts had still not unpacked their belongings from trunks and wooden cases delivered from Hyde Park to the White House when the president gave his first address on the crisis and the concerns Americans had about their banks and their money.

Radio, Roosevelt believed, was the way to do it. Prior to radio, presidential speeches had been reported on in the newspapers, and by the 1920s had mainly been shown in newsreels and recorded for later use. Roosevelt's predecessor, Herbert Hoover, had tried to communicate by radio, but did so rarely and poorly. His speaking style was condescending and stilted. He came across to listeners as distant and impersonal; the inferior quality of the radio broadcast and reception did not help.

A NEWLY ELECTED PRESIDENT REASSURES THE NATION IN THE MIDST OF ECONOMIC COLLAPSE.

National Museum of American History

Commercial radio was a new phenomenon; however, its popularity had mushroomed quickly from the first broadcasts in late 1920 from station KDKA in Pittsburgh. And while new radios had sold for a hefty average price of $139 in 1929, their cost was down to $47 by the time of Roosevelt's talk. The economy had not depressed sales, especially as the installment plan had become popular as a means of purchasing them. Ownership of radios had gone from one third of U.S. households in the late 1920s to some 60 percent by 1933.

Roosevelt informed the Columbia Broadcasting team and others that he was going to give the radio talk so they could block out the time and make the arrangements. Robert Trout, a radio announcer, recalled that it was one of his colleagues, "Harry Butcher or Ted Church who had the original idea of calling the speech a 'Fireside Chat,' and while I don't actually remember which it was, I do recall that a day or two before the broadcast President Roosevelt approved the idea and said it fit the kind of informal talk that he meant to give."

For the first Fireside Chat, CBS technician Clyde Hunt was among those asked to set up microphones upstairs in the White House in the Lincoln Study. Subsequent chats were held in the Diplomatic Reception Room on the ground floor of the White House. Hunt installed a microphone on a heavy brass base specifically designed for use on the president's desk.

In an account that Trout's wife later sent to the Smithsonian, he recalled:

We had a new sign on our microphones that said "CBS." Before that, the signs said "Columbia" and the authorities in New York had begun to notice that, in pictures published in the newspapers, the signs on the microphone of the only other network were easily readable—"NBC"—but one could seldom make out all those little letters that spelled "Columbia." So, at last, they had decreed new microphone signs and President Roosevelt, when he had seated himself at the table from which he was going to broadcast, looked at the

microphones and then addressed his first words to us in the form of an historic question. He said: "What is CBS?"

According to Trout they started to explain, but then a crisis intruded—no one could find the president's written speech. They were due to begin broadcasting live on the radio in just a few minutes—at ten P.M.

White House staff went scurrying around to look for the president's copy but couldn't find it. Time was ticking away. Steve Early, the press secretary, took off to his office to get the copy he'd used for the press release—but he'd never make it in time. Another aide, Carleton Smith, had a mimeographed copy that was intended to be released to the newspapers after the broadcast. The president used that, and had had to remember where he had made edits and improvise some of them. Subsequently, Roosevelt's original edited copy was discovered in his bed, where he had last read it.

Roosevelt smoked a cigarette as he gave the radio talk. Indeed, the CBS crew worried that as his cigarette burned down he would burn himself and interrupt the broadcast. Roosevelt's presentation was straightforward and given in his natural voice, a bit slowed down from his usual cadence. He had a fine radio voice. Many commentators later opined it sounded patrician but not jarringly so. He did not condescend to his listeners—indeed, there was a good bit of technical talk, as Roosevelt explained the banking crisis and how he was handling it. He was firm and confident, but not histrionic, and ended with the following statement:

There is an element in the readjustment of our financial system more important than currency, more important than gold, and that is the confidence of the people themselves. Confidence and courage are the essentials of success in carrying out our plan. You people must have faith; you must not be stampeded by rumors or guesses. Let us unite in banishing fear. We have provided the machinery to restore our financial system, and it is up to you to support and make it work.

It is your problem, my friends, your problem no less than it is mine. Together we cannot fail.

Whether they listened on CBS or any one of the several other radio networks that broadcast the talk, many Americans felt as if the president were speaking to them personally. One wrote: "last evening as I listened to the President's broadcast I felt that he walked into my home, sat down and in plain and forceful language explained to me how he was tackling the job."

Roosevelt's chat had a dramatic and entirely new effect: it personalized the presidency for a vast number of Americans. It is estimated that by the time of his last address, some two thirds of American households had listened to his voice. As family members gathered around a radio in a living room or kitchen and turned a dial, they invited the president into their homes.

Naming the radio addresses Fireside Chats amused Roosevelt because Washington's weather—especially during the hot and humid months—seemed so inconsistent with the image of the president sitting beside a fireplace.

Roosevelt knew how important the Fireside Chats were in bringing the country along, and defended to his staff the extensive amount of time he used to prepare for them. The Fireside Chats continued through most of World War II until January 6, 1945, as he engaged and reassured the American people. Fearing that his own physical disability caused by polio would be perceived as weakness, Roosevelt believed he needed to control the way he was seen in his public appearances. On radio, though, facing some of the toughest challenges in the nation's history—the Depression and then the war—through his broadcasted voice, he came across as strong and at home with his countrymen.

The Smithsonian acquired this CBS microphone in 1964 from the Columbia Broadcasting System, Inc., and the locally affiliated station, WTOP Radio, which had held on to it. WTOP staff engineer Granville Klink had served as steward of this and other microphones and could vouch for its

historical role. Its identity was also confirmed by Clyde Hunt, the technician who had helped set up the original broadcast. In 1996, the Smithsonian also acquired one of the other microphones used in the Fireside Chats, an RCA Type 50-A with the National Broadcasting Company logo on the top and sides. It had been saved by Carleton Smith, who had been the radio announcer for the Fireside Chats and who went on to a distinguished career with NBC.

John L. Lewis (1880–1969), one of America's foremost labor leaders, wore this badge at the 1936 United Mine Workers of America (UMWA) convention held in Washington, D.C. The badge came to the Smithsonian as part of the Scott Molloy Labor Collection—about ten thousand artifacts documenting the history of workers' organizations in American society gathered by Molloy, a labor activist and labor historian at the University of Rhode Island who served as the president of his local Transit Workers' Union and earned his PhD while driving a bus. The iconography of the badge, with its red, white, and blue

JOHN L. LEWIS'S UNION BADGE

A DECORATION SYMBOLICALLY ACKNOWLEDGES THE AMERICAN CHARACTER OF THE LABOR MOVEMENT AT A PIVOTAL TIME.

National Museum of American History

ribbon, the American eagle, and the U.S. Capitol, very directly asserts the patriotism of the union at a time when the labor movement was at a political crossroads. The badge speaks to the direction taken.

The labor movement in the United States has a complex history. Efforts prior to the Civil War by men and women to organize workers in small shops, factories, and mills were typically small-scale, regional, and short-lived. Their demands, though, were common and persistent—a fair wage, sensible hours and benefits, and decent working conditions. Until the case of *Commonwealth v. Hunt* in 1842, when a Massachusetts court decided that unions were legal, workers who banded together seeking such improvements could be and were convicted of criminal conspiracy to restrain the trade of their employers.

With the post–Civil War expansion of the railroad, coal, iron and steel, mining, and textile industries, the organization of labor in the United States changed. The need for workers in the northern manufacturing mills drew large numbers of immigrants from Ireland and Germany while the building of railroads in the West drew workers from China. Owners and managers, seeking profits, kept wages low. Citizens wanted restrictions on new immigrants who might depress their wages. New immigrants wanted and needed

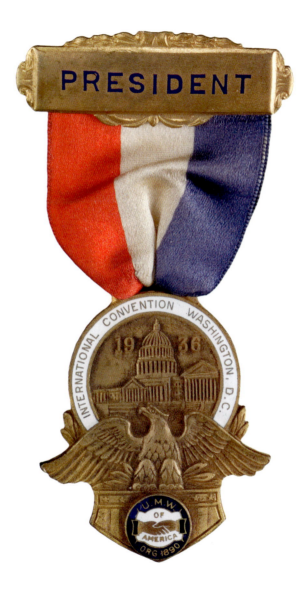

UNITED MINE WORKERS UNION PRESIDENT'S BADGE

National Museum of American History

jobs. Employers did not want new immigrants to bring with them revolutionary ideas, particularly from Europe, about workers' rights, socialism, and communism; they wanted them to become truly "American." But some of those Americans believed laboring for fair wages was in conformity to American ideals—not some foreign ideology.

The result of these social and economic tensions was a succession of attempts over several decades in the latter half of the nineteenth and early twentieth centuries to organize unions—from the failed National Labor Union to the successful International Ladies' Garment Workers' Union (ILGWU), from the radical Socialist International Workers of the World, which wanted to overthrow the U.S. capitalist system, to the American Federation of Labor (AFL), which organized skilled trades but long neglected more unskilled occupations employing women, immigrants, and minorities. Periodic strikes, lockouts, boycotts, and violence made the line between business and labor a contentious one.

The federal government tended to avoid intervening in disputes between business owners and labor, save in special circumstances and then typically on the side of business. The Sherman Antitrust Act of 1890, intended to curb the power of business monopolies, ironically had its first major application against the Railway Union in the Pullman strike of 1894. The Haymarket bombing associated with the Chicago labor strike of 1886, the Homestead Carnegie steel lockout and strike of 1892, the Cripple Creek, Colorado, miners' strike of 1894, and the New York shirtwaist strike of 1909 were among the most jarring of the spasms that focused public concern. Unions bore the brunt of nativist fears of Communist and Socialist influences on U.S. politics, fears that led to federal anti-immigration legislation, including the Quota Act of 1921 and the National Origins Act of 1924. Some unions spurned new immigrants, but others became de facto aid organizations for them, assisting immigrants in finding jobs and homes, learning English, and gaining citizenship.

John Lewis lived this history. He was born the son of Welsh immigrants in Cleveland, Iowa—essentially a coal-mining camp—and went to

work as a miner at the age of fifteen. Elected as a local delegate to the United Mine Workers of America convention in 1906, he rose quickly through the union. In 1911 he was hired by Samuel Gompers, head of the American Federation of Labor, to organize coal and steel workers. Lewis later returned to the UMWA, becoming acting president in 1919. In November of that year he called his first major coal union strike, and 400,000 miners walked off their jobs. President Woodrow Wilson obtained a court injunction to stop it, which Lewis obeyed, famously telling his members, "We cannot fight the Government." Months later he was elected president of the UMWA, a post he would hold for four decades.

At the time, coal miners around the world tended to be sympathetic to socialistic approaches to the industry. Coal mining was a tough, brutal, and risky business. Coal was vital to the economy, and owners could make very high profits, especially if they could save money by skimping on safety, or by paying workers low wages. Miners and unions thought it better for governments, rather than private owners, to operate those mines.

Through the 1920s, Socialists and Communists tried to seize control of UMWA locals, and had some success in the Midwest. Lewis, no radical, fought these actions. But he also had to fight for labor contracts with coal mine owners. In 1924 he tried to get mine workers a $7.50 per day basic wage in a new three-year contract; when that failed, he called a strike. He then faced off against the owners, who brought in nonunion labor. It took constant campaigning and organizing to pressure the owners while holding the union membership firm. Lewis was able to settle the strike, but had to deal with UMWA radicals who wanted to hold out and even take control of the union. In response, Lewis assumed tighter supervision over the locals, packing union leadership with hand-picked subordinates and using the union's publications and conventions to discredit left-wing radicals. Sometimes this conflict degenerated into armed assaults and fraudulent union elections. By the late 1920s, Lewis had expelled some of the radicals, who formed their own alternative mine workers' unions.

The 1930s were a turning point for organized labor. From afar, the

Soviet Union was seen by some to have a thriving and fair economy, while America was in a Depression. Did the Depression represent the failure of capitalism? Should the United States adopt more carefully managed, Socialist, or even Communist approaches to its economy? Business, Republicans, and people on the right tended to think that President Roosevelt was doing just that with his New Deal. A number of intellectuals, leftists, and unionists believed Roosevelt needed to go further—turning policies already regarded as "pink" into those that were "red," or Communist.

Lewis had to navigate carefully and made a choice. He joined together support for two causes—strengthening the union and reelecting Roosevelt. Membership in the UMWA had fallen to seventy-five thousand. Lewis led a massive union membership drive, declaring, "The President wants you to join the UMW!" To enlarge membership he appealed to immigrant workers who had never voted and never before joined the union in large numbers. He recruited African Americans, causing some resentment in white coal country even though the union's charter discouraged discrimination on the basis of race, gender, and national origin.

Lewis believed that organizing labor on the basis of industries (for example, everyone who worked in steel mills) rather than by trades or crafts (such as electricians who worked in different industries) would make unions more popular and effective. The AFL was organized around the trades, generally those of higher-skilled workers. Lewis knew that unskilled workers also needed representation, and he pushed the AFL to endorse industrial unionization. In 1935 Lewis formed the AFL's Committee for Industrial Organization with the UMWA, the steelworkers, the ILGWU, and the clothing workers, among others.

Union organizing and membership expanded rapidly with the passage in 1935 of the National Labor Relations Act (NLRA), also known as the Wagner Act, which protected the rights of workers and unions to organize, engage in collective bargaining, and participate in strikes and other activities. It also created the National Labor Relations Board to oversee rela-

tionships between the businesses and unions. This proved a huge boost for Lewis's overall unionization efforts.

Lewis's success at union recruiting—he added hundreds of thousands of new members to the UMWA alone—combined with Roosevelt's labor-friendly New Deal policies to make unions a powerful force in the 1936 presidential election. Lewis genuinely did not want labor to be painted red by the radicals, nor did he want conservatives, the business community, or nativistic opponents to disparage the union movement—as they often did—because of its association with immigrant workers and leftists. He scheduled the 1936 election-year Mine Workers Union convention for Washington, D.C., to showcase the patriotism and all-American character of the union. The patriotic iconography of Lewis's own presidential badge was meant to refute the suspicion that unions were somehow anti-American. Union badges had been designed and worn for decades as markers of identity, solidarity, and authority. Although many incorporated red-white-and-blue-colored ribbon and the eagle, others had symbolism suggestive of different loyalties—badges with red ribbon and engravings of the world's continents, indicating a more class-oriented labor struggle. In choosing a badge with the American eagle, the U.S. Capitol building, and the colors of the flag, Lewis was proclaiming that unionism was part and parcel of American life.

The American left was brought into the fold of New Deal liberalism; Roosevelt won the 1936 election with heavy labor support. Lewis's industrial strategy proved successful, with unions reaching collective-bargaining agreements with General Motors and U.S. Steel in 1937. While some of the union legislation that had passed was subsequently ruled unconstitutional, most of it stayed in place and has defined the relationship between business and labor ever since.

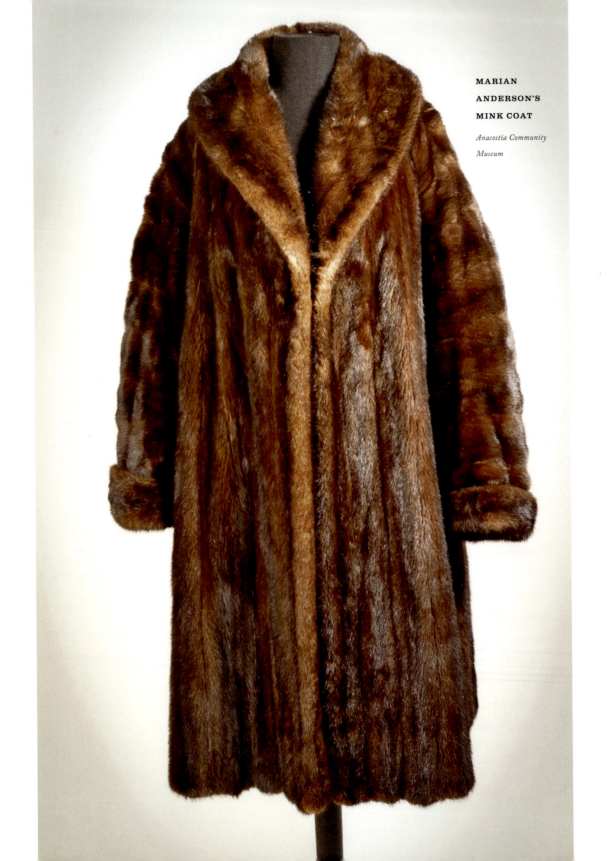

On Easter Sunday, April 9, 1939, African American contralto Marian Anderson performed an unprecedented open-air concert on the steps of the Lincoln Memorial in Washington to a huge live audience and to millions more over the radio. The actor and playwright Ossie Davis, then a student at Howard University, was in the crowd and reported on the experience:

MARIAN ANDERSON'S MINK COAT

It was a cold and dreary day, and Marian Anderson was on the front steps in her mink coat. Standing there were seventy-five thousand people, and the student body [of Howard University] was included, listening to her. All of a sudden, I had a transformation that was almost of a religious nature. Ah, something in her singing, something in her voice, something in her demeanor entered me and opened me up and made me a free man. And, in a sense, I never lost that. So, she became the kind of angel of my redemption through her art. Also, her example taught me, in a very concise fashion, exactly what I wanted to be about. I wanted to be able to do with writing what she was able to do with music and song. . . . Marian Anderson, on that particular day, opened the doors of my prison, and I walked out a free man.

AN EVENT MARRED BY RACIAL PREJUDICE IS TRANSFORMED INTO A MOMENT OF NATIONAL ACCLAIM AND RESPECT.

Anacostia Community Museum

The mink coat became a symbol of the day, reminding all that the concert took place outdoors—not by initial design, but because Marian Anderson had been denied an indoor stage at Constitution Hall because she was African American. The coat attests to the fact that a narrow act of racial prejudice had been transformed into a public performance that commanded national respect. The fact that it was a mink coat—a recognized symbol of high status for women at the time—also illustrates that despite stereotypes

and obstacles, an African American woman could transcend entrenched social and cultural barriers to achieve fame, fortune, and success.

Marian Anderson (1897–1993) was born and raised in Philadelphia to religious, working-class parents. She was close to her grandfather, who had been freed from slavery, and was influenced by his stories of the struggles of African Americans to achieve respect and equality. Anderson's prodigious vocal talents were recognized from an early age, as a singer for Philadelphia's Union Baptist Church and People's Chorus and later for the Camp Fire Girls. Her church pastor led an effort to raise funds for her to attend South Philadelphia High School. After graduating, Anderson applied to an all-white Philadelphia music academy but was summarily turned away after being told, "We don't take colored." She persisted, studying with a private tutor, and in 1925 won a singing contest that earned her a performance with the New York Philharmonic.

Anderson's career took off from there. She acquired a voice coach and manager, gave classical singing recitals, and, in 1928, made her debut at Carnegie Hall, then the apex of American performance venues. In spite of this, systemic racial prejudice meant that very few American theaters and opera companies would allow Anderson to perform. Undaunted, Anderson embarked on a singing tour of Europe. The tour and the acclaim received from European critics established her reputation in the United States. Composer Jean Sibelius and others were moved by her contralto voice and deep, soulful renditions; she formed lasting relationships in the international classical music community.

In 1934, Sol Hurok, famed theatrical producer and impresario, became Anderson's manager; with his acumen and her reputation, the walls of racial segregation began to crumble. In 1935, she opened her American tour with a recital at New York's Town Hall to a rousing reception, and she gave standing-room-only concerts in theaters across much of the United States and Europe in the years that followed. The Europeans, particularly Scandinavian and Russian fans, had "Marian fever." In Salzburg, conductor Arturo Toscanini told her she had a voice "heard once in a hundred years." At home

in the United States, Anderson gave perhaps five or six dozen concerts a year. While on tour she would sometimes face discrimination—denied a room at a whites-only hotel or a table at a restaurant. Jim Crow segregation was not limited to the South: Albert Einstein hosted her after she was refused accommodation in Princeton, New Jersey, before a performance at the university. She and Einstein became lifelong friends. While Anderson faced these indignities on the road, her studio recordings of arias became big sellers.

For Easter 1939, Anderson was scheduled to perform in Washington, D.C., in a concert sponsored by historically black Howard University. The search for a venue was complicated, as the nation's capital was still a segregated town. A church venue did not work out, and the auditorium at a black high school was too small.

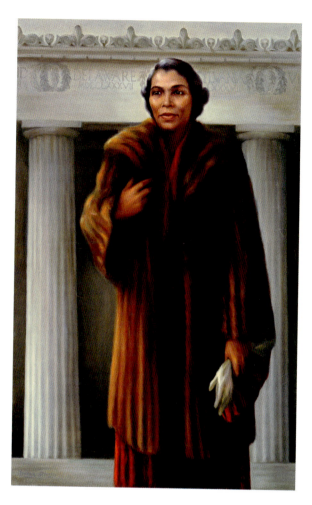

MARIAN ANDERSON BY BETSY GRAVES REYNEAU

National Portrait Gallery

White and black audiences wanted to attend. Still, the city government denied Anderson use of Central High School, because it was a white school and its policies forbade admission to an integrated audience. The denial provoked petitions and outrage among the District of Columbia's black leaders, the black community, and their liberal white supporters. Hurok tried to book Constitution Hall, which was administered by the Daughters of the American Revolution (DAR), an organization of white women representing descendants of Revolutionary War officers, officials, and soldiers.

The DAR turned Anderson down, claiming that the hall was booked. But it became apparent that in fact they did not want to host a black performer or set a precedent of integrating the hall with a mixed audience. Their refusal produced protests. Eleanor Roosevelt, who had become a member shortly after her husband became president, spoke out, saying, "To remain as a member implies approval of that action, and therefore I am resigning."

Marian Anderson commented, "I am not surprised at Mrs. Roosevelt's action because she seems to me to be one who really comprehends the true meaning of democracy. I am shocked beyond words to be barred from the capital of my own country after having appeared almost in every other capital in the world."

Following Eleanor Roosevelt's example, hundreds of other members resigned from the DAR. Some local branches distanced themselves from the DAR's decision, while others vocally supported it. The national press picked up the story, and as the controversy escalated, the D.C. Board of Education reversed its decision and approved the concert permit for Central High, but it was too late. The president and Eleanor Roosevelt, working with Anderson's manager, Sol Hurok, and Walter White of the National Association for the Advancement of Colored People, arranged with Secretary of the Interior Harold Ickes to hold the concert under the auspices of the National Park Service at the Lincoln Memorial. The plan immediately captured the national imagination. One reporter wrote, "Out of the narrow-minded mixture of red tape and prejudice which has kept Marian Anderson, the great negro contralto, from the concert stage in this capital of democracy, is growing as if with divine justice one of the most notable tributes of recognition ever accorded a member of this long suffering race."

The day of the concert, crowds began to arrive before dawn. They came prepared with blankets, umbrellas, and raincoats, as the weather promised to be cold and wet. Police were in full force; some five hundred uniformed officers patrolled the Mall in case there was any trouble. The crowd swelled to more than seventy thousand people, black and white. Anderson arrived by

train at Union Station at 1:25 P.M. She was hosted at the home of Gifford Pinchot, a Roosevelt adviser, a Republican, the founder of the Forest Service, and a former governor of Pennsylvania, before arriving at the memorial at 4:30. A simple wave of her gloved hand brought forth thunderous applause.

At 5:00 she took her place on the steps, adorned in her mink coat and matching hat. She was introduced by Harold Ickes, who stood before an assemblage of microphones broadcasting across the United States as well as to Canada and Mexico. "In this great auditorium under the sky, all of us are free," he said.

Anderson then took off her mink hat, and began her first selection, "America." Closing her eyes, then opening them and gazing upward to the sky, she sang, "My country 'tis of Thee, / Sweet Land of Liberty / of thee *we* sing." A hush of silence fell over the crowd as she concluded; many were moved to tears. No one applauded, sensing that to do so would have been an intrusion upon a sacred moment.

Accompanied by her pianist, Kosti Vehanen, Anderson then sang two arias, "O Mio Fernando" and the haunting "Ave Maria." When she sat down for a break, the audience erupted in an outpouring of emotion and appreciation.

The second half of her performance included spirituals, "Gospel Train," "Trampin'," and "My Soul Is Anchored in the Lord." She closed the concert with the resonant "Nobody Knows the Trouble I've Seen." Then, briefly, Anderson addressed her audience. Without politics or commentary, she humbly apologized for not being a good speaker, and thanked them sincerely for their attention and appreciation.

The mink coat from that day came to the Smithsonian more than fifty years later. Anderson and her husband, Orpheus Fisher, had long made a lovely home called Marianna Farm in Connecticut. Fisher died in 1986, and in 1992 the family was moving the now-frail Anderson to Oregon to be closer to them. As her nephew, James DePriest, the longtime conductor of the Oregon Symphony, described it, they found seven of her furs. Most were in terrible condition. But the long brown mink coat was there. It had

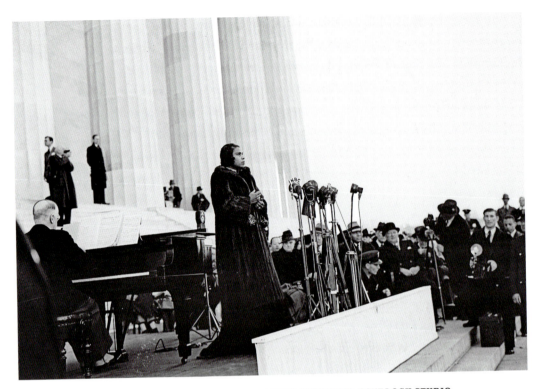

MARIAN ANDERSON AT LINCOLN MEMORIAL BY ROBERT SAUNDERS, SCURLOCK STUDIO

National Museum of American History

a tan lining and elegant gold trimming with her monogram. They had heard that the Smithsonian's Anacostia Museum was mounting an exhibition about the black history of Washington, D.C., and agreed to donate the mink to become part of the permanent collection.

After the Lincoln Memorial concert, Anderson went on to enjoy a full and acclaimed career. She entertained the troops performing concerts during World War II, and finally appeared at the DAR's Constitution Hall for a Red Cross benefit concert in 1943. In 1955, she became the first African American to perform at the Metropolitan Opera in New York. She sang at the presidential inaugurations of both Dwight D. Eisenhower and John F. Kennedy. She served as a U.S. representative to the UN Human Rights

Committee and as a goodwill ambassador. She toured the world. Active in the civil rights movement, she returned to the Lincoln Memorial with the Reverend Dr. Martin Luther King Jr. to sing for the March on Washington in 1963. And when she did her farewell performance tour, she began it at Constitution Hall and completed it at Carnegie Hall. She was honored for her achievements with a host of awards, from the UN Peace Prize to a Congressional Gold Medal and the National Medal of Arts. She received a Grammy Lifetime Achievement Award, and, upon her death in 1993, the U.S. government honored her by placing her likeness on a commemorative medal and a postage stamp.

Anderson inspired other classical artists of color, such as sopranos Leontyne Price and Jessye Norman. In her later years, she befriended and mentored mezzo-soprano and Washington, D.C., native Denyce Graves. In one of those "only at the Smithsonian moments," I had the opportunity of talking with Denyce Graves following the groundbreaking ceremony for the Smithsonian's National African American Museum of History and Culture. Graves had sung the national anthem at the event, and President Obama, who had made a speech, had invited some of the attendees back to the White House. As we waited for the president and Mrs. Obama, Graves asked me how the new museum was acquiring its collections. I told her that people were coming forth with all sorts of things from their attics and basements that told the story of African Americans in this country. She confided that she had something, and wanted to know if the Smithsonian might be interested. She told me how Marian Anderson had befriended her and given her a dress—though not the one worn that Easter Sunday—as a keepsake. I noted that we had the mink coat, and said that it would be glorious to reunite these two items. Months later, Graves donated the dress as a tangible reminder of the grace and talent of Marian Anderson.

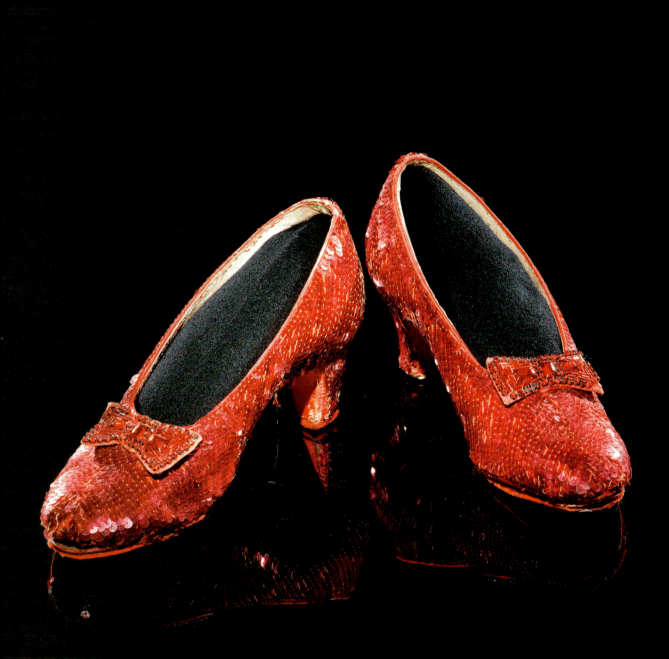

DOROTHY'S RUBY SLIPPERS FROM *THE WIZARD OF OZ*

National Museum of American History

™ & © *Turner Entertainment Co.*

60

I t took more than heel clicking to bring Dorothy's ruby slippers from the 1939 movie *The Wizard of Oz* to the Smithsonian. The acquisition began with an unsolicited letter in 1979:

I am currently the owner of the red shoes worn by Judy Garland in the Wizard of Oz. If the Smithsonian is interested in receiving them as a gift, or if you know of a museum that would be interested, please contact me.

DOROTHY'S RUBY SLIPPERS

The Smithsonian responded that it was indeed interested in the ruby slippers—one of the most famous Hollywood props of all time. It was collecting artifacts that documented American popular culture, and the Metro-Goldwyn-Mayer Depression-era film, with its reassuring tale of Kansan Dorothy Gale, a character played by Garland, was certainly that: it had won several Academy Awards, introduced the hit song "Somewhere Over the Rainbow," and become a classic to generations of movie fans. In the film, the shoes, delivered by the Good Witch after a disaster, carry Dorothy along a yellow brick road accompanied by her dog, Toto, and faithful companions, the Scarecrow, the Tin Man, and the Cowardly Lion. They survive a staggering array of challenges thrown at them by a wicked witch and arrive at a dazzling city of glittering fashion and novelty to seek wisdom from the wizard. They discover that the wizard is a charlatan, but Dorothy finds that the slippers hold the key to her finding happiness—her way back home.

A YOUNG GIRL'S FICTIONAL QUEST AND HER MAGICAL SHOES REMIND AMERICA THAT THERE IS "NO PLACE LIKE HOME."

National Museum of American History

The ruby red slippers celebrate the glamour of Hollywood's escapism as a relief from the troubles of daily life while also reminding us that plain old home isn't so bad and, ultimately, is where we belong. Some film histori-

GREAT DEPRESSION (1929 TO 1940)

421

ans believe the slippers represented Dorothy's independence and femininity, granting her magical powers while also causing her a lot of trouble. They led her to strong leaders and also enabled her to overcome their failures. Critics agree that the ruby slippers provide a fascinating, mythic symbol of American ambivalences about home, coming of age, and authority.

Before pursuing the acquisition, the provenance or origin and chain of possession had to be checked to ensure authenticity, and research confirmed that the shoes had been purchased in 1970 at an MGM auction of props and costumes. They had rested for years in relative obscurity on the storage shelves at the studio. Now these relics of a bygone age of Hollywood filmmaking would come to the Smithsonian through a donor who asked to remain anonymous.

It is not known exactly how many pairs of slippers were created for Garland and her stand-in, Bobbie Koshay. Estimates range from six to ten pairs. The shoes differed slightly in size, depending on whether they would be featured in close-ups, for walking, or for dancing. Curators know that the Smithsonian's pair was used for dancing sequences because they have a layer of felt on the soles that helped muffle the sounds of shoe leather on the soundstage floor.

The ruby slippers were designed by Gilbert Adrian, MGM Studios' chief costume designer. Just like any other standard movie costume, they were fabricated by the wardrobe personnel at MGM Studios in Culver City, California, and were intended to last for the six months of the film's shooting schedule.

The movie was among the first to use Technicolor—an innovative technology for color filmmaking that was to have a profound effect upon the slippers' design. Technicolor was invented by three men, Herbert Kalmus and Daniel Comstock, two Massachusetts Institute of Technology graduates (the "Tech" in Technicolor as a nod to their alma mater), and W. Burton Wescott, and was just reaching aesthetic and commercial success. Walt Disney had produced *Snow White and the Seven Dwarfs* in Technicolor, and it became the top-grossing film of 1938. All the film studios

started looking for projects to show off the vivid new imagery, and MGM chief Louis B. Mayer, envious of Disney's success, put his money on *The Wizard of Oz*.

The fantasy tale was based on L. Frank Baum's 1900 novel, *The Wonderful Wizard of Oz*. Baum's book and its thirteen sequels previously had been made into a cartoon, a stage musical, and several silent motion pictures before Mayer purchased the film rights for a whopping $75,000. Mayer envisioned a film made primarily for children, but he quickly realized he would have to sell a lot of tickets to adults to recoup his investment. Although eleven-year-old Shirley Temple was perhaps Mayer's first choice for the role, she did not work out. Instead, the lead went to the sixteen-year-old and very adult-sounding Garland, which helped broaden the film's appeal to teens and young adults.

Mayer correctly sensed that the story would strike a particularly resonant chord in a country struggling with despair and uncertainty in the wake of the Depression and the Dust Bowl. Americans needed reassurance and self-confidence. They would find it in a film that would demonstrate the triumph of the honest, traditional values of the rural heartland, albeit through the filter of fantastic, magical powers. Mayer was not alone in sensing the need for such a story. Jerry Siegel and Joe Shuster had been developing a character that burst on the scene in 1938 in Action Comics #1—Superman—who, coming to Earth from another planet, was adopted by a Kansas family and used his superpowers for "truth, justice and the American way."

Mayer thought the multihued realm of Oz—and its Art Deco Emerald City—would be an ideal vehicle to show off MGM's mastery of the innovative new visual technology. He came up with the idea of beginning the film on the tornado-ravaged prairie in sepia-tinted black and white in order to contrast it with the jaw-dropping, spectacularly colorful Land of Oz shot in three-strip Technicolor film.

For the generations of Americans who have grown up on the 1939 movie, it is hard to imagine that the magical shoes were, in Baum's book and in earlier theatrical versions of the tale, supposed to be silver. The adaptation

of Baum's books into a screenplay was entrusted to a number of writers, some of whom worked independently, spinning off several subplots that were never filmed but are nonetheless found in an early script in the Smithsonian's collection. But it was English novelist and playwright Noel Langley who is credited, in one of his numerous script revisions at the beginning of the summer of 1938, with a new stage direction that reads simply, "the ruby shoes appear on Dorothy's feet, glittering and sparkling in the sun." The change in color was intended to capitalize on the visual impact of the Technicolor process.

To achieve the effect, Adrian's wardrobe staffers tested several approaches for the slippers' design. One method was to buy a pair of leather shoes and spray them with patent-leather-looking paint, but this looked visually flat and unsatisfactory on Technicolor film. After several other experiments, Adrian came up with two designs for the slippers. One pair resembled something from a Middle Eastern fantasy. The slippers were covered with red sequins and costume jewelry with ornate curled toes. These became known

as the Arabian Test Shoes and were used only for test photographs of the costumes.

A second stylistic approach was to dye a commercially manufactured basic pair of silk pumps red. A red silk fabric sewn with rows of approximately twenty-three hundred crimson-colored sequins was then attached to the shoe. Adrian had to make a series of adjustments and calculations to achieve colors that would look right on camera. When filmed under the intensely bright lights required by the Technicolor camera, bright red appeared orange on-screen, and so dark burgundy, nearly brown, sequins were used to create a glistening ruby red. In October 1938, two weeks before film shooting began, Adrian added a final touch. He placed butterfly-shaped red leather bows garnished with red rhinestones, beads, and costume jewels on top of the slippers. This was reportedly at the request of director George Cukor—one of four different directors who worked on the project—who felt the butterfly bow helped convey Dorothy's youth and innocence.

The Smithsonian's slippers are size 5C silk-covered leather pumps with a small heel of one and a half inches. The right shoe has a label that reads "Innes Shoe Company, Los Angeles, Hollywood, Pasadena," confirming that the ruby slippers were fashioned from a manufactured pair of shoes.

Today, four pairs of ruby slippers that were used for the film, as well as the pair of Arabian Test Shoes, are known to exist. In 1938, the cost of making a pair of ruby slippers was estimated at about $15. At an auction in 2011, a pair used in *The Wizard of Oz* reportedly sold for more than $2 million—a dramatic indication of their value as a revered icon of twentieth-century American culture.

Although the sequins are now fading, the slippers have not lost their fame. They are among the most popular items on display at the National Museum of American History, where they continue to remind viewers that there is magic in everyday life, as well as in Hollywood.

61

"This Land Is Your Land" by Woody Guthrie is one of the most popular and long-lived tunes in the American songbook. Children learn it, often in elementary school. Some think it is such a cheerful and rousing song expressing a sense of collective national identity that it should be our national anthem.

WOODY GUTHRIE'S "THIS LAND IS YOUR LAND"

AN AMERICAN BALLADEER PENS AND SINGS A POPULIST ANTHEM FOR A NATION EMERGING FROM THE GREAT DEPRESSION.

Center for Folklife and Cultural Heritage

Woodrow Wilson "Woody" Guthrie (1912–67) was born in Okemah, a small town in Oklahoma, and was named for the Democratic presidential candidate by his father, a businessman involved in real estate, newspaper writing, and local and state politics. His mother, a teacher for the Creek Indians, was afflicted with Huntington's disease and was committed to an asylum when he was a teenager.

Guthrie learned to play the harmonica and guitar as a youth, and although he thought of himself as a musical vagabond, he was a voracious reader, and a member of both the high school band and the glee club. He went to live with his father in Pampa, Texas, when he was a teenager and married there when he was twenty-one. The Great Depression hit hard, as did a terrible drought. The lack of water combined with years of destructive farming practices left the Great Plains susceptible to wind erosion, and the region became known as the Dust Bowl. Guthrie left Pampa and joined thousands of others, including native Oklahomans, derisively known as Okies, heading to California looking for work and opportunity. This migration of poor, rural working folks trying to escape despair for an unknown but hopeful future stimulated much of his early songwriting.

Guthrie settled in Los Angeles, playing hillbilly and folk music on a radio program called *The Oklahoma and Woody Show*. He also included his own songs based on his Dust Bowl migration experience. His show evolved

ORIGINAL MASTER ACETATE RECORDING OF WOODY GUTHRIE'S "THIS LAND IS YOUR LAND"

Center for Folklife and Cultural Heritage

and was fairly successful. Guthrie's populist lyrics and social criticism led him to meet strong-minded New Deal Democrats, Socialists, and Communists and to a gig writing a regular column—"Woody Sez" for *People's World*. His prolabor views unnerved radio station sponsors and, facing censorship, Guthrie headed east to New York.

There, Guthrie was introduced to the leftist folk music scene through actor Will Greer. Early in 1940, he became frustrated hearing Kate Smith's version of Irving Berlin's "God Bless America" repeatedly on the radio. Berlin had written the song in 1918, but revised it in 1938, given the dark storm clouds of war gathering over Germany and Europe. Smith premiered the song on radio on the anniversary of World War I's Armistice Day that year, backed by a full orchestra playing a very dramatic arrangement. The song became very popular, but it annoyed Guthrie, who found it syrupy and overly celebratory. As he traveled across the country Guthrie had seen firsthand too much poverty, homelessness, and joblessness—many who did not seem to be so blessed. On February 23, 1940, Guthrie wrote his response.

Guthrie first titled the song "God Blessed America for Me." His lyrics were populist and hard-hitting. On one hand, the song celebrated the breadth and diversity of the United States, its natural beauty and bounty, and a profound, democratic sense that all Americans owned the country. On the other hand, it addressed tough issues—the Depression, the disparity of wealth, and economic and social injustice.

A few weeks later, in March, American folklorist Alan Lomax recorded hours of song and conversation with Guthrie for the Library of Congress, but the session did not include this new song. Guthrie also recorded the *Dust Bowl Ballads* for Victor Records. Around that time, Guthrie met Pete Seeger and the two became lifelong friends, traveling across the United States, engaging in spirited discussions, performing in concerts, taking up causes, and recording albums together. Guthrie also made friends with African American folk and blues musician Lead Belly. They hung out in Lead Belly's Manhattan apartment, performed together or on the same bill, and even joined together for a New York radio show.

Lomax recommended Guthrie for a job narrating and playing music for a film about the construction of the Grand Coulee Dam on the Columbia River. Guthrie headed to the Pacific Northwest and loved it, writing more than two dozen songs in 1941, including "Roll On Columbia." But years later, after World War II had ended, the sponsor, the Department of the Interior, became uncomfortable with Guthrie's leftist politics and canned the film.

Guthrie then headed back to New York, joining with Pete Seeger, Millard Lampell, Lee Hays, Butch Hawes, Bess Lomax, Sis Cunningham, and other musicians to form the Almanac Singers. They lived in a communal house in Greenwich Village, sponsored and participated in hootenannies, and penned and sang pro-union, protest, and peace songs. They were against the entry of the United States into World War II, but once Germany invaded the Soviet Union, they became prowar and anti-Nazi. Guthrie wrote "This machine kills fascists" on his guitar.

WOODY GUTHRIE
BY SID GROSSMAN

National Portrait Gallery

Among the New Yorkers, Guthrie was regarded as the most authentic artist on the folk music scene on account of his rural, Southern background and hard-won Dust Bowl experience. Lomax encouraged him to write an autobiography. The book, *Bound for Glory,* was published in 1943 and became a classic.

Guthrie wanted to perform for the troops during World War II, but ended up joining the Merchant Marine with singing buddy Cisco Houston. On leave in March 1944, Guthrie visited the New York City studio of Moses Asch, then the founder and operator of Asch Records. The small label

EARLY
HANDWRITTEN
DRAFT OF "THIS
LAND IS YOUR
LAND" BY WOODY
GUTHRIE, NEW
YORK CITY,
FEBRUARY 23, 1940

*Courtesy of the Woody
Guthrie Foundation ©
Woody Guthrie
Publications, Inc.*

later would be absorbed into Asch's life work, Folkways Records. Asch (1905–86) was a fiercely independent music producer who ran more of a cause than a record company. Inspired by a conversation with Albert Einstein, Asch made it his mission to record, literally, the sounds of the planet and its people. Son of famed Yiddish playwright Sholem Asch, he gravitated toward left-leaning intellectuals, songwriters with a message, and a whole variety of ethnic, religious, and other exotic traditions.

"One day, Woody comes in and squats himself on the floor," recalled Asch. "He just sits there—very wild hair, clean shaven, and clothing one would associate with a western person, and says 'I've heard about ya.' We got into a discussion. The simplicity of his speech was so deep that you start to remind yourself of Walt Whitman. . . . So we became friends."

In Guthrie, Asch thought he had found an authentic voice of the people. The two came to an agreement—Asch would record everything Guthrie wanted to sing, and whenever Guthrie needed money to spend, Asch would dole some out.

In April 1944, a month after they first met, Guthrie came in to Asch's studio six different times for recording sessions. Sometimes accompanied by Houston, Seeger, and Sonny Terry, Guthrie recorded at least 150 songs—a fraction of the 3,000 songs he wrote. Asch was

interested mainly in Guthrie's labor, war, antifascist, and children's songs. He regarded Guthrie foremost as a poet, and this was poetic outpouring. Guthrie and the other musicians sat in a tiny ten-by-seven-foot sound studio with monotone microphones, while Asch sat in the adjacent control room. In the last session, Guthrie recorded "This Land Is Your Land." The master was a ten-inch disk made out of blackened shellac—magnetic audiotape had not yet been invented. Asch recorded at 78 rpm, meaning the disk could not hold more than three minutes of music. The song clocked in at two minutes and forty-three seconds.

The shellac master, matrix number 114, is in the Moses and Frances Asch Folkways Collection in the Ralph Rinzler Folklife Archives at the Smithsonian Center for Folklife and Cultural Heritage—along with hundreds of other Guthrie masters and the tens of thousands of recordings Asch produced in his career and later donated to the Smithsonian. On the master, the title of the song is written in pencil as "This Land Was Made for You and Me."

Guthrie's song was later published by Ludlow Music, headed by Howie Richmond, who worked with Guthrie. Compared to the original lyrics and the recorded song, the written version took on the more familiar title and repeating chorus line of "This Land Is Your Land, This Land Is My Land." The published version had an additional stanza not in the 1940 lyrics, and Guthrie at various times altered the old ones, such as:

> *Nobody living can ever stop me,*
> *As I go walking that freedom highway;*
> *Nobody living can ever make me turn back*
> *This land was made for you and me.*

Asch didn't issue the recorded song until 1951, and when he did, it was for a children's record on the Folkways label. It was a 1946 "cleaned-up" version, as the Socialist-sounding lyrics about private property and relief did not accord with either the period or the audience. Instead, Asch recognized

that the song, with choruses repeating the first stanza, was catchy and up-beat. Pete Seeger thought it too simple.

Ludlow's Richmond allowed the song to be included in school music textbooks with permission, but for free, and the promotional strategy worked. Music and classroom teachers found it an easy song for their students to learn and sing as a group. It was sung at camps and by all sorts of youth groups, and became immensely popular.

In the 1960s, it became an anthem of the folk music revival, and later the antiwar protest movement. It has been covered by hundreds of musicians, including Bob Dylan and Peter, Paul, and Mary. Bruce Springsteen and Pete Seeger performed it at the Lincoln Memorial for the inaugural concert of President Barack Obama.

Music historians had long wondered whether Guthrie's original 1944 recorded version of the song included the controversial private property verse of his written lyrics. Shellac disks get brittle over time, and when the Smithsonian acquired the Folkways collection in 1987, the master was showing its age—even decomposing chemically. Thanks to Folklife archivist Jeff Place and sound engineer Pete Reiniger, the Smithsonian was able to conserve the master and play the song. Indeed, the private property verse was included.

Guthrie passed away in 1967, a songwriting legend. Ralph Rinzler, who was my mentor at the Smithsonian, learned folk songs from Guthrie and worked for Asch. He led the effort to acquire the Folkways collection for the Smithsonian in the mid-1980s so that Guthrie's legacy, and that of other musicians, could be studied and would help inspire future generations.

GREATEST

GENERATION

(1941 TO 1945)

U.S.S. *OKLAHOMA* **POSTAL HAND STAMP** *National Postal Museum*

D ecember 7, 1941, was called a "date which will live in infamy" by President Franklin Delano Roosevelt and is seared into the memory of generations of Americans.

That morning, the Imperial Japanese Navy launched a surprise attack against the U.S. naval base at Pearl Harbor, Hawaii. The base was attacked by more than 350 Japanese planes— bombers, fighters, and torpedo craft launched from 6 aircraft carriers in the Pacific Ocean. The result was devastation—8 U.S. battleships were damaged and 4 were sunk; 3 cruisers and 4 destroyers were also seriously damaged. Almost 200 U.S. aircraft were destroyed. More than 2,400 Americans were killed and almost 1,200 wounded. The Japanese Imperial Command achieved its tactical aim, which was to impair the ability of the U.S. Pacific fleet to defend islands in the vast region from Japanese takeover. The attack prompted the United States to declare war on Japan, and days later led to U.S. entry into World War II in Europe as well.

Among the battleships at Pearl Harbor was the U.S.S. *Oklahoma*, a World War I–era ship built by the New York Shipbuilding Corporation in New Jersey for about $6 million. It was almost 600 feet long and 100 feet wide, with a displacement of about 28,500 tons and a top speed of approximately 20 knots. With its sister ship, *Nevada,* it was among the first naval vessels to use oil fuel rather than coal. The ship was launched in March 1914 and commissioned in May 1916 with ten 14-inch guns and twenty 5-inch guns. It protected ships in convoy across the Atlantic Ocean. Among its early duties, the *Oklahoma* escorted President Woodrow Wilson to peace negotiations in France in 1919. In the late 1920s, the ship was modernized and upgraded with the addition of eight more 5-inch guns. In 1936 it helped rescue refugees and Americans fleeing the Spanish Civil War. It was then

62

U.S.S. *OKLAHOMA* POSTAL HAND STAMPS

A SIMPLE ITEM THAT HELPED CONNECT SERVICEMEN TO THEIR LOVED ONES SURVIVES THE ATTACK ON PEARL HARBOR.

National Postal Museum

stationed in the Pacific, and in 1940 its home port was shifted from San Pedro, California, to Pearl Harbor. Antiaircraft guns and extra armor were added.

Oklahoma, like all naval ships, was equipped to offer postal services, both for essential military communications and to provide the crew with a link to home. Letters connected deployed military men and women to their home communities. With today's e-mail, cell phone service, Skype, instant messaging, tweeting, and the like, it is hard to imagine how important it was to receive a letter from a friend, family member, neighbor, or colleague. The power of mail resides not only in the words communicated but also in its uniquely tangible and durable nature. The recognizable handwriting of a parent, the perfumed scent of a wife or girlfriend, a familiar sketch from a friend, all brought servicemen and servicewomen momentarily closer to the life and people they cared most about. Mail call was always popular, and the distribution and opening of letters and parcels allowed sailors and officers to escape from boredom, drills, and other duties. Similarly, sending a letter out through the ship's post office was a way to reassure the folks back home that everything was all right.

Outgoing letters were stamped by hand in *Oklahoma*'s shipboard post office. Such hand stamps indicated the date and general time a letter or parcel was mailed and if any special services were required, such as registered or special delivery. They showed the originating post office, in this case, in capital letters, "U.S.S. OKLAHOMA."

Navy postal clerks on *Oklahoma* last stamped the mail on Saturday, December 6, 1941. They used these two hand stamps, both of which indicate the date. The duplex hand stamp was used as a cancellation stamp for all types of outgoing mail. The registered-mail hand stamp would have been used occasionally for sending important documents or special parcels, but mainly for official naval mail. Official mail was and continues even today to be an important means of conducting business and relaying information. Mail stamped "REGISTERED" was recorded and secured, and included official documents classified as secret.

The postal clerks did not have the chance to change the date on the hand stamps before the attack on Pearl Harbor began early Sunday morning. Moored in Battleship Row, *Oklahoma* was hit on its port side by three torpedoes at the outset of the attack. It began to capsize when it was hit by more torpedoes, reportedly nine in all. As the men abandoned ship or took up antiaircraft positions on the adjacent *Maryland,* they were strafed by air fire. Within minutes *Oklahoma* rolled over on its side, its keel exposed. Hundreds were trapped inside and in danger of being drowned or killed in the damaged ship.

After the attack, servicemen could hear tapping coming from inside the hull. With civilian help, they organized a rescue attempt. It took them two days to cut through the hull and free some thirty-two trapped seamen. All told, of the more than twenty-one hundred men serving on the *Oklahoma,* more than four hundred were killed or missing and several dozen were wounded. The ship lay severely damaged and inoperable.

Some seven months later, the Navy began complex salvage operations. Twenty-one derricks were used to attach high-tensile steel cables from *Oklahoma* to hydraulic winching machines on the shore. It took almost a year to right the ship. Navy teams removed human remains as well as other items. The ship was refloated and towed to dry dock, where guns, machinery, and ammunition were salvaged. Though the hull was repaired, initial plans to reuse the ship were canceled and it was decommissioned in 1944 and later sold for scrap. While being towed across the Pacific to the San Francisco scrap yard, *Oklahoma* started taking on water and sank on May 17, 1947.

The hand stamps survived the attack on Pearl Harbor and were likely recovered by the Navy in the salvage operation. The Navy turned them over to the Post Office Department, which transferred them to the Smithsonian in the mid-1960s. These

U.S.S. ***OKLAHOMA***
DUPLEX
HAND STAMP
National Postal Museum

simple tools tell a poignant story. On their last day of regular use, clerks stamped mail that made its way back home and to other military installations. Some of these letters were probably the last letters that some families received from their service members, a powerful reminder of the role that mail played during war time. On the next day, the bombing prevented any more of the usual work—the changing of the dyes in these hand stamps and processing of the mail; instead it brought a life-and-death struggle that thrust the United States into World War II.

This plane was used in 1944 and 1945 for the training of the Tuskegee Airmen, America's first African American military pilots, who fought with valor and determination against a backdrop of institutional racism during World War II.

That the Tuskegee Airmen had to fight for their place in the U.S. military is a telling tale. Following the Civil War, black soldiers served in the U.S. Army on the central plains and in the West. Those in the Tenth Cavalry Regiment were called Buffalo Soldiers by Native Americans. With the ratification of the Thirteenth Amendment, the door to military careers and service for black soldiers seemed to open firmly at last. Four "colored" regiments were among the first to be called into service in the Spanish-American War (1898) and played a crucial role in the Caribbean and Philippine campaigns. The Ninth and, especially, Tenth cavalries gained fame and five individual Medals of Honor for protecting Teddy Roosevelt's famous Rough Riders in their advance up San Juan Hill. Though the black regiments were heralded for their heroism, Roosevelt, as president, bowed to racist pressure, and the military became increasingly segregated from the turn of the twentieth century on. Blacks could not serve in the Marines and were denied advancement in the Navy and Coast Guard.

In 1917, Fort Des Moines opened as the first black officers' training camp for the Army's "colored regiments." More than thirteen hundred black officers received commissions in World War I. In spite of heroic service, after the war returning troops found white society more closed and hostile to them than before. Some historians have drawn a correlation between the increase in violence against blacks and postwar fears that black veterans would demand civilian advancement commensurate with their service.

The segregation of black troops and their exclusion from higher rungs of military service continued in the 1920s and 1930s. Blacks participated in the

SPIRIT OF TUSKEGEE

THE VEHICLE FOR AFRICAN AMERICAN FLYERS TO SERVE THEIR COUNTRY IN WORLD WAR II PAVES THE WAY FOR THE INTEGRATION OF AMERICA'S ARMED SERVICES.

National Museum of African American History and Culture

SPIRIT OF TUSKEGEE *National Museum of African American History and Culture*

segregated army regiments under white commanders. The Navy and other branches allowed African Americans to perform menial work. A 1925 study held that blacks lacked the "aptitude to fly." This only made it very difficult, if not impossible, for African Americans to break into the elite Air Corps.

This changed in 1939, when civil rights leaders successfully advocated for federal funds for the training of African American pilots, albeit through civilian flight schools, including one at the small Kennedy Field at Tuskegee Institute in Alabama. There were both black and white instructors, led by African American trainer Charles "Chief" Anderson. Black pilots were trained on small Piper Cub aircraft. In March 1941, First Lady Eleanor Roosevelt came to Tuskegee; the U.S. Army Air Corps' 99th Pursuit Squadron had just been formed to include black pilots, and they would be trained at Tuskegee. Roosevelt's visit, which included her flying in a plane piloted by Anderson, drew attention to the program and the qualifications of the pilots being trained. Roosevelt recognized the inadequacy of Kennedy Field and arranged for the donation of foundation money to help construct a new, larger airfield nearby. It would be named Moton Field after Robert R. Moton, who succeeded Booker T. Washington as director of the Tuskegee Institute.

When the 99th Pursuit Squadron moved to Tuskegee it drew upon pilots trained in the civilian programs. Thirteen pilots started as cadets, first at Kennedy, then at Moton when construction was complete. Cadets trained on PT-13, PT-17, and PT-19 biplanes. The PT-13D Kaydet was the standard primary trainer airplane flown by the United States during the late 1930s through World War II. It was a militarized version of a civilian model designed in 1933 by Lloyd Stearman. After Boeing purchased Stearman's company in 1938 it continued to produce the plane. Easy to handle, with a cruising speed of just 104 miles per hour and a backseat for the instructor, the Kaydet was generally liked by student trainees at Tuskegee and other bases.

At Moton, the thirteen black trainees received their primary instruction

from black civilian instructors and white Army Air Corps pilots. Of the first group of trainees, six graduated to the next phase. The cadets moved on to basic and advanced training. The commander and the instructors were white, and black enlisted men serviced the unit. On March 7, 1942, the first group of five African American pilots graduated from advanced training school. Another squadron, the 100th, was soon formed, followed by the 332nd Fighter Group. By the end of the year, more than 3,400 men, almost all black, were stationed at the Tuskegee Army Air Field, receiving basic, advanced, and transition flight training, and servicing the unit and base. The training was rigorous; those who didn't make the grade as pilots might become navigators and bombardiers. The first class included Captain Benjamin Oliver Davis Jr., who served as commandant of cadets and would eventually be promoted to commander of the 332nd and to the rank of general in the U.S. Air Force. In all, 992 pilots were trained in Tuskegee from 1941 to 1946, almost half served overseas, and 150 lost their lives in accidents or combat.

The Tuskegee-trained pilots flew almost one thousand missions, mainly escorting bomber crews, but also dive-bombing enemy targets. They eventually became known as red-tailed angels because the tails of their fighter planes were painted red. They gained a reputation for their fierce protection of bomber crews. They were first deployed to French Morocco and then to Tunisia. They also participated in missions over Sicily and Italy, and went on to escort missions over Eastern and Central Europe, including Germany and its capital city, Berlin. The Tuskegee pilots destroyed more than 100 enemy aircraft in the air and another 150 or so on the ground, in addition to almost 1,000 rail cars, as well as boats, barges, and an Italian destroyer. The group earned 3 Distinguished Unit Citations, and members were awarded 1 Silver Star, 14 Bronze Stars, 96 Distinguished Flying Crosses, 744 Air Medals, and 8 Purple Hearts. Their record contributed to President Harry S. Truman's decision to integrate the U.S. Armed Services, and they have provided a modern model for African American military service to

the nation that has endured for decades. The Tuskegee Airmen earned the respect of their fellow white airmen and soldiers. They demonstrated that their abilities were the equal of anyone's, and made a striking case for racial equality and civil rights.

The plane in the Smithsonian's collection has its own unlikely history. In 2005, Matthew Quy, at the time a thirty-five-year-old active duty Air Force captain, bought it at a public auction. The Kaydet had been used as a crop duster for decades and was a complete wreck. Quy had grown up wanting to fly, and one of his great passions was to fly an open-cockpit plane. He bought the wreck, intending to restore it and use it for thrill rides. In researching the history of the plane, he sent its serial number, 42-17724, to the Air Force. The response surprised him—the Kaydet was one of those used to train Tuskegee Airmen. Inspired by the significance of the object, he and his wife, Tina, changed their plans and decided to restore it to its original glory as a tribute to America's first black fliers. Quy was able to get parts from other Kaydets that had also survived the war.

Quy restored the plane, named it the *Spirit of Tuskegee,* and toured it around the country, visiting various Tuskegee Airmen reunions and air shows. He took numerous airmen up in the plane and let several fly it. Many signed their names on the plane. In 2011, he flew the Kaydet to Moton Field for the last time, and then flew up to Andrews Air Force Base near Washington, D.C., so that it could be formally accepted and registered into the collection of the Smithsonian's National Museum of African American History and Culture. Lonnie Bunch, the museum's director, accepted the plane at a meeting of Tuskegee Airmen. For Bunch, the significance was both institutional and personal. Institutional because of the inspiring story it told; personal because when he first joined the Smithsonian, it was as a staff member of the National Air and Space Museum, and his mentor was Louis Purnell, a decorated Tuskegee Airman in the 99th Pursuit Squadron and one of the first African American curators at the Smithsonian.

The plane continued to make history at the Smithsonian, becoming the

first aircraft to be conserved in the new Mary Baker Engen Restoration Hangar at the Air and Space Museum's Steven F. Udvar-Hazy Center. In 2015, the *Spirit of Tuskegee* will be moved to the Mall in Washington, D.C., where it will be exhibited prominently in the new National Museum of African American History and Culture.

I t is arguably America's most famous World War II–era home-front poster. It depicts a muscular and determined—though attractive and shapely—female factory worker wearing lipstick and makeup, and patriotically outfitted in a red and white bandana and blue work shirt. She says, "We can do it!"—which speaks both to the determination of the country to win the war and to the role American women played in that effort by working in the defense industries.

The poster was designed by artist J. Howard Miller, who was hired by Westinghouse Electric Corporation's War Production Coordinating Committee in 1942 to develop a series of images for the company's wartime production campaign. The posters were intended to keep up morale among workers.

The Smithsonian acquired a collection of these wartime posters from Miller in two batches, thirteen in 1985 and thirty-two the following year. Each poster is dated. The series provides a window into how the Westinghouse campaign evolved over the years. Generally they emphasized the teamwork between the company and its workers in the face of common enemies, like Japan's Prime Minister Hideki Tojo and Germany's Chancellor Adolf Hitler. The posters also highlighted problems such as worker absenteeism and carelessness.

The "We Can Do It!" poster, along with other efforts, encouraged women to succeed in manufacturing and factory jobs that had been considered "man's work" until then. With so many men entering the armed services, women were crucial to the success of American manufacturing, especially the production of weapons, ships, and armaments. The poster projected the idea of female patriotism expressed through manual labor in factories.

The poster seems so iconic to us today, but it was not widely distributed

"WE CAN DO IT!" POSTER OF ROSIE THE RIVETER

A WORLD WAR II IMAGE POINTS TO THE IMPORTANCE OF WOMEN WORKERS ON THE HOME FRONT.

National Museum of American History

GREATEST GENERATION (1941 TO 1945)

445

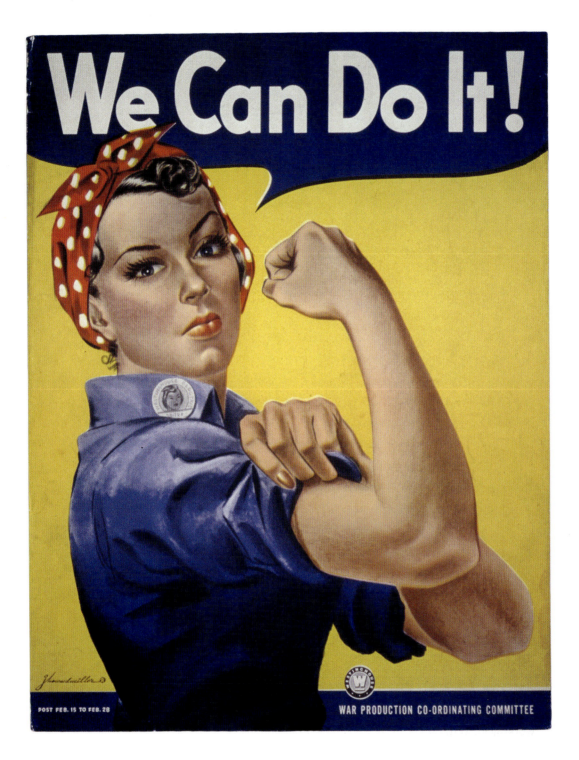

"WE CAN DO IT!" POSTER BY HOWARD MILLER *National Museum of American History*

at the time. On the contrary, it was displayed in midwestern Westinghouse factories for just two weeks or so in February 1942 and seen by relatively few workers. The poster in the Smithsonian's collection is an original print. It is surprisingly rare—less than a handful are known to exist.

Posters—colorful lithographic prints on cheap paper, designed for short-term display—evolved as a form of popular advertising art in the late nineteenth century. They came of age as a propaganda tool during World War I. The American Red Cross advertised "victory bonds" with dramatic images of glamorous, angelic nurses, while federal agencies drummed up public support for American involvement through lurid images of monstrous German "Huns" brutalizing civilians. By the time America entered World War II in 1941, the persuasive art of the poster had been refined, and the messages were even more widespread, all reminding Americans in one way or another that it was everyone's duty to support the war effort.

While many posters appealed to men to serve, many others enforced the idea that women too could do their part, emphasizing that the far-off wars in Europe and the Pacific were threatening families and homes in America. Women were asked for their support as mothers, wives, and sisters by taking pride in the military service of their sons, husbands, and brothers. As home-makers, women were called upon to make the best of food rations, to forgo feminine luxuries like silk stockings, and to tend backyard "victory gardens" to produce vegetables for the family table. They were urged to volunteer as nurses or to serve the USO. And when men were not available, women were encouraged to step into production jobs at factories that were making goods and equipment to support the military.

The stigma against working women had grown during the Depression, when women's labor was viewed as taking away jobs from men, who were presumably the primary wage earners for families. Women's manual labor was also associated with "unladylike" behavior. In the 1940s, these popular posters, advertisements, and even songs had to do the work of conveying the idea of women's wartime labor as a supportive affirmation of the traditional working- and middle-class family, not a threat to it.

Among those messages was the 1942 song "Rosie the Riveter," named for a fictional female factory worker laboring for the war effort. Written by Redd Evans and John Jacob Loeb, the upbeat song, with its vocal and musical simulation of the riveting machine (the "brrrrrrrrrr" in the lyrics) was recorded by various artists, including the popular big band leader Kay Kyser. It became a hit.

> All the day long, whether rain or shine
> She's a part of the assembly line
> She's making history, working for victory
> Rosie, brrrrrrrrrrr, the riveter

The next year, for its Memorial Day issue, the popular *Saturday Evening Post* magazine published an image of Rosie the Riveter from an original Norman Rockwell painting. Much like Miller's poster rendition, Rockwell's Rosie evokes a patriotic theme with her red hair, white skin, and blue shirt and overalls set against the waving American flag. She is a large, brawny woman, with lipstick, rouge, and a leather wristband, easily bearing a pneumatic riveter and sporting working headgear. She wears a series of buttons illustrating support for the U.S. war effort. Her lunch pail identifies her as "Rosie." She munches a hearty sandwich while her feet rest comfortably on Hitler's manifesto, *Mein Kampf.* Rockwell based his Rosie on a Vermont neighbor who worked as a telephone operator, not a riveter.

The image was immensely popular. It was subsequently used by the U.S. government for war-bond drives. Numerous depictions of "real Rosies" followed as reporters and publicists found workers named Rose performing heavy-duty manual tasks in factories across the United States. Other characters also emerged—Winnie the Welder, for example—to call attention to the various roles played by women in military production.

The propaganda effort to cross the gender line was successful. Before the war, about 12 million women worked outside the home, mainly in clerical, administrative, and service jobs; by the end of the war, this number was up

to 18 million. Some 350,000 women served in the armed forces; an additional 6 or 7 million entered the domestic workforce. Most women were employed in traditionally female jobs, but some 3 million took up manual work in industrial plants. Most important, many African American women worked in defense plants alongside their white counterparts. The scale of this employment drive was so significant that it led many employers to reclassify factory jobs as "female" in an effort to pay lower wages to women than would have been the case had they retained the designation as "male"

ROSIE THE RIVETER BY NORMAN ROCKWELL

Crystal Bridges Museum of American Art

jobs. Union officials fought this, fearing that when men returned from their military service to work in the factories they would suffer the lower wages.

Even during the war years, there was a good deal of speculation over what would happen to women employed in these industrial jobs once the war ended. When it did, industries encouraged women to relinquish their jobs to returning veterans; many were forced out, and others went willingly, happy to have their husbands home and start families.

Neither Westinghouse nor Miller identified the character in his poster as Rosie the Riveter. Nor did they identify the person upon whom the graphic image was based—though many speculate that Miller was inspired by a 1941 photograph of a then-seventeen-year-old Michigan factory worker named Geraldine Hoff.

The poster was "rediscovered" and revived in the 1970s as part of the women's movement. Large numbers of women were once again entering the workforce in a variety of roles, finding their way in male-dominated professions and workplaces. It was only at this point that the poster was apocryphally identified with Rosie the Riveter. Rosie was regarded as an inspirational figure, transformed from the midcentury's perky tomboy into a precedent-setting champion for modern women seeking empowerment in the workforce. The poster image itself became very popular, as it fit within a contemporary, pop-culture "cartoon" aesthetic.

From the 1980s onward, the image became the subject of veneration, alteration, and parody. In 1984, DC Comics created a character called Rosie the Riveter in a Green Lantern story. She wields a rivet gun as a weapon. More recently, she has been featured as a character in video games: in Fallout 3 there are billboards featuring Rosies assembling atomic bombs while drinking Nuka-Cola. Several popular entertainers have also appropriated the Rosie image. In her "Candyman" music video, Christina Aguilera poses Rosie-like while emulating the famous Andrews Sisters' vocal harmonies of the World War II era. Beyoncé Knowles also used the theme, in her 2010 "Why Don't You Love Me" music video. There is even a Rosie the Riveter action figure based on Miller's poster design. Its maker—Accoutrements—

advertises her appeal to customers in contrast to other female roles: "You can use her to beckon your Barbies out of their mansions and into the factories to do their part."

It is a measure of how effective Rosie was at conveying the importance and aspirations of working women that—although the actual number of women in Rosie-like heavy manufacturing jobs was statistically very small, and the poster itself was not widely distributed or displayed for very long—the image remains so familiar today.

In the wake of the Japanese attack on Pearl Harbor, almost 120,000 Japanese Americans, two-thirds of them U.S. citizens, were forced out of their homes and into confinement by the U.S. government. Many would spend the war years living behind barbed wire and under armed guard. Painters, artists, and craftspeople used what spare materials they had to express their feelings about confinement and the contradictions the camps represented to their Americanized way of life. This is captured well in a 1944 painting, *Thinking of Loved One* by Henry Sugimoto, who was interned in Camp Jerome in Arkansas.

JAPANESE AMERICAN WORLD WAR II INTERNMENT ART

By the early 1940s, despite prejudices and legal restrictions, Japanese Americans had established thriving communities in Hawaii and California. Most had roots in agriculture, having been recruited to work in Hawaii's sugarcane fields and on California's fruit and vegetable farms since the 1860s. In Hawaii, under the kingdom and then after U.S. annexation (1898), they took up trades and businesses, and built schools, churches, and cultural organizations. By 1940, people of Japanese ancestry accounted for almost 40 percent of the islands' residents. In California, Japanese immigrants became successful farmers, fishermen, and small businessmen. Japan's victory in the Russo-Japanese War (1904–5) occasioned increased American prejudices about a "yellow peril," and contributed to a 1907 congressional prohibition on the immigration of Japanese from Hawaii to the U.S. mainland. Immigration opponents contended that Asians were ineligible for naturalized citizenship given their reading of the Naturalization Act of 1790, which they believed permitted only whites to become citizens. In a 1922 ruling, *Takao Ozawa v. U.S.,* the U.S. Supreme Court upheld a Hawaiian statute that de-

U.S. CITIZENS AND PERMANENT RESIDENTS, FORCIBLY REMOVED FROM THEIR HOMES, EXPRESS THEIR ANGUISH IN CONFINEMENT AND THEIR LOYALTY TO THE NATION.

National Museum of American History

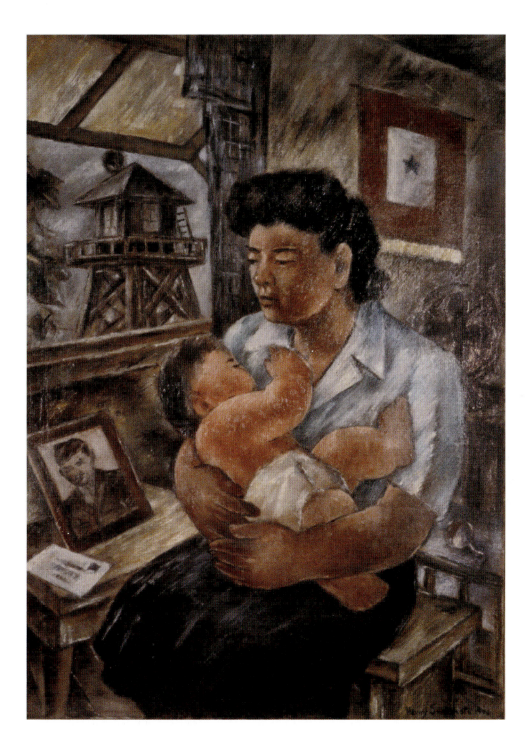

THINKING OF LOVED ONE BY HENRY SUGIMOTO *National Museum of American History*

nied Japanese immigrants citizenship on these grounds. Subsequently, the Asian Exclusion Act of 1924 ended further Japanese immigration for permanent residence. Although prohibited from becoming citizens and owning property on their own, many Japanese people owned homes, farms, and businesses in the names of their children born in the United States. These children, citizens by birth, were called Nisei, a term meaning "the second generation," and many strove to be assimilated into American culture.

The attack on Pearl Harbor was a catalyst for questioning the loyalty of all people of Japanese ancestry living in the United States. Within hours of the attack FBI agents and local and military police took 736 people into custody. Days later, the number nearly doubled, and included Shinto and Buddhist priests, newspapermen, community leaders, language teachers, and subscribers to suspect publications. On February 19, 1942, swayed by War Department officials as well as politicians, President Franklin D. Roosevelt signed Executive Order 9066, authorizing military authorities to exclude "any and all persons" from designated areas of the country as necessary for national defense. This allowed the uprooting of Americans of Japanese ancestry from their West Coast communities and their confinement in isolated and heavily guarded camps. Although the United States was also at war with Germany and Italy, government officials did not recommend that citizens or resident aliens originating from those countries be rounded up as a group and confined. While German or Italian enemies were often viewed as misguided victims of despotic leaders, Japanese people were disparaged collectively in racist wartime propaganda. The executive order essentially gave the military broad authority over the civilian population, even though some officials in the U.S. Department of Justice, including FBI director J. Edgar Hoover, believed it was unconstitutional.

The first step in the massive effort was the registration of all Japanese Americans. As was declared by commanding officers, "A Jap's a Jap. It makes no difference whether the Jap is a citizen or not." The U.S. West Coast was divided into 108 exclusion areas, with the residents of each ordered to report to a central point in their neighborhoods from which they would be

taken to an "approved destination." "Evacuees" could take only those possessions they could carry. For many Japanese American homeowners and small businessmen, evacuation also meant selling out—quickly, and at a huge loss, later estimated at more than a billion dollars.

For most, the destinations turned out to be one of sixteen temporary "assembly centers" in California, Oregon, Washington State, and Arizona. These were hastily requisitioned fairgrounds, racetracks, or other public facilities. Detainees had to stay at these places for several months. Sanitation, food service, and health-care facilities were of the lowest standards. At Tanforan and Santa Anita racetracks in California, internees were sent to facilities that had held horses.

The final destinations included dozens of prisons, jails, military installations, and ten "relocation" camps, quickly and poorly constructed by the War Relocation Authority (WRA). These camps were stark military barracks with tar-paper walls and few amenities. Conditions varied, from hot and dusty Manzanar in California and Poston and Gila River in Arizona to humid and rainy Jerome and Rowher in Arkansas and the cold winter of Heart Mountain in Wyoming and Minidoka in Idaho. All the camps were geographically and socially isolated. The internees would live behind barbed-wire fences, watched over by armed military police in guard towers.

For many, the trauma of internment included scores of small indignities endured each day that limited individual freedom and familial pride. All of the WRA centers operated farms, with food products often exchanged between camps. Internees worked for substandard wages, ranging from twelve dollars a month for full-time agriculture work to nineteen dollars a month for physicians, dentists, and other professionals. Still, most internees managed to recoup a sense of self-respect and communal aspiration. Each camp functioned as a school district. Civic associations, religious observances, baseball games, Boy Scout troops, parent-teacher associations, dances, theater companies, and athletic competitions helped ease the burden of life in the shadow of the watchtower.

In 1996, at a Smithsonian event in Los Angeles, I sat with Senator Alan

Simpson and former congressman Norm Mineta, who both had served as regents of the Institution. They recalled how they had met. Mineta, the young son of Japanese immigrants, had been sent off with his family from San Jose, California, to the Heart Mountain center in Cody, Wyoming. He loved baseball, and took his bat with him, but it was confiscated as a potential weapon when they arrived. Settled in Area 24, 7th Barrack, Unit B, Mineta participated in the Boy Scouts and met a young Simpson, a Boy Scout of the same age whose troop visited the camp. Though separated by ancestry and a fence, they became friends—and renewed that friendship decades later when both came to serve in the U.S. Congress. It was heartening to know they had transcended the divisions that had led to the camp.

One of the few opportunities for self-expression in the camps was through art. People used natural materials, like freshwater shells from California's Tule Lake and wood fragments from the Arkansas Delta, as well as found objects, like buttons and discarded shutters, to make into poignant artworks. Henry Sugimoto, a schooled and successful artist who was interned first in Jerome and later at Rohwer, painted dozens of canvases documenting internment life. This painting depicts a mother and newborn in Camp Jerome. The irony is clear—a baby, born in America, the land of the free, is comforted by its mother in sight of a watchtower restricting that freedom, while his father is fighting for the United States in the war effort (the blue star flag indicates a fighting family member). Years later, when I came to know and work with another regent of the Smithsonian, Doris Matsui, a member of Congress from California who was born in the barbed-wire enclosures of Poston camp, the image hit home.

In the painting, the Japanese American mother gazes, somewhat wistfully, at a photograph of an American in uniform—her husband, fighting for the nation's freedom. He is one of those who enlisted in the 442nd regiment of the U.S. Army. Though people of Japanese ancestry—citizens and noncitizens—were initially classified as "enemy aliens" for the purpose of military service shortly after the attack on Pearl Harbor, that changed

by January 1943. Nisei in Hawaii had already formed the 100th Infantry Battalion, which was later incorporated into the 442nd. Some twenty-five thousand Nisei eventually served in the war effort—several thousand in intelligence roles in the Pacific, but most as infantry in Europe, where they served with pride and honor. These troops endured high casualty rates and were among the most decorated in U.S. Army history. Among them was Daniel "Dan" Ken Inouye, who lost an arm in an assault on an enemy position in Italy. His heroism later earned him the Medal of Honor.

In December 1944, the forced incarceration ended following a U.S. Supreme Court ruling, in the case of *Ex parte Endo,* that claims of military necessity could not justify holding American citizens against their will. The camps were closed down, and each internee received a twenty-five-dollar payment and transportation home. Many internees found that their preinternment communities had disappeared, their homes and businesses lost. In following years, a postwar housing shortage, competition with returning veterans for jobs, and continued discrimination added to their difficulties. In some West Coast communities residents did welcome home old neighbors; in others there were cases of vandalism and threats against life and property. Japanese Americans reestablished communities and organizations and started their fight for compensation and an apology. Veterans of the 442nd and internees led the way. When Hawaii became a state in 1959, Inouye became a congressman and later went on to a distinguished five-decades-long career in the Senate. Mineta served as mayor of San Jose, congressman, and cabinet secretary under presidents William J. Clinton and George W. Bush.

These leaders proved instrumental in supporting and encouraging a benchmark exhibition, A More Perfect Union: Japanese Americans and the U.S. Constitution, at the Smithsonian's National Museum of American History to mark the two-hundredth anniversary of the Constitution in 1987. The exhibition examined the issue of government removal and forced incarceration, life in the camps, the military service of the Nisei, and the constitutional implications of a government imprisoning its own citizens en masse. As Senator Inouye noted:

It was a time when some of us had to take extraordinary steps when our Constitution did not require it, to prove to our neighbors that we were worthy of being called Americans. The price was very heavy. There was much blood that had to be shed. But looking back, I can say with pride that I was part of it.

Soon after, the 100th Congress passed H.R. 442, formally apologizing to detainees and granting each $20,000 as restitution. President Ronald Reagan signed the bill into law as the Civil Liberties Act of 1988. The next year Senator Inouye helped the Smithsonian mount a Folklife Festival program on Hawaii, demonstrating the multicultural vitality of his home state. He also sponsored the legislation that created the National Museum of the American Indian, so that the Native American story could be told in the nation's capital. Inouye personified how lessons learned from injustices—such as the internment—could be used to encourage respect among all Americans.

General Dwight D. Eisenhower (1890–1969), five-star general in the United States Army, supreme commander of the Allied Forces in Europe during World War II, was the man ultimately responsible for planning and executing the invasion of France in 1944, the action that would eventually lead to the end of the war on the western front.

Among the huge and various logistical and strategic matters that Eisenhower had to contend with was the Army uniform—the basic dress that soldiers wore every day. Eisenhower thought the uniform, particularly the long wool jacket, was poorly fitted for combat. It was too restrictive. The long coat was also shapeless and drab. Conscious of how he and the military presented itself, he wanted a uniform that would be neater and more flattering.

In March 1943, Eisenhower called for his tailor, Michael Popp, to take the Army's wool field jacket and modify it to his specifications. Popp, the son of immigrants from the Serbo-Croatian region of the Austro-Hungarian Empire, was born in Ohio in 1905 and had joined the U. S. Army in 1942; he had been assigned as a tailor to Eisenhower's staff during the North African campaign.

According to an aide, Eisenhower wanted the jacket to be "very short, very comfortable, and very natty looking." Popp took the Army-issued M-1944—also known as the ETO (European Theater of Operations) jacket—and turned it into the "Eisenhower jacket," or "Ike jacket," as it became known, after Eisenhower's nickname. Popp shortened the length; where it had somewhat flared out toward the bottom, he tailored it so it hugged the waist; he cleaned up the collar so that it had a more elegant line; and he tailored the shoulders so they would form a clear outline.

66

AUDIE MURPHY'S EISENHOWER JACKET

AN INNOVATION OF A MILITARY LEADER WELL ATTUNED TO PRACTICALITY AND PUBLIC PERCEPTION SETS A FASHION TREND.

National Museum of American History

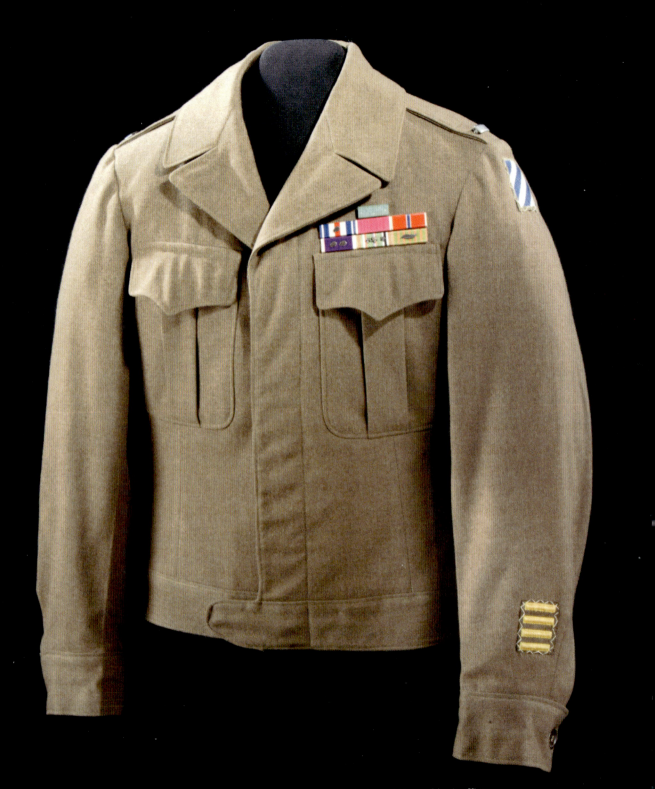

AUDIE MURPHY'S EISENHOWER JACKET *National Museum of American History*

"The Boss was pleased with it and began to wear it, and when we got ours, all of us on the staff yelled for Popp. He was a good guy and he cut down all of our jackets to make them look as much as possible like the one the Boss wore," an Eisenhower military aide explained. The Eisenhower jacket became standard issue for U.S. troops beginning in November 1944. Following Ike's example, other officers individualized their uniforms. Different people and units made numerous changes following Ike's model. Some added side slash pockets, others patch pockets or flaps and buttons. Others modified the waist tabs.

While the jacket built on traditional military issue, it embraced a new style based upon the battle needs and contemporary demands, one entirely befitting Eisenhower's persona. The general regarded it as practical—a value that he would later champion as president of a growing middle-class nation. It was "smart," and thus mirrored Eisenhower's military and political savvy. That it was regarded as stylish—or snappy—belied any suggestion that Ike was just some naïve farm boy from Kansas. It spoke to his sophistication.

The Smithsonian has several Eisenhower jackets represented in its collections. One is depicted in a portrait of General Eisenhower that was used for the cover of the January 1, 1945, issue of *Time* magazine when he was selected as man of the year for 1944. Eisenhower was chosen because of his leadership of the Allied invasion of the European mainland, beginning with D-Day on June 6 on the Normandy coast. In the cover art, the top of his well-tailored jacket sets off his four-star Army hat (he was given his fifth star in December 1944) and the flags of the Allies waving behind him. The uniform speaks to the dichotomy American leaders, as celebrities in a democracy, have to bridge—the common identity as a soldier that Eisenhower shared with his troops, and the fame and glamour of his elevated command position.

An actual Ike jacket came to the Smithsonian through a former curator at the National Museum of American History, Steven Lubar. It was his father's uniform. William Lubar had been stationed at the Pueblo Army Airbase in Colorado. On home leave to Philadelphia in 1944, his father, a

great admirer of General Eisenhower, and a tailor, made the alterations for his son, imitating the new style.

The Ike jacket featured here belonged to World War II hero Audie L. Murphy (1925–71). Murphy was the son of poor sharecroppers from Texas. He tried to sign up for the Marines but was turned down because he did not meet the minimum physical requirements. Falsifying his age, he enlisted in the U.S. Army and became one of the most decorated soldiers in the war, fighting in nine campaigns, being wounded three times, and earning some thirty decorations and awards. The bar on the top of the shoulder of his Eisenhower olive-drab field jacket indicates his rank as a Second Lieutenant. The patch on the upper-left sleeve signifies he was in the Third Infantry Division; service bars decorate his lower-left sleeve. The chest ribbons reveal that Murphy was the recipient of the Medal of Honor, Distinguished Service Cross, Silver Star, Legion of Merit, Bronze Star, and Purple Heart, among others.

Murphy was regarded as a soldier's soldier, and he became a national hero after the war. He was pictured on the cover of *Life* magazine in 1945. Actor Jimmy Cagney saw the cover and encouraged Murphy to come to Hollywood and pursue a career in the movies. Murphy had mixed results: he wrote a best-selling book, *To Hell and Back,* about his war experience and starred in a popular 1955 film of the same name, but after some initial success, his acting career floundered, and he found himself playing parts in low-budget Westerns. Problems with gambling and what we now recognize as posttraumatic stress disorder led to depression, drug addiction, and errant behavior. Murphy ultimately died in a plane crash and was buried with full honors at Arlington National Cemetery.

While the Ike jacket was intended for wear in battle, most soldiers preferred to save it for noncombat situations. Following the war, returning veterans wore their jackets primarily as badges of honor, to show to neighbors and prospective employers that they had served in the war.

Eisenhower made an exemplary transition back to civilian life, becoming president of Columbia University before being called back to serve as

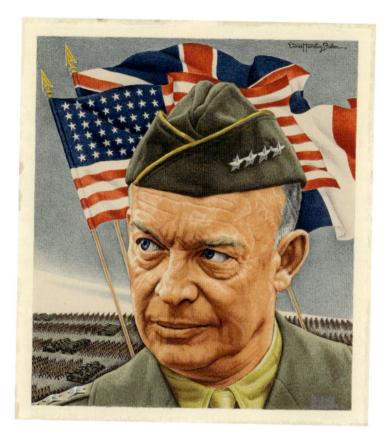

supreme commander of NATO. In 1952, with a slogan reflecting America's regard for his character and service—"I like Ike"—Eisenhower was elected president of the United States, and reelected in 1956. Among his accomplishments were ending the Korean War, signing significant civil rights legislation, and supporting the building of the interstate highway system. Under his tenure, the U.S. Postal Service adopted the Ike jacket—albeit in blue rather than olive drab—as part of its official uniform. And while Ike's presidency was later characterized by the baby boomers as an era of complacency and cultural conservatism, the jacket reminds us of the quietly revolutionary accomplishments of Eisenhower's leadership in both war and in peace.

DWIGHT D. EISENHOWER **BY ERNEST HAMLIN BAKER**

National Portrait Gallery

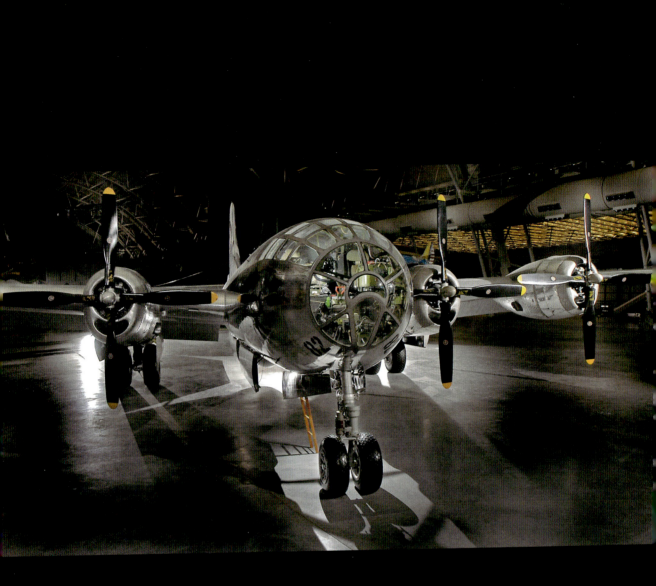

ENOLA GAY BOMBER *National Air and Space Museum*

The *Enola Gay* is the American Boeing B-29 Superfortress bomber, commanded by U.S. Army Air Forces Colonel Paul Tibbets, that dropped the atomic bomb on Hiroshima, Japan, on August 6, 1945, destroying much of the city, killing vast numbers of its inhabitants, and leading to the end of World War II in the Pacific.

In December 1944, Tibbets took command of the new 509th Composite Group and began developing a plan for the delivery of atomic bombs against Germany and Japan. The 509th was activated at Wendover Army Air Field, Utah, and eventually included more than two hundred officers and some fifteen hundred enlisted men, along with fifteen modified B-29 bombers and various support services. The bombers were being built by the Glenn L. Martin Company in Bellevue, Nebraska. The B-29s were especially equipped with the modifications needed to drop the atomic bomb. Among them were a bomb bay with pneumatic doors, special propellers, modified engines, and the elimination of protective armor and gun turrets to reduce weight.

ENOLA GAY

THE BOMBER ENDS WORLD WAR II IN THE PACIFIC, USHERS IN THE ATOMIC AGE, AND STIRS CONTROVERSY OVER ITS EXHIBITION.

National Air and Space Museum

Tibbets selected the aircraft that would fly the first mission in May 1945 when it was still on the assembly line. When completed, Captain Robert Lewis of the 509th Composite Group flew the plane from Omaha to Utah and then on to Guam. In July, it was flown to North Field on Tinian in the Mariana Islands. United States forces had captured Tinian in the summer of 1944 in order to create a base from which to launch B-29 bombing raids on the Japanese home islands. It became the base for the 509th Composite Group.

The bomb the 509th would be dropping was a radically new type of weapon. The idea of using uranium to create a powerful chain reaction of destruction emerged in 1939. Albert Einstein, hearing of German experiments, wrote to President Franklin D. Roosevelt imploring him to establish a program to develop such a weapon, lest the Germans produce it first. The

PLUTONIUM
SAMPLE FROM
1941

*National Museum of
American History*

Manhattan Project, under the command of General Leslie Groves, was created to produce a nuclear bomb. Physicist Robert Oppenheimer led scientists and technicians at Los Alamos, New Mexico, to develop two types of atomic bombs. One was a gun-fission weapon made with uranium-235, a rare isotope extracted in factories at Oak Ridge, Tennessee. The other was an implosion-type device made with plutonium-239, a synthetic element produced in nuclear reactors at Hanford, Washington. A test of the latter type of weapon at Trinity Site near Alamogordo, New Mexico, on July 16, 1945, demonstrated the extraordinary power of the "gadget"—as it was called.

The untested uranium bomb, code-named Little Boy, was to be dropped on Hiroshima; a plutonium bomb, the Fat Man, would be dropped on Nagasaki.

The plane destined to drop Little Boy on Hiroshima was given the circle R tail markings of the Sixth Bomb Group. It flew eight training missions in July and then two combat missions, dropping what were called pumpkin bombs on targets in Kobe and Nagoya, Japan. The brainchild of Tibbets and Navy Captain William Parsons of the Ordnance Division at Los Alamos and devised by the California Institute of Technology, the pumpkin bombs housed conventional explosives, but offered ballistic and handling characteristics similar to those of the atomic bomb and were useful for training the crews.

Little Boy came to North Field in pieces in several air and sea deliveries. The main bomb assembly came in a wooden crate secured to the deck of the U.S.S. *Indianapolis,* a Portland-class U.S. Navy cruiser. The crate weighed about five tons, and was almost twelve feet long, four feet wide, and four feet tall. In Captain Charles McVay's quarters was a lead-lined steel container.

It weighed three hundred pounds and was locked into brackets welded to his deck. It contained the assembled projectile for the bomb with nine enriched uranium-235 rings. The ship delivered her cargo at Tinian on July 26.

Four days later, on her way to Guam, the *Indianapolis* was torpedoed by a Japanese submarine, sinking in twelve minutes. Of the 1,196 crew on board, about 300 went down with the ship, and hundreds of others died at sea in the four days before rescue operations saved 317 survivors.

Three different aircraft arrived at Tinian on July 28 and carried the six uranium-235 target disks, allowing for the complete assembly of the bomb, which would contain about 140 pounds of enriched uranium.

On July 31, the crew flew a rehearsal flight for the mission. Lewis assumed he was going to pilot the B-29, but flew instead as copilot when Tibbets decided to fly the mission and named the airplane *Enola Gay*, after his mother. Later, he would express second thoughts about the choice of name. The bomb was loaded on August 5. Among inscriptions scribbled on its shell was "Greetings to the Emperor from the men of the *Indianapolis*," a poignant payback message for the ship's sinking.

The ultimate decision to drop the bomb rested with Harry S. Truman, who had become president in April with the death of Franklin Roosevelt. Germany surrendered in May, but the Japanese military leadership resolved to continue fighting. The war in the Pacific had been brutal, with about 100,000 U.S. military personnel killed. United States military leaders were planning for a land invasion of Japan that might stretch the war into 1946 and beyond. They were convinced that the invasion would lead to hundreds of thousands of U.S. casualties. They sought alternatives. One was to use poisonous gas. A massive B-29 fire-bombing campaign had devastated Japanese cities, but had not forced a Japanese surrender. The atomic bomb would inflict unprecedented destruction, but might force surrender without an invasion. Impressed by the Trinity test, Truman was ready to go ahead. On July 26, Britain's Winston Churchill and Chinese leader Chang Kai-shek joined the president in issuing the Potsdam Declaration, calling for Japan to offer unconditional surrender or face "prompt and utter destruction."

Allied forces broadcast the key points into Japan and dropped flyers to alert the civilian population. The Japanese leadership rejected the declaration as nothing new and reiterated the determination to fight on.

A high-level U.S. targeting committee considered where to drop the bomb. The aim was to persuade Japanese leaders to surrender. This meant bombing a large urban center where the extent of the blast damage and devastation would be absolutely apparent and unprecedented. Four cities were considered—Kyoto, Kokura, Niigata, and Hiroshima. Secretary of War Henry Stimson rejected Kyoto, a historic cultural center. It was replaced by Nagasaki. Hiroshima, a military center and a key port, was surrounded by hills that would magnify the blast's effects.

The *Enola Gay* had a crew of twelve, but only three men—Tibbets; Parsons, the weaponeer; and bombardier Thomas Ferebee—were aware

ENOLA GAY ON THE TARMAC

National Air and Space Museum

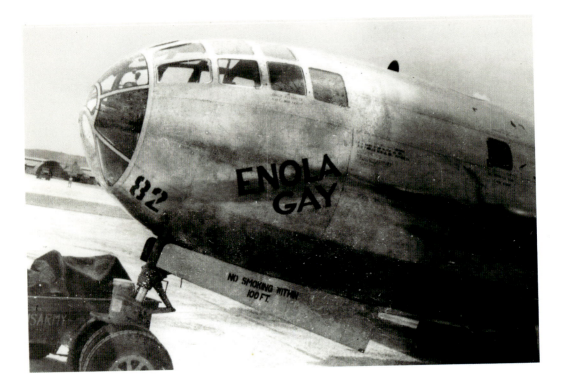

of the nature of the mission before takeoff. The *Enola Gay* left Tinian at 2:45 A.M. Two other B-29s—the *Necessary Evil,* carrying scientific observers and cameras, and the *Great Artiste,* which had instruments to record blast measurements—took off separately. The three planes rendezvoused over Iwo Jima and set course for Hiroshima.

Parsons and an assistant armed the bomb in the air. Though radar had detected the approach of the American planes, the Japanese failed to attack them with either fighters or antiaircraft batteries, assuming that a small formation would inflict only limited damage.

An American reconnaissance aircraft, the *Straight Flush,* flying over Hiroshima indicated clear skies. The *Enola Gay* arrived at about thirty-two thousand feet, and at 8:09 A.M. Tibbets started his bomb run, handing over control to Ferebee. The aiming point was the Aioi Bridge. Six minutes later the *Enola Gay* dropped the bomb.

The bomb exploded at its predetermined altitude of about 1,900 feet above the city. Because of crosswinds, it missed the bridge—though only by 800 feet—and detonated over the Shima Surgical Clinic, exploding with the force of about 12,500 tons of TNT. A mushroom cloud rose into the sky. Approximately eighty thousand people were killed as a direct result of the blast. As many as fifty-five thousand more would die in the months to come of related injuries and radiation sickness. Much of the city was leveled. The *Enola Gay* crew was both awed and cheered by what they had unleashed as they first surveyed the damage and then returned to base.

With no Japanese surrender forthcoming and in order to demonstrate to the Japanese leadership that the United States had the capability of delivering multiple atomic attacks, on August 9, the U.S. B-29 bomber *Bockscar* dropped the Fat Man plutonium bomb on Nagasaki. Again, the devastation and casualties were horrendous. The message was clear, and on August 15, in a radio address to the nation, Japanese Emperor Hirohito announced the surrender. This was formally ratified on September 2. The war was over.

In November 1945, Lewis flew the *Enola Gay* back to the United States. It was formally transferred to the Smithsonian in 1946 and over the years

stored at various locations, going to Andrews Air Force Base in Maryland in 1953. In 1960, the Smithsonian started a yearlong process to disassemble the plane, and then transported its components to a storage facility in Suitland, Maryland. In 1984, the Smithsonian began restoration of the bomber at its Paul Garber facility.

The *Enola Gay* became the center of a controversy in 1994–95 when the National Air and Space Museum proposed using the restored aircraft as the centerpiece for an exhibition commemorating the fiftieth anniversary of the end of World War II and the birth of the atomic age. The exhibition, called The Crossroads: The End of World War II, the Atomic Bomb and the Cold War, explored the causes and context of the war in the Pacific, the events of the war, the rationale for dropping the bomb, and the consequences.

Though the museum involved outside scholars and stakeholders in the development of the exhibition, including U.S. veterans and both American and Japanese authorities, some critics (led by the Air Force Association) objected to an early script. They thought the treatment too sympathetic to the Japanese, excusing Japanese war aggression by citing racist U.S. policies, downplaying Imperial Army brutality in the Pacific, portraying the decision to drop the bomb as more an exertion of U.S. might than an effort to save the lives of servicemen, highlighting the nuclear destruction, and blaming nuclear proliferation and other ills on the bombing. Critics accused the curators, and particularly museum Director Martin Harwitt, of presenting a revisionist view of the war's end. The Air Force Association among others mobilized public opinion and petitioned Congress to cancel the planned exhibition.

Harwitt accused some of the critics of discounting the factual evidence and wanting a mere celebratory display. A number of scholars agreed; others did not. Attempts to discuss and modify the exhibition script proved futile.

Exhibition planning developed under Smithsonian Secretary Robert McCormick Adams, but damage control fell to his successor, I. Michael Heyman, a former chancellor of the University of California at Berkeley

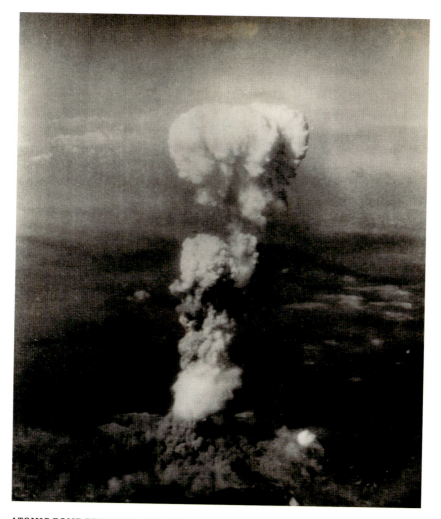

ATOMIC BOMB EXPLODES OVER HIROSHIMA *National Air and Space Museum*

and a U.S. Marine veteran. Confronted with a letter from Congress signed by scores of members, comments from President Clinton, and thousands of angry Americans, Heyman decided to cancel the full exhibition in late January 1995 and opted instead for a simple display at the museum of the *Enola Gay*'s forward fuselage along with video footage of the mission and an interview with the crew. Estranged from the Smithsonian's leader-

ship, Congress, and the regents, Harwitt resigned as director. The exhibit opened in June and ran for almost two years, occasioning a few incidents of protest.

Specialists continued to work on the restoration. The *Enola Gay* was shipped in pieces to the National Air and Space Museum's Steven F. Udvar-Hazy Center at Dulles Airport in Chantilly, Virginia, during the spring of 2003, and its reassembly was completed in August. The fully restored plane was on display for the museum's opening in December, its massive presence rather than its simple, succinct signage marking its awesome significance.

COLD WAR

(1946 TO 1991)

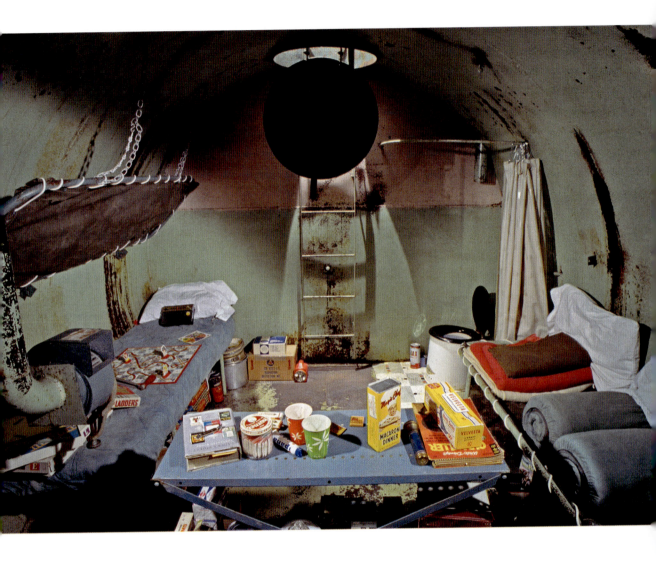

FALLOUT SHELTER *National Museum of American History*

The fallout shelter illustrates the pervasive fear of nuclear attack and its aftermath in the 1950s and 1960s, at the height of the cold war between the United States and the Soviet Union. This particular unit—a freestanding, double-hulled steel structure—was installed beneath the front yard of Mr. and Mrs. Murland E. Anderson of Fort Wayne, Indiana. The residents of Fort Wayne were concerned that they might become targets due to the large number of military industrial sites in the region. They, like thousands of other American families, sought ways to protect themselves from a potential nuclear catastrophe.

<div style="text-align:right">

68

</div>

FALLOUT SHELTER

AMERICANS
TRY TO COPE
WITH THE
UNCERTAINTY
OF THE COLD
WAR AND THE
PROSPECT OF
A NUCLEAR
ATTACK.

*National Museum of
American History*

The American public's experience with nuclear warfare began at the end of World War II. Initial public reaction in the United States and Europe to the bombings of Hiroshima and Nagasaki in August 1945 was extremely positive, as the use of nuclear weaponry was believed to have expedited the surrender of Japan and spared Allied lives. Footage of the cities immediately after bombing remained classified for decades for fear of alienating public opinion. However, as uncensored reports emerged, the public realized the unimaginable human suffering caused by the bombs, and fear of this newfound capacity for man-made destruction began to outweigh celebration. Among the most notable postattack accounts of the bombings were Wilfred Burchett's dispatches in the *Daily Express* and John Hersey's *Hiroshima,* published in the *New Yorker* on the first anniversary of the bombings in 1946.

When the Soviets successfully detonated their first nuclear weapon on August 29, 1949, at the Semipalatinsk Test Site in present-day Kazakhstan, it was widely interpreted as a warning that the United States was now vulnerable to nuclear attack. Further driving American fears was an increasing awareness of the horrific aftereffects of radiation exposure. The dangers of being exposed to highly radioactive postexplosion particles called fallout,

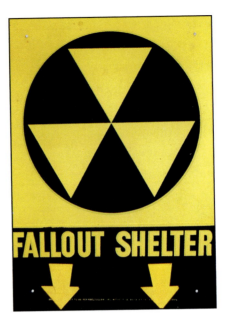

was becoming known—or at least widely rumored. Popular culture responded to this new, widespread fear; in 1954, the film *Godzilla*, featuring a monster born from the effects of the nuclear warfare in Japan, found a widespread audience.

During the cold war, the possibility of nuclear confrontation between the two superpowers loomed large in the public imagination to an extent that is today difficult to imagine. A national emergency warning alarm system (NEAR—National Emergency Alarm Repeater), based on the air-raid siren warning system of World War II, was implemented in the United States in 1956. In 1963, it was succeeded by the Emergency Broadcast System, a distinctive warning signal to be played on all radio and television stations in the event of a nuclear attack (euphemistically termed "an actual emergency"). But nuclear warfare posed the new challenge of avoiding not only the blast itself but the fallout afterward.

Governments in the United States and Europe quietly designated reinforced underground bunkers as safe retreats for high-ranking officials in

case of nuclear attack while assuring the population at large that there was little danger. In the United States, the luxury Greenbrier Resort in White Sulphur Springs, West Virginia, 248 miles from Washington, D.C., was outfitted in 1958 with an elaborate underground facility to house high-ranking federal officials for several months in the event of an attack. The Federal Civilian Defense Administration (FCDA) distributed information broadly on how to survive a nuclear attack. Existing public buildings with sturdy basements were designated as civilian fallout shelters, marked with a distinctive yellow and black symbol, and films were distributed to schools, where children practiced federally mandated, and in actuality pointless, "duck and cover" drills. In September 1961, the U.S. government announced the Community Fallout Shelter Program, publicized by a letter from President Kennedy published in *Life* magazine.

In response to popular demand, the FCDA also published plans for how people could build their own fallout shelters, endorsing the idea that Americans could survive nuclear war, one family at a time. In the Midwest, there was already a tradition of residential basement storm cellars, which existed to shelter families from tornadoes. Individuals in other parts of the country soon latched on to this idea, updating their shelters with heavy concrete or lead linings to protect against radiation, and stocking them with the recommended supplies, including seven gallons of water per person (half a gallon per day), nonperishable food, receptacles for human waste, a first-aid kit, a flashlight, and a battery-operated radio for news of the outside world.

The FCDA also recommended storing board games, books, and magazines to help pass the time until it was safe to emerge. Shelters—such as this one—were equipped with generators for power and filtered air ventilation. Their decorations tended to be spartan, reflecting a grim, survivalist aesthetic.

Novels of the period, like Nevil Shute's apocalyptic *On the Beach*, Pat Frank's *Alas, Babylon*, and Fletcher Knebel's *Seven Days in May*, and their offshoot dramatizations instilled a public fear and maybe even in-

ured citizens to the prospect of nuclear war and its devastating aftermath. A chilling episode of the immensely popular television series *The Twilight Zone* entitled "The Shelter" stoked anxieties at the time by depicting panicked neighbors destroying a wealthy family's shelter in the effort to save themselves.

In October 1962, the Cuban missile crisis brought the United States and the Soviet Union to the very brink of nuclear war. Newspapers published accounts of how little time people would have to seek shelter in the event of a nuclear attack. I remember as a young teenager thinking I would have nineteen minutes to retrieve my younger brother in elementary school, hurry home, and hide in a nearby community basement fallout shelter.

In its aftermath, the crisis was interpreted as a demonstration of the concept of mutually assured destruction—the idea that neither the United States nor Russia would launch a nuclear attack knowing that the other could retaliate in kind. Stanley Kubrick's 1964 black comedy *Dr. Strangelove or: How I Learned to Stop Worrying and Love the Bomb* satirized this concept, along with cold war stereotypes and the futility of public safety efforts. Whether because of that increased sense of futility or through extended exposure and adjustment to the concept of nuclear annihilation, nuclear fallout shelters became the subject of widespread ridicule by the 1970s.

The Andersons maintained their fallout shelter from 1955 through the 1960s. They bought it from a Fort Wayne realtor who sold fallout shelters as a side business. Installation proved problematic. It was not adequately anchored against Fort Wayne's high water table, and in 1961 the shelter popped to the surface of the Andersons' front yard just in time for the Cuban missile crisis. That event precipitated a frenzy of shelter-building activity, and the Andersons' unit was quickly reinterred. In 1968, Vera Howey purchased the property, including the shelter, from the Andersons. By 1989, the Howeys were tired of the attention the shelter attracted and contacted the Smithsonian to see if the museum was interested in its acquisition. Curator William L. Bird was. He believed the fallout shelter was "a key

icon of Cold War domesticity reflecting the vision of civilian life in the atomic age between Presidents Truman and Kennedy." He and a group of colleagues had the shelter exhumed and brought to the Smithsonian.

For exhibition purposes, a window was cut in the side, the deteriorated cots were replaced, and the shelter was stocked with the kinds of provisions one might have found in 1950s Indiana. It continues to remind museum visitors of the pervasive anxiety of the cold war era caused by the looming threat of annihilation.

69

MERCURY *FRIENDSHIP 7*

On October 4, 1957, the Soviet Union successfully launched an R-7 intercontinental ballistic missile carrying a 185-pound, basketball-sized satellite named Sputnik (often translated as "traveling companion"). This was the world's first man-made object to be placed into Earth's orbit, traveling at about 17,000 miles an hour some 500 miles above Earth and emitting a continual *beep-beep* radio signal. Sputnik's launch came as a surprise to many Americans, and there was widespread anxiety that the United States had lost its technological superiority on the world's stage. A month later, the Soviets launched a much larger Sputnik 2, with a Samoyed-terrier canine aboard as a passenger, suggesting that manned space flight was not too far behind. The cold war had now moved into space. The "space race" between the United States and the Soviet Union, two major world powers of the post–World War II era, was on. Though the Soviets got there first, the Mercury *Friendship 7* flight would help America catch up.

The United States had been working on its own satellite launch programs. In light of U.S. public pressure after Sputnik, the Navy tried to make up some lost ground, and in December 1957 it launched a rocket carrying the Vanguard TV3 satellite. With a television audience expectantly watching, the rocket failed on the launchpad; the press called the mission "flopnik" and "kaputnik." The U.S. Army, competing against the U.S. Navy, successfully launched Explorer I in January 1958, while another Navy Vanguard failed in February, before one finally succeeded in March. Overall, Americans were dismayed by what seemed like the jolting inferiority of U.S. rockets to those of the Soviets. The public pressured Congress and the administration of President Dwight D. Eisenhower to accelerate develop-

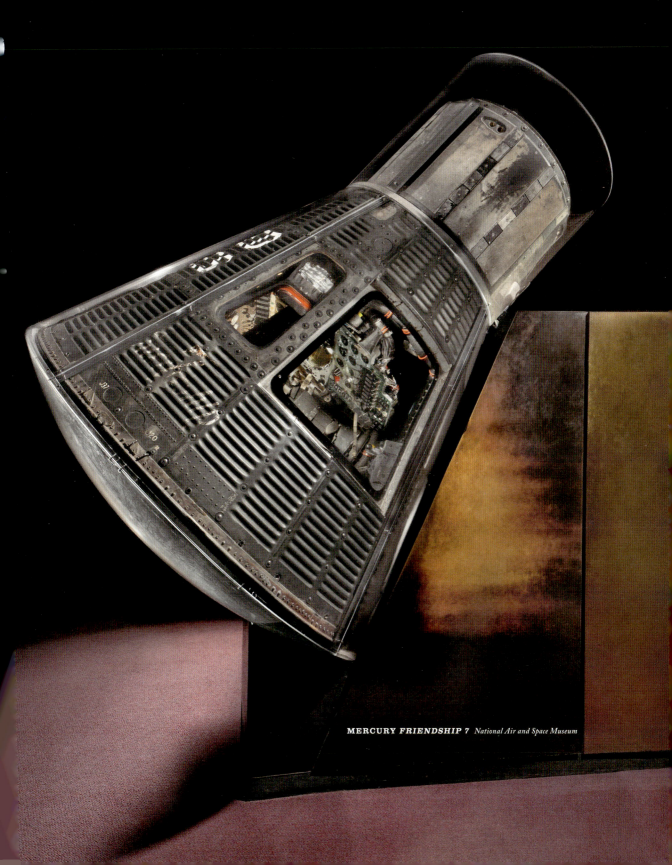

MERCURY FRIENDSHIP 7 *National Air and Space Museum*

ment of a national space program. Americans also questioned the quality of their educational system and research infrastructure to support space travel. Enhanced federal funding, particularly for science, mathematics, and engineering, was supported as a matter of national security.

Eisenhower, well aware of interservice rivalries, and heeding the advice of scientists, statesmen, and political leaders, formed the National Aeronautics and Space Administration (NASA) as a civilian government agency; it came into existence on October 1, 1958. Its first mission, Project Mercury, was to put an American into orbit.

NASA sought a quick way of doing this by designing and building a small nose-cone capsule that could be launched into space atop a rocket. The challenge, aside from achieving a successful launch and orbit, would be to keep the pilot, or astronaut—Greek for "star sailor"—alive in space and through the return to Earth, unlike the Russian dog, which had died during her journey. A NASA aeronautical engineer, Max Faget, pioneered the idea of a conical spacecraft with a cylindrical nose. It had a broad, flat base covered by a heat shield. This would create a shock wave to slow down the spacecraft as it plunged back toward Earth, while protecting the astronaut and equipment from the intense heat of atmospheric reentry. The heat shields for the Mercury project would be made of fiberglass and resin. NASA chose a Redstone rocket as the launch vehicle for its first suborbital flights because of its dependability, then later switched to the more powerful Atlas rocket, which could deliver a capsule with the higher velocity needed for orbital flights.

In April 1959, NASA chose astronauts for the Mercury program after reviewing some five hundred active military test pilots. NASA did not seriously consider women. The final list of candidates went through a grueling battery of medical and fitness tests. The chosen "Mercury Seven" included Alan Shepard Jr., Virgil "Gus" Grissom, John Glenn Jr., Scott Carpenter, Wally Schirra Jr., Gordon Cooper Jr., and Donald "Deke" Slayton. The country finally had a public face to its race with the Soviets; the men became instant American heroes. The astronauts participated in a rigorous

training program. As former test pilots, they insisted on playing a role in the design of the craft. For example, the Mercury capsule included only two small, round, awkwardly placed portholes of little use to the astronauts. The astronauts insisted on a window over their heads so they could see out from their seated position. They also contributed to the interior layout so they could more easily and effectively operate manual controls should any of the automated systems fail.

In September 1959, the Soviets crashed a 177-pound capsule called Luna 2 on the surface of the Moon, and the following month they used Luna 3 to photograph the hidden far side. In the public's eye, the United States appeared to be falling further behind. It wasn't until January 1961 that, at least perceptually, the United States seemed to be making substantial progress. Ham, a four-year-old Cameroonian chimpanzee, was successfully launched on a suborbital space flight in a Mercury capsule. The chimp was named after the Holloman Aerospace Medical Center at the New Mexico Air Force base, where he was trained to push levers in response to blinking-light signals. This enabled NASA scientists to assess the effects of space travel upon performance as a prelude to human flight. More important, the space capsule returned Ham to Earth alive after a sixteen-minute flight, demonstrating the viability of manned flight. Ham then took up residence at the Smithsonian's National Zoo for seventeen years before retiring to live out his days at the North Carolina Zoo.

Americans planned to beat the Soviets by sending a manned rocket, *Freedom 7,* into space in March 1961. But technical problems delayed the launch, and on April 12, the Soviets got there first, making cosmonaut Yuri Gagarin not only the first person in space but also the first to orbit Earth. On May 5, 1961, the United States scrambled to catch up and launched its first American, astronaut Alan Shepard, into space on a suborbital flight that took fifteen minutes and twenty-two seconds.

Less than three weeks later, President Kennedy addressed Congress, challenging it to fund a program that would give the United States the undisputed lead in the exploration of space:

I believe this nation should commit itself to achieving the goal, before this decade is out, of landing a man on the Moon and returning him safely to Earth. No single space project in this period will be more impressive to mankind, or more important in the long-range exploration of space; and none will be so difficult or expensive to accomplish.

This was a bold statement, and on the face of it seemed quite ambitious. Less than sixty years after the Wright brothers' first powered flight wobbled a few feet off the ground for a few moments, the notion of landing a man on the Moon was still the stuff of science fiction movies and books. The sheer ambition of Kennedy's goal sent a determined and visionary message to the American public about space as the new American frontier. But perhaps more intentionally, Kennedy's message was also intended for the Soviet Union, which presumably also sought a manned Moon landing. Kennedy put the Soviet leadership on notice that the United States was not going to cede the control of space without a fight. Kennedy's speech helped bring even more public attention to the U.S. space effort.

The Soviets' lead narrowed on February 20, 1962, when forty-one-year-old John Glenn was propelled into space from Cape Canaveral, Florida, atop an Atlas rocket. Glenn was a seasoned Marine Corps test pilot. Born in Ohio, he had flown fifty-nine combat missions in World War II and had served as a jet fighter pilot in the Korean War, shooting down three MiG-15 fighter jets. In 1957, before being selected as a NASA astronaut, he had set a speed record for a coast-to-coast transcontinental flight.

Glenn's space capsule, the *Friendship 7,* was fabricated by McDonnell Aircraft Corporation. Its skin and structure were made of titanium, with nickel-steel alloy and beryllium shingles. It was a small spacecraft—about six feet across at its base and a bit over eleven feet long, weighing barely more than a ton and a half. The capsule was so compact that the astronauts joked: "You don't get into it, you put it on."

Glenn became the first American to orbit Earth, making three orbits

in *Friendship 7* over the course of a flight that was just about five hours from liftoff to splashdown. Glenn wore a space suit and was strapped into a form-fitting fiberglass seat designed to ease the accelerations of launch and reentry. He kept in touch by radio with Mercury Mission Control at NASA and its worldwide network of ground stations in places as far away as Zanzibar and Australia.

With the equipment on board, Glenn was able to report on observations from space, monitor his physical condition, and conduct a few experiments. He took pictures out the window using two cameras and a jury-rigged pistol grip to accommodate his bulky space gloves. He also had to engage manual controls to adjust the heading of the spacecraft in orbit, and to assure proper functioning of his heat shield, which was a matter of high concern during his flight because of an errant signal indicator suggesting it was loose. If the heat protection did not work, Glenn knew the last thing he'd feel would be a pulse of heat at his back before he burned up upon reentry into Earth's atmosphere.

But the heat shield held and Glenn safely reentered the atmosphere nearly twenty miles above Earth's surface. *Friendship*'s parachute deployed at about eleven thousand feet. Glenn splashed down in the Atlantic Ocean and was picked up by the U.S.S. *Noa*. The capsule was pulled up on deck, where Glenn fired the explosive hatch and exited to the crew's and the country's acclaim, including a congratulatory call from President Kennedy. Once he was back in the United States, a Washington, D.C., parade, an address to a joint session of Congress, and a New York ticker-tape parade followed. Glenn was the hero of a grateful nation.

NASA conducted an assessment of *Friendship 7* and then sent it on what became known as its fourth orbit—a goodwill tour around the world. In three months, the capsule traveled to thirty cities. It was exhibited in museums and other venues, and seen up close by nearly four million people in London, Paris, Madrid, Accra, Cairo, Tokyo, Manila, and Bombay. The capsule finally arrived at the Smithsonian in November 1962. It was placed on display in the Arts and Industries Building initially and then moved into

the Milestones of Flight Gallery in the National Air and Space Museum, which opened on the National Mall for the U.S. Bicentennial in 1976.

John Glenn was elected in 1974 to the first of four terms in the U.S. Senate, representing his home state of Ohio. During his tenure, he participated in numerous Smithsonian programs and remained a constant champion of the museum. In 1998, at age seventy-seven, he journeyed into space once again, this time for nine days. He served as a payload specialist on the space shuttle *Discovery,* providing scientists with data on the effects of space on older people. More than a decade later he was still serving the space program, on the tarmac, welcoming *Discovery* after its last journey.

T he Huey helicopter is perhaps the most recognizable military icon of the Vietnam War—firing from the air in combat, transporting troops, evacuating casualties, and moving supplies. Its distinctive appearance, its rotating flight blades with their signature *whup-whup-whup* sound, were constantly welcomed as a sign of the support and relief it brought U.S. troops.

HUEY HELICOPTER

Some five thousand or more Huey helicopters flew in-country in Vietnam. Although some helicopters were used in World War II, and a few more in the Korean War, it was not until the Vietnam era that helicopters came to be used so extensively and in such a variety of roles.

Technically, the Huey emerged from advances in helicopter propulsion, specifically the adaptation of the gas turbine engine in the 1950s. Older, heavier engines weighed down helicopters, whereas because the new gas turbine engines were much more efficient they were lighter and produced more power. This development enabled the design and construction of smaller, lower-profile, more nimble aircraft. Though first designed as an aerial ambulance, the XH-40 Bell utility helicopter's usefulness was recognized as potentially wide ranging.

The XH-40 was called the HU-1 (Helicopter Utility) when the U.S. Army took delivery, and it is from that designation that the helicopter got its nickname, "Huey." The Department of Defense reversed the name to UH-1, but the nickname stuck. With larger engines and increased capacity, the UH-1 was developed through successive models.

Tactically, the Hueys fit with the U.S. Army's idea of an "air cavalry," and grew out of theoretical military discussions in the mid-1950s of achieving troop mobility on a nuclear battlefield. This evolved in more practical ways as officers considered ways of fighting conventional battles that could take advantage of highly mobile aircraft. Helicopters could replace trucks and

THE "WORKHORSE" OF THE VIETNAM WAR IS REMEMBERED FOR ITS ROLE IN BATTLE, RESCUE, AND HEALING.

National Museum of American History

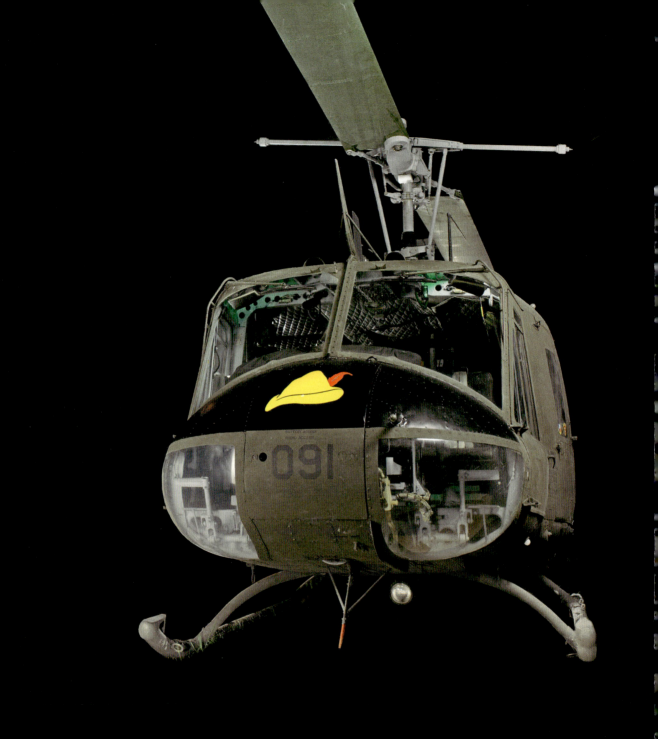

HUEY HELICOPTER *National Museum of American History*

other ground transport in quickly and effectively moving troops around a battlefield, particularly in tough, contested terrain.

The first Hueys were produced at Bell's Fort Worth, Texas, plant and began arriving in Vietnam in 1962. The UH-1D's fuselage size could accommodate large cargo doors and twin cabin windows on each side of the craft. Its large rotor was powered by a Lycoming engine, giving it a top speed of more than 120 miles per hour and a range of almost 300 miles. The UH-1D medevac version could carry six stretchers and one medical attendant. The troop carrier could hold a dozen troops, with a crew of two. The Huey was easily configured for a variety of missions, including as a gunship with an extensive array of guns and rockets.

The Huey was the warhorse of combat for U.S. troops, provoking a strong experiential and emotional attachment in just about everyone involved in the conflict. As Smithsonian curator Roger Connor notes, "[U.S.] Soldiers in Vietnam loved and loathed the Huey. The Huey brought them to the gates of hell, but it also . . . provided deliverance." In a typical air-assault mission, Huey troop carriers, called slicks because they were stripped of most other equipment, inserted troops deep in enemy territory while Huey gunships, equipped with machine guns, grenade launchers, and other weaponry, typically escorted the transports. Helicopters could quickly insert an infantry company into battle and support their fighting closely from the air. This especially suited the guerrilla nature of Vietnam War battles, fought over varied and shifting terrain. To enemy Vietnamese, Hueys were seen as malevolent predatory birds coming to swoop in and attack.

As a medical transport, the Huey evacuated hundreds of thousands of combat casualties throughout the war years and saved tens of thousands of American lives. Its mobility in battlefield situations assured that many wounded soldiers could be rapidly sent to medical facilities for treatment. Hueys also brought troops food, water, supplies, and ammunition.

The Hueys became a visual emblem of combat to tens of millions of viewers watching war coverage on the nightly news, in documentaries, and in feature films. In movies like *The Green Berets,* starring John Wayne and

David Janssen, the helicopters signaled a robust and effective U.S. effort. But to critics of the war, the Huey took on the ominous image of an impersonal, aggressive United States sweeping into the lives of peasants and causing untold damage and legions of unintended victims. This ominous image came across in some Vietnam War protests and in film depictions like Francis Ford Coppola's *Apocalypse Now,* Oliver Stone's *Platoon,* and Stanley Kubrick's *Full Metal Jacket.*

It was opposition to the war back in the United States that eventually brought the Hueys and the U.S. troops home. The bipartisan political support for U.S. involvement in stemming Communist aggression in Vietnam—carried forward and accelerated by presidents, the U.S. Congress, the media, and the public—had eroded over the years. Questions about the motives and legitimacy of the U.S.-allied South Vietnamese government and military leadership, coupled with a huge military escalation that produced little by way of concrete gains, exacerbated growing domestic resistance to the military draft. An increasing lack of confidence in the aims and tactics of the Vietnam conflict turned politicians, the media, and the public away from support for the war. Revelations about inflated enemy casualty figures, the corruption of the United States' Vietnamese allies, and the massacre of civilians at My Lai undermined confidence in the war and its moral basis.

The Huey in the Smithsonian's American history collection has a multifaceted history. It came off the Bell assembly line in 1965, with the official designation 65-10091. It was deployed to Vietnam in 1966 and used in battle by the Army and the Marines, as indicated by the nomenclature on its tail section. It was flown by members of the 173rd Assault Helicopter Company, the Robin Hoods, as they were called. Ed Walsh was its first chief, and it was his crew that named her "091." The Huey performed many missions and had multiple purposes. She was shot up three times; on her last mission on January 7, 1967, she was hit in the cockpit, the hydraulic system was damaged, and the helicopter crash-landed.

Declared a loss, the damaged 091 was brought back to the United States. Repaired, she flew with units at Fort Sill in Oklahoma and Fort Stewart

in Georgia, and later at the aviation school at Fort Rucker in Alabama. In 1971, the 091 was assigned to the National Guard, and by 1973 she was in Germany. There she served with the Twenty-fourth Engineering Group at Sembach Air Base, where she was again refurbished and used mainly to ferry VIPs. The 091 ended up with NASA, and by 1995 was sold to the Texas Air Command Museum for $3,500. This organization enlisted U.S. Helicopter in Ozark, Alabama, to restore her to flying condition.

In 2002, Arrowhead Films leased 091 for use in the documentary film *In the Shadow of the Blade*. Veterans of the 173rd dressed her nose with their signature yellow hat, and then sent the battle-scarred helicopter off for a ten-thousand-mile journey. The 091 landed at reunions, ceremonies, and events in towns, cities, and military bases across the country. It was visited by Vietnam veterans, their families, and others. During these stops, people left letters, patches, badges, photographs, pins, flags, and other personal items in her padded cockpit lining. Some sat in her seats. Ernie Bruce, a Robin Hood pilot who had flown the 091 in Vietnam, took the pilot's seat and again flew the Huey for the film. The documentary crew filmed these many encounters and collected oral histories, seeing firsthand how the presence of the Huey helped heal many of the war's emotional wounds.

The Texas Air Command Museum had intended to sell the 091 Huey, and arrangements with a Canadian logging company were moving forward as the documentary was being filmed. The engagement of Vietnam War veterans in the film project, though, provoked an unexpected development. This Huey's appearance—its sound and smell—rekindled the wartime experience in veterans' memories. That inspired a "Save America's Huey" drive that enlisted DynCorp, a helicopter and aircraft servicing contractor; Bell Helicopter, its mother company; and a nonprofit organization. The partners came up with about $400,000 for the Texas Air Command Museum so that they could donate the helicopter to the Smithsonian.

The actual donation took place in 2004. The Huey, with six Medal of Honor recipients as passengers, flew over the National Mall and landed next to the National Museum of American History. The characteristic sound of

the Huey brought people out of Washington's downtown office buildings and museums. The Huey was put on display in the Price of Freedom exhibition, with the patches, pins, and other mementos left intact. It is one of the few objects in the exhibition that visitors, particularly Vietnam veterans, make a pilgrimage to see. Curators have found flowers, photographs, and other tokens surreptitiously added to the Huey exhibit, much as park rangers find them at the Vietnam Memorial on the Mall nearby. The Smithsonian's visitors remind us that the Huey is not just a historical artifact; it is a powerful, emotive touchstone of the war in Southeast Asia.

Pandas are a distinctive and rare species of bear found in remote, high-altitude bamboo forests in central and western China. We humans find them adorable. Biologists speculate that our emotional response is related to their bodily proportions: their oversized heads relative to the size of their torsos trigger a subconscious association to a human baby.

In 1972, two pandas, Ling-Ling and Hsing-Hsing, were given to the National Zoo as a symbol of the thawing of cold war relations between the United States and the People's Republic of China. Not everyone was happy about the diplomacy, but the panda pair immediately became the most popular inhabitants of the Smithsonian's living collection.

In February 1972, U.S. President Richard Nixon traveled to mainland China, ending twenty-two years of diplomatic separation. China had been a Communist country since 1949, when the forces of Mao Zedong defeated the Nationalist forces of the Kuomintang, led by Chiang Kai-shek. Mao and the Communists proclaimed the People's Republic of China, with its capital in Beijing. Chiang, his army, and two million supporters fled to the offshore island of Taiwan and declared its major city, Taipei, the capital of the Republic of China. The United States recognized this small, Nationalist government, not the larger Communist mainland government. This action diplomatically defined the cold war in Asia.

Although a staunch anti-Communist, Nixon realized that by supporting Taiwan and refusing to acknowledge the mainland regime, the United States was actually encouraging an alliance between the Chinese Communists and the Soviet Union. His travel to the mainland effectively acknowledged Communist rule. During the trip he signed the Shanghai Communiqué, in which both nations agreed to work toward normalization of relations. The United States agreed to pull its troops out of Taiwan and to acknowledge

PANDAS FROM CHINA

ADORABLE
MAMMALS
FROM CHINA
BREED
DIPLOMACY
WITH THE
UNITED STATES
AND RAISE
AWARENESS
ABOUT
ENDANGERED
SPECIES.

National Zoological Park

PANDAS LING-LING
AND HSING-HSING

National Zoological Park

that the capital of the "one China" was Beijing while the People's Republic agreed that the Communist regime would not "seek hegemony in the Asia Pacific region."

Nixon's normalizing of relations with China was viewed by some conservatives, including members of his own Republican Party, as a betrayal of American ideals. By cooperating with the People's Republic of China, they argued, Nixon was granting legitimacy to a totalitarian regime. On the other hand, proponents argued that closer relations with the United States would lead to change for the better in China.

Nixon's eight-day visit was heavily televised. He and his wife, Pat, visited the Forbidden City, the Ming Tombs, and the Great Wall, and were guests at a state banquet where they encountered such exotic fare as thousand-year-old eggs and tiny songbirds *en brochette*. The reciprocal presentation of gifts between host and guest is quite important in Chinese culture, and in this case the gifts needed to suitably mark the occasion that Nixon referred to as "the week that changed the world."

The Chinese gift: two pandas that had been captured in the wild months before. The pandas were strongly desired by the Smithsonian's National Zoo; no American zoo had hosted a panda for two decades. It was a wonderful goodwill gesture. What animals would the United States give China in return? According to Ted Reed, the zoo's director at the time, this caused some consternation and debate.

American bald eagles were thought by the U.S. Department of State to be inappropriate because no one was sure exactly how friendly the relationship between the two countries was. Mountain lions suggested a killer and were ruled out, as were grizzly bears as they symbolized the Soviet Union. Mountain sheep, goats, and pronghorn antelope were all deemed too delicate for the trip. American elk and deer were not sufficiently different from Chinese elk and deer to merit a gift. The National Zoo and State Department settled on American bison, but the Beijing Zoo already had some. Musk oxen were settled on as a compromise. As the National Zoo had no musk oxen, the Smithsonian purchased a pair from the San Francisco Zoo.

What to name the pandas was also debated. Radio commentator Paul Harvey suggested "Ping" and "Pong," reflecting the visit of the U.S. table tennis team to Beijing the year before. Congress liked that choice too, but the Smithsonian kept Hsing-Hsing for the male and Ling-Ling for the female, explaining that "we should honor the generosity of such a gift as well as the people of the People's Republic of China by retaining their Chinese names."

The pandas arrived at the zoo in Washington, D.C., in April and were welcomed by Pat Nixon. During the formal presentation, Ling-Ling ate her panda porridge, licked the bowl clean, and put it on her head. Both pandas became instant celebrities. They were photographed and filmed thousands of times, featured on an episode of *Mister Rogers' Neighborhood,* and graced the cover of *National Geographic.* Panda cutout kits were sent to schoolteachers around the country. Thousands of Americans sent letters about the pandas to the Smithsonian; children sent paintings and drawings.

The zoo had to figure how to house the pandas. For each panda zoo specialists created an indoor cage space of 1,250 square feet and a private sleeping den of 150 square feet. The Panda House was kept around 50 degrees Fahrenheit in order to replicate their home climate at 10,000 to 15,000 feet in elevation. Outdoor space consisted of an expansive terraced area with trees and a pond. The pandas were fed twice daily and had constant access to potted bamboo. The morning feeding was a special panda porridge consisting of rice, vitamin and mineral supplements, honey, and a dash of salt. The afternoon feeding included the same porridge mixed with Milk-Bone dog biscuits; fruits and vegetables such as carrots, apples, and cooked sweet potatoes; and freshly cut bamboo stalks.

The pandas' lifestyle earned some media criticism, as they were said to be living "like mandarins at U.S. taxpayer expense." They were ensconced in air-conditioned quarters, enjoying their terraced garden and "his-and-her wading pools" at an initial one-time cost of about $550,000. The zoo defended the costs—they would be only about $4,000 annually—and the treatment, as these were rare and valuable animals with a special diplomatic status.

Diplomacy, though, was discarded when it came to their sex life. Pandas have only a two- or three-day period once a year that allows for reproduction. Copulation is quick and often awkward for pandas in captivity. The pair's mating difficulties were well-known; the zoo referred to the scrutiny as "prurient panda publicity." Nationally syndicated newspaper columnist Art Buchwald penned a satirical column, "Panda Marriage Troubles All," humorously tracing Hsing-Hsing's lack of romantic desire to his upbringing during China's Cultural Revolution, "when making love was denounced as a bourgeois capitalist activity to distract the masses." Over the years, the *Washington Post* has run an annual "Panda Pregnancy Watch," keeping readers informed on the latest signs of a possible pregnancy, which is difficult to determine. The couple eventually produced five cubs, but none survived more than a few days. Neither mating nor artificial insemination, nor even bringing in another, more robust suitor, succeeded in producing a viable offspring.

Ling-Ling died from heart failure at the age of twenty-three at the end of 1992. Hsing-Hsing lived several more years, to the advanced age of twenty-eight. He had to be euthanized in 1999 due to a painful and debilitating kidney disease.

The Smithsonian then successfully negotiated the ten-year loan of a new pair of pandas, Mei Xiang and Tian Tian, for an annual loan fee of $1 million. No federal funds were used, and the loan fee was designated for research on panda reproduction and survival in Chengdu, in China's Sichuan Province.

The zoo's premier wildlife veterinarian and reproductive scientist Jo Gayle Howard developed numerous advances and mentored other zoologists in an effort to see the pandas thrive. These two did not mate successfully; Mei Xiang was artificially inseminated by Howard, and in 2005 gave birth to Tai Shan, causing "Pandamania" in Washington, D.C. Webcams trained on the panda enclosures proved very popular. The cub gained a nickname, "Butterstick," from his tiny, though typical, six-inch and four-ounce size at birth. As stipulated in the loan agreement, he had to return to China in

2010 to enter a breeding program. Washingtonians greatly lamented his departure.

When the musk oxen presented to the Chinese, Milton and Matilda, died in 1980, the United States donated replacements, Koyuk and Tanana. Needless to say, they haven't been anywhere near as big a hit in China as the pandas have been in the United States.

Since the initial gift of the pandas, the United States has become China's largest trading partner. Diplomatic relations have evolved, but are still complicated—and still involve the pandas. In 2000, while the Smithsonian's zoo was negotiating with the Chinese government for the acquisition of pandas to replace Hsing-Hsing and Ling-Ling, I was leading the efforts of its Folklife Festival to feature a program on the living traditions of the Tibetan diaspora. We were planning to bring to the National Mall in Washington, D.C., hundreds of Tibetan artists, craftspeople, dancers, singers, and cultural specialists, including Buddhist priests, to demonstrate to the public the desires and challenges of keeping their culture alive outside of Tibet. We planned to do this in an educational, nonpolitical way for ten days over the Fourth of July holiday period. We expected to attract about one million visitors. I met with the Dalai Lama numerous times and he agreed to participate. The Chinese government objected. Noting their position, I nonetheless asserted that they had no right to dictate what Americans heard, especially on their most public grounds, during a time commemorating their own freedoms. "The National Mall of the United States is not Tiananmen Square," I told the embassy. The Chinese government protested to the State Department and the White House, and threatened to reject their loan of the pandas if the Dalai Lama appeared at the festival. Thankfully, cooler heads prevailed, and the Smithsonian and, more important, the American people got both. The Dalai Lama spoke to a huge crowd on July 2, 2000, and the pandas came soon after.

The possibility of another cultural dustup occurred in 2012. As the zoo was renegotiating the agreement for the pandas, the Smithsonian's Hirshhorn Museum and Sculpture Garden and the Arthur M. Sackler Gallery

of Asian art were planning three exhibits by the world-renowned Chinese dissident artist Ai Weiwei. The panda negotiations were successfully concluded and the exhibitions were produced, but Weiwei was not allowed to leave China and attend the opening at the Smithsonian.

Politics aside, the presence of pandas at the National Zoo since the 1972 Nixon visit has made it one of the leading centers for giant panda biology and conservation. This is essential, as the giant pandas are an endangered species. Only about sixteen hundred are estimated to live in the wild while just over three hundred live in captivity in zoos and breeding centers around the world. The National Zoo sees their pandas as "ambassadors for conservation." While this is a different diplomatic role than the one foreseen by Nixon, it is certainly a most worthwhile one.

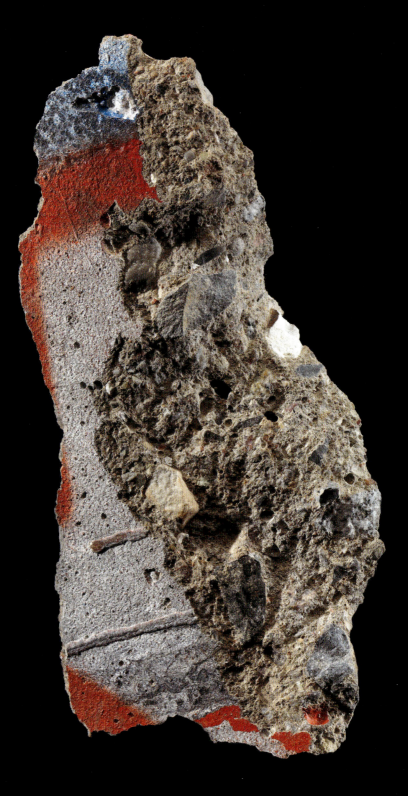

BERLIN WALL FRAGMENT *National Museum of American History*

U sually the Smithsonian likes its artifacts—its treasures—in one piece. This one has special meaning precisely because it is broken!

Its story began when the Allied capture of Berlin in May 1945 effectively ended World War II in Europe. The Nazi government was defeated. At least forty million European civilians and military personnel had died, tens of millions were injured, more were dislocated. Europe was

BERLIN WALL FRAGMENT

in shambles. Berlin, the imperial capital of Prussia and of Nazi Germany, lay in ruins. One third of the city had been destroyed during air raids and in street-to-street fighting during the final Battle of Berlin. Troops of the Soviet Union occupied the city on behalf of the Allies, and in the ensuing months turned over three sections of Berlin to France, the United Kingdom, and the United States, as called for by the terms of the London Protocol of 1944. To make things more awkward, the divided city of Berlin was surrounded by Soviet-controlled Germany. The division of Germany into an eastern zone, occupied by the Soviets, and a western zone, occupied by the other Allies, was to be temporary, an interim arrangement until the country could be reconstituted and reunified.

A BARRIER TO FREEDOM THAT DEFINED THE COLD WAR ALSO SIGNALS ITS END.

National Museum of American History

That plan took longer than expected, as divisions between the democratic West and the Communist East hardened in the war's aftermath. Soviet-backed Communist governments took power in Eastern Europe. Speaking in Fulton, Missouri, in March 1946, Winston Churchill provided a graphic image of this division to the American public: "From Stettin in the Baltic to Trieste in the Adriatic, an iron curtain has descended across the Continent."

Berlin became the focal point of this East-West divide. When in 1948 the United States, France, and Britain devised plans to unite their occupation zones into West Berlin and to better integrate it with the rest of west-

ern Germany through currency reform, the Soviets reacted with the Berlin Blockade, cutting off all road corridors to Berlin. The United States, France, and Britain now could not bring supplies in to the two million inhabitants of the western part of the city. The Soviets made food a weapon of the cold war, increasing provisions available to Berliners in its eastern zone, while at the same time restricting the flow of provisions to the western sections of the city. Realizing that this amounted to a siege, the western Allies countered with the Berlin Airlift, a massive, expensive, and complex effort to supply western Berlin by airplane shipments. The air bridge, as Berliners called it, continued for eleven months, until in May 1949 the Soviets relented and once again allowed trucks and vehicles to travel through eastern Germany to get to Berlin.

Tensions continued to escalate between the politically repressed and economically depressed eastern Berlin and the democratically oriented and more prosperous western sector of the city. Seeking work, wages, and a better quality of life, thousands of East German citizens made their way to West Berlin. On Sunday night, August 13, 1961, as most city residents slept, a desperate East German government began to close the border between the two halves of the city. Troops installed barbed-wire fences, with concrete blocks to follow, until in a few months the East German government had constructed a wall of concrete 12 feet high and 103 miles long. The East German government called it the antifascist protection wall, implying that its purpose was to protect its citizens from the pernicious, dangerous, and invasive influences of the West. However, everyone knew that its real purpose was to imprison its own citizens.

Official checkpoints were established to allow controlled travel between East and West. American, French, and British citizens passed through the Wall at the deliberately intimidating Checkpoint Charlie, with its full complement of armed military officials and guard dogs, while other nationalities were allowed to pass through a handful of other heavily guarded gateways. West Berliners were initially kept away from the Wall by West

German police and U.S. military support troops so as not to provoke an armed response from East German troops and a possible escalation of the conflict.

On June 16, 1963, U.S. President John F. Kennedy visited West Berlin and, with the Wall as his backdrop, declared,

> Freedom has many difficulties and democracy is not perfect . . . but we never had to put up a wall to keep our people in. All free men, wherever they may live, are citizens of Berlin, and therefore, as a free man, I take pride in the words, "Ich bin ein Berliner."

The Wall, as a symbol of the cold war, grimly persisted over the decades. Over time, West Berliners painted their side of the Wall in bright colors, scrawling messages of freedom, taunting the Communists with graffiti, both poignant and irreverent. Easterners, though allowed to cross beyond the Wall in theory, were rarely permitted to do so, for fear they would defect. In the decades following its construction, about five thousand people made their escape, some over the Wall, but more through tunnels under it. Officially, 136 people were killed trying to cross, but the number could actually be several times that; hundreds more were seriously injured, mainly when the sandy soil under the Wall collapsed on their makeshift escape tunnels.

In 1980, Ronald Reagan was elected president of the United States. A vehement anti-Communist, he labeled the Soviet Union an "evil empire." He saw the Soviets as not only intent on nuclear-military escalation and world domination but as morally bankrupt.

In 1987, President Reagan stood at the Berlin Wall to deliver a direct challenge to the Soviet Union and its leader, Mikhail Gorbachev, using the Berlin Wall as the emblem of Soviet intransigence:

> There is one sign the Soviets can make that would be unmistakable, that would advance dramatically the cause of freedom and peace.

General Secretary Gorbachev, if you seek peace, if you seek prosperity for the Soviet Union and Eastern Europe, if you seek liberalization: Come here to this gate! Mr. Gorbachev, open this gate! Mr. Gorbachev, tear down this Wall!

Gorbachev did not tear down the Wall, but in no small part because of the reforms he put into motion, holes in the Iron Curtain were opening in Hungary and Poland. East Germany was a failing state; there was even talk of reunification. On November 9, 1989, news spread throughout Berlin—there would no longer be restrictions on travel or the movement of residents between East and West. It turns out that a minor official had spoken in error, but it was too late. Berliners on both sides joyfully began to dismantle the Wall in a celebration of freedom. Government authorities did nothing to stop them.

A young assistant, John F. W. Rogers, had accompanied Reagan to Berlin on the president's first trip to the city in 1983. He had known of the construction of the Wall from his childhood, and had seen images of East Germans trying to escape to freedom. As the presidential party departed from Tempelhof Airport, Rogers gazed down from his window and was struck by "this most visible form of tyranny and what it stood for—the keeping in and keeping out, and the shocking contrast between the two halves of the city below. . . . I couldn't imagine such an intractable barrier ever changing in our lifetimes," he recalled.

Although no longer in the White House, Rogers and three of his former colleagues from the Reagan administration, Michael Castine, Fred Ryan, and Jonathan Miller, decided to return to Germany on their own in February 1990 so they could see for themselves the events unfolding in Berlin. They were on the west side of the city and encountered a man using a hammer and chisel to remove chunks of the Wall. The man offered the Americans his tools, so they too could join in the demolition. The group took him up on it, and Rogers did what he thought would never be possible—he personally helped dismantle the odious barrier to freedom.

The trio took a duffle bag of fragments back to the United States, a triumphant echo of their earlier flight. Rogers went on to a successful career in the State Department and at Goldman Sachs, and served as the chair of the board at the Smithsonian's National Museum of American History. The museum's Berlin Wall fragments came from him, a testament to the stubborn persistence of the pursuit of freedom.

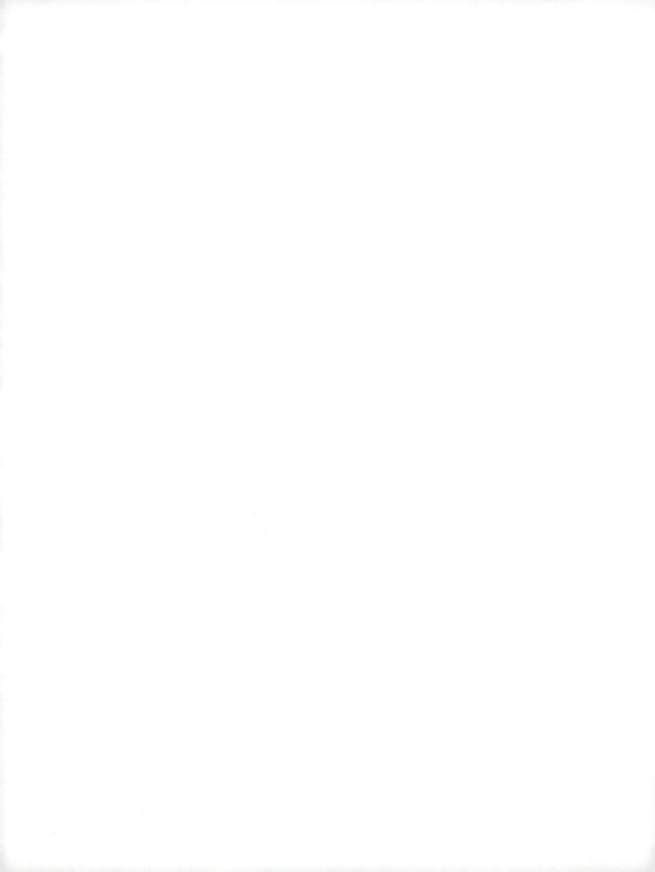

NEW
FRONTIERS

(1950s to 1980s)

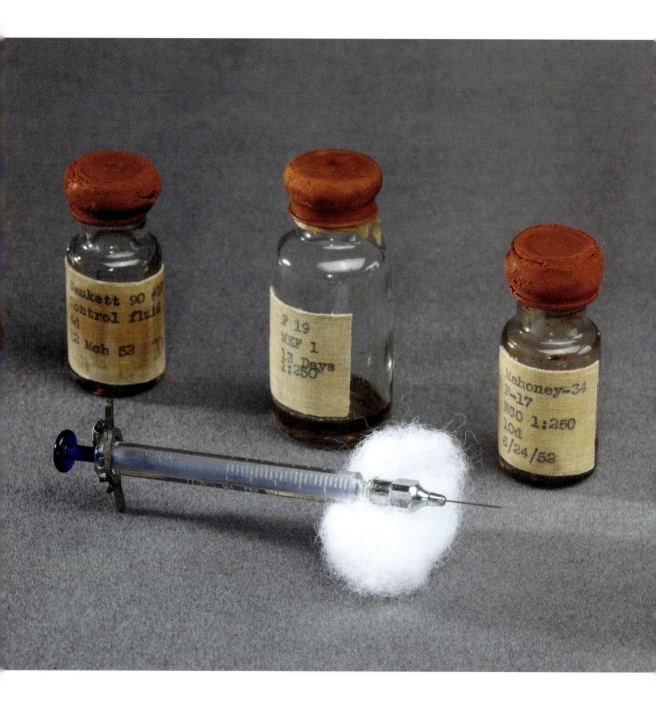

VIALS WITH SALK POLIO VACCINE AND SYRINGE *National Museum of American History*

As American cities grew in number and expanded in size in the late nineteenth century, crowded urban areas gave rise to a variety of epidemics. Whereas outbreaks of such diseases as tuberculosis, typhus, and cholera could be attributed to unsanitary living conditions often associated with poverty, poliomyelitis, or polio for short, devastated rich and poor alike.

JONAS SALK'S POLIO VACCINE

Early in the twentieth century polio became one of the world's most feared diseases. Although more people died of other maladies, polio's dramatic physical effects—especially in vulnerable children—combined with the modern expectation that science had the power to understand and prevent or cure it gave powerful momentum to the development of a polio vaccine.

For Americans, the fact that President Franklin D. Roosevelt had contracted it stood as a constant reminder that no one was exempt from the disease. Roosevelt's leadership in organizing the National Foundation for Infantile Paralysis in the late 1930s, later known as the March of Dimes, helped to finance medical research toward treatments and prevention and to support the care of people who had polio.

Finding a cure or prevention for polio took on added impetus in the early 1950s. Emerging from the Great Depression and a world war, young parents and veterans found polio an intolerable threat to hard-won economic and social security as well as the better world promised to their children. The only thing they feared more was a nuclear attack by the Soviets. In 1952, more than fifty thousand new polio cases were reported in the United States, and panic gripped the American public, leading to the closing of public swimming pools for fear that close contact and shared unsanitary water would promote its spread. Summer camps suspended operations.

EXPERIMENTAL DRUG TREATMENTS LEAD TO THE DEFEAT OF A HORRIBLE DISEASE FEARED BY THE AMERICAN PEOPLE.

National Museum of American History

Families were encouraged to keep children indoors and isolated in an effort to contain the disease.

Families struck by polio were subject to quarantine and social ostracism. Sometimes children and parents were quarantined separately, resulting in further isolation and dread of the disease. Children who suffered from the effects of polio often required braces, crutches, oxygen tanks, or wheelchairs for life. They were frequently excluded from conventional school and extra-curricular activities, with little in the way of a formalized support network to draw upon for resources.

The emergence of the March of Dimes grassroots fund-raising campaign so successfully tapped America's spirit of volunteerism and the desire of neighbor to help neighbor that the effort significantly influenced the way all charities approached fund-raising. The National Foundation for Infantile Paralysis sought small donations—literally a dime, or ten cents, from millions of individuals. This also fostered empowerment and activism, which gave everyone a sense of both urgency and ownership in the efforts to find a vaccine. The fund-raising campaigns were tremendously successful, collecting hundreds of millions of dollars—a huge portion of all charitable giving in the United States. Among the foundation's investments were millions of dollars for research to fund efforts led by Jonas Salk and Albert Sabin to develop vaccines. Funds would support the scientific research, equipment and supplies, and vaccine trials.

Jonas Salk (1914–95) was born in New York City to Jewish Russian immigrant parents with little formal education. A dazzling student, he attended public high school and the City College of New York, and then New York University Medical School.

Instead of pursuing a clinical career involving work with patients, Salk went into virology, devoting himself to research first on influenza and then on the polio virus. Dr. Salk did his work at the Virus Research Labs at the University of Pittsburgh in Pennsylvania over the course of several years. He produced vaccines of several experimental types that had been grown in cultures of monkey kidney tissue. He came to the conclusion that an inacti-

vated, or killed, rather than a weakened and living, virus was the best course for developing a safe and effective vaccine.

The polio virus exists in hundreds of different strains, all of which could be categorized into three major types, called Mahoney, Saukett, and MEF-1. After developing and testing the vaccine in animals—tens of thousands of rhesus monkeys died in the process—Salk first tested it on humans on July 2, 1952. In that initial human trial, he used a hypodermic syringe to inoculate children at the D. T. Watson Home for Crippled Children near Pittsburgh. These children had already contracted polio, so Salk's test was designed to prove that his vaccine would do no harm and create a higher level of immunity than a natural infection. He injected them with a strain that matched their original polio infection—the Mahoney strain, the remains of which are in the vial on the right on page 508.

Salk then tested his vaccine on residents of the Polk State School for the Feeble-Minded of Western Pennsylvania. He also announced that he had tested the vaccine on himself, his wife, and three sons as well as members of his laboratory staff. Between May 1953 and March 1954 Salk inoculated more than five thousand people.

The vaccine, which included all three strains of dead virus, was finally ready for a massive field trial, the most elaborate in history. It involved some 1.8 million schoolchildren, of whom about one fourth were inoculated. Twenty thousand physicians and health workers, tens of thousands of school personnel, and hundreds of thousands of volunteers cooperated with the trials. Funding came from more than 100 million people through the March of Dimes, supported by donations of equipment, syringes, and other materials from companies.

On April 12, 1955, the tenth anniversary of Roosevelt's death, the results were announced from the University of Michigan to an anxious America by radio and television: the vaccine was deemed to be 80 to 90 percent effective. It worked. The nation was joyous, and Salk became a national and international hero. Millions would be saved from contracting the disease.

Smithsonian curators have long been keen to document medical accom-

plishments through its collections. George Griffenhagen, an associate curator in the Smithsonian's Division of Medicine, planned an exhibition and solicited materials from Salk, pharmaceutical manufacturers, and the National Foundation for Infantile Paralysis. The exhibition opened in the Arts and Industries Building on the National Mall in 1958. It included a reproduction of an Egyptian stele from 1300 B.C. that depicts poliomyelitis—the first known indication of the existence of the disease. The exhibition featured twelve vials containing residues of the various vaccines used in Salk's trials as well as a rack of six flasks that Dr. John F. Enders used to grow the virus in cultures of human tissue—work that won him the Nobel Prize. IBM punch cards, used to record essential information about the children taking part in the trials, were also included, as was a Roosevelt dime, representing the hundreds of millions of contributions made over the years. Most memorably, the exhibition was opened by eleven-year-old Randy Kerr, the child who received the first inoculation in the 1954 field trial. The exhibition was very well received. Since then, the vials have been loaned and featured in a number of displays as a success story of both medical research and public commitment to the eradication of disease.

Jacqueline Lee Bouvier Kennedy (1929–94) was known for her beauty, style, and glamour, and for the glittering cultural events she brought to the White House. She was a strong supporter of the nation's arts and heritage, and helped lead the country through the aftermath of one of the most shattering events in modern U.S. history, the assassination of her husband.

74

First ladies of the United States are not elected, but Jacqueline Kennedy's term on the world stage began the day of her husband's inauguration. John Fitzgerald Kennedy, the scion of a wealthy Boston Irish family, had been a World War II naval hero and U.S. senator. He'd just barely defeated the Republican candidate, Vice President Richard M. Nixon, in the November 1960 election to become the first Roman Catholic to hold the office. On Inauguration Day, this forty-three-year-old Harvard-educated Democrat would become the youngest elected president in American history—replacing Dwight D. Eisenhower, who at that time had been the oldest. And as if to bring home the point, Kennedy's wife, the well-educated debutante daughter of a New York stockbroker who'd just given birth to her second child, was more than a decade younger at thirty-one!

January 20, 1961, was a bone-chilling twenty-two-degree day in Washington, D.C. A nor'easter had hit the day before, and the U.S. Army had been called out to clear eight inches of snow. President Eisenhower drove with Kennedy to the U.S. Capitol for the inaugural ceremonies. There, government officials, family, and guests gathered on the eastern side of the building for the noontime swearing-in. Eisenhower, bundled in an overcoat and scarf, looked old and dignified; Kennedy, taking off his overcoat, looked young and exuberant. Marian Anderson sang the national anthem. An aged Robert Frost, one of the great poets of his generation, had planned

JACQUELINE KENNEDY'S INAUGURAL BALL GOWN

A DRESS ILLUSTRATES THE STYLE AND YOUTH OF A NEW PRESIDENT AND FIRST LADY.

National Museum of American History

to read a new work composed for the occasion, but the sun glare prevented him from reading it, so he recited an old favorite, "The Gift Outright," instead.

Chief Justice Earl Warren administered the oath over the Fitzgerald family Bible. Then it was the new president who spoke, recognizing the transformational significance of his election. "Let the word go forth . . . that the torch has been passed to a new generation of Americans," he said.

Kennedy recognized the universal rights of man as being endowed by God, but more temporal works, whether eliminating poverty or making war, as being in mortal hands. In uplifting rhetoric, Kennedy reiterated America's standing in a cold war world: "Let every nation know . . . that we shall pay any price, bear any burden, meet any hardship, support any friend, oppose any foe, to assure the survival and the success of liberty." At the same time, he challenged Americans to contribute their time and talents in the world and at home, famously declaring, "Ask not what your country can do for you—ask what you can do for your country." He foreshadowed what would become major programs of his administration—confrontation of Communist aggression, support for the United Nations, initiation of the Alliance for Progress in Latin America, creation of the Peace Corps, promotion of civil and human rights, commitment to manned space flight, and support for the arts.

It was a speech charting new frontiers and optimistic possibilities for a strong, humane, and generous America. The Kennedys as a couple mirrored this youthful orientation in contrast to the older, paternalistic model of national leadership represented by the Eisenhowers. The image was buttressed that night at inaugural balls, a custom initiated in the early days of the republic.

The Kennedys had five official balls—one at the national armory and the others at local hotels, including the Mayflower. Jacqueline wore a sheath gown of white *peau d'ange* ("angel's skin"—a type of silk) under silk chiffon with a bodice completely embroidered in silver thread and encrusted with brilliants. The bodice is veiled by a sleeveless, high-necked, loose overblouse

of white chiffon. With the ball gown is a matching floor-length cape of white *peau d'ange* boasting three layers of white chiffon. The cape is very simple, with slits for the arms and a stand-up collar fastened with two embroidered buttons. Ethel Frankau of Bergdorf Custom Salon designed and made the dress based on Mrs. Kennedy's sketches and suggestions.

Jacqueline Kennedy looked striking, stunning, and sophisticated, almost ethereal, in the gown. Fashionably thin and projecting confidence, she had the bearing of an haute couture model. The contrast between the youthful first lady, popularly called Jackie, and the older, though stylish Mamie Eisenhower—who favored dresses in mauve and floral prints—was dramatic. Jackie's gown was streamlined and monochromatic, featuring restrained ornamentation and reflecting a very modern sensibility. Photographers had a field day, and images of Jackie were published across the globe. The *Washington Post* reported that Mrs. Kennedy's "career as a major fashion influence was beginning impressively."

In her role as first lady, Jacqueline Kennedy led the effort to restore the rather dreary White House furnishings, artwork, and interior design. She wholeheartedly supported the formation of the White House Historical Association to undertake the redecoration, and in February 1962 she invited the American people inside to see the results. She greeted millions in an unprecedented network television tour of the Presidential Mansion, which, adopting a historical usage, she called "the people's house." She promoted performances at the White House and encouraged the nation's artists while also advocating for historic preservation. One of the buildings she saved was the old Corcoran Gallery of Art across the street from the White House—the capital city's first institution dedicated to art—so that instead of being demolished, it was turned over to the Smithsonian and eventually reopened as the Renwick Gallery.

As other first ladies had, Jacqueline Kennedy donated her inaugural gown to the Smithsonian to become part of its collection. It was sent by messenger from the White House in August 1962. Mrs. Kennedy wrote to Smithsonian Secretary Leonard Carmichael, "It is particularly meaningful

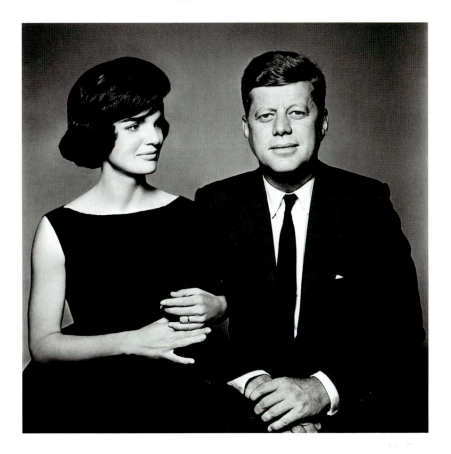

to me that the presentation of my dress marks the Fiftieth Anniversary of one of the most popular sections of the Smithsonian Institution."

The First Ladies Collection had begun in 1912 with the receipt of the Empire-style gown of Helen Herron Taft, wife of the twenty-seventh president, William H. Taft, worn for the 1909 inaugural ball. The idea for the collection originated with Mrs. Julian James and Mrs. Rose Gouverneur Hoes, two public-spirited citizens of Washington, D.C. After Helen Taft's donation, former first ladies and their descendants were approached for dresses.

When Mrs. Kennedy's gown arrived, it was displayed, along with others in the collection, in a series of period rooms in the Arts and Industries

Building. Dresses were presented on custom-made mannequins. All, including Kennedy's, had heads with hairstyles fashioned after a portrait or photograph. The collection was later transferred to the new building that became the National Museum of American History, where it became one of the Smithsonian's most popular exhibitions. As the collection's long-term curator Margaret Klapthor noted at the time, it represented the "changes in American period costume from the administration of President George Washington to that of the present day."

Jacqueline Kennedy's inaugural dress represents a first lady who projected a sense of youthful optimism and style—but also grace and gravitas—at home and abroad. She proved exceedingly popular on the world stage—so much so that President Kennedy, summarizing a state visit to France to see his counterpart, Charles de Gaulle, half-jokingly introduced himself to the press saying, "I am the man who accompanied Jacqueline Kennedy to Paris."

Following her husband's assassination in Dallas on November 22, 1963, as Vice President Lyndon B. Johnson took the oath of presidential office, Mrs. Kennedy stood next to him wearing the double-breasted pink with navy trim collared Chanel wool suit splattered with her husband's blood. She showed incredible character and fortitude in guiding her family and the nation through the ensuing shock, grief, and disruption. With an eye toward history, she planned the state funeral. And she lovingly held her young children as they mourned the loss of their father.

Mrs. Kennedy's marriage to Greek shipping magnate Aristotle Onassis in 1968 created public shock and even anger, but was generally accepted over the years by the American public, and she became "Jackie O." After her second husband's death, she worked as a respected book editor for Viking Press and then Doubleday. She became a highly regarded, even beloved, figure who generally shunned celebrity.

In 1985, during a nationwide Festival of India, Jacqueline Kennedy Onassis visited a major living exhibition entitled Aditi: A Celebration of Life that my friend and colleague Rajeev Sethi curated and I coordinated at the Smithsonian's National Museum of Natural History. The exhibition

of singing, dancing, and craftsmanship was quite popular, and had been opened by Indian Prime Minister Rajiv Gandhi and First Lady Nancy Reagan. When Jackie came by with our mutual friend and exhibition supporter Elizabeth Moynihan (wife of New York Senator Daniel Patrick Moynihan) she was incredibly gracious, meeting with all the Indian performers, craftspeople, and artisans, most of whom were from poor, low-caste backgrounds and persecuted, marginal communities. Dignitaries and celebrities have to endure a lot of surprising things in public, and she good-naturedly allowed one of the Indians to put a *tika*—a red mark—on her forehead. Then behind the scenes, in a remarkable show of respect, the former first lady sat down with the Indian participants, kids clamoring on her lap, and shared an Indian meal with the group, eating as others did, with her hand. Having visited India, she knew its profound meaning. That act of sharing this meal was so simple, and so elegantly done, but breathtaking in its evocation of a common, shared humanity.

75

Food acquisition, processing, and cooking are central to all humans and have gone through their own transformations in America, from an act of subsistence to the product of an industrial economy. In the domestic sphere, we have gone from outdoor hearths with open fires to ultradesigned kitchens barely used for cooking and eating. The nation has had its share of notable cookbooks, such as Catherine Beecher's 1841 *Treatise on Domestic Economy* and Irma Rombauer's 1931 *Joy of Cooking.*

JULIA CHILD'S KITCHEN

AN ENGAGING
WOMAN'S
ADVENTURES
WITH COOKING
FRENCH FOOD
IN HER HOME
KITCHEN
TRANSFORMS
THE AMERICAN
PALATE.

*National Museum of American
History*

Volumes promote certain values from "home economy" to "slow food" and concerns from kitchen efficiency and hygiene to nutrition and environmental sustainability. Most have a utilitarian bent, guiding hardworking homemakers to prepare meals efficiently and well, given limited time and resources. Classical French cuisine, with its time-consuming sauces and exacting preparation methods, had largely been viewed as the purview of the professional chef—almost always male—and of elite restaurants, men's dining clubs, or wealthy households that employed one. Julia Child (1912–2004) changed that. By using her own kitchen as a classroom and turning food preparation into charming and entertaining televised performances, she demystified haute cuisine, recasting the act of cooking as a refined middle-class cultural pursuit. Contemporary stars Martha Stewart, Alice Waters, Emeril Legasse, and many others follow the example she set.

Julia McWilliams was born to upper-middle-class parents and spent her youth in California. She went east to Smith College and studied history, and then, after graduating, worked for a home-furnishing company in New York, writing advertising copy among other things. She moved back to California to write and volunteer with the Junior League before joining the Office of Strategic Services (OSS)—the predecessor to the Central Intelligence Agency—during the war years. Bright, hardworking, of large

stature—she was six feet three inches tall—and with an eye for detail, she rose from a typist to become a researcher on top secret matters for the OSS head, General Bill Donovan, in Washington, D.C. In 1944 she was sent to Ceylon (now Sri Lanka), where she met another OSS operative, Paul Child, whom she married in 1946 when back in the United States. Among their fellow OSS colleagues were Mary Livingston and her future husband, S. Dillon Ripley, who later became secretary of the Smithsonian. Julia ended her war career in China, and then, with Paul's move to the State Department, the couple relocated back to Washington. In 1948, they were sent to Paris, where Paul worked as a cultural attaché on exhibitions for the U.S. Information Service. Paul had a sophisticated palate and was a lover of French cuisine, and Julia too found the food to be a culinary revelation. A memorable meal was "an opening up of the soul and spirit for me," she later recalled.

Julia took classes at the famed Parisian Le Cordon Bleu cooking school, apprenticed on her own with several noted French master chefs, and joined a women's cooking club. Through the club she met Simone Beck and Louisette Bertholle, two French cooks and authors who came up with the idea of writing a French cookbook for Americans. It needed Child's talent for straightforward prose and for translating so that it would appeal to American readers. The three started cooking classes for American women in the Childs' kitchen and began testing recipes. Through the 1950s, as the Childs served in France, Germany, and Norway, Julia continued to test recipes, translate items from French to English, and figure out how to convey the crucial details of the cooking along with appreciation for the cuisine.

Their book was submitted to Houghton Mifflin, but was rejected because it was long and too encyclopedic. With help from editor Avis DeVoto in Cambridge, Massachusetts, they approached Alfred A. Knopf, which published the seven-hundred-plus-page work as *Mastering the Art of French Cooking* in 1961. The coauthored volume became a surprising and whopping success, selling more than one hundred thousand copies in its first year. A second volume was published years later.

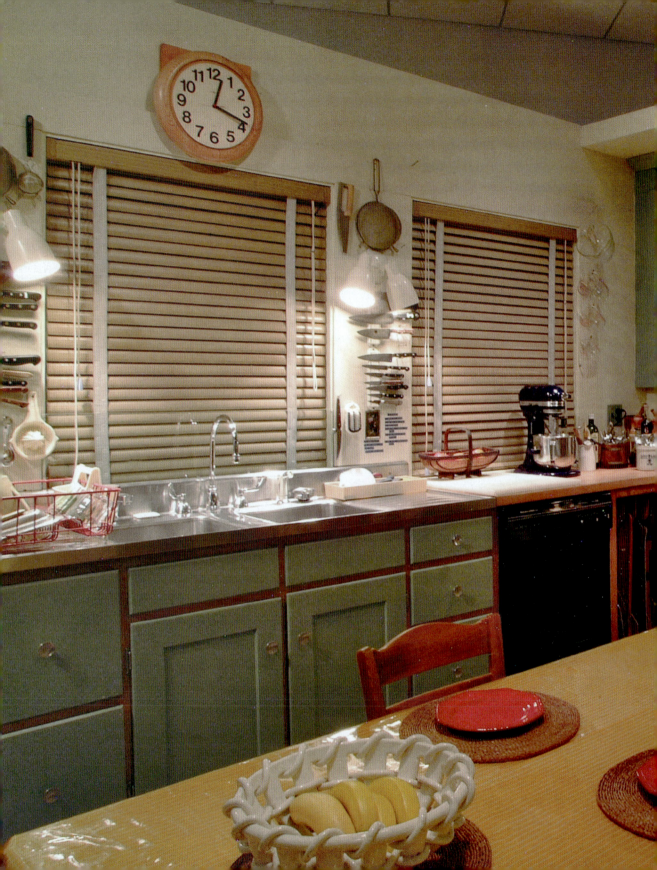

After more than a decade abroad, the Childs moved to Cambridge. Because of the success of her book, Julia appeared on an educational television program in the Boston area, which led to an eleven-year run as *The French Chef* (1963–73), produced by WGBH-TV. The show was a huge hit. Julia's verve and cooking talent, coupled with her distinctive, high-pitched conversational voice, engaged viewers in an idiosyncratically entertaining, encouraging manner. Men and women alike tuned in to turn humdrum menus into masterpieces; functional kitchens became studios for the culinary arts.

Why were Julia Child's book and television program so successful? The time was right: Jackie Kennedy, of French background and elegant taste, was in the White House, adding glamour to American public life. Maybe Child's cooking provided a broadly accessible pathway for women to identify with First Lady and President Kennedy—as Julia herself suggested decades later. Alternatively, maybe Julia had turned the kitchen into a place for intelligence, talent, and mastery, a domestic setting where many women, denied a skilled job in the workforce, could nonetheless seek personal growth and fulfillment. Or maybe the exploration of French cuisine represented the hankering for adventurous new experiences and signaled the cultural turn of the 1960s away from the conventional and toward the foreign and exotic.

In any case, there was no question that Julia's larger-than-life size and personality gave her a commanding presence on television. In the decades that followed, she demonstrated a persistent influence on how Americans related to their food. She wrote several other cookbooks, made celebrity appearances, and was the star of more television cooking shows bearing her name: *Julia Child & Company, Julia Child & More Company, Dinner at Julia's, Cooking with Master Chefs, In Julia's Kitchen with Master Chefs, Baking with Julia,* and *Julia & Jacques Cooking at Home.*

For several of the later shows, the television filming was done in her Cambridge home kitchen. Indeed, it became the historical artifact of Julia Child's life's work.

The kitchen was no ordinary one. It had been specifically designed by

Julia and Paul. They designed the counters to stand several inches higher than usual in order to accommodate Julia's height. Paul traced the outline of each pot on the pegboard walls so every utensil would have its own place in the zone where it would be used. The large six-burner Garland range allowed for the simultaneous preparation of several dishes. On the other hand, the kitchen looked lived in—a real person's kitchen. Paul chose bright, cheerful blues and greens as this room would host guests and become what Julia would call the beating heart of the household. It had butcher-block countertops, plain cabinets, and a big welcoming wood table for family and friends. Millions of viewers grew to know the kitchen well, feeling that it was they who spent time there, cooking, eating, learning, and laughing with a charming, if eccentric, neighbor.

Paul Child died in 1994. By 2001 Julia was planning to move to a retirement home in Santa Barbara, California. Several people interested in culinary traditions and popular culture urged Smithsonian curators to acquire the kitchen. They and her friends and producers also encouraged Julia to make the donation. That, and perhaps having a soft spot for the Smithsonian as a result of having known the Ripleys from the OSS days, led her to readily agree.

In August, the three curators from the Smithsonian's National Museum of American History, Rayna Green, Paula Johnson, and Nanci Edwards, arrived at Julia's Cambridge home to undertake the task of collecting something from her kitchen. Paula Johnson recalled, "We had gone up thinking we might simply discuss a donation of 'the most significant' objects, but once we got there, we all agreed that we needed to ask her about collecting the entire kitchen. We spent a day and a half inventorying all the contents of the fourteen-by-twenty-foot room. Julia allowed us access to every nook and cranny, and left us to our work. As Nanci and I measured the walls and cabinetry to create an accurate plan, Rayna video-recorded all the contents in the cabinets and drawers. We followed up with a complete listing of everything, categorized by location. The more we worked, the more we appreciated Julia's organizational style and her curatorial sensibilities."

With Julia's old production crew and producer, Geoff Drummond, the curatorial team returned early on the morning of September 11, 2001, to document her kitchen in preparation for its move to Washington. But instead of filming an oral history with Julia as planned, they were all gathered around the television in the kitchen watching the horrible news of the attacks on the World Trade Center and Pentagon. Eventually, Julia, a bit frail at eighty-nine, but still rock solid in spirit and determination, reminded the group of how much needed to be accomplished that day, and, though shaken, they settled in.

The curators interviewed Julia about some of the more unusual kitchen objects and about her life in the house and what the kitchen meant to her. In November and December, the team returned to collect the twelve hundred–plus items—"everything *and* the kitchen sink!"

The kitchen was first put on display in the American history museum in 2002. It was an immense hit. As Green recalled, "People would walk into the museum, go right to the visitors' information desk, and ask, 'Where's Julia?'" Ever popular as a pilgrimage stop for foodies, the exhibition reminded people of the delight in good cooking at a time when American kitchens were increasingly a fast-food drive-in. Recent books and movies, such as *Julie & Julia,* starring Meryl Streep, have brought renewed attention to an iconic figure of the nation's culinary history.

In 2012, Julia Child's kitchen was moved to a larger space, where it now anchors a more complete treatment of food in post–World War II America—examining everything from changes in agricultural production to cooking technologies, from the introduction of new foods to slow food. Included are the two bottles of California wine made by Warren Winiarski and Mike Grgich that bested French wines at a famous international tasting in 1976. Though Winiarski and Grgich's daughter Violet joined a celebration to mark the opening of the exhibition, we resisted the temptation to uncork these museum artifacts to pour a congratulatory toast.

1973 STAG'S LEAP
WINE CELLARS
CABERNET
SAUVIGNON AND
1973 CHATEAU
MONTELENA
CHARDONNAY

National Museum of
American History

Oral contraception, or the birth control pill, represents the fruition of a long and arduous process, part scientific, part political, to realize a dream held by many women throughout history to gain control over the means of reproduction.

The Smithsonian has two plastic vials of Enovid, the first birth control pill approved by the U.S. government. They date from the 1950s. Among the first pills developed

THE PILL AND ITS DISPENSER

by a pharmaceutical company, they were used in clinical trials to establish the efficacy of oral contraception. The vials are labeled FOR INVESTIGATIONAL USE ONLY. One was donated by Mary Ann Johnson, a technician who worked at the Foundation of Experimental Biology, which helped to develop the Pill; the other was donated by the Margaret Sanger Center of New York City, a Planned Parenthood health clinic named for a leading historical proponent of contraception. The dispenser, also in the Smithsonian, was invented not by a big pharmaceutical company but by an ingenious spouse who wanted to help his wife.

A DRUG LONG IN THE MAKING GIVES WOMEN REPRODUCTIVE FREEDOM, BUT NOT WITHOUT CONTROVERSY.

National Museum of American History

The idea of a "miracle pill" as a means of avoiding pregnancy was long a dream of Margaret Sanger, the nurse and women's rights advocate who coined the term "birth control" in 1914 and founded the American Birth Control League, the precursor to Planned Parenthood. Sanger and others faced prosecution under the so-called Comstock laws. The federal Comstock Act, enacted in 1873, and similar laws in several dozen states made it illegal to sell or disseminate any drug or device that could terminate or prevent a pregnancy, as well as any books, pamphlets, or advertisements that advocated such. Fines and jail time awaited violators.

Despite facing arrest, Sanger and others persisted in efforts over the ensuing decades to offer women safe and effective means of birth control as

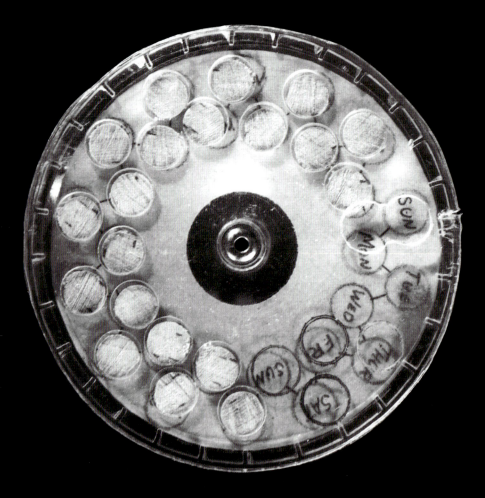

WAGNER'S PILL DISPENSER PROTOTYPE *National Museum of American History*

a way to empower them to control the size of their families based on fiscal and other resources. The eugenics movement, a social philosophy that sought to improve the genetic composition of a given population, also embraced the birth control agenda, as some advocates argued that the numbers of the poor, disabled, or otherwise "unfit" could be decreased by promoting contraception.

Legal constraints notwithstanding, many Americans welcomed and practiced various means of birth control. In 1936, a Supreme Court decision made it legal for doctors to mail contraceptives and birth control literature across state lines. Sales of condoms, diaphragms, cervical caps, and other devices and instructional literature generated hundreds of millions of dollars. By the early 1950s, in addition to abstinence, the Catholic Church sanctioned the rhythm method as a natural means of birth control—the calendar-based contraception method involving, simply, the avoidance of intercourse during those days of the menstrual cycle when a woman is most fertile.

Sanger continued to hope for a miracle pill—an inexpensive, easily taken oral contraceptive—into her seventies. She secured funding support for her quest from Katharine McCormick, heiress to a fortune from the agricultural equipment manufacturer International Harvester, and herself a science graduate from the Massachusetts Institute of Technology. Developments by a number of medical researchers in the 1950s led to the use of the hormone progesterone along with estrogen as an oral contraceptive. The hormones prevent pregnancy by suppressing ovulation; no egg is released by the ovaries and therefore fertilization cannot occur. McCormick funded endocrinologist Gregory Pincus at the Foundation of Experimental Biology in Worcester, Massachusetts, to develop a drug. She also funded his partnership with renowned Harvard obstetrician John Rock to conduct limited clinical trials. They took the drug to G. D. Searle, a pharmaceutical company whose chief chemist, Frank Colton, had developed a synthetic form of progesterone. Searle called the product Enovid, and it was first prescribed and sold for treating menstrual disorders. At about the same time, Parke-

Davis, another drug company, developed Norlutin, a progestin, or synthetic hormone, made from Mexican yams, as a comparable product, also used to treat menstrual disorders. By the late 1950s women were starting to use both drugs in an off-label way for birth control.

Searle was intent on bringing Enovid to market and conducted larger-scale clinical trials in Puerto Rico. Enovid proved successful in preventing pregnancy, but led to side effects that were later corrected by reducing the dosage from 10 milligrams to 5 milligrams. Further trials were held in Haiti and Mexico City, and in May 1960, the U.S. Food and Drug Administration approved Searle's request to manufacture and sell Enovid as the first birth control pill.

Almost immediately after approval, hundreds of thousands of women were on "the Pill." The Pill could be taken easily and was both relatively safe and effective. It was hailed by many women as providing a measure of freedom and security with regard to their reproductive choices. Advocates noted how the Pill could allow families to make clear and rational choices about having children. Its opponents pointed to possibilities that the Pill could herald a new sexual revolution, leading to promiscuity and the decline of individual and social morals. Others worried that it could also lead to dwindling population growth. The Catholic Church, among others, opposed the intrusion of human intervention in the "natural" state of affairs and what they regarded as the divine gift of life.

John Rock, who had conducted the first human trials of the Pill in his Boston fertility clinic, was a Catholic who argued that because the Pill mimicked a woman's natural cycle and was therefore an extension of the rhythm method, it did not violate the Catholic Church's prohibition of birth control. While the Church did not ultimately agree, the argument gave many women enough justification to decide to use the Pill.

The Pill's developers had expected a strong backlash, but beyond some heated rhetoric, it was relatively mild. President Eisenhower had publicly stated that birth control was none of the government's business. Within a few years, more than two million women had a prescription for the Pill. The

SEARLE'S
CONTAINER OF
ENOVID

National Museum of
American History

market—and, more important, women—had spoken. They wanted control of their lives, so the controversy and the small risk associated with taking the Pill did little to stem its widespread use.

But taking the Pill had practical challenges. It was prescribed to be taken daily for twenty-one days, followed by seven days of no pill. Its effectiveness depended upon users complying with this schedule. Searle and other pharmaceutical companies knew this, but packaged the pill in the usual plastic vials.

In 1962, David Wagner, an engineer in Illinois, was keen to ensure that his wife found an easy way to take the medication after she gave birth to their fourth child. "I was constantly asking her whether she had taken 'the Pill' and this led to some irritation and a marital row or two," he explained in a letter to the Smithsonian. His first solution was a piece of paper with the calendar marked out and a pill placed on each date; in a household full of children, of course, "this lasted until the paper and pills were knocked to the floor." Wagner then set about trying to create a container that would do the same type of thing while holding the pills safely. He made a prototype pill dispenser out of materials he found at home: plastic, paper, transparent tape, a snap fastener taken from a toy, and thin mock pills made from sawing up a wooden dowel stick. The snap fastener holds three round plastic plates. The bottom plate designates the day of the week. The middle plate holds twenty wooden "pills." It rotates so as to match up with the day pill taking begins. The top plate has a single hole for dispensing a pill and, once removed, reveals the day of the week that the pill was taken. The device was designed to be about the same size as a makeup compact, so that women could carry it discreetly in their purses. Wagner filed his patent application with this prototype and two years later was awarded the patent for the first oral contraceptive pill dispenser. Many other models and versions have followed this basic "dial pack" design.

The Pill is an example of a tiny object with large consequences. The Pill, as birth control opponents had feared, facilitated a sexual revolution in the 1960s, and beyond that, it redefined previously circumscribed cultural

expectations about sexual behavior. Its consequences were felt in school, at home, in the workplace, and in public life. The Pill ultimately gave women a larger degree of control over their lives. They could now have a choice in the timing of their education, career, and motherhood. The resulting cultural shifts gave rise to the women's movement of the 1960s and 1970s, as women demanded equal access to opportunities and institutions previously restricted to men. Oral contraception aided their efforts to succeed in managing their home lives, attaining high levels of educational and career achievement, and occupying positions of power in the civic and political life of the nation.

"One small step for [a] man, one giant leap for mankind," declared astronaut Neil Armstrong as he stepped onto the Moon's surface on July 21, 1969. In a heart-stopping moment televised live to some 600 million people back on Earth, Armstrong and his lunar module pilot, Edwin "Buzz" Aldrin, fulfilled the historic pledge made by President John F. Kennedy for the United States to land a man on the Moon "before this decade is out."

Armstrong and Aldrin descended to the Moon's powdery surface—"magnificent desolation," as Aldrin described it—while the third member of the team, Michael Collins, orbited the Moon from their lunar module.

The three astronauts on the Apollo 11 mission were propelled into space atop a powerful Saturn V rocket that blasted off from Kennedy Space Center in Florida on July 16. Saturn V reached Earth's orbit with the help of three rocket "stages"—sections with their own engines and fuel supply, the first two of which were jettisoned after use. After orbiting Earth, the rocket's third stage reignited, sending the mission's payload toward the Moon. Three days later, the spacecraft, called *Columbia*, was orbiting the Moon. The spacecraft consisted of three modules, or component vehicles, that attached and separated from each other. The service module provided power, propulsion, water, oxygen, and other support. The lunar module, called *Eagle* when in flight, would descend to the Moon, and its top portion would bring the astronauts back up. The command module housed the astronauts and computer controls and life-support systems—the only portion of the craft that would return to Earth.

The lunar module with Armstrong and Aldrin aboard separated from the rest of the spacecraft and fired up its descent-stage engines to leave lu-

NEIL ARMSTRONG'S SPACE SUIT

FULFILLING PRESIDENT KENNEDY'S CALL, THE UNITED STATES PUTS A MAN ON THE MOON.

National Air and Space Museum

nar orbit and land on the Moon's surface, aiming for a relatively flat region named the Sea of Tranquility. About two hours later, *Eagle* landed a bit off target in a boulder-strewn area. The astronauts secured the lander and named their new location Tranquility Base. Scheduled to sleep but finding it impossible to do so given their excitement, they began their preparations to leave the craft. Aldrin, a Presbyterian, took private communion—the first religious service on the Moon.

Opening the hatch, Armstrong deployed the camera that would capture his step onto the Moon and then descended down a ladder. Aldrin followed. They relocated the camera, setting it on a tripod, filmed the surrounding area, and went to work over the next two hours. They took pictures of the lunar module so that its status could be assessed; planted an American flag on the surface; and, with a hammer, scoops, and tongs, collected about forty-seven pounds of rock and lunar soil samples for later study back on Earth. The astronauts deployed scientific equipment, including a seismograph to measure tremors and a laser retroreflector to measure the exact distance between Earth and the Moon, and took a congratulatory radio call from President Richard M. Nixon.

After Aldrin and Armstrong had returned to the lander, they jettisoned some of their unneeded equipment and rested for several hours before preparing the *Eagle* for a return flight to rendezvous and redock with the orbiting *Columbia*. *Eagle*'s ascent stage blasted off from the Moon's surface, leaving behind the lower section of the lunar module. As it did, Aldrin saw the American flag topple over when it was hit with the exhaust blast. Also left behind on the lander's ladder was a plaque with drawings of Earth's Eastern and Western Hemispheres and an inscription with the signatures of President Nixon and the astronauts:

HERE MEN FROM THE PLANET EARTH FIRST SET FOOT UPON THE MOON JULY 1969, A.D. WE CAME IN PEACE FOR ALL MANKIND

They also left a memorial bag with a silicon disk containing goodwill statements by Nixon and former U.S. Presidents Dwight D. Eisenhower, John F. Kennedy, and Lyndon B. Johnson as well as messages from other world leaders. Among other items, the bag contained a golden olive branch as a symbol of peace, a patch from the ill-fated Apollo 1 mission, and medals heralding Soviet cosmonauts.

The Moon has only a negligible atmosphere, with no air for humans to breathe. Its gravity is just one-sixth of Earth's, and its temperature ranges are extreme—above the boiling point of water in the sun, approaching absolute zero in the shade. Everything Armstrong and Aldrin did on the Moon depended on their space suits and their portable life-support systems—which provided the microenvironments they needed to survive. The suits insulated them from the Moon's extreme temperatures, provided protection from environmental hazards and cosmic rays, enabled them to breathe, and allowed them to move about and do their work. The suits hosted the equipment that allowed the astronauts to communicate with each other, with Collins in *Columbia* above the Moon, and with Mission Control back on Earth. The suits also enabled Mission Control to monitor the bodily functions of the astronauts so they could head off or deal with stresses and dangers.

So, how did these space suits—so crucial to the Apollo mission—come to be? As Allison Davis noted in her *Wired* magazine review of Nicholas de Monchaux's fascinating study called *Spacesuits: Fashioning Apollo*, "Neil Armstrong's first footfall on the Moon was one small step for man, but it was one giant leap for a maker of ladies' girdles."

The Mercury astronauts had basically worn modified high-altitude air flight suits done up in silver to give them a futuristic appearance. But the Mercury astronauts were stationary—strapped into their seats. Something dramatically more functional was needed to walk and work on the Moon. Engineers had envisioned a hard suit—a shell made out of fiberglass, aluminum, and plastic. In testing such suits, however, NASA found them lacking—failing to provide the necessary flexibility and integration

of pressurized life-support systems. In 1965 a NASA competition allowed International Latex Corporation (ILC) to participate with David Clark Company, Hamilton Standard, and BFGoodrich. ILC was not a newcomer to the field, for in addition to producing Playtex bras and girdles, it had been fabricating high-altitude pressure suits for the Air Force since the 1950s and had worked on space suits with Hamilton Standard in the early 1960s. ILC came up with a winning concept and, ultimately, the space suits that would be worn on the Moon.

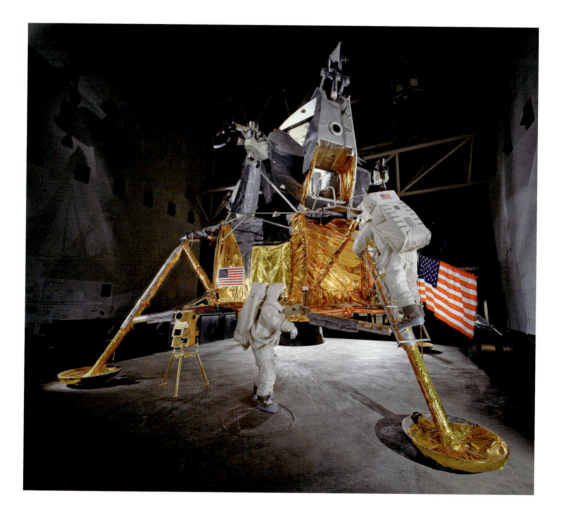

ILC engineers and textile designers developed a soft suit, designated A7L, that built on the success of the suits worn in the Gemini program, but also took into consideration fire-retardant safety measures necessitated after the tragic Apollo 1 fire that had killed Gus Grissom, Ed White, and Roger Chaffee. Their suit was composed of some twenty-six layers of material that could withstand pressurization, protect the astronauts, and also provide the flexibility needed for the mission. The suit weighed about 56 pounds by itself, but 189 pounds when combined with life-support systems.

The suit had a liquid-circulating, temperature-modulating undergarment closest to the skin. Suit layers were composed of Teflon-coated Beta cloth, Mylar, Dacron, Kapton, and Chromel R, a woven stainless steel. The Chromel R would protect the astronauts from sharp objects on the Moon's surface and dangers from abrasion or from being hit by micrometeorites. The suit was fitted with rubber and neoprene to allow flexibility in arm, knee, and hip joints, and with a system of nylon tunneling and steel cables to restrain it from ballooning from pressurization. Two sets of zippers held the suit closed, the outer one running from the back of the neck down to the crotch and up the front, and covered by a Beta cloth flap. The torso of the suit included two sets of connectors for hoses—blue for good air, red for bad—which could be hooked up to the mobile life-support system or attached to that on the *Eagle*. Diverter valves and pressure indicators enabled the astronauts to measure oxygen flow and control it in the helmet and torso sections of the space suit.

The pressure bubble helmet was made of clear polycarbonate, giving the astronauts a wide field of vision—necessary because of limited neck mobility in the suit. The astronauts could move their heads within the helmet but not turn the helmet itself. The helmet connected to the suit with a neck ring and had a comfort pad at the back that linked it to the airflow system. Communications were built not into the helmet but rather into what the astronauts called their Snoopy caps, worn on the head under the helmet. On the Moon's surface, the astronauts donned an "overhelmet," which had two visors—an outer one for protection from micrometeorites and

ultraviolet light and a twenty-four-karat-gold-coated one that reduced the light entering the helmet, hence reducing overheating. A Beta cloth collar and hood attached with Velcro covered the back of the head and the neck ring, also protecting against overheating. The gloves had an outer shell of Chromel R fabric and thermal insulation to provide protection, with fingertips made of blue-colored silicone rubber, allowing for a needed fine sense of touch. They were attached to the arms of the suit by anodized aluminum connection rings. Outer boots, which left the footprints on the lunar surface, completed the ensemble. They were made of Chromel R uppers and Beta cloth tonguing and lining, with thirteen layers of aluminized Mylar and Kapton. They had blue silicone soles and added layers of Beta felt for temperature and puncture protection.

While space suit customization had begun with the Mercury and Gemini programs, ILC expanded the idea, hand tailoring and crafting the suits to each individual astronaut to meet the demand for mobility required to perform the tasks on the Moon.

Though there were minor complaints—the astronauts had some hand discomfort and noted that their headgear felt warmer in the sunlight and cooler in shade—the ILC space suits worked exceedingly well. Both Armstrong and Aldrin loped hundreds of yards around their Moon base in the low gravity with no problem. They had no difficulty setting up equipment, wielding a geological hammer, manipulating a camera, and using other tools. The space suits had pockets for storage and a "bio-belt" to monitor the astronauts' vital signs.

There were a few glitches, less to do with the suits proper and more to do with the equipment they carried. The large portable life-support system carried as a backpack made it awkward for the astronauts to squeeze through the Moon lander hatch, and the remote control unit carried on their chests made it impossible to see their feet—while the world saw Armstrong's foot touch down, he himself could not.

After leaving the Moon, Armstrong and Aldrin reunited with Collins in *Columbia*. They fired up the engines again and sped out of lunar orbit

toward Earth. *Eagle* was jettisoned away, and in all likelihood plunged back to the Moon. Near Earth, the command module separated from the service module and fell to Earth with the astronauts inside, deploying its parachute and splashing into the Pacific Ocean near Johnston Atoll, about 860 miles west of Hawaii, where it was safely recovered by a U.S. Navy ship.

The space suits and other materials were dry-cleaned upon their return amid fears that the lunar dirt and dust could possibly contain unknown bacteria and viruses that could have disastrous effects on Earth. Dry-cleaning was also recommended by Smithsonian conservators as a standard practice in the preservation of textiles. The effectiveness and consequences of this treatment have been debated. Among the items coming to the Smithsonian's National Air and Space Museum in the early 1970s were the command module *Columbia*—often called Apollo 11—the unflown lunar module, the space suits, and related paraphernalia.

Armstrong's and Aldrin's space suits have required ongoing conservation treatment. As Amanda Young, the former conservator for these suits, explained, they were designed to withstand extreme conditions "for a short period, but it turns out they can resist nothing for a long period of time." The suits were exposed to high humidity levels in Florida, Houston, and Washington, which did not serve them well. The tubing inside the suits includes polyvinyl chloride, which becomes gummy and then hardens as it decays. During the mission, lunar regolith—the Moon's surface debris,

which is sticky and sharp—became embedded in them, even cutting into the chromium steel fibers of the Chromel R fabric used to protect the astronauts' hands and feet. In storage, they are covered with unbleached muslin cloth to help absorb the hydrochloric acid they emit. Keeping them in strict climate-controlled environments helps with their conservation, but they are in a fragile state. Indeed, Armstrong's suit was taken off exhibition in 2006 so that it could receive more intensive treatment.

Tens of millions of visitors have seen the Apollo 11 command module since it came to the National Air and Space Museum; many have imagined what it was like to pilot the craft to the Moon and back. Michael Collins, who carried out that task, subsequently became the director of the museum for a period, and also the undersecretary of the Smithsonian. I get a continual kick out of knowing that I occupy his office, ascending to it in the castle every day—a much easier task, I suspect, than traveling from Earth to the Moon and back. But part of my job is to ensure that the millions of museum visitors get a little bit of that experience—and they do, each time they place their fingers on a sliver of rock sitting on public display, and literally touch the Moon.

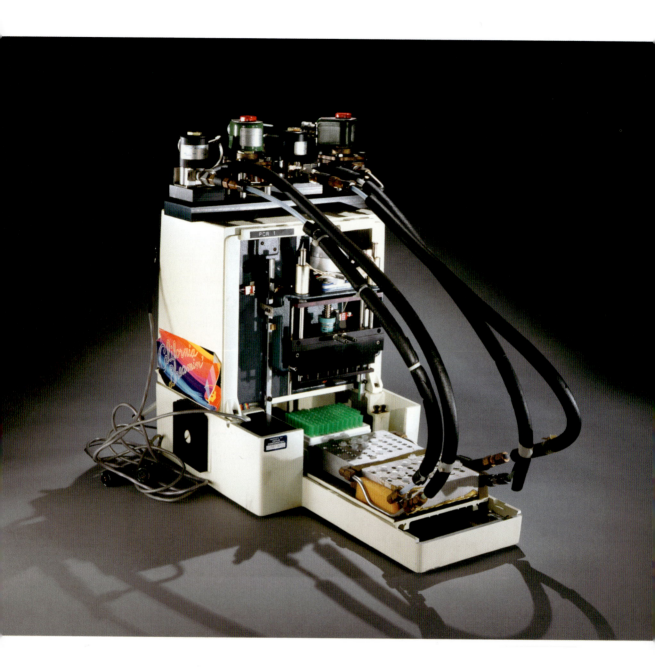

"MR. CYCLE" PCR MACHINE *National Museum of American History*

T his little machine, which sits rather unpretentiously in the Smith-sonian, is behind just about all contemporary scientific research in genetics and represents one of the most significant scientific advances of the late twentieth century. Affectionately called Mr. Cycle, this is the prototype for the technology employed by scientists to study DNA.

DNA is the basic building block of life, a type of molecule found in the cells of all known living organisms. DNA

"MR. CYCLE" PCR MACHINE

uses combinations and sequences of four biological molecules called nucleotides—guanine, adenine, thymine, and cytosine—to encode infor-mation about the development and functioning of an organism. In 1953, American molecular biologist James Watson and British scientist Francis Crick published a groundbreaking study describing the structure of DNA. Their paper built on the work of many scientists before them, including British molecular biology pioneer Rosalind Franklin. Watson and Crick theorized that the DNA molecule was a double-stranded helix that looked somewhat like a spiral staircase. The nucleotides form the steps of the staircase.

In cells, DNA is organized into sets of locations, or genes, that are lo-cated along chromosomes. Human beings, for example, have about thirty thousand genes organized along forty-six chromosomes arrayed in pairs. When body cells regularly multiply, they replicate these pairs of chromo-somes. In sexual reproduction, however, the chromosomal pairs in a cell separate, forming new cells, called gametes, that fuse with the gametes of the opposite sex to form the code for another human being. Differences in DNA account for the differences both between species and between individuals within a species. Individuals have their own unique profiles in-

A DEVICE THAT CAN REPLICATE DNA ENABLES A REVOLUTION IN GENETIC SCIENCE.

National Museum of American History

dicated by the exact sequence of their DNA. All sorts of characteristics, from eye and hair color to proclivity and susceptibility to certain diseases, may be encoded in one's DNA.

In order to conduct research on DNA, a scientist needs to generate thousands or even millions of copies of the specific segment of the DNA that he or she would like to study. The polymerase chain reaction—known as PCR—makes this happen. DNA polymerase is an enzyme found in most living things that naturally copies DNA. In 1983, Kary Mullis, a chemist at the Cetus Corporation, a biotechnology firm in Emeryville, California, discovered a way to exploit this mechanism for the exponential amplification of any desired DNA sequence.

Mullis's PCR technique was slow and labor intensive, working on principles similar to nature's own method for replicating DNA. The copying technique depends on a series of biochemical reactions. Although the reactions are straightforward, requiring only a few chemicals, it is an incredibly time-consuming process to perform by hand. Because different steps of the reaction take place at different temperatures, scientists were required to stand at the lab bench for several hours, moving a sample back and forth between water baths of different temperatures and adding the polymerase enzyme. While they appreciated the technique, they were eager for an automated machine that could perform the reaction for them. Cetus engineers began looking for ways to automate the process. Mr. Cycle was the solution.

Mr. Cycle automated Mullis's PCR technique, allowing scientists to obtain the copies of DNA they needed for experiments in an efficient manner. By modifying an instrument they had previously used for liquid handling, Cetus developed a machine that automatically controlled the multiple water baths, enzyme additions, and the heating and cooling, enabling scientists to produce large samples of DNA strands. Smithsonian research assistant Mallory Warner explains that the PCR machine is like "a photocopier for genetic material." The PCR technique became standard, and Mullis was awarded the Nobel Prize in Chemistry in 1993 for its development.

Without the PCR machine, advances such as the mapping of the hu-

man genome would not have been possible. It enabled scientists to clone and analyze DNA in an efficient manner. It prepares samples to test paternity and for inherited disease, and criminologists depend on it for forensic analysis, like identifying trace elements of DNA at crime scenes. It helps paleobiologists analyze the ancient DNA in fossils so they can understand evolutionary processes; it enables bioarchaeologists to examine the DNA in mummies at prehistoric sites so they can chart health and migration patterns of ancient people. All of these have now become common in scientific research, and they were all made possible by the invention of this machine.

The Smithsonian acquired Mr. Cycle in 1993 due to the efforts of curators Patricia Gossel and Ramunas Kondratas, who had recognized its significance several years earlier. When the Nobel Prize went to Mullis, the curators installed Mr. Cycle alongside a movie prop from the film *Jurassic Park*—the piece of amber with a mosquito preserved inside that was filled with the blood and ersatz DNA of a dinosaur. The film's entire premise depended upon the PCR amplification of DNA to drive the plot, and the display drew attention to the interplay between scientific reality and cinematic fantasy.

Kondratas, who specialized in medical technology, also ran a video interview project to document the innovations that were revolutionizing the field. He recorded oral histories with several dozen scientists, engineers, and technicians involved in the development of medical-imaging CAT scanners, cell sorters, small virus sequencers, ultrasound, and the ultracentrifuge. Among those interviewed were Mullis and others at Cetus who played a role in the development of PCR. These videos, held in the collections of the Smithsonian Institution Archives, provide a superb record of modern scientific discovery. They also have been used regularly by lawyers working on medical and scientific patent cases.

T he space shuttle *Discovery* arrived like no other acquisition in the history of the Smithsonian.

On April 17, 2012, carried atop a modified Boeing 747 jet, it flew over the National Mall in Washington, D.C., and the greater metropolitan area several times. As General J. R. "Jack" Dailey, the director of the National Air and Space Museum, quipped, recalling the early barnstorming years of aviation, "If

SPACE SHUTTLE *DISCOVERY*

you give a fly boy a crowd, he'll keep showing off as long as he can." More than a million people came out of their homes, schools, offices, workplaces, and vehicles and looked toward the sky. Everything else stopped. It was an amazing sight.

A SINGLE
SPACESHIP
TRAVELS
ALMOST 150
MILLION
MILES TO
SERVE HUMAN
EXPLORATION
OF SPACE.

*National Air and Space
Museum*

The journey also marked the last time *Discovery* would fly. The Boeing 747 landed at Dulles International Airport, where *Discovery* was off-loaded, towed to the boundary gate, and paraded through to meet its sister ship, *Enterprise,* which since 2003 had been on display next door in the museum's Steven F. Udvar-Hazy Center. The 180,000-pound *Discovery* would now become a treasured artifact; NASA's space shuttle program had come to an end.

It had begun forty years before, when, in 1972, President Richard Nixon announced the development of a reusable space shuttle, or space transportation system (STS). Up to that time, NASA used one-shot, disposable rockets to launch people into space. The idea of a spacecraft that could launch like a rocket but land like an airplane had been the subject of theoretical work going back to the 1920s, but it wasn't until the late 1960s that NASA began design, cost, and engineering studies in earnest for a reusable spacecraft. A number of aerospace companies explored the concept; eventually, NASA determined that a craft consisting of an orbiter attached to

SPACE SHUTTLE

DISCOVERY

National Air and Space Museum

solid rocket boosters with an external fuel tank made the most sense, given its development budget and schedule, and the agency awarded the prime building contract to Rockwell International.

Until then, spacecraft used ablative heat shields that burned away to dissipate heat as they reentered Earth's atmosphere. Designers came up with the idea of covering the orbiter with insulating ceramic tiles that could absorb the heat of reentry without damaging the vehicle or harming the astronauts. The orbiter would land on a runway rather than "crashing" into the sea, as previous capsules had done. Because jet engines for atmospheric flight were sacrificed to meet cost and weight limits, the orbiter would have to fly like a glider during its return. It would have only one chance to land safely—no wave-offs or fly-arounds.

Starting in June 1974, a working aircraft was built as a test spaceship. Designated as NASA Orbiter Vehicle OV-101, it was used to test the aerodynamics of the space shuttle's final descent and landing. Carried aloft to about twenty-five thousand feet on top of a 747 carrier aircraft, it was not equipped with rocket engines or functional heat shield tiles. OV-101 was initially given the name *Constitution*, as it was readied for its debut on September 17, 1976—Constitution Day—during the celebration of the U.S. Bicentennial. A letter-writing campaign organized by fans of the popular television show *Star Trek* convinced President Gerald Ford to ask NASA to call the new vehicle *Enterprise*, the name of the fictional starship in the TV series. When the first orbiter rolled out of the assembly plant, most of the cast and creators of *Star Trek* were on hand. In 1977, *Enterprise* completed a series of approach and landing test flights at Edwards Air Force Base in California. It then went on to do vibration tests in Alabama and facility fit checks at launch sites in Florida and California. NASA ferried *Enterprise* to the 1983 Paris Air Show, and then retired it to the National Air and Space Museum in 1985.

Meanwhile, two more space shuttle orbiters were constructed, *Columbia* and *Challenger*, followed soon by *Discovery* and *Atlantis*, to make a fleet of four. *Columbia* made the first flight in 1981, the first-ever space test flight

with a crew on board. The year 1985 was a banner year, with a record-setting nine shuttle missions. The next year in space was to be even busier.

A much-heralded Teachers in Space program was instituted to stimulate American public interest in space exploration and study, and to demonstrate that spaceflight was safe for the rest of us. Christa McAuliffe, a high school social studies teacher from Concord, New Hampshire, was selected from more than ten thousand applicants to join a space shuttle mission. On January 28, 1986, with millions of Americans—including classrooms and auditoriums filled with children—watching on television, the mission ended in an explosion seventy-three seconds after liftoff. All seven *Challenger* crew members perished. It was a shocking national tragedy. The shuttle program was suspended while the cause of the disaster was investigated and addressed. NASA considered revamping *Enterprise* for space flight, but that proved impractical. *Endeavour* was built to replace *Challenger* in the shuttle fleet.

Shuttle flights resumed in 1988, and eighty-six successful missions were completed over the next fifteen years. Then tragedy struck again. On February 1, 2003, after reentering Earth's atmosphere, the shuttle *Columbia*, which unbeknownst to NASA had been damaged during launch, broke up over Texas, and seven crew members died, this time just minutes from landing. NASA again grounded the space shuttle program after the accident, made changes, and returned the shuttles to service.

Discovery became the workhorse of the space shuttle fleet, executing every type of mission the shuttle was meant to fly. Entering service in 1984, it was the first production orbiter—that is, the finished model, more refined than its predecessors, the development orbiters *Columbia* and *Challenger*. *Discovery* completed 39 missions and spent a total of 365 days in space, traveling more than 148 million miles. It orbited Earth more than 5,800 times at about 17,500 miles per hour. *Discovery* delivered the Hubble Space Telescope and other satellites into space, and its crews retrieved, repaired, and returned or redeployed a number of others. It deployed planetary exploring craft, carried out classified Department of Defense work, supported

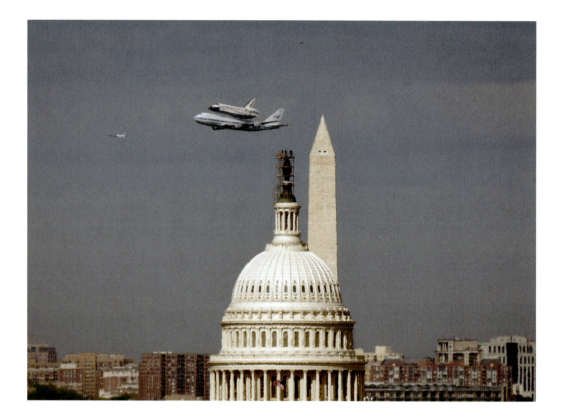

SPACE SHUTTLE

DISCOVERY

ABOARD A

747 OVER

WASHINGTON, D.C.

NASA/Rebecca Roth/Corbis

Spacelab and SPACEHAB laboratory research missions, participated in Shuttle-Mir missions with the Russians, and completed assembly, resupply, and crew exchange missions for the International Space Station. *Discovery* held a special place in the space program—184 different astronauts and 32 different commanders, including 2 women commanders, served as crew for its flights. It returned John Glenn to space in 1998, and it returned the United States to space after the losses of *Challenger* and *Columbia*.

A year after the *Columbia* tragedy, President George W. Bush announced that the space shuttles would be retired upon completion of the International Space Station. While the shuttles had served their purposes well—chiefly carrying massive payloads and large crews into Earth's orbit—they could not travel to the Moon or to Mars. New programs and vehicles would

accomplish those goals. *Discovery,* having carried out its last mission to the International Space Station in 2011, was readied to enter the second phase of its life, becoming a beacon for educating and inspiring the public about space travel. In the Smithsonian, *Discovery* would be seen by millions of people annually in context with other great achievements in aviation and space exploration.

Discovery is the size of a Boeing 737 airliner, 122 feet long with a 78-foot wingspan and a vertical stabilizer 57 feet high. Its aluminum airframe is covered with silica/ceramic thermal protection tiles and blankets. To be readied for the museum it was "safed" by removing thrusters and other components that might out-gas toxic propellant fumes. Other hazards, such as explosive and spring-loaded devices, were disarmed or removed. This preparation took months. The three main engines and a few other internal parts were removed for reuse, study, or exhibit outside the craft, but the crew cabin was cleaned and left intact as it was configured on its last space journey.

NASA and the Smithsonian arranged the shuttle exchange for 2012. *Discovery* would come to the Smithsonian, and the *Enterprise* would go to the Intrepid Sea, Air & Space Museum in New York. When the big day came, *Enterprise* was towed out of the Udvar-Hazy Center's space hangar and set on the runway lined up nose to nose with *Discovery.* The transfer ceremony included the participation of Senator John Glenn, the administrator of NASA, the chair of the Smithsonian Board of Regents, the secretary of the Smithsonian, General Dailey, a large contingent of astronauts, and an audience of shuttle program workers, Smithsonian staffers, and an enthusiastic public. As *Discovery* and *Enterprise* stood on view, it was impossible to miss how weathered and worn *Discovery* looked compared to the pristine *Enterprise.* Though in excellent condition, its discolored tiles showed the burns and bruises of many reentries into the atmosphere.

It really hit me: *Discovery* had been a space age truck—a dependable means of moving goods and people a long way on an ethereal highway. Though Glenn and others lamented what they took to be the premature end of the shuttle program, and speculated that maybe a spectacular shuttle

flyover around Washington months or years earlier as a public relations event might have saved it, all appreciated *Discovery*'s service and wished it well in its new role, on display and permanently preserved as a museum object in the national collections. Then *Enterprise* was moved to adjacent Dulles Airport, lifted and mounted onto the 747 carrier aircraft, and flown to New York City to be exhibited at the Intrepid Sea, Air & Space Museum.

Curators and conservators were reluctant to see *Enterprise* depart. They had put more than two decades of service into caring for, studying, and interpreting the shuttle test vehicle. Months after having been put on display in New York, *Enterprise*'s tail section suffered some minor damage when Hurricane Sandy hit the region and collapsed the temporary structure housing the shuttle. Conservators at the Intrepid had the situation well in hand, though, making the necessary repairs. Back in Washington, D.C., the thrill of receiving "the champion of the shuttle fleet" went a long way toward offsetting the loss of *Enterprise*. *Discovery* surely ranks as one of the most exciting acquisitions in Smithsonian history.

CIVIL

RIGHTS

(1947 TO NOW)

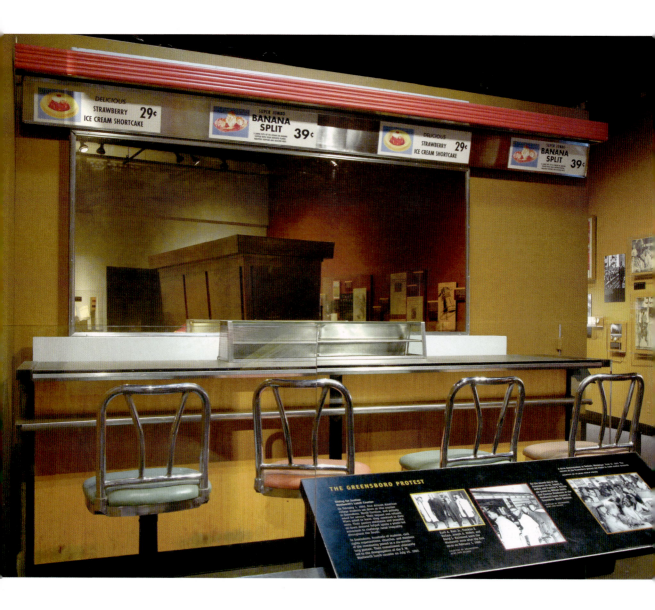

GREENSBORO LUNCH COUNTER *National Museum of American History*

On Monday, February 1, 1960, four African American men entered the Greensboro, North Carolina, F. W. Woolworth's and sat down on stools at the lunch counter. Until that moment, the stools had never been occupied by black customers. The four men, Franklin McCain, Ezell Blair Jr., Joseph McNeil, and David Richmond, were freshmen at the Agricultural and Technical College of North Carolina. They asked to be served and were refused. Instead of getting up and leaving, these men, later known as the Greensboro Four, launched a sit-in protest that lasted for six months. It energized the civil rights movement and its drive for equality for African Americans.

The lunch counter and stools, installed when Woolworth's moved into the building at 132 South Elm Street in 1938, were the same as those found in hundreds of communities across the nation. Lunch counters in department stores were common, a way for chain-store managers to get shoppers buying household goods and incidentals to spend a bit more money. The counters also became a place where people in the community would congregate, catch up on news, gossip, and even transact business. This was the case for the large twenty-five-thousand-square-foot Woolworth's in Greensboro, with its long L-shaped counter accommodating more than sixty seats. In Greensboro, as in much of the South, although blacks could shop, racist Jim Crow laws prevented them from eating at the counter—that was reserved for whites only. In Greensboro, as elsewhere, African Americans were served only at the take-out section of the counter.

Greensboro had been the site of a variety of civil rights activities in the 1950s. A Bennett College sociology professor named Edward Edmonds had led groups protesting inferior schools for blacks as well as the whites-only public swimming pool at Lindley Park. The local chapter of the National Association for the Advancement of Colored People (NAACP)

80

GREENSBORO LUNCH COUNTER

FOUR AFRICAN AMERICAN STUDENTS BEGAN A SIT-IN TO DESEGREGATE AN EATERY AND ENERGIZE THE CIVIL RIGHTS MOVEMENT.

National Museum of American History

had led efforts to desegregate the municipal golf course. The Reverend Dr. Martin Luther King Jr. came to Greensboro in 1958 and gave a sermon at the Bennett College chapel that Ezell Blair, one of the four men, recalled, "brought tears to my eyes." Blair's father, a shop teacher at the high school, led a drive soon after the speech to get merchants selling to the black community to hire more African Americans.

Another of the four young men, Joseph McNeil, would later recall the impetus for the students' protest. After he had grown up and graduated from high school in North Carolina, his family moved to New York while he enrolled in the black technical college in Greensboro to study engineering. When returning from Christmas vacation after visiting his family that first year, he found his bus journey south especially disturbing. "In Philadelphia I could eat anywhere in the bus station. By Maryland, that had changed." In the Richmond, Virginia, Greyhound station, he couldn't buy a hot dog at a food stand reserved for whites. "I was still the same person, but I was treated differently." Once back at school in Greensboro, he and his three friends decided to act. The idea of a sit-in protest, he noted, had been around for a while. The four agreed ahead of time that their protest would be nonviolent, and that they would miss no classes. The students arrived at the Woolworth's at about 4:30 P.M. and stayed until closing, an hour later, without being served.

The men returned to the store the next day, at about 10:30 A.M., this time joined by more than a dozen other A&T students who all made small purchases in the store to establish that they were paying customers. Jack Moebes, a photographer with the *Greensboro News & Record,* took a photo of four students at the counter, two of the original four—McNeil and McCain—along with William Smith and Clarence Henderson. That photograph was published on the front page of the newspaper and became widely circulated. The students again asked to be served, but were refused. As white customers left, black students took their places. The students spoke softly and read at the counter. They wrote a letter to the head of Woolworth's asking that the discrimination end. They left after noon, but

promised to return the next day with more and more students—for weeks if necessary, until they were served. They also encouraged women students at local Bennett College to join the protest. Blair noted that the students had to act because adults in the region had become somewhat resigned to segregation.

The next day, scores of students from A&T—about one third of them women—showed up for the sit-in. Woolworth's said it would abide by local custom and not serve blacks. In subsequent days protesters were joined by black women from Bennett College and three white coeds from Greensboro College, as well as black high school students. Whites, some carrying Confederate flags, taunted protesters, began to block the aisles, and tried to prevent blacks from taking seats at the Woolworth's counter. The police had to intervene to keep protesters and counterprotesters apart; the presence of the white coeds inflamed the situation. Three white men were arrested. As negotiations between city officials and the students failed to end the protest, it garnered increasing national attention. By Saturday, hundreds of people crowded into the Woolworth's lunch counter area. A bomb threat led to the store's evacuation, and the protest moved down the street to the Kress store, which then closed. The students agreed to a cooling-off period following a meeting with town and college officials so that a solution could be found.

It wasn't, and when the protests resumed, outside picketers were added and black adults began an economic boycott of downtown stores. The Greensboro sit-in inspired similar protests in other North Carolina and southern cities. In March, President Dwight D. Eisenhower expressed his support for the rights of the students to be served under the law. The economic impact on Woolworth's was devastating. On July 25 it served its own black employees at the counter and the next day ended its segregation policies chainwide. Hundreds of other stores followed suit as the impact of the Greensboro sit-in spread across the South, from lunch counters to other civic institutions.

The students' courageous action inspired the Student Nonviolent Coordinating Committee (SNCC) and motivated young blacks from across

the nation to become activists in the civil rights movement. One of those students was Cordell Reagon, who participated in a Nashville sit-in. He later joined with a preacher's daughter from Albany, Georgia—Bernice Johnson—and with Rutha Harris, Charles Neblett, and others to form the SNCC Freedom Singers. Bernice later became the founder and leader of the music group Sweet Honey in the Rock, and a curator at both the Smithsonian Folklife Festival and the National Museum of American History as well as one of my mentors.

Much of the civil rights movement was documented by Folkways Records through the efforts of folk musician and musicologist Guy Carawan and the support of Pete Seeger. Seeger, Carawan, and Zilphia Horton of the Highlander Folk School are credited with helping to turn an African American hymn into the anthem of the civil rights movement—"We Shall Overcome." Among Folkways' recordings are speeches by Martin Luther King Jr. and other civil rights leaders, as well as the protest songs of the Freedom Singers and others. All these recordings now reside at the Smithsonian as an aural history of the civil rights movement.

In October 1993, Smithsonian curator Bill Yeingst learned that Woolworth's was closing the Greensboro store as part of a companywide downsizing. "I called the manager right away," he recalled, "and my colleague Lonnie Bunch and I went down and met with African American city council members and a group called Sit-In Movement, Inc." Woolworth's officials agreed that a piece of the counter should go to the Smithsonian, and volunteers from the local carpenters' union worked with Smithsonian staff to remove and crate for shipment an eight-foot section with four stools. Yeingst got the museum to contract with a fine arts shipping company and then rode with the objects through a terrible snowstorm to bring the stools, counter section, soda fountain, signs, cornice and fume vent, sign holder, and small accessories such as a notebook of recipes from Greensboro to Washington. Since then, the counter has been prominently exhibited at the National Museum of American History, where it is used virtually every day

for historical reenactments that enable visitors to feel what it was like to sit in at that counter in February 1960.

In 2011, the Smithsonian had the very special honor of hosting three of the surviving Greensboro Four—McNeil, McCain, and Jibreel Khazan (formerly Ezell Blair Jr.)—at the museum to be reunited with the lunch counter. Introduced by former SNCC leader, now longtime Congressman John Lewis, the men, along with David Richmond posthumously, were honored by Secretary Wayne Clough with the James Smithson Bicentennial Medal in recognition of their contribution to civil rights in America.

With typical, joyous bravado, Muhammad Ali announced to the crowd of reporters, Smithsonian museum officials, and cheering spectators assembled for the March 1976 donation ceremony that his Everlast boxing gloves would become "the most famous thing in this building!" His autographed gloves would be placed in a new exhibition, A Nation of Nations, mounted to celebrate the American Bicentennial. Ali also donated his autographed boxing robe.

MUHAMMAD ALI'S BOXING GEAR

A HEAVY-
WEIGHT
CHAMPION
BECOMES A
VOICE OF
CONSCIENCE
AND A
NATIONAL
HERO.

*National Museum of
American History, National
Museum of African American
History and Culture*

Then only thirty-four years old, Ali had already become an American legend and international celebrity. Self-nicknamed "The Greatest," he gained fame for his boxing skills, his charisma, and the controversy he generated outside the ring.

Ali was born as Cassius Marcellus Clay Jr. in Louisville, Kentucky, in 1942. He was named after his father, who was himself named after Kentucky's leading nineteenth-century white abolitionist. His very name embodied the ongoing struggle against racism in the Jim Crow South. When Clay was twelve years old, his bike was stolen. He vowed vengeance, telling police officer Joe Martin that he would "whup" the thieves. Martin was also a boxing coach at Louisville's Columbia Gym and told Clay he'd better learn to fight if he expected to make good on his vow. Martin took Clay under his wing and for the next six years tutored the young boxer to six Kentucky Golden Gloves titles, two national Golden Gloves titles, an Amateur Athletic Union national title, and to the 1960 Rome Olympics. In Rome, Ali proved vastly superior to the competition and easily won the gold medal in the light-heavyweight division.

Clay turned professional after the Olympics. His Louisville promoters enlisted Angelo Dundee as his trainer, and Clay trained at the Dundee family's 5th Street Gym in Miami Beach, Florida. Ali used standard Ever-

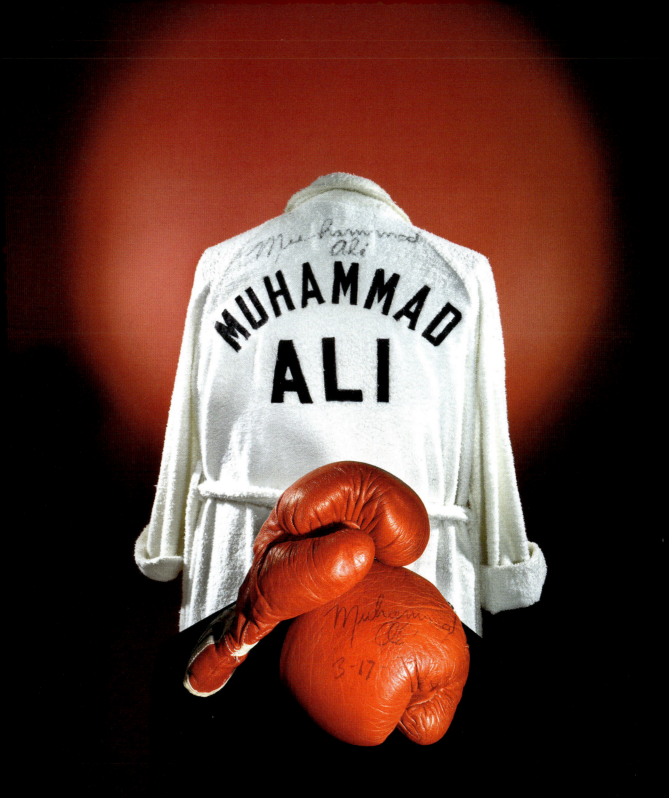

MUHAMMAD ALI BOXING GLOVES AND ROBE *National Museum of American History*

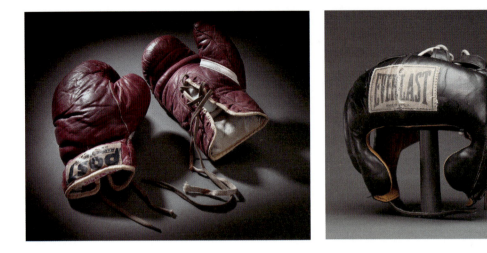

last head guards for his training; it is one of these from this time that was acquired by the Smithsonian almost fifty years later.

Over the next few years, Clay was undefeated, scoring nineteen wins, fifteen by knockout, over opponents including Sonny Banks, Archie Moore, Doug Jones, and Henry Cooper. Now the top contender for the heavyweight title, Clay faced champion Sonny Liston in February 1964. Liston was a strong favorite, but Clay, undeterred, taunted the champ at the weigh-in the day before the bout. He called Liston a "big ugly bear" and said he would "float like a butterfly and sting like a bee." And in fact Clay dominated the fight, dancing around Liston, connecting repeatedly, and winning on a technical knockout after the sixth round. It was after this fight that Clay proclaimed himself The Greatest.

Clay had previously sought membership in the Nation of Islam, but had been turned away, allegedly because he was a boxer. Now, following his triumph over Liston in 1964, the movement's leaders, Elijah Muhammad and Malcolm X, recognized the publicity his fame would bring to the movement. Initially, Muhammad was going to rename Clay "Cassius X," but then, after a major dispute with Malcolm X, announced instead that Clay would henceforth be known as Muhammad Ali. Many mainstream

reporters refused to honor Ali's new name, with the notable exception of Howard Cosell. Promoter Don King also encouraged adoption of the new name. Ali met Liston for a rematch in 1965, which Ali won in a surprisingly quick first-round knockout, though there was much commentary about the so-called phantom punch that forced Liston to the mat but few viewers were able to see.

Ali then faced former champ Floyd Patterson. Patterson refused to recognize Ali by his Muslim name, and Ali taunted Patterson in the ring by yelling "What's my name?" as he dominated the fight. He was then supposed to fight Ernie Terrell in Chicago, but by this point his controversial persona and public outspokenness, especially regarding the Vietnam War, began to do serious damage to his career. The World Boxing Association (WBA) stripped him of his title, while the other competing organization sanctioning the sport, the World Boxing Council (WBC), did not. Terrell backed out of the fight, but became the WBA champion by fighting others for the crown that had been taken away from Ali.

Ali continued to be recognized by the WBC, *The Ring* magazine, and popularly as the world heavyweight champion, but more state boxing commissions refused to sanction his fights given what they took to be his unpatriotic statements against the Vietnam War. Ali had been classified as 1-A, eligible to be drafted into the U.S. Army. Ali regarded himself as a conscientious objector, and he made a number of statements about war being against the teaching of Islam and famously declared, "I don't have no personal quarrel with those Viet Cong."

Ali fought several matches overseas before returning to the United States to face Terrell in Texas in 1967. Ali repeated the "What's my name?" taunting in the ring and called Terrell an Uncle Tom. He defeated Terrell soundly in a unanimous decision, and the WBA then restored his title.

Ali, called for induction into the military soon after, refused to respond, subjecting himself to arrest, prison, and fines. He was arrested, and in quick order the various state athletic commissions stripped him of his license to box; this time both the WBA and WBC took away his title. Ali was con-

victed at trial; the decision was upheld by a court of appeals, and the case—*Clay v. United States*—headed to the Supreme Court.

Ali also voiced controversial beliefs influenced by the Nation of Islam at a time when the moral positions of the Reverend Dr. Martin Luther King Jr. and other civil rights leaders, rooted in more familiar Judeo-Christian oratory, were achieving more mainstream acceptance. Ali talked about "white slavemasters" trying to dominate people the world over. He advocated for racial separatism rather than integration.

Bereft of his championship title and unable to box, Ali became a controversial public figure. Even after he became estranged from the Nation of Islam and from Elijah Muhammad, Ali continued to make public statements that alienated many fans, black and white; but they also gained him new fans, particularly among younger people focused more on political and social issues than on boxing as a sport.

As Ali's draft evasion appeal made its way to the Supreme Court, the antiwar movement grew, with most young people, many liberals, and more and more leaders opposed to U.S. involvement in Vietnam. The generation gap widened. Political radicalism grew and faced off against the establishment. The Reverend Dr. Martin Luther King Jr. and presidential candidate Robert Kennedy were assassinated. Amid all this, Ali's commentary and antiwar stand appeared less and less outrageous. In 1970, Georgia and then New York restored his license to fight. Once back in the ring, Ali defeated Jerry Quarry and Oscar Bonavena. The next spring, he faced champion Joe Frazier at Madison Square Garden in a match dubbed the Fight of the Century. Ali lost the fight, but a month later won a bigger fight, *Clay v. United States*. In a unanimous decision, the Supreme Court overturned his conviction on a technicality.

Ali began his comeback in earnest, defeating Quarry and Patterson again and losing to Ken Norton. Meanwhile, Frazier had lost the championship to George Foreman in 1973. Ali beat Frazier in their 1974 rematch. Now Ali would face the undefeated, seemingly overpowering Foreman for the title.

Ali challenged Foreman to fight in an unprecedented location, Kinshasa, in what was then Zaire. Promoter Don King brilliantly organized the arrangements and scheduled the fight for October 30, 1974. The fight, known as the Rumble in the Jungle, would become an international mega-event, a huge spectacle, celebrating the match and Ali's return to widespread public prominence. It would allow a huge fan base to appreciate how Ali, the underdog in boxing and politics, had fought his way back against the establishment. It would also make a significant political statement connecting the African continent to the life of African Americans. Training for the fight for six months, first in Pennsylvania and then in Zaire, Ali wore a simple white terry cloth cotton robe, emblazoned with "Muhammad Ali," which he would later donate to the Smithsonian.

In the fight, Ali used a "rope-a-dope" strategy to tire Foreman out. He covered up, letting Foreman expend his energy hitting him, until the eighth round, when Ali burst into a furious offensive flurry to win the championship. Ali's was a remarkable comeback that captured the imagination of sports fans around the world.

That Ali was donating his boxing gloves and white championship robe to an exhibition celebrating the bicentennial of the United States had a measure of irony, but when he strode into the Smithsonian in 1976 as heavyweight boxing champion of the world, he was warmly and loudly greeted by the public, his past notoriety well behind him. Statements at the time that the gloves had been worn for the Foreman fight proved erroneous. The gloves Ali donated were red and pristine, while the gloves worn in Kinshasa were brown and well used.

Ali regained the championship title for an unprecedented third time in 1978, and retired from boxing in 1981. He continued to make media and public appearances, but focused on promoting products, humanitarian causes, and, of course, his legacy. Building on his boxing career and outsized persona, he became a symbol of courage, independence, and determination. He was adored by the world when he lit the flame for the 1996 Atlanta Olympics. His stoic acceptance of Parkinson's disease as well as his philan-

thropic work went a long way toward restoring a sympathetic and admiring fan base even among those who had been alienated by his political views in the 1960s. His Parkinson's makes his fifty-year-old boxing headgear all the more poignant, as physicians and researchers have examined the role thousands of punches received over a long career played in the development of the disease. As they have done throughout his career, many people continue to root for him as he faces this latest challenge.

Designed by Milton Glaser (b. 1929), this poster of Bob Dylan (b. 1941) was originally included as an insert in the 1967 Columbia record album *Bob Dylan's Greatest Hits*. Some six million copies of the poster were hung everywhere listeners appreciated Dylan's music. The combination of Bob Dylan's songs and the poster captured the attention and the imagination of a generation.

BOB DYLAN POSTER BY MILTON GLASER

Born to a Jewish family and originally named Robert Zimmerman, Dylan was raised in the Iron Range region of Minnesota. In high school in the mid-1950s, he played the new rock-and-roll music that was then catching on. As he matured he was attracted to American folk music, with its depth of emotion and themes of despair and struggle, and was particularly drawn to the lyrics of Woody Guthrie. In 1961 he arrived in New York City, where people like the musician Pete Seeger, the folklorist Alan Lomax, and the record producer Moses Asch were engaged in exploring musical styles and their significance. Dylan made a pilgrimage to visit Guthrie, who was hospitalized at the time with Huntington's disease. Dylan modeled himself after the famed singer-songwriter—someone who would tackle the serious issues of the day and represent the downtrodden and oppressed. Dylan met Ramblin' Jack Elliott, Dave Van Ronk, Odetta, Mike Seeger, John Cohen and the New Lost City Ramblers, and others in the folk music revival, and started performing where it was booming, in coffeehouses in Greenwich Village. When Dylan opened at Gerde's Folk City for the Greenbriar Boys, he caught the attention of the *New York Times* music critic Robert Shelton, who wrote a laudatory review that attracted strong public attention.

Though Dylan had sought to record for Asch and Folkways Records, just like Guthrie, instead he was signed by John Hammond to Columbia Records. At the same time, he recorded for other labels using a pseudonym.

A PORTRAIT OF THE COUNTER-CULTURE'S BARD ILLUSTRATES THAT THE "TIMES THEY ARE A-CHANGIN'."

National Portrait Gallery

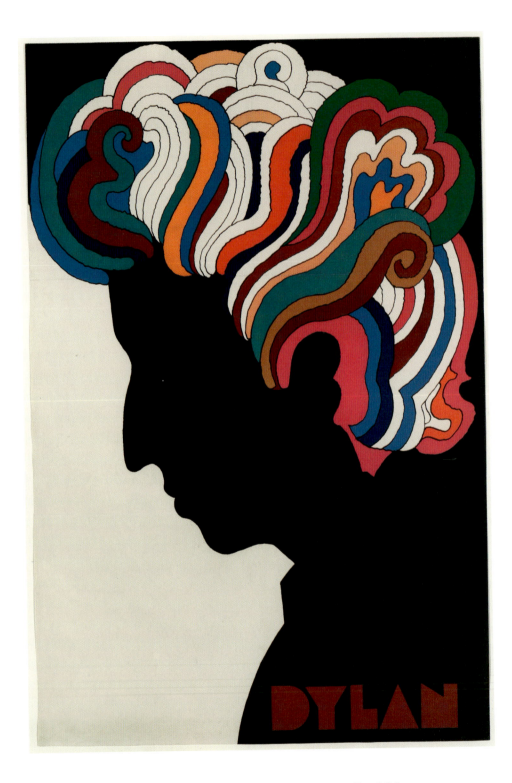

BOB DYLAN POSTER BY MILTON GLASER *National Portrait Gallery*

He recorded for Sis Cunningham's *Broadside* magazine, published by Folkways, under the name Blind Boy Grunt. His first 1962 Columbia album, *Bob Dylan*, included folk, blues, and gospel tunes and two original songs. While the album was by no means a hit, it introduced audiences to his characteristic voice. As Joyce Carol Oates wrote, "When we first heard this raw, very young, and seemingly untrained voice, frankly nasal, as if sandpaper could sing, the effect was dramatic and electrifying." Coupled with acoustic guitar and harmonica, Dylan's voice was viewed as authentic, much in the way Guthrie had been received by the previous generation.

Dylan's second album, released in 1963, earned him a reputation as a creative singer-songwriter and protest singer. He joined Pete Seeger, the SNCC Freedom Singers, and others at the Newport Folk Festival and the Highlander Folk School—a social justice leadership training organization. In August, Dylan performed with Marian Anderson; Mahalia Jackson; Peter, Paul and Mary; and Joan Baez at the Lincoln Memorial on the National Mall for the March on Washington. They provided musical selections prior to the Reverend Dr. Martin Luther King Jr.'s "I Have a Dream" speech. Dylan led with "When the Ship Comes In," then performed "Only a Pawn in Their Game," about the June 1963 assassination of civil rights leader Medgar Evers, and joined with others in the civil rights anthem "Keep Your Eyes on the Prize." Peter, Paul and Mary sang "Blowin' in the Wind," a song written by Dylan that they had turned into a popular hit.

With the albums that followed, Dylan became the leading singer-songwriter for the emerging counterculture of the 1960s, and by mid-decade, songs like "Blowin' in the Wind," "The Times They Are A-Changin'," and "Mr. Tambourine Man" were standards at concerts and protest demonstrations. Dylan's simple aesthetic of powerful poetry, simple guitar chords, and expressive harmonica riffs had exceptional appeal. Within a few years, Dylan was the bard for a generation growing up to question the social and political status quo.

While others labeled him the voice of the new generation, Dylan himself expressed his reservations, none too subtly, in "It Ain't Me, Babe." In the

1965 album *Bringing It All Back Home,* Dylan experimented with musical styles and themes. He ventured into love ballads and songs in a more ironic key, as well as a more electrified sound, later termed "folk rock," that disappointed many of his more traditionalist fans. Songs such as "Like a Rolling Stone," "Subterranean Homesick Blues," and "Just Like a Woman" demonstrated Dylan's artistic virtuosity and were tremendously influential among youth and other musicians. "Like a Rolling Stone," featured on the *Highway 61 Revisited* album, reached number two on the U.S. music charts. It has since been named by *Rolling Stone* magazine as the greatest song of all time.

The year 1966 brought an unwelcome hiatus from Dylan's ceaseless productivity; he was in a terrible motorcycle accident, and took some time to recover. To fill the void, Columbia Records decided to release a greatest hits album. John Berg, Columbia's art director, asked Milton Glaser to create a poster of Dylan that would be included in the album. The graphic designer had created only a few other posters at this point, but he took up the challenge.

Glaser had studied art at New York's Cooper Union and in Italy on a Fulbright scholarship. He was familiar with a broad range of European and American approaches to graphic representation. Glaser found inspiration for the Dylan poster from a self-portrait created by Marcel Duchamp, the French surrealist painter. Duchamp had his heyday in the early twentieth century but was being rediscovered by the American pop artists of the 1960s, who were inspired by the Dada movement Duchamp led. Duchamp's 1957 self-portrait showed his silhouetted head in a white square set into a black border. Glaser used a similar composition, but reversed it, representing Dylan's head facing left in black against a white background.

To this design Glaser added his own 1960s twist: he turned Dylan's wild and unkempt hair into vividly colored, swirling ribbons. This suggested the psychedelic imagery coming out of the counterculture of the West Coast—the evocations of the LSD hallucinogenic experience, the Day-Glo decorative paintings of author and activist Ken Kesey and his Merry Pranksters,

San Francisco's Fillmore theater posters and the light shows that were the hallmark of Grateful Dead and Jefferson Airplane concerts.

Glaser also cited other, more historical, more artistic influences, noting, "I was interested in Art Nouveau at the time. That was an influence for the colors and shapes in the picture." Dylan's kinetic, colored hair contrasts sharply with the flat black-on-white profile, animating what would otherwise be a rather stark representation. The result is a portrait that seems simple yet exudes profound dignity—Dylan as a modern philosopher-poet with gravitas, and yet of the new age. Glaser added a bold typeface with the simple one-word legend "Dylan."

The poster became an instant hit. Glaser went on to do hundreds of other posters and other memorable graphics, including **I ♥ NY.**, a fabulously successful logo and promotional tagline for New York State at a time—the mid-1970s—when the region, and especially New York City, was experiencing a financial crisis, high crime, and other ills, and needed the love.

Both Bob Dylan and Milton Glaser were awarded the National Medal of Arts in 2009 by President Barack Obama, and both have helped the Smithsonian, albeit in different ways. Glaser has participated in a number of exhibitions at the Cooper-Hewitt, National Design Museum over the decades and has helped in its educational programs. In 2006 the museum gave him the National Design Award for lifetime achievement.

For his part, Dylan helped the Smithsonian acquire Folkways Records. One summer in the late 1980s he was visiting the Smithsonian Folklife Festival and met with my mentor, Smithsonian Assistant Secretary Ralph Rinzler. The two knew each other from the 1960s folk movement—both had visited Guthrie, worked with Folkways, and participated at the Newport Folk Festival and Highlander School. Rinzler, a mandolin player, was a member of the Greenbriar Boys when Dylan opened for them in his breakthrough performance. Rinzler explained that Folkways' owner and founder, Moses Asch, was retiring and, thanks to the Asch family, was willing to donate its recordings and archives and sell its business interest to the

Smithsonian, which envisioned it as a "museum of sound"—a documentary record of people's music from across the United States and around the globe.

The Smithsonian needed a way to pay for the acquisition, and Rinzler asked Dylan if he would consider performing on a benefit album, along with other artists, to raise the necessary funds. The plan was to have contemporary musicians cover songs performed by Woody Guthrie and Lead Belly that had been recorded for Folkways.

Dylan agreed and also helped secure the participation of Bruce Springsteen and Willie Nelson. With the efforts of Columbia Records vice president Don DeVito and Woody Guthrie's former manager Harold Levanthal, Columbia Records produced the album, *Folkways: A Vision Shared*. It included Dylan, Springsteen, Nelson, U2, Emmylou Harris, Taj Mahal, Little Richard, Fishbone, Sweet Honey in the Rock, John Cougar Mellencamp, Pete Seeger, Arlo Guthrie, Brian Wilson, and Doc Watson. It won a 1988 Grammy Award and earned enough money for the acquisition.

I am still proud to have helped make the acquisition and the album possible, and for the next two decades, I helped oversee Smithsonian Folkways under the capable direction of two of my most outstanding scholar-educator-colleagues, Tony Seeger and Dan Sheehy. Aided by Grateful Dead drummer and ethnomusicologist Mickey Hart, we were able to reengineer recordings and completely digitize the holdings—some forty thousand tracks and tens of thousands of pages of documentary notes. We have cared for the archive, made hundreds of new recordings, sold almost $100 million worth of songs, paid royalties to artists around the world, reached tens of millions of teachers and students with educational materials, and received an additional six Grammy Awards and eighteen nominations.

The jacket is unassuming, black satin polyester with a nylon lining, but the man who wore it was a giant in the struggle for justice among the poorest Americans. The jacket bears the red, white, and black logo of the United Farm Workers of America and the name "Cesar Chavez" embroidered in white letters on the front. Cesar Chavez (1927–93) inspired a nation to seek justice for migrant farmworkers. It represents the measure of success of its owner—it was worn late in Chavez's life, when he had achieved considerable acclaim not only for his union work but as a towering figure of the movement for civil rights and just causes. Indeed, the jacket has a pinned-on button declaring "No Grapes." The jacket was donated to the Smithsonian by his widow shortly after his death.

83

CESAR CHAVEZ'S UNION JACKET

A LABOR ACTIVIST WEARS AN EMBLEM FOR HUMANITARIAN TREATMENT AND ECONOMIC JUSTICE.

National Museum of American History

Chavez was born in Arizona to Mexican American parents who owned a grocery store and ranch. During the Depression, they lost their land, and later, their house. They moved to California and worked as migrant laborers, picking peas and lettuce in the winter, cherries and beans in the spring, corn and grapes in the summer, and cotton in the fall. Chavez dropped out of school to work in the fields before joining the U.S. Navy in 1944. After serving for two years, he returned to California, married his sweetheart, Helen Fabela, and settled in San Jose, where he raised a family and labored as a farmworker.

In the early 1950s, Chavez met Fred Ross, an associate of the radical community organizer Saul Alinsky. Ross and Alinsky sought to galvanize Mexican Americans in California and train young activists in what they called the Community Service Organization (CSO). Chavez joined the group, as did a Stockton, California, activist named Dolores Huerta. They would be lifelong allies. Chavez spoke out against police brutality, traveled

CIVIL RIGHTS (1947 TO NOW)

573

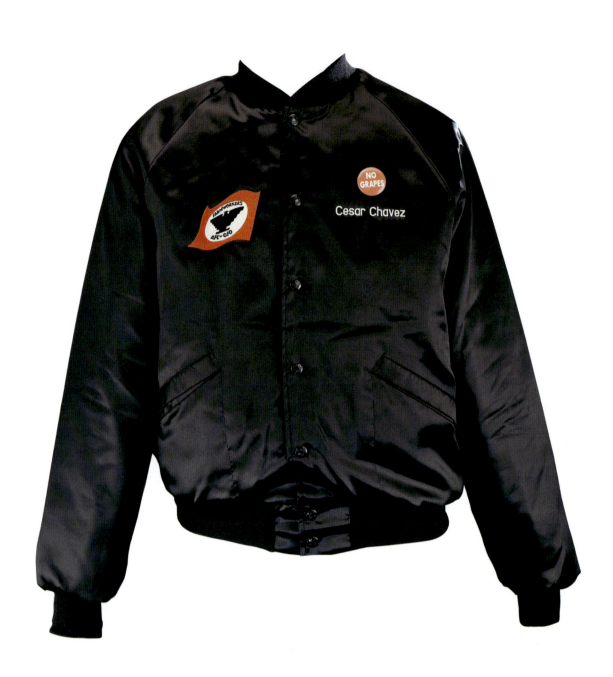

CESAR CHAVEZ'S UNION JACKET *National Museum of American History*

to register voters, and made speeches for workers' rights, eventually becoming the organization's director in 1958.

Meanwhile, the AFL-CIO, in an attempt to unionize farmworkers, established the Agricultural Workers Organizing Committee (AWOC). Larry Itliong, a Filipino American, became a leader, along with Huerta and others.

In 1962, Chavez and Huerta tried to get the CSO to focus on unionizing farmworkers, but to no avail, so they formed the National Farm Workers Association (NFWA). They spent the next several years in meetings with workers, conducting home visits, and building an organization of largely Mexican American laborers and activists. They chose an emblem that was easily recognizable and resonated with Mexican Americans. It featured at its center an eagle with wings in the shape of an inverted Aztec pyramid, and the colors black for struggle, red for sacrifice, and white for hope. The emblem stuck, even as the organization evolved, and is essentially the same as the one displayed on Chavez's jacket.

The NFWA mainly advocated for higher wages and humane working conditions. At the time, most migrant farmworkers made about $0.90 an hour, while the federal minimum wage was $1.25. Farmworkers also had few benefits and virtually no security. They did backbreaking work in the field with no toilets or other facilities. They had to pay daily rent for substandard housing, often with no power or plumbing. State regulations governing safety and treatment were often ignored by farm owners and supervisors.

Chavez and Huerta also opposed the Bracero Program established by the U.S. government and urged its discontinuation. *Braceros* were farmworkers from Mexico who were allowed to work in the United States on a temporary basis in order to alleviate agricultural labor shortages during World War II. Due to pressure from farm owners, the program was continued every year into the early 1960s. Given chronically low wages in Mexico, *braceros* were willing to work for less than Americans and to accept substandard working conditions. Chavez thought the *braceros* were unfairly exploited,

used by farm owners to undercut American farmworker pay, benefits, and demands for a union.

A turning point for the farmworkers came in 1965 with the walkout of hundreds of grape pickers in the Coachella Valley. When the growers tried to pay workers less than the minimum wage, Filipino AWOC members refused to work. They were followed by Chicanos and others. Because the growers were under tremendous pressure to harvest their grapes, they relented on the matter of wages after ten days, but refused to recognize any unionization.

By the beginning of September, migrant pickers had followed the ripening of grapes to Delano, a farm region north of Bakersfield. The AWOC's Itliong led another strike when farm owners refused to pay them $1.25 per hour. The growers tried to bring in Chicano scabs, so the AWOC reached out to Chavez, with his strong Mexican American base in the NWFA, to support the strike. At a key workers' meeting at Delano's Our Lady of Guadalupe Catholic Church, to shouts of *"Viva la Huelga,"* Chavez agreed.

Chavez brought thousands of Chicano workers with him, and within weeks the number of farms struck grew from eight to more than thirty. In spite of the strike, there was a record harvest of grapes. Chavez realized his victory would not be won just in the fields; he had to stop the grapes from being shipped, bought, and eaten in order to put pressure on the growers to negotiate contracts with a union. He sent activists to the docks in Oakland. The unionized longshoremen agreed not to load harvested grapes for shipment and cases of grapes were left to rot. The cooperation of the International Longshoremen's and Warehousemen's Union in the San Francisco Bay area inspired Chavez to launch a formal boycott against the two largest businesses buying from the Delano growers.

On March 16, 1966, the U.S. Senate Committee on Labor and Public Welfare's Subcommittee on Migratory Labor held a hearing. Senator Robert Kennedy expressed support for the farmworkers. The next day, Chavez and workers began a three-hundred-mile march from Delano to Sacramen-

to, the state's capital, to pressure the growers and the state government to deal with the demands of the Mexican and Filipino American farmworkers. Luis Valdez, Agustín Lira, and others formed El Teatro Campesino, a performing group that would ride on the back of a truck and express the marchers' concerns through song. Their creativity extended to film and graphic arts, and deeply influenced Chicano visual culture for decades.

The march captured some national attention, but the strike and the cause of unionization would take years to settle. In August 1966, the NFWA and AWOC merged to become the United Farm Workers Organizing Committee (UFWOC), with Chavez as its director and Dolores Huerta organizing a national boycott of California table grapes. Some growers agreed to allow workers to vote on unionization—but they had to choose between the UFWOC and the Teamsters, and though Chavez prevailed, conflict with the Teamsters persisted for years. Other growers resisted unionization.

Chavez drew the support of civil rights leader Ralph Abernathy and Senator Walter Mondale, and identified closely with the Reverend Dr. Martin Luther King Jr.'s struggle for civil rights and nonviolent-protest methods. Following Mahatma Gandhi's example, Chavez fasted in the name of justice. In 1972, during a twenty-four-day fast in Arizona, Chavez, with Huerta, came up with the Spanish language slogan "*Sí, se puede*," used as a rallying cry for the farmworker cause. The saying was later adapted by Latino civil rights and immigration advocacy organizations, and by the first presidential campaign of Barack Obama in its English version as "Yes, we can."

Though they had concentrated their efforts in California, Chavez, Huerta, and the UFWOC supported the formation of farmworker unions in other states, including Texas, Wisconsin, and Ohio. By the early 1970s it won the right to organize and represent some ten thousand farmworkers in collective agreements and was accepted as a union—the United Farm Workers of America (UFW)—by the AFL-CIO.

In 1975, though lacking funds and political clout, the UFW staged a march for farm labor reform from San Francisco to the Gallo Winery in

Modesto, California. It began modestly, but some fifteen thousand people eventually joined in—reasserting Chavez's strength and support for the farmworkers. Farm labor reform soon followed in the California legislature, including the banning of the hated short-handled hoe, the *azada de mango corto*. This implement, long used in farm fields, forced workers to bend close to the ground to weed and thin crops. Growers liked it because it enabled laborers to work quickly and efficiently. But for workers it meant continuous and repeated bending that led to back pain and sprains—conditions that became protracted over time and ultimately affected workers' health and livelihoods. Finally, thanks in no small part to Chavez's efforts, the State of California ruled that the hoe was an occupational hazard and disallowed its use.

The Smithsonian has such a short-handled hoe in its collection. It is a simple hand tool, with a metal blade welded to a metal neck and a wooden handle, made in the 1930s. It was presented to the secretary of the Smithsonian, Michael Heyman, in San Jose in 1997. It belonged to and was used in the fields by farmworker Librado Hernandez Chavez as well as by his son, Cesar Chavez, whose efforts brought its use to an end.

A similar type of short-handled hoe was displayed in a case for an exhibition on the Bracero Program in 2009 in the National Museum of Ameri-

can History. I walked through a preview of the exhibition before it opened to the public with Hilda Solis, President Obama's secretary of labor. She teared up when viewing the hoe, telling us about her father, who had been a *bracero*. She said he never talked about it much: though not particularly proud of their work, the *braceros* did their best to support their families. Now, she noted, it was her job to see to it that even the poorest of the nation's laborers work in a humane and dignified way. Cesar Chavez would have been proud.

84

Handmade and hand-lettered, now on paper faded, worn, and discolored, the simple signs express a big idea—the hope for equality under the law. The Smithsonian holds twelve picket signs that come from the collection of Frank Kameny (1925—2011), a pioneer in the gay rights movement.

GAY CIVIL RIGHTS PICKET SIGNS

HOMEMADE SIGNS OF WHITE HOUSE PICKETERS PREPARE THE WAY FOR THE GAY RIGHTS MOVEMENT.

National Museum of American History

Born in New York City, Kameny was a student at Queens College when he was drafted into the U.S. Army. He served in Europe and returned to Queens to graduate with a degree in physics in 1948. He then went on to Harvard, earning an MA and a PhD in astronomy. He moved to Washington to teach at Georgetown University in 1956, and the following year took a federal civilian job as an astronomer with the U.S. Army Map Service. In the fall, he was arrested late at night in Lafayette Park, across the street from the White House, a popular cruising area at the time. He refused to give details about his private life to his superiors, and by January 1958 was fired from government service because of his assumed homosexuality. He protested this dismissal all the way to the Supreme Court in 1961. Although the Court declined to hear his petition, it is considered a landmark, the first U.S. civil rights claim based on sexual orientation.

In 1961, Kameny cofounded the Washington, D.C., chapter of the Mattachine Society, devoted to civil rights for gays and lesbians. Gays at the time were expressing concerns about discrimination in employment, the exclusion of gays in the military, and police harassment. There were a few local protests in New York and San Francisco in late 1964. Inspired by the 1963 March on Washington, Kameny led his Mattachine Society chapter, along with other like-minded homophile groups—as they were then called—to organize three protests in front of the White House. Their protest took the form of a picket line, with seven men and three women holding these handmade signs and parading around a circuit on the sidewalk. Kameny

FIRST CLASS CITIZENSHIP FOR HOMOSEXUALS

DISCRIMINATION AGAINST HOMOSEXUALS IS AS IMMORAL AS DISCRIMINATION AGAINST NEGROES & JEWS

Homosexual Citizens WANT TO SERVE THEIR COUNTRY TOO

GAY RIGHTS PROTEST SIGNS *National Museum of American History*

developed a dress code for the protesters—men had to wear ties, preferably with a jacket; women were required to wear skirts. Kameny wanted homosexuals to be seen as "presentable and employable."

Though modeled on the civil rights movement, the approach to public protest was modest, polite, and sedate. It was also much smaller and more disciplined than the rising antiwar demonstrations. Students for a Democratic Society, a left-wing radical antiwar group, organized a March Against the Vietnam War in Washington on April 17, 1965. Some fifteen to twenty thousand people marched down Pennsylvania Avenue in front of the White House. The press made much of the fact that many were students with long hair, beards, and backpacks. They were joined by protest singers Joan Baez, Judy Collins, and Phil Ochs. Kameny chose the same day and the next for his first protest on the White House sidewalk. Though the signs varied in their specific message, they asserted the right of homosexuals to be treated as citizens equal to others. The protesters also took issue with Cuba's treatment of homosexuals.

Subsequent picket-line and poster protests were organized in front of the White House in May and again in October. Kameny also helped organize a similar protest in Philadelphia on July Fourth at Independence Hall. Among the signs were FIRST CLASS CITIZENSHIP FOR HOMOSEXUALS, END OFFICIAL PERSECUTION OF HOMOSEXUALS, SEXUAL PREFERENCE IS IRRELEVANT TO FEDERAL EMPLOYMENT, HOMOSEXUAL CITIZENS WANT TO SERVE THEIR COUNTRY TOO, THE PURSUIT OF HAPPINESS AN INALIENABLE RIGHT FOR HOMOSEXUALS ALSO, and DISCRIMINATION AGAINST HOMOSEXUALS IS AS IMMORAL AS DISCRIMINATION AGAINST NEGROES & JEWS.

The signs focused on the equal rights of all citizens, making the point that homosexuals were not some alien or unpatriotic group—but rather just like normal, upstanding citizens. The protesters aimed their attention at government policy close to Kameny's case, Executive Order 10450. This directive had been signed by President Eisenhower in 1953 during the Red

Scare days of Senator Joseph McCarthy. McCarthy had gone after supposed Communists in the U.S. Armed Services, State Department, and public life, challenging their loyalty to the country. While Eisenhower was not allied with McCarthy's effort, he nonetheless had to address security concerns in the government. The executive order disqualified people for federal service if they had a "sexual perversion," a category that included homosexuality at the time. A year earlier, in 1952, the American Psychiatric Association had issued the first edition of their *Diagnostic and Statistical Manual of Mental Disorders,* in which they had classified homosexuality as a "sociopathic personality disturbance." The Pentagon, State Department, and other government departments had discriminatory hiring practices based on the presumption that being homosexual made one a security risk. Kameny criticized the Civil Service Commission for failing to defend the rights of homosexuals.

The small number of orderly White House protesters dressed in business attire did not generate much media attention or public support; Vietnam was the issue of the day. After the October protest, the Mattachine Society gave up on the tactic.

But Kameny did not give up on the larger cause. He coined the term "Gay Is Good" in 1968; that phrase too would later appear on the signs of gay rights marchers. He advocated on behalf of homosexual servicemen seeking honorable discharges from the military, and worked to get the American Psychiatry Association to stop considering homosexuality a personality disorder.

Work by Kameny, the Mattachine Society, and other such groups provided a basis for articulating some of the demands by the gay community during and following the Stonewall riots, generally regarded as the watershed moment in the gay rights movement. In the early morning hours of Saturday, June 28, 1969, police officers tried to raid the Stonewall Inn, a popular gay bar in New York City's Greenwich Village—a neighborhood home to the well-known gay poet Allen Ginsberg, antiwar activists, folk

singers, and others. The bar, technically more of a private club than a public bar, had two dance floors and was frequented mainly by gay men, but also by lesbians, cross-dressers, drag queens, and hustlers—not quite projecting the image cultivated by Kameny's White House protests. The bar's owners were connected to organized crime. Stonewall had been raided often since its opening a few years before, as police sought to clean the neighborhood of "sexual deviants." Indeed, Stonewall had just been raided a few days before. This time when police showed up, the bar patrons resisted. Pushing, searches, harassment, arrests, and resistance escalated, first with the two hundred or so patrons and then with hundreds of others who gathered outside; the police called in reinforcements and a tactical squad. Angry gay men taunted and threw coins and bottles at police, and police aggressively clubbed members of the crowd and rioters. Three days of demonstrations and confrontations ensued, involving thousands of protesters and hundreds of police. Many regarded it as the event where gay people, increasingly affirming their identity and a new terminology, said they'd had enough harassment and asserted their rights in a bolder, more explicit way than ever before. On the anniversary of Stonewall a year later, thousands of gay people and their supporters marched from Greenwich Village to Central Park in what became the first gay pride parade. Communities of supporters in other cities held similar marches to mark the event.

In 1971, with a special election called for the District of Columbia to send a delegate to Congress, Kameny ran for the office. He again produced posters and flyers for the race. While Stonewall had been a far cry from the White House protests, he explicitly had it in mind in his statement as a candidate:

I am a homosexual American citizen determined to move into the mainstream of society from the backwaters to which I have been relegated. Homosexuals have been shoved around for time immemorial. We are fed up with it. We are starting to shove back and we're going to keep shoving back until we are guaranteed our rights.

He came in fourth—Walter Fauntroy became D.C.'s delegate to Congress.

Frank Kameny gave some of his papers to the Library of Congress and in 2006 donated another collection, along with picket signs from the 1965–68 era, to the Smithsonian. When he did so, he visited the Smithsonian's National Museum of American History. Curator Harry Rubenstein carefully prepared for the donation. Behind the scenes he placed Kameny's signs alongside the portable desk on which Thomas Jefferson drafted the Declaration of Independence, the inkwell used by President Abraham Lincoln in drafting the Emancipation Proclamation, and the pin worn by Alice Paul, who went to jail picketing the White House for women's suffrage. "Frank, this is where the pickets fit into American history," Rubenstein said.

Kameny's legacy of fighting for gay rights extended to contemporary debates over the repeal of sodomy laws, the protection and extension of civil rights to lesbian, gay, bisexual, and transgender citizens, and the repeal of the military's "Don't ask, don't tell" policy for gay people in the armed services.

In 2009, John Berry, director of the Office of Personnel Management, a former Smithsonian colleague, and at the time the U.S. government's highest-ranking openly gay official, met with Kameny, then eighty-four years old. Berry offered him a formal apology for the consequences of being dismissed from his job solely on the basis of sexual orientation, as was allowed under prior government policy. In response, a teary-eyed Kameny declared, "Apology accepted!"

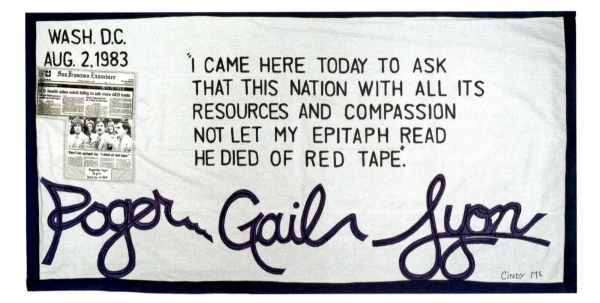

AIDS QUILT PANEL MEMORIALIZING ROGER LYON, MADE BY GERT "CINDY" MCMULLIN

National Museum of American History

There is nothing else like it in the world and never has been. The AIDS Memorial Quilt extends for 1.3 million square feet and weighs more than 54 tons. It is made up of some 48,000 separate panels, mainly individual rectangles, most measuring three feet by six feet, that incorporate and memorialize some 93,000 people—all victims of the AIDS (acquired immune deficiency syndrome) epidemic.

The panel at the Smithsonian honors activist Roger Gail Lyon, who died of AIDS in 1984. Shortly after being diagnosed, Lyon testified before Congress to appeal for funding to combat the growing epidemic, saying, "This is not a political issue. This is a health issue. This is not a gay issue. This is a human issue. And I do not intend to be defeated by it. I came here today to ask that this nation, with all its resources and compassion, not let my epitaph read 'He died of red tape.'"

AIDS MEMORIAL QUILT PANEL

ONE CLOTH PANEL IN THE LARGEST WORK OF FOLK ART EVER CREATED PERSONALIZES THE IMPACT OF A TRAGIC EPIDEMIC.

National Museum of American History

The issue of red tape concerned the very recognition of the disease and government action—or lack thereof—to treat it. AIDS started to be recognized as a disease in June 1981, with the Centers for Disease Control identifying five reported cases of a similar flulike syndrome and a specific type of deadly pneumonia usually found in people with suppressed immune systems. What was striking was that all five subjects were previously healthy young men and all were homosexual. By July, a rare form of skin cancer, also typical of people with suppressed immune responses, was identified in gay men in Los Angeles and New York City. By the end of the year, there were 159 recorded cases of this "new disease." Because the illness was first identified in the homosexual population in America, it was nicknamed "gay cancer" or "the gay plague." However, medical researchers now believe that AIDS originated in the early twentieth century, and was transferred from infected chimpanzees to people by way of tainted meat consumption in sub-Saharan Africa.

By 1983, researchers identified the human immunodeficiency virus (HIV) that caused AIDS; some thirty-three countries reported cases of HIV/AIDS in their populations. Even though by year's end more than two thousand people in the United States had died of the disease, including women, heterosexual men, and infants, the illness was associated with gay men and tapped into pervasive social prejudice against homosexuality. This prejudice, amplified by the strong political influence of some conservative evangelical Christian leaders, led to a widespread belief that the disease was a direct result of homosexual behavior. Popular evangelist Jerry Falwell asserted that AIDS was "a lethal judgment of God on America for endorsing this vulgar, perverted, and reprobate lifestyle," thus making tolerance itself a fatal transgression.

Activists associated with the gay communities in San Francisco, Los Angeles, and New York publicly criticized the federal government's response to the spread of the disease as disproportionately small when compared to the funding spent on other health crises. Research identified additional risk factors for transmission, including intravenous drug use and Haitian origins, granting the disease a secondary association with poor, urban black populations. Activists claimed the government's failure to act constituted genocide against gays and poor blacks. While the development of an antibody test in 1985 was heralded as a breakthrough in prevention, its use by the federal government to safeguard the blood supply was also feared by some advocates as a tool that would be used to identify and discriminate against victims of the disease.

In the summer of 1985, an Indiana public school district denied admission to Ryan White, a thirteen-year-old boy who had contracted AIDS as a result of blood transfusions he received to treat hemophilia. The White family's battle to allow Ryan to attend school drew widespread press attention to victims of the disease and tapped into pervasive fears that AIDS could be transmitted by casual contact. Soon after, Rock Hudson, a popular Hollywood romantic leading man of the 1950s and 1960s, issued a press release acknowledging that he was suffering from AIDS and was gay. The

impact of Hudson's announcement was seismic. For the first time, many Americans identified AIDS with a beloved person with whom they felt familiar and safe. Hudson's friend and erstwhile costar Elizabeth Taylor was among the first major celebrities to publicly advocate for funding for AIDS research and public awareness of the disease. As other celebrities came forward, the tide of public opinion turned. People began to encourage congressional support for research and stronger public appreciation for the concerns of the gay community.

Roger Lyon's family did not know he was gay before he was afflicted by the disease. Lyon worked as a salesman for a leasing company in San Francisco. Diagnosed in early 1983, he testified before a congressional subcommittee in Washington, imploring its members to support AIDS research and treatment. Later in the year, he participated in an AIDS vigil in San Francisco, the theme of which was "People Are Dying; Cut the Red Tape." Lyon and another AIDS sufferer unrolled a red scroll with the names of the 118 Bay Area residents who had died of the disease.

The AIDS quilt originated inadvertently with Cleve Jones, a Quaker gay rights activist and one of the organizers of the annual candlelight march in memory of gay civil rights leader and San Francisco Supervisor Harvey Milk and Mayor George Moscone, both of whom were assassinated in 1978. For the 1985 march, Jones, who had lost his friend actor Marvin Feldman, to the disease, asked fellow marchers to inscribe the names of their departed friends and loved ones on the placards they carried. At the end of the march, Jones and others taped the placards to the walls of the San Francisco Federal Building. This graphic patchwork memorial inspired the idea of a massive AIDS quilt.

Jones and friends took up the cause of making quilt panels. Feldman's was the first. Cindy McMullin was best friends with David Case, Roger Lyon's lover. She made three panels in Lyon's honor, including the one that hangs in the Smithsonian and features his poignant statement about red tape. Her panels incorporate a variety of media, including newsprint from the *San Francisco Examiner*'s account of his testimony. Her other panels

incorporate get-well cards made for Roger by fifth graders in a Catholic school Roger visited shortly before his death. McMullin became an early volunteer with the NAMES Project Foundation, as the quilt organizers' group was formally called. The group rented a Market Street warehouse in San Francisco and began to accumulate hundreds of quilt panels for eventual public display.

Each panel captured a personal story in different ways. Many were sewn in cotton embroidery or appliqué with conventional materials; others were spray painted; some incorporated Barbie dolls, car keys, feathers, toys, sneakers, credit cards, official badges, and even a Sony Walkman. Taken individually, each panel pointed to a life lost, and to the pain of close friends and family; overall, their abundance served as a call for compassion, understanding, and action.

The quilt was displayed for the first time on the National Mall in Washington, D.C., on October 11, 1987, during the National March on Washington for Lesbian and Gay Rights. Some forty thousand Americans had died of the disease by this time. The quilt included 1,920 panels. It was displayed again in 1988, and then in 1989, having by then grown five times its original size. On the Mall, visitors to the quilt typically walked among its panels reading them quietly, conversing in hushed tones. The panels offered a great national memorial reminiscent of the endless sea of graves across the Potomac River in Arlington National Cemetery, each one a testament to a young life lost too early.

In the decades since, millions of people around the world have died of AIDS. Research and treatment progressed to the point where a diagnosis is no longer an automatic death sentence. Currently, about one million Americans and more than thirty million people around the globe are living with HIV/AIDS. While treatment can now drastically reduce transmission, there is still no vaccine or cure.

The AIDS quilt played a major role in destigmatizing the disease, by conveying to the broader public the humanity of those who had been afflicted and died. In 2012, the Smithsonian hosted the AIDS quilt and its

AIDS QUILT ON
THE NATIONAL
MALL IN 1996

AP Photo/Ron Edmonds

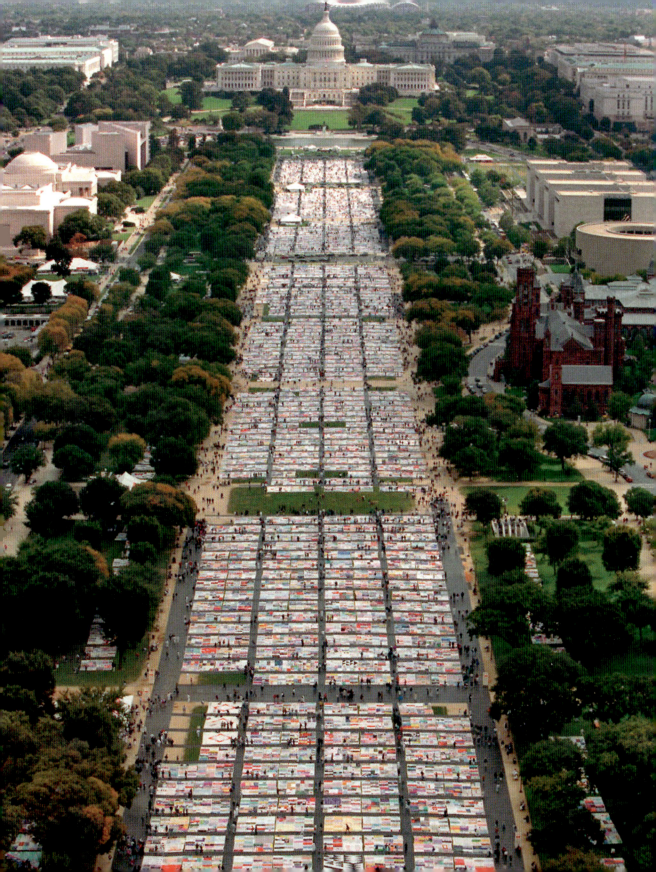

makers and stewards at the annual Folklife Festival, to mark the twenty-fifth anniversary of the first 1987 display. Once again, thousands of quilt panels were spread out on the National Mall; demonstrations of sewing and conservation, cataloging, and exhibiting the quilt gave visitors a sense of how it was made, cared for, and understood. Julie Rhoad, head of the NAMES Project Foundation, spoke eloquently to the quilt's significance:

> I think each panel of this quilt is beautiful in its own way. I remember a panel maker said in one of their letters: "How does a mother begin to sum up the life of her son in a three-foot by six-foot piece of cloth?" I think people will not only see a glimpse into a person's life, but they will see how people loved them and how important they were. There are panels that have all sorts of things on them from flags to feathers to sequins; bowling balls, wedding rings, ashes, poems, photographs—all sorts of records of the person's life. When you look at it from up close and personal, the intimacy and detail lovingly stitched into each one of these panels is evidence of love and life.

During the festival hundreds of volunteers read the names of those memorialized in the quilt. It was a moving experience, both of deep personal emotion and of shared national sadness. For the occasion, Smithsonian staff made a special panel honoring friends who had succumbed to the disease, and every day, as I walked among the panels, I remembered my cousin Gari, who died too young from AIDS.

POP

CULTURE

(MID-TWENTIETH CENTURY to NOW)

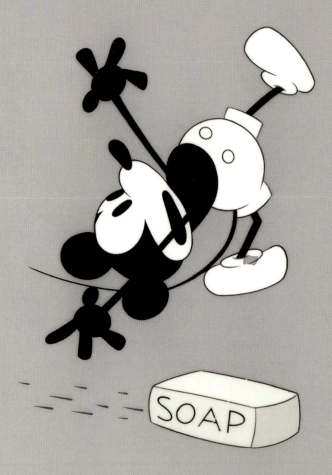

MICKEY MOUSE IN *STEAMBOAT WILLIE* *National Museum of American History* © *Disney*

Mickey Mouse was born on a cross-country train ride early in 1928. Walt Disney (1901–66), was traveling with his wife, Lillian, from New York to Los Angeles. He was under some pressure to develop a new character for his fledging animation studio. "I had this mouse in the back of my head," he recalled, "because a mouse is a sort of a sympathetic character in spite of the fact that everybody's frightened of a mouse . . . including myself." Disney called the mouse Mortimer, but his wife thought it sounded too pompous. She suggested "Mickey" instead.

WALT DISNEY'S MICKEY MOUSE

A SIMPLE CARTOON MOUSE INSPIRES THE FILM ANIMATION INDUSTRY AND PROPELS A WORLDWIDE AMERICAN ENTERTAIN-MENT GIANT.

National Museum of American History

Mickey could not have arrived at a better time. Disney's small studio had been drawing and animating a cartoon character named Oswald the Lucky Rabbit on contract with Universal Studios. A dispute forced Disney to cut his ties to Universal, and because Universal owned the lucky rabbit, Disney had to find another character. The mouse could be the successor. But Mickey had to be drawn. That job fell to Ub Iwerks, Disney's cartoonist, chief animator, and occasional business partner. Iwerks came up with the characteristic use of circles for Mickey's head and ears, and his limber, flexible, evocative body ripe for animation. Mickey has big pupils, a black nose at the end of a long snout, and four fingers on ungloved hands. He wears shorts—always implied to be red, even when presented in black and white, and oversized shoes. Iwerks also drew Minnie, Mickey's female companion, in a similar fashion.

Disney quickly produced two cartoon shorts in 1928—*Plane Crazy,* in which an anthropomorphic Mickey tries to imitate Charles "Lindy" Lindbergh and fly, and *The Gallopin' Gaucho*—both drawn and animated by Iwerks and his team, including Wilfred Jackson, Les Clark, Johnny Cannon, and Dick Lundy. Animation was tedious work—a six-minute short required some forty thousand drawings. To make the work more efficient, animators would draw figures like Mickey on sheets of transparent cel-

luloid, called cels, which could be placed upon and moved across drawings of backgrounds while being filmed in order to create the appearance of sequential action.

Both cartoons were silent films, as was typical of the time. While some short films at the time had a primitive audio track, it was the success of *The Jazz Singer*, a full-length feature starring Al Jolson and released the previous October, that excited audiences. The film included song-and-dance and dialogue sequences where the sound matched up with the film. This was a major innovation and gave filmgoers a new sense of possibility for the cinematic experience. By 1928, theaters were starting to get sound equipment so they could carry the new talkies. As a result, despite the charm of the new Mickey Mouse character and fine quality of the animation, Disney could not find a distributor interested in getting his short animated films into movie theaters.

Disney thought the new audio innovation could work for him, though. He had Iwerks and his team develop a third Mickey Mouse feature, called *Steamboat Willie*, a very loose derivative of Buster Keaton's slapstick role in *Steamboat Bill Jr.*, a silent movie released earlier in the year. In the seven-minute animated cartoon, Mickey pilots a steamboat along a river, fights with the oafish Captain Pete, gets animal passengers and a late-arriving Minnie on board, plays a frenetic duet with Minnie, and angers the captain, who consigns him to peeling potatoes.

The question for Disney was whether, if presented with sound, the audience would believe that drawings could talk, sing, and dance. In order to make them believe, the animation had to give Mickey personality and humanlike qualities, not only in bodily movement but also in traits like curiosity, anger, and mischievousness. Sound could help achieve this effect, but it had to be closely synchronized with the animated movements to achieve the desired impact. Animator Wilfred Jackson recalled that Walt and his brother Roy Disney arranged a trial screening after they had done a few scenes of the animation to test whether the audio illusion would work. They projected the film and then, in order to test the concept, had Jackson play

a mouth organ, Iwerks play percussion, and others produce various sound effects, like clanging spittoons. Walt did the squawky voices. Though their performance was rough, Disney thought it could work. Jackson said that "Turkey in the Straw" was his favorite tune, and it became the musical number in the film.

When the animation was complete, Disney headed east to have the sound work done. Stopping in Kansas City, he had his old friend Carl Stalling do the score. To produce the music for the soundtrack, Disney hired conductor Carl Edouarde. Musicians would watch the animation and try to play along, but they couldn't keep up and would lose the connection between the sound and the movement. Disney filmed and projected a bouncing ball on-screen for the musicians so they could visualize the beats as they played. The technique worked. Disney secured Pat Powers's Cinephone to do the technical sound-on-film production, which brought picture and audio together.

Disney lacked a good distribution agent at the time but was able to get a showing of *Steamboat Willie* in New York City. It premiered on November 18, 1928, and ran for two weeks at the Colony Theater, playing before the movie *Gang War*.

No one remembers *Gang War*, but the Disney short was a hit. Mickey visually whistles in time with the soundtrack whistle. The ship's steam horns go off in sync with the sound effects. When Mickey and Minnie inventively play their improvised "Turkey in the Straw" duet using pots, pans, animal tails, teeth, and other body parts as instruments, their visual movements are exactly attuned to the music. The scenes were not only credible, they were technically sophisticated, aesthetically engaging, and just plain funny.

Even though it took Disney a few years and some travail to make adequate film distribution arrangements, *Steamboat Willie* put the enterprise on the path to success. The use of synchronized soundtracks with the creative animation helped Mickey Mouse develop into the most popular cartoon character of the time, quickly eclipsing Felix the Cat, and winning Disney an Academy Award in 1932.

This early success didn't stifle Disney's imagination Mickey's personality

evolved over the years. Always positive, he went from hero to victim, sometimes cheerful, sometimes shy. He could be the mischievous loner, determined inventor, hopeful suitor, or responsible leader. In 1929, Mickey spoke for the first time, with Disney providing the voice—a role he would fill for almost two decades. Mickey's appearance evolved a bit over the years too: he put on white gloves, his shape morphed, with color film he acquired a pinkish flesh tone, his shorts were now actually red, and his shoes became yellow. He sometimes added other clothing and hats too, like the blue, white-star-laden one worn by the Sorcerer's Apprentice in the classic 1940 animated film *Fantasia*. Mickey also acquired a stable of new cartoon friends and colleagues—Goofy, Donald Duck, and Pluto, among others—who provided new stories and themes.

Disney achieved great success with Mickey, in part because of his own business and marketing savvy. Disney started a fan club for Mickey in 1929 that within a few years had some eight hundred chapters and one million children as members. In 1930, Mickey starred in a newspaper comic strip that was widely syndicated and ran for decades. After successful shorts and full-length feature films, comic books, publications, and television followed, including the memorable *Mickey Mouse Club*. Mickey was heavily merchandised, appearing as a toy, and on watches, lunch boxes, and scores of other goods, including video games, all with special appeal to young children.

Mickey's growth was of course tied to that of the Walt Disney Company, which became an American and increasingly worldwide entertainment powerhouse. The Disneyland theme park opened in Anaheim, California, in 1955, followed by Walt Disney World Resort near Orlando, Florida, in 1971, where Mickey was presented in the form of a meetable costumed character that children adored. Disney parks in France and Japan cemented Mickey's presence abroad, as did the Disney cable television channel and its other film and entertainment enterprises. A global success of this magnitude always attracts challenges and critics, and the lovable mouse is no exception. For some years and in some quarters, "Mickey Mouse" as a term has been used pejoratively to indicate a lack of substance or shallow consumer-

ism, and Disney's famous mascot has sometimes been taken as a symbol of American cultural expansion and imperialism.

Walt Disney harbored no such pretensions about Mickey:

> All we ever intended for him or expected of him was that he should continue to make people everywhere chuckle with him and at him. We didn't burden him with any social symbolism; we made him no mouthpiece for frustrations or harsh satire. Mickey was simply a little personality assigned to the purposes of laughter.

In 1988, the Smithsonian celebrated the sixtieth anniversary of Mickey Mouse with the cooperation of the Walt Disney Company and the Disney family. Disney's nephew Roy, corporation CEO Michael Eisner, and others gathered at the National Museum of American History for a very special event. Walt Disney had said, "I only hope that we never lose sight of one thing—that it was all started by a mouse." Taking that advice to heart, the Walt Disney Studios donated to the Smithsonian six original penciled line drawings of Mickey Mouse made for *Steamboat Willie* from its archive. The studio also had them restruck as cels, as the original cels had long since vanished.

Roy Disney personally selected the drawings. In one, Mickey is slipping along on a bar of soap, his arms outstretched, his eyes wide in anticipation. It occurs early on, at about the one-minute-sixteen-second mark of *Steamboat Willie*. The image captures just a fraction of a second of the action, but the emotion it conveys is unmistakable. Mickey had just been pushed off the bridge and down the steps by the boat's captain. He's sliding toward a collision. The scene seems a bit silly and untenable at first, but leads to Mickey's stellar performance and incredible success. In that sense, perhaps, it is rather like the story of Walt Disney himself.

87

RCA TELEVISION SET

THE MODEL
THAT
PREMIERED AT
NEW YORK'S
1939 WORLD'S
FAIR LEADS TO
A WORLDWIDE
PHENOMENON.

*National Museum of
American History*

Television was a dream of many inventors and engineers in the closing decades of the nineteenth century. The development of the movie camera, particularly innovations by Thomas Edison, made it possible to imprint visual images on film and project them for viewing. But television required something more: the transformation of visual images into pulses of electric current that could be transmitted over long distances—following Samuel Morse's example with the telegraph and Alexander Graham Bell's with the telephone. As was the case with other inventions in the industrial age, it took a number of advances to bring the technology to a practical and economically viable state.

In the 1880s, German inventor Paul Nipkow, while still a student, experimented with the transmission of moving pictures. He developed a scanning system that could divide a picture into a mosaic of points and lines. His process involved a spinning disk with holes that allowed light to pass through, activating a light-sensitive selenium sensor that generated electrical pulses. In the early 1900s, Russian scientist Boris Rosing used a rotating mirror-drum scanner to better capture images and a cathode ray tube to better receive their electronic transmission. He was able to see basic geometric shapes. Vladimir Zworykin, a student who assisted Rosing, emigrated to the United States in 1919 and worked on the development of television for Westinghouse. Zworykin then moved to RCA (Radio Corporation of America) to head their efforts, where he developed and patented an image transmitter called the iconoscope in 1923. In 1926, Scotsman John Logie Baird transmitted moving silhouette images in which one could discern faces using an improved version of Nipkow's electromechanical scanner. Meanwhile, Hungarian engineer Kalman Tihanyi and Japanese engineer Kenjiro Takayanagi made advances using electronic scanning and cathode-

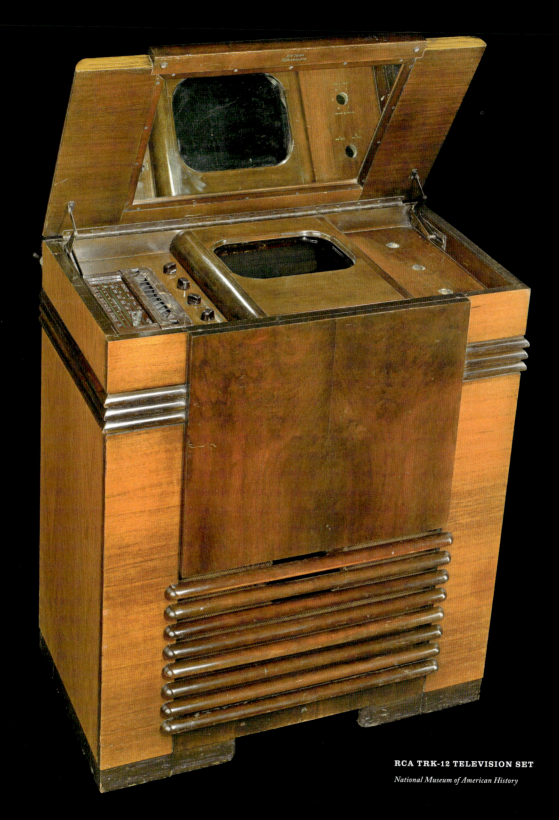

RCA TRK-12 TELEVISION SET

National Museum of American History

ray-tube receiving technology. The next year, Russian inventor Léon Theremin was able to improve the resolution of received images.

Philo Taylor Farnsworth demonstrated an electronic transmission and reception system that led to the proliferation of modern television. Farnsworth was a brilliant twenty-one-year-old inventor, a Mormon from Utah who had tinkered with motors, radios, and other devices as a boy, and who had dropped out of the Naval Academy. Farnsworth conceived of a system to capture moving images in a form that could be coded onto radio waves and transformed back into a picture on a screen. In September 1927, in his San Francisco lab, Farnsworth scanned images with a beam of electrons using what was essentially a primitive television camera, an image dissector, as he called it. At one point, Farnsworth supposedly transmitted the image of a dollar sign, because an investor had asked about seeing some dollars from the invention. In 1928, Farnsworth demonstrated his transmission system for the press.

Farnsworth's advances impressed RCA head David Sarnoff. In 1931 RCA offered to buy Farnsworth's television technology patents for $100,000 with the stipulation that the young inventor work for RCA and Zworykin. Farnsworth refused and joined another company, Philco. A series of patent-infringement suits and countersuits followed in the 1930s involving Farnsworth, Zworykin, and RCA. Farnsworth formed partnerships in Britain and Germany, split from Philco to form his own company, and competed with RCA in the United States. He also competed against a Marconi-EMI partnership in the UK on the commercial development of the new technology and the transmission of images from the 1936 Berlin Olympics to small audiences. Farnsworth and Zworykin both won patent cases, and in 1938, Sarnoff and Farnsworth agreed to cross-license the patents. The way was cleared for RCA to proceed commercially with television.

RCA, which ran popular radio stations through its National Broadcasting Company (NBC), successfully transmitted the opening ceremony of the New York World's Fair on April 20, 1939, including a speech by President Franklin D. Roosevelt, making him the first sitting president to appear on

television. That so few people could view the transmission was not lost on RCA, which is why it showcased the first commercial model television, the TRK-12, at the fair. It appeared in a display called "the living room of the future," and presaged the role the television would play in American homes. The TRK-12 was developed for limited commercial service in the New York area. Its experimental nature and high price, about $600, made it a very exclusive product. Still, RCA began broadcasting some programs, and on May 17 televised with a single camera for the first time a baseball game, a college match between Princeton and Columbia. Over the next two years RCA sold about seven thousand television sets, mainly in New York and Los Angeles. Broadcasts were crude and audiences tiny even after RCA's competition, the Columbia Broadcasting System (CBS), began two fifteen-minute daily newscasts, which featured hard-to-discern commentators running pointers over impossible-to-decipher maps.

While the internal mechanisms of the technology were developed by RCA engineers, design of the television set's housing commenced. Greek-born John Vassos, RCA's lead industrial designer for more than forty years, brought his love for Art Deco to the task. Vassos designed a variety of things, from microscopes and radios to Nedick's food stands—an early New York City fast-food chain—and even a new mascot for RCA that Sarnoff ultimately rejected.

The RCA TRK-12 in the Smithsonian's collection comes from Frank Mason, vice president of NBC in the 1930s. Mason came to Washington, D.C., to serve as special assistant to the secretary of the Navy during World War II. The TRK-12 had been installed in his Park Avenue apartment so that he could show early broadcasts to parties of industrial, financial, and government people. He kept a set of NBC folding studio chairs in his living room for the purpose. The picture tube was five inches in diameter by twelve inches tall and mounted at the top of the unit. A hinged lid held a mirror. The audience actually saw the image as a reflection. The unit also came with a familiar radio receiver, an addition made simple by the similarity of the technology. Decades later, Mason remembered hosting two

particular broadcasts in 1939, a boxing match in October and a military ceremony from Governors Island in December.

The development of television slowed during World War II with companies such as RCA turning their efforts to military production. Issues of wavelength allocations and government regulation of the new media also had to be worked out. A key ruling by the Federal Communications Commission upheld by the Supreme Court in 1943 required NBC to sell one of its two radio networks; that became the American Broadcasting Company. ABC then turned to television. During the war years experimental television stations broadcast in Chicago, Philadelphia, Los Angeles, Schenectady, New York, and New York City. Commercial television broadcasting began its ascent in 1947. The number of television sets entering American homes shot up exponentially from about six thousand in 1946 to some twelve million by 1951. By 1955, half of all U.S. homes had one. They varied in price and style from very basic to luxury models.

With the proliferation of television sets and broadcasting came programs and advertising in the form of commercials to pay for them. Programs in the 1950s like Milton Berle's popular *Texaco Star Theater*, with its gasoline-company sponsor, enticed millions to tune in. The comedic *I Love Lucy*, with the zany Lucille Ball, parodied home life and family; the *Howdy Doody* and *Kukla, Fran and Ollie* shows provided fare for children. Movies like *Gone With the Wind* came to the small screen, gaining more popularity than ever before, while variety shows, like *The Ed Sullivan Show*, introduced new entertainers—Americans would meet the Beatles here a decade later. Game shows, boxing matches, and other sports events made the television popular among both women and men. Television spawned a whole series of other products, like TV trays and TV dinners, and became a new center of home life.

Television also allowed the nation to share common experiences, and became a contested arena for political beliefs during the cold war. Senator Joseph McCarthy, the House Un-American Activities Committee, and others sought to blacklist producers, writers, and entertainers they thought

to be Communists or left-leaning sympathizers. CBS instituted a loyalty oath for its employees. Edward R. Murrow launched a television documentary series called *See It Now* that eventually exposed McCarthy and his shoddy tactics. News on television became a whole new way of sharing information when NBC's *Huntley-Brinkley Report* went on the air in 1956, competing with the newspapers and radio. The televised presidential debate between Senator John F. Kennedy and Vice President Richard Nixon showed the power of the medium to influence viewers. For those who saw the broadcast, Kennedy was generally deemed the winner, appearing well poised and attractive compared to the slouching, poorly shaven vice president.

CBS's Walter Cronkite became "the most trusted man in America" as he anchored the nightly news. Television coverage of the Kennedy assassination united a nation in grief and mourning; Cronkite and other reporters' coverage of the Vietnam War swayed public opinion; the nation gathered together around television sets as Neil Armstrong set foot on the moon; and it held its breath watching the U.S. hockey team win the "Miracle on Ice" at the 1980 Olympics.

The Smithsonian has a rich collection of the artifacts of television history. My favorite is the iconic Aristo stopwatch from the longest-running news program in history, *60 Minutes*. The watch was used from the 1970s to the 1990s, when it was replaced with a digital image. But there is so much more, including the coonskin cap worn by Fess Parker in the title role of *Davy Crockett,* the black mask and silver bullet of *The Lone Ranger,* Archie Bunker's living room chair from *All in the Family,* African slave Kunta Kinte's manacles from *Roots,* the directional signpost from Korean War medical show *M*A*S*H,* Fred Rogers's red sweater from his children's show *Mister Rogers' Neighborhood,* comedian Jerry Seinfeld's puffy shirt, and newspaper columnist Carrie Bradshaw's laptop from *Sex and the City*.

Among the more recent accessions is the judges' desk from the musical talent show *American Idol.* It represents the trend toward reality TV and au-

dience participation in determining the outcome of a television show. Over the twelve seasons of *American Idol* fans have cast some five billion votes for their favorite singers. Cast by phone, text, and online, the voting is an amazing illustration of grassroots, technology-fueled, pop culture democracy.

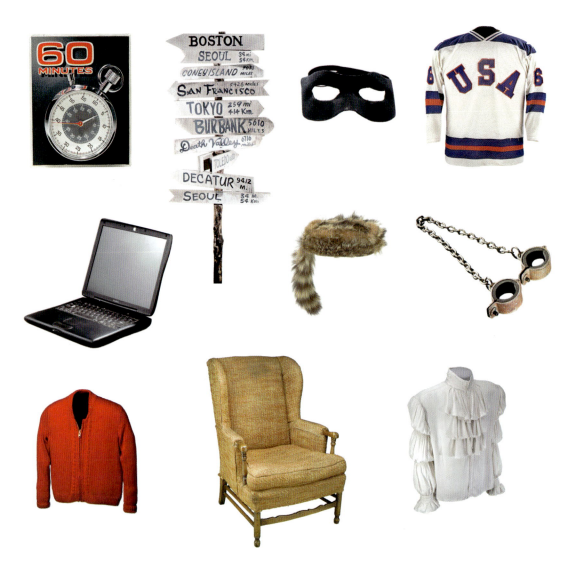

From left to right, top row to bottom row: **60 MINUTES STOPWATCH, M*A*S*H SIGNPOST, LONE RANGER'S MASK, U.S. OLYMPIC HOCKEY TEAM JERSEY, CARRIE BRADSHAW'S LAPTOP, DAVY CROCKETT'S CAP** *©Disney,* **ROOTS MANACLES** ™ *& © Warner Bros. Entertainment Inc.,* **MISTER ROGERS'S SWEATER, ARCHIE BUNKER'S CHAIR, SEINFELD'S PUFFY SHIRT** *Castle Rock Entertainment. (S13). National Museum of American History*

R ock and roll," as the lyrics say, "is here to stay." The music combined disparate genres into a new form of aesthetic expression that melded a new technology—the electric guitar—with the social tensions of youth and race emerging in post–World War II America. Boosted and further transformed by the British invasion of the Beatles and Rolling Stones, rock and roll has had a profound impact on the nation's youth, on the entertainment industry, and on social movements, both in the United States and around the world.

CHUCK BERRY'S GIBSON GUITAR

So who started it all? Music historians and critics argue about this. While rock and roll had its antecedents in the late 1940s and early 1950s, including Goree Carter, Jimmy Preston, Sister Rosetta Tharpe, Bill Haley, Ike Turner, Carl Perkins, Big Joe Turner, Bo Diddley, Fats Domino, Little Richard, Wanda Jackson, and Jerry Lee Lewis, most critics attribute rock's founding to two key artists—Elvis Presley (1935–77) and Chuck Berry (b. 1926). Both transformed music and its performance, enthralled audiences while aggravating detractors, and inspired musicians who followed. Both brought new energy to live shows and crossed boundaries of racial, regional, sexual, and generational comfort in creative and entertaining ways. They both spoke particularly to teenagers, who were anxiously receptive to a jolt of rebellion in the mid-1950s.

AN INSTRUMENT DEFINES A NEW SOUND CALLED ROCK AND ROLL.

National Museum of African American History and Culture

As a young man barely out of his teens, Elvis combined Mississippi Delta blues, gospel, and an emerging rockabilly sound. He was, as Sam Phillips, the man who first recorded him for Sun Records, opined, a white guy who sounded black. He was called the King of Rock and Roll and has had enormous staying power as a cultural icon even today, long after his death—and at the Smithsonian we have ample collections documenting his impact.

Chuck Berry was the other musical giant. His material was original. His

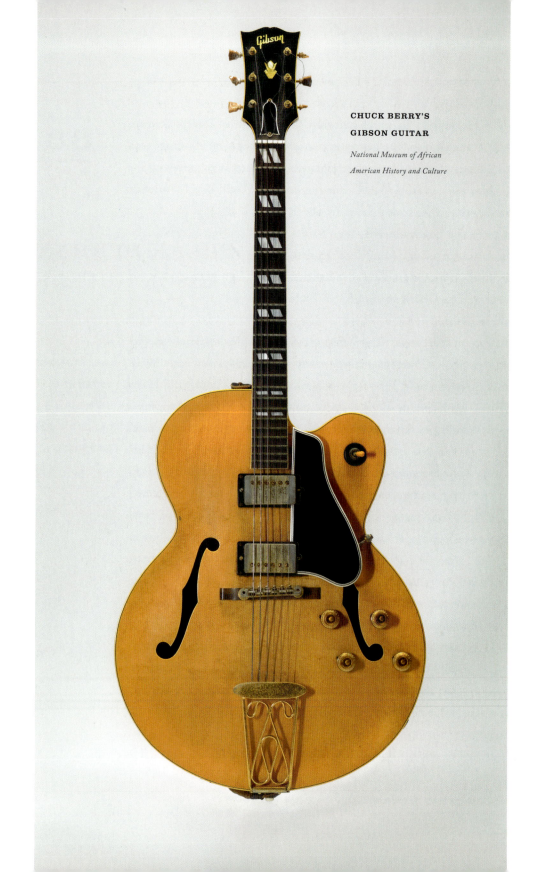

artistry with the guitar marked it as the signal instrument of the musical movement. Berry took rhythm and blues, gave it a strong backbeat, and made it electric, faster, and more energetic. His pointed lyrics on tough topics and tensions recall those in country ballads and the blues, while his blazing guitar solos were built on the riffs of improvisational jazz and the exuberance of honky-tonk.

Berry grew up in a middle-class family in St. Louis, Missouri. A crime in his teenage years landed him in a reformatory, where he sang with a choir. Released at twenty-one, he played in pianist Johnnie Johnson's trio. He performed rhythm and blues, knew Muddy Waters's Chicago blues, was familiar with Bill Monroe's emerging bluegrass music, and even mixed some country and rockabilly into his gigs for white audiences. Berry, visiting Chicago in 1955, was sent by Waters to see Leonard Chess, his record producer. Chess was a Polish Jewish immigrant who had come to the South Side of Chicago, run a club, and with his brother started an independent record company working with African American performers. Like his colleague Sam Phillips, Chess was looking for new, talented musicians who could aesthetically integrate the disparate styles of black and white popular music of the day. Listening to Berry, Chess became intrigued not with his more conventional rhythm and blues but by his adaptation of Bob Wills's country-and-western recording of "Ida Red." Chess ended up producing the recording, called "Maybellene," featuring Berry and an amazing band— Johnnie Johnson on piano, Jerome Green on the maracas, Jasper Thomas on the drums, and Willie Dixon on bass. "Maybellene" sold more than a million copies, reaching number one on *Billboard*'s rhythm-and-blues chart and number five on the best-sellers chart.

"Maybellene" was among the very first rock-and-roll hits. Bill Haley's 1954 "Rock Around the Clock" did not become popular until about the same time, when it was featured in the movie *Blackboard Jungle* and re-released. Berry followed "Maybellene" the next year with "Roll Over Beethoven," and subsequently "Rock and Roll Music" and "Johnny B. Goode." Berry started calling his guitar "Maybellene."

Berry's lyrical success revolved around guitars, teens, and cars. He celebrated the instrument in the *faux*-autobiographic "Johnny B. Goode," asserting he could "play the guitar like ringing a bell." Johnny couldn't read or write very well, signaling a rebellious attitude toward school—a sentiment Berry captured in his first album, called *After School Session*, which was released in 1957. In songs like "School Day (Ring! Ring! Goes the Bell)" his lyrics resonated with teens of the era, capturing their sense of boredom in school, working hard in various subjects, dealing with mean teachers, and awaiting the end of the school day. As he sang to teenage students, "Soon as three o'clock rolls around / You finally lay your burden down." In songs like "Sweet Little Sixteen" he addressed adolescent stirrings and attractions, again finding expression in music. Girls coming of age in lipstick and high heels relished dancing at the bandstand only reluctantly returning to the classroom. Music and dance, and the powerful beat of rock and roll's electric guitar was in a way a proxy for sexual exploration. As he sang in "Rock and Roll Music" ("It's got a backbeat, you can't lose it"), music was a liberating force.

Berry knew how to use language in a casual, but witty and rhythmic way. Though he was at least twice their age, his lyrics and music spoke directly to teenagers and their experience during the 1950s and early 1960s. He wrote about teens ejoying their cars going to drive-ins and listening to music on car radios or on café jukeboxes, "Where hamburgers sizzle on an open grill night and day / Yeah, and a jukebox jumping with records like in the U.S.A." Berry's energetic performances, replete with his characteristic one-legged hop and duckwalk signaled a youthful vitality and joy in bodily exuberance that mirrored his boundary-busting lyrics.

When Berry met with Smithsonian historian Kevin Strait in 2011, the musician showed him the guitar nicknamed "Maybellene" and agreed to donate it to the new National Museum of African American History and Culture, along with his electric-red Cadillac Eldorado convertible.

Berry is still a flamboyant character, even in his eighties. He has been through many highs and lows, marred by lawbreaking, including tax evasion

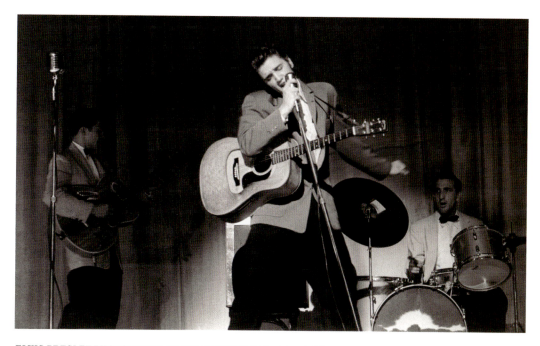

***ELVIS PRESLEY* PHOTOGRAPH BY JAY LEVITON** *National Portrait Gallery*

and sexual offenses, but he has been honored and recognized for his contri-
bution to rock and roll. He was invited to perform at the White House by
President Jimmy Carter; he was in the very first group of inductees to the
Rock and Roll Hall of Fame; and his recording of "Johnny B. Goode"—
along with recordings of Beethoven, Mozart, Stravinsky, and two dozen
or so others—was included on a gold disk aboard the NASA space probe
Voyager as a demonstration for extraterrestrials (if there are any) of the type
of music we humans make. I can only imagine what they would make of
Berry's song! Back on Earth, Berry insisted on having the Smithsonian's
historian Kevin Strait share a dozen Eskimo ice cream bars with him as he
negotiated the donation.

The guitar is a semiacoustic Gibson ES-350T. The wood is light, and
the tuning keys are damaged. Berry's aides, Strait, and other Smithsonian
curators initially thought the guitar might be the first "Maybellene," the one

played by Berry in performances and during those Chess Records sessions in the late 1950s. But more thorough inspection of a black and orange label visible through one of the F holes revealed a serial number, A33643, and the place of manufacture—Kalamazoo, Michigan.

From the serial number, it appears that the guitar was likely used in the early 1960s and maybe up to the early 1970s. Photographs of Berry playing in the 1950s show the same model Gibson with black pickups. This 1960s version has silver pickups. Berry played the Smithsonian's "Maybellene" for such hits as "Nadine," "No Particular Place to Go," "You Never Can Tell," and "Memphis, Tennessee."

The guitar and his artistry with it were central to Berry's success and particularly influential in paving the way for the British musical invasion of the 1960s. The Beatles' John Lennon and the Rolling Stones' Keith Richards were especially influenced by Berry, adapting elements of his style and covering his songs. Richards later reflected, "Chuck was my man. He was the one who made me say 'I want to play guitar,'" and it was Lennon who famously said that "if you tried to give rock and roll another name, you might call it 'Chuck Berry.'"

Berry's guitar provides a good case of technology paired with aesthetics in the right social moment. His music, and rock and roll in general, would have been impossible without the electric guitar—an instrument that really developed in the 1930s and 1940s in the jazz and big-band era. Having an amplified sound that could feed into loudspeakers enabled the soft-sounding guitar to be heard by audiences, especially when competing with louder horns and percussive drums. Gibson designated its first electric guitars "E" for electric. The designation "S" referred to the Spanish-style guitars, typically played against the body, while "H" stood for Hawaiian lap-style guitars. The Gibson ES-350 was released in 1947 as a "new generation" Gibson electric guitar. It is a semiacoustic guitar, meaning it has a hollow body. While it could be played without amplification in a quiet setting, it is typically played amplified for performance. The hollow body provides

greater resonance than a solid body guitar and has a sweet, plaintive, even funky tone. The ES-350T, such as this one, was an updated adaptation of the ES-350, having a thinner, easier-to-handle body and a shorter scale, making it easier to play the new jazz chords. It also allowed for two extra frets, offering musicians more freedom and flexibility in their play. Berry liked the guitar for its versatility and ease; so too did Keith Richards, Eric Clapton, and others. Now this guitar will help tell the story of the development of American creativity in the Musical Crossroads exhibit in the National Museum of African American History and Culture.

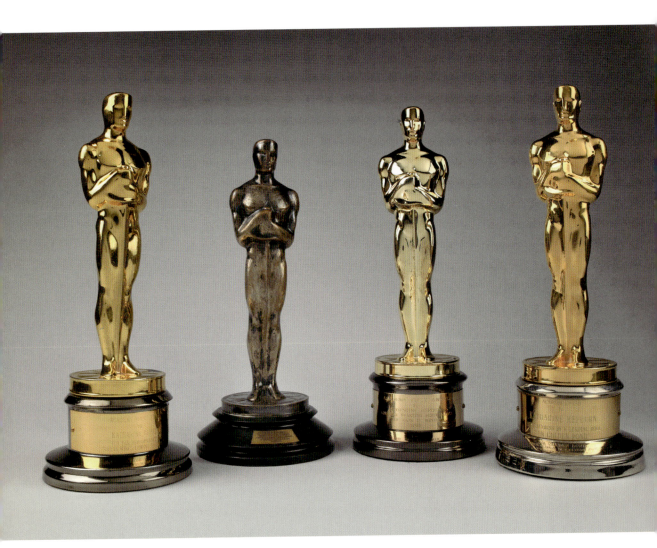

KATHARINE HEPBURN'S OSCARS *National Portrait Gallery*

W hen Katharine Hepburn won the first of her Best Actress Academy Awards for the 1933 film *Morning Glory*, it not only marked the beginning of her magnificent career, it sparked a legend. On March 15, 1934, a young entertainment reporter named Sidney Skolsky, covering his first awards ceremony, was supposedly stumped as to how to spell *statuette*, and instead wrote, "Katharine Hepburn won the Oscar for her performance as Eva Lovelace in *Morning Glory*." This statuette was the first to be publicly dubbed Oscar, and the name stuck.

KATHARINE HEPBURN'S OSCARS

The statuettes are given by the Academy of Motion Picture Arts and Sciences, established in 1927 by the legendary film producer Louis B. Mayer, one of the founders of Metro-Goldwyn-Mayer (MGM). The Academy Awards began as a way to promote the new film industry, then seeking to displace staged vaudeville as the predominant form of theatrical entertainment in the United States. Vaudeville had variable, perhaps declining, production values, and the Academy Awards could attune Americans to the higher artistic standards envisioned for the movies. The awards would honor outstanding achievement in different disciplines of the film industry and bring together celebrities for a large, glamorous publicity event. Mayer was somewhat more cynical in retrospect, saying, "I found that the best way to handle [filmmakers] was to hang medals all over them. . . . If I got them cups and awards they'd kill themselves to produce what I wanted. That's why the Academy Award was created."

The first Academy Awards ceremony was on May 16, 1929, for films made in 1927–28. *Wings* won the Best Picture award, decided by the vote of the Academy's founding members, among them Mayer, Douglas Fairbanks,

A TALENTED ACTRESS WINS AWARDS NOW SYNONYMOUS WITH HIGH-QUALITY ARTISTIC ACHIEVEMENT.

National Portrait Gallery

Mary Pickford, Sid Grauman (of "Chinese Theatre" fame), and United Artists head Joseph Schenck.

Mayer gave MGM art director Cedric Gibbons the task of designing an award trophy. Gibbons developed a concept for a statuette but needed a model. Gibbons's future wife, Dolores del Río, introduced him to Emilio "El Indio" Fernández, a Mexican film director and actor who agreed to pose nude for it. A young sculptor, George Stanley, turned Gibbons's sketch into clay. Then Sachin Smith cast the statuette in bronze and gold-plated it. The first statuettes were thirteen and a half inches high and weighed eight and a half pounds. They each had a low pedestal modeled upon a film reel of five spokes, signifying the five original branches of the Academy of Motion Picture Arts and Sciences: actors, directors, producers, technicians, and writers.

The original source for naming the statuette Oscar is somewhat contested. One account has the Academy's executive secretary, Margaret Herrick, nicknaming the statuette in 1931 after her uncle Oscar, who actually was her cousin. Skolsky claimed that he used the name—popular among vaudeville entertainers, as in "Hey, Oscar, ya got a cigar?"—as a spoof. He was tired of sitting through hours of tedious self-congratulations at the ceremony, and so his use of the name was a putdown of sorts. Walt Disney, though, had used the term in a positive way when he thanked the Academy for his award. One biography of Bette Davis claims that she named the statuette after her first husband, band leader Harmon Oscar Nelson, but that was probably apocryphal. There are other legends as well. By 1939, the Academy formally adopted the name.

During the early 1940s, the Oscar was made out of plaster rather than metal in deference to the American war effort. Winners could trade them in for gold-plated ones after the war. In 1945, the pedestal was lengthened while the size of the statuette remained the same. The material also changed, from bronze to an alloy, britannium, that was coated in twenty-four-carat gold. As a result Katharine Hepburn's next three Academy Awards differed from the first in size and composition.

Additionally, over time the gilding wore off her initial Oscar. Hepburn's four Oscars for Best Actress are still the most by any actor, male or female, and are ample testament to the enormity of her talent. Katharine Houghton Hepburn (1907–2003) was born of old Yankee stock in Hartford, Connecticut. Her father was a prominent urologist and her mother an ardent suffragist who campaigned for birth control with Planned Parenthood founder Margaret Sanger. Hepburn was tomboyish in behavior and dress. She attended elite Bryn Mawr College, where she discovered acting. Her distinctive voice riled critics in Baltimore and New York, but her stage performances attracted the attention of a Hollywood talent scout, and she was invited to a screen test for RKO in 1932. She made her film debut later that year, to great acclaim, opposite John Barrymore in *A Bill of Divorcement*. Her first Academy Award–winning performance, as a naïve actress struggling amid big-city theatrical intrigue in *Morning Glory*, followed.

Hepburn was lauded for her portrayal of Jo in *Little Women* (1933), but her return to the stage in a play called *The Lake* inspired writer Dorothy Parker to quip, "Katharine Hepburn runs the gamut of emotions from A to B." Hepburn's career suffered in the mid-1930s, and she was labeled "box office poison." She lost the *Gone with the Wind* role of Scarlett O'Hara to Vivien Leigh in 1938. Her quirkiness, which had attracted positive notice initially, seemed to wear thin with Depression-era audiences eager for more traditional, romantic heroines.

Feeling stymied by RKO, Hepburn brazenly bought out her studio contract and took charge of finding her own projects. With help from her paramour, the wealthy Howard Hughes, Hepburn purchased the rights to the Broadway hit *The Philadelphia Story*. Philip Barry wrote the lead role for her, and Hepburn played the icy socialite tamed by love—embodied by her frequent costar Cary Grant. The role cleverly capitalized on her own problematic public image as too cool, too independent, and too aristocratic, and the movie won over audiences. In the 1940s, she worked for MGM, where she made successful movies with gruff leading man Spencer Tracy. Their on-screen partnership played upon a battle-of-the-sexes tension and

ambiguity, as in *Woman of the Year* and *Adam's Rib,* while they maintained an off-camera affair. Audiences warmed to Hepburn as a haughty, independent woman brought to heel by a gruff male character played by Humphrey Bogart in *The African Queen.* Her last of nine films with Tracy, *Guess Who's Coming to Dinner,* garnered Hepburn her second Academy Award, in 1967. The following year, she won again, playing a spunky yet vulnerable Eleanor of Aquitaine to Peter O'Toole's Henry II in the historical drama *The Lion in Winter.* Her final Oscar came in 1981 for playing the devoted wife to the curmudgeonly grandfather played by Henry Fonda in *On Golden Pond.* In later years, she made television appearances and took occasional parts, making her final screen appearance in 1994 at the age of eighty-seven.

Getting those Oscars to the Smithsonian proved a curatorial adventure for National Portrait Gallery historian Amy Henderson. Back in 1988 Henderson was seated at a Washington, D.C., dinner party next to Garson Kanin, the Broadway writer and director, who wrote two of Hepburn and Tracy's films. Kanin was also Hepburn's next-door neighbor and was donating his papers to the Library of Congress. Henderson expressed the hope of getting a Hepburn portrait for the Smithsonian. With Kanin's support, Henderson wrote to Hepburn and soon received a reply to call her on the telephone. As Henderson tells it,

> I called the number, and she answered! After much tap dancing, I got her to agree to see me. It turned out that her Turtle Bay town house, where she'd lived since 1929, was chock-full of portraits of her— she'd known artists her whole life, and there was a Cecil Beaton of her above the fireplace in her bedroom, sculptures of her swimming, and many others. She was exactly Hepburn-esque. When I first arrived, she said, "You know, I was a movie star from my first days in Hollywood!" Well, yes, I knew that.
>
> She did not have the Oscars on display, but when I did a One Life exhibition on her at the Portrait Gallery to celebrate her one-hundredth birthday (after she'd died), the Hepburn estate loaned

them to us. I also made them dig through the warehouse to find one of her famous red cashmere sweaters—complete with gardening stains. For that exhibition, the Oscars were mounted near the Everett Raymond Kinstler portrait Hepburn called her favorite. The estate was so happy with how many people saw the exhibition that they decided to give the National Portrait Gallery the Oscars, and since then we have displayed them in our twentieth-century gallery with the Kinstler portrait.

Nearly forty million people watched the Academy Awards telecast in 2013, and a million more each year see Hepburn's Oscars at the National Portrait Gallery and learn of her tremendous contributions to the cinematic arts.

90

HOPE DIAMOND

AN AMAZING GIFT BECOMES AMERICA'S CROWN JEWEL.

National Museum of Natural History

O n Monday morning, November 10, 1958, mailman James Todd picked up a plainly wrapped package at Washington's general post office and drove about a mile west on Constitution Avenue to deliver it to the addressee—Dr. Leonard Carmichael at the Smithsonian's National Museum (now the National Museum of Natural History). The package had been mailed from New York City a few days before. The postage was only $2.44, but registry and insurance—for a million dollars—brought the total up to $145.29. The package came from Harry Winston, a renowned Fifth Avenue jeweler. In it was the forty-five-carat blue Hope diamond, one of the largest and most famous diamonds in the world.

A crowd of officials, notables, and the press gathered for the delivery. The diamond was presented by the jeweler's wife, Edna Winston, because Harry avoided crowds and didn't want his picture taken. The gem was put in a new display case, and attendance at the museum immediately doubled. The diamond was a huge celebrity.

Smithsonian Secretary Carmichael hailed the diamond as a wonderful scientific specimen—but no one bought that. Winston, who possessed some of the world's largest and most interesting diamonds, was donating the Hope for other reasons. Chief among them was his idea that the United States was a world power and, like other leading nations, should have an outstanding collection of jewels. Since the United States, unlike France, England, or Russia, had no kings and queens, no treasuries or crown jewels, it had to rely on its citizens—people like Harry Winston, who was sometimes called the king of diamonds—to come forth and make the donations that would build such a collection. The Hope diamond was famous, legendary. Winston believed his donation would stimulate others to give their gems too. He turned out to be right.

The Hope had been good to Winston. He had used it as the center-

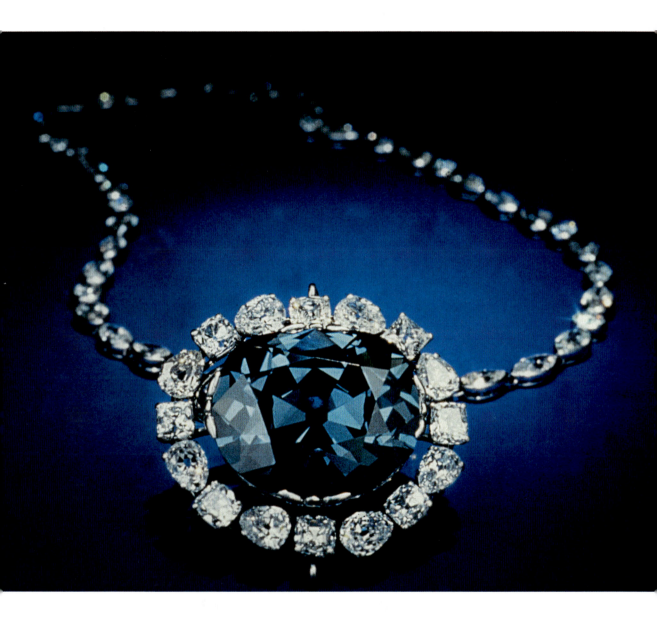

HOPE DIAMOND *National Museum of Natural History*

piece of something he created in the early 1950s and called the Court of Jewels. Winston would ship his largest and best-known diamonds around the country to be used for charity events. Local models and high-society women would wear the gems for benefit luncheons, performances, and exhibits to raise money for a host of good causes. The Hope, which Harry Winston called his baby, anchored the tours to towns large and small; it even went to Toronto and Cuba. For Winston, the Hope was a fabulous, regal gem that attracted attention and donations for charity.

Much of the public, however, thought otherwise. There had been, over the years—even decades—numerous stories about how the Hope diamond carried an ancient curse. Winston's donation of the gem to the Smithsonian led commentators to question the wisdom of accepting it. If the Smithsonian was the national museum and it acquired the Hope diamond, then the country would own it—and might then the American people be cursed? "Turn it down," urged many letter writers to the Smithsonian and President Eisenhower.

The curse story was made up, a modern folktale concocted by French jeweler Pierre Cartier in Paris in 1910 to entice an ultrarich American, Evalyn Walsh McLean, to buy the gem. Over the years, entertainer May Yohe, who had once been Mrs. Hope, publicized and dramatized the story, as did McLean herself. They attributed deaths, revolutions, bankruptcy, and divorce to the stone's malevolent curse.

The blue diamond was originally a roughly cut gem of about 112 carats when Jean Baptiste Tavernier bought it in the Golconda region of India in the mid-1600s. He sold it to King Louis XIV of France at Versailles in 1668 along with more than a thousand other diamonds. The king had it cut to a magnificently symmetrical 67-carat gem valued at about $3.6 million in today's currency and renamed it the French Blue. The diamond passed down as part of the crown jewels to Louis XV and Louis XVI. The latter wore it as part of his knightly decoration, the Order of the Golden Fleece. There are apocryphal stories that it was worn by Queen Marie Antoinette, but there is no evidence of that. When she and her husband were impris-

oned after the outbreak of the French Revolution, the crown jewels were put in a warehouse, publicly exhibited, and, in September 1792, stolen. The gem went missing for some twenty years until a 45-carat blue diamond thought to be cut from the French Blue turned up with an English diamond merchant, who likely sold it to British King George IV.

When Napoleon became emperor of France, he swore to recover all the French crown jewels, including the blue diamond. He failed. George IV celebrated the diamond as a trophy for defeating his enemy. The British king, though, was a spendthrift who almost bankrupted the throne, and after his death in 1830, his executor, the Duke of Wellington, had to dispose of the blue diamond to settle debts. He probably sold it to banker Henry Philip Hope—from whom the diamond took its name.

The Hope family was among England's wealthiest. They had aided American colonial commerce, and helped finance the Louisiana Purchase. They accumulated land, castles, Dutch and Flemish paintings, and other riches. But in the course of a few generations, they squandered that wealth. By 1887 the diamond had descended to Lord Francis Hope. He bet badly on horses, business enterprises, and an American showgirl wife, May Yohe. He lost his fortune and his wife, and after a series of court cases was allowed to sell the Hope diamond. It was purchased by a New York jeweler, Joseph Frankel's Sons Co., in 1902.

Frankel's hoped to make a quick sale, as they'd put up much of their capital to buy it. Instead, it sat in their vault. The 1907 Bankers' Panic took its toll on the company—it was diamond rich but cash poor and going bankrupt. The first stories about the Hope diamond being unlucky came in the financial pages of the *New York Times,* which stated that the gem was responsible for Frankel's failure. Other newspapers in Washington and London picked up the story and made it increasingly elaborate—blaming the executions of Louis XVI and Marie Antoinette, Hope's bankruptcy and divorce, and Frankel's collapse on the malevolent influence of the blue diamond.

The Hope diamond was sold to other diamond dealers, finally coming to the Cartier brothers in Paris. Pierre Cartier was enchanted by a novel,

The Moonstone, written decades earlier by English author Wilkie Collins. In the story, a large yellow diamond had formed the eye of the idol of a Hindu deity in India. It had been stolen, first by a Muslim conqueror and then by a British soldier. The god had cursed the stone, and misfortune would strike all who owned it until it was properly returned. Cartier applied the Moonstone story to the Hope diamond, telling Evalyn Walsh McLean it was cursed by a Hindu god, and embellishing a bit more, blaming the French and Turkish revolutions on its baleful influence.

Evalyn and her husband, Ned, bought the diamond. The McLeans were among the richest families in the United States, owning banks, real estate, and the *Washington Post.* They were close friends of future president Warren Harding and his wife. Evalyn paraded the diamond around Washington and made much of it publicly, until in 1919, her ten-year-old son, Vinson, was struck down and killed by a car near their estate. Newspapers proclaimed that the Hope diamond really was cursed. The curse story was only amplified by ensuing events—Ned McLean went insane, the family lost the *Post* in bankruptcy, a desperate attempt to recover the Lindbergh baby by paying a ransom to the kidnappers with money from pawning the diamond failed, and Evalyn's daughter committed suicide. After Evalyn died, her estate sold the diamond to Harry Winston.

Winston originally wanted to half-donate, half-sell the diamond to the Smithsonian. The Smithsonian planned to use diamonds the federal government confiscated from smugglers to pay Winston some of the price. The Smithsonian and Winston haggled with the Bureau of Internal Revenue for almost two years to determine the value of the donation. After the deal almost fell through, a smart lawyer worked out a method by which Winston could make his donation and take a tax deduction over the course of a decade.

Though the Smithsonian had the diamond, others wanted it too—including Charles de Gaulle, the president of France. He wanted to do what Napoleon could not—reunify the French crown jewels, albeit for a temporary exhibition at the Louvre Museum in 1962.

The French approached the Smithsonian, which was reluctant to make the loan—what if it didn't come back? The French hinted they were considering a dramatic loan to the United States. The Smithsonian stood firm in its opposition until First Lady Jacqueline Bouvier Kennedy called Secretary Carmichael asking that the Hope be sent to Paris. The secretary called the Smithsonian chancellor Earl Warren, Chief Justice of the United States. They decided to accede to Jackie's request and she penned a note—"Thank you. Thank you. Thank you."

In May 1962, the Hope diamond was sent to the Louvre and returned to the Smithsonian at the end of an immensely popular monthlong exhibit. In December, the French loan came to the United States. It was a painting of an intriguing woman with an enigmatic smile—the *Mona Lisa* by Leonardo da Vinci. The *Mona Lisa* was shown at the National Gallery of Art in Washington and at the Metropolitan Museum of Art in New York, seen by more than a million and a half visitors who waited in lines for hours to see the masterpiece.

Since that time curators at the Smithsonian, chiefly Jeff Post, have conducted numerous scientific studies of the diamond. It formed about ninety miles below the earth's surface more than a billion years ago. Its blue color comes from a small number of boron atoms mixed in with carbon. It glows a bright red-orange after being exposed to ultraviolet light. In short, the diamond offers a biopsy of the deep and ancient earth—and an opportunity for us to learn from it.

And the curse? As Jeff Post says, "Since the arrival of the Hope diamond, the National Gem Collection has grown steadily in size and stature, and is today considered by many to be the finest public display of gems in the world. For the Smithsonian Institution, the Hope diamond obviously has been a source of good luck."

The diamond is now enshrined in a redesigned Harry Winston Gallery at the Smithsonian—delighting and intriguing millions annually. And the brown paper box it came in? It has long been a treasured item in the National Postal Museum, illustrating the dependability of the U.S. Postal Service.

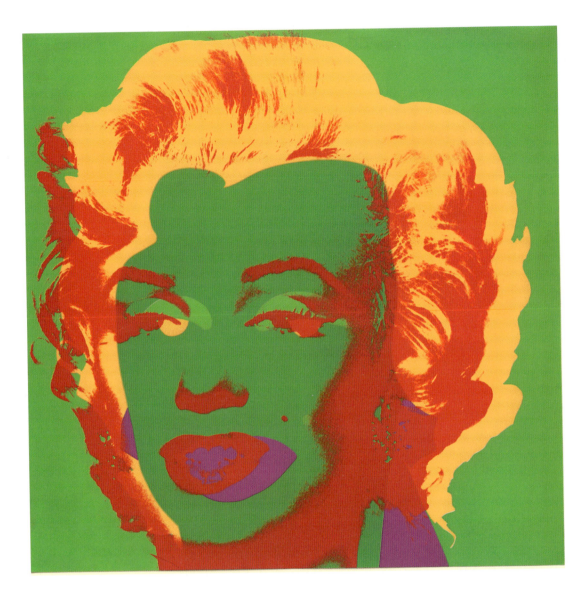

MARILYN MONROE BY ANDY WARHOL *National Portrait Gallery*

Image and Artwork © 2012 The Andy Warhol Foundation for the Visual Arts, Inc./Licensed by ARS

R ags to riches; fame and fortune; beauty; sex, love, and money; glamour and tragedy. Movie star Marilyn Monroe had it all, and Andy Warhol visually captured the spirit of her story—and of the society that made it possible. Marilyn Monroe was born Norma Jeane Mortenson in Los Angeles, California, on June 1, 1926, and was quickly given the new last name Baker. With an unknown father and an unstable mother, Norma Jeane bounded between foster care and orphanages during her childhood until finding a home with family friends. When she was sixteen she married neighbor Jim Dougherty, whom she had been dating for several months. He enlisted in the Merchant Marine and shipped out to the Pacific theater in 1943. Norma Jeane lived with his parents and worked in the Radio Plane Munitions Factory in Van Nuys, spraying and inspecting parts—essentially, a Rosie the Riveter—and later divorced.

She was photographed—as a brunette—for a morale-boosting feature on women workers for *Yank, The Army Weekly*. Although her photograph was not published, the photographer recognized her beauty and recommended her to a modeling agency. She became a model and bleached her hair blond to imitate one of her idols, the glamorous movie star Jean Harlow. Modeling success scored her a movie contract with Twentieth Century-Fox. For Fox, she changed her name to Marilyn Monroe and appeared in a few bit parts. She then signed on with Columbia, and had an overbite corrected to soften her appearance, but without a breakthrough, she ended up modeling again. In one instance, she was paid fifty dollars for being photographed lying in the nude atop red silk fabric.

She continued to model and play small movie roles. Her break came with the Metro-Goldwyn-Mayer film *The Asphalt Jungle,* for which her performance as a young mistress of an aging criminal garnered good reviews. This

<div style="text-align:right">

91

ANDY WARHOL'S MARILYN MONROE

A CONTEMPORARY ARTIST PROVIDES INSIGHTFUL VISUAL COMMENTARY ON A POPULAR SEX SYMBOL.

National Portrait Gallery

</div>

led to a small but showy comedic role in *All About Eve,* which won the Oscar for Best Picture of 1950. She had some work done on her nose—again smoothing her features and softening her look. Courses at the University of California, Los Angeles, and more movie parts followed. In 1952 she appeared on the cover of the nationally popular weekly *Look* magazine wearing a Georgia Tech sweater to celebrate female enrollment at that university. That year, her nude picture appeared anonymously in a calendar. After speculation about her identity and facing a possible scandal, she admitted it was her. She explained she had been compelled to do it because she was a poor, aspiring actress who needed the money to pay for rent. She proved a sympathetic figure, and the combination of her sex appeal and naïveté resonated with the public. Her popularity was on the rise.

Soon thereafter she appeared on the cover of *Life* magazine as "The Talk of Hollywood." Other stories followed—juxtaposing her physical beauty and aspirations with stories of an ugly and challenging childhood. Hers was an American Cinderella story. She started dating New York Yankee baseball star Joe DiMaggio, and her celebrity skyrocketed with coverage of the budding romance.

Monroe's celebrity drew curious audiences to her RKO films. In *We're Not Married!* her role as a bathing-suit-clad beauty contestant was criticized as exploitative. Monroe was then cast as the *femme fatale* scheming to kill her husband in the 1953 film *Niagara.* Her sensuality drew a good deal of attention, and film critics regarded her performance as establishing the Marilyn Monroe "look."

Monroe's breakout role was in the musical comedy *Gentlemen Prefer Blondes,* made famous not least for her magnificent performance of the song "Diamonds Are a Girl's Best Friend." But it was her empathetic, likable role in *How to Marry a Millionaire* that made her one of Hollywood's biggest money-making stars. Her appearance on the cover of the first issue of Hugh Hefner's *Playboy* magazine at the end of the year capped her position as a larger-than-life sex symbol for American men, and as the model to be emulated or rejected by American women. Early in 1954, Monroe

married DiMaggio—linking Hollywood and New York, movies and base-ball. Americans regarded it as a fairy-tale marriage, one between two royal houses of popular culture. The couple honeymooned in Japan, and while DiMaggio attended to business matters, Monroe performed in ten USO shows over four days for some 100,000 grateful U.S. troops in Korea.

Monroe was regarded by many as promulgating a "dumb blonde" person-ality and flaunting her sexuality beyond the bounds of good taste—which she did. But she was also vulnerable and struggling with a barrage of anxi-eties, including stage fright, fear of big crowds, and insecurity about being valued just for her looks.

Within nine months, Monroe and DiMaggio were divorced. Monroe went on to star in many other films, with mixed results. She earned acco-lades and commercial success with *The Seven Year Itch, Bus Stop, The Prince and the Showgirl,* and *Some Like It Hot,* but had disappointing outcomes with other films. She married esteemed playwright Arthur Miller, but this marriage too ended in divorce. She also struggled with mental health prob-lems and addiction to barbiturates and died in August 1962 of a drug over-dose that was ruled a probable suicide.

Although he'd never met her, Andy Warhol (1928–87) was struck by Monroe's death. Born Andrew Warhola to working-class, immigrant, Carpatho-Rusyn Byzantine Catholic parents, Warhol grew up in Pittsburgh, Pennsylvania. He suffered from a number of debilitating childhood diseases, and the socially isolating recovery periods led him to develop a variety of imaginative talents and escapist fantasies that were nurtured by reading DC Comics and celebrity magazines. He studied commercial illustration, silk screening, and print making at Pittsburgh's Carnegie Institute of Technol-ogy, experimenting with various techniques and graduating with a BFA in pictorial design in 1949. He moved to New York City, where he designed advertisements for magazines, promotional pieces for musical bands, and, by the late 1950s, record album covers. He also created and exhibited his own artwork, and by the early 1960s he was just becoming known in New York.

Marilyn Monroe posthumously helped propel Warhol's fame. Following

her death, he created a color-drenched portrait of the star using a publicity photograph from *Niagara*. Warhol sought to convey both her glamour and her fragility, capturing her iconic role as a sex symbol and the air of vulnerability that hung over her from birth to her tragic death.

Warhol's electric, color-saturated portrait evokes the actress's vibrancy and personality. It portrays Monroe with her eyes and trademark pouty mouth highlighted in bold tones, drawing viewers to those areas, which epitomize her sex-symbol status.

Far from being celebratory though, Warhol suggests that Monroe, an icon of Hollywood, was a casualty of the very movie industry that made her a star. The portrait emphasizes a highly artificial view of culturally proscribed female sexuality. Monroe is presented as a commodity. By using silk screens and producing numerous versions in different colors, Warhol suggested how Monroe had become a manufactured product—sold and exploited. The National Portrait Gallery has four artist's proofs in a series of ten silk screen prints featuring the same likeness of Monroe executed in different colors.

The idea of commercial reproduction and personal alienation is vividly represented by another Warhol work derived from the same publicity still. The silk screen painting shows the actress's disembodied lips reproduced over and over again for almost sixteen feet. It hangs in the Smithsonian's Hirshhorn Museum.

In the portrait, the tension between Monroe as a person and her manufactured image is conveyed by Warhol's deliberate misalignment of the registration of colors—so that they overlap, somewhat jarringly. Monroe's beauty is presented in discordant imperfection. As former National Portrait Gallery curator Anne Goodyear puts it, "Warhol created a powerful metaphor for the dissolution of Monroe's career."

Warhol's approach might also have reflected sensitivity to social codes of gender, possibly heightened by his own self-described asexuality. A tragic victim of her sexuality, and of male dominance, Monroe's distinctive and highly artificial looks and manner provided inspiration for drag perfor-

MARILYN MONROE'S LIPS BY ANDY WARHOL *Hirshhorn Museum and Sculpture Garden*

Image and Artwork © 2012 The Andy Warhol Foundation for the Visual Arts, Inc./Licensed by ARS

mances. Indeed, later in the 1980s, Warhol himself would appear in a series of photographs by Christopher Makos, with wig and makeup mimicking Marilyn Monroe while calling attention to the subversion of social norms by wearing typical male clothing, including a tie. Warhol's Monroe images could be a commentary on the viewer's complicit participation in her fatal exploitation, and our own implication in the social pressures that contributed to it.

92

The McDonald's sign is found everywhere in the United States and in about 120 other countries around the world. It beckons hungry customers to eat what has become known as fast food, and to share a common experience that has helped define contemporary global culture.

This sign was made in the United States for a McDonald's in Japan. Both sides of the sign display white Japanese lettering on a red background that features the English word *McDonald's* repeatedly. The sign is recognizable because of the color scheme and the characteristic

McDONALD'S GOLDEN ARCHES SIGN

AN AMERICAN FAST-FOOD ENTERPRISE DEFINES CONTEMPORARY GLOBALISM.

National Museum of American History

McDonald's golden arches. Approximately nine feet high by five feet wide, the sign is electrified so that it can be lit at night. It was acquired by the Smithsonian for the A Nation of Nations exhibition in 1976, a signature program of the celebration of the United States Bicentennial. The arches represent one of the ways that the United States has spread its products and creations around the world. Of course, they didn't start out that way.

In 1940, brothers Richard and Maurice McDonald opened the first McDonald's Bar-B-Q drive-in restaurant with carhops in San Bernardino, California. In 1948, the brothers, nicknamed Dick and Mac, redesigned their menu, focusing on their fifteen-cent hamburger and just a few other items: a cheeseburger, potato chips, soft drinks, milk, and coffee. The next year, French fries replaced potato chips and the brothers added thick milk shakes. By 1953, enjoying financial success, the brothers were beginning to franchise a small number of restaurants in Arizona and California. They had architect Stanley C. Meston design the eateries with two large golden arches on each side of the buildings, creating a modern, clean, almost futuristic look.

In 1954, Ray Kroc, a Multimixer milk-shake machine salesman, became interested in the McDonald brothers' operation. They were doing a

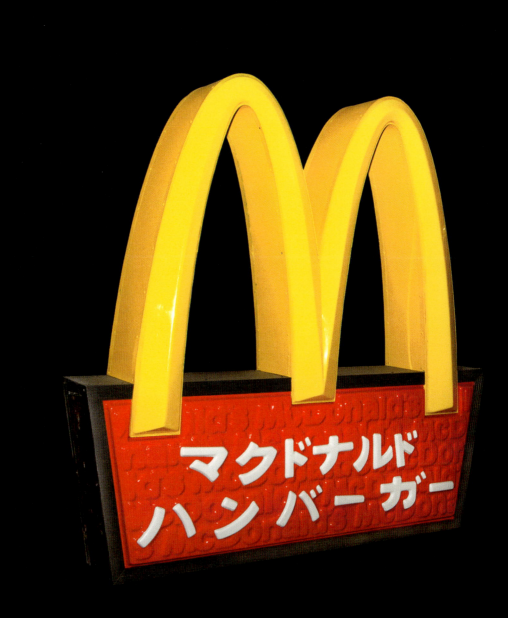

MCDONALD'S SIGN *National Museum of American History*

booming business, offering a limited menu of high-quality, speedily served foods. Kroc and the brothers discussed organizing similar drive-in restaurants on a larger scale around the country. Kroc became the McDonald's franchising agent. He opened his first franchise restaurant in Des Plaines, Illinois, in a red-and-white-tiled building featuring two large golden arches following Meston's design. The architecture attracted a good bit of public attention. So did his sign, with a smaller golden arch, which announced I MILLION SERVED. Kroc started the McDonald's Corporation and hired counterman Fred Turner, who would soon be director of operations and encourage food quality, cleanliness, and service as McDonald's trademark values.

The company, under Kroc's direction, bought out the McDonald brothers and the rights to the name. The company provided centralized standards and guidance to all franchises. Each franchise would offer customers the same standard fare from approved suppliers at an inexpensive price. A common brand identity and decor reinforced the availability of a common menu in each franchise restaurant. A set of operating procedures assured that the food would be served quickly and efficiently to drive-in customers and that the restaurants would be clean and well serviced.

McDonald's restaurants depended on the widespread use of the car and the need and desire of Americans to pick up a quick, casual, low-cost takeaway meal. With the growth of suburbs and baby boomers reaching driving age, there was increased demand for such informal meals. At the same time, the McDonald's approach was consistent with other forms of standardization in the United States in the late 1950s and early 1960s. Consumer brands for a host of food, health-care, automotive, and apparel products were being promoted in retail stores. Big chain stores, like Sears, were starting to spread to large, mainly white residential suburbs. Network television reached people everywhere and offered the same programs to all. As President Eisenhower encouraged the building of the interstate highway system, travelers looked for the familiar and expected in restaurants like Howard Johnson's as well as hotels like Holiday Inn and gas and service stations.

The early McDonald's depended on a consumer's desire for predictability in food quality and price.

As more people invested in, built, and ran franchises, McDonald's signs proliferated. They continued to add to the number of people served—reaching 100 million in 1958 from almost one hundred restaurants. In 1962, a McDonald's restaurant in Denver, Colorado, for the first time offered indoor seating for customers. By the following year, the number of franchises had grown to five hundred and the signs read 1 BILLION SERVED. In 1966, McDonald's produced its first television commercial, which featured the fictional character Ronald McDonald. Two years later, the company opened its first franchise in another country, Canada. In 1969, the company retreated from its red-and-white-tile decor, but revamped the increasingly popular golden arches, turning them into more of a logo. The graphic rendition of the arches was made considerably higher and narrower, turning the arches into an M to reinforce the McDonald's name. It is these stylized arches that appear on the Smithsonian's McDonald's sign.

Over the years, McDonald's simple menu evolved, due in part to suggestions from franchisees. A Fillet-o-Fish did well, but Kroc's own favorite—a Hulaberger, made with a slice of pineapple and cheese, was a flop. Successes included the Big Mac and Quarter Pounder hamburgers and the Egg McMuffin breakfast sandwich. The McDonald's Corporation adopted ancillary charitable activities. Among the more popular are the Ronald McDonald Houses, which enable parents to find affordable and comfortable accommodations close to their hospitalized children. My wife and I joined many thousands of other parents who have benefited from that program for a few days when our daughter underwent an operation in a Baltimore hospital.

McDonald's continues to proliferate throughout the world. I was in Moscow in 1990 when the first McDonald's opened there in the midst of new openness policies of glasnost and perestroika. Some thirty thousand people were served in one day. I was amazed at how Russians waited patiently in long lines for what is regarded as fast food, and how they were willing to

pay what was, for them, an exorbitant price to taste a hamburger and fries. Clearly, they were buying more than food—they were buying into a global culture of consumer products from which they had been long excluded.

A number of critics have used McDonald's as a metaphor for a pernicious form of cultural imperialism, by which the spread of American commercial products overwhelms the culinary, fashion, craft, and entertainment traditions of other countries, leading to derivative and typically uninspired contemporary goods and to the demise of homegrown creativity. *Jihad vs. McWorld* is what noted scholar Benjamin Barber called the tension between the local/traditional and the global/corporate in his bestselling book by that title.

McDonald's actually has been quite savvy about selling a standard global product—albeit with American roots—while also adapting to local tastes. It uses kosher meat in Israel and *halal* meat in Muslim countries. In deference to Hindus and Muslims, it serves neither beef nor pork in India. It serves a Teriyaki McBurger in Japan, a McFalafel in Egypt, a chicken and flatbread McArabia in Morocco, a McAloo Tikki Burger made out of potatoes and peas in India, and a Flaming Hot Doritos burger in Mexico, among many other variants.

McDonald's has weathered criticism in works like Eric Schlosser's book *Fast Food Nation* and Morgan Spurlock's documentary film *Super Size Me*. Both authors contend that the McDonald's menu has too many high-fat, high-calorie processed foods that contribute to obesity and other health problems—particularly among the young and the poor, who nowadays make up a large portion of fast-food customers. McDonald's has been responsive, adding salads, fresh fruit, yogurt, and other items to its "healthy menus" in order to retain and attract customers. McDonald's fast-food service, with its highly standardized method of manufacture and limited menu, has also spawned reaction from a number of chefs, culinary critics, and foodies who have given the "slow food" label to efforts that personalize cooking, utilize locally distinctive ingredients, and take more time and pleasure from the very act of food preparation and dining.

Come what may, McDonald's has been a huge financial success and established a benchmark for global business. It is the largest food-service company on the planet, serving almost 70 million people a day in more than 34,000 restaurants in more than 100 countries, and generating almost $190 billion in company and franchise revenue annually. In 1994, McDonald's calculated it had gone over the 100-billion-served mark and decided to put the phrase BILLIONS AND BILLIONS SERVED on its signs—a sum the McDonald brothers could scarcely have imagined.

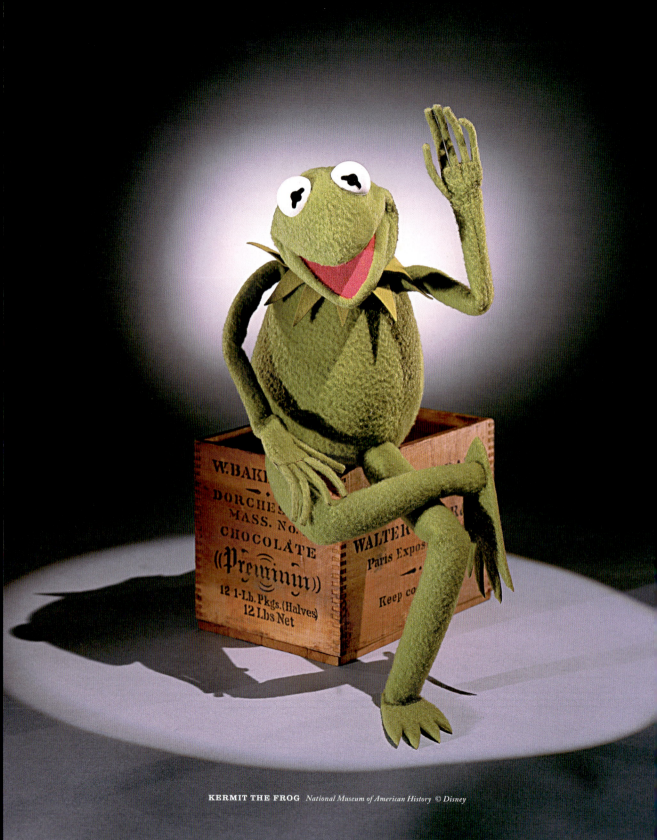

KERMIT THE FROG *National Museum of American History* © *Disney*

He's a frog puppet with a green felt fabric skin, originally taken from an old cloth coat. His body is hollow, allowing for hand operation and manipulation. The puppet has steel support wires in the arms. The legs are stuffed and hang loosely. The puppet's eyes are modestly formed with half Ping-Pong balls, and the mouth with red cloth topped with a pink cloth tongue. This is an accurate description of the physical puppet, but it certainly doesn't do justice to the character known the world over as Kermit the Frog! Kermit is an American icon, recognized worldwide as the star of *The Muppet Show, Sesame Street,* and eight motion pictures, including *The Muppet Movie* (1979) and *The Muppets . . . Again!* (2014).

As Kermit tells the story: "I was born a tadpole in the swamp, one of 3,265 brothers and sisters." Soon after dropping his tail, he became the first of his siblings to learn to play the banjo (which just happened to be floating by). He left the swamp, and along the way met the man who changed his life, Jim Henson.

In fact, Kermit is the creation of master puppeteer Jim Henson (1936–90). Henson was born in Mississippi, and at age ten moved with his family to Hyattsville, Maryland, near Washington, D.C. Like many young people, Henson was fascinated by the family's first television set, and especially entranced by an early television show featuring puppets, Burr Tillstrom's *Kukla, Fran and Ollie.* As a high school senior, Henson began to make puppets for a local station's Saturday-morning children's show. Then in 1955, as a freshman at the University of Maryland, he helped create a brief puppet show called *Sam and Friends* for television station WRC-TV in Washington, D.C. That show included a simple character made of cloth—retrieved from his mother's discarded spring coat—with eyes made of Ping-Pong balls. Though this character was not yet called a frog, this was, indeed, the

KERMIT THE FROG

THE MUPPET STAR HELPS CHILDREN LEARN IN A THOROUGHLY ENGAGING MANNER.

National Museum of American History

forerunner to Kermit. This was a major breakthrough for both Kermit and Henson. The show ran for seven years and brought Henson together with Jane Nebel, whom he later married.

At the University of Maryland, Henson studied commercial design and textile arts, developing puppets and characters and experimenting with foam-rubber creations. He wanted puppet characters to be alive and have personalities. He preferred cloth hand-and-rod puppets to wooden marionettes, as the former provided more lifelike fluid motion compared to the stilted movements of the latter. Henson thought that to be more evocative puppets had to appear to be able to express themselves, and the puppeteer, by synchronizing mouth movements with humanly voiced speech, would help accomplish this.

Sam and Friends led to television appearances on such programs as *The Tonight Show* and *The Ed Sullivan Show* as well as numerous local and national commercials. In the early 1960s, Henson and his wife formed Muppets, Inc. Together with writer Jerry Juhl and puppeteer Frank Oz, they developed a variety of puppet characters for television, such as the piano-playing Rowlf the Dog for *The Jimmy Dean Show*.

Then, in 1969, Children's Television Workshop asked Jim Henson to work on a new children's series for public television—*Sesame Street*. The show, which has run for more than forty years, features such characters as Big Bird, Grover, Oscar the Grouch, Bert and Ernie, the Cookie Monster, and, of course, Kermit the Frog. *Sesame Street* proved to be a television landmark—demonstrating that this still-young medium could serve a profound educational purpose. *Sesame Street* could teach the alphabet, numbers, directions, songs, and lessons about geography, science, art, history, and just about everything through the colorful puppet characters, varied human hosts, and outstanding guests. The show revolutionized children's television. *Sesame Street* made learning entertaining and fun.

Sesame Street was also radical in terms of its choice of setting, presenting a racially diverse, inner-city urban neighborhood as a friendly, nurturing

place. The show introduced children nationwide to an extended family of African American and Latino "neighbors" as well as an amusing array of "monsters," puppets whose quirks of behavior and appearance led to lessons in tolerance and negotiating differences.

And Kermit was key to the show's success. He played a television reporter or commentator, straight man or lecturer. Many saw Kermit as an alter ego of Henson, serious and softly assertive, talented but not overbearing, sometimes frustrated, but always trying to bring out the best in others.

Sesame Street was timely and hip—culturally in tune with the baby-boomer adults who would watch the show with their young children. I know, because my wife and I did so with our two daughters.

It was on *Sesame Street* that Kermit first sang one of his most famous songs, "Bein' Green." The song was written by composer Joe Raposo for *Sesame Street*'s first season and addressed the difficulty—and the joy—of being different. Kermit accepts his greenness because it goes along with who he is—a frog—but he wonders whether it would be better to be yellow or red or gold. He sings about slights, but finds reasons to be proud about being green—which, he concludes, is beautiful. Kermit's message not only appealed to young children, teaching self-confidence and tolerance, but also to adults—Frank Sinatra, Van Morrison, Diana Ross, Ray Charles, Tony Bennett, and many others have covered the song.

While thrilled at the success of *Sesame Street,* Henson wanted to reach an audience beyond preschoolers and their parents. This instinct gave birth to one of the most popular—and the first truly international hit—television series of all time, *The Muppet Show,* which ran from 1976 to 1981. Jim Henson explained that Kermit's job on *The Muppet Show* was much like his own: "trying to hold together this group of crazies to actually get the job done."

The Muppet Show introduced a whole new cast of unforgettable Muppet characters, including Fozzie Bear, Gonzo the Great, Animal, Dr. Teeth, Statler and Waldorf, and—most memorable of all—Miss Piggy. Though

she began the show as a mere chorus pig, Miss Piggy soon became a huge star, an international phenomenon, and (whether he likes it or not) the love interest of Kermit the Frog.

With the success of *The Muppet Show*, Hollywood called the frog. In 1979, Kermit and his *Muppet Show* friends starred in the hugely successful *The Muppet Movie*, in which Kermit performed another of his signature musical numbers, "The Rainbow Connection." Written by Paul Williams and Kenneth Ascher, this beautiful, moving song captured the wonder and wanderlust of Kermit, in many ways mirroring Judy Garland's "Somewhere Over the Rainbow" from *The Wizard of Oz*. Kermit sings wistfully about his dreams:

> *Someday we'll find it*
> *The Rainbow Connection*
> *The lovers, the dreamers and me*

The song rose to near the top of the *Billboard* charts, was nominated for an Academy Award, and was subsequently sung by Judy Collins, Justin Timberlake, Willie Nelson, Sarah McLachlan, and many others.

In 1990, following Jim Henson's death, Kermit and the other classic *Muppet Show* characters became part of the Walt Disney Company. With new movies like *The Muppets* and *The Muppets . . . Again!*, Internet viral hits like the *Muppets'* "Bohemian Rhapsody," and being honored with stars on the Hollywood Walk of Fame, Kermit and his Muppet friends remain as vital, fresh, and entertaining as ever.

Through it all, the simple frog has endured. Whether called *Cocas o Sapo* in Portuguese, *la Rana René* in Latin America, or *Kamel* in Arabic, Kermit has remained a hero and friend to generations of young and old around the world.

The Kermit puppet in the Smithsonian collection first came on loan from the Jim Henson Company in 1980 when the Puppeteers of America and the UNIMA—the international puppetry organization—sponsored a

World Puppetry Festival in Washington, D.C. I worked on that festival for the Smithsonian. The puppet was formally donated in 1994. A stitched label on the back says, "Property of the Muppets / ha! / Henson Associates, Inc. / New York, NY Kermit the Frog." The term "ha!" stands for Henson Associates and was their trademark. Jim Henson, whom I met while working on the festival, took joy in bringing Kermit and his colleagues to hundreds of millions across the planet. It is a joy that continues to this day.

94

In 1977, movie producer George Lucas released the first of his six *Star Wars* films. It was a massive commercial success and a global cultural event. The fictional story, which purported to take place "a long time ago," provided a futuristic vision of a universe richly populated with an assortment of intelligent life but still engaged in the age-old struggle between good and evil. Audiences were intrigued by the richness of the fictional universe Lucas had created, and by the film's superior special effects. Space battles, exotic humanoid species, and a startling array of robots all seemed so real.

STAR WARS' R2-D2 AND C-3PO

ROBOTIC CHARACTERS WITH PERSONALITY ANIMATE A HUGE MOVIE HIT AND SIGNAL HUMAN ATTITUDES TOWARD TECHNOLOGY.

National Museum of American History

From Darth Vader and Luke Skywalker to Yoda, Princess Leia, Obi-Wan Kenobi, Han Solo, and Chewbacca, *Star Wars* is chock-full of intriguing characters. Among the most endearing are two robots, or droids (short for androids), named R2-D2 and C-3PO, whose roles continued through the series.

The Smithsonian's collections include costumes worn by actors to portray the robots R2-D2 and C-3PO in *Return of the Jedi,* the third of the films, produced and released in 1983. Both costumes relied on a combination of electronic gadgetry and the actors' own motions to create these two very different droid characters with distinctly human personalities. The costumes were designed from artwork by Ralph McQuarrie and were fabricated by Elstree Studios in England.

R2-D2 looks more like a small fancy blue-and-white garbage can than a human being. In the films, R2-D2 is a droid, a helpmate created to interface with computers and service starships on behalf of humans. He is a highly competent technician who efficiently performs complicated tasks well beyond human capability. Though visibly a machine, he has a personality that alternates between comic and courageous. He communicates with expres-

C-3PO AND R2-D2
FROM *STAR WARS*
National Museum of American
History

sive squeals and head spins, lumbers around on stubby legs, and repeatedly saves the lives of his human masters.

Several R2-D2 units, specialized according to function, were needed to make a single movie scene. Some, like the ones that glided around spaceships, were controlled remotely. Others, like this one, were costume shells in which an actor sat and manipulated the droid movements. The actions of the different R2-D2s would be filmed and then edited into a final composite.

Actor Kenny Baker wore this R2-D2 costume. Baker was of sufficiently small stature to fit inside the forty-four-inch-high unit. The costume has a body of aluminum and epoxy, built up with fiberglass cloth over a layer of foam, and the head is spun aluminum. The entire costume weighed sixty-eight pounds. The exterior is painted in blue and white enamel, and there are lightbulbs for the electronic panels.

The costume's head is removable. There is a small seat inside, with a seat belt. It is equipped with a handle for the actor to control the movement of the head. There are two six-volt battery packs for powering and blinking the winker lights and the other fiber-optic displays on opposite sides of the head. The robot's power source also enabled the body to rock forward and backward. Baker could put his feet in the droid's hollow "feet" to steady himself while doing this. Small zippered boots in these hollows allowed Baker to secure himself.

As R2-D2 was intended to look worn for the film, the costume is somewhat weathered. It has some dirty paint splashes, and some of the paint is scraped away. Discolored adhesives were employed to simulate age.

C-3PO, R2-D2's sidekick and character foil, is called a protocol droid in the films. While R2-D2 looks like a machine, C-3PO—even with gold "skin"—more closely resembles a human in form, movement, and character. The C-3PO character can speak six million languages, and thus interfaces with the diverse cultures of Lucas's imaginary galaxy as a robotic translator and diplomat. C-3PO is talkative, tentative, sometimes even meek and cowardly, a counterpoint to the terse, brave, and more certain R2-D2.

Like the R2-D2 units, more than one C-3PO costume was used for each movie. The C-3PO costume, worn by actor Anthony Daniels, is five foot eight and weighs thirty pounds. The torso is made of fiberglass; the legs combine leotard, socks, and fiberglass; the arms are aluminum; and the pelvis and feet are rubber. The sole of C-3PO's boots imitated that of the Apollo 11 astronauts, a homage to the feat of man walking on the moon. C-3PO was a less-complicated costume to operate than R2-D2, but required more character acting, given the anthropomorphic nature of the droid. Some have argued that his effete mannerisms and British accent were intended to make him into a comic version of an English butler, a servile literary stereotype, while R2-D2 was created as more of a sentient "pet," or sidekick. In any case, combined, the duo is more personable than calculating, more comical than threatening, and thus a refreshing alternative to the more sinister robots of much science fiction literature and film.

The Smithsonian had tried to acquire R2-D2 when *Star Wars* first came out in 1977 and had been told that it and C-3PO were going to be used in sequels and were not available. So curator David Noble wrote to Lucas in July 1983, following the release of *Return of the Jedi,* to reiterate that the National Museum of American History was very interested in the robot costumes. He suggested "the Smithsonian as a suitable retirement home for your mechanical stars." He also guaranteed their long-term preservation and availability to the public. Lucas's company responded, offering to donate the two *Star Wars* costumes for R2-D2 and C-3PO, requesting only "that they are not to be retired to the museum's 'attic' or 'junkyard.'"

Since the R2-D2 costume would be displayed without the actor Baker inside to operate it, the Smithsonian requested that prior to the donation, Lucas Films modify R2-D2's head by means of a variable, intermittent rotation device that would move forty-five degrees backward and forward every thirty to forty seconds—so as to engage visitors. They also modified the electrical circuitry of both costumes, so that while the batteries were left in their original position, their function was taken over by a transformer and AC adapter with controls outside the unit, to ensure uninterrupted power

during long-term display. The original lights were also replaced with long-lasting three- to five-year bulbs.

Since coming to the Smithsonian in 1984, the costumes have engaged tens of millions of visitors.

After the first set of three films was released, Lucas produced three more from 1999 to 2005. The *Star Wars* films have made great entertainment, but they have also become a cultural touchstone, not only for avid fans but now for several generations of Americans. The droids are more than movie stars in these films; they are indicators of the place robots might occupy in the human experience. R2-D2 and C-3PO are familiar friends meant to help us, not inscrutable rogues destined to overthrow their human masters. Today, real robots are more prevalent than ever before. They mostly work on industrial production lines carrying out tedious, repetitive tasks, but scientists and engineers are working to extend the use of robots to much more sophisticated functions that are difficult for humans to complete. It is likely we will see more of them in the future—as aids for medical treatment and surgery, for military uses, and for security purposes. This too extends to space, with such machines as NASA's Robonauts, or humanoid robots, being used for mission activities. Indeed, we might expect that robots one day will explore for us "a galaxy far, far away."

DIGITAL

AGE

(1945 TO NOW)

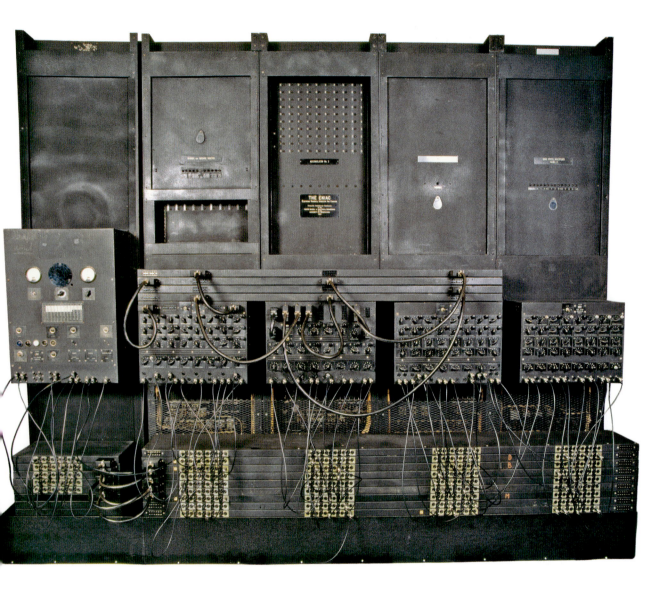

SECTIONS OF THE ENIAC COMPUTER *National Museum of American History*

T here was a time, prior to the creation of ENIAC—the Electronic Numerical Integrator and Computer—that a "computer" referred to a person, typically a woman, whose job was to perform series after series of complex, repetitive computations. With the advent of this general-purpose, operational, high-speed electronic device, computers became what we think of today—machines. ENIAC's successful creation launched the computer industry in the United States and paved the way for what we now call the digital age. ENIAC filled a room on its own, and many of the elements that survive today are preserved at the Smithsonian.

ENIAC

When it was first publicly revealed on Valentine's Day, February 14, 1946, at the Moore School of Electrical Engineering of the University of Pennsylvania, ENIAC was perhaps the largest and most complicated electronic device in the world. It occupied a 50-by-30-foot area of the building, where its 40 computing panels were arranged, U-shaped, along three walls. Each of the units was about 2 feet wide by 2 feet deep by 8 feet high. It had approximately 18,000 vacuum tubes, 70,000 resistors, 10,000 capacitors, 6,000 switches, 1,500 relays, and literally miles of wires and cables. It weighed almost 30 tons and needed about 150 kilowatts of power to operate.

The machine had been in development for several years. Prior to World War II, mathematicians, physicists, and engineers had been working on ways of improving efficiency in doing complex calculations, though such initiatives lacked sizable financial investment and support. Whereas it might take a person ten seconds to add together two ten-digit numbers, it would take four seconds with a mechanical hand calculator, and about a third of a second using the Bush differential analyzer—one of the giant mechanical calculators of the era.

With U.S. entry into World War II, the armed services had computa-

AN ELECTRONIC COMPUTER DEVELOPS OUT OF WORLD WAR II COMPUTATIONAL NEEDS AND SETS THE PATHWAY TOWARD THE DIGITAL AGE.

National Museum of American History

tional needs that overwhelmed their staff and their own mathematical and engineering capabilities. The Ordnance Department at the Aberdeen Proving Ground in Maryland was a case in point. It required quick and accurate information about ballistics. It worked to develop ordnance ranging tables that could predict with precision where artillery shells and other projectiles would land. A number of variables had to be considered—the mass and velocity of the ordnance, the angle at which it was fired, the topography of the land, wind speed, and other factors. The mathematics for solving a series of differential equations to account for these variables is arduous. Doing the computations by hand for a single problem could take hours.

The Ballistic Research Laboratory of the Ordnance Department at Aberdeen had a long-standing relationship with the Moore School at the University of Pennsylvania. The Moore School was a hotbed for those working on improvements to calculation. There was recognition of the limitations of the mechanical calculating devices, which would often fail, and several scientists and engineers sought some type of electromechanical solution. By the early 1940s, a similar project was under way at Harvard with the development of a project called the Mark I calculator. At the Moore School, physicist John Mauchly was interested in improving calculations for his analysis of meteorological and cryptological data, and his colleague John Presper Eckert, an electrical engineer frustrated with the apparatus for mechanical calculation, were committed to the research. They had authored an influential concept paper on a different type of calculator, a machine that would replace mechanical wheels and gears with electrical pulses.

As Aberdeen expanded with America's involvement in the war, a reserve officer, Lieutenant Herman Heine Goldstine, came on staff. He had received his PhD in mathematics at the University of Chicago and was assigned as the Army liaison to work with the engineers at the University of Pennsylvania. With a talented scientific cadre around him, Goldstine encouraged further work on the idea of electronic computations. On June 5, 1943, the U.S. government signed a contract with the University of Pennsylvania for $61,700 for six months of research and development of Project PX, an

electronic numerical integrator and computer. Over the course of the next three years, there would be nine amendments to the contract, which would eventually total just under $500,000 and call for the testing of a pilot version of the device at the university and final delivery to Aberdeen.

As Mauchly, Eckert, and the staff at the Moore School started to put together their machine, they realized that instead of relying on gears, they could use electric counters—what they called flip-flop switches made up of thousands of vacuum tubes—for the machine's circuitry. The use of vacuum tubes in electrical circuitry had become popular with the radio. Circuits could be programmed with logical functions, so that an "and" operation would add pulses in a series, while an "or" operation would add a pulse if any one of a specified array of circuits was completed. Internally, ENIAC employed the familiar base 10 system, using the numbers 1 to 9 and then moving to the next decimal place. Eckert and Mauchly thought about making it base 2, similar to our more current computing system, with 0s and 1s. But they decided that would be too difficult and time consuming. The base 10 system is the major reason why ENIAC required so many vacuum tubes in the circuitry.

The ENIAC had component parts that allowed for different functions. Of its 40 large panels, 20 were accumulators, which could add, subtract, and hold large numbers in its memory. These accumulators could save results, and one calculation could trigger another and another in a series. ENIAC could solve 5,000 addition problems per second, which was a huge gain in performance—more than 1,000 times faster than the mechanical calculators. However, by today's standards, when microprocessors can do 100 million additions per second, this increase seems infinitesimally small. ENIAC's multiplier unit controlled 4 of the accumulators and could perform almost 400 multiplication operations per second; a divider/square-rooter unit controlled 55 accumulators to perform 40 division or 3 square-root operations per second. Other units included the initiator, for starting and stopping the machine, a cycling unit for synchronizing the others, a master programmer for controlling looping operations, and 3 function table units. Other units

handled the reading of IBM punch cards, as a way of inputting data, and the printing or punching out of results.

As someone who worked with ENIAC later remarked, "Now we think of a computer as one which you carry around with you. The ENIAC was one that you kind of lived inside.... You could wander around inside it and watch the program being executed on lights, and you could see where the 'bullet' was going. Instead of your holding a computer, this computer held you."

The remarkable achievement of ENIAC is how well it worked. The vacuum tubes failed far less frequently than anticipated and were not too numerous to be cumbersome. This represented a real engineering accomplishment; the designers had chosen their tubes and designed their circuits in such a way that the tubes' performance exceeded expectations.

ENIAC became fully operational at the University of Pennsylvania by the fall of 1945, months before its public unveiling. Although success came too late to really help in the war effort, ENIAC worked on ballistic and H-bomb calculations through the year, and moved from Philadelphia to Aberdeen, where it was reconstituted in 1947. It was used until October 1955. By that time, it had become antiquated technology, superseded by computers like the EDVAC and ORDVAC. For decades afterward, ENIAC was implicated in patent disputes regarding the invention of the computer and its technology.

ENIAC marked a milestone in the development of computing, and Smithsonian curators, well aware of ENIAC's significance, began to visit Aberdeen Proving Ground in 1957 in order to identify which elements of ENIAC should be transferred to the museum. The Smithsonian needed enough functioning components to demonstrate the working of the machine, but could not store and operate the whole computer. It also insisted on having full title from the U.S. Army so that the museum would not be hamstrung in its display of this benchmark computer. Ironically, it took longer to negotiate the donation from the Army than it did to build ENIAC. Finally, in 1962, the deal was concluded and the Smithsonian acquired

many components, which were reassembled as an animated unit for visitors. In another important acquisition, David Allison, a curator at the National Museum of American History, conducted a video interview with Eckert, to capture for the record his recollections of the development of ENIAC and the beginnings of the digital age.

APPLE'S
MACINTOSH COMPUTER

A MARRIAGE
OF HIGH
TECHNOLOGY
AND GREAT
DESIGN, A
DESKTOP
COMPUTER
SETS A NEW
STANDARD FOR
SUCCESSFUL
DIGITAL
PRODUCTS.

*National Museum of American
History*

Sometime in the not too distant future, visitors to the Smithsonian will see this Macintosh personal computer in a museum case. It will look awfully old, and they'll wonder what all the fuss was about. When it was first released in January 1984, the Macintosh was out to make news and history. It was intended by Apple's cofounder Steve Jobs to be revolutionary. Jobs essentially said so in a television commercial developed by the Los Angeles ad firm Chiat/Day and directed by feature film director Ridley Scott. It aired during professional football's Super Bowl championship game, cost $1.5 million, and was watched by more than seventy-five million viewers.

The commercial is set in a dystopian fantasy world mirroring George Orwell's classic cautionary tale, *1984.* People are gray, androgynous drones; they look alike, move in lockstep, and sit in rows listening to the monotonal "information purification directives" of a Big Brother–like ruler who fuzzily appears on a giant screen. A woman athlete, in bright red running shorts and with an image of the Macintosh emblazoned on her white shirt, is chased by the Thought Police as she sprints toward the screen with a large hammer. Like an Olympian, she hurls the hammer at the screen, shattering it to pieces and awaking people from their slumber as a voice-over accompanied by scrolling text announces, "On January 24, Apple Computer will introduce Macintosh. And you'll see why 1984 won't be like '1984.'" The commercial then fades to black and the Apple logo appears.

The commercial aired only once, on January 22, 1984, but its story line and the Macintosh computer itself became touchstones of the personal computer revolution.

Jobs was intent on marketing a personal computer that was different from the one offered by IBM, the dominant company in the business and

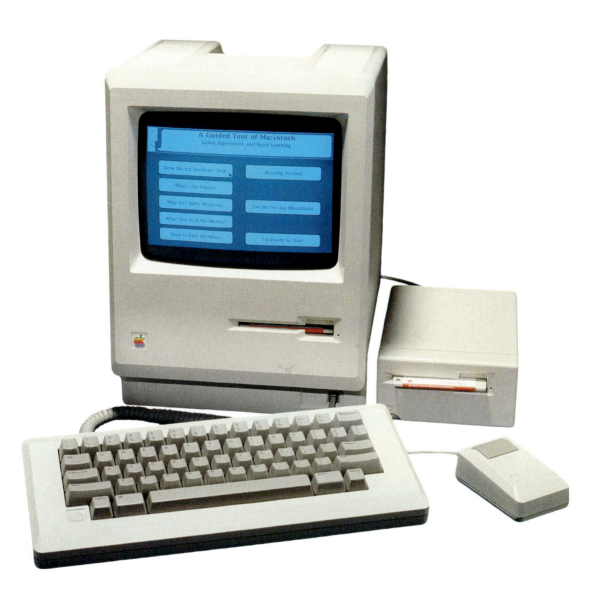

On screen:

A Guided Tour of Macintosh
Listen, Experiment, and Enjoy Learning

Show Me my Electronic Desk	Mousing Around
What's the Finder?	
Why Do I Have Windows?	Let Me Use my Macintosh!
What Else is in the Menus?	
Time to Play the Maze!	I'm Ready to Stop!

MACINTOSH COMPUTER, MODEL M0001 *National Museum of American History*

AN APPLE I
MOTHERBOARD

*Courtesy of the Computer
History Museum*

implicitly represented by Big Brother in the commercial. The IBM PC was the product of a giant corporation that had made its fortune building large, commercial mainframe computers. It was considered unfriendly to users, and depended on a software interface— MS-DOS, developed by Microsoft's Bill Gates and his partners. The IBM PC and the clones modeled on it were largely intended for office and business use, and it showed. Programmer Mitch Kapor, whose Lotus 1-2-3 spreadsheet application helped popularize the IBM PC, summarized the differences this way: "The IBM is a machine you can respect. The Macintosh is a machine you can love."

Apple came a long way quickly to develop the Macintosh. The company started out in a Silicon Valley garage with two friends, Steve Jobs and Steve Wozniak, who were both tech geeks interested in microcomputers. Wozniak had the stronger technical knowledge, Jobs a stronger sense of design, entrepreneurial deal making, and marketing skill. They had created the first Apple when Wozniak programmed an MOS 6502 microprocessor on a motherboard in BASIC and connected it to a keyboard and a screen to sell to a few hundred hobbyists. The two formed Apple, succeeded in raising money, and engineered technical improvements that led to the much more finished Apple II. While somewhat awkwardly designed, the Apple II was a completely assembled personal computer. It sold about 140,000 units in its first few years and made considerable profits. When Apple went public on December 12, 1980, the company was capitalized at $1.8 billion, netting Jobs more than $200 million and Wozniak more than $100 million.

Flush with cash, Apple developed two new computers using an innovative graphical user interface (GUI) that grew out of internal efforts as well as a project at Xerox's Palo Alto Research Center (PARC). Jobs was

convinced that GUI, with overlapping "windows," icons and cut-copy-paste editing, represented the future of personal computing and the prospect for further commercial success. One of the computers, Lisa—believed to be named after Jobs's daughter—was envisioned as a premium personal computer targeted at elite users, but it proved too expensive to succeed in the marketplace. The other, the Macintosh, was an easy-to-use computer for the average consumer. With a reasonable retail cost of about $2,500, the Macintosh was much more expensive than IBM PCs or clones, but it was much more likable.

The Macintosh was developed to be a friendly, approachable, and aesthetically pleasing machine—one with a personality that would be used for personal, creative use. It quickly acquired its nickname, the "Mac."

The Mac proved to be a critical and commercial success. Technically, in terms of processing speed and memory, it was not the most powerful personal computer of the time, but aficionados, designers, artists, teachers, and students loved it. Instead of the cumbersome, hard-to-remember MS-DOS interface, which required the user to type in cryptic commands to instruct the computer to perform particular operations, the Mac had a graphical interface that made working on it easy and highly intuitive. It simulated a desktop and had icons to click on with a cute, recently developed device

THE APPLE II *(left)* **AND THE APPLE LISA 2** *(right)*

National Museum of American History

called a mouse. It had a finder to help you navigate, and folders where you could save your work. It had a trash can where you could drag and delete unwanted work. The system software and programs were totally integrated, so you did not have to worry about various applications working. You could basically open up something like MacWrite or MacPaint and just get going.

The Mac developed a cadre of loyal followers. It sold about seventy thousand units in the first few months, which was good, but small compared to the sales of PCs. A lack of third-party applications initially limited what people could do with their Macs. In the next few years, versions featuring expanded memory and additional applications for design, graphics, desktop publishing, spreadsheets, and children's educational use made it very popular.

Jobs envisioned the Mac to be more like an everyday household or personal appliance than a piece of machinery. It also had to look cool and hip so as to reflect a certain lifestyle that for Jobs connected the technical engineering geeks of Silicon Valley to the edgy counterculture of San Francisco and the Bay Area. It had to be appealing or, as he told his engineers, "friendly." This literally meant anthropomorphizing the machine. Lisa, with a thick band of plastic over its screen, looked to Jobs like it had a Cro-Magnon–like forehead. It was short and squat and asymmetrical. The Mac screen was put above the CPU, which made it taller. It took on a human look. Its forehead was beveled back to give it a more open, cheerful appearance. The screen became its eyes. The disk drive looked like a mouth, and the beveled base a chin. The specially designed roller-ball mouse allowed a full range of on-screen movement while promoting hand and arm interactivity with the machine. The Mac thus became a physical extension of the user, and what was done through its programs became an extension of the user's mind, emotions, and creativity.

Jobs's use of clean lines, tawny ABS (acrylonitrile butadiene styrene) textured plastic casing, and simple on-screen fonts for the Mac spoke to a modernist, Bauhaus aesthetic. The Mac mirrored Jobs's own rather ascetic tastes, quirks, and proclivities, but also relieved the machine of imposing a

STEVE JOBS

PHOTOGRAPH BY

DIANA WALKER

National Portrait Gallery

specific domineering personality. It was a friendly vessel and could become whatever—or whomever—the user wanted it to be. As it turned on, the Mac welcomed users with a simple and unassuming "Hello." This feature and the Mac's futuristic clean, off-white look were reminiscent of the fictional mainframe named HAL in Stanley Kubrick's acclaimed 1968 film, *2001: A Space Odyssey*. In that classic, HAL, an obvious parody of IBM, goes rogue, rebelling against human control. While Jobs's design of the Mac did control user choice—with no plug-ins or modifications and complete hardware/software integration—it did so in a seemingly benevolent way, and the small, simple profile of the Mac, with its rainbow apple logo, belied

the thought of any hidden, ulterior technology that would usurp the user's will. Jobs brilliantly positioned the Mac among designers, artists, and counterculture types as a tool for democratizing creativity, not limiting it.

The innovations developed by Jobs and Apple for the Mac set the path for their future success. They melded advanced technology and elegantly simple design with an eye toward consumer ease of use, and developed a marketing strategy that made the product "cool." With this approach, Jobs made Apple one of the largest and most profitable companies in history and the leader in the digital revolution that transformed how billions of people communicate worldwide. The Mac laid the foundation for other enormously popular products, like the iPod and iTunes, the iPhone, and the iPad, all of which too have found their places in the Smithsonian's collections.

I t almost seems passé now, the 1990s conception of the digital age as the electronic superhighway, an idea given material form by Nam June Paik (1932–2006), a media artist and Korean immigrant to the United States. The work is comprised of 336 television video screens installed on a steel and wooden structure and organized by multicolored neon tubes in the shape of the continental United States and its individual state boundaries. At thirty-two feet wide, it takes

NAM JUNE PAIK'S
ELECTRONIC SUPERHIGHWAY

up a wall in the Smithsonian American Art Museum. A companion piece on an adjacent wall adds Alaska and Hawaii—much like an insert in a gazetteer.

A MODERN ARTWORK REFLECTS THE HIGH-SPEED, ELECTRONICALLY CONNECTED NEW AGE.

Smithsonian American Art Museum

I've walked along the piece many times and stared at many of those screens. They play a variety of images appropriate to each state, some historical and iconic, others contemporary and quite idiosyncratic. Kansas projects excerpts from the black-and-white portions of *The Wizard of Oz*. Idaho shows images of potatoes, Kentucky displays the eponymous Derby horse race, and Iowa presents the place where presidents are made. Texas shows the then-timely burning of the Branch Davidian compound in Waco after cult members held a fifty-day standoff with the FBI. Arkansas displays footage of Bill and Hillary Clinton, as well as film clips of one of Paik's early collaborators, performance artist Charlotte Moorman. Small handmade wooden signposts are suspended by wire throughout the installation and offer handwritten movie titles, like *Oklahoma!* and *Meet Me in St. Louis*. Overall, the work seems like a fanciful journey across America, connected through electric imagery and flowing neon light.

The piece was inspired by Paik's kaleidoscopic experiences as an immigrant in the United States. Paik was born in Korea, where he trained as a

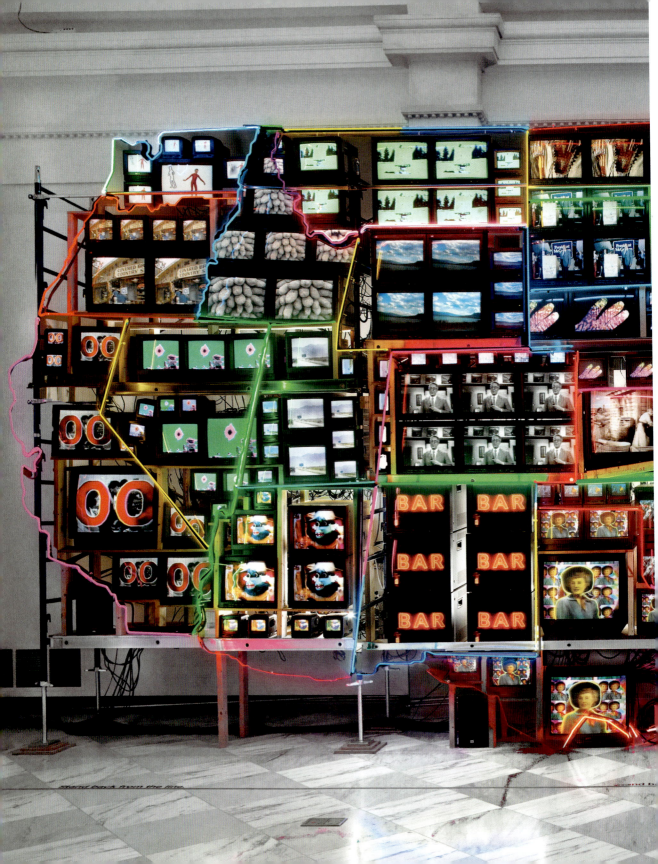

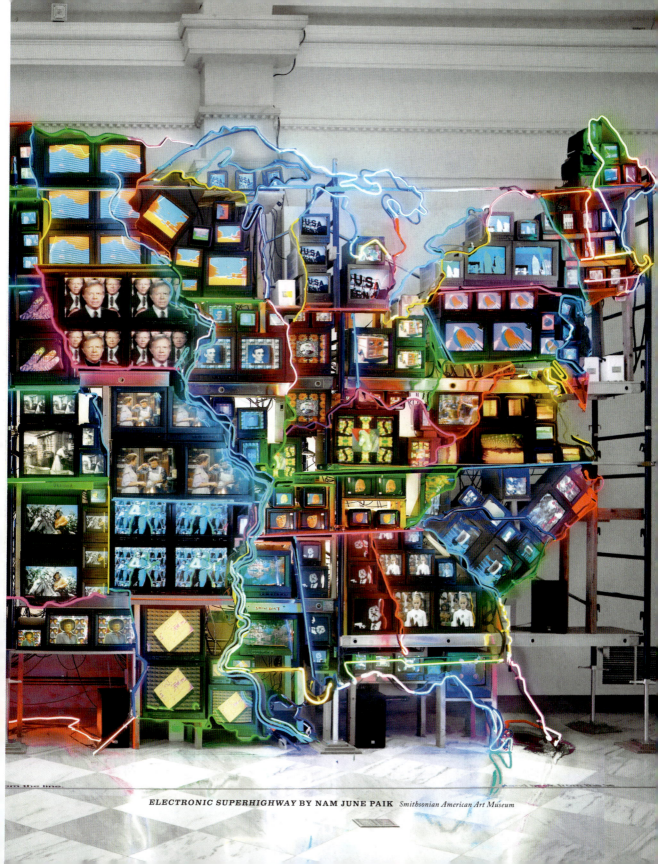

ELECTRONIC SUPERHIGHWAY BY NAM JUNE PAIK *Smithsonian American Art Museum*

classical pianist, and then, with his family, fled to Japan in 1950 during the Korean War. There he attended university and wrote his thesis on Austrian *avant-garde* composer Arnold Schoenberg, who pioneered atonal music. Paik then moved to Munich, Germany, to continue his studies. He met John Cage and Karlheinz Stockhausen, composers who were reexamining musical arrangements as well as artists starting to experiment with video and electronic art. When he moved to New York in 1964, Paik was part of an artistic movement challenging conventional media and its boundaries. His art aimed to represent the somewhat chaotic and frenetic but culturally situated flow of contemporary experience rather than objects or simple ideas.

Paik is often considered a father of video art. In 1969 he gained some notice and notoriety for the artwork *TV Bra for Living Sculpture*, representing the "boob tube." *TV Cello* stacked television sets playing cello performances in the shape of a cello. His *TV Buddha* had a sculpted Buddha figure gazing at his own image in the TV monitor as it is captured by closed-circuit video.

Paik first used the term *superhighway* in 1974 to refer to postindustrial telecommunications. His *Electronic Superhighway*, created almost two decades later, recalls Marshall McLuhan's influential idea that "the medium is the message." Paik saw new forms of electronic communication as linking the whole country, its past and future. Rather than automobiles traversing the nation's interstate highway system, electronic pulses would tie Americans together. Like the more conventional highway, the electronic form would offer an open road, great mobility, and the freedom to roam. Paik cleverly uses neon—a glowing enticement to travelers, beckoning them to new places and experiences—to form the outline of states. But instead of a linear and consistent narrative of the country and its people, Paik uses a multiplicity of images, sounds, and voices from the various states to assemble cacophonous, discordant, and diverse views into a national story.

Paik's choice of video content projected on the screens reflects this variety as well as the juxtapositions of history and cultural expressions in each state. He exposes central tensions in American society—between tradition

and innovation, nostalgia and progress. His editing style uses quick, flashing images, as might be seen through a car window passing along a highway, to suggest the speed and transience of contemporary life and experience. This fragmented cinematic presentation signals channel surfing and information overload. The piece is always on, like television and now the Internet, a constant twenty-four-hours-a-day and seven-days-a-week presence.

Paik was enthused by media of the moving image, and optimistic about their future potential. Though perhaps anxious about the content of popular television and film, he was hopeful that electronic media could be harnessed to create a national and global cybercommunity. People would be united, not by things or material objects but by the rich character of experience. The means of communication—the electronic superhighway—would define human society and provide people with the stimulation and sense of identity they once left home to discover in the larger world. Notes Smithsonian curator John Hanhardt, the piece "celebrates this country which was so important" to Paik. The idea of the electronic superhighway became a popular way to speak about and represent the digital age. Companies aspired to create its communications hubs, its technology and equipment. Political leaders called for the inclusion of people left out.

The *Electronic Superhighway* came to the Smithsonian as a gift from the artist. It was originally installed at the Holly Solomon Gallery on Hudson Street in New York City's SoHo district. Because of the limitations of the space, the piece could be only fifteen feet high. Hence Paik "folded" the southern parts of Texas and Florida onto the floor to make it fit. Even though the Smithsonian American Art Museum has higher ceilings, Paik, consulting with the museum's director, Betsy Broun, decided to replicate the original installation. One important change was made. The installation includes a closed-circuit television camera so that viewers could see themselves on a screen, thus forming part of the United States. In the SoHo installation, that screen was located in the position of New York; now Paik moved it to the neon location of Washington, D.C.

Other factors relating to the rapid advancement of technology that con-

cerned Paik have also affected his work. Projected images were originally played from laser discs. With that medium becoming obsolete, the museum transferred the program to DVD and is now moving it to a solid-state video player. Another, more pressing conservation problem is that the video screens depend upon cathode-ray-tube technology, but such tubes are now obsolete and a rarity. As they reach the end of their lifespan, the overall piece will start going dark, and eventually die. To present and maintain an artwork as originally envisioned by an artist using vintage technology takes considerable effort and expense. Curators and conservators increasingly face this challenge with all sorts of artwork, from film and video to sound recordings and multimedia installations. The technology that produced these pieces can, only with considerable difficulty and expense, be maintained or replicated to allow for the presentation of the work as intended by the artist. Museums thus struggle through the irony of permanently displaying art that by its very nature thrives on continual change. Paik would have liked that!

NEW

MILLENNIUM

(2000 TO

THE FUTURE)

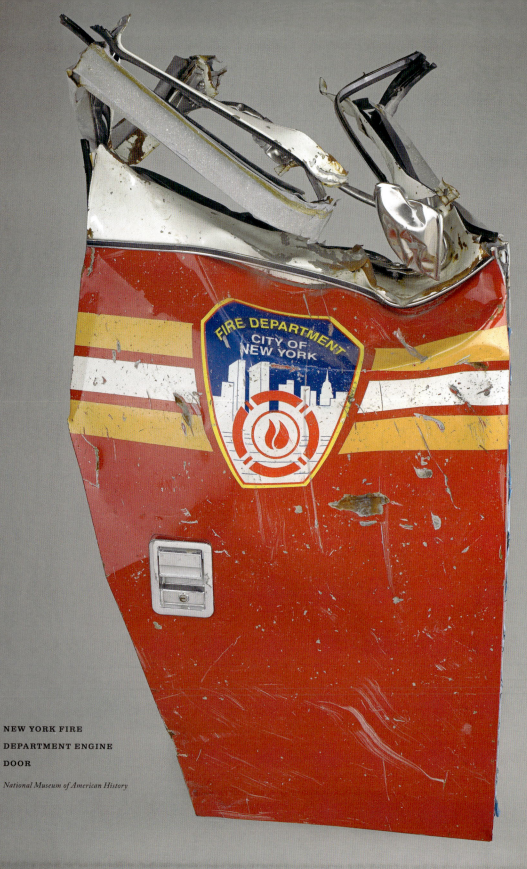

NEW YORK FIRE
DEPARTMENT ENGINE
DOOR

National Museum of American History

O n September 11, 2001, nearly three thousand Americans and people of other nationalities died in terrorist attacks at the World Trade Center in New York, at the Pentagon in Arlington, Virginia, and in a downed airliner at Shanksville, Pennsylvania. Hijackers, incited and coordinated by Khalid Sheikh Muhammed under the auspices of Al-Qaida and sanctioned by Osama bin Laden, took over four airliners on the morning of September 11. At 8:46 a.m., the hijackers crashed American Airlines Flight 11 into the North Tower of the World Trade Center; United Airlines Flight 175 was flown into the South Tower at 9:03 A.M.; American Airlines Flight 77 collided with the Pentagon at 9:37 A.M.; and at 10:03 A.M. United Airlines Flight 93 hurtled to the ground in Shanksville.

NEW YORK FIRE DEPARTMENT ENGINE DOOR FROM SEPTEMBER 11

CRUMPLED AND DAMAGED ARTIFACTS POINT TO THE TRAGEDY AND HEROISM OF AMERICA'S MOST HORRIFIC DAY.

National Museum of American History

The results were devastating. All the passengers and crew members on the airplanes perished. At the World Trade Center, thousands made their way down the stairs and survived; however, hundreds were trapped in the buildings' upper floors. Some two hundred people jumped or fell to their deaths to avoid fires caused by the crash; most of the victims died as the towers crumbled.

Ordinary citizens exhibited extraordinary heroism. On Flight 93, passengers rushed the cabin to fight for control of the plane. Their bravery succeeded in derailing the terrorists' plan to crash the plane into either the U.S. Capitol or the White House. At the Pentagon, civilians and military personnel courageously pulled their coworkers away from the flames and fumes of the jet that had crashed through the building's outer wall.

In New York, members of the police and fire departments rushed to the

scene in lower Manhattan. Hundreds entered the World Trade Center towers and climbed the stairs to rescue survivors while others treated victims on the ground. More than four hundred first responders became victims themselves when the buildings collapsed.

The staff of the Smithsonian, like all Americans, was horrified and devastated by the attack—and, given the proximity of Smithsonian museums to the targets (the George Gustav Heye Center, adjacent to New York's Battery Park, and the museums on the National Mall in Washington, D.C.), the tragedy struck close to home. We lost colleagues, friends, and loved ones.

As the nation, led by President George W. Bush and New York Mayor Rudolph Giuliani, grieved and looked for a way to understand and respond to the attacks, the Smithsonian, as the national museum, took on a very important job. We started to document the artifacts of September 11 so they could be preserved in collections and in the future help convey the impact of the events of the day. This task, which Congress later officially endorsed, was a difficult one, as recalled by Peter Liebhold, a curator at the National Museum of American History:

On Wednesday [September 13], I came back to work. I am a museum curator, so I immediately began thinking about what should be preserved—that's what we do. I made a list and shared it with others, who added their suggestions.

Some wanted to quickly assemble teams to descend on the three sites and gather ephemeral evidence of the terrorist attacks. Some were horrified by the death and destruction (we usually document high points in history) and thought we should wait ten or twenty years until it was clear what was significant . . .

There is no magic formula for collecting museum objects, but it takes a certain kind of person to do the job. Collecting curators like

to listen to stories, are willing to ask strangers for precious objects, and are doggedly persistent.

One of our most effective tools for collecting was reading the newspaper. One member of our team, David Shayt, read a story in the *New York Times* about a window washer named Jan Demczur. Trapped between floors on an elevator in the North Tower, Jan used his squeegee to pry open the door and cut through numerous layers of sheet rock and flee to safety. After numerous phone calls, David found Jan and convinced him to donate his uniform and dust-covered squeegee.

Curator Jennifer Jones worked with the 311th Quartermaster Company of Mortuary Affairs. In one of the most disturbing moments of the collecting initiative, Jennifer, Bill [Yeingst, another curator], and I spent an afternoon in a dark, claustrophobic nineteenth-century stable at Fort Myer sorting through the contents of red bio-hazard bags looking for icons of the attack. This was not like any collecting trip I had ever experienced.

One of the longest-lasting efforts was the quest for artifacts from Flight 93. After several years . . . we finally gained access to the wreckage of the plane. When we arrived at the small airport where the material was stored, we found the airplane wreckage was in twenty-foot-long ocean-going shipping containers . . . in the near dark I looked for artifacts with a flashlight and fought back fears about what I might accidentally encounter.

Collecting often requires archival research. Bill and I spent many days going through thousands of photos maintained by the FBI. From crime scene images to haunting photos shot by participants who did not survive, the pictures put a human face on the September 11 attacks. Viewing the images made the experience far more personal. What I most desperately try to forget are things I saw in the photographs.

We were very driven yet remained respectful. We never directly contacted the relatives of someone killed—we always went through intermediaries so families could easily refuse our requests. Many of our conversations with participants and donors were hours long and often included a lot of crying—us included. It is difficult dealing with death and frankly none of us were prepared for the task.

Like soldiers and their war stories, curators don't often talk about the experience of collecting. I am proud of our efforts collecting artifacts related to September 11. It is an important piece of history and should be preserved.

FUSED
COMMEMORATIVE
MEDALLIONS
FROM THE
PENTAGON

*National Museum of
American History*

Each of the items collected by Liebhold and the National Museum of American History team told an incredibly rich story.

There was a remnant of the World Trade Center's external sheathing that was recovered at the processing site at Fresh Kills on Staten Island. When the Twin Towers were completed in 1973, they were noted for their incredible 110-story height and gleaming exterior. It was the aluminum alloy sheathing that gave the buildings a golden sheen at both sunrise and sunset. Architect Minoru Yamasaki first wanted to use more expensive stainless steel, but the highly reflective alloy sheathing enhanced the towers' soaring appearance, and cemented their stature as New York City landmarks. Now they were gone.

From the Pentagon came a jumble of souvenir medallions that might have been minted to commemorate the 2001 swearing-in of Thomas E. White Jr. as secretary of the Army. The heat from the fireball and blaze of the crash was so intense that it fused them together.

One of the items that touched me deeply was the crash-scarred logbook of Lorraine Bay, a thirty-seven-year veteran flight attendant and one of the seven crew

members who perished on United Flight 93. She recorded information in the book about her flights. That morning, she and other crew members had gathered to go over their assignments. A bit earlier that morning, my sister-in-law Clarie Miller, a flight attendant for American Airlines, was at Dulles airport picking up my nephew, who had just arrived on a red-eye flight from Los Angeles. Clarie met with her friends staffing the crew of Flight 77 that would return to Los Angeles. She had worked with them for many years, and they spent some time catching up before hugging good-bye. She expected to see them again; that never happened because their flight crashed into the Pentagon.

The crumpled New York City Fire Department pumper engine door came from Squad Company 1 in Brooklyn. This is an elite group charged with responding quickly to emergency situations. The call for help went out just as the firehouse shift was changing. The squad raced across the Brooklyn Bridge to the World Trade Center. Twelve firefighters from Company 1 lost their lives trying to rescue trapped office workers from the South Tower.

Other Smithsonian museums reacted in their unique ways. At the Postal Museum, curators cognizant of the meaning of the U.S.S. *Oklahoma* hand stamp from Pearl Harbor were able to recover a hand stamp from New

York's Church Street post office, which serviced the World Trade Center. It bears the date of the attack, "Sep 11, 2001."

Years later, the Smithsonian American Art Museum was able to acquire a Roy Lichtenstein *Modern Head* sculpture associated with September 11. Lichtenstein first created his series of machine-looking humanoid heads in 1974. In 1989, the artist made four in brushed steel, one of which was later painted a vibrant blue. The Public Art Fund of New York City installed this thirty-one-foot sculpture in Battery Park City, one block from the World Trade Center. It survived the attacks with only surface scratches and was

temporarily used by the FBI as a message board during its investigations. It was removed a few months later and subsequently donated to the Smithsonian, where it is now installed on the grounds of the Reynolds Center for American Art and Portraiture in downtown Washington, D.C. It reminds me of how much the meaning of an object can change, as this sculpture, originally a commentary on the diminution of humanity, now offers a message about its endurance.

For the one-year anniversary of the attack, many of the objects collected by the Smithsonian were displayed at the American History Museum in an exhibition entitled September 11: Bearing Witness to History. For visitors, and even for our staff, seeing these items and learning their stories was hard to bear. The gallery was eerily and respectfully quiet. "History" was not some vaguely remembered facts or celebrated recollection—it was shockingly close and connected to us all. The conservators even coated a column fragment from the World Trade Center in wax so people could touch it, which tens of thousands did.

A decade later, we opened a temporary special exhibit, placing a small number of September 11 objects on tables with simple cloth coverings. The artifacts were not in cases and were directly accessible. Visitors stood in long lines and spoke in hushed tones as they approached each object. Our experts stood by to talk or answer questions; however, visitors were largely left to experience the articles on their own. Being in such intimate proximity to these historical objects was almost overwhelming. I think almost every visitor had a sacred, reverential moment. One, a teenager who had been only a few years old at the time of the attacks, said something like "I knew it was a bad thing that happened, but I guess I was much too young to really feel it. Now I do." Nothing speaks more to the museum experience than that.

Shepard Fairey's "Hope" poster became the iconic campaign image for Barack Hussein Obama, the first African American president of the United States.

Fairey (b. 1970), a Los Angeles–based graphic designer and street artist, had long designed posters and images for T-shirts, skateboards, and advertising campaigns. Born in Charleston, South Carolina, he graduated from the Rhode Island School of Design and had numerous showings of his work in New York and elsewhere. Prior to 2008, his most famous work had been an image of French wrestler André the

SHEPARD FAIREY'S *BARACK OBAMA* "HOPE" PORTRAIT

A UBIQUITOUS
IMAGE AIDS
A HISTORIC
PRESIDENTIAL
CAMPAIGN.

National Portrait Gallery

Giant paired with the ambiguous slogan "Obey."

When Obama announced his candidacy for president, Fairey wanted to support him. He thought about making images of Obama and distributing them. Not wanting to embarrass the candidate— Fairey had been arrested for his graffiti art—he consulted with the campaign. When Fairey received the go-ahead, he designed and made his first portrait in early 2008. "I wanted to convey that Obama had vision—his eyes sharply focused on the future—and compassion, that he would use his leadership qualities for the greater good of America in a very patriotic way," Fairey recalled. He found a digital photograph of Obama on the Internet using a Google image search. Fairey completed the first version quickly—a portrait of Obama with a stenciled face, upward glance, and the caption "Progress." He produced a few hundred posters, sold them, and then used the proceeds to make more.

The artist intended for the image to be widely reproduced and go viral on the Internet. Fairey's image was not an official image of the presidential candidate, but it caught on as a grassroots phenomenon and exceeded his greatest expectations.

When it did, the Obama campaign suggested "Hope" as a caption—which Fairey saw as appropriately optimistic and linked to the candidate's

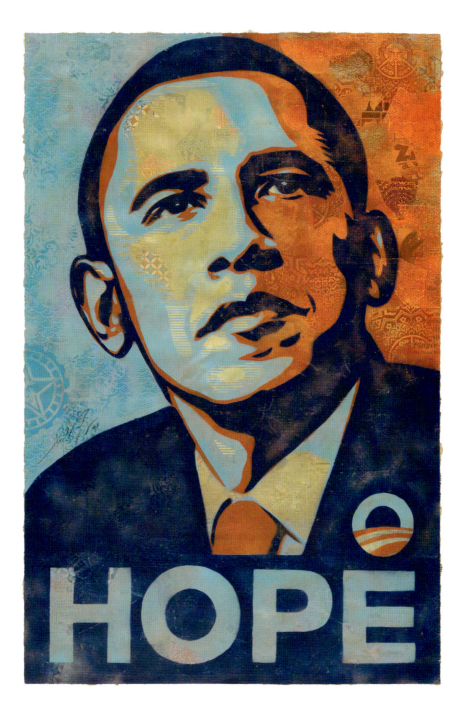

BARACK OBAMA "HOPE" BY SHEPARD FAIREY *National Portrait Gallery*

book, *The Audacity of Hope*. Fairey also used "Change" as an alternative caption. Campaign supporters and grassroots organizations disseminated tens of thousands of T-shirts, posters, and stickers. Obama supporters held up posters at campaign rallies. Fairey himself produced mural-sized versions; a free, downloadable graphic generated hundreds of thousands of copies, especially among social-media-savvy youth. While Fairey's work is suggestive of Andy Warhol's pop-art representations of celebrities, he meant his work not as ironic commentary but as social activism, his goal being to help get Obama elected.

Typically, mass-produced versions of images are based on adaptations of an original fine artwork. In Fairey's case, this order was reversed. Given the popularity of the Obama posters, hip-hop mogul Russell Simmons commissioned Fairey to produce a fine-art version.

Fairey produced three large-format collages, one for Simmons, a second for a charity auction, and a third for exhibition purposes. Fairey translated the calm, cool Obama pose onto a rich, elegant surface of decorative papers and old newsprint. The support paper is a white Coventry Rag with a vellum finish. The collage is formed with vintage newspaper clippings and silk-screened material on French Speckletone antique cream paper. Words pop up out of the newsprint: "Stay up," "beautiful," "fresh," "player," "best," all barely subliminal messages Fairey wanted to convey about candidate Obama. A gel was used as an adhesive to create a matte finish.

The artist cleverly used red for the shadow side of the face and blue for the highlight side, playing off Obama's famous speech to the 2004 Democratic National Convention that red states and blue states were all joined as the United States of America. Fairey used a number of common paints—Montana navy blue spray paint, paprika Rust-Oleum, and Arctic blue, sky blue, cream, and colonial red paints. He then sanded the surface to bring out the texture of the collage and coated it with a polyurethane stain and a final layer of Minwax. The overall effect is a vibrant, robust, rich, nuanced, and multilayered, yet subtly subdued, image of Barack Obama, an aesthetic statement that Fairey thought well matched the candidate.

One of the collages was placed with Washington, D.C., gallerist and Georgetown professor Martin Irvine, who displayed it as part of a group exhibit, Regime Change Starts at Home. National Portrait Gallery curators visited the Irvine Contemporary gallery, saw the collage, and expressed interest. Irvine then approached art collectors Heather and Tony Podesta (the brother of Obama's transition cochairman John Podesta) about buying it and giving it to the Smithsonian. The Podestas agreed, donating the piece in honor of Tony's late mother, Mary K. Podesta, shortly before the presidential inauguration in January 2009. I was organizing the Smithsonian's programs for the inauguration weekend and we prominently displayed the work in the museum.

Days later, while we were hosting an important conference titled Smithsonian 2.0, younger digerati from Facebook, Myspace, Flickr, and other organizations saw the Fairey artwork at the National Portrait Gallery. A number were amazed at both the size and the texture of the work. They had seen the image on television or on computer screens. In those media it was a bit flat and uniform compared to this work of fine art. Fairey's collage provided a good case study of the interplay between the tangible and the electronic in the digital age.

After its display, conflict over the original creation of the piece emerged. Fairey used a digital image of Obama that came from an original photograph taken by Mannie Garcie, a freelancer working for the Associated Press at the time. The Associated Press contemplated action against Fairey for using the image without obtaining the rights to do so. Fairey dubiously claimed he had taken his inspiration from another image, and then initiated legal action, asking a judge to rule that his manipulation of the Associated Press image was legitimate in terms of the fair use provisions of the copyright law. In 2011, the two parties agreed to settle and share copyright ownership, though legal action continues.

Fairey's poster was not the only image of Obama displayed by the Smithsonian during the 2009 inaugural period or accessioned into its permanent collections. Smithsonian curators were well aware of the global impact of

Obama's candidacy. The election was greeted with particular enthusiasm in Africa, above all in Kenya, the homeland of Obama's father, where the new American president was embraced as a kind of native son. Curators at the National Museum of African Art learned that traditional decorative cloths, called *kanga,* depicting Obama were being made in Tanzania for use in Kenya. *Kangas* are typically rectangular panels of brightly dyed cotton cloth used by women as wrap garments and for a variety of household purposes. The museum already had a collection of more than one hundred factory-printed cloths from all over Africa, including those celebrating African leaders and presidents George W. Bush and John F. Kennedy, and thought the addition of an Obama *kanga* would demonstrate how contemporary events half a world away are incorporated into African life. The museum acquired two examples, a blue cloth and an orange cloth, both displayed during the 2009 inaugural. *Kangas* typically have Swahili text imprinted on them, and the Obama cloths include phrases like *"Hongera Barack Obama,"* meaning "Congratulations, Barack Obama."

HONGERA
BARACK OBAMA

National Museum of
African Art

The Smithsonian also collected election ephemera and campaign material in the United States, as it has done for decades. Our collections include materials from the earliest American elections. We have mock-wood axes carried by supporters of Abraham Lincoln's campaign, along with buttons, hats, posters, and signs from just about every presidential race. The new National Museum of African American History and Culture collected material used in Obama's Northern Virginia campaign field office, including posters, banners, newspaper clippings, flyers, photographs, clipboards, maps, and whiteboards. Additionally, the museum acquired a pair of sneakers created by Cleveland, Ohio, shoe artist Van Taylor Monroe. The shoes are a pair of white Nike Air Force 1 basketball sneakers that Monroe painted over with the image of Obama's face in gray scale against a blue background. On the left shoe the message is "Yes We Can" while on the right shoe the message is "Hope." Monroe made about fifty pairs of the sneakers with variations—replacing the English phrase on some with *"Sí Se Puede,"* Cesar Chavez's Latino civil rights call meaning "Yes We Can." Monroe made a special pair for the Smithsonian, as the originals went to President Obama.

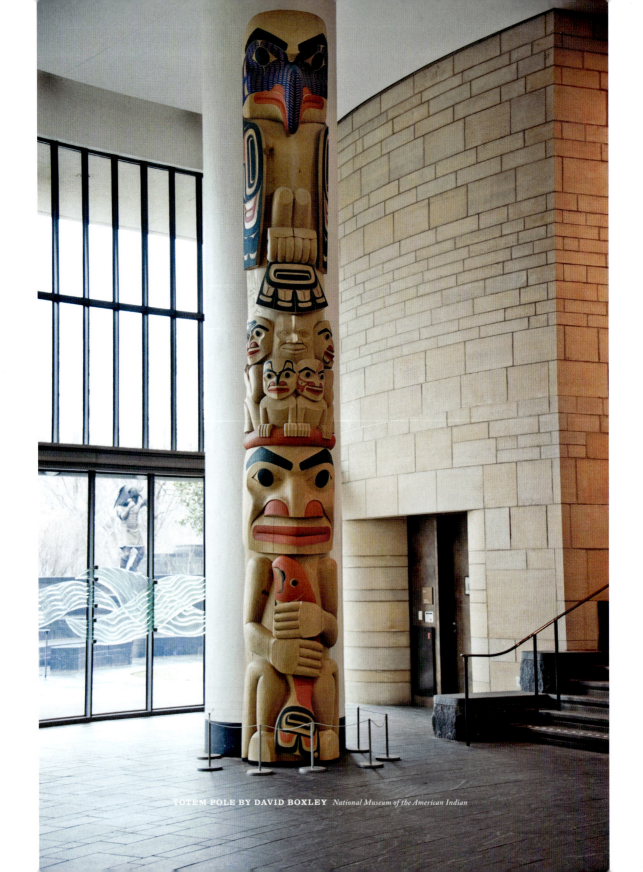

TOTEM POLE BY DAVID BOXLEY *National Museum of the American Indian*

W e are still here." This is the basic message of the totem pole carved by Alaskan Tsimshian native David Boxley and now ensconced in the atrium of the Smithsonian's National Museum of the American Indian on the National Mall in Washington, D.C.

It was also the rallying cry of the grand opening of the museum on September 21, 2004. The museum was the result of legislation introduced by Senator Daniel K. Inouye of Hawaii and Congressman Ben Nighthorse Campbell of Colorado and signed by President George H. W. Bush in 1989.

On the beautiful September morning of the opening, more than twenty-five thousand Native people from more than six hundred tribes and communities, from Inuit in the north of Canada to Suya of the Amazon rain forest and almost every place in between, strode in celebration down the Mall from near the Washington Monument to the foot of the U.S. Capitol. They were joined by about sixty thousand other supporters and well-wishers to mark the occasion, including the president of Peru, a Quechua-speaking Indian, and representatives and spokespeople of other native peoples as far away as New Zealand and India. Those rejoicing in the opening viewed the creation of the museum as a mark of respect for the resiliency, heritage, and accomplishments of indigenous people everywhere. I have never been prouder as a Smithsonian staffer and scholar than for having played a role in that museum opening.

Underlying the celebratory events and the museum itself was the idea that cultural diversity within American and world society is to be respected. People have a fundamental right to be who they culturally want to be; and people's heritage and traditions—from various forms of knowledge to particular values and worldviews—may prove helpful in living contemporary lives and developing aspirations for the future.

Such a display was unthinkable a century earlier. Spencer Fullerton Baird,

DAVID BOXLEY'S TSIMSHIAN TOTEM POLE

A CONTEMPORARY NATIVE AMERICAN ARTIST PRESERVES AND EXTENDS HIS TRADITIONAL CULTURE.

National Museum of the American Indian

then assistant secretary of the Smithsonian, proposed bringing American Indians to the 1876 Centennial Exposition so they could demonstrate the customary use of artifacts and materials that would be on display. Though President Ulysses Grant supported the idea, Congress did not agree, even if they were of the "cleanest and finest" sort.

It was not until the 1960s, following the March on Washington and the growth of the civil rights movement, that ideas for the democratization of culture caught on fully at the Smithsonian. Smithsonian Secretary S. Dillon Ripley wanted to liven up the Mall and the museums. He sought to "take the instruments out of their cases and let them sing," so he hired impresario James Morris to bring that idea to fruition. Morris hired musician and folklorist Ralph Rinzler and together they started the Festival of American Folklife in 1967 to showcase the living traditions, performing skills, knowledge, talent, and artistry of all peoples who call America home. They engaged Native American educators and scholars like Alfonso Ortiz, Lucille Dawson, Helen Schierbeck, Clydia Nahwooksy, Rayna Green, Suzan Shown Harjo, and others, like Tom Vennum and Diana Parker, to help represent the cultures of American Indians year after year at the festival. Thousands came and millions of visitors appreciated the annual public performances of music, dance, song, and ritual, as well as the demonstrations of craftsmanship, artistry, cooking, medicinal practice, and other skills.

While Native American culture found a place at the festival, and at the National Museum of American History and National Museum of Natural History, an opportunity surfaced that laid the foundation for a museum dedicated entirely to Native Americans. In the late 1980s the Smithsonian was able to acquire the George Gustave Heye collection, a private New York City museum of some 800,000 artifacts. Many in Indian country and in Congress were convinced that Native people needed a museum to tell their uniquely American story from their own perspective. Heye's treasures of Indian life from across the centuries and across the Americas, under the umbrella of the Smithsonian, could help that effort.

American Indians had been removed from their land, slaughtered, killed

off by disease, and converted. Native children had been taken away from their families and sent to missionary schools for their "own good." Their buffalo had been killed to the point of extinction. Native nations had been disappointed with broken treaties and humiliated by racist stereotypes. Yet through it all, Native people had persevered, as had some of their traditional knowledge and insight, artistry and talents. The museum could be a place to show not only the past but how Native people draw upon their culture to define and redefine their place in the world.

Smithsonian Secretary Robert M. Adams appointed Richard West as the founding director of the museum in 1990. West spent more than a decade in consultations with Native peoples throughout the hemisphere and working with hundreds of collaborating tribes, donors, scholars, educators, artists, and architects, as well as a committed board and a dedicated staff, to build the museum and its programs.

There are ancient items in the museum, including artifacts of the Incas, the Maya, and the Aztecs; stone tools from the Native peoples of the Caribbean; drawings and dresses, weavings and baskets, of Indians across North America. There are also new things, from Fritz Scholder's contemporary paintings to Ben Nighthorse Campbell's handmade jewelry. There is Brian Jungen's inventive sculpture made from golf bags and sneakers inside, and massive adobe sculptures gracing the museum's grounds outside. The museum also displays three gifts from astronaut John Herrington, the first American Indian to walk in space and visit the International Space Station. Herrington, an aeronautical engineer with NASA's space shuttle program, donated a special Chickasaw flag, an eagle feather, and a flute that he carried into space. David Boxley's totem pole joined this array in 2012.

Totem poles among the coastal tribes of the Pacific Northwest have long been recognized for their traditional importance in conveying the identity of a family or a clan through carved and painted images, typically of animals supernaturally related to the kinship group. The poles would stand outside a communal house and usually tell a story—like an origin myth, or a particularly poignant episode in the history of the group. The Smithsonian

was among the first museums to send collectors into the Pacific Northwest. Throughout the 1870s, the Smithsonian's Spencer Baird worked to ensure that the institution would gather the finest artifacts. Collections like these found permanent support through the Smithsonian's Bureau of American Ethnology, which became a driving force in the study and research of Native American tribes from the late nineteenth century and into the middle of the twentieth century. Other museums, most notably the American Museum of Natural History in New York, followed suit in the late nineteenth century with the collections and research work of scholars like Franz Boas, a seminal figure in the founding of American anthropology.

Kevin Gover, West's successor as the director of the museum, thought the institution needed a contemporary totem pole in order to show the continuity of the living tradition. After viewing Boxley's work at the museum's annual Native arts fair, Gover commissioned him to make one.

Boxley is a highly reputed Native artist and carver who lives on the Alaskan island of Kingston, near Ketchikan. He was raised largely by his grandparents and became interested in art as a youngster. He became a schoolteacher and learned totem pole carving after becoming entranced by Native traditions. Asked why, he says that the culture was disappearing and he had to help make sure it survived. "My mother's generation was punished for speaking their own language, sent off to boarding schools and made to feel ashamed of who they were," he says. "I have to reach back, past my mother's generation to my grandfather's and even past that."

Boxley is proud to be Tsimshian and thought himself "very fortunate to be a part of the culture that means so much to our people." He realized that traditional art was embedded in local ceremony and had been harshly impacted by changes affecting the community. He learned his art largely on his own by studying old designs and visiting museums. Now he has made about seventy totem poles and acquired an international reputation. He has made totem poles for fellow Tsimshian, and is most proud of one he made for his grandfather's house. But in a shift from the traditional context, he has also made them for organizations, corporations, and collectors. He has

made other items as well, such as masks for his Native dance group and a speaker stick for the 1990 U.S.–Soviet Union Goodwill Games, which was used in place of a more conventional torch. The speaker stick is a traditional item that indicates who gets to speak in an assembly, and it was carried at the Goodwill Games by American Indian runner Billy Mills, an Olympic gold medalist.

Boxley's Smithsonian totem pole started out as a 3,000-pound, 22-foot-long log of a 500-year-old red cedar that he and his son prepared, carved, and transported to Washington to finish and paint in the museum's atrium in front of the visiting public. The carved motifs on the totem pole tell a story from Boxley's own clan. A young boy was walking along a beach when he came upon an eagle entangled in a fishnet. The boy freed the eagle (top motif) and it flew away. The boy grew up to become the chief of his village, which was struck by a famine that threatened its people (middle motif). As he walked along the same beach wondering what to do, a salmon fell out of the sky and landed at his feet, providing sustenance for his people (bottom motif). He looked up and saw the eagle he had rescued years before. "He didn't realize that the eagle was a *nax-nox*. In my language that means spirit guardian, a supernatural creature," said Boxley. "The moral of the story is that one good turn deserves another."

Just as Boxley creates designs for his totem poles based upon traditional motifs, he also adapts tools and supplies to serve similar cultural purposes. He uses store-bought latex paints rather than making them from natural pigments, which were traditionally composed of copper oxide and charcoal mixed with salmon eggs and fixed with urine, because they are easier to obtain and the color lasts longer.

Boxley recognizes the important role his carving plays in encouraging Tsimshian youth to embrace their culture. He has seen a real upswing in Native attitudes over the years. "There's few of us," he said, "but we're alive and well."

Gover understands the role of the museum in this effort. "We're saying that here in the capital city of the United States of America there is a place

for traditional Native art. And to the extent that any aspiring artist is out there wondering whether they should pursue it, we hope we're sending the signal that it's valuable, it's meaningful, and we want it."

To underscore the point, when Boxley and his son were finishing up the totem pole at the museum, he noted that Tsimshian back home were watching their work via Webcam and seeing images of the totem pole on the museum's Web site. It was an amazing cultural commentary on the accessibility of Native culture in a digital age. "They've been calling and e-mailing and saying how proud they are . . . and it chokes me up to know that," the artist reflected.

T his book begins with the geological formation of North America and the small multicellular creatures that give us insight into the basic biological processes of life on this planet. The book's last object enables us to look outward into the enormity of time and space, toward other planets, and perhaps other life in the universe. The object is the Giant Magellan Telescope currently being constructed with the Smithsonian's leadership. It is the most futuristic of objects, the product of our super computer-enabled advanced knowledge of astrophysics. Yet it speaks to one of the most ancient impulses of the human species:

GIANT MAGELLAN TELESCOPE

A TELESCOPE BEING BUILT IN CHILE WILL ALLOW UNPRECEDENTED HUMAN EXPLORATION OF THE UNIVERSE.

Smithsonian Astrophysical Observatory

to look toward the heavens and imagine the significance of everything "up there" for all of us "down here."

The telescope, in enabling us to look so far out into space, also allows us to look back in time. Light travels at about 186,000 miles per second. When we look up in the daylight sky, we are not seeing the sun as it currently is but as it was about eight minutes ago, since it takes that long for the light radiating from this familiar star to travel 93 million miles to Earth. Similarly, when the Giant Magellan Telescope (GMT) receives light waves from the depths of the universe, those waves will have originated from points as far as 76 sextillion (76,000,000,000,000,000,000,000) miles away. It will have taken those waves some 13 billion years to arrive on Earth, meaning they left their source about a billion years after the big bang, and roughly 9 to 10 billion years *before* Earth even formed. Hence, this last object actually enables us to witness time long before—billions of years prior to—the formation of the Burgess Shale fossils, the first object in the book!

The Giant Magellan Telescope will not fit into a Smithsonian museum. It is instead being built high in the Atacama Desert region of Chile, eighty-five hundred feet above sea level on Las Campanas Peak. Its clear, dry air and its isolation from human civilization make it an ideal location for as-

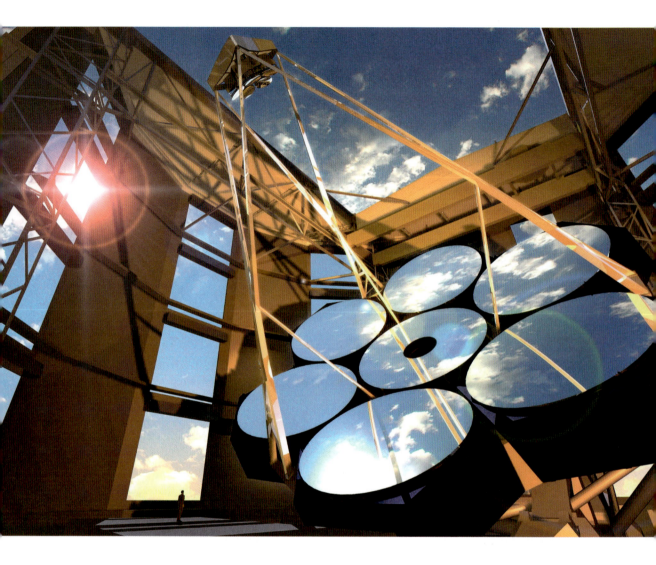

CONCEPTUAL RENDERING OF THE GIANT MAGELLAN TELESCOPE

Smithsonian Astrophysical Observatory

Image courtesy of GMTO Corporation

tronomical observations. The telescope's final price tag will come in at more than $700 million to design and build, and around $35 million more per year to operate. The Smithsonian Astrophysical Observatory is central to the effort to complete the project and formed a consortium with other organizations specializing in astrophysics research, including Harvard University, the Carnegie Institution for Science, the University of Chicago, the University of Arizona, the University of Texas at Austin, Texas A&M University, Korea Astronomy and Space Science Institute, Australian National University, and Astronomy Australia Ltd.

Astronomy for the Smithsonian in a sense predates its formal founding. Congress's debate as to how James Smithson's bequest should be allocated carried on throughout the 1830s and 1840s. John Quincy Adams, who sponsored the legislation that established the Smithsonian, suggested that the institution be an astronomical observatory. Adams had also been a supporter of founding such an observatory at Harvard in the early 1820s. Without enough financial support, however, that idea languished until the 1840s, when a group of investors came together and built a fifteen-inch telescope known as the Great Refractor, thus establishing the Harvard College Observatory. That telescope became the finest and most significant telescope of its day.

The Smithsonian Astrophysical Observatory was formally founded in 1890 by Secretary Samuel P. Langley, and was housed in a shed behind the Smithsonian Institution Castle. Langley was the leader of the "new astronomy," which successfully advanced from mere observation of the positions of celestial bodies to scientific interest in measuring their composition and understanding their properties. Langley used a small portable refractor for celestial observation and heliostats to study solar radiation. He was succeeded as observatory director by Charles G. Abbot, who established observation stations in the United States, South America, and Africa to continue solar research. In 1955, the Smithsonian and Harvard University forged a new relationship when the Smithsonian Astrophysical Observatory moved to Cambridge, Massachusetts, and Harvard's astronomy chairman, Fred

Lawrence Whipple, became its first director. This led to the establishment of the joint Harvard-Smithsonian Center for Astrophysics in 1973 as well as a coordinated research program. This collaborative effort has produced major scientific successes ranging from the detection of the Soviet satellite Sputnik in 1957 to astronomical experiments, meteoritical and cometary studies, and explorations of theoretical astrophysics. The Smithsonian's partnerships do not end there, however; the Astrophysical Observatory operates the Multiple-Mirror Telescope with the University of Arizona on Mount Hopkins and the Submillimeter Array atop Mauna Kea in Hawaii. It also supports major NASA missions, such as the Spitzer Space Telescope and operates the Chandra X-ray Observatory. With Harvard, the Smithsonian is a partner in the Magellan Telescopes in Chile—the precursors to the Giant Magellan—and continues to care for the old Great Refractor on the Cambridge campus.

Research projects have enabled Smithsonian, Harvard, and collaborating scientists to discover the acceleration of the expanding universe, the structure for the distribution of galaxies, evidence of black holes, and the existence of other planets beyond our solar system.

The expectation is that the Giant Magellan Telescope will improve scientific understanding of exploding stars, supernovas, and gamma-ray bursts. It will enable astronomers to image planets in orbits around other stars, and help astrophysicists determine their chemical composition. It will also help scientists probe black holes in unprecedented detail and test theoretical models of such little understood phenomena as dark energy and dark matter.

The Giant Magellan Telescope is scheduled to become operational in 2020—twenty-twenty being an apt metaphor for perfect sight. It is designed to be one of the world's largest optical telescopes, allowing scientists to capture light ranging from the near ultraviolet through the visible to the infrared part of the electromagnetic spectrum. The telescope will consist of seven 8.4-meter diameter segments (each about 28 feet across) configured with six of them surrounding a central segment. Each of the segments

consists of a cast and polished mirror. Segments are coordinated and calibrated through the use of complex instrumentation and computer software enabling them to work together as one extremely large 80-foot-diameter telescope. This will provide astronomers an unprecedented surface for collecting light from stellar observations. Scientists will be able to see faint objects that are unobservable today. So powerful will the GMT be that it could allow one to see the equivalent of a candle flame on the Moon.

The success of the Giant Magellan Telescope, like other optical telescopes before it, depends upon the quality of its mirrors. The GMT's primary mirrors are being made at the Steward Observatory Mirror Lab in Tucson, Arizona, in a manner requiring the most advanced engineering and glass-making technology. A huge mold, filled with twenty tons of Ohara E-6 borosilicate, is placed in a giant rotating oven, where it is "spin cast" at a peak temperature of 2,150 degrees Fahrenheit. The oven spins at a few rotations per minute, creating a natural parabolic shape in the glass. The mold is itself honeycombed, which means the mirror is mainly hollow, and thus weighs about one fifth of what it would otherwise weigh if solid. After cooling, the mirror is polished and must conform to within one millionth of an inch of the shape required. Polishing is done by a computerized machine that looks like a high-tech Zamboni on an ice-skating rink.

The first of the segments was cast in 2005; its precision polishing took several years to complete. When all the large mirror segments are fabricated, each weighing about eighteen tons, they will be installed in a massive fifteen-story, thousand-ton superstructure on the Chilean mountaintop. The light from the seven primary mirrors will be reflected off seven smaller secondary mirrors, and down through a hole in the central segment of the telescope, where it will be captured by advanced digital-imaging cameras and spectrographs. The concentrated light will be analyzed to determine the distance and chemical composition of the radiating object. Computer programs will provide "adaptive optics," essentially removing the blurring effect of viewing the skies through Earth's atmosphere. The resultant images, which can be viewed on a screen and photographed, will be about

ten times sharper than those currently obtained by the Hubble Space Telescope—at this time the most advanced extraterrestrial instrument we have. It will then be up to astronomers, astrophysicists, geologists, and others to interpret those images.

The Giant Magellan Telescope will provide a new celestial window on the much larger universe. This magnificent telescope will tell us much more about our planet—and, no doubt, many new ones. This latest Smithsonian effort promises to open many new chapters in the history of our nation and the world, and help answer the most profound human questions we have: Where are we? How did we get here? Where might we be going?

There are so many great things, important things, fun things, that tell the story of American history in the collections of the Smithsonian that are not included in this selection of 101 objects that we could fill up many more books with the next 101, and the next, and so on.

Our Smithsonian curators know this. When we started, the National Museum of Natural History sent over a list of more

WHAT'S NOT INCLUDED?

than one hundred items to be considered just from its own collections—and it wasn't the only museum to do so. The National Portrait Gallery has portraits of many thousands of people important in American history, and kindly made an annotated and illustrated list for me. My colleagues at the National Postal Museum said they had a stamp for everything—which they do—along with many other artifacts and artworks. The Archives of American Art came up with materials from its fabulous collection—diaries, drawings, doodles, and photographs that could supplement many of the likely objects to make it into the book. In a similar vein, the archives of the Center for Folklife and Cultural Heritage, with its Folkways collection, said it had a song for every major event.

Many objects I thought I might include are not here. For example, I initially wanted to feature Benjamin Franklin's printing press—what better symbol of colonial America's struggle for freedom? And besides, Franklin always identified himself as a printer. But the press we have at the Smithsonian might have been the one he used as a young man in England—maybe not the best illustration of the principle. We had just acquired his suit of clothes, so characteristic of his image, but when compared with his walking stick, I had to go with the latter, given the better story it told of our nation's dedication to liberty.

I thought the teddy bear—the endearing stuffed animal named after

Teddy Roosevelt—would make it in; it didn't. My wife lobbied for the inclusion of the monarch butterfly—what a great story it tells of species migration, of the changing ecology of North America and research. But since I had already been convinced to use Martha the passenger pigeon, the monarch seemed somewhat redundant and lost out.

Despite some heavy curatorial lobbying, Barbie didn't make it in. That decision was perhaps balanced by the fact that a Superman comic book or baseball cards of Willie Mays, Mickey Mantle, Hank Aaron, and Roberto Clemente didn't make it either.

In general, I would have liked to include more objects of everyday America—the pots and pans of kitchens; items of the factory, farm, port, office, and shop. I thought an early American census jug would be good—showing both early manufacture and the growth of the country—but we just ran out of room. More stamps, coinage, and money would have helped document the practical and fiscal systems that made the country work—and I was tempted to include some of those exemplary items we have at the Smithsonian: an 1804 silver dollar, a rare 1933 gold double eagle, and a $100,000 bill.

I would have liked to feature more folk art indicative of the grassroots artistry and diversity of America—wonderful Hispanic weaving and santo carvings from the Southwest, Pueblo pottery, Native baskets, New England scrimshaw, as well as the more recent story scroll cloths made by Hmong immigrants documenting their journey to the United States from Southeast Asia. We considered a number of objects documenting immigration, migration, diaspora, and exile. These included a beautifully crafted square piano made by a German immigrant to Cincinnati in the 1830s and a Hibernia Fire Company hat made by Irish immigrants to Philadelphia in the early nineteenth century; a silk Torah mantle brought by Jewish immigrants drawn by the Gold Rush to the Congregation Emanu-El in San Francisco and a wine label illustrating Italian heritage that helped brand Mondavi family wine in the early twentieth century. All of these items reflected on the ways in which immigrants affected and contributed to the larger civic

life of the nation. We thought of using photographs of arrivals at Ellis Island, a set of instructions in Chinese created to aid immigrants through Angel Island, and a makeshift Styrofoam boat that helped bring refugees fleeing Castro's Cuba to Florida's shores to illustrate how places like New York, Boston, San Francisco, and Miami became magnets in the United States for people seeking freedom and opportunity. We ended up telling this important story of the varied peopling of America through a number of other objects.

I seriously considered four sculptures that didn't make it in. One was Horatio Greenough's 1840 sculpture of George Washington, representing the first president as a half-naked Zeus. The second was *America,* a copy of a large sculpture made in London in 1864, featuring a bison, Native Americans, and a female America or Columbia, that was installed in the Smithsonian Castle in the nineteenth century. The third was Luis Jiménez's *Vaquero,* an energetic and colorful sculpture of a Mexican American cowboy atop a blue horse, exhibited outside the Donald W. Reynolds Center in downtown Washington, D.C., which offers a lively contrast to the city's somewhat staid equestrian statues. The fourth was the drawings, plans, and documentation of Christo and Jeanne-Claude's *Running Fence,* a fabric fence installed in the 1970s along the California countryside and down to the sea, which drew attention to our relationship with the environment.

I would have liked more art in general—a Civil War work of Winslow Homer, a Harlem Renaissance painting by William H. Johnson, an image of the Southwest by Georgia O'Keeffe, and a painting of Depression-era work by one of the New Deal artists. I would have liked to include a Jackson Pollock, not only because he pioneered abstract expressionist art and an innovative technique but also because he had been influenced by traditional Native American aesthetics—which he studied in his collection of Smithsonian ethnographic reports.

Inclusion of more sports equipment, trophies, medals, uniforms, and photographs could have told the story of people like Jim Thorpe, Jesse Owens, Jackie Robinson, Billie Jean King, and Kerri Strug, who not only

excelled as athletes, but through their accomplishments and character gave our nation cherished, even heroic, moments. I would have liked to include more items that have entertained the American people and given them joy. We seriously considered the sheet music of Duke Ellington, the Howdy Doody puppet, a sparkling portrait of Lucille Ball, Selena's costume, and a number of other pop culture icons.

Some of my colleagues advocated for more scientific apparatus. I tried to include Einstein's pipe, as a way into his beloved genius and service to his adopted country. We looked for something from the Panama Canal to show U.S. engineering prowess, but failed to find the right object.

Since Washington is a political town, I thought we might have more on political campaigns and programs. The Smithsonian has a superb collection of campaign buttons and memorabilia dating back to early presidential elections. We were interested in more recent material as well, and almost included the mangled file cabinet of Dr. Lewis Fielding, which once contained the files of his patient Daniel Ellsberg, who had leaked the Pentagon Papers, a classified history of the Vietnam War, to the *New York Times*. The cabinet was broken into by "the Plumbers," whose later Watergate capers brought down a president. We also considered the Contract with America—yes, the actual copy donated to the Smithsonian by Newt Gingrich.

I suppose the simple answer for what is not included in the book is "a lot." But if there is any saving grace, it is that this book is just the mere tip of the iceberg. Each and every object at the Smithsonian tells a story, reveals something interesting, and helps us understand a bit of who, where, and how we are. Fortunately, our museums continue to collect and be ever more inclusive—because our history will continue to be made, and we and our successors will have many more stories to tell.

The Smithsonian's collections have been accumulated over the course of more than a century and a half. Often objects are used today in ways that their original collectors could never have imagined. This is why the Smithsonian employs hundreds of scientists and scholars, and why hundreds of fellows from across the globe come to the Smithsonian to pursue their graduate and post-graduate research studies. New technologies such as electron microscopes,

OLD THINGS, NEW STUDIES

CAT scans, and DNA analyses, coupled with scholarly curiosity and new partnerships, enable us to glean new information from the objects in our collections. Old collections can be used to help answer new questions or test emergent theories.

Consider for a moment the bird collections at the Smithsonian. Stimulated by the work of Spencer Baird in the mid-nineteenth century, specimens were collected to document the full range and characteristics of birds in America and then around the world. As evolutionary studies progressed, scientists examined the physical traits of specimens to understand various adaptive processes. When the collection was formed, no one knew about DNA analysis. The bird specimens now provide a literal archive of DNA and allow scientists and evolutionary biologists to examine the genetic codes of these samples to try to determine how different species developed.

Having the collection helped launch the field of forensic ornithology. Today, "bird strikes" occur when aircraft hit birds, as happened, for example, with the "miracle on the Hudson," when a plane took off from LaGuardia Airport in New York, hit a flock of birds, and, thankfully, made an emergency landing in the East River, with all aboard surviving. In that case as well as others, the airline sends the remains of these bird strikes to the Smithsonian, where one of my colleagues, the aptly named Carla Dove,

and her team use the extensive bird collection in the National Museum of Natural History as a reference to identify the species and subspecies of the birds hit. This information aids the authorities in planting vegetation and adapting the airports to keep specific kinds of birds away.

Having collections with great time depth also enables longitudinal studies. When the United States built the Panama Canal, the Smithsonian undertook a biological survey, collecting flora and fauna, based on which its scientists anticipated tremendous, irrevocable changes to the ecosystem, including the diminution of species on account of the linking of the Atlantic and the Pacific watersheds through the canal. Conducting a restudy almost a hundred years later, a team led by Eldredge "Biff" Bermingham, now the director of the Smithsonian Tropical Research Institute, unexpectedly found that the diversity of fish species had increased. In another case, when the BP oil spill occurred in the Gulf of Mexico in 2010, to help determine the impacts, Smithsonian scientists were able to provide some baseline data about the species typically found in the affected area because we had collections of aquatic and marine life dating back decades.

In the historical and cultural area, Smithsonian researchers bring all sorts of technologies to the fore in reexamining collections for clues about how people lived. One of our physical anthropologists, Bruno Froelich, has subjected skeletons of prehistorical and early historical cultures to CAT scans. This has led to knowledge, for example, that such populations exhibited diseases like arterial sclerosis. That being the case, medical researchers now know they have to look for the disease's causes not just in modern-day factors but in those that extend back in time. Archaeologists at the Smithsonian use various dating techniques, such as AMS (accelerator mass spectrometry) radiocarbon and Strontium-90, and powerful electron microscopes to study human, vegetable, animal, and inorganic remains to reveal new knowledge about evolution and the adaptation and development of various prehistoric societies. Our archaeologists have examined artifactual remains from Newfoundland to understand the early Viking settlement in America, while physical anthropologists have examined human remains at

Jamestown and other early European settlements to help paint a picture of diet, living conditions, disease, and other factors in colonial life. Indeed, Doug Owsley, a physical anthropologist in the National Museum of Natural History, was able to determine that residents of Jamestown resorted to cannibalism during the "starving time" winter of 1609–10 by examining the knife-cut impressions left on the recently unearthed skull of one of the unfortunate teenage colonists.

Items in the collections are frequently being rediscovered and examined anew. Our philatelic curators and researchers have been using high-powered microscopes and new chemical analytic techniques to reconstruct the inks and processes for printing stamps in nineteenth-century America. When conservators were working on the Wright *Flyer* and preparing it for reexhibition, they were able to examine in detail the way Orville and Wilbur had repaired and replaced certain parts after the flights at Kitty Hawk. This revealed more about how they conceived of flight. Art Molella and his colleagues at the Smithsonian's Lemelson Center for the Study of Invention & Innovation have examined different versions of products made by inventors—from the Edison lightbulb to the electric guitar—with the view of understanding the processes of innovation such as testing and feedback in the development of an invention.

New research and findings sometimes develop as a result of partnerships and technological advances, as, for example, occurred with the Smithsonian's Carlene Stephens and her group. They teamed with scientists and computer technicians at the Library of Congress and the University of California's Livermore Laboratory, and were able to recover the long-lost sounds of Alexander Bell's recordings from the late nineteenth century by reading grooves in the media with an optical laser and turning them into digital audio files. Sometimes new historical revelations result from hearing family folklore and oral traditions, such as was the case in finding the inscriptions in Abraham Lincoln's watch.

Reexaminations of our art collections also provide new insights. Art historian Ellen Miles and her team were able to examine paints and painting

techniques to establish the order and authenticity of Gilbert Stuart's paintings of George Washington. Art historian Eleanor Harvey has undertaken a masterful study of Civil War–era art. She has been able to combine examination of specific paintings with the letters, diaries, and other information generated by the soldiers and civilians present at the historical scenes depicted. What emerges is the way in which painters like Winslow Homer and others used the landscape—rolling hills, the starry or stormy sky, fields of flowers and crops—to aesthetically encode the aspirations and horrors of the war. As a result of her work, we can now view these paintings through a new, enlightened lens.

While the collections of the Smithsonian can appear static to the casual museum visitor, just so much "stuff" to keep, store away, and sometimes exhibit, they are anything but. They provide a source of primary data about America's and the world's natural and human history. They are critical to our understanding of that history and its processes. The challenge for the Smithsonian and all museums with such collections is to be able to take care of them, preserve them, and ensure that high-quality scholarship can be applied to them so that they might reveal new knowledge that can enlighten, excite, and inspire us, and future generations.

OBJECT SPECIFICATIONS
AND PHOTOGRAPHIC CREDITS

Unless otherwise specified, all objects of the Smithsonian are photographed by the Smithsonian Institution.

JACKET

Detail from Star-Spangled Banner. Smithsonian Institution, National Museum of American History, Kenneth E. Behring Center.

INTRODUCTION

12 Gold sovereign, Great Britain, 1838, American Type Founders Company, gold, dia. 0.866 in. (22 mm.), weight 0.28152 oz. (7.981 g.). Smithsonian Institution, National Museum of American History, Kenneth E. Behring Center, cat. no. 85.441.1579, accession 1985.0441. Transferred from United States Mint 1923.

17 James Smithson's crypt. Smithsonian Castle. Photograph by Eric Long, Smithsonian.

BEFORE COLUMBUS

1. BURGESS SHALE FOSSILS

20 Burgess Shale fossils, British Columbia, Middle Cambrian, Smithsonian Institution, National Museum of Natural History: *Aysheaia pedunculata*, Walcott, 1911, size range 1–6 cm., cat. no. 235880; *Marrella splendes* (possible arthropod), Walcott, 1912, size range 2.5–19 mm., cat. no. 2266619; *Hallucigenia sparsa* (onycophoran), Walcott, 1911, size range 0.5–3 cm. long, cat. no. 83935; *Oleanoides serratus* (trilobite), cat. no. 58588b; *Canadia spinosa (Anelid)*, Walcott, 1911, size range 2–4.5 cm., cat. no. 83929c; *Waptia fieldensis*, Walcott, 1912, size usual length 7.5 cm., cat. no. 83948e; *Ehmaniella burgessensis*, size range up to 27.5 mm., cat. no. 116246a. Photographs by Chip Clark, Smithsonian.

24 *Pikaia gracilens*, chordate, British Columbia, Middle Cambrian, Walcott, 1911, size averages about 4 cm. Smithsonian Institution, National Museum of Natural History, USNM 83940b. Photograph by Chip Clark, Smithsonian.

2. BALD EAGLE

26 Bald eagle. Smithsonian Institution, National Zoological Park. Photograph by Jessie Cohen, Smithsonian.

28 Crest hat in the form of an eagle, 1860–1880, Chilkat Tlingit, wood, abalone/haliotis shell, paint, 6.889 x 14.606 in. (17.5 x 37.1 cm.). Smithsonian Institution, National Museum of the American Indian, cat. no. 11/2947.

29 Great Seal of the United States of America, obverse/front. Original displayed in the Exhibit Hall of the Department of State, Washington, D.C.

3. CLOVIS STONE POINTS

32 Clovis stone points, Drake Cache, Colorado, United States. Smithsonian Institution, National Museum of Natural History, top row, left to right, cat. nos. A561339, A561337, A561329, A561332, A561331, A561338, and A561340; bottom row, left to right, cat. nos. A561327, unnumbered, A561328, A561330, A561333, and A561334. Image by Marcia Bakry, Smithsonian.

35 Cast of a flint spearhead, Ridgley Whiteman, Curry County, New Mexico, United States. Smithsonian Institution, National Museum of Natural History, cat. no. A341725-0, accession: 104449.

4. MISSISSIPPIAN BIRDMAN COPPER PLATE

38 Copper plate (human figure), Etowah, 1300–1375, Cartersville, Bartow County, Georgia, United States, repoussé sheet copper, 12.9921 x 9.44882 in. (33 x 24 cm.). Smithsonian Institution, National Museum of Natural History, cat. no. A91117, accession: 014255.

NEW WORLD

5. CHRISTOPHER COLUMBUS'S PORTRAIT

44 Christopher Columbus, unidentified artist, 1584, Paris, France, engraving on paper (from André Thevet's volume of collected biographies, *Les Vrais Pourtraits et Vies des Hommes Illustres*), sheet: 12⅝ x 8⅞ in. (32 x 22.5 cm.), mat: 18 x 14 in. (45.7 x 35.6 cm.). Smithsonian Institution, National Portrait Gallery, object no. NPG.2009.78.

47 *Portrait of a Man, Said to Be Christopher Columbus* (b. 1446–d. 1506), Sebastiano del Piombo (Sebastiano Luciani) (Italian,

Venice (?) 1485/86–1547 Rome), 1519, Italy, oil on canvas, 42 x 34¾ in. (106.7 x 88.3 cm.). Metropolitan Museum of Art. Gift of J. Pierpont Morgan. © The Metropolitan Museum of Art, image source: Art Resource, NY.

49 Christopher Columbus single, Mint, 1893, United States of America, paper, ink (black), engraving, 1 x 1½ in. (2.54 x 3.82 cm.). Smithsonian Institution, National Postal Museum, object number 1980.2493.1645.

6. SPANISH MISSION HIDE PAINTING OF SAINT ANTHONY

52 Hide painting of Saint Anthony of Padua, Franciscan B, 1720, United States, New Mexico, Tesuque, painting, hide, tanned, paint, 20½ x 15⁵⁄₁₆ x ³⁄₁₆ in. (52 x 39.5 x 0.5 cm.). Smithsonian Institution, National Museum of American History, Kenneth E. Behring Center, cat. no. 176401, accession: 31785. Gift of Dr. J. Walter Fewkes.

7. POCAHONTAS'S PORTRAIT

57 Pocahontas, illustration in *Baziliogia, a Booke of Kings*, London, Compton Holland, 1618, Simon van de Passe, 1616, engraving, image: 6⅞ x 4¾ in. (17.5 x 12 cm.), book (open): 11¼ x 13 x 5 in. (28.6 x 33 x 12.7 cm.). Smithsonian Institution, National Portrait Gallery, object no. NPG.77.43.

59 Matchlock musket, about 1650, Massachusetts, United States, 10 x 63.5 x 3.25 in. (25.4 x 161.29 x 8.255 cm.). Smithsonian Institution, National Museum of American History, Kenneth E. Behring Center, cat. no. 43435, accession: 164794.

60 *Nova Britannia: Offering Most Excellent Fruites by Planting in Virginia. Exciting all such as be well affected to further the same* (printed for Samuel Macham, and are to be sold at his shop in Pauls Church-yard, at the Signe of the Bul-head), Robert Johnson, 1609, London, book cover. Tracy W. McGregor Library, Albert and Shirley Small Special Collections Library, University of Virginia.

61 *The Manner of Their Attire and Painting Them Selves*, John White, 1585–1593, North America, watercolor, 10.35 x 5.905 in. (26.29 x 14.99 cm.). © The Trustees of the British Museum.

62 *Pocahontas*, unidentified artist, copy after the 1616 engraving by Simon van de Passe, oil on canvas, stretcher: 30½ x 25½ x 1 in. (77.5 x 64.8 x 2.5 cm.), frame: 36½ x 31½ x 2½ in. (92.7 x 80 x 6.4 cm.). Smithsonian Institution, National Portrait Gallery, object no. NPG.65.61. Transfer from the National Gallery of Art; gift of the A. W. Mellon Educational and Charitable Trust.

8. PLYMOUTH ROCK FRAGMENT

64 Plymouth Rock fragment, granite, Plymouth, Massachusetts, United States, 2¾ x 4¼ x ⅞ in. (6.985 x 10.795 x 2.2225 cm.). Smithsonian Institution, National Museum of American History, Kenneth E. Behring Center, cat. no. 012058, accession: 52309. Gift of Mrs. Virginia L. W. Fox.

9. SLAVE SHACKLES

70 Slave shackles, before 1860, iron, 2½ x 9 x 1¼ in. (6.35 x 22.86 x 3.175 cm.). Smithsonian Institution, National Museum of African American History and Culture, accession: 2008.10.4.

72 Manilla, twelfth to eighteenth centuries, Nigeria, copper alloy, 8 x 4 x 1¾ in. (20.3 x 10.2 x 4.4 cm.). Smithsonian Institution, National Museum of African Art, accession: 2002-10-35. Gift of Tom Joyce and museum purchase with funds donated by Carl Jennings.

72 Commemorative trophy head, Benin Kingdom court style, late fifteenth to early sixteenth century, Edo peoples, Nigeria, copper alloy, iron inlay, 9⅛ x 6¼ x 7⅞ in. (23.2 x 15.9 x 20 cm.). Smithsonian Institution, National Museum of African Art, accession: 82-5-2. Purchased with funds provided by the Smithsonian Collections Acquisition Program. Photograph by Franko Khoury, Smithsonian.

72 Tusk [detail, slave caravan], Kongo peoples, Congo, Democratic Republic of Congo, ca. 1860, ivory, 28½ x 5¾ x 2⅜ in. (72.4 x 14.6 x 6 cm.). Smithsonian Institution, National Museum of African Art, accession: 96-28-1. Photograph by Franko Khoury, Smithsonian.

75 Stowage of the British slave ship *Brookes* under the regulated slave trade act of 1788, 1788 (?), print, etching. Rare Book and Special Collections Division, Library of Congress.

10. AMERICÆ NOVA TABULA (MAP)

79 Map of North and South America, Willem Blaeu, ca. 1648, North America–South America, engraving, paper, 16⅛ x 21⅞ in. (40.9575 x 55.5625 cm.). Smithsonian Institution, National Museum of American History, Kenneth E. Behring Center, cat. no. 24335, accession: 251493. Gift of Mrs. Francis P. Garvan.

82–83 *Universalis cosmographia secundum Ptholomaei traditionem et Americi Vespucii alioru[m]que lustrations*, Martin Waldseemüller, 1507, St. Dié, France, map on twelve sheets, sheets: 18.11 x 24.8031 in. (46 x 63 cm. or smaller) (128 x 233 cm.). Geography and Map Division, Library of Congress.

LET FREEDOM RING

11. DECLARATION OF INDEPENDENCE

86 Declaration of Independence by Stone, printer's copy, William J. Stone, engraving, 33¾ x 27¼ in. (85.725 x 69.215 cm.). Smithsonian Institution, National Museum of American History, Kenneth E. Behring Center, cat. no. 4685, accession: 21086. Gift of Mrs. E. J. Stone.

88 The Declaration of Independence desk (Thomas Jefferson's desk), Benjamin Randolph, 1775–1776, Philadelphia, Pennsylvania, United States, mahogany, fabric, baize (part material), 3⅝ x 15¾ x 9⅝ in. (9.2075 x 40.005 x 25.0825 cm.). Smithsonian Institution, National Museum of American History, Kenneth E. Behring Center, cat. no. 31819, accession: 67435. Transfer from U.S. Department of State.

88 Thomas Jefferson, June 1776, rough draft of the Declaration of Independence (first page), 1776, manuscript. The Thomas Jefferson Papers, Manuscript Division, Library of Congress.

89 Broadside. In Congress, July 4, 1776, A Declaration By the Representatives of the United States of America, In General Congress assembled (also known as the Dunlap Declaration of Independence), John Dunlap, July 4, 1776, Philadelphia,

Pennsylvania, United States, sheet: 18.5039 x 14.9606 in. (47 x 38 cm.). Broadside Collection, Rare Books and Special Collections Division, Library of Congress.

90 Engrossed Declaration of Independence, August 2, 1776, records of the Continental and Confederation Congresses and the Constitutional Convention, 1765–1821. United States National Archives and Records Administration.

91 In Congress, July 4, 1776, The Unanimous Declaration of the Thirteen United States of America (also known as the Goddard Broadside of the Declaration of Independence), printed by Mary Katharine Goddard, 1777, Baltimore, Maryland, United States. Broadside Collection, Rare Books and Special Collections Division, Library of Congress.

12. GEORGE WASHINGTON'S UNIFORM AND SWORD

94 George Washington's uniform, 1789, wool, metal, buff wool rise-and-fall collar, buff cuffs and lapels, buff lining, metal buttons, 72 x 36 x 36 in. (182.88 x 91.44 x 91.44 cm.). Smithsonian Institution, National Museum of American History, Kenneth E. Behring Center, cat. no. 16148, accession: 13152.

97 George Washington's battle sword, John Bailey, ca. 1765–1778, Fishkill, New York, United States, green (hilt color), ivory (hilt material), leather (scabbard material), silver (blade material), bone (overall material), overall: 3½ x 36¼ x 1¼ in. (8.89 x 92.075 x 3.175 cm.). Smithsonian Institution, National Museum of American History, Kenneth E. Behring Center, cat. no. 32010, accession: 68016.

13. BENJAMIN FRANKLIN'S WALKING STICK

98 Benjamin Franklin's walking stick, ca. 1783, crabtree wood, gold cap, 46½ x 1⅜ x ⅜ in. dia. at tip. Smithsonian Institution, National Museum of American History, Kenneth E. Behring Center, cat. no. 032011, accession: 68016. Transfer from U.S. Department of State.

100 Benjamin Franklin (copy after Charles Nicholas Cochin), Johann Martin Will (1727–1806), 1777, mezzotint on paper, 11⅞ x 9¼ in. (30.1 x 23.5 cm.). Smithsonian Institution, National Portrait Gallery, object no. NPG.69.30.

103 Benjamin Franklin medallion, Jean-Baptiste Nini (1717–1786), 1777, terra-cotta, 4⅜ in. (11.1 cm.). Smithsonian Institution, National Portrait Gallery, object no. NPG.66.12.

14. GILBERT STUART'S LANSDOWNE PORTRAIT OF GEORGE WASHINGTON

106 *George Washington* (Lansdowne portrait), Gilbert Stuart (1755–1828), 1796, Germantown, Pennsylvania, United States, oil on canvas, stretcher: 97½ x 62½ in. (247.6 x 158.7 cm.), frame: 111⅝ x 76½ x 7 in. (283.5 x 194.3 x 17.8 cm.). Smithsonian Institution, National Portrait Gallery, object no. NPG.2001.13. Acquired as a gift to the nation through the generosity of the Donald W. Reynolds Foundation.

109 *George Washington* (Athenaeum portrait), Gilbert Stuart (1755–1828), 1796, oil on canvas, 48 x 37 in. (121.9 x 94 cm.). Smithsonian Institution, National Portrait Gallery, object no. NPG.80.115. Owned jointly with the Museum of Fine Arts, Boston (1980.1); William Francis Warden Fund, John H. and

Ernestine A. Payne Fund, Commonwealth Cultural Preservation Trust.

15. STAR-SPANGLED BANNER

112 Star-Spangled Banner, Mary Pickersgill, 1813, Baltimore, Maryland, United States, wool (overall material), 30 x 34 ft. (9.144 x 10.3632 m.). Smithsonian Institution, National Museum of American History, Kenneth E. Behring Center, cat. no. 13649, accession: 54876.

114 White House timber burned in the fire of 1814, wood, 2⅛ x 5¾ x 3¾ in. (5.3975 x 14.605 x 9.525 cm.). Smithsonian Institution, National Museum of American History, Kenneth E. Behring Center, cat. no. 274163, accession: 274163. Gift of Ralph E. Becker.

115 *A View of the Bombardment of Fort McHenry*, J. Bower, ca. 1814, color aquatint (lithograph), image size: 10.9 x 17 in. (27.8 x 43.3 cm.). Courtesy of the Maryland Historical Society, H89.

117 "The Star-Spangled Banner" (original handwritten manuscript), Francis Scott Key (1779–1843), banner (song), 1814, Fort McHenry, Baltimore, Maryland, United States manuscript. Courtesy of the Maryland Historical Society, 54315.

119 Repair work on the Star-Spangled banner, unknown photographer, 1914, photographic print. Smithsonian Institution Archives, History Division, ID: 27897 or MAH-27897.

121 Team of conservators, 1999. Smithsonian Institution, National Museum of American History, Kenneth E. Behring Center.

16. THOMAS JEFFERSON'S BIBLE

124 Thomas Jefferson's Bible, "The Life and Morals of Jesus of Nazareth," ca. 1820, United States, leather, paper, 8⅜ x 5⅛ x 1 in. (21.2725 x 13.0175 x 2.54 cm.). Smithsonian Institution, National Museum of American History, Kenneth E. Behring Center, cat. no.158231, accession: 147182.

YOUNG NATION

17. CONESTOGA WAGON

130 Conestoga wagon, 1840–1850, Pennsylvania, United States, wood and iron, 17 ft. 10 in. x 12 ft. 6 in., blue body, red running gear, decorative ironwork. Smithsonian Institution, National Museum of American History, Kenneth E. Behring Center, cat. no. 321453, accession: 243296.

18. ELI WHITNEY'S COTTON GIN

135 Eli Whitney's cotton gin model, 1790, Georgia, United States, 10 x 17½ x 14 in. (25.4 x 44.45 x 35.56 cm.). Smithsonian Institution, National Museum of American History, Kenneth E. Behring Center, cat. no. T.8756.

19. JOHN DEERE'S STEEL PLOW

140 John Deere's plow, 1838, Grand Detour, Illinois, United States, wood, iron, steel, 14¹⁵⁄₁₆ x 18⅛ x 48⁷⁄₁₆ in. (37.9413 x 46.0375 x 123.031 cm.). Smithsonian Institution, National Museum of American History, Kenneth E. Behring Center, cat. no. 38A04, accession: 148904. Gift of Deere and Company.

146 1851 Singer's sewing machine patent model, Isaac Merritt Singer, 1851, New York, New York, United States, cast iron (head, base cams, and gear wheels). Smithsonian Institution, National Museum of American History, Kenneth E. Behring Center, cat. no. T06054.000, accession: 48865.

148 Sewing machine patent models collage, all items, Smithsonian Institution, National Museum of American History, Kenneth E. Behring Center: Greenough's patent model, John James Greenough, before 1842, Washington, D.C., wood, metal, 10 x 14 x 6 in. (25.4 x 35.56 x 15.24 cm.), cat. no. T06048.000, accession: 48865; Bean's patent model, Benjamin W. Bean, 1843, New York, New York, wood, metal, 7½ x 10 x 9 in. (19.05 x 25.4 x 22.86 cm.), cat. no. T06049.000, accession: 48865; Corliss's patent model, George Henry Corliss, 1843, Greenwich, New York, wood, metal, 16¾ x 21 x 13½ in. (42.545 x 60.96 x 34.29 cm.), cat. no. T06110, accession: 89797; Howe Jr.'s patent model, Elias Howe Jr., 1846, Cambridge, Massachusetts, United States, metal, wood, 12 x 9 x 11 in. (30.48 x 22.86 x 27.94 cm.), cat. no. T.6050, accession: 48865; Bachelder's patent model, John Bachelder, 1849, Boston, Massachusetts, United States, wood, metal, leather, 13 x 19 x 15 in. (33.02 x 48.26 x 38.1 cm.), cat. no. T06051.000, accession: 89797; Robinson's patent model, Frederick R. Robinson, 1850, Boston, Massachusetts, United States, wood, metal, 22 x 19 x 15 in. (55.88 x 48.26 x 38.1 cm.), cat. no. T.6111, accession: 89797; Wilson's patent model, Allen Benjamin Wilson, 1850, invented in Adrian, Michigan, United States, drawing made in Pittsfield, Massachusetts, United States, wood, 6¼ x 7 x 11 in. (15.875 x 17.78 x 27.94 cm.), cat. no. T06052.000, accession: 48865; Grover and Baker's patent model, William O. Grover and William E. Baker, 1851, Roxbury, Massachusetts, United States, wood, metal, 9 x 12 x 10¾ in. (22.86 x 30.48 x 27.305 cm.), cat. no. T06053.000, accession: 48865; Wilson's patent model, Allen Benjamin Wilson, 1851, Watertown, Connecticut, United States, wood, metal, 3 x 4½ x 6 in. (7.62 x 11.43 x 15.24 cm.), cat. no. T06112.000, accession: 89797; Avery's patent model, Otis Avery, 1852, Honesdale, Pennsylvania, United States, metal, 9 x 13 x 10 in. (22.86 x 33.02 x 25.4 cm.), cat. no. T06114.000, accession: 89797; Bradeen's patent model, John G. Bradeen, 1852, Boston, Massachusetts, United States, brass, wood, 9 x 10 x 10 in. (22.86 x 25.4 x 25.4 cm.), cat. no. T08634.000, accession: 89797; Hodgkins's patent model, Christopher Hodgkins, 1852, Boston, Massachusetts, United States, metal, 9 x 14 x 10 in. (22.86 x 35.56 x 25.4 cm.), cat. no. T08702.000, accession: 89797; Miller's patent model, Charles Miller, 1852, St. Louis, Missouri, brass, 10 x 8 x 7 in. (25.4 x 20.32 x 17.78 cm.), cat. no. T06113.000, accession: 89797; Wilson's patent model, Allen Benjamin Wilson, 1852, Watertown, Connecticut, United States, metal, wood, 5 x 6½ x 12 in. (12.7 x 16.51 x 30.48 cm.), cat. no. T06055.000, accession: 48865; Wickersham's patent model, William Wickersham, 1853, Lowell, Massachusetts, United States, metal, 14 x 12 x 15 in. (35.56 x 30.48 x 38.1 cm.), cat. no. T06117.000, accession: 89797.

150 Levi's brown duck trousers, Levi Strauss & Co., 1873–1896, San Francisco, California, United States, cotton, metal (part material), leather (label), waist: 27½ in. (69.85 cm.), overall length: 35¾ in. (90.805 cm.), Levi Strauss label: 2³⁄₁₆ x 3¼ in. (5.23875 x 8.255 cm.). Smithsonian Institution, National Museum of American History, Kenneth E. Behring Center, cat. no. 256979, accession: 256979.002. Gift of Walter Haas Jr.

152 Sun stone capital or Mormon sun stone, 1844, Nauvoo, Illinois, United States, white fossiliferous limestone, 53 x 72 x 18 in. (134.6 x 182.9 x 45.7 cm.). Smithsonian Institution, National Museum of American History, Kenneth E. Behring Center, cat. no. 1989.0453.01, accession: 1989.0453. Purchase from Historical Society of Quincy & Adams County, Quincy, Illinois.

SEA TO SHINING SEA

158 Lewis and Clark Expedition pocket compass, Thomas Whitney, ca. 1804, Philadelphia, Pennsylvania, United States, mahogany, brass, silver plate, paper, glass, measurements closed: 1½ x 4 x 4 in. (8.89 x 8.89 x 3.81 cm.). Smithsonian Institution, National Museum of American History, Kenneth E. Behring Center, cat. no. 38366, accession: 122864. Gift of Miss Mary McCabe.

163 Route about May 24–30, 1805, and Lewis's route about July 30–31, 1806, Lewis and Clark Expedition Maps and Receipt. Yale Collection of Western Americana, Beinecke Rare Book and Manuscript Library.

166 Steam locomotive, John Bull, Robert Stephenson and Company, 1831, United Kingdom, England, Newcastle upon Tyne, assembled in Camden, New Jersey, United States, iron, wood, copper, brass, 11½ x 7½ x 36¼ ft. (3.5052 x 2.286 x 11.049 m.). Smithsonian Institution, National Museum of American History, Kenneth E. Behring Center, cat. no. 180001, accession:15804.

168 John Frazee to Lydia Frazee, May 18, 1834, letter: four pages, handwritten, illustrations, 9.055 x 7.086 in. (23 x 18 cm.). Smithsonian Institution, Archives of American Art, John Frazee Papers, digital ID: 3369.

170 The last spike, William T. Garrett Foundry, San Francisco, California, United States, 17⁹⁄₁₀ carat gold, alloyed with copper. Iris & B. Gerald Cantor Center for Visual Arts at Stanford University. Gift of David Hewes.

171 Commemorative demonstration ride in 1981 to celebrate John Bull's 150th anniversary. Smithsonian Institution, National Museum of American History, Kenneth E. Behring Center, and Smithsonian Institution Archives, neg. 81-11824. Photograph by Kim Nielsen, Smithsonian.

173 Colt holster model Paterson revolver (5), Colt's Patent Firearms Manufacturing Company, ca. 1839, Paterson, New Jersey, United States, iron, wood, measurements overall: 5 x 13¾ x 1½ in. (12.7 x 34.925 x 3.81 cm.). Smithsonian Institution,

National Museum of American History, Kenneth E. Behring Center, cat. no. 251084, accession: 48865.

175 Cased 5 holster model revolver, Patent Arms Manufacturing Company, ca. 1840. Autry National Center, Los Angeles, 98.178.1.

25. MORSE-VAIL TELEGRAPH

178 Morse-Vail telegraph key, Samuel Finley Breese Morse and Alfred Vail, 1844, Morristown, New Jersey, wood, brass, 3 x 2 x 6.75 in. (7.62 x 5.08 x 17.145 cm.). Smithsonian Institution, National Museum of American History, Kenneth E. Behring Center, cat. no. 181411, accession: 31652.

180 Part of Morse's telegraph apparatus, U.S. Patent #4,453, Samuel Finley Breese Morse, 1846, United States, wood, iron wire, brass, relay: 7 x 11¼ x 4½ in. (17.78 x 28.575 x 11.43 cm.); register: 8 x 17½ x 4 in. (20.32 x 44.45 x 10.16 cm.); tape reel: 9¼ x 10 x 1¼ in. (23.495 x 25.4 x 3.175 cm.); coil disks (each): ⅛ x 12½ in. (0.3175 x 31.75 cm.); key on base: 2 x 2¾ x 10 in. (5.08 x 6.985 x 25.4 cm.). Smithsonian Institution, National Museum of American History, Kenneth E. Behring Center, cat. no. 251265, accession: 221482.

180 Tape message, Samuel Finley Breese Morse, 1844, Baltimore, Maryland, United States, paper, 1½ x 27¾ in. (3.81 x 70.485 cm.). Smithsonian Institution, National Museum of American History, Kenneth E. Behring Center, cat. no. 001028, accession: 65555.

183 Joseph Henry's electromagnet, 1831, New Haven, Connecticut, iron, cloth, copper, 18 x 20 x 12 in. (45.72 x 50.8 x 30.48 cm.). Smithsonian Institution, National Museum of American History, Kenneth E. Behring Center, cat. no. 181343, accession: 26705.

26. MEXICAN ARMY COAT

187 Mexican Army frock coat, ca. 1840, blue wool with red piping and facings, guilt buttons and gold-colored shoulder strap, 37¼ x 19 in. (94.61 x 48.26 cm.). Smithsonian Institution, National Museum of American History, Kenneth E. Behring Center, cat. no. 16156, accession: 13152.

189 Sam Houston's rifle, United States, steel, wood, brass, 8½ x 52 x 3¾ in. (21.59 x 132.08 x 9.525 cm.). Smithsonian Institution, National Museum of American History, Kenneth E. Behring Center, cat. no. 16085, accession: 13152.

27. GOLD DISCOVERY FLAKE
FROM SUTTER'S MILL

192 Gold flake, 1848, Coloma, Sutter's Mill, California, United States, gold (overall material), measurement: 9⁄32 in. (0.7 cm.). Smithsonian Institution, National Museum of American History, Kenneth E. Behring Center, cat. no. 135 (1861).01, accession: 000135.

28. MARTHA, THE LAST PASSENGER PIGEON

198 Martha, the last passenger pigeon (*Ectopistes migratorius*). Smithsonian Institution, National Museum of Natural History, cat. no. USNM 223979.

202 *Passenger Pigeon* (*Ectopistes migratorius*), by John James Audubon, autumn 1824, watercolor, gouache and graphite, 26½ x 18¼ in., with mat: 40 x 30 in., negative #28062, accession:

1863.17.62. Collection of the New-York Historical Society. Digital image created by Oppenheimer Editions.

A HOUSE DIVIDED

29. FREDERICK DOUGLASS'S
AMBROTYPE PORTRAIT

206 Frederick Douglass, unidentified artist, 1856, quarter-plate ambrotype, image: 4³⁄₁₆ x 3⅜ in. (10.6 x 8.6 cm.), case (open): 4¹¹⁄₁₆ x 7½ x ½ in. (11.9 19.1 x 1.3 cm.). Smithsonian Institution, National Portrait Gallery, object no. NPG.74.75. Purchased with funds from an anonymous donor.

210 "Men of Color" recruitment broadside, Frederick Douglass, et al., 1863, printing ink on rag paper, 95 x 49 x 3 in. (2527.3 x 124.46 x 7.62 cm.). Smithsonian Institution, National Museum of African American History and Culture, accession: 2012.133. Photograph by Eric Long, Smithsonian.

30. HARRIET TUBMAN'S HYMNAL AND SHAWL

213 Harriet Tubman's hymn book, *Gospel Hymns 2*, P. P. Bliss and Ira D. Sankey, ca. 1876, ink on paper, 8³⁄₁₆ x 5⅜ x ⁹⁄₁₆ in. (20.7963 x 13.6525 x 1.42875 cm.). Smithsonian Institution, National Museum of African American History and Culture, accession: 2009.50.25. Gift of Charles L. Blockson.

213 Lace shawl given to Harriet Tubman by Queen Victoria, ca. 1897, London, silk lace and linen, 36½ x 28½ in. (92.71 x 72.39 cm.). Smithsonian Institution, National Museum of African American History and Culture, accession: 2009.50.39. Gift of Charles L. Blockson.

31. EMANCIPATION PROCLAMATION PAMPHLET

218 Emancipation Proclamation "pocket copy," published by John Murray Forbes, 1862, United States of America, ink on paper, 3¼ x 2⅛ in. (8.3 x 5.4 cm.). Smithsonian Institution, National Museum of African American History and Culture, accession: 2012.40.

221 Telegraph office inkstand (Emancipation Proclamation inkstand), mid-19th century, ca. 1863, brass, glass, brass lid, 5¼ x 13⅜ x 8¾ in. (13.335 x 33.9725 x 22.225 cm.). Smithsonian Institution, National Museum of American History, Kenneth E. Behring Center, cat. no. 244699.02, accession: 244699. Transfer from the Library of Congress.

32. CHRISTIAN FLEETWOOD'S MEDAL OF HONOR

225 Christian Fleetwood's Medal of Honor, 1862, bronze, silk, 4¼ x 2⁵⁄₁₆ x ¼ in. (10.795 x 5.23875 x 0.635 cm.). Smithsonian Institution, National Museum of American History, Kenneth E. Behring Center, cat. no.: AF*046054.1, accession: 178781.

228 Christian Fleetwood, head-and-shoulders portrait, facing slightly left, William Edward Burghardt Du Bois, ca. 1900, photographic print. Prints and Photographs Division, Library of Congress, LC-USZ62-118565.

33. APPOMATTOX COURT HOUSE FURNISHINGS

230 Appomattox Court House chair (Lee's), maple, cane, 45½ x 18½ x 20 in. (115.57 x 46.99 x 50.8 cm.), Smithsonian Institution, National Museum of American History, Kenneth E. Beh-

ring Center, cat. no. 15820, accession: 591.40, gift of Bridget O'Farrell; Appomattox Court House table, pine, 20 x 32 in. (50.8 x 81.28 cm.) (top) 15¼ x 22 in. (38.735 x 55.88 cm.) (base), Smithsonian Institution, National Museum of American History, Kenneth E. Behring Center, cat. no. 039767, accession: 124419, gift of Mrs. Elizabeth Custer; Appomattox Court House chair (Grant's), mahogany, leather, 37½ x 21¾ x 17⅝ in. (95.25 x 55.245 x 44.7675 cm.), Smithsonian Institution, National Museum of American History, Kenneth E. Behring Center, cat. no. 010517, accession: 45493, gift of the Estate of Gen. Wilmon W. Blackmar.

34. ABRAHAM LINCOLN'S HAT

236 Abraham Lincoln's top hat, J. Y. Davis, mid-nineteenth century, United States, Washington, D.C., silk, paper, 7 x 10¾ x 12 in. (17.78 x 27.305 x 30.48 cm.). Smithsonian Institution, National Museum of American History, Kenneth E. Behring Center, cat. no. 9321, accession: 38912. Transfer from the War Department.

239 Prison hoods of the Abraham Lincoln conspirators, 1865, canvas, cotton rope, 14 x 13 x 12 in. (35.56 x 33.02 x 30.48 cm.). Smithsonian Institution, National Museum of American History, Kenneth E. Behring Center, cat. no. 10245, accession: 42272. Transfer from the War Department, ID COLL.CON-HDS.005001.

241 Abraham Lincoln, Alexander Gardner, 1865, albumen silver print, image: 17¹¹⁄₁₆ x 15³⁄₁₆ in. (45 x 38.6 cm.), mat: 24⅜ x 19¾ in. (61.9 x 50.2 cm.), frame: 29½ x 25⅛ x 2¾ in. (74.9 x 63.8 cm.). Smithsonian Institution, National Portrait Gallery, object no. NPG.81.M1.

243 Abraham Lincoln's watch, 1850s, Springfield, Illinois, United States, marked Geo. W. Chatterton, gold, glass, metal, gold (watch chain material), wood; metal; fabric (box material), watch: 2 x 3 x ½ in. (5.08 x 7.62 x 1.27 cm.), watch chain: 13 in. (33.02 cm.). Smithsonian Institution, National Museum of American History, Kenneth E. Behring Center, cat. no. 219098.01, accession: 219098. Gift of Lincoln Isham, great grandson of Abraham Lincoln.

MANIFEST DESTINY

35. ALBERT BIERSTADT'S
AMONG THE SIERRA NEVADA, CALIFORNIA

246 *Among the Sierra Nevada, California*, Albert Bierstadt, 1868, Sierra Nevada, California, United States, oil on canvas, 72 x 120⅛ in. (183 x 305 cm.), frame: 96¼ x 144⅜ x 7¼ in. (244.5 x 366.7 x 18.4 cm.). Smithsonian Institution, Smithsonian American Art Museum, accession: 1977.107.1. Bequest of Helen Huntington Hull, granddaughter of William Brown Dinsmore, who acquired the painting in 1873 for "The Locusts," the family estate in Dutchess County, New York.

250 *El Capitan, Yosemite Valley*, from the portfolio Parmelian Prints of the High Sierras, Ansel Adams, ca. 1925, printed 1927, gelatin silver on paper, 9⅞ x 11⅞ in. (25.1 x 30.1 cm.). Smithsonian Institution, Smithsonian American Art Museum, 1992.101.11. © 2013 The Ansel Adams Publishing Rights Trust.

36. KING KAMEHAMEHA III'S FEATHER CAPE

253 Feather cape (*'ahu'ula*), 1829, Hawaii, East Polynesia, United States, base, feathers from the *'i'iwi* (*Vestiaria coccinea*) and *'o' o* (*Maho nobilis*), 21¾ x 36¼ x ⅜ in. (55.2 x 92 x 0.9 cm.). Smithsonian Institution, National Museum of Natural History, cat. no. 000135.

255 *King Kamehameha III*, Robert Dampier, 1825, oil on canvas, 20⅛ x 24¼ in. (51.1 x 61.6 cm.). Honolulu Museum of Art 1951 (1066.1). Gift of Eliza Lefferts Cooke, Charles M. Cooke III, and Carolene Alexander Cooke Wrenn in memory of Dr. C. Montague Cooke Jr.

37. AMERICAN BUFFALO

260 Buffalo hunt on the southwest prairies, John Mix Stanley, 1845, oil on canvas, 40½ x 60¾ in. (102.9 x 154.3 cm.). Smithsonian Institution, Smithsonian American Art, accession: 1985.66.248,932. Gift of the Misses Henry.

262 Lone Dog winter count, 1800–1870, hide, 106 x 77 in. (270 x 196 cm.). Smithsonian Institution, National Museum of the American Indian, accession: NMAI 1/617. Photograph by NMAI Photo Services, Smithsonian.

265 Buffalo behind Smithsonian Institution Castle, south yard, ca. 1886–1889, unknown photographer, photographic print, 4 x 3 in. (10.16 x 7.62 cm.). Smithsonian Institution, Smithsonian Institution Archives, ID: 8008A or MAH 8008A.

38. SITTING BULL'S DRAWING BOOK

268 Sitting Bull pictographic autobiography, 1882, twenty-two drawings: graphite, colored pencil, and ink, 8.267 x 13.385 in. (21 x 34 cm.). Smithsonian Institution, National Museum of Natural History, National Anthropological Archives, NAA MS 1929b.

269 Buckskin coat worn by General George Armstrong Custer, ca. 1870, Montana, North Dakota, United States, buckskin, metal, overall: 27 x 24 in. (68.58 x 60.96 cm.). Smithsonian Institution, National Museum of American History, Kenneth E. Behring Center, cat. no. 013044, accession: 54045.

270 *Sitting Bull*, Bailey, Dix, and Mead, 1882, Fort Randall, United States, albumen silver print, 4¹³⁄₁₆ x 3⁹⁄₁₆ in. (12.2237 x 9.04875 cm.). Smithsonian Institution, National Portrait Gallery, object no. NPG.96.176.

271 Sitting Bull drawing of him in battle with Assiniboines, Sitting Bull, 1882, one drawing: graphite and colored pencil, 8.267 x 13.385 in. (21 x 34 cm.). Smithsonian Institution, National Museum of Natural History, National Anthropological Archives, NAA INV 08590000.

273 Red Horse's drawing of Indians fighting Custer's troops at Battle of Little Bighorn, 1881, one drawing: graphite, colored pencil, and ink, 24.0157 x 36.2205 in. (61 x 92 cm.). Smithsonian Institution, National Museum of Natural History, National Anthropological Archives, MS 2367A, Inv. 08569200.

39. BUGLE FROM THE U.S.S. *MAINE*

275 Bugle from the U.S.S. *Maine*, before 1898, metal, 4 x 14 x 2½ in. (10.16 x 35.56 x 6.35 cm.). Smithsonian Institution, National Museum of American History, Kenneth E. Behring Center, cat. no. 31188, accession: 66761.

278 "Remember the *Maine*" match case, ca. 1898, brass, 1¼ x 2½ x ½ in. (3.2 x 6.3 x 1.2 cm.). Smithsonian Institution, Cooper-Hewitt National Design Museum, accession: 1980-14-1161. Gift of Stephen W. Brener and Carol B. Brener.

INDUSTRIAL REVOLUTION

40. ALEXANDER GRAHAM BELL'S TELEPHONE

282 Alexander Graham Bell's large box telephone, Alexander Graham Bell and Francis Blake Jr. inventors, 1876, Boston, Massachusetts, wood, iron, brass, parchment, mica, 6¼ x 7½ x 12½ in. (15.875 x 19.05 x 31.75 cm.). Smithsonian Institution, National Museum of American History, Kenneth E. Behring Center, cat. no. 308214, accession: 70856.

284 Alexander Graham Bell liquid transmitter, 1876, Boston, Massachusetts, wood, iron, brass, parchment, 9¼ x 6 x 7 in. (23.495 x 15.24 x 17.78 cm.), Smithsonian Institution, National Museum of American History, Kenneth E. Behring Center, cat. no. 252600, accession: 49064; Alexander Graham Bell single-pole prototype, 1876, Boston, Massachusetts, iron, wood, plastic, parchment, brass, copper, 6½ x 5 x 11 in. (16.51 x 12.7 x 27.94 cm.), Smithsonian Institution, National Museum of American History, Kenneth E. Behring Center, cat. no. 251549, accession: 48850; Alexander Graham Bell double-pole prototype, 1876, Boston, Massachusetts, iron, wood, plastic, parchment, brass, copper, 6 x 4 x 8 in. (15.24 x 10.16 x 20.32 cm.), Smithsonian Institution, National Museum of American History, Kenneth E. Behring Center, cat. no. 251613, accession: 48850.

286 Alexander Graham Bell's large box telephone (top view), see above 282.

41. THOMAS EDISON'S LIGHTBULB

290 Demonstration incandescent lamp, Thomas Alva Edison, 1879, Menlo Park, Edison, New Jersey, United States, bristol-board filament, wood and cloth (box material), 6 x 2⅜ in. (15.24 x 6.0325 cm.). Smithsonian Institution, National Museum of American History, Kenneth E. Behring Center, cat. no. 320504, accession: 241402. From International Business Machines, Inc., William J. Hammer Collection.

42. FRÉDÉRIC BARTHOLDI'S *LIBERTY*

296 *Liberty* enlightening the world, Frédéric Auguste Bartholdi, 1884, painted terra-cotta, tin (crown), 46 x 12 x 11 in. (116.8 x 30.5 x 28.0 cm.). Smithsonian Institution, Smithsonian American Art Museum. Transfer from the U.S. Capitol, XX76.

43. ANDREW CARNEGIE'S MANSION

302–3 Andrew Carnegie's mansion, garden façade, Cooper-Hewitt National Design Museum. Smithsonian Institution. Photograph by Dennis Cowley, Smithsonian.

307 Carnegie steel beam imprint at Carnegie mansion (located on the east side of the first floor, between the gallery corridor and the butler's pantry), Cooper-Hewitt National Design Museum. Smithsonian Institution. Photograph © James Rudnick.

308 *Lunch atop a Skyscraper,* Charles Ebbets, 1932, New York, United States. © Bettmann/Corbis.

44. FORD MODEL T

310 Ford Model T roadster, 1926, Ford Motor Company, Detroit, Michigan, United States, steel, glass, rubber, measurements: 12 ft. x 5 ft. 6 in. x 5 ft. 10 in. (365.759 x 167.639 x 177.799 cm.). Smithsonian Institution, National Museum of American History, Kenneth E. Behring Center, cat. no. 333777, accession: 305326. Gift of John T. Sickler. Photograph by Jeff Tinsley, Smithsonian.

312 Selden automobile patent model, George B. Selden, 1879, Rochester, New York, United States, metal, overall: 7½ x 6½ x 11 in. (19.05 x 16.51 x 27.94 cm.). Smithsonian Institution, National Museum of American History, Kenneth E. Behring Center, cat. no. 252678, accession: 49064.

313 Duryea motor carriage, Frank J. Duryea and Charles E. Duryea, 1893, Springfield Massachusetts, United States, wood, steel, overall: 81 x 64 x 97 in. (205.74 x 162.56 x 246.38 cm.). Smithsonian Institution, National Museum of American History, Kenneth E. Behring Center, cat. no. 307199, accession: 65715. Gift of Inglis M. Uppercu.

45. WRIGHT BROTHERS' *KITTY HAWK FLYER*

318–19 1903 Wright Flyer (or Wright Brothers' *Kitty Hawk Flyer*), Wilbur and Orville Wright, 1903, Dayton Ohio, United States, spruce and ash, covered with muslin, wingspan: 40 ft. 4 in (12.3 m.), length: 21 ft. (6.4 m.), height: 9 ft. 3 in. (2.8 m.), weight, empty: 605 lbs. (274 kg.). Smithsonian Institution, National Air and Space Museum, Inv. A19610048000. Gift of the Estate of Orville Wright. Photograph by Dane Penland, Smithsonian.

324 24-cent Curtiss Jenny invert single stamp. Scott Catalogue USA: C3a, 1918, United States, paper; ink (carmine rose and blue), engraving; adhesive, ⅞ x 1 in. (2.22 x 2.54 cm.). Smithsonian Institution, National Postal Museum, accession: 0.217665.1.

46. BAKELIZER PLASTIC MAKER

326 Bakelizer, Leo H. Baekeland, 1909, Yonkers, New York, United States, iron, each detached leg: 45¾ in. (116.205 cm.); overall: 71½ x 35 x 40 in. (181.61 x 88.9 x 101.6 cm.); vessel: 45 in. (114.3 cm.); base: 47½ in. (120.65 cm.). Smithsonian Institution, National Museum of American History, Kenneth E. Behring Center, cat. no. 1983.524.1, accession: 1983.0524. Gift of Union Carbide Corporation, Specialty Chemicals Division. Photograph by Harold Dorwin, Smithsonian.

MODERN NATION

47. JAMES WHISTLER'S *HARMONY IN BLUE AND GOLD: THE PEACOCK ROOM*

332 *Harmony in Blue and Gold: The Peacock Room*, James McNeill Whistler (1834–1903), 1876–1877, United States, 165.98 x 241.49 x 404.01 in. (421.6 x 613.4 x 1,026.2 cm.). Smithsonian

Institution, Freer Gallery of Art and Arthur M. Sackler Gallery, F1904.61. Gift of Charles Lang Freer.

335 Fighting peacocks, detail, see above.

48. BERNICE PALMER'S KODAK BROWNIE CAMERA

340 Bernice Palmer's Kodak Brownie camera, Eastman Kodak Company, 1912, Rochester, New York, United States, wood, glass, plated metal, and copper alloy, overall: 5¼ x 4 x 6¼ in. (13.335 x 10.16 x 15.875 cm.). Smithsonian Institution, National Museum of American History, Kenneth E. Behring Center, cat. no. 1986.0173.38, accession: 1986.0173. Gift of Bernice Palmer Ellis.

344 Iceberg that sank *Titanic*, 1912, photograph. Smithsonian Institution, National Museum of American History, Kenneth E. Behring Center, cat. no. 1986.0173.33, accession: 1986.0173. Gift of Bernice Palmer Ellis.

345 *Titanic* survivors wearing borrowed clothes, 1912, photograph. Smithsonian Institution, National Museum of American History, Kenneth E. Behring Center, cat. no. 1986.0173.24, accession: 1986.0173. Gift of Bernice Palmer Ellis.

49. HELEN KELLER'S WATCH

347 Helen Keller's watch, Rossel & Fils, ca. 1865, Switzerland, gold (watch case material), brass (watch movement material), watch: 2⅝ x 1⅞ x ½ in. (6.6675 x 4.7625 x 1.27 cm.); case: 2½ x 2½ x ¾ in. (6.35 x 6.35 x 1.905 cm.). Smithsonian Institution, National Museum of American History, Kenneth E. Behring Center, cat. no. 335239, accession: 314555. Gift of Phillips Brooks Keller and Mrs. Gordon Erwin; Helen Keller's watch (back).

350 Ed Roberts's wheelchair, Stanford Rehab Engineering, 1996, Palo Alto, California, United States, steel, leather, rubber, 42 x 24 x 46 in. (106.68 x 60.96 x 116.84 cm.). Smithsonian Institution, National Museum of American History, Kenneth E. Behring Center, cat. no. 1995.0179.01, accession: 1995.0179.

50. SUFFRAGISTS' "GREAT DEMAND" BANNER

352 "Great Demand" banner, probably Emma Louthan, ca. 1917, United States, yellow silk, applied purple silk letters, 67 x 65 in. (170.179 x 165.099 cm.). Smithsonian Institution, National Museum of American History, Kenneth E. Behring Center, cat. no. 2009.0207.01, accession: 2009.0207. Gift of Martin Gilmer Louthan in honor of his mother Marie Gilmer Louthan.

356 "Jailed for Freedom" pin, National Women's Party, 1917, silver, 1½ x 1 in. (3.81 x 2.54 cm.). Smithsonian Institution, National Museum of American History, Kenneth E. Behring Center, cat. no. 1987.0165.025, accession: 1987.0165. Gift of Alice Paul Centennial Foundation, Inc.

357 *Susan B. Anthony*, Sarah James Eddy, oil on canvas, with frame: 76 x 61 in., without frame: 61½ x 45½ in. Smithsonian Institution, National Museum of American History, Kenneth E. Behring Center, accession: 64601. Gift of National American Woman Suffrage Association.

51. KU KLUX KLAN ROBE AND HOOD

360 KKK hood, 12 x 12 x 8½ in. (30.48 x 30.48 x 21.59 cm.), and robe, 49 x 32 x 21 in. (124.46 x 81.28 x 53.34 cm.). Smithsonian Institution, National Museum of American History, Kenneth E. Behring Center, cat. no. 286282.08, accession: 286282 and cat. no. 286282.06, accession: 286282. Gift from Mr. Kenton H. Broyles.

363 "We Are All Loyal Klansmen," album cover, Chas. E. Downey, 1923, published in Wyano, Pennsylvania, courtesy The Lilly Library, Indiana University, Bloomington, Indiana.

365 Ku Klux Klan parade, Washington, D.C., September 13, 1926, gelatin silver. Prints and Photographs Division, Library of Congress. Photograph by National Photo Co.

52. WORLD WAR I GAS MASK

367 World War I gas mask, rubber, fabric, metal canister, 15¾ x 10 x 4½ in. (40.005 x 25.4 x 11.43 cm.). Smithsonian Institution, National Museum of American History, Kenneth E. Behring Center, accession: 64127.

53. LOUIS ARMSTRONG'S TRUMPET

372 Louis Armstrong's trumpet, Selmer trumpet, Henry Selmer, 1946, Paris, brass, 5¾ x 21⅞ x 4¾ in. (14.605 x 55.5625 x 12.065 cm.). Smithsonian Institution, National Museum of African American History and Culture, accession: 2008.16.1.

376 Dizzy Gillespie's B-flat trumpet, King Musical Instruments, 1981, Eastlake, Ohio, United States, brass, 17 x 16 x 5 in. (43.18 x 40.64 x 12.7 cm.). Smithsonian Institution, National Museum of American History, Kenneth E. Behring Center, accession: 1986.0003.

54. SCOPES "MONKEY TRIAL" PHOTOGRAPH

378 William Jennings Bryan (seated at left) being interrogated by Clarence Seward Darrow during the trial of *State of Tennessee vs. John Thomas Scopes*, July 20, 1925. Smithsonian Institution, Smithsonian Institution Archives, image #2005-26262. Photograph by Watson Davis.

55. *SPIRIT OF ST. LOUIS*

385 Ryan NYP *Spirit of St. Louis*, Ryan Airlines, Co., 1927, San Diego, California, United States, wingspan: 46 ft. (14 m.), length: 27 ft. 8 in. (8 m.), weight, gross: 5,135 lbs. (2,330 kg.), fabric, metal, glass, Ra-226. Smithsonian Institution, National Air and Space Museum, Inv. A19280021000. Gift of Charles A. Lindberg. Photograph by Eric Long, Smithsonian.

388 Lockheed Vega 5B, Amelia Earhart, ca. 1920–1930, Lockheed Aircraft Co., wingspan: 41 ft. (12.49 m.), length: 27 ft. 6 in. (8.38 m.), height: 8 ft. 2 in. (2.49 m.), weight, empty: 1,650 lbs. (748 kg.). Smithsonian Institution, National Air and Space Museum, Inv. A19670093000. Photograph by Eric Long, Smithsonian.

389 Flying coat, Amelia Earhart, ca. 1920–1930, light brown leather with gray tweed wool lining, measurements: back, collar to bottom: 36 in. (91.4 cm.), shoulder to shoulder: 17 in. (43.1 cm.). Smithsonian Institution, National Air and Space Museum, Inv. A19610155000. Gift of Lewis B. Miller. Photograph by Mark Avino, Smithsonian.

389 Flight goggles, Amelia Earhart, ca. 1920–1930, metal frame with leather padding and adjustable elastic band, steel, glass, and elastic, 7½ x 2 x 1 in. (19.04 x 5.079 x 2.539 cm.). Smithsonian Institution, National Air and Space Museum, Inv. A19580054000. Gift of Richard Evans. Photograph by Eric Long, Smithsonian.

56. BABE RUTH AUTOGRAPHED BASEBALL

392 Babe Ruth autographed baseball, 1929, United States, cork, cushioned, rubber, yarn, horse hide. Smithsonian Institution, National Museum of American History, Kenneth E. Behring Center, cat. no. 1993.0460.01, accession: 1993.0460. Gift from Juliana C. and Robert M. Jones, in memory of their father, Thomas J. Jones.

395 *Babe Ruth*, Nickolas Muray, 1927, printed 1978, gelatin silver print, image: 9⅝ x 7¹¹⁄₁₆ in. (24.5 x 19.5 cm.), sheet: 9¹⁵⁄₁₆ x 8 in. (25.2 x 20.3 cm.), mat: 22 x 16 in. (55.9 x 40.6 cm.). Smithsonian Institution, National Portrait Gallery, object no. NPG.78.150. Photograph by Nickolas Muray, © Nickolas Muray Photo Archives.

GREAT DEPRESSION

57. FRANKLIN D. ROOSEVELT'S "FIRESIDE CHAT" MICROPHONE

400 CBS Radio microphone, 1933–1945, Washington, D.C., United States, 8 x 4 in. (20.32 x 10.16 cm.), base: 8 in. dia. (20.32 cm.), coiled cord. Smithsonian Institution, National Museum of American History, Kenneth E. Behring Center, cat. no. 233610.01, accession: 233610. Gift of the Columbia Broadcasting System, Inc. (CBS), and WTOP-Radio, through Roy Meachum, director of radio promotion and Granville Klink, staff engineer, WTOP-Radio.

58. JOHN L. LEWIS'S UNION BADGE

407 John L. Lewis's union badge, United Mine Workers of America, 1936, United States, metal, fabric, 4 x 2 x ¼ in. (9.5 x 5 cm.). Smithsonian Institution, National Museum of American History, Kenneth E. Behring Center, cat. no. 1989.0693.3777, accession: 1989.0693. Purchase from Scott Molloy.

59. MARIAN ANDERSON'S MINK COAT

412 Marian Anderson's mink coat, maker unknown, mink, silk, 27½ x 47 x 4 in. (69.85 x 119.38 x 10.16 cm.). Smithsonian Institution, Anacostia Community Museum, accession: 1992.0034.0001. Gift of James DePriest on behalf of Marian Anderson.

413 Mink coat, detail, see above.

415 *Marian Anderson*, Betsy Graves Reyneau, 1955, oil on canvas, stretcher: 60¼ x 38⅜ x 1 in. (153 x 97.5 x 2.5 cm.), frame: 64¼ x 42³⁄₁₆ x 2⅛ in. (163.2 x 107.2 x 5.4 cm.). Smithsonian Institution, National Portrait Gallery, object no. NPG.67.76. Gift of the Harmon Foundation.

418 *Marian Anderson at Lincoln Memorial*, Robert Saunders, 1939, cellulose acetate photo negative, Scurlock Studio Records,

ca. 1905–1994. Smithsonian Institution, National Museum of American History, Kenneth E. Behring Center, Archives Center.

60. DOROTHY'S RUBY SLIPPERS

420 Dorothy's ruby slippers, Adrian, 1939, Los Angeles, California, United States, textile, leather, plastic, sequins, felt, 5 x 3 x 9½ in. (12.7 x 7.62 x 24.13 cm.). Smithsonian Institution, National Museum of American History, Kenneth E. Behring Center, cat. no. 1979.1230.01, accession: 1979.1230. Ruby slippers from *The Wizard of Oz* courtesy of Warner Bros. Entertainment Inc.™ and © Turner Entertainment Co. (s13).

424 Technicolor camera, Technicolor Corporation, 1937, United States, asbestos insulation, steel, aluminum, leather, 37¹³⁄₁₆ x 21⅝ x 35⅞ in. (96 x 55 x 91.1 cm.). Smithsonian Institution, National Museum of American History, Kenneth E. Behring Center, cat. no. 8166, accession: 260112.

61. WOODY GUTHRIE'S "THIS LAND IS YOUR LAND"

427 Woody Guthrie's "This Land Is Your Land" original acetate. Smithsonian Institution, Center for Folklife and Cultural Heritage, Ralph Rinzler Folklife Archives and Collections. Photograph by Michael Barnes, Smithsonian.

429 *Woody Guthrie*, Sid Grossman, ca. 1946–1948, gelatin silver print, image/sheet: 13⅛ x 10³⁄₁₆ in. (33.4 x 25.9 cm.), mat: 28 x 22 in. (71.1 x 55.9 cm.). Smithsonian Institution, National Portrait Gallery, object no. NPG.92.60. © Miriam Grossman Cohen.

430 Original handwritten song lyric "This Land Is Your Land" by Woody Guthrie. "This Land Is Your Land." Words and music by Woody Guthrie. WGP & TWO-© Copyright 1956 (Renewed) 1958 (Renewed) 1970 (Renewed) 1972 (Renewed) Woody Guthrie Publications, Inc., and Ludlow Music, Inc., New York, New York. Administered by Ludlow Music, Inc. Used by Permission.

GREATEST GENERATION

62. U.S.S. *OKLAHOMA* POSTAL HAND STAMPS

434 U.S.S. *Oklahoma* postmark hand stamp, 1941, Hawaii, United States, wood, metal, paint, 5¼ x 1¼ in. (13.34 x 3.18 cm.). Smithsonian Institution, National Postal Museum, accession: 1992.2002.2.

437 U.S.S. *Oklahoma* duplex hand stamp, 1941, Hawaii, United States, wood, rubber, wooden handle: 1½ x 2⁹⁄₁₆ x 3¾ in. (3.8 x 6.5 x 9.5 cm.), rubber stamp: 1⅜ x 2¾ x ½ in. (3.5 x 7 x 1.3 cm.). Smithsonian Institution, National Postal Museum, accession: 1992.2002.369.

63. *SPIRIT OF TUSKEGEE*

440 *Spirit of Tuskegee*, Boeing-Stearman PT-13D Kaydet, Boeing Aircraft Co., ca. 1944, Wichita, Kansas, steel, aluminum, copper alloy, wood, polyester, rubber, plastic, wingspan: 32 ft. 2 in. (9.8 m.), length: 25 ft. (7.6 m.), height: 9 ft. 2 in. (2.8 m.). Smithsonian Institution, National Museum of African American History and Culture, accession: 2011.82.

64. "WE CAN DO IT!"
POSTER OF ROSIE THE RIVETER

446 "We Can Do It!" photolithograph, J. Howard Miller, ca. 1942, Glenshaw, Pennsylvania, United States, paper, 22 x 17 in. (55.88 x 43.18 cm.). Smithsonian Institution, National Museum of American History, Kenneth E. Behring Center, accession: 1985.0851. Purchase from J. Howard Miller.

449 *Rosie the Riveter*, Norman Rockwell, 1943, oil on canvas, 52 x 40 in. (132.1 x 101.6 cm.). Crystal Bridges Museum of American Art, Bentonville, Arkansas. Photograph by Dwight Primiano. Printed by permission of the Norman Rockwell Family Agency. Copyright © 1946 The Norman Rockwell Family Entities.

65. JAPANESE AMERICAN WORLD WAR II INTERNMENT ART

453 *Thinking of Loved One*, Henry Sugimoto, ca. 1944, oil on canvas. Smithsonian Institution, National Museum of American History, Kenneth E. Behring Center, cat. no. 1984.1118.02, accession: 1984.1118.

66. AUDIE MURPHY'S EISENHOWER JACKET

460 Audie Murphy's olive drab field jacket, World War II, wool, olive drab, plastic, 26⅜ x 27³⁄₁₆ in. (67 x 69 cm.). Smithsonian Institution, National Museum of American History, Kenneth E. Behring Center, cat. no. 1985.0428.01, accession: 1985.0428.

463 *Dwight D. Eisenhower*, Ernest Hamlin Baker, 1945, gouache on board, sheet: 12 x 11 in. (30.5 x 27.9 cm.), mat: 28 x 22 in. (71.1 x 55.9 cm.). Smithsonian Institution, National Portrait Gallery, object no. accession NPG.97.TC41. Purchased with funds from Rosemary L. Frankeberger. © Ernest Hamlin Baker.

67. *ENOLA GAY*

464 Boeing B-29 Superfortress *Enola Gay*, Boeing Aircraft Co., Martin Co., 1945, Omaha, Nebraska, United States, polished overall aluminum finish, 29 ft. 6⁵⁄₁₆ in. x 99 ft. 1 in. (9 x 30.2 m.), weight: 71,825.9 lbs. (32,580 kg.). Smithsonian Institution, National Air and Space Museum, Steven F. Udvar-Hazy Center, Inv. A19500100000. Photograph by Dane Penland, Smithsonian.

466 Sample of plutonium-239, Emilio Segre and Glenn Seaborg, 1941, Lawrence Berkeley National Laboratory, Berkeley, California, United States, metal (overall material), platinum (plate material), wood (cigar box material), box (closed): 35⁷⁄₁₆ x 7½ x 6¼ in. (90 x 19 x 15.9 cm.), disc: ⁹⁄₁₆ in. (1.5 cm.). Smithsonian Institution, National Museum of American History, Kenneth E. Behring Center, cat. no. N-09384, accession: 272669.

468 Boeing B-29 Superfortress *Enola Gay* on the ground at North Field, Tinian, Marianas Islands, 1945. Smithsonian Institution, National Air and Space Museum, Inv. A19500100000, accession: 1988-0027, neg. SI-88551.

471 Aerial view from tail gunner's position of Boeing B-29 Superfortress *Enola Gay* of cloud of smoke billowing twenty thousand feet above Hiroshima, Japan, after the explosion of the "Little Boy" atomic bomb, August 6, 1945. Smithsonian Institution, National Air and Space Museum, SI-2003-18754. Photograph by S/Sgt George R. Caron.

COLD WAR
68. FALLOUT SHELTER

474 Fallout shelter, Universal Tank & Iron Works, Inc., ca. 1955, Indianapolis, Indiana, United States, steel, 15 x 13 x 10 ft. (4.572 x 3.9624 x 3.048 m.). Smithsonian Institution, National Museum of American History, Kenneth E. Behring Center, cat. no. 2005.0051.04, accession: 2005.0051. Gift of Timothy L. and Vera R. Howey.

476 Fallout shelter sign, ca. 1945. Image courtesy of Cold War Museum, Warrenton, Virginia.

69. MERCURY *FRIENDSHIP 7*

481 Mercury *Friendship 7*, McDonnell Aircraft Corporation, 1962, United States, skin and structure: titanium, heat shield: phenolic resin, fiberglass, shingles: nickel-steel alloy, beryllium, shingles removed, height: 9 ft. 4 in., width: 6 ft. 1 in. (2.845 x 1.85 m.), weight: 2,900 lbs. (1,354.9 kg.). Smithsonian Institution, National Air and Space Museum, Inv. A19670176000. Photograph by Eric Long, Smithsonian.

70. HUEY HELICOPTER

488 Huey helicopter 091, (Bell UH-1 Iroquois), Bell Helicopter Co., 1965, United States, weight: 5,932 lbs. Smithsonian Institution, National Museum of American History, Kenneth E. Behring Center, cat. no. 2004.3023.01, accession: 2001.3023. Photograph by Hugh Talman, Smithsonian.

71. PANDAS FROM CHINA

494 Ling-Ling and Hsing-Hsing pandas. Smithsonian Institution, National Zoological Park. Gift by the people of the People's Republic of China to the people of the United States. Photograph by Jessie Cohen, Smithsonian.

72. BERLIN WALL FRAGMENT

500 Berlin Wall fragment, 15 x 16 in. (38.1 x 40.64 cm.). Smithsonian Institution, National Museum of American History, Kenneth E. Behring Center. Gift of John F. W. Rogers.

NEW FRONTIERS
73. JONAS SALK'S POLIO VACCINE

508 Salk polio vaccine, Mahoney strain, Jonas E. Salk, 1952, Pittsburgh, Pennsylvania, United States, vaccine residue, polio virus (drug active ingredients), 2³⁄₁₆ x ⅞ in. (5.5 x 2.3 cm.); Saukett strain, 2³⁄₁₆ x ⅞ in. (5.5 x 2.3 cm.); MEF-1 strain, 2⁹⁄₁₆ x 1⅛ in. (6.5 x 2.8 cm.), Smithsonian Institution, National Museum of American History, Kenneth E. Behring Center, cat. nos./accession: 221419.04, 221419.05, 221419.06. Jonas Salk's syringe, Becton, Dickinson and Company, ca. 1950, glass (plunger material), glass (barrel material), glass (tip, force material), steel (handle material), metal, steel (needle material), 4⅛ x 1⅛ x ⅛ in. (10.4 x 2.8 x 1 cm.). Smithsonian Institution, National Museum of American History, Kenneth E. Behring Center, cat. no. 221419.07, accession: 221419.

74. JACQUELINE KENNEDY'S INAUGURAL BALL GOWN

514 Jacqueline Kennedy's inaugural gown, Ethel Frankau of Bergdorf Custom Salon, 1961, off-white silk chiffon over *peau d'ange*, embroidered with silver thread. Smithsonian Institution, National Museum of American History, Kenneth E. Behring Center, cat. no. 234793.01, accession: 234793. Gift of Mrs. John F. Kennedy.

517 *John F. Kennedy and Jacqueline Bouvier Kennedy*, Richard Avedon, January 3, 1961, 28 x 28 in. (71.12 x 71.12 cm.). Smithsonian Institution, National Museum of American History Kenneth E. Behring Center, Photographic History Collection, accession: 270571. Gift of Richard Avedon.

75. JULIA CHILD'S KITCHEN

522–23 Julia Child's kitchen at the Smithsonian Institution, National Museum of American History, Kenneth E. Behring Center, accession: 2001-0253. Gift of Julia Child. Additional related objects, gift of Philadelphia Cousins and the Trustees of the Julia Child Foundation, accessions: 2009.0091 and 2012-0043.

526 1973 Stag's Leap Wine Cellars cabernet sauvignon, made by Warren Winiarski, Stag's Leap Wine Cellars, 1973, Napa, California, United States, glass, 12 x 3 in. (30.48 x 7.62 cm.), Smithsonian Institution, National Museum of American History, Kenneth E. Behring Center, cat. no. 1996.0029.01, accession: 1996.0029, gift of Warren Winiarski, Stag's Leap Wine Cellars; 1973 Chateau Montelena Chardonnay, made by Mike Grgich, Chateau Montelena Winery, 1973, Calistoga, California, United States, glass, 12 x 3 in. (30.48 x 7.62 cm.), Smithsonian Institution, National Museum of American History, Kenneth E. Behring Center, cat. no. 1996.0028.01, accession: 1996.0028, gift of James Barrett.

76. THE PILL AND ITS DISPENSER

528 Wagner DialPak patent model (prototype Pill dispenser and patent), David P. Wagner, 1962, United States, paper, plastic, staples, pencil, double-faced transparent tape. Smithsonian Institution, National Museum of American History, Kenneth E. Behring Center, cat. no. 1995.0057.01, accession: 1995.0057.

530 Enovid Oral Contraceptive, G. D. Searle and Company, 1955–1960, Chicago, Illinois, United States, norethynodrel, 5 mg. (drug active ingredients), mestranol, 0.075 mg. (drug active ingredients), 2³⁄₁₆ x ⅞ in. (5.5. x 2.3 cm.). Smithsonian Institution, National Museum of American History, Kenneth E. Behring Center, cat. no. 1982.0531.032, accession: 1982.0531. Gift of the Margaret Sanger Center of New York City.

77. NEIL ARMSTRONG'S SPACE SUIT

534 Neil Armstrong, Apollo 11 pressure suit A7-L, ILC Industries, Inc., 1969, United States, overall materials: beta cloth, rubber, nylon, plastic connectors, aluminum (red, blue), neck ring: aluminum wrist locking rings, aluminum (red, blue), zipper: brass with neoprene gasket, 5ft. 6¹⁵⁄₁₆ in. x 2 ft. 8⁵⁄₁₆ x 11 in. (170.02 x 82 x 28 cm.). Smithsonian Institution, National Air and Space Museum, Inv. A19730040000. Photograph by Mark Avino, Smithsonian.

537 Apollo lunar module 2 (LM-2), Grumman Aircraft Engineering Corporation, United States, aluminum, titanium, aluminized Mylar and aluminized Kapton blankets, 22 ft. 11 in. x 14 ft. 1 in. (6.985 x 4.293 m.), weight: 8,499.9 lbs. (3,855.5 kg.). Smithsonian Institution, National Air and Space Museum, Inv. A19711598000. Photograph by Eric Long, Smithsonian.

540 Lunar sample, Apollo 15, rock #15016, weight: 923 g. up to 13 cm. across. Courtesy of the National Aeronautics and Space Administration.

78. "MR. CYCLE" PCR MACHINE

542 "Mr. Cycle" thermal cycler-PCR (polymerase chain reaction) DNA (deoxyribonucleic acid) machine, 1985–1986, metal, plastic, rubber, 2¾ x 13 x 21¹⁵⁄₁₆ in. (55.3 x 33 x 55.8 cm.). Smithsonian Institution, National Museum of American History, Kenneth E. Behring Center, cat. no. 1993.0166.01, accession: 1993.0166. From Roche Molecular Systems, Inc., through Thomas J. White, Ph.D.

79. SPACE SHUTTLE *DISCOVERY*

547 Space shuttle orbiter vehicle OV-103, *Discovery*, Rockwell International, United States, service dates: 1984–2011, 78 ft. wingspan x 122 ft. long x 57 ft. high. Smithsonian Institution, National Air and Space Museum, Inv. A20120325000. Transfer from NASA. Photograph by Dane A. Penland, Smithsonian.

550 Shuttle *Discovery* flies over Washington, D.C., to new home, April 17, 2012. Photo © Rebecca Roth/NASA/Handout/Corbis.

CIVIL RIGHTS

80. GREENSBORO LUNCH COUNTER

554 Greensboro lunch counter, F. W. Woolworth Co., 38 x 15 x 15 in. (96.52 x 38.1 x 38.1 cm.). Smithsonian Institution, National Museum of American History, Kenneth E. Behring Center, cat. no. 1994.0156.01, accession: 1994.0156.

81. MUHAMMAD ALI'S BOXING GEAR

561 Muhammad Ali's gloves, Everlast, ca. 1974, United States, leather, fabric, 10½ x 6 in. (26.67 x 15.24 cm.), Smithsonian Institution, National Museum of American History, Kenneth E. Behring Center, cat. no. 1977.1073.01, accession: 1977.1073, gift of Muhammad Ali; Muhammad Ali's robe, ca. 1974, United States, fiber, cotton, 47 x 23 in. (119.38 x 58.42 cm.), Smithsonian Institution, National Museum of American History, Kenneth E. Behring Center, cat. no. 1977.1073.02, accession: 1977.0001073, gift of Muhammad Ali.

562 Cassius Clay (Muhammad Ali), training gloves, Post Manufacturing Co., ca. 1960, leather, cotton, 10 x 5½ x 4 in. (25.4 x 13.97 x 10.16 cm.), Smithsonian Institution, National Museum of African American History and Culture, accession: 2012.173.3ab. Photograph by Eric Long, Smithsonian.

562 Muhammad Ali's headgear, 5th Street Gym, ca.1973, Everlast Worldwide, Inc., United States, leather, 8½ x 10½ x 7 in. (21.59 x 26.67 x 17.78 cm.), Smithsonian Institution, National

Museum of African American History and Culture, accession: 2011.82.

82. BOB DYLAN POSTER BY MILTON GLASER

568 Dylan poster, Milton Glaser, 1966, offset lithograph on white weave paper, image/sheet: 33 x 22 in. (83.8 x 55.9 cm.). Smithsonian Institution, National Portrait Gallery, object no. NPG.94.57. © Milton Glaser.

571 "I Love New York" logo is a registered trademark/service mark of the New York State Department of Economic Development, used with permission. Plan a New York State Getaway. Visit Iloveny.com.

83. CESAR CHAVEZ'S UNION JACKET

574 Cesar Chavez's union jacket, 1980s–1990s, California, United States, polyester (shell material), nylon (lining material), 26 x 25 in. (66.04 x 63.5cm.). Smithsonian Institution, National Museum of American History, Kenneth E. Behring Center, cat. no. 1993.0409.01, accession: 1993.0409. Gift of Helen Chavez.

578 *Azada de mango corto*, short-handled hoe (owned by Librado Hernandez Chavez, father of Cesar), 1936, San Jose, California, United States, metal (blade material), welded to metal neck, wood (handle material), 5 x 16 in. (12.7 x 40.64 cm.), overall; 4 x 6 in. (10.16 x 15.24 cm.), blade. Smithsonian Institution, National Museum of American History, Kenneth E. Behring Center, cat. no. 1998.0197.01, accession: 1998.0197. Gift of Rita Chavez Medina.

84. GAY CIVIL RIGHTS PICKET SIGNS

581 Gay rights picket signs: "First Class Citizenship for Homosexuals," paper, wood, 48 x 24½ in. (121.92 x 62.23 cm.); "Homosexual Citizens Want to Serve Their Country Too," paper, 22 x 28 in. (55.88 x 71.12 cm.); "Discrimination Against Homosexuals Is As Immoral As Discrimination Against Negroes & Jews," paper, 22 x 28 in. (55.88 x 71.12 cm.). Smithsonian Institution, National Museum of American History, Kenneth E. Behring Center, accession: 2006.0223. Gift of Kameny Papers Project.

85. AIDS MEMORIAL QUILT PANEL

586 AIDS memorial quilt panel, Gert McMullin in memory of Roger Lyon, 1985–1990, San Francisco, California, United States, textile, 35¹¹⁄₁₆ x 70⅞ x ³⁄₁₆ in. (90.6 x 180 x .5 cm.). Smithsonian Institution, National Museum of American History, Kenneth E. Behring Center, cat. no. 1998.0254.01, accession: 1998.0254. Gift of Gert "Cindy" McMullin.

591 National Mall with AIDS quilt. © 2013 The Associated Press/ Ron Edmonds.

POP CULTURE

86. WALT DISNEY'S MICKEY MOUSE

594 Mickey Mouse in *Steamboat Willie* (animation cell after a pencil drawing), 1928, 12½ x 16 in. (31.75 x 40 cm.). Smith-

sonian Institution, National Museum of American History, Kenneth E. Behring Center, cat. no. 1988.0434.01, accession: 1988.0434. Gift of Roy Disney and Michael Eisner in honor of Mickey's sixtieth birthday. © Disney.

87. RCA TELEVISION SET

601 RCA TRK-12 television set, Radio Corporation of America (RCA) Corporation, 1939, United States, wood, glass, metal, plastic, 40¾ x 34½ x 20½ in. (103.505 x 87.63 x 52.07 cm.). Smithsonian Institution, National Museum of American History, Kenneth E. Behring Center, cat. no. 326100, accession: 258911. Gift from Col. Frank E. Mason.

606 Television artifacts: *60 Minutes* stopwatch, 1970s–1990s, United States, metal and glass, 3⁹⁄₁₆ x 2¹⁵⁄₁₆ in. (9 x 2.5 x 7.5 cm.), Smithsonian Institution, National Museum of American History, Kenneth E. Behring Center, cat. no. 1998.0265.01, accession: 1998.0265, with permission CBS News; *M*A*S*H* signpost, 1970–1972, wood, metal, 9 x 35 in. (22.86 x 88.9 cm.), Smithsonian Institution, National Museum of American History, Kenneth E. Behring Center, cat. no. 1983.0095.237, accession: 1983.0095.237, *M*A*S*H* © 1972 Twentieth Century Fox, All Rights Reserved; Lone Ranger's mask, 1949–1957, felt, rubber, resin, 2⁹⁄₁₆ x 5³⁄₁₆ x 4¾ in. (6.5 x 13.5 x 12 cm.), Smithsonian Institution, National Museum of American History, Kenneth E. Behring Center, cat. no. 2000.0111.01, accession: 2000.0111, donated by Dawn Moore; U.S. Olympic ice hockey team jersey, 1980, synthetic fabric, 32½ x 24 in. (82.55 x 60.96 cm.), Smithsonian Institution, National Museum of American History, Kenneth E. Behring Center, cat. no. 1984.0940.05, accession: 1984.0940, gift of *Sports Illustrated*, with permission *Sports Illustrated; Sex and the City* computer, Apple Computer, Inc., plastic, 10 x 12½ x 1½ in. (25.4 x 31.75 x 3.81 cm.), Smithsonian Institution, National Museum of American History, Kenneth E. Behring Center, cat. no. 2004.0163.01, accession: 2004.0163, with permission, Apple™; Davy Crockett coonskin cap, fabric, raccoon skin, leather, 23 x 7 x 7 in. (58.42 x 17.78 cm.), Smithsonian Institution, National Museum of American History, Kenneth E. Behring Center, cat. no. 1990.0489.06, accession: 2004.0040, gift of Fess Parker, with permission Walt Disney Enterprises; Kunta Kinte's manacles from *Roots*, 1977, metal, rubber, 6½ x 53 in. (16.51 x 134.62 cm.), Smithsonian Institution, National Museum of American History, Kenneth E. Behring Center, cat. no. 1993.0170.02, accession: 1993.0170, courtesy of Warner Bros. Entertainment Inc.™ and © Warner Bros. Entertainment Inc. (s13); Mister Rogers's sweater, 1968–1984, fiber, acrylic, metal (zipper material), 27 x 31 in. (68.58 x 78.74 cm.), Smithsonian Institution, National Museum of American History, Kenneth E. Behring Center, cat. no. 1984.0219.01, accession: 1984.0219, with permission The Fred Rogers Company; Archie Bunker's chair from *All in the Family*, T.A.T. Productions, 1971–1979, wood (frame, arms, legs, stretcher material), fabric, 40 x 26 x 31 in. (101.6 x 66.04 x 78.74 cm.), Smithsonian Institution, National Museum of American History, Kenneth E. Behring Center, cat. no. 1978.2146.01, accession: 1978.2146.01, *All in the Family* courtesy Sony Pictures

Television; Seinfeld's puffy shirt, 1989–1998, fabric, 35 x 20 in. (88.9 x 50.8 cm.), Smithsonian Institution, National Museum of American History, Kenneth E. Behring Center, cat. no. 2004.0245.01, accession: 2004.0245, courtesy of Warner Bros. Entertainment Inc.™ and © Castle Rock Entertainment (s13).

88. CHUCK BERRY'S GIBSON GUITAR

608 Chuck Berry's guitar, Gibson Guitar Corporation, 1960, Kalamazoo, Michigan, United States, wood, metal, velvet. Smithsonian Institution, National Museum of African American History and Culture, accession: 2011.137.2. Gift of Charles E. Berry.

611 *Elvis Presley* photograph, Jay B. Leviton, 1956, gelatin silver print, 9⅝ x 15⁷⁄₁₆ in. (24.4475 x 39.2113 cm.). Smithsonian Institution, National Portrait Gallery, object no. NPG.93.76. Photo credit: © JAY: Leviton-Atlanta.

89. KATHARINE HEPBURN'S OSCARS

614 Katharine Hepburn's Oscars: Best Actress for *Guess Who's Coming to Dinner*, 1967, gold-plated brittanium with black metal base: 13⅛ x 5³⁄₁₆ x 5³⁄₁₆ in. (33.3 x 13.2 x 13.2cm.); Best Actress Academy Award for *Morning Glory*, 1933, bronze with black metal base, dimensions with base: 11¾ x 5⅜ x 5⅜ in. (29.8 x 13.7 x 13.7cm.); Best Actress for *The Lion in Winter*, 1968, gold-plated brittanium with black metal base: 13 x 5⅛ x 5⅛ in. (33 x 13 x 13cm.); Best Actress for *On Golden Pond*, 1981, gold-plated brittanium with black metal base: 13¼ x 5¼ x 5¼ in. (33.7 x 13.3 x 13.3cm.). Smithsonian Institution, National Portrait Gallery, AD/NPG.2009.2, AD/NPG.2009.3, AD/NPG.2009.4, AD/NPG.2009.5. Gift of the Estate of Katharine Hepburn.

90. HOPE DIAMOND

621 Hope diamond, designed by Pierre Cartier, 1910, cushion antique brilliant with a faceted girdle and extra facets on the pavilion, platinum setting surrounded by sixteen white pear-shaped and cushion-cut diamonds, length: 25.60 mm., width: 21.78 mm., depth: 12.00 mm., weight: 45.52 carats. Smithsonian Institution, National Museum of Natural History, accession: 217868. Gift of Harry Winston Inc.

91. ANDY WARHOL'S *MARILYN MONROE*

626 *Marilyn Monroe*, Andy Warhol, 1967, printer: Aetna Silkscreen Products, Inc., publisher: Factory Additions, screen print on paper, image/sheet: 36 x 36 in. (91.5 x 91.5 cm.). Smithsonian Institution, National Portrait Gallery, object no. NPG.97.51. Gift of Daniel Salomon. Image and Artwork © 2013 The Andy Warhol Foundation for the Visual Arts, Inc./Licensed by ARS.

631 *Marilyn Monroe's Lips*, Andy Warhol, 1962, synthetic polymer, silkscreen ink and pencil on canvas, A (left): 82¾ X 80¾ in. (210.7 x 204.9 cm.); B (right): 82¾ x 82⅜ in. (210.7 x 209.7 cm.). Smithsonian Institution, Hirshhorn Museum and Sculpture Garden, 72.313.A-B. Gift of Joseph H. Hirshhorn. Image and Artwork © 2013 The Andy Warhol Foundation for the Visual Arts/Licensed by ARS.

92. McDONALD'S GOLDEN ARCHES SIGN

633 McDonald's restaurant sign for the Japanese market, 1975, 9 x 5 ft. (2.74 x 1.524 m.). Smithsonian Institution, National Museum of American History, Kenneth E. Behring Center, cat. no. 1983.0020.01, accession: 1983.0020.

93. KERMIT THE FROG

638 Muppet's Kermit (known as Kermit the Frog), Jim Henson, 1970, Jim Henson Productions, New York, United States, fiber, synthetic, rayon, fabric, felt, metal, wire, plastic, green, 27 x 28 x 6 in. (68.58 x 71.12 x 15.24 cm.). Smithsonian Institution, National Museum of American History, Kenneth E. Behring Center, cat. no. 1994.0037.01, accession: 1994.0037. Gift of the Jim Henson Production Company, New York City. © Disney.

94. *STAR WARS'* R2-D2 AND C-3PO

645 *Star Wars'* R2-D2 and C-3PO from *Return of the Jedi*, 1983, San Rafael, California, United States, R2-D2: body of aluminum and epoxy, fiberglass, foam, spun aluminum, 44 x 26 x 28½ in. (111.76 x 66.04 x 72.39 cm.), weight: 68 lbs.; C-3PO: leotard, fiberglass, rubber, aluminum, 68 x 34 x 20 in. (172.7 x 86.4 x 50.8 cm.), weight: 30 lbs. Smithsonian Institution, National Museum of American History, Kenneth E. Behring Center, cat. nos. 1984.0302.01, 1984.0302.02, accession: 1984.0302. Gift of Lucasfilm Ltd. (through Howard Roffman), *Star Wars: Episode IV-A New Hope*™ and © 1977–2013 Lucasfilm Ltd. All rights reserved. Used under authorization. Unauthorized duplication is a violation of applicable law. Courtesy of Lucasfilm, Ltd.

DIGITAL AGE

95. ENIAC

650 ENIAC (Electronic Numerical Integrator and Computer), 1945, United States. Smithsonian Institution, National Museum of American History, Kenneth E. Behring Center, cat. nos. 321732.01, 321732.02, 321732.03, 321732.04, accession: 242457.

96. APPLE'S MACINTOSH COMPUTER

657 Apple "Classic" Macintosh personal computer (Model M0001), Apple Computer, Inc., 1984, Cupertino, California, United States, plastic, metal, 13½ x 16 x 20 in. (34.29 x 40.64 x 40.64 cm.). Smithsonian Institution, National Museum of American History, Kenneth E. Behring Center, cat. no. 1985.0118.01, accession: 1985.0118. Gift from Apple Computer,.

658 Apple I motherboard, Apple Computer, Inc., 1976, California, United States, 3 x 14 x 14 in. (7.62 x 35.56 x 35.56 cm.). Image courtesy Computer History Museum, object ID X210.83Ap.

659 Apple II personal computer, Apple Computer, Inc., 1977, Cupertino, California, United States, plastic, metal, 4 x 15 x 17 in. (10.2 x 38.1 x 43.2 cm.). Smithsonian Institution, National Museum of American History, Kenneth E. Behring Center, cat. no. 1990.0167.01.1, accession: 1990.0167. Gift of J. and D. J. Warner.

659 Apple Lisa 2 personal computer, Apple Computer, Inc., 1983, Cupertino, California, United States, plastic, glass, metal, 14 x 19 x 14 in. (35.56 x 48.26 x 35.56 cm.). Smithsonian Institution, National Museum of American History, Kenneth E. Behring Center, cat. no. 2005.0056, accession: 2005.0056. Gift of Roslyn Lang.

661 *Steve Jobs*, Diana Walker, 1982 (printed 2011), digital inkjet print, image: 17½ x 12⅛ in. (44.4 x 30.7 cm.), sheet: 22 x 17⅛ in. (55.9 x 43.3 cm.). Smithsonian Institution, National Portrait Gallery, object no. NPG.2011.40. Gift of Diana Walker. © Diana Walker.

97. NAM JUNE PAIK'S *ELECTRONIC SUPERHIGHWAY*

664–65 *Electronic Superhighway: Continental U.S., Alaska, Hawaii*, Nam June Paik, 1995, United States, forty-nine-channel closed-circuit video installation, neon, steel and electronic components, approx. 15 x 32 ft. (4.572 x 9.7536 m.). Smithsonian Institution, Smithsonian American Art Museum, accession: 2002.23. Gift of the artist. © Nam June Paik Estate.

NEW MILLENNIUM

98. NEW YORK FIRE DEPARTMENT ENGINE DOOR FROM SEPTEMBER 11

670 New York Fire Department truck door, 9/11, date unknown, manufacturer unknown, metal, rubber, fabric, paper, 61.811 x 40.55 x 34.252 in. (157 x 103 x 87 cm.). Smithsonian Institution, National Museum of American History, Kenneth E. Behring Center, cat. no. 2002.0055.04, accession: 2002.0055. Gift from New York City Fire Department.

674 Fused commemorative medallions (from Pentagon), metal, 2 x 3½ x 2½ in. (5.08 x 8.89 x 6.35 cm.). Smithsonian Institution, National Museum of American History, Kenneth E. Behring Center, cat. no. 2002.0279.19, accession: 2002.0279.

675 Cladding fragment, 9/11, date unknown, aluminum, 55 x 16 x 9 in. (139.7 x 40.64 x 22.86 cm.). Smithsonian Institution, National Museum of American History, Kenneth E. Behring Center, cat. no. 2002.0205.05, accession: 2002.0205.

675 United Airlines Flight 93 flight logbook, Lorraine Bay, 1992–1996, paper, 9½ x 11¼ x 2 in. (24.13 x 28.575 x 5.08 cm.). Smithsonian Institution, National Museum of American History, Kenneth E. Behring Center, cat. no. 2003.0051.03, accession: 2003.0051.

676 *Modern Head*, Roy Lichtenstein, 1974/1990, painted stainless steel, 372 x 232 x 8 in. (944.9 x 589.3 x 20.3 cm.). Smithsonian Institution, Smithsonian American Art Museum, accession: 2008.28A-F. Gift of Jeffrey H. Loria in loving memory of his sister, Harriet Loria Popowitz. © Estate of Roy Lichtenstein.

99. SHEPARD FAIREY'S *BARACK OBAMA* "HOPE" PORTRAIT

679 *Barack Obama*, Shepard Fairey (1970–), 2008, United States, hand-finished collage, stencil, and acrylic on heavy paper, sheet: 69⁹⁄₁₆ x 46¼ in. (176.7 x 117.5 cm.), frame: 73¾ x 50 x 2 in. (187.3 x 127 x 5.1 cm.). Smithsonian Institution, National Portrait Gallery, object no. NPG. 2008.52. Gift of the Heather and Tony Podesta Collection in honor of Mary K. Podesta. © 2008 Shepard Fairey/ObeyGiant.com.

682 *Hongera Barack Obama*, factory printed cloth, 2008, Tanzania, cotton, synthetic dye, 39¾ x 61¹³⁄₁₆ in. (101 x 157 cm.). Smithsonian Institution, National Museum of African Art, accession: 2009-2-1. Anonymous donor. Photograph by Franko Khoury, Smithsonian.

100. DAVID BOXLEY'S TSIMSHIAN TOTEM POLE

684 Totem pole, David Boxley and David Robert Boxley, 2001–2012, red cedar, latex paint, 22 ft. (6.7056 m.). Smithsonian Institution, National Museum of the American Indian, accession: 26/8612. Photograph by R. A. Whiteside. © David Boxley.

688 Totem pole, British Columbia, Haida Gwaii, Canada, 1901, wood, pigment, 75.3 x 10.7 x 9 cm., cat. no. 16/8754. Courtesy of the Division of Anthropology, American Museum of Natural History. Photo © Denis Finnin.

101. GIANT MAGELLAN TELESCOPE

692 Giant Magellan telescope. Image courtesy of GMTO Corporation.

TIME LINE OF AMERICAN HISTORY

APPROXIMATE YEARS AGO

525 million Evolutionary burst of diverse life forms in North America

5–24 million Miocene epoch, with development of mammals, woodlands, and prairies in North America recognizable today

15–40,000 Range of first migrations of people into North America

CURRENT ERA (A.D.)

1000 Vikings establish temporary Vinland settlement in Newfoundland

1100s Cahokia mounds reach peak habitation

1492 Columbus lands in Caribbean on first of four voyages

1521 Spanish colonists found San Juan, Puerto Rico

1565 Saint Augustine, Florida, founded by Spanish, first permanent European colony in what becomes the continental United States

1598 Don Juan Oñate declares possession of land north of the Rio Grande for Spain and establishes first permanent Spanish settlement in the region

1607 British Virginia Company establishes Jamestown, first permanent English settlement in America

1608 Samuel de Champlain establishes Quebec on the St. Lawrence River, the first French settlement in America

1619 First Africans arrive at Jamestown and placed in servitude; Virginia House of Burgesses established

1620 Settlers from England and the Netherlands sail on *Mayflower*, sign Mayflower Compact, and found Plymouth Colony

1625 The Dutch West India Company establishes New Amsterdam on Manhattan Island

1652 First coins minted in English colonies at Boston; colonial population is about 50,000

1654 Virginia colonial court legalizes slavery

1664 English capture New Amsterdam and rename it New York

1670 Lords Proprietors begin settling Charleston, South Carolina

1680 Pueblo revolt against Spanish rule

1681 Quaker William Penn establishes colony of Pennsylvania

1682 French explorer Robert de La Salle finds the Mississippi basin, eventually naming it Louisiana

1754 French and Indian War between Britain and France begins

1764 British pass the Stamp and Sugar Acts

1770 Boston Massacre

1773 British pass Tea Act; Boston Tea Party

1774 First Continental Congress meets in Philadelphia to discuss negotiating tax relief and greater self-governance with British

1775 Continental Congress creates Continental Army, Navy, and Marines; American Revolutionary

War begins when British troops fire on colonial militiamen at Lexington and Concord, Massachusetts; George Washington commissioned by the Continental Congress to lead troops

1776 Declaration of Independence written in Philadelphia and printed copies circulated

1777 Continental Congress sends Articles of Confederation to the states and approves first official flag; American troops winter at Valley Forge

1778 Benjamin Franklin secures treaty of alliance with France

1783 American Revolutionary War ends with the Treaty of Paris, about 25,000 Americans dead

1787 Constitutional Convention adopts the U.S. Constitution

1788 Ratification of the Constitution of the United States; George Washington elected first president of United States

1789 Constitution goes into effect; U.S. Congress meets for first time with New York City as the temporary capital

1790 Supreme Court meets for first time; Philadelphia becomes second temporary capital; U.S. Census established with the population at almost 4 million, 95 percent rural; District of Columbia created as permanent capital, named for George Washington

1791 Ratification of Bill of Rights; first bank of the United States established; Whiskey Rebellion begins

1792 Cornerstone of the White House set; Coinage Act establishes U.S. currency and gold standard

1793 Samuel Slater establishes water-powered textile mill in Rhode Island; first Fugitive Slave Law passes

1800 President John and Abigail Adams move into Presidential Mansion; Library of Congress established; Thomas Jefferson elected third president

1803 Jefferson purchases Louisiana from Napoleon's France; Supreme Court decides *Marbury v. Madison*, establishing principle of judicial review

1804 Lewis and Clark lead Corps of Discovery to explore Louisiana territory and find an overland route to the Pacific, aided by Shoshone guide Sacagawea

1807 Robert Fulton sails first steamboat up the Hudson from New York to Albany

1812 War of 1812 begins as the United States declares war on Britain

1814 Burning of Washington; Francis Scott Key writes "Star-Spangled Banner" in Baltimore; treaty to end the War of 1812 signed, about 20,000 American dead

1815 General Andrew Jackson defeats British at New Orleans

1816 First Seminole War as U.S. forces under Jackson battle Indian tribes in Spanish Florida and border areas

1819 Spain cedes Florida to the United States

1820 Missouri Compromise balances number of new slave and nonslave states

1823 Monroe Doctrine declares the Americas to be in the U.S. sphere of influence

1825 Erie Canal opens from Albany to Buffalo and Lake Erie

1828 Andrew Jackson elected president

1830 President Jackson signs Indian Removal Act; Joseph Smith founds the Church of Latter-day Saints and promulgates *The Book of Mormon*

1831 Supreme Court decides *Cherokee Nation v. Georgia*, resulting in the relocation of American Indians via the Trail of Tears; Nat Turner leads slave uprising in Virginia

1835 Second Seminole War begins as United States fights against Native tribes in Florida

1836 Texas declares independence from Mexico; defeat of Texans at Alamo mission by Mexican forces

1837 Financial markets collapse as Panic of 1837 begins a six-year economic depression

1839 Louis-Jacques-Mandé Daguerre invents daguerreotype photograph

1842 Massachusetts Supreme Court upholds rights of workers to organize in *Commonwealth v. Hunt*

1845 United States annexes the Republic of Texas and it becomes a state; term "Manifest Destiny" coined; Irish potato famine leads more than 1 million immigrants to the United States

1846 Mexican-American War begins; Smithsonian Institution established by act of Congress

1848 Treaty of Guadalupe Hidalgo ends war with Mexico with United States gaining territory in the west; discovery of gold at Sutter's Mill, California, sets off "Gold Rush"; Harriet Tubman escapes slavery and begins guiding others to freedom; Seneca Falls Convention

1850 U.S. population about 23 million, 85 percent rural; Compromise of 1850 bills pass, including the Fugitive Slave Law

1852 *Uncle Tom's Cabin* by Harriet Beecher Stowe published

1854 Commercial treaty with Japan by Commodore Matthew C. Perry "opens" the East to trade and culture; Gadsden Purchase expands U.S. territory in the southwest; Kansas-Nebraska Act ratified, opens territory for development of transcontinental railroad, also allows new states to choose slavery through popular sovereignty

1855 Third Seminole War begins in Florida to remove American Indians and restrict their settlement

1857 Supreme Court's *Dred Scott* decision

1859 Radical abolitionist John Brown leads unsuccessful raid on arsenal at Harpers Ferry, West Virginia

1860 Abraham Lincoln elected president; South Carolina becomes first of eleven states to secede from Union

1861 Confederate States of America established with Jefferson Davis as president; Civil War begins when Confederates fire on federal Fort Sumter, near Charleston, South Carolina

1862 Land grant colleges established with the Morrill Act; Congress passes Homestead Act, spurring settlement of the Midwest

1863 President Lincoln issues Emancipation Proclamation, freeing slaves in states in rebellion; Battle of Gettysburg

1864 Abraham Lincoln reelected president

1865 Thirteenth Amendment outlawing slavery ratified; Civil War ends leaving about 360,000 Union and 260,000 Confederate men dead; Lincoln assassinated; Ku Klux Klan founded

1867 Congress passes Reconstruction Acts in Confederate States; United States purchases Alaska from Russia

1868 President Andrew Johnson impeached; Fourteenth Amendment providing for due process and equal protection of the law ratified

1869 Golden Spike at Promontory Point, Utah, joins the Central Pacific and Union Pacific railroads to create Transcontinental Railroad; Yellowstone in Wyoming Territory becomes first national park

1870 Fifteenth Amendment giving African American men the right to vote ratified; first African Americans elected to the U.S. Congress; John D. Rockefeller and partners establish Standard Oil in Ohio

1871 Chicago fire destroys much of downtown area

1873 Mark Twain and Charles Dudley Warner coin "The Gilded Age" for era of political corruption and economic disparity; Comstock Act prohibiting mailing of obscene literature is passed

1876 Alexander Graham Bell patents telephone; U.S. Centennial Exposition opens in Philadelphia; Lt. Colonel George A. Custer defeated by Sioux at Little Bighorn

1877 Federal troops withdraw from the South, marking the end of Reconstruction; Thomas Alva Edison invents phonograph

1879 Edison patents incandescent lightbulb

1881 President James D. Garfield assassinated; Booker T. Washington opens Tuskegee Institute

1882 Chinese Exclusion Acts forbid Chinese immigration

1886 Dedication of Statue of Liberty in New York Harbor; American Federation of Labor organized to advocate for fair wages and better working conditions

1888 George Eastman invents first Kodak camera

1890 National American Woman Suffrage Association founded; Sherman antitrust law prohibits certain monopolies; Ghost Dance religion gains adherents in Indian country; Battle of Wounded Knee

1892 Ellis Island in New York Harbor opens and becomes the busiest U.S. immigration station; Sierra Club founded to protect the natural environment; Homestead Strike at Andrew Carnegie's steelworks

1893 World's Columbian Exposition opens in Chicago; Panic of 1893 results from a railroad investment and a run on the gold supply

1894 Pullman Palace Car workers in Illinois stage labor action, leading to massive American Railway Union strike led by Eugene Debs; President Grover Cleveland calls in troops and breaks the strike

1895 Booker T. Washington and other African American leaders acquiesce to segregation in return for basic services in the South—called the "Atlanta Compromise"

1896 Supreme Court in *Plessy v. Ferguson* rules that "separate but equal" is constitutional; Jim Crow laws proliferate; William McKinley elected president on a pro-gold, high tariff platform

1898 Spanish-American War begins with U.S.S. *Maine* blown up in Havana Harbor; Cuba becomes independent while territories of Puerto Rico, Guam, and Philippines are ceded by Spain to the United States; Hawaii annexed to the United States

1900 U.S. population reaches 76 million, 60 percent rural

1901 President William McKinley assassinated, Theodore Roosevelt succeeds him; J. P. Morgan buys out Andrew Carnegie, organizes U.S. Steel, nation's first billion-dollar company

1903 Orville and Wilbur Wright fly the first manned airplane at Kitty Hawk, North Carolina; United States acquires Panama Canal Zone from Colombia, clearing way to build passage between Atlantic and Pacific

1905 Founding convention of Industrial Workers of the World; Audubon Society founded to promote protection of endangered species of birds and their habitats

1907 Patent for Bakelite, a synthetic plastic, filed by L. H. Baekeland

1908 Henry Ford's company produces the first Model T

1909 National Association for the Advancement of Colored People founded in Springfield, Illinois

1911 Fire at New York's Triangle Shirtwaist factory kills 146 immigrant women workers

1912 U.S. Chamber of Commerce founded; luxury liner R.M.S. *Titanic* sinks on its maiden voyage

1913 Sixteenth Amendment allowing income tax is ratified; Federal Reserve Bank is created; Armory Show, introducing European avant-garde art to the United States, opens in New York; women's suffrage march in Washington, D.C.

1914 World War I begins in Europe; death of Martha, the last passenger pigeon, draws public attention to need for wildlife conservation; Panama Canal officially opens

1915 D. W. Griffith's controversial silent film *Birth of a Nation* aids revival of the Ku Klux Klan; German submarine sinks RMS *Lusitania*

1916 Jeannette Rankin of Montana is first woman elected to the House of Representatives; Margaret Sanger opens nation's first birth control clinic in Brooklyn, New York; Louis Brandeis is first Jewish justice appointed to the Supreme Court

1917 United States enters World War I on the Allied side; first commercial jazz recording, "Livery Stable Blues," made in New Orleans; women's suffrage advocates stage march down Fifth Avenue in New York and silent vigil outside the White House

1918 Allies win World War I, about 116,000 American war dead; global influenza pandemic begins, killing 600,000 Americans in three years

1919 Eighteenth Amendment on the prohibition of alcohol ratified; Treaty of Versailles rejected by U.S. Senate

1920 Nineteenth Amendment grants women the right to vote; KDKA begins radio broadcast in Pittsburgh; slight majority of Americans live in cities

1924 American Indians granted citizenship; American Immigration Act passed

1925 Scopes "Monkey Trial" in Tennessee

1927 Charles A. Lindbergh flies nonstop across the Atlantic in the *Spirit of St. Louis;* Babe Ruth hits 60 home runs and the Yankees win the World Series; Supreme Court upholds constitutionality of forced sterilizations in *Buck v. Bell;* first motion picture "talkie," *The Jazz Singer,* released

1928 Walt Disney introduces Mickey Mouse in *Steamboat Willie*

1929 "Black Tuesday" stock market crashes, Great Depression begins

1930 Severe drought marks onset of the Dust Bowl

1931 Hattie Caraway of Arkansas becomes the first woman elected to the U.S. Senate; "The Star-Spangled Banner" officially adopted as the national anthem

1932 Franklin Delano Roosevelt elected president, promises "New Deal"; Amelia Earhart flies solo across the Atlantic; New York City's Empire State Building is completed, becoming world's tallest building

1933 Prohibition ends; Adolf Hitler elected chancellor of Germany; Nobel Prize–winning physicist Albert Einstein settles in the United States

1935 President Roosevelt signs Social Security Act; federal government launches Works Progress Administration; Wagner Act guarantees collective bargaining; Committee for Industrial Organizations founded

1936 African American athlete Jesse Owens wins four gold medals at Berlin Olympics

1938 House Un-American Activities Committee formed to investigate Communist influence in the United States; Fair Labor Standards Act is passed

1939 World War II begins in Europe with Germany's invasion of Poland; *Gone with the Wind* and *The Wizard of Oz* are released; Marian Anderson performs at Lincoln Memorial after being refused at Constitution Hall

1940 First woman, Frances Perkins, appointed to a U.S. president's cabinet

1941 Japanese forces bomb U.S. military installation at Pearl Harbor, Hawaii; United States declares war on Japan; war with Germany and its allies follows

1942 Navajo and Basque code talkers employed in the Pacific Theater to disguise communications; Rosie the Riveter popularized on the home front; Executive Order 9066 leads to forced relocation and internment of Japanese Americans; Manhattan Project to develop nuclear weapons begins

1943 Allies invade Italy

1944 D-Day invasion of Normandy in Europe, major battles in the Pacific; World Bank and International Monetary Fund established; Roosevelt signs GI Bill of Rights

1945 Nazi Germany falls; Roosevelt dies; the *Enola Gay* drops atomic bomb on Hiroshima, Japan; a second is dropped on Nagasaki; World War II ends with more than 400,000 American war dead; United Nations is established; concentration camps liberated; Yalta Conference begins negotiations for postwar Europe

1946 Philippines becomes an independent republic from the United States

1947 Jackie Robinson becomes the first African American to play major league baseball; cold war between the United States and USSR begins

1948 Marshall Plan Act is passed by Congress to reconstruct Western Europe; Berlin blockade by the Soviet Union prompts U.S. airlift; UN promulgates Universal Declaration of Human Rights, championed by Eleanor Roosevelt

1949 NATO is established; UN headquartered in New York City

1950 Korean War begins; U.S. population is about 161 million, 64 percent urban

1952 Puerto Rico becomes a U.S. commonwealth; United States tests hydrogen bomb in Pacific

1953 Korean War ends with about 36,000 American war dead

1954 Supreme Court decides *Brown v. Board of Education,* ruling that racial segregation violates Fourteenth Amendment; Sen. Joseph McCarthy accuses officials and public figures of being Communists

1955 Jonas Salk's polio vaccine widely available; Rosa Parks refuses to give up her seat on a public bus, leading to Montgomery Bus Boycott; fourteen-year-old African American Emmet Till brutally killed in Mississippi; Chuck Berry releases "Maybellene"

1956 Elvis Presley releases his first number-one hit, "Heartbreak Hotel"

1957 Soviet Union launches Sputnik, leading to space race with the United States; President Eisenhower sends federal troops to Little Rock, Arkansas, to enforce school integration

1958 United States establishes National Aeronautics and Space Administration (NASA); Explorer I, first American satellite, launched

1960 John F. Kennedy elected first Catholic president; students conduct sit-ins at the Greensboro, North Carolina, Woolworth's counter; Food and Drug Administration approves "the Pill"

1961 East Germany builds the Berlin Wall; United States severs diplomatic relations with Castro's Cuba; Bay of Pigs invasion fails; Alan Shepard's first manned American space flight; civil rights movement Freedom Rides start; Kennedy establishes Peace Corps

1962 Marilyn Monroe dies; Cuban missile crisis; Rachel Carson's *Silent Spring* published; Lt. Col. John Glenn becomes first U.S. astronaut to orbit Earth

1963 Reverend Dr. Martin Luther King Jr. delivers "I Have a Dream" speech on the National Mall; President Kennedy assassinated; Bob Dylan records "Blowin' in the Wind"; Julia Child's *The French Chef* debuts on WGBH television station

1964 Beatles appear on *Ed Sullivan Show;* Civil Rights Act signed by President Johnson; Tonkin Gulf Resolution signed by President Johnson, authorizing U.S. involvement in Vietnam War

1965 President Johnson signs act creating Medicare to provide health care benefits to Americans over sixty-five; protests against U.S. bombings of North Vietnam in Washington, D.C.; civil rights march in Selma, Alabama; Cesar Chavez emerges as a leader of farm worker movement with Delano grape strike; Malcolm X assassinated; Immigration and Nationality Act broadens immigration to the United States

1967 Thurgood Marshall becomes first African American Supreme Court justice; Muhammad Ali arrested for refusing to enlist, stripped of boxing titles

1968 Sen. Robert F. Kennedy assassinated in Los Angeles; Reverend Dr. Martin Luther King Jr. assassinated in Memphis; American Indian Movement founded; violent protests at Democratic National Convention in Chicago

1969 Woodstock music festival draws nearly half million to upstate New York; Apollo 11 astronaut Neil Armstrong becomes first man to walk on the Moon; Stonewall riot in New York; Native American occupation of Alcatraz during the Red Power Movement

1970 Environmental movement celebrates first Earth Day; four students shot by National Guardsmen during Kent State antiwar protests

1971 *New York Times* publishes first of the Pentagon Papers, classified history of the Vietnam War; Twenty-sixth Amendment extends vote to eighteen-year-olds

1972 President Richard Nixon visits China and Soviet Union; Watergate scandal begins; pandas come to the National Zoo

1973 Watergate hearings are televised; President Nixon impeachment proceedings begin; Supreme Court ruling in *Roe v. Wade* guarantees woman's right to choose abortion; United States faces Arab oil embargo and energy crisis over support to Israel

1975 Last evacuation from Saigon; South Vietnam surrenders to the North, President Ford declares end

to Vietnam War with about 58,000 American war dead; Microsoft founded

1977 Blackout in New York City; George Lucas's film *Star Wars* debuts

1978 American Indian Freedom of Religion Act; President Carter mediates Camp David accords, with Israel and Egypt signing peace treaty

1979 United States establishes diplomatic relations with China; Three Mile Island nuclear mishap in Pennsylvania almost causes meltdown; Iranian students storm U.S. embassy in Tehran and take Americans hostage

1980 United States boycotts Moscow Olympic Games; former actor and California Governor Ronald Reagan is elected president; personal computer (PC) launched by IBM; U.S. Olympic hockey team wins "Miracle on Ice" gold medal

1981 Iranians release hostages as President Reagan is sworn in; first AIDS case recognized by the Centers for Disease Control; Sandra Day O'Connor sworn in as the first woman Supreme Court justice; U.S. embassy in Beirut bombed

1982 Vietnam Veterans Memorial, designed by Maya Lin, dedicated on the National Mall

1984 Steve Jobs introduces Apple Macintosh computer; Soviet Union boycotts U.S. Olympic Games

1986 Space shuttle *Challenger* disaster; first laptop computer available

1987 In Berlin, President Reagan urges Soviet leader Mikhail Gorbachev to "tear down this wall"; United States and Soviet Union sign arms control treaty to reduce nuclear weapons

1989 Berlin Wall is dismantled

1990 Congress passes Americans with Disabilities Act

1991 Following Iraq's invasion of Kuwait, President George H. W. Bush launches Operation Desert Storm, the first Gulf War; Soviet Union breaks up, cold war ends; World Wide Web launched

1993 World Trade Center bombing in New York kills six Americans

2000 U.S. population is about 291 million, 81 percent urban; human genome decoded

2001 September 11 attacks destroy World Trade Center in New York, damage Pentagon in Washington, D.C., and result in crashed plane near Shanksville, Pennsylvania; President George W. Bush declares "war on terror"; United States launches air attacks in Afghanistan and topples Taliban government

2002 President Bush creates Department of Homeland Security

2003 United States invades Iraq and ousts Saddam Hussein; space shuttle *Columbia* explodes on reentry, killing crew

2007 Nancy Pelosi becomes first woman Speaker of the House of Representatives

2008 Barack Obama elected first African American president

2009 Sonia Sotomayor becomes first Hispanic appointed to the Supreme Court

2011 Osama bin Laden killed by U.S. Navy Seals in Pakistan; about 6,000 Americans dead in war on terror

2012 Barack Obama reelected

MAPS

NATIVE AMERICANS AT EUROPEAN CONTACT, 1500s–1700s

Atlantic Ocean

Gulf of Mexico

Pacific Ocean

Does not include all tribes
and groups; territories are
approximate and imputed

Not shown: Alaskan native
groups, Hawaiians

© 2013 Jeffrey L. Ward

INNU
MICMAC
ABENAKI
MASSACHUSETT
WAMPANOAG
NARRAGANSETT
ALGONQUIN
HURON
MAHICAN
IROQUOIS
SUSQUEHANNA
ERIE
DELAWARE
POWHATAN
CATAWBA
TUSCARORA
OTTAWA
POTAWATOMI
MIAMI
SHAWNEE
CHEROKEE
YAMASEE
CREEK
TIMUCUA
CALUSA
CREE
OJIBWA
SAUK
FOX
ILLINOIS
OSAGE
CHICKASAW
CHOCTAW
NATCHEZ
IOWA
DAKOTA (SIOUX)
QUERECHOS
PAWNEE
KIOWA
WICHITA
CADDO
COAHUILTEC
BLACKFEET
ASSINIBOINE
MANDAN
HIDATSA
CHEYENNE
OGLALA SIOUX
ARAPAHO
COMANCHE
CROW
UTE
NAVAJO
PUEBLO
HOPI ZUNI
APACHE
PAPAGO
CONCHIO
YUMA
SHOSHONE
TLINGIT
HAIDA
NEZ PERCE
FLATHEAD
SALISH
CHINOOK
KLAMATH
PAIUTE
POMO
YOKUT
CHUMASH
COCHIMI

Legend

- Northwest
- California
- Southwest
- Plateau
- Great Basin
- Great Plains
- Subarctic
- Eastern Woodlands
- Southeast

0 Mi. 300

0 Km. 300

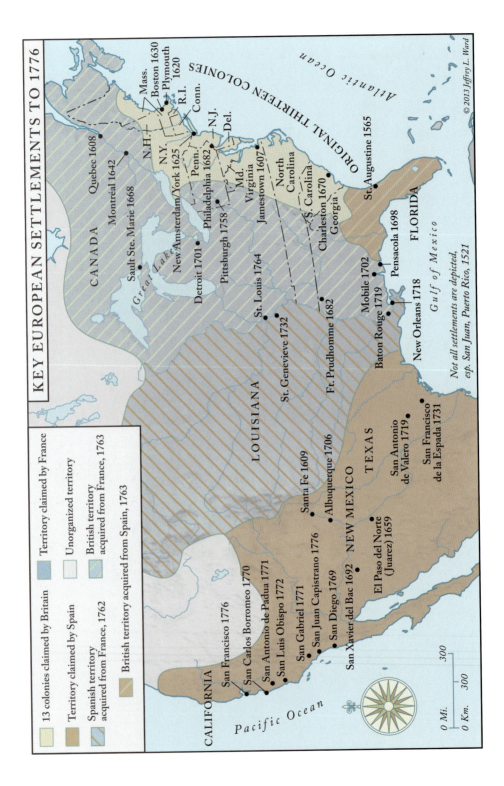

KEY EUROPEAN SETTLEMENTS TO 1776

13 colonies claimed by Britain

Territory claimed by Spain

Spanish territory acquired from France, 1762

British territory acquired from Spain, 1763

Territory claimed by France

Unorganized territory

British territory acquired from France, 1763

CANADA

Quebec 1608

Montréal 1642

Sault Ste. Marie 1668

Great Lakes

Detroit 1701

Pittsburgh 1758

St. Louis 1764

St. Genevieve 1732

Ft. Prudhomme 1682

LOUISIANA

Santa Fe 1609

Albuquerque 1706

TEXAS

San Antonio de Valero 1719

San Francisco de la Espada 1731

El Paso del Norte (Juarez) 1659

NEW MEXICO

San Xavier del Bac 1692

San Diego 1769

San Juan Capistrano 1776

San Gabriel 1771

San Luis Obispo 1772

San Antonio de Padua 1771

San Carlos Borromeo 1770

San Francisco 1776

CALIFORNIA

Pacific Ocean

ORIGINAL THIRTEEN COLONIES

Atlantic Ocean

Mass.
Boston 1630
Plymouth 1620
R.I.
Conn.
N.H.
N.Y.
New Amsterdam/York 1625
N.J.
Penn.
Del.
Philadelphia 1682
Md.
Virginia
Jamestown 1607
North Carolina
S. Carolina 1670
Charleston 1670
Georgia
St. Augustine 1565

FLORIDA

Pensacola 1698

Mobile 1702

Baton Rouge 1719

New Orleans 1718

Gulf of Mexico

Not all settlements are depicted, esp. San Juan, Puerto Rico, 1521

0 Mi. 300
0 Km. 300

© 2013 Jeffrey L. Ward

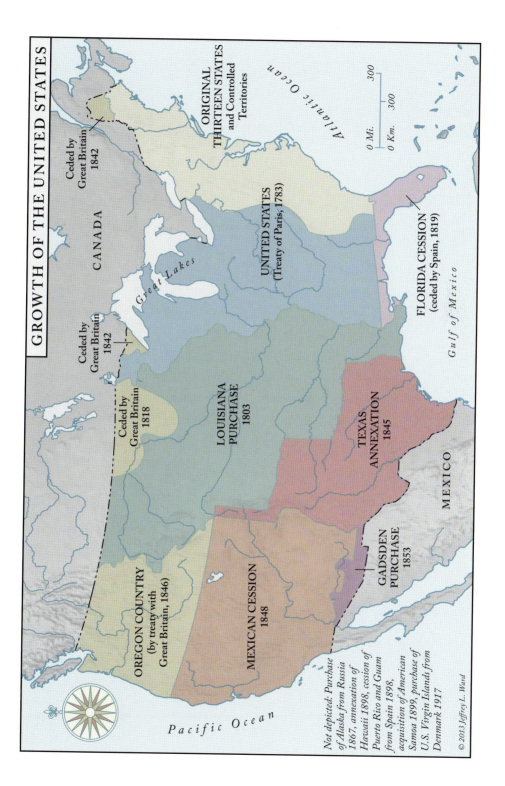

GROWTH OF THE UNITED STATES

ORIGINAL THIRTEEN STATES and Controlled Territories

UNITED STATES (Treaty of Paris, 1783)

FLORIDA CESSION (ceded by Spain, 1819)

Ceded by Great Britain 1842

Ceded by Great Britain 1842

Ceded by Great Britain 1818

CANADA

Great Lakes

Atlantic Ocean

Gulf of Mexico

LOUISIANA PURCHASE 1803

TEXAS ANNEXATION 1845

MEXICO

OREGON COUNTRY (by treaty with Great Britain, 1846)

MEXICAN CESSION 1848

GADSDEN PURCHASE 1853

Pacific Ocean

Not depicted: Purchase of Alaska from Russia 1867, annexation of Hawaii 1898, cession of Puerto Rico and Guam from Spain 1898, acquisition of American Samoa 1899, purchase of U.S. Virgin Islands from Denmark 1917

0 Mi. 300
0 Km. 300

© 2013 Jeffrey L. Ward

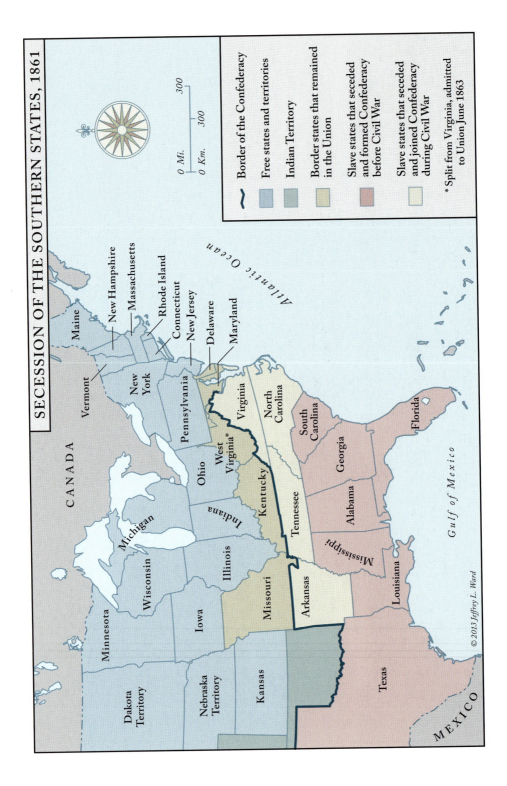

SECESSION OF THE SOUTHERN STATES, 1861

Border of the Confederacy

Free states and territories

Indian Territory

Border states that remained
in the Union

Slave states that seceded
and formed Confederacy
before Civil War

Slave states that seceded
and joined Confederacy
during Civil War

* Split from Virginia, admitted
to Union June 1863

0 Mi. 300

0 Km. 300

CANADA

Atlantic Ocean

Maine

Vermont

New Hampshire

Massachusetts

Rhode Island

Connecticut

New Jersey

Delaware

Maryland

New York

Pennsylvania

Virginia

North Carolina

South Carolina

Georgia

Florida

West Virginia *

Ohio

Kentucky

Tennessee

Indiana

Illinois

Michigan

Wisconsin

Minnesota

Iowa

Missouri

Arkansas

Mississippi

Alabama

Louisiana

Dakota Territory

Nebraska Territory

Kansas

Texas

Gulf of Mexico

MEXICO

© 2013 Jeffrey L. Ward

THE UNITED STATES TODAY, WITH YEARS OF STATEHOOD

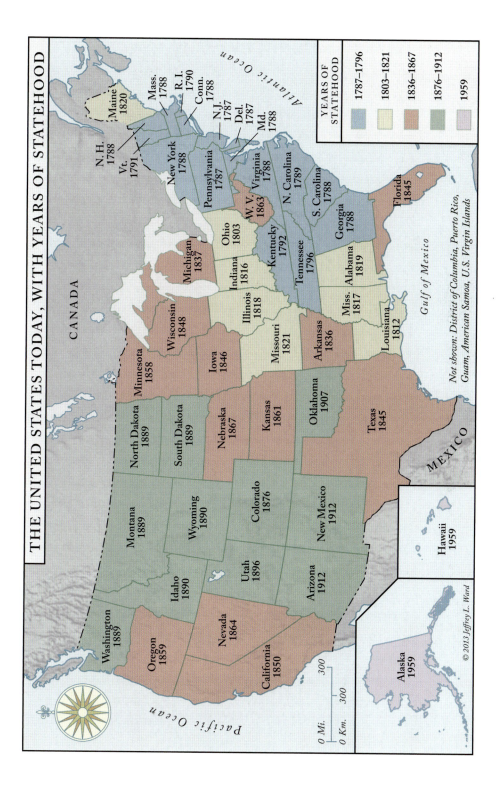

YEARS OF STATEHOOD

- 1787–1796
- 1803–1821
- 1836–1867
- 1876–1912
- 1959

Not shown: District of Columbia, Puerto Rico, Guam, American Samoa, U.S. Virgin Islands

CANADA

MEXICO

Atlantic Ocean

Pacific Ocean

Gulf of Mexico

Maine 1820
Mass. 1788
R.I. 1790
Conn. 1788
N.H. 1788
Vt. 1791
New York 1788
Pennsylvania 1787
N.J. 1787
Del. 1787
Md. 1788
W.V. 1863
Virginia 1788
N. Carolina 1789
S. Carolina 1788
Georgia 1788
Florida 1845
Ohio 1803
Kentucky 1792
Tennessee 1796
Alabama 1819
Michigan 1837
Indiana 1816
Illinois 1818
Miss. 1817
Wisconsin 1848
Iowa 1846
Missouri 1821
Arkansas 1836
Louisiana 1812
Minnesota 1858
North Dakota 1889
South Dakota 1889
Nebraska 1867
Kansas 1861
Oklahoma 1907
Texas 1845
Montana 1889
Wyoming 1890
Colorado 1876
New Mexico 1912
Idaho 1890
Utah 1896
Arizona 1912
Washington 1889
Oregon 1859
Nevada 1864
California 1850
Hawaii 1959
Alaska 1959

0 Mi. 300
0 Km. 300

© 2013 Jeffrey L. Ward

NOTES

Digital records for almost eight million items in the Smithsonian's collections are found online (http://collections.si.edu/search/) and have been used in the research for just about each of the objects in this volume. Selections of text from these records and from related museum signage is not referenced below.

The unpublished curatorial files for the objects provided a great deal of information as did direct communications with the objects' curators at the Smithsonian. Unless otherwise noted, quotes indicated in the text from the curators, scholars, and scientists are from these communications.

References below are only for quotes from published works used in the text when the source is not explicitly clear. Hundreds of sources were used for the essays and to have included all of them in this volume would add about one hundred pages to the text, making the book both physically unwieldy and much more expensive. For the complete bibliography, please go to www.penguinSmithsonianAmericanHistory101.edu.

As sources, Web sites were accessed between August 2012 and June 2013.

FOREWORD

xi "increase and diffusion": James Smithson, "Last Will and Testament," in Heather Ewing, *The Lost World of James Smithson: Science, Revolution and the Birth of the Smithsonian* (New York: Bloomsbury, 2007), p. 304-05.

INTRODUCTION

11 "to found at": James Smithson, "Last Will and Testament," in Heather Ewing, *The Lost World of James Smithson: Science, Revolution and the Birth of the Smithsonian* (New York: Bloomsbury, 2007), p. 304-05.

17 "the remains of": Alexander Graham Bell, in Smithsonian Institution, Annual Report of the Board of Regents of the Smithsonian Institution (Washington, D.C.: Government Printing Office, 1905), p. xxiv.

7. POCAHONTAS'S PORTRAIT

63 "penetrating, intelligent gaze": James Ring Adams, "The New Rebecca, A Pocahontas Mystery," *American Indian,* Summer 2013, p. 37.

8. PLYMOUTH ROCK FRAGMENT

68 "This Rock has": Alexis de Tocqueville, *Democracy in America,* vol. 1, Henry Reeve, tr. (Cambridge, MA: Sever and Francis, 1863), p. 29.

69 "We didn't land": Malcolm X in Alex Haley, *The Autobiography of Malcolm X: As Told to Alex Haley* (New York: Ballantine Books, 1999), p. 205.

12. GEORGE WASHINGTON'S UNIFORM AND SWORD

95 "a suit of": George Washington, *The Papers of George Washington*, Colonial Series, vol. 4 (Charlottesville, VA: University Press of Virginia, 1983–95), p. 86.

97 "in the defense": the will of George Washington, *The Papers of George Washington*, http://gwpapers.virginia.edu/documents/will/text.html#28.

13. BENJAMIN FRANKLIN'S WALKING STICK

100 "My picture is": PBS television documentary, "Benjamin Franklin, World of Influence," http://www.pbs.org/benfranklin/l3_world_celebrity.html.

102 "It is you": Charles Gravier and Thomas Jefferson, "Milestones: 1776–1783, Benjamin Franklin: First American Diplomat, 1776-1785," U.S. Department of State, Office of the Historian, http://history.state.gov/milestones/1776-1783/BFranklin.

103 "My fine crab-tree": the last will and testament of Benjamin Franklin, Franklin Institute, http://www.fi.edu/franklin/family/lastwill.html.

103 "to keep in memory": Samuel T. Washington, letter to George W. Summers, *The New England Historical and Genealogical Register,* "The Swords of Washington," by Coronel Thornton A. Washington, of Washington, D.C., 1894, vol. 48, p. 23.

103 "Let the sword": George Summers, *Journal of the House of Representatives of the United States at the Third Session of the Twenty-seventh Congress Begun and Held at the City of Washington in the Territory of Columbia,* December 5, 1842, and in the sixty-seventh year of the independence of the United States (Washington, D.C.: Gales and Seaton, 1843), p. 331, http://books.google.com/books?id=w4tHAQAAIAAJ&printsec=frontcover#v=onepage&q=let%20the%20sword&f=false.

14. GILBERT STUART'S LANSDOWNE PORTRAIT OF GEORGE WASHINGTON

107 "a warm friend": William Bingham in *George Washington: A National Treasure,* National Portrait Gallery (Washington, D.C.: Smithsonian Institution, 2002), p. 59.

15. STAR-SPANGLED BANNER

116 "the American flag": Francis Scott Key, Star-Spangled Banner and the War of 1812, Smithsonian Institution Encyclopedia, http://www.si.edu/Encyclopedia_SI/nmah/starflag.htm.

116 "We have no": George Amistead, Star-Spangled Banner National Historic Trail, Defining a Nation, http://starspangledtrail.net/defining-a-nation/symbols/flag/.

118 "a holy relic": in Lonn Taylor, Jeffrey Brodie, and Kathleen Kendrick, *The Star-Spangled Banner: The Making of an American Icon* (New York: HarperCollins, 2008), p. 84.

118 "moral sensitivity": ibid., p. 90.

16. THOMAS JEFFERSON'S BIBLE

123 "a wall of separation": Thomas Jefferson, letter to the Danbury Baptists (to messers. Nehemiah Dodge, Ephraim Robbins, and Stephen S. Nelson, a committee of the Danbury Baptist association in the state of Connecticut), January 1, 1802, Library of Congress, http://www.loc.gov/loc/lcib/9806/danpre.html.

123 "I am a sect": Thomas Jefferson in "History of the Jefferson Bible," Harry R. Rubenstein and Barbara Clark Smith, *The Jefferson Bible: The Life and Morals of Jesus of Nazareth,* extracted textually from the Gospels in Greek, Latin, French, and English (Washington, D.C.: Smithsonian Books, 2011), p. 30.

126 "contrary to reason": ibid., p. 11.

19. JOHN DEERE'S STEEL PLOW

143 "the plow that broke the Plains": movie, Pare Lorentz, dir., 1936, Library of Congress, Motion Picture, Broadcasting and Recorded Sound Division, Prelinger Archives, http://archive.org/details/plow_that_broke_the_plains.

20. ISAAC SINGER'S SEWING MACHINE

150 "If you don't come in Sunday": promotional advertisement by Solow/Wexton, Inc., International Ladies' Garment Workers' Union, 1966, http://designarchives.aiga.org/#/entries/%20year%3A%221966%22/_/detail/relevance/asc/112/7/14019/if-you-dont-come-in-sunday-dont-come-in-monday/1.

21. NAUVOO TEMPLE SUN STONE

154 "noble marble edifice": Thomas L. Kane, March 26, 1850, in the *Journal of History,* vols. 1–2, "Early Settlement at Garden Grove," Herman C. Smith, January 8, 1908, p. 103.

22. LEWIS AND CLARK'S POCKET COMPASS

161 "Beginning at the mouth": Thomas Jefferson, *The Works of Thomas Jefferson: 1799–1803,* vol. 11, orig. 1905 (New York: Cosimo, Inc., 2010), p. 424.

162 "28° west of south": map, Lewis and Clark, route about June 2–July 10, 1805, WA MSS 303, Yale Collection of Western Americana, Beinecke Rare Book and Manuscript Library.

164 "has taken on": Harry Rubenstein, http://www.pbs.org/lewisandclark/inside/york.html.

23. JOHN BULL STEAM LOCOMOTIVE

168 "A few minutes": John Frazee, letters to family, 1819–1836, box 1, folder 5, Archives of American Art, http://www.aaa.si.edu/collections/container/viewer/John-Frazee-Letters-to-Family—280100.

169 "the greatest achievement": Stephen Ambrose, *Nothing Like It in the World. The Men Who Built the Transcontinental Railroad, 1863–1869* (New York: Simon & Schuster, 2000), introduction.

170 "railroads carried everything": John H. White, *The John Bull: 150 Years a Locomotive* (Washington, D.C.: Smithsonian, 1981).

24. SAMUEL COLT'S REVOLVER

172 "the celebrated Dr. Coult": William B. Edwards, *The Story of Colt's Revolver: The Biography of Col. Samuel Colt* (Harrisburg, PA: Stackpole Company, 1953), p. 23.

26. MEXICAN ARMY COAT

186 "What do we want": attributed to Daniel Webster, Ben Perley, *Perley's Reminiscences of Sixty Years in the National Metropolis,* vol. 1 (Philadelphia: Hubbard Brothers, 1886), chap. 15, p. 213.

188 "it is our manifest destiny": John L. O'Sullivan, *The West,* episode two (1806–1848): *Empire upon the Trails,* Public Broadcasting Service, http://www.pbs.org/weta/thewest/program/episodes/two/.

188 "for the development": John L. O'Sullivan, *The Louisiana Purchase and American Expansion, 1803–1898,* chap. 7, "A Promise of Expansionism," Paul Kens, Sandford Levinson, and Bartholomew H. Sparrow, eds. (Lanham, MD: Rowman & Littlefield, 2005), p. 139.

191 "a grandson of Gen. Santa Anna": Matias Romero, Mexican ambassador, to Secretary of State Frederick T. Frelinghuysen, April 1884.

27. GOLD DISCOVERY FLAKE FROM SUTTER'S MILL

193 "found that it": Hubert Howe Bancroft, *West American History*, vol. 32, chap. 4, "Affairs About the Coloma Saw-Mill During the Spring of 1848," The Bancroft Company, 1902, p. 74.

194 "the first piece of gold": Joseph Folsom, a label written by Joseph. L. Folsom, U.S. Army assistant quartermaster, at the U.S. National Museum, 1848, record unit 305, reel 14, acc. 1861 #135, Smithsonian Institution Archives.

194 "the acquisition of California": James Knox Polk, State of the Union address, December 5, 1848, in the American Presidency Project, http://www.presidency.ucsb.edu/ws/?pid=29489 and http://www.presidentialrhetoric.com/historicspeeches/polk/stateoftheunion1848.html.

196 "How long would a museum last": memorandum from George Merrill, record unit 305, reel 14, acc. 1861 #135, Smithsonian Institution Archives.

196 "The discovery of this gold": Charles D. Walcott to Samuel M. Shortridge, February 17, 1925, ibid.

28. MARTHA, THE LAST PASSENGER PIGEON

199 "countless numbers": Samuel de Champlain, *Voyages of Samuel de Champlain 1604–1610*, vol. 2 (Boston: Prince Society, 1878), pp. 68–69, http://books.google.com/books?id=Q_kWAAAAYAAJ&printsec=frontcover#v=onepage&q&f=false.

199 "The air was literally": John James Audubon and William Macgillivray, *Ornithological Biography, or an Account of the Habits of the Birds of the United States of America: Accompanied by Descriptions of the Objects Represented in the Work Entitled The Birds of America, and Interspersed with Delineations of American Scenery and Manners*, vol. 1, *Passenger Pigeon*, p. 321, Darlington Digital Library: http://digital.library.pitt.edu/cgi-bin/t/text/pageviewer-idx?c=darltext;idno=31735056284882;seq=347;cc=darltext;view=image;page=root;size=s;frm=frameset.

203 "With the blessing": "Last of the Passenger Pigeons to Fly Again," *Washington Evening Star*, August 26, 1966, copy from record unit 305, acc. #57354, Smithsonian Institution Archives.

29. FREDERICK DOUGLASS'S AMBROTYPE PORTRAIT

208 "A new world had": Frederick Douglass, "My Escape from Slavery," *Century Illustrated Magazine*, vol. 23, n.s., 1, November 1881, pp. 125–31, Electronic Text Center, University of Virginia Library: http://etext.lib.virginia.edu/etcbin/toccer-new2?id=DouEsca.sgm&images=images/modeng&data=/texts/english/modeng/parsed&tag=public&part=all.

208 "as a color": Frederick Douglass, letter to William Lloyd Garrison, September 16, 1845, *The Frederick Douglass Papers: 1842–1852*, series three, John R. McKivigan, ed. (New Haven: Yale University Press, 2009), p. 54.

208 "with features distorted": Frederick Douglass, "Negro as Man" speech, mid-1850s, cited in Donna M. Wells, "Frederick Douglass and the Progress of Photography," http://www.huarchivesnet.howard.edu/2092huarnet/freddoug.htm.

209 "much more kindly and amiable expression": Frederick Douglass, review of Wilson Armistead, *A Tribute for the Negro*, cited in ibid.

209 "The humblest servant girl may now": Frederick Douglass, "Pictures and Progress" speech, 1863, the Frederick Douglass Papers at the Library of Congress, p. 8, http://memory.loc.gov/cgi-bin/ampage?collId=mfd&fileName=28/28009/28009page.db&recNum=7&itemLink=%2Fammem%2Fdoughtml%2FdougFolder5.html&linkText=7.

209 "swaying the heart by the eye": Frederick Douglass, cited in *Civil War Visual Culture: Frederick Douglas* at http://jamig.wordpress.com/frederick-douglass/.

210 "I would not permit": Joseph Henry, letter to Alexander Dallas Bache, April 4, 1862, Marc Rothenberg, et al., eds., *The Papers of Joseph Henry*, vol. 10, *The Smithsonian Years: January 1858–December 1865* (Washington, D.C.: Smithsonian Institution in Association with Science History Publications, 2004), pp. 249–51.

211 "the White man's president": Frederick Douglass, "Oration in Memory of Abraham Lincoln," delivered at the unveiling of the Freedmen's monument in memory of Abraham Lincoln, Lincoln Park, Washington, D.C., April 14, 1876.

211 "Though Mr. Lincoln shared": ibid.

211 "an African prince": Elizabeth Cady Stanton, letter read at the funeral of Frederick Douglass, cited in R.W.B. Lewis and Nancy Leis, "American Characters: Visual and Verbal Imaginings over the Centuries," *Ideas*, vol. 6, no. 1, 1999.

211 "We can't change": Richard Kurin, speech, February 22, 2012, groundbreaking for the National Museum of African American History and Culture, Washington, D.C., cited in Marsha Mercer, "New Ground Has Been Broken in Racial History," http://www.tricities.com/news/article_87a171f5-34d3-5085-8e35-a48626d79dea.html.

30. HARRIET TUBMAN'S HYMNAL AND SHAWL

212 "Moses of her people": Sarah Hopkins Bradford, *Harriet, the Moses of Her People* (New York: Geo. R. Lockwood & Son, 1886).

214 "Of all the whole creation": Sarah Hopkins Bradford, *Scenes in the Life of Harriet Tubman* (Auburn, NY: W. J. Moses, 1869), p. 41, http://books.google.com/books?id=mUgDAAAAYAAJ&printsec=frontcover#v=onepage&q&f=false.

31. EMANCIPATION PROCLAMATION PAMPHLET

220 "I never, in my life": Abraham Lincoln in Ida Minerva Tarbell, *The Life of Abraham Lincoln: Drawn from Original Sources and Containing Many Speeches, Letters and Telegrams Hitherto Unpublished, and Illustrated with Many Reproductions from Original Paintings, Photographs, Etcetera, New Editions with New Matter*, vol. 2 (New York: Macmillan Company, 1920), p. 125.

220 "but if it shall contribute": Abraham Lincoln in Frank Boott Goodrich, *The Tribute Book, a Record of the Munificence [&c.] of the American People During the War for the Union* (Auburn, NY: Derby & Miller, 1865), p. 161, http://books.google.com/books

?id=oysOAAAAQAAJ&printsec=frontcover#v=onepage&q&f=false.

222 "Some man who seemed": Booker T. Washington, *The Booker T. Washington Papers*, vol. I: *The Autobiographical Writings*, Louis R. Harlan, ed. (Chicago: University of Illinois Press, 1972), p. 225.

222 "Just as I took": Thomas Wentworth Higginson, *Army Life in a Black Regiment* (Boston: Osgood, & Co., 1870), p. 40, http://books.google.com/books?id=dk8IAAAAQAAJ&pg=PA40&dq.

32. CHRISTIAN FLEETWOOD'S MEDAL OF HONOR

226 "Once let the Black man": Frederick Douglass in Frederic May Holland, *Frederick Douglass: The Colored Orator* (New York and London: Funk & Wagnalls, 1891), p. 301, http://books.google.com/books?id=Ic3TAAAAMAAJ&printsec=frontcover#v=onepage&q=brass%20letters&f=false.

226 "A double purpose": Christian Fleetwood, letter to Dr. James Hall, Baltimore, June 8, 1865, in National Park Service, http://www.nps.gov/rich/historyculture/writings3.htm (original letter located in the Carter G. Woodson collection at the Manuscript Division, Library of Congress).

229 "nation's renewed and determined": Edith Fleetwood, letter, November 18, 1947, record unit 305, acc. 178781, Smithsonian Institution Archives.

229 "the last one": Theodore Belote, letter to J. E. Graf, December 8, 1947, record unit 305, acc. 178781, Smithsonian Institution Archives.

229 "true democracy": Fleetwood, letter, November 18, 1947.

33. APPOMATTOX COURT HOUSE FURNISHINGS

232 "We, the undersigned": terms of surrender, Appomattox Court House: The Surrender, National Park Service at http://www.nps.gov/apco/the-surrender.htm.

233 "The surrender has taken place": Orville T. Babcock, "Lee's Surrender," Babcock Papers, Chicago Historical Society.

234 "the Ark of the Covenant": Elizabeth B. Custer in "Where Grant Wrote Peace," *Harper's Weekly*, vol. 55, June 24, 1911, pp. 7–8, http://faculty.css.edu/mkelsey/usgrant/souvenir.html.

234 "every veteran and the son": Patrick O'Farrell, letter to E. W. Whitaker, June 15, 1885, record unit 305, acc. 59149, Smithsonian Institution Archives.

34. ABRAHAM LINCOLN'S HAT

240 "under any circumstance": Joseph Henry, cited in "Abraham Lincoln: An Extraordinary Life," National Museum of American History, http://americanhistory.si.edu/lincoln/introduction.

35. ALBERT BIERSTADT'S
AMONG THE SIERRA NEVADA, CALIFORNIA

248 "the most horrible desert": Gordon Hendricks, "The First Three Western Journeys of Albert Bierstadt," *Art Bulletin,* vol. 46, no. 3, September 1964, pp. 333–65, College Art Association, http//www.jstor.org/stable/3048185.

249 "vast machinery of": "Among the Sierra Nevada, California,"

exhibition label, Smithsonian American Art Museum, 6 http://americanart.si.edu/collections/search/artwork/?id=2059.

249 "probably did more": Eleanor Harvey, "Trove of American Art in Newly Renovated Smithsonian Building," http://www.voanews.com/content/a-13-2006-11-14-voa59/400156.html.

36. KING KAMEHAMEHA III'S FEATHER CAPE

254 "a very high ceremonial": William Bolton Finch to his sister Elizabeth Bolton, April 22, 1848, folder 274, National Anthropological Archives.

257 "We need Hawaii": President William McKinley remark to George Cortelyou in 1898, in H. Wayne Morgan, *William McKinley and His America* (Kent, OH: Kent State University Press, 2003), p. 225.

38. SITTING BULL'S DRAWING BOOK

269 "I wish it": Sitting Bull in "Sitting Bull's Surrender. He Indicates What He Would Like to Have, and How He Wants to Live," *Crawfordsville Star,* vol. 10, no. 25, Crawfordsville, IN, Thursday, July 28, 1881, http://news.google.com/newspapers?nid=2247&dat=18810728&id=4ZknAAAAIBAJ&sjid=YgQGAAAAIBAJ&pg=3705,6051224.

39. BUGLE FROM THE U.S.S. *MAINE*

277 "I laid down my pen": Charles Dwight Sigsbee, *The "Maine": An Account of Her Destruction in Havana Harbor* (New York: Century Co., 1899), pp. 63–73.

278 "Remember the *Maine*, to hell with Spain": *The Sun*, New York, April 20, 1898, p. 1.

40. ALEXANDER GRAHAM BELL'S TELEPHONE

283 "Mr. Watson, come here": Alexander Graham Bell, letter to Alexander Melville Bell, March 10, 1876, family papers, folder: Alexander Melville Bell, family correspondence, Alexander Graham Bell, 1876, p. 2, http://memory.loc.gov/cgi-bin/query/P?magbell:1:./temp/~ammem_SbCT.

285 "the greatest marvel": Joseph Henry, in Bruce Bell, *Minutes of the Philosophical Society of Washington*, p. 214.

286 "free and easy": Circuit Court of the United States, Northern District of Illinois, *In Equity, American Bell Telephone Company et al., Complainants, V. American Cushman Telephone Company et al., Defendants*, vol. 3 (Boston: Alfred Mudge and Son, 1887), p. 1507.

288 "This stuff makes the hair stand": Carlene Stephens in Brett Zongker, "Early Alexander Graham Bell Recordings Played," http://news.yahoo.com/early-alexander-graham-bell-recordings-played-181237019.html.

41. THOMAS EDISON'S LIGHTBULB

294 "problem is solved": *Providence Evening Express*, January 2, 1880, p. 4.

42. FRÉDÉRIC BARTHOLDI'S *LIBERTY*

295 "kindly and impassable": Frédéric Auguste Bartholdi, "The Statue of Liberty Enlightening the World," *North American Review*, New York, 1885, p. 36, http://books.google.com/books?id=p02VNP45RdsC&pg=PA36&lpg=PA36&dq.

300 "Give me your tired": Emma Lazarus, "The New Colossus," in Emma Lazarus and Josephine Lazarus, *The Poems of Emma Lazarus, in Two Volumes,* vol. 1, *Narrative, Lyric, and Dramatic* (Boston and New York: Houghton, Mifflin, 1889), p. 203, http://books.google.com/books?id=UgY1AAAAMAAJ&printsec=frontcover&dq.

43. ANDREW CARNEGIE'S MANSION

304 "most modest, plainest": Andrew Carnegie in "The New Carnegie Mansion in New York," *Atlanta Constitution,* February 24, 1901, p. A12, http://search.proquest.com/news/docview/495669832/13D3676A0BA6A86F840/12?accountid=46638.

44. FORD MODEL T

313 "I will build," Henry Ford in Robert Burlingame, *Henry Ford* (New York: Quadrangle Books, 1970), p. 8.

45. WRIGHT BROTHERS' *KITTY HAWK FLYER*

317 "Dear Sirs: I am": Wilbur Wright, letter to the Smithsonian Institution, May 30, 1899, Smithsonian Institution Archives, http://siarchives.si.edu/history/exhibits/stories/letter-dated-may-30-1899.

323 "first man-carrying": Smithsonian exhibition label, The Wright Flyer: From Invention to Icon, http://airandspace.si.edu/wrightbrothers/icon/feud.html.

46. BAKELIZER PLASTIC MAKER

327 "*schmiere*": Adolf von Baeyer, in *Bakelite, The Material of a Thousand Uses. The Career of the First Real Plastic,* Bakelite Museum History, http://www.bakelitmuseum.de/e/bakges-e.htm.

328 "new chemical substance": "New Chemical Substance," *New York Times,* February 6, 1909, p. 4, http://search.proquest.com/hnpnewyorktimes/docview/96956830/13D3680F10A5AB6C179/1?accountid=46638.

48. BERNICE PALMER'S KODAK BROWNIE CAMERA

341 "You press the button": George Eastman, *A Brief History of Design & Usability at Kodak,* http://www.kodak.com/US/en/corp/researchDevelopment/whatWeDo/development/designUsability/history.shtml.

49. HELEN KELLER'S WATCH

349 "We felt that [Helen]": Elizabeth Keller, letter, December 8, 1974, National Museum of American History Registrar Files.

50. SUFFRAGISTS' "GREAT DEMAND" BANNER

355 "encircle the President's Mansion": "Suffragist Siege of the White House Will Climax Today," *Atlanta Constitution,* March 4, 1917, p. 6.

356 "be made safe for democracy": "The President Calls for War Without Hate: Washington, April 2 at 8:30 O'clock This Evening," *New York Tribune,* April 3, 1917, p. 1.

358 "There can be no question": William Henry Holmes to Ravenel, June 12, 1919, record unit 305, acc. 64601, Smithsonian Institution Archives.

52. WORLD WAR I GAS MASK

366 chemists' war: G. J. Fitzgerald, "Chemical Warfare and Medical Response During World War I," *American Journal of Public Health,* 98, vol. 4, April 2008, pp. 611–25, http://www.ncbi.nlm.nih.gov/pubmed/18356568.

53. LOUIS ARMSTRONG'S TRUMPET

371 "the purest, finest": Louis Armstrong in Armstrong and Benny Goodman, *Swing That Music* (Cambridge, MA: Da Capo Press, 1993), p. 100, http://books.google.com/books?id=Z2uGj_063lUC&pg=PA100&dq.

371 "the inevitable city": Pierce F. Lewis, *New Orleans: The Making of an Urban Landscape,* 2nd ed. (Chicago: Center for American Places, University of Chicago Press, 2003).

375 "sin in syncopation": Anne Shaw Faulkner, "Does Jazz Put the Sin in Syncopation," *Ladies Home Journal,* August 1921.

375 "rhythmic beat of our everyday lives": Irving Berlin, cited in Kathy J. Ogren, *The Jazz Revolution: Twenties America and the Meaning of Jazz* (New York: Oxford University Press, 1992), p. 144.

375 "the world's greatest": Roy Hemming and David Hajdu, *Discovering Great Singers of Classic Pop: A New Listener's Guide to the Sounds and Lives of the Top Performers* (New York: Newmarket Press, 2012), p. 22.

377 "If it weren't for him": Dizzy Gillespie cited in Daniel Stein, *Music Is My Life: Louis Armstrong Autobiography, and American Jazz* (Ann Arbor, MI: University of Michigan Press, 2012), p. 1.

54. SCOPES "MONKEY TRIAL" PHOTOGRAPH

382 "You insult every": Clarence Darrow, in Arthur Weinberg, ed., *Attorney for the Damned: Clarence Darrow in the Courtroom* (Chicago: University of Chicago Press, 1989), p. 200.

382 "to cast ridicule": William Jennings Bryan in ibid., p. 117.

382 "We have the purpose": Clarence Darrow in ibid., p. 218.

383 "are too obvious": Charles D. Walcott, cited in Pamela Henson, "The Smithsonian and Evolution," unpublished manuscript, Smithsonian Institution Archives.

55. *SPIRIT OF ST. LOUIS*

388 "As soon as I": Amelia Earhart, http://airandspace.si.edu/collections/artifact.cfm?id=A19580054393.

56. BABE RUTH AUTOGRAPHED BASEBALL

393 "God, we liked": Waite Hoyt, http://historywired.si.edu/detail.cfm?ID=76.

398 "The greatest crowd": Waite Hoyt, http://www.historywired.si.edu/object.cfm?ID=76.

57. FRANKLIN D. ROOSEVELT'S "FIRESIDE CHAT" MICROPHONE

401 "My friends, I want": Franklin D. Roosevelt, March 12, 1933, in David Halberstam, "The Powers That Be," National Museum of American History Registrar Files and http://collections.si.edu/search/results.htm?q=roosevelt+microphone.

402 "Harry Butcher or Ted Church": Robert Trout, "The First

Fireside Chat," manuscript in the accession file, National Museum of American History, Smithsonian Institution.

402 "We had a new sign": ibid.

403 "There is an element": Franklin D. Roosevelt, op. cit.

404 "last evening as I": March 1933, http://www.150.si.edu/150trav/remember/r217a.htm.

58. JOHN L. LEWIS'S UNION BADGE

409 "We cannot fight": John L. Lewis, cited in Louis Francis Budenz, *This Is My Story* (New York: McGraw-Hill, 1947), p. 52.

410 "The President wants you to join the UMW!": Philip S. Klein and Ari Arthur Hoogenboom, *History of Pennsylvania* (New York: McGraw-Hill, 1973), p. 461.

59. MARIAN ANDERSON'S MINK COAT

413 "It was a cold": Ossie Davis, "Speaking Freely," video interview transcript, First Amendment Center, Nashville, Tennessee, http://www.firstamendmentcenter.org/black-history-month-special-2.

414 "We don't take colored": Black History in Pennsylvania, Marian Anderson, "Classical Music and Opera Singer" by Eric Ledell Smith, http://www.portal.state.pa.us/portal/server.pt/community/beginnings/18088/marian_anderson/617864.

414 "Marian fever": University of Pennsylvania Library Special Collections MA Register 4.

414 "heard once in a hundred years": Arturo Toscanini, ibid.

416 "To remain as a member": Eleanor Roosevelt, in *Lewiston Evening Journal*, February 27, 1939, p. 6.

416 "I am not surprised at Mrs. Roosevelt's": Marian Anderson in *New York Times*, February 27, 1939.

416 "Out of the narrow-minded": Raymond Clapper, "Millions Will Hear Miss Anderson Sing," *Pittsburgh Press*, April 6, 1939, p. 2.

417 "In this great auditorium": Harold Ickes, http://www.newyorker.com/arts/critics/atlarge/2009/04/13/090413crat_atlarge_ross.

60. DOROTHY'S RUBY SLIPPERS

421 "I am currently": Fred Carr, letter to Harry Lowe, September 18, 1979, Curatorial Files, National Museum of American History.

423 "truth, justice and": *The Adventures of Superman*, radio serial, WOR, New York, February 12, 1940.

424 "the ruby shoes appear": script of Noel Langley, cited in Rhys Thomas, "The Ruby Slippers: A Journey to the Land of Oz," *Los Angeles Times*, March 13, 1988, http://articles.latimes.com/1988-03-13/entertainment/ca-1511_1_ruby-slipper.

61. WOODY GUTHRIE'S "THIS LAND IS YOUR LAND"

430 "This Land Is Your Land": words and music by Woody Guthrie. WGP/TRO-© Copyright 1956, 1958, 1970, 1972 (copyrights renewed) Woody Guthrie Publications, Inc. & Ludlow Music, Inc., New York, NY (administered by Ludlow Music, Inc.). All Rights Reserved. Used by Permission.

430 "One day, Woody": Moses Asch, cited in Jeff Place and Robert Santelli, *Woody at 100: The Woody Guthrie Centennial Collection*, Smithsonian Folkways Recordings, 2012, p. 43.

62. U.S.S. OKLAHOMA POSTAL HAND STAMPS

435 "date which will live": Franklin D. Roosevelt, "The President's Message: Text from a Broadcast," *New York Times*, December 9, 1941, p.1, http://search.proquest.com/news/docview/105572546/13D36A4EF221A9F7C70/4?accountid=46638.

63. SPIRIT OF TUSKEGEE

441 "aptitude to fly": Army War College, "The Use of Negro Manpower in War," issued October 30, 1925.

64. "WE CAN DO IT!" POSTER OF ROSIE THE RIVETER

448 "Rosie the Riveter": lyrics by Redd Evans and John Jacob Loeb, 1942.

451 "You can use her": accoutrements advertisement, Rosie the Riveter Action Figure, www.pophistorydig.com/?p=877.

65. JAPANESE AMERICAN WORLD WAR II INTERNMENT ART

454 "A Jap's a Jap": General John L. Dewitt, Commander Western Defense Command, 1942, Smithsonian Institution Online Exhibition, November 7, 2001. A More Perfect Union: Japanese Americans and the U.S. Constitution, http://amhistory.si.edu/perfectunion/non-flash/removal_process.html.

458 "It was a time": Daniel Inouye, "The Price Was Very Heavy," interview, 2001, Smithsonian Institution, A More Perfect Union: Japanese Americans and the U.S. Constitution, http://amhistory.si.edu/perfectunion/transcript.html.

66. AUDIE MURPHY'S EISENHOWER JACKET

459 "very short, very comfortable": "Cool Things—Ike Jacket," Kansapedia, Kansas Historical Society http://www.kshs.org/kansapedia/cool-things-ike-jacket/10216.

461 "The Boss was pleased": Sgt. Mickey McKeough, Butler County Biographies, March 1943, p. 12, http://lanepl.org/scanned/BUTLER%20BIOS/butler%20bios%2013-18.pdf.

67. ENOLA GAY

467 "prompt and utter destruction": Potsdam Declaration, proclamation defining the terms for the Japanese surrender, July 26, 1954, #13, Robert L. C. Butow, *Japan's Decision to Surrender* (Stanford, CA: Stanford University Press, 1954), http://afe.easia.columbia.edu/ps/japan/potsdam.pdf.

68. FALLOUT SHELTER

478–79 "a key icon of Cold War": William L. Bird, memo dated July 23, 1990, in Civilian Defense Collection, National Museum of American History.

69. MERCURY FRIENDSHIP 7

484 "I believe this nation": John F. Kennedy, special message to the Congress on urgent national needs, May 25, 1961, IX Space,

online by Gerhard Peters and John T. Woolley, The American Presidency Project, http://www.presidency.ucsb.edu/ws/index.php?pid=8151.

484 "You don't get into it": John H. Glenn Jr., February 20, 1962, in "Mercury Capsule Friendship 7" by Michael Neufield, National Air and Space Museum.

70. HUEY HELICOPTER

489 "[U.S.] Soldiers in Vietnam": Roger Connor, "Huey Helicopter: Steed for the 'Sky Cavalry,'" in *Engaging Objects*, Mary Jo Arnoldi, ed. (Washington, D.C.: Smithsonian Scholarly Press, 2013).

71. PANDAS FROM CHINA

495 "seek hegemony in the Asia Pacific region": joint communiqué of the United States of America and the People's Republic of China, February 27, 1972, Shanghai Communiqué.

495 "the week that changed": Richard Nixon in "Nixon's China Game," *PBS American Experience*, http://www.pbs.org/wgbh/amex/china/sfeature/nixon.html.

496 "we should honor the generosity": Smithsonian's public information officer, record unit 365, box 24.4, Smithsonian Institution Archives.

496 "like mandarins at": *Newsweek*, April 30, 1973.

496 "his-and-her wading pools": "The High Cost of Pandas," *Spokane Daily Chronicle*, May 2, 1973, p. 4.

497 "prurient panda publicity": Theodore Reed to S. Dillon Ripley, May 8, 1974, May 29, 1975, record unit 365, box 24.8, Smithsonian Institution Archives.

497 "when making love was denounced": Art Buchwald, "Panda Marriage Troubles All," *Lakeland Ledger*, May 19, 1975, p. 12A, http://news.google.com/newspapers?nid=1346&dat=19750519&id=zu0vAAAAIBAJ&sjid=8PoDAAAAIBAJ&pg=3977,4900591.

499 "ambassadors for conservation": National Zoological Park, Frequently Asked Questions, 2002, http://nationalzoo.si.edu/animals/giantpandas/frequentlyaskedquestions/default.cfm.

72. BERLIN WALL FRAGMENT

501 "From Stettin in the Baltic": Winston Churchill, speech at Westminster College, Fulton, Missouri, March 5, 1946, National Churchill Museum, http://www.nationalchurchillmuseum.org/cold-war-quotes.html.

503 "Freedom has many difficulties": John F. Kennedy, remarks in the Rudolph Wilde Platz, Berlin, June 26, 1963, Gerhard Peters and John T. Woolley, The American Presidency Project, http://www.presidency.ucsb.edu/ws/?pid=9307.

503 "There is one sign": Ronald Reagan, remarks on East-West relations at the Branderburg Gate in West Berlin, June 12, 1987, Gerhard Peters and John T. Woolley, The American Presidency Project, http://www.presidency.ucsb.edu/ws/?pid=34390.

504 "this most visible": John F. Rogers, personal communication with Heather Ewing, 2012.

74. JACQUELINE KENNEDY'S INAUGURAL BALL GOWN

515 "Let the word": John F. Kennedy, inaugural address, January 20, 1961, Gerhard Peters and John T. Woolley, The American Presidency Project, http://www.presidency.ucsb.edu/ws/?pid=8032.

515 "Let every nation": ibid.

515 "Ask not what": ibid.

516 "career as a major": Dick Darcey, "First Lady Sets the Fashion," *Washington Post*, January 21, 1961, p. B9, http://search.proquest.com/hnpwashingtonpost/docview/141556739/13D65AF426621BC145F/1?accountid=46638.

518 "changes in American": Margaret W. Brown Klapthor, *The First Ladies Hall*, Smithsonian Institution, 1965, exhibition booklet, p. 1.

518 "I am the man": John F. Kennedy, twelfth news conference at the Palais de Chaillot in Paris, remarks and question and answer period at the press luncheon in Paris, June 2, 1961, Gerhard Peters and John T. Woolley, The American Presidency Project, http://www.presidency.ucsb.edu/ws/?pid=8170.

75. JULIA CHILD'S KITCHEN

521 "an opening up of the soul": "Obituary: Julia Child," *The Economist*, August 26, 2004, at http://www.economist.com/node/3127191.

525 "We had gone up thinking": Paula Johnson, "10 Questions for the Smithsonian Curators Who Cooked Up Julia Child's Kitchen Exhibit," *Gourmet Live*, August 15, 2012.

526 "everything *and* the kitchen": http://americanhistory.si.edu/kitchen/diary04_01.htm.

526 "People would walk": Rayna Green, *Gourmet Live*, op. cit.

76. THE PILL AND ITS DISPENSER

531 "I was constantly": David Wagner in Patricia Peck Gossel, "Packaging the Pill," *Manifesting Medicine: Bodies and Machines*, Robert Bud, Bernard Finn, and Helmuth Trischler, eds. (Newark, NJ: Hardwood Academic Publishers, 1999), p. 106.

531 "this lasted until": ibid.

77. NEIL ARMSTRONG'S SPACE SUIT

533 "One small step": Neil Armstrong in John Noble Wilford, "Men Walk on Moon. Astronauts Land on Plain; Collect Rocks, Plant Flag," *New York Times*, July 21, 1969, p. 1.

533 "before this decade": John F. Kennedy, special message to the Congress on urgent national needs, May 25, 1961, IX Space, Gerhard Peters and John T. Woolley, The American Presidency Project, http://www.presidency.ucsb.edu/ws/index.php?pid=8151.

536 "Neil Armstrong's first footfall": Allison P. Davis, "The Epic Battle Behind the Apollo Spacesuit," reviewing Nicholas de Monchaux, *Spacesuits: Fashioning Apollo*, *Wired Magazine*, February 28, 2011, http://www.wired.com/magazine/2011/02/pl_spacesuits_showdown.

80. GREENSBORO LUNCH COUNTER

556 "brought tears to": Exell Blair in Charles E. Cobb Jr., *On the Road to Freedom: A Guided Tour of the Civil Rights Trail* (Chapel Hill, NC: Algonquin Books, 2012), p. 102.

556 "In Philadelphia": Joseph McNeil in Owen Edwards, "Courage at the Greensboro Lunch Counter," *Smithsonian Magazine*, February 2010, http://www.smithsonianmag.com/arts-culture/Courage-at-the-Greensboro-Lunch-Counter.html.

556 "I was still the same": ibid.

558 "I called the manager right away": Bill Yeingst, ibid.

81. MUHAMMAD ALI'S BOXING GEAR

560 "the most famous": Muhammad Ali at a donation ceremony, March 17, 1976, http://collections.si.edu/search/results.htm?view=&dsort=&date.slider=&q=muhammad+ali+gloves and http://www.smithsonianlegacies.si.edu/objectdescription.cfm?ID=121.

562 "big ugly bear": cited in Gerald Early, *The Muhammad Ali Reader* (New York: Ecco, reprint, 2013), p. 17.

562 "float like a butterfly": ibid., p. xix.

563 "I don't have no": "Clay to Appeal Draft on Religious Beliefs," *The Blade* (Toledo, OH), February 19, 1966, p. 11.

564 "white slavemasters": Early, op. cit., p. 147.

82. BOB DYLAN POSTER BY MILTON GLASER

569 "When we first": Joyce Carol Oates, "Dylan at 60," in *Studio A: The Bob Dylan Reader*, Benjamin Hedin, ed. (New York: W. W. Norton, 2004), p. 259.

571 "I was interested": Milton Glaser, http://www.smithsonianmag.com/arts-culture/Sign-of-the-Times-Bob-Dylan.html.

84. GAY CIVIL RIGHTS PICKET SIGNS

582 "presentable and employable": Frank Kameny in John Loughery, *The Other Side of Silence—Men's Lives and Gay Identities: A Twentieth-Century History* (New York: Henry Holt, 1998), p. 271.

584 "I am a homosexual": Frank Kameny, campaign announcement, The Rainbow History Project, Kameny for Congress, http://www.rainbowhistory.org/html/kameny_for_congress.html.

585 "Frank, this is where the pickets": Harry Rubenstein, http://www.washingtonblade.com/2011/10/20/kamenys-storybook-ending/.

585 "Apology accepted!": Frank Kameny, cited in Ed O'Keefe, "Eye Opener: Apology for Frank Kameny," *Washington Post*, June 29, 2009, http://voices.washingtonpost.com/federal-eye/2009/06/eye_opener_june_29_2009.html.

85. AIDS MEMORIAL QUILT PANEL

587 "This is not a political": Roger Gail Lyon, federal response to AIDS: hearings before a subcommittee of the Committee on Government Operations, House of Representatives, 98th Congress, 1st Session, August 1–2, 1983 (Washington, D.C.: Government Printing Office, 1983).

588 "a lethal judgment": Jerry Falwell, "AIDS: The Judgment of God," Liberty Report, April 1987, cited in Earl E. Shelp and Ronald Sunderland, *AIDS and the Church: The Second Decade* (Louisville, KY: Westminster John Knox Press, 1992), p. 23.

592 "I think each": Julie Rhoad, speech at the opening ceremony, Smithsonian Folklife Festival, 2012, http://blogs.smithsonianmag.com/aroundthemall/2012/07/unfolding-the-aids-memorial-quilt-at-the-folklife-festival/.

86. WALT DISNEY'S MICKEY MOUSE

595 "I had this mouse": Walt Disney, http://historywired.si.edu/object.cfm?ID=121.

599 "All we ever intended": Walt Disney, fact sheet, Accession File, National Museum of American History.

599 "I only hope": Walt Disney, ibid.

88. CHUCK BERRY'S GIBSON GUITAR

607 "Rock and roll": Dave White (né David White Tricker), song lyric, 1958.

610 "Soon as three o'clock": Chuck Berry, "School Days" song lyric.

610 "It's got a backbeat": Chuck Berry, "Rock and Roll Music" song lyric.

610 "Where hamburgers sizzle": Chuck Berry, "Back in the USA" song lyric.

612 "Chuck was my man": Keith Richards, *Best of Guitar Player*, December 1992.

612 "if you tried": John Lennon, the official site of Chuck Berry: Quotes, http://www.chuckberry.com/about/quotes.htm.

89. KATHARINE HEPBURN'S OSCARS

615 "Katharine Hepburn won": "Films Crown Hepburn, Laughton Year's Best," Sidney Skolsky, March 16, 1934, newspaper clipping, name unreadable.

615 "I found that": Louis B. Mayer in Scott Eyman, *Lion of Hollywood: The Life of Louis B. Mayer* (New York: Simon & Schuster, 2005), p. 117.

617 "Katharine Hepburn runs": Dorothy Parker in Gerald Bordman and Thomas Hischak, *The Oxford Companion to American Theatre* (New York: Oxford University Press, 2004), p. 304.

618 "I called the number": Amy Henderson, personal communication with Heather Ewing, December 2012.

90. HOPE DIAMOND

625 "Thank you": Jacqueline Kennedy, letter to Secretary Leonard Carmichael, April 10, 1962, cited in Richard Kurin, *Hope Diamond: Legendary History of a Cursed Gem* (New York: Smithsonian Books/HarperCollins, 2006), p. 278.

625 "Since the arrival of the Hope": Jeffrey Post, *The National Gem Collection* (Washington, D.C., and New York: Smithsonian Institution and Harry N. Abrams, 1997), p. 27.

91. ANDY WARHOL'S *MARILYN MONROE*

630 "Warhol created a powerful": Anne Goodyear, exhibition label, 2006, http://collections.si.edu/search/results.htm?view=&dsort=&date.slider=&q=warhol+marilyn.

93. KERMIT THE FROG

639 "I was born a tadpole": http://en.wikipedia.org/wiki/Kermit_the_Frog, cited in Muppet Wiki, http://muppet.wikia.com/wiki/Kermit's_Family.

641 "trying to hold together": Jim Henson, *It's Not Easy Being*

Green and Other Things to Consider (New York: Hyperion, 2005), p. 37.

642 "Someday we'll find it": Paul Williams and Kenneth Ascher, "The Rainbow Connection," lyrics from *The Muppet Movie* (1979), originally performed by Kermit the Frog (Jim Henson), Jim Henson Productions, http://kids.niehs.nih.gov/games/songs/movies/rainbowmid.htm.

94. *STAR WARS*' R2-D2 AND C-3PO

647 "the Smithsonian as a suitable": David Noble, letter to Lucasfilm, Inc., July 1983, Registrar Files, National Museum of American History.

647 "that they are not": Lucasfilm, Inc., letter to David Noble, January 5, 1984, Registrar Files, National Museum of American History.

95. ENIAC

654 "Now we think": in Harry Reed, ACM history panel, *Fifty Years of Army Computing from ENIAC to MSRC*. A record of a symposium and celebration, November 13–14, 1996, p. 153, http://www.arl.army.mil/www/pages/shared/documents/50_years_of_army_computing.pdf.

96. APPLE'S MACINTOSH COMPUTER

658 "The IBM is a machine": Mitch Kapor in Steve Levy, *Insanely Great. The Life and Times of Macintosh, the Computer That Changed Everything* (New York: Penguin Books, 2000), p. 163.

660 "friendly": Walter Isaacson, *Steve Jobs* (New York: Simon & Shuster, 2011), p. 129.

97. NAM JUNE PAIK'S *ELECTRONIC SUPERHIGHWAY*

666 *superhighway*: Nam June Paik, "Media Planning for the Post-Industrial Society: The 21st Century Is Now Only 26 Years Away," proposal to the Rockefeller Foundation, 1974.

667 "celebrates this country": John Hanhardt, http://eyelevel.si.edu/2011/08/celebrate-this-nam-june-paiks-birthday-.html.

98. NEW YORK FIRE DEPARTMENT ENGINE DOOR FROM SEPTEMBER 11

672 "On Wednesday [September 13]": Peter Liebhold, http://amhistory.si.edu/september11/2011/collecting.asp.

99. SHEPARD FAIREY'S *BARACK OBAMA* "HOPE" PORTRAIT

678 "I wanted to convey": Shepard Fairey, "Art for Obama, Designing Manifest Hope and the Campaign for Change," Shepard Fairey and Jennifer Gross, eds. (New York: Abrams Image, 2009), p. 7.

100. DAVID BOXLEY'S TSIMSHIAN TOTEM POLE

686 "cleanest and finest": in James Conway, *The Smithsonian: 150 Years of Adventure, Discovery and Wonder* (New York: Alfred A. Knopf and Washington, D.C.: Smithsonian Books, 1996), p. 122.

686 "take the instruments": S. Dillon Ripley, cited in Richard Kurin, *Smithsonian Folklife Festival: Culture Of, By, and For the People* (Washington, D.C.: Smithsonian Institution, 1998), p. 8.

688 "My mother's generation": David Boxley in Michael E. Ruane, "Museum Gets Totem Pole Newly Carved in Ancient Wood," *Washington Post*, January 7, 2012, http://articles.washingtonpost.com/2012-01-07/local/35441322_1_totem-pole-tsimshian-museum.

688 "I have to reach back": ibid.

688 "very fortunate to be": ibid.

689 "He didn't realize": ibid.

689 "The moral of the story": ibid.

689 "There's few of us": ibid.

689 "We're saying that": Kevin Gover in ibid.

690 "They've been calling": David Boxley in ibid.

INDEX

Page numbers in *italics* refer to illustrations.

Aaron, Hank, 698
Abbott, Charles G., 323–24, 387, 693
Aberdeen Proving Ground, 652–55
Abernathy, Ralph, 577
abolitionists, abolitionism, 116–17, 139, 217
Acosta, José de, 31
Adams, Ansel, 250, 251
Adams, James Ring, 63
Adams, John, 87, 89, 91, 92, 102, 181
Adams, John Quincy, 92, 103–4, 274, 693
Adams, Robert McCormick, 470–71, 687
Aditi: A Celebration of Life, 518
Adler, Cyrus, 126–27
Adrian, Gilbert, 422, 424–25
Aerodrome, 321–22, 323, 324
Afghanistan, 122
AFL-CIO, 575, 578
African Americans, 10, 217, 221, 349, 353, 361, 410, 413, 449, 565
 in Tuskegee Airmen, 439–44
 See also specific African Americans
African Queen, The, 618
After School Session, 610
Agassiz, Louis, 380
Agricultural Workers Organizing Committee (AWOC), 575, 576, 577
Aguilera, Christina, 450
Ahlborn, Richard, 156
AIDS quilt, 8, 9, 586, 587–92, 590
"Ain't Misbehavin'," 375
Air Corps, 441–44
Air Force Association, 470

Air Service Reserve Corps, 384
Ai Weiwei, 499
Alabama, 39, 200, 221
Alamo, Battle of, 188
Albert, Prince Consort, 237
Albright, Madeleine, 122
Aldrin, Edwin "Buzz," 533, 535, 536, 539–40
Alexandria Masonic Lodge, 190–91
Alfred A. Knopf, 521
Algonquian Indians, 58
Ali, Muhammad, 9
 boxing gear of, 560–66, 561
Alinsky, Saul, 573
All About Eve, 628
Alliance, Treaty of, 101
Alliance for Progress, 515
Allies, 366, 368
All in the Family, 605
Allison, David, 655
Almanac Singers, 429
Al-Qaida, 671
Ambrose, Stephen, 169–70
America, 699
Americæ nova tabula (map), 78–83, 79
American Birth Control League, 527
American Broadcasting Company, 604
American buffalo, 8, 259–66, 260, 265
American Cancer Society, 328
American Chemical Society, 328
American Civil Liberties Union (ACLU), 349, 381, 382, 383
American Federation of Labor (AFL), 408, 410, 575, 578
American Idol, 605–6

American Institute of Chemical Engineers, 330
American Ornithologists' Union, 203
American Philosophical Society, 160
American Psychiatric Association, 583
American Revolution, 91, 95, 96, 97, 100–102, 105, 107, 108, 118, 160
Americans with Disabilities Act, 350
American Telephone and Telegraph Company (AT&T), 287
American University, 369
Among the Sierra Nevada, California (Bierstadt), *246,* 247–51
Ampère, André-Marie, 180
Anagnos, Michael, 348
Ancient Monuments of the Mississippi Valley (Squier and Davis), 40
Anderson, Charles "Chief," 441
Anderson, Marian, 513, 569
 mink coat of, *412,* 413–19
Anderson, Murland E., 475
Andrew, John A., 226
Andrews Sisters, 450
Andrus, Leonard, 143
Anthony, Susan B., 215, 353, 354, 357, 358
Anthony of Padua, Saint, painting of, 51–55, 52
Antietam, Battle of, 219
Apache Indians, 51
Apocalypse Now, 490
Apollo 11, 4, 533, 540, 541
Appalachian Mountains, 80
Apple, 656–62, 657, 658, 659
Appleton, Eben, 118, 119
Appomattox Campaign, 231

Appomattox Court House, furnishings of, *230,* 231–35
Arabian Test Shoes, 425
Arapaho Indians, 269
Archer, Frederick Scott, 325
Arizona, 54, 186, 354, 455
Arkansas, 159, 200, 221, 455
Arlington National Cemetery, 278, 462
Armistead, George, 114, 116, 118–19
Armistead, Wilson, 209
Armistice Day, 428
Armstrong, Louis, trumpet of, 10, 371–77, *372*
Armstrong, Neil, 9, 605
 space suit of, 533–41, *534*
Army Corps of Engineers, 278
Army of Northern Virginia, 231
Arrangement in Grey and Black: Portrait of the Artist's Mother (Whistler), 334
Art and Money; or, the Story of Room (Whistler), 335
Articles of Capitulation, 233
Asch, Moses, 429–30, 567, 571
Asch, Sholem, 430
Ascher, Kenneth, 642
Asch Records, 429–30, 432, 567
Ashmun Institute, 224
Asian Exclusion Act of 1924, 454
Asphalt Jungle, The, 627–28
Assad, Hafez al-, 370
Assiniboine Indians, 271, 272
Associated Press, The, 681
Astor, Caroline, 306
Astor, John Jacob, IV, 343
Astor family, 305
Athenaeum (Stuart), 105
Atlanta, Ga., 233
Atlantis, 31
Atlantis, 548
Atlas, Babylon (Frank), 477
atomic bomb, 465–72
Audacity of Hope, The (Obama), 680
Audubon, John James, 199–201
Australia, 23, 194, 328
Austro-Hungarian Empire, 366, 459
Avedon, Richard, *517*

"Ave Maria," 417
Aztecs, 40

Babb, Cook and Willard, 306
Babcock, Orville E., 233
Baekeland, Leo, 327–28
Baez, Joan, 569, 582
Bailey, John, 96–97
Baird, John Logie, 600
Baird, Spencer Fullerton, 13–14, 15, 191, 201, 685–86, 688, 701
Baird's Bunting, 201
Bakelite, 328–30
Bakelite Corporation, 329–30
Bakelizer plastic maker, 325–30, *326*
Baker, Ernest Hamlin, *463*
Baker, Kenneth, 646, 647
bald eagle, *26,* 27–30
Bald Eagle Protection Act, 29
Ball, Lucille, 700
Baltimore, Md., 111, 113, 118, 299
Bangladesh, 151
Banks, Sonny, 562
Barber, Benjamin, 636
Barbie, 698
Barnum, P.T., 249
Barrymore, John, 617
Bartholdi, Frédéric, *Liberty* of, 9, 295–300, *296*
Bartholdi Pedestal Fund, 300
Bartlett, Truman, 242
Baum, L. Frank, 423–24
Beatles, The, 376, 604, 607, 612
Bedloe Island, 298
Beecher, Catherine, 520
Beecher, Henry Ward, 210
Behring, Kenneth, 120
Beijing Zoo, 495
"Bein' Green," 641
Bel Geddes, Norman, 329
Bell, Alexander Graham, 17, 346, 348–49, 600, 703
 telephone, *282,* 283–88, *284, 286,* 292
Bell, Mabel, 17
Bell Telephone Company, 286
Belote, Theodore, 229
Benin, 71
Bennett, Tony, 641
Benz, Karl, 311

Berg, John, 570
Berkebile, Don H., 316
Berle, Milton, 604
Berlin, 248
Berlin, Battle of, 501
Berlin, Irving, 375, 428
Berlin Airlift, 502
Berlin Wall, 8, *500,* 501–5
Bermingham, Eldredge "Biff," 702
Berry, Chuck, Gibson guitar of, 607–13, *608*
Berry, John, 585
Bertholle, Louisette, 521
Berwick, Rachel, 204
Bessemer, Henry, 304
Bethlehem Steel, 307
BFGoodrich, 537
Bible, 31, 123–28, *124,* 179
Bierstadt, Albert, 8, *246,* 247–51
Big Foot, 273
Billboard, 609
Bill of Divorcement, A, 617
Billy the Kid, 176
Bingham, William, 105, 107
Bird, William L., 69, 478–79
birdman, *38,* 39–42
Birds of America (Audubon), 200, 201
Birds of the World, 204
birth control pill, 527–32, *528*
Birth of a Nation, 362, 364
bison, 8, 259–66, *260,* 265
Blackmore, Wilmont, 233–34
Black Sox scandal, 394
Blaeu, Willem, 78, 83
Blair, Ezell, Jr., 555, 556, 559
Blake, Francis, 287
Bliss, P.P., 215
Blockson, Charles L., 216
Blockson, Jacob, 216
"Blowin' in the Wind," 569
Bockscar, 469
Bogart, Humphrey, 618
Bonaparte, Louis-Napoleon, emperor of France, 159, 295
Bonavena, Oscar, 564
Book of Mormon, 154
Booth, John Wilkes, 239
Bosnia, 122
Boston, Mass., 182, 286, 299
Bound for Glory, 429
Bower, John, *115*

Boxley, David, *684,* 685–90
BP oil spill, 702
Bracero Program, 575–76, 578–79
Braddock, Edward, 95
Bradford, Lewis, 65
Bradford, William, 67
Brady, Mathew, 182, 241, 242
Branch Davidians, 663
Braziliogia, a Book of Kings, 56
Brewster, William, 66
Bridgman, Laura, 348
Bringing It All Back Home, 570
Broadside, 569
Broun, Betsy, 667
Brown, John, 214, 231
Broyles, Kenton, 364
Bruce, Ernie, 491
Bryan, Thomas, 220
Bryan, William Jennings, 277, 379,
 382–83
Buffalo, N.Y., 182, 305
Buffalo Bill's Wild West Show, 272
Bunch, Lonnie, 77, 211, 216, 443
Burchett, Wilfred, 475
Bureau of Ethnology, 39, 54
Bureau of Mines, 369
Burgess Shale fossils, *20,* 21–25
Burned-over District, 153
Bush, George H. W., 350
Bush, George W., 16, 120–21, 457,
 550, 672, 682
Bus Stop, 629
Butcher, Harry, 402
Butler Act, 381, 382

C-3PO, 644–48, *645*
Cage, John, 666
Cagney, Jimmy, 462
Cahokia, 40–41, 42
California, 55, 169, 186, 193–97, 354,
 452, 455
California State Fair, 196
Cambridge School for Young Ladies,
 349
Camden & Amboy Railroad, 168–69
Camino Real, 51
Campbell, Ben Nighthorse, 685, 687
Camp Fire Girls, 414
Camp Jerome, 452, 455, 456
Canada, 214

Canary Islands, 47, 71
"Candyman," 450
Cannon, Johnny, 595
Capehart, Henry, 233
Cape Verde Islands, 72–73
Capitan, El (Adams), *250*
Carawan, Guy, 558
carbon dating, 34–35
Carmichael, Leonard, 516–17,
 620, 625
Carnegie, Andrew, 10, 301–9, *302*
Carnegie, Louise, 305, 307
Carnegie Corporation, 308–9
Carnegie Hall, 414, 419
Carnegie Hill, 307
Carnegie Mansion, 309
Carnegie Steel Company, 304
Caron, Jean-Bernard, 24
Carpathia, R.M.S., 343
Carpenter, Scott, 482
Carson, Kit, 174
Cartagena, 81
Carter, Goree, 607
Carter, Jimmy, 610
Cartier, Jacques, 199
Cartier, Pierre, 622, 623–24
Cartridge Company, 177
Carver, George Washington, 16
Carver, John, 66
Case, David, 589
Casey, Charles, 229
Cash, Johnny, 377
Castine, Michael, 504
Castro, Fidel, 699
Catholic Church, 529, 530
Catlin, George, 176, 261
Catoctin Mountains, 80
Catt, Carrie Chapman, 354, 356
CBS, *400,* 402–5
celluloid, 327
Centennial Exposition, 1876, 686
Center for Folklife and Cultural
 Heritage, 697
Central America, 151
Central Pacific Railroad, 170
Central Powers, 366
Cetus Corporation, 544
Chaffee, Roger, 538
Chaffin's Farm, Battle of, 228
Challenger, 548, 549, 550
Chamber of Commerce, 196

Champlain, Samuel de, 199
Chanute, Octave, 320
Charbonneau, Toussaint, 163
Charles, Ray, 641
Chavez, Cesar, 682
 union jacket of, 4, 573–79, *574*
Chavez, Hernando, 579
Checkpoint Charlie, 502
Cherokee Indians, 139
Chess, Leonard, 609
Cheyenne Indians, 269
Chiang Kai-shek, 467
Chicago, Ill., 196, 305
Chicago Historical Society, 235
Chicago Times-Herald, 312
Chicago World's Fair, 48, 170, 235,
 336
Child, Julia, 520–26, *522–23*
 kitchen of, 4, 10
Child, Paul, 521, 525
Chile, 81
China, 23, 151, 194, 195, 257, 276,
 406, 493–99
chlorine, 366, 368
chloropicrin, 369
Choctaw Indians, 139, 371
Christman, Margaret, 110
Christo, 699
Church, Ted, 402
Churchill, Winston, 467, 501
Church of Jesus Christ of Latter-day
 Saints, 153–56
Church of the Heavenly Rest, 307
Cincinnati Zoological Garden, 203
Cinephone, 597
City Beautiful movement, 336
Civic Biology, 380–81
Civil Disobedience (Thoreau), 189
Civil Liberties Act of 1988, 458
Civil Rights Act (1964), 364
Civil War, 7, 10, 118, 139, 169, 190,
 209, 211, 214, 217, 224–29,
 237–38, 239–40, 243, 251, 267,
 301, 353
Clansman, The, 362
Clapton, Eric, 613
Clark, Les, 595
Clark, William, *158,* 159–64, *163*
Clay, Cassius Marcellus, Jr., 560. *See
 also* Ali, Muhammad

Clay v. United States, 564
Clemente, Roberto, 698
Clermont, 165
Cleveland, Grover, 257, 276, 300
Cleveland, Oh., 299, 305
Clinton, Hillary Rodham, 120, 663
Clinton, William J., 457, 471, 663
Clough, Wayne, 211, 288, 559
clovis stone points, *32, 35,* 31–37
coal, 406, 409
Cochrane, Alexander, 114
cocoa, 73
Cody, Buffalo Bill, 176, 263
coffee, 73
Cohen, John, 567
Cohen, Joshua, 127
cold war, 475–79
Cole's Hill, 67
Collins, Judy, 582, 642
Collins, Michael, 536, 539–40, 541
Collins, Wilkie, 624
Colorado, 159, 186, 354
Colored High School Cadet Corps, 228
Colored Waifs' Home for Boys, 374
Colossus of Rhodes, 297
Colt, Samuel, 172–77
 Colt's revolver, *173*
Colton, Frank, 529
Columbia, 533, 539, 541, 548–49, 550
"Columbia" (Wheatley), 48
Columbia Broadcasting System, 603. *See also* CBS
Columbian Institute, 256
Columbia Records, 567, 569, 570, 572
Columbia University, 308, 462
Columbus, Christopher, 78, 83
 portrait of, *44,* 45–50
Columbus commemorative stamp, *49*
Comanche Indians, 261–62
Commonwealth v. Hunt, 406
Community Fallout Shelter Program, 477
Community Service Organization, 573
compass, *158,* 159–64
Comstock, Daniel, 422
Comstock Act, 527
Conestoga wagon, *130,* 131–33
Congregation Emanu-El, 698

Congressional Compromise of 1850, 212
Congressional Union for Woman Suffrage, 355
Connor, Roger, 489
Constable, William, 110
Constantinople, 46, 208
Constitution, U.S., 92–93, 137, 361, 457
Constitutional Convention, 102
Constitution Hall, 413, 415–16, 419
Continental Congress, 87, 88, 91, 95
Contract with America, 700
Contributions to Knowledge, 40
Cook, James, 252
Cooke, William, 181, 182
Coolidge, Calvin, 387
Coolidge, Eleanora Wayles Randolph, 93
Cooper, Gordon, Jr., 482
Cooper, Henry, 562
Cooper-Hewitt Museum, 309
Coppola, Francis Ford, 490
Corcoran Gallery of Art, 516
Cordon Bleu, Le, cooking school, 521
Cornell, Ezra, 182
Cornwallis, General, 102
Corps of Discovery, 160–64
Cosell, Howard, 563
cotton, 73, 134, 136–39
Cotton Club, 377
cotton gin, 10, 134–39, *135*
Cotton States International Exhibition, 127
Cox, Palmer, 342
Crick, Francis, 543
Cripple Creek, Colo., 408
Croatan, 80
Cronkite, Walter, 605
Crosby, Bing, 377
"Cross of Gold" speech, 381
Crossroads, The: The End of World War II, the Atomic Bomb and the Cold War, 470
Crow Indians, 271
Crowley v. Smithsonian, 383
Cuba, 47, 48, 73, 274, 276, 277, 278
Cuban missile crisis, 478
Cukor, George, 425
Cultural Revolution, 497

Cunningham, Sis, 429, 569
Curtiss, Glenn H., 323
Curtiss Jenny biplane, 324, *324,* 389
Cusco, 81
Custer, Elizabeth, 234
Custer, George Armstrong, 234, 267, 273
 jacket of, *269*
Cutting, James Ambrose, 209

Daguerre, Louis, 182
Dailey, J. R. "Jack," 546, 551
Daily Express, 475
Dakotas, 269
Dalai Lama, 498
Dalmeny, Lord Harry, 108
Daniels, Anthony, 647
Darrow, Clarence, 379, 380, 382–83
Darwin, Charles, 380
Daughters of the American Revolution (DAR), 415–16
David Clark Company, 537
Davis, Allison, 536
Davis, Benjamin Oliver, Jr., 442
Davis, Bette, 616
Davis, Edwin Hamilton, 41
Davis, Jacob, 150
Davis, Jefferson, 231, 243
Davis, J.Y., 237
Davis, Nelson, 215
Davis, Watson, *378, 379*
Davy, Humphry, 291
Dawson, Lucille, 686
Day of Jubilee, 222
D-Day, 461
DDT, 29
Dean, James, 204
Debs, Eugene, 382
Declaration of Independence, 8, *86,* 87–93, *88, 89, 91,* 99, 100, 123, 208, 353, 585
Declaration of Sentiments, 353
Deere, John, 10, *140,* 141–44
Defense Department, U.S., 549–50
de Forest, Lockwood, 307
de Gaulle, Charles, 518, 624
De la Rue, Warren, 291
de las Casa, Bartolomé, 73
Delaware, 217, 355
De La Ware, Lord, 60

Deliverance, 60
del Piombo, Sebastiano, *47, 49*
del Río, Dolores, 616
Demczur, Jan, 673
de Monchaux, Nicholas, 536
Dempsey, Jack, 397
DePriest, James, 417–18
de Soto, Hernando, 39
DeVito, Don, 572
DeVoto, Avis, 521
*Diagnostic and Statistical Manual
 of Mental Disorders,* 583
"Diamonds Are a Girl's Best
 Friend," 628
Dickens, Charles, 153
Diddley, Bo, 607
Diderot, Denis, 102
Dillehay, Tom, 35, 36
DiMaggio, Joe, 628, 629
"Dinah," 375
Dinsmore, William Brown, 249
Discovery, 9, 58, 486, 546–52, *547,*
 548, *550,* 551
Disney, Lillian, 595
Disney, Roy, 596, 599
Disney, Walt, 422, 595, 596, 616
District of Columbia Compensated
 Emancipation Act, 217, 219
Dixon, Willie, 609
DNA, 36, 543–44, 701
Dole, Sanford, 257
Dominican Republic, 47
Domino, Fats, 607
Donovan, Bill, 521
Dorothy, 4
 ruby slippers of, *420,* 421–25
Dougherty, Jim, 627
Douglass, Frederick, 8, *206,* 207–11,
 214, 226, 354
Dove, Carla, 701–2
"Dream a Little Dream of Me," 376
Dred Scott decision, 118
Dreyfuss, Henry, 329
Dripps, Isaac, 167–68
*Dr. Strangelove or: How I Learned
 to Stop Worrying and Love the
 Bomb,* 478
Drummond, Geoff, 526
D. T. Watson Home for Crippled
 Children, 511
Duchamp, Marcel, 570

Dundee, Angelo, 560
Dunlap, John, 88–89, *89*
Duryea, Charles, 312
Duryea, Frank, 312
Duryea Motor Carriage, *313*
Duryea Motor Wagon Company, 312
Dust Bowl, 423, 426, 429
Dust Bowl Ballads, 428
Dutch West Indies Company, 73–74
Dylan, Bob, 432
 poster of, 567–72, *568*
DynCorp, 491

Eagle, 533, 535, 538, 540
Earhart, Amelia, 6, 388–91, *389*
Early, Steve, 403
Earp, Wyatt, 176
Eastern Railroad Company, 286
Eastman, George, 327, 339
Eastman Kodak Company, 339
Ebbets, Charles, *308*
Eckert, John Presper, 652, 653, 655
Eckert, Thomas, 219
École des Beaux-Arts, 299
Eddy, Sarah J., 357, *357*
Ederle, Gertrude, 398
Edgewood Arsenal, 369
Edison, Thomas, 9, 287, 300, 341, 600
 lightbulb of, 9, 289–94, *290*
Edison Electric Light Company, 292
Edison General Electric, 293–94
Edmonds, Edward, 546
Edouarde, Carl, 597
Ed Sullivan Show, The, 604, 640
EDVAC, 654
Edwards, Nancy, 525
Egypt, 40
Egypt Bringing Light to Asia
 (Bartholdi), 297
Eiffel, Alexandre Gustave, 298–99
Eiffel Tower, 299
Einstein, Albert, 415, 430, 465
Eisenhower, Dwight D., 358, 376,
 418, *463,* 480, 482, 513, 515,
 530, 536, 557, 582, 622, 634, 666
Eisenhower, Mamie, 515, 516
Eisenhower jacket, 459–63, *460*
Eisner, Michael, 599
Eklund, Jon, 325, 330
elections, U.S., 1936, 411

electromagnets, 181, 183
Electronic Superhighway (Paik) *665,*
 666, 667
Ellicott, Andrew, 161
Ellington, Duke, 375, 700
Elliott, Ramblin' Jack, 567
Ellis, Bernice Palmer, 344–45
Ellis, Janice, 127–28
Ellsberg, Daniel, 700
Ellsworth, Annie, 182
Ellsworth, Henry Leavitt, 182
Emancipation Proclamation, 210,
 217–23, *218, 221,* 225, 226,
 233, 585
Emergency Broadcast System, 476
Emerson, Ralph Waldo, 181, 210
Empire State Building, 307
Endangered Species Act, 203
Enders, John F., 512
ENIAC, *650,* 651–55
Enola Gay, 10–11, *464,* 465–72, *468*
Enovid, 527, 529, 530, *530*
Enterprise, 548, 551, 552
Equal Rights Amendment, 358
Erie Canal, 132, 153, 167
Etowah, 41, 42
eugenics movement, 529
Evans, Redd, 448
evolution, 379–83
Executive Order 9066, 454
Ex parte Endo, 457
Exploratory Expedition, U.S., 256
Explorer I, 480
*Extermination of the American Bison,
 The* (Hornaday), 264

Fabela, Helen, 573
Faget, Max, 482
Fairbanks, Douglas, 615
Fairey, Shepard, 4, 678–83
 Barack Obama "Hope" portrait
 (Fairey), *679*
fallout shelter, *474,* 475–79, *476*
Falwell, Jerry, 588
Fantasia, 598
Faraday, Michael, 180
Farnsworth, Philo Taylor, 602
Fast Food Nation (Schlosser), 636
Fat Man, 466
Faunce, Thomas, 67

Federal Civilian Defense Administration (FCDA), 477
Federalist Papers, 107
Felix the Cat, 597
Ferdinand II, king of Aragon, 46, 48, 51
Ferebee, Thomas, 468–69
Fernández, Emilio "El Indio," 616
Fewkes, Jesse Walter, 54
Fielding, Lewis, 700
Fifty-fourth Massachusetts Infantry, 226
Finch, William Bolton, 254
Finlayson, John, 338
Finlayson, Richard, 338
Fireside Chats, 401–5
First Amendment, 123, 365
First South Carolina Volunteers, 222
Fish and Wildlife Service, U.S., 29
Fishbone, 572
Fisher, Orpheus, 417
Flag Act, 116
flappers, 374
Fleetwood, Christian, Medal of Honor of, 224–29, *225*
Fleetwood, Edith, 228
Fletcher Henderson's Orchestra, 374
Florida, 80, 200, 221
Flyer, 11, 317–24, *319, 703*
Folding Pocket Kodak camera, 341
Folklife Festival, 76, 258, 265, 458, 558, 571, 590
Folkways Records, 430, 431, 558, 567, 571–72, 697
Folsom, Joseph L., 193
Fonda, Henry, 618
Food and Drug Administration, U.S., 530
Forbes, John Murray, 221
Forbidden City, 495
Ford, Gerald, 548
Ford, Henry, 312, 315, 316
Ford, Thomas, 155
Ford Foundation, 315
Ford Motor Company, 312
Ford's Theatre, 238–39, 240
Foreign Miner's License law, 195
Foreman, George, 564–65
Fort Buford, 269
Fort Des Moines, 439
Fort Duquesne, 95

Fort McHenry, 111, 114–16, 118, 121
Fort Monroe, 217
Fort Randall, 267, 270
Fort Rucker, 491
Fort Sill, 490
Fort Stewart, 490–91
Fort Yates, 270
49ers, 194–95
Foundation of Experimental Biology, 527
Fourth Colored Troops, 229
Fowler, Amelia Bold, 119, *119*
Fox, Gustavus Vasa, 68–69
France, 366, 371
Franciscans, 52–53
Francis of Assisi, Saint, 54
Franco-American Treaty of Amity and Commerce, 101
Franco-American Union, 297
Frank, Pat, 476
Frankau, Ethel, 516
Frankl, Paul T., 329
Franklin, Benjamin, 8, 12, 28, 87, 88, 89, 102, 103, *103,* 104, 237, 295, 697
walking stick of, *98,* 99–104
Franklin, Rosalind, 543
Frazee, John, 168–69
Frazier, Joe, 564
Freedman's Savings and Trust Company, 228
Freedman's Savings Bank, 211
Freer, Charles Lang, 14, 336
Freer Gallery, 333
Frelinghuysen, Frederick T., 191
French and Indian War, 95, 100
French Revolution, 623
Friendship 7, 480–87, *481*
Froelich, Bruno, 702
Frost, Robert, 513–14
Fugitive Slave Act, 214
Full Metal Jacket, 490
Fulton, Robert, 165, 172

Gale, Leonard, 182
Gallopin' Gaucho, The, 595
Gammon Harvester Company, 144
Gandhi, Mahatma, 577
Gandhi, Rajiv, 519

Gang War, 597
Garcie, Mannie, 681
Gardner, Alexander, 241–42
Gardullo, Paul, 223
Garland, Judy, 421, 423, 642
Garrett, Pat, 176
Garrison, William Lloyd, 208
gas mask, 366–70, *370*
Richardson-Flory-Kops (RFK) version, 369
gay rights, *581,* 5805
G. D. Searle, 529, *530,* 531
General Bakelite Company, 328
General Electric Company, 293–294
General Motors, 315, 411
Gentlemen Prefer Blondes, 628
George Gustave Heye collection, 686
George III, king of England, 87, 89–90
George IV, king of England, 623
George V, king of England, 376
Georgia, 39, 134, 200
Georgia Sea Islands, 222
Germany, 356, 366, 368, 406, 454, 465
Gershwin, George, 375
Ghana, 122
Ghent, Treaty of, 116, 141
ghost dance movement, 272–73
Giant Magellan Telescope, 691–96, *692*
Gibbons, Cedric, 616
"Gift Outright, The" (Frost), 515
Gila River, 455
Gilded Age, 301, 336, 344
Gillespie, Dizzy, 377
trumpet of, *376*
Gilmore, Charles, 31, 33
Gilpin sulky plow, 144
Gingrich, Newt, 700
Ginsberg, Allen, 583
Giuliani, Rudolph, 672
Glaser, Joe, 376
Glaser, Milton, 567–72, *568*
Glazer, Lee, 338
Glenn, John, Jr., 480, 482, 484–85, 550, 551
"God Bless America," 428
Goddard, Mary Katherine, 90, *90*
Godspeed, 58
Godzilla, 476

gold, 170, 267
Gold Rush, *192*, 193–97, 247, 256–57, 698
gold sovereign, *12*
Goldstine, Herman Heine, 652
Gone With the Wind, 604, 617
Goodwill Games, 689
Goodyear, Anne, 630
Goodyear, Charles, 325
Gorbachev, Mikhail, 503
Gospel Hymns No. 2, 215
Gospel of Wealth, The (Carnegie), 306
"Gospel Train," 417
Gossel, Patricia, 545
Gould, Stephen Jay, 24
Gould family, 305
Gover, Kevin, 688, 689–90
Graddy, Lisa Kathleen, 358–59
Grand Coulee Dam, 429
Grange, Red, 397–98
Grant, Cary, 617
Grant, Ulysses S., 189, 226, 227, 231–32, 234, 263, 297, 298, 361
Grant's Tomb, 234
Grateful Dead, 571, 572
Grauman, Sid, 616
Graves, Betsy, *415*
Graves, Denyce, 419
Gravier, Charles, Comte de Vergennes, 102
Gray, Elisha, 285
Great Artiste, 469
Great Britain, 354, 366
Great Chicago Fire, 220
"Great Demand" banner, 8, *352,* 353–59
Great Depression, 7, 358, 375, 394, 401, 404, 421, 423, 426, 428, 447, 509, 573
Great International Exhibition, 327
Great Lakes, 80, 167
Great Mahele, 256
Great Serpent Mound, 395
Great Wagon Road, 131
Great Wall of China, 495
Greeks, 40
Greeley, Horace, 211
Green, Jerome, 609
Green, Rayna, 525, 526, 686
Green Berets, The, 489–90

Greenbriar Boys, 571
Greenbrier Resort, 477
Greene, Catharine, 136
Greenland, 23
Greensboro lunch counter, *554, 555–59*
Greensboro News & Record, 556
Greer, Will, 428
Grgich, Mike, 526
Griffenhagen, George, 512
Griffith, D.W., 362, 364
Grissom, Virgil "Gus," 482, 538
Grossman, Sid, *429*
Groves, Leslie, 466
Guadalupe Hidalgo, Treaty of, 189–90, 193
Guam, 278, 465, 467
Guess Who's Coming to Dinner, 618
Guggenheim, Benjamin, 343
Gunpowder Neck, 369
Guthrie, Arlo, 572
Guthrie, Woody, 426–32, *427, 429, 431,* 567, 572
 "This Land Is Your Land" and, 426–27

Hague Convention (1899), 366, 368
Haida totem pole, *688*
Haiti, 47, 159, 219
Haley, Bill, 607, 609
Hall, Donald, 386
Hamilton Standard, 537
Hammond, John, 567
Hancock, John, 89, 96
Hanhardt, John, 667
Harding, Warren, 624
Harjo, Suzan Shown, 686
Harlow, Jean, 627
Harlow House, 69
Harmony in Blue and Gold: The Peacock Room (Whistler), 332, 333–38
Harpers Ferry, 231
Harper's Weekly, 241
Harris, Clara, 238
Harris, Emmylou, 572
Harris, Rutha, 558
Harrison, Benjamin, 257
Harry Winston Gallery, 625
Hart, Mickey, 572
Harvard University, 693–94

Harvey, Eleanor, 249, 704
Harvey, Paul, 496
Harwitt, Martin, 470, 472
Havana, 81, 278
Hawaii, 252–58, 277, 456–57
Hawes, Butch, 429
Hawkins, Coleman, 375
Haymarket bombing, 408
Hays, Lee, 429
Hearst, William Randolph, 276, 277, 278
Heart Mountain, 455, 456
"Heebie Jeebies," 375
Hefner, Hugh, 628
"Hello, Dolly!," 376
Henderson, Amy, 618
Henderson, Clarence, 556
Henry, Joseph, 12–13, 181, 183–84, *183,* 194, 210, 239–40, 284, 380
Henson, Jim, 640, 641, 642, 643
Herrick, Margaret, 616
Herring, Augustus, 320
Herrington, John, 687
Hersey, John, 475
Heye, George Gustav, 15
Heyman, I. Michael, 470–71, 578
Hibernia Fire Company, 698
Hidatsa tribe, 265–66
Higginson, Thomas Wentworth, 222
Highway 61 Revisited, 570
Hindus, 40
Hiroshima, Japan, 466, 468, 469, *471,* 475
Hiroshima (Hersey), 475
Hirshhorn Museum and Sculpture Garden, 398
Hispaniola, 73
Hitler, Adolf, 445, 448
Hitz, John, 346
Hoes, Rose Gouverneur, 517
Hoff, Geraldine, 450
Holy Week, 363–64
Homer, Winslow, 704
Homestead Carnegie steel lockout, 408
Hongera Barack Obama, 682
Honguedo Strait, 80
Hoover, Herbert, 197, 401
Hope, Lord Francis, 623
Hope diamond, 9, 620–25, *621*
"Hope" portrait of Obama (Fairey), *679*

Hornaday, William Temple, 263–65
Horton, Zilphia, 558
Hot Five, 375
Houghton Mifflin, 521
House of Nobles, 256
House Un-American Activities
 Committee, 605
Houston, Cisco, 429, 430
Houston, Sam, *189*
Howard, Edgar, 33
Howard, JoGayle, 497
Howdy Doody, 605, 700
Howe, Elias, 147
Howe, Julia Ward, 353
Howey, Vera, 478–79
How to Marry a Millionaire, 628
Hoyt, Waite, 398
Hsing-Hsing (panda), 493, 496,
 497, 498
Hudson, Rock, 588–89
Hudson Bay, 80
Hudson River, 167
Huerta, Dolores, 573, 577
Huey helicopter, 487–92, *488*
Hughes, Howard, 617
Hull, Lytle, 249
Hungary, 504
Hunt, Clyde, 402
Hunt, Walter, 147
Huntington, Helen, 249
Huntley-Brinkley Report, 605
Hurok, Sol, 414, 416
Hurricane Sandy, 552
Hurston, Zora Neale, 364
Hussein, Saddam, 370
Hussey, Obed, 143, 144
Hyatt, John Wesley, 327
Hyde Park, 401
Hypo helmet, 368

Ickes, Harold, 416, 417
Idaho, 354, 455
Illinois, 141
I Love Lucy, 605
immigrants, 406, 408
Imperial Dragon, 364
I. M. Singer and Co., 149
Incas, 40
India, 151
Indiana, 141

Indianapolis, U.S.S., 467
indigo, 73, 134
Industrial Workers of the World, 349
Inouye, Daniel "Dan" Ken, 266,
 457–58, 685
Interior Department, U.S., 176, 429
International Harvester, 529
International Ladies' Garment
 Workers' Union (ILGWU),
 150–51, 410
International Latex Corporation
 (ILC), 537
International Longshoremen's
 and Warehousemen's Union,
 576–77
International Space Station, 551
In the Shadow of the Blade, 491
Intrepid Sea, Air & Space Museum,
 551, 552
Iowa, 159
Iraq, 370
Ireland, 406
iron, 406
Iron Curtain, 501, 504
Irvine, Martin, 681
Isabella I, queen of Castile, 47
Israel, 31, 40
"It Ain't Me, Babe," 569
Italy, 442, 454
Itliong, Larry, 575
Iwo Jima, 122, 469

Jackson, Andrew, 116
Jackson, Charles Thomas, 181, 184
Jackson, Mahalia, 569
Jackson, Stonewall, 189
Jackson, Wanda, 607
Jackson, Wilfred, 595, 596
"Jailed for Freedom" pin, 356, *356*
Jamaica, 76
James, Julian, 517
James I, king of England, 56, 63, 65
Jamestown, 56, 59–60, 62, 76, 80
Janssen, David, 490
Japan, 203, 276, 328, 465, 467–70
Japanese Americans, 9
 interment art of, 452–58, *453*
Jay, John, 103, 105
Jay Treaty, 108
jazz, 371–77

Jazz Singer, The, 596
Jeanne-Claude, 699
Jeckyll, Thomas, 333
Jefferson, Thomas, 12, 40, 87–88, *88,*
 89, 91, 92, 102, 113, 137, 141,
 159, 160–61, 162, 295, 585
 Bible of, 123–28, *124*
Jefferson Airplane, 571
Jihad vs. McWorld (Barber), 636
Jim Crow, 233, 415
Jiménez, Luis, 699
Jobs, Steve, 656, 658, 660–62, *661*
John Bull steam locomotive, 165–71,
 166
John F. Kennedy and Jacqueline Bouvier
 (Avedon), *517*
"Johnny B. Goode," 609, 610
Johnson, Bernice, 558
Johnson, Johnnie, 609
Johnson, Lyndon B., 518, 536
Johnson, Mary Ann, 527
Johnson, Paula, 525
Johnson, Walter, 393–94
Johnson, William H., 699
Johnston, Paul, 344–45
Jolson, Al, 596
Jones, Bobby, 398
Jones, Cleve, 589
Jones, Doug, 562
Jones, Evan, 397, 398
Jones, Jennifer, 673
Jones, Juliana C., 393
Jones, Robert M., 393
Jones, Thomas J., 393
Joseph Frankel's Sons Co., 623
Joy of Cooking (Rombauer), 520
Juhl, Jerry, 640
Julie & Julia, 526
Jurassic Park, 545
Justice Department, U.S., 454
"Just Like a Woman," 570

Ka'ahumanu, queen regent, 254
Kahn, Otto, 307
Kalakaua, David, 257
Kalmus, Herbert, 422
Kamehameha II, king of Hawaii, 254
Kamehameha III, king of Hawaii,
 255
 feather cape of, 252–58, *253*

Kamehameha V, king of Hawaii, 257
Kameny, Frank, 580, 582–85
Kanin, Garson, 618
Kansas, 159, 264, 354
Kansas City, Mo., 162, 196
Kapor, Mitch, 658
Karraker, Celine, 330
KDKA, 402
Keller, Elizabeth, 349–50
Keller, Helen, 346–51
 watch of, *347*
Kellogg, Remington, 229
Kendall, Amos, 182
Kennedy, Jacqueline, 524, 625
 inaugural gown of, 4, 513–19,
 514
Kennedy, John F., 418, 477, 478,
 483–84, 503, 513, 524, 533, 536,
 605, 682
Kennedy, Robert, 564, 576
Kennedy, Stetson, 364
Kentucky, 217
Kenya, 682
Kermit the Frog, 4, *638*, 639–43
Kerr, Randy, 512
Kesey, Ken, 570
Key, Francis Scott, 115–18, *116*
Khalid Sheikh Muhammed, 671
Khazan, Jibreel, 559
King, Billie Jean, 699
King, Don, 563, 565
King, Martin Luther, Jr., 419, 556,
 558, 564, 569, 577
King Oliver's Creole Jazz Band, 375
Kitty Hawk, N.C., 321–22, 703
Klapthor, Margaret, 518
Klink, Granville, 404–5
knapping, 33
Knebel, Fletcher, 478
Knight Hawks, 364
Knights of the Golden Circle, 190
Knowland, William, 197
Knowles, Beyoncé, 450
Kodak, 327
Kodak Brownie Camera, 339–45, *340*
Kondratas, Ramunas, 545
Korean War, 463, 487, 666
Koshay, Bobbie, 422
Koyuk (musk ox), 498
Kroc, Ray, 632, 634
Kubrick, Stanley, 478, 490, 661

Kukla, Fran and Ollie, 604
Ku Klux Klan, 233, *360*, 361–65,
 363
Kunhardt, Dorothy Meserve, 242
Kyser, Kay, 448

Laboulaye, Édouard René Lefebvre
 de, 295, 299
Lacey, John F., 202–3
Lacey Act, 29, 203
Ladies' Garment Workers' Union, 408
Lafayette, Marquis de, 101, 102, 118,
 295
LaFollette, Marcel Chotkowski, 379
Lakota Sioux, 267, 270–71
Lampell, Millard, 429
Lander, Frederick W., 247
Landis, Kenesaw Mountain, 396–97
Langley, Noel, 424
Langley, Samuel, 264, 288, 317, 320,
 321–22, 323, 324, 693
Lansdowne, marquis of, 105, 107
Last Spike, 170
Latin America, 515
Lauer, Matt, 109–10
Laurasia, 21
Lawrence Berkeley National
 Laboratory, 288
Lazarus, Emma, 300
Lead Belly, 428, 572
Lee, Robert E., 189, 231–33, 234, 238
Legasse, Emeril, 520
Leiden group, 66
Lemelson Center for the Study of
 Invention & Innovation, 703
L'Enfant, Pierre Charles, 337
Lennon, John, 612
Leonardo da Vinci, 625
Lewis, Jerry Lee, 607
Lewis, John, 211
Lewis, John Delaware, 108
Lewis, John L., union badge of,
 406–11, *407*
Lewis, Meriwether, *158,* 159–64, *163*
Lewis, Robert, 465, 467, 469–70
Leyland, Frederick Richards, 333,
 334, 336
Libby, Willard, 34
Liberator, 208
Liberia, 224, 240

Liberty Enlightening the World
 (Bartholdi), 9, 295–300, *296*
Library of Congress, 83, 92, 127,
 288, 428
Lichtenstein, Roy, 675–76, *676*
Liebhold, Peter, 672
Life, 462, 477
lightbulb, 9, 289–94, *290*
Liholiho, 254
"Like a Rolling Stone," 570
Lili'uokalani, queen of Hawaii, 257
Lincoln, Abraham, 14, 92, 184, 189,
 209–10, 211, 231, *241,* 243, 401,
 585, 682
 assassination of, 238–40
 Emancipation Proclamation of,
 210, 217–23, *218, 221,* 224,
 226, 233
 hat of, 3, *236,* 237–43
Lincoln, Robert Todd, 232
Lincoln Memorial, 416
Lincoln Memorial Association, 240
Lindbergh, Charles, 4, 6, 323–24, 384,
 386–88, 595
Lindbergh baby, 624
Ling-Ling (panda), 493, 496, 498
Lion in Winter, The, 618
Lira, Augustín, 577
Liston, Sonny, 562
Little Bighorn, Battle of, 234, 269,
 273
Little Boy, 466
Little Richard, 572, 607
Little Rock, Ark., 376
Livingston, Mary, 521
Livingston, Robert, 87
Lockheed Aircraft Company, 390
Lockheed Vega 5B, 390
Lodge, Henry Cabot, 276
Loeb, John Jacob, 448
Loeser, Lucien, 193–94
Loewy, Raymond, 329
Lomax, Alan, 428–29, 567
Lomax, Bess, 429
London, 248, 486
London Science Museum, 323–24
Lone Ranger, The, 605, *606*
Long Island, 305
Loughead, Allan, 390
Louis Armstrong House Museum,
 376

Louisiana, 159, 200
Louisiana Purchase, 186, 623
Louisiana Territory, 159–60
Louis XIV, king of France, 622
Louis XV, king of France, 622
Louis XVI, king of France, 101, 622, 623
Louthan, Marie Gilmer, 358
Louvre Museum, 624
Lubar, Steven, 461
Lubar, William, 461–62
Lucas, George, 644, 647, 648
Lucasfilm, 647
Ludlow Music, 431, 432
Luna 2, 483
Lunch Atop a Skyscraper (Ebbets), *308*
Lundy, Dick, 595
Lusitania, R.M.S., 366
Lyceum Observer, 224
Lyon, Roger Gail, 587, 589–90

Macaulay, Dr., 127
McAuliffe, Christa, 549
McCabe, Robert A., 164
McCain, Franklin, 555, 556, 559
McCarthy, Joseph, 582–83, 604–5
McCormick, Cyrus, 144
McCormick, Kathleen, 529
McDonald, Maurice, 632, 634
McDonald, Richard, 632, 634
McDonald's sign, 8, 632–37, *633*
McDonnell Aircraft Corporation, 484
Macintosh, *653*, 656–62
McKinley, William, 257, 276, 277, 278, 320
McLachlan, Sarah, 642
McLean, Evalyn Walsh, 622, 624
McLean, Ned, 624
McLean, Vinson, 624
McLean, Wilmer, 231, 233, 234–35
McLuhan, Marshall, 666
McMillan, James, 337
McMillan Plan, 337
McMullin, Cindy, 589–90
McNeil, Joseph, 555, 556, 559
McQuarrie, Ralph, 644
McVay, Charles, 466–67
Madison, Dolley, 114
Madison, James, 113

Mahoney, B.F., 386
Mahoney strain, 511
Maine, U.S.S., 10
 bugle from, 274–79, *275*
Makos, Christopher, 631
Malcolm X, 69, 562
Mandan tribe, 265–66
Manhattan Project, 466
Manifest Destiny, 188
manillas, 71–72, *72*
Mantle, Mickey, 698
Manzanar, 455
Mao Zedong, 493
March Against the Vietnam War, 582
March of Dimes, 509, 510
March on Washington, 419, 569, 580, 686
Maria Anna, countess of Forbach, 101–2
Marian Anderson (Reyneau), *415*
Marian Anderson at Lincoln Memorial (Sanders), *418*
Marie Antoinette, queen of France, 622, 623
Marilyn Monroe's Lips (Warhol), *631*
Maroons, 73, 76–77
Marshall, James, and Sutter's Mill, 193, 194
Martha, last passenger pigeon, 203–4, 698
Martí, José, 274
Martin, Joe, 560
Maryland, 214, 217
Maryland Colonization Society, 224
*M*A*S*H*, 605, *606*, 700
Mason, Frank, 603–4
Massachusetts, 138
Massasoit people, 67
Mastering the Art of French Cooking (Child, Beck, and Bertholle), 521
Material Culture Forum, 6
Mather, Cotton, 199
Matilda (musk ox), 498
Matlack, Timothy, 89
Matsui, Doris, 456
Mattachine Society, 580, 583
Mauchly, John, 652, 653
Mayas, 40
"Maybellene," 609, 612
Mayer, Louis B., 615
Mayflower, 65

Mayflower Compact, 66
Maynard, George, 322
Mayo, Frederick, 125–26
Mays, Willie, 698
Meade, George, 189
Medal of Honor, 10
MEF-1 strain, 511
Mein Kampf (Hitler), 448
Mei Xiang (panda), 497
Mellencamp, John Cougar, 572
Melville, Herman, 247
"Memphis, Tennessee," 612
Mencken, H.L., 379
Mercator, Gerardus, 78
Mercury spacecraft, 4
Merrill, George, 196
Meserve, Frederick Hill, 242
Mesopotamians, 40
Metro-Goldwyn-Mayer, 421, 422, 423, 615, 617, 627
Metropolitan Museum of Art, 49
Mexican-American War, 10, 176, 183, 186, 188–91, 193, 231, 232, 274
Mexicans, 80
Mexico, 81, 151, 203, 214, 366
Mexico City, 232
Michigan, 141
Mickey Mouse, 9, *594*, 595–99
Mickey Mouse Club, 598
Middle Passage, 8, 71, 74, *75*
Migratory Bird Treaty, 29, 203
Miles, Ellen, 108, 703–4
Milestones of Flight Gallery, 486
Milk, Harvey, 589
Miller, Arthur, 629
Miller, Claire, 674–75
Miller, J. Howard, 445, *446*, 448, 450, 451
Miller, Jonathan, 504
Miller, Phineas, 137, 138
Mills, Billy, 689
Milton (musk ox), 498
Mines and Mining Department, 196
Mineta, Norm, 456, 457
Mine Workers Union, 411
Ming Tombs, 495
Minidoka, 455
Minneapolis, Minn., 299
Minnesota, 141, 159
Mir, 550
Mississippi River, 167

Mississippi Valley, 221
Missouri, 159, 217
Missouri Compromise, 188
Mister Rogers' Neighborhood, 496
Moby-Dick (Melville), 247
Moche people, 80
Model T Ford, 8, *310,* 311–16
Modern Head (Lichtenstein), 675–76, 676
Mohawk River, 167
Molella, Art, 703
Molloy, Scott, 406
Molnar, Cindy Lou, 110
Monacan Indians, 40
Mona Lisa (Da Vinci), 625
monarch butterfly, 698
Mondale, Walter, 577
Monks Mound, 39, 41
Monroe, Bill, 609
Monroe, James, 274
Monroe, Marilyn, 9, *626,* 627–31
Monroe, Van Taylor, 682
Monroe Doctrine, 274
Montana, 159, 200, 263, 265, 354
Moonstone, The (Collins), 624
Moore, Archie, 562
Moorman, Charlotte, 663
Moran, Thomas, 247
More Perfect Union, A, 457
Morgan, John Pierpont, 292, 304
Morning Glory, 615, 617
Morocco, 442
Morris, James, 686
Morris, Simon Conway, 24
Morris, William, 333
Morrison, Van, 641
Morse, Edward Lind, 184
Morse, Samuel, 12, 179–82, 183, 184–85, 600
Morse-Vail telegraph, 12, *178,* 179–85, *180*
Moscone, George, 589
Moscow, 248, 635
Moses and Frances Asch Folkways Collection, 431
motion picture camera, 341
Moton, Robert R., 441
Moton Field, 441–42
Mound C, 41
Mount Washington, 21
Moynihan, Daniel Patrick, 519

Moynihan, Elizabeth, 519
"Mr. Cycle" PCR machine, *542,* 543–45
Mister Rogers' Neighborhood, 605, *606*
"Mr. Tambourine Man," 569
Muhammad, Elijah, 562, 564
Mullis, Kary, 544
Muppets, 4, *638,* 639–43
Muppet Show, The, 639, 641–42
Murphy, Audie, 459–63, *460*
Murray, Anna, 207
Murrow, Edward R., 605
Museum of History and Technology, 197
Musical Crossroads, 613
"Muskrat Ramble," 375
mustard gas, 369
My Bondage and My Freedom (Douglass), 209
"My Soul Is Anchored in the Lord," 417

"Nadine," 612
Nagasaki, Japan, 466, 468, 469, 475
Nahwooksy, Clydia, 686
NAMES Project Foundation, 592
Napoleon I, emperor of France, 111, 159–60, 623
Narrative of the Life of Frederick Douglass, an American Slave (Douglass), 208
Nasca Nacisire (buffalo), 265–66
Natchez Indians, 371
National Academy of Design, 181
National Aeronautics and Space Administration (NASA), 482, 484, 491, 537, 546, 548, 648, 687
National African American Museum of History, 419, 610, 613
National Air and Space Museum, 324, 443, 470, 472, 540, 548
National American Woman Suffrage Association (NAWSA), 354, 357
National Archives, 220
National Association for the Advancement of Colored People, 349, 416, 555–56
National Bison Ranges, 264
National Bison Society, 264

National Broadcasting Company (NBC), 602, 604
National Emergency Alarm Repeater, 476
National Farm Workers Association (NFWA), 575, 576, 577
National Foundation for Infantile Paralysis, 509, 510, 512
National Geographic, 496
National Labor Relations Act (NLRA), 410–11
National Labor Union, 408
National Mall, 223, 266, 337, 486, 590, *590,* 592, 685
National March on Washington for Lesbian and Gay Rights, 590
National Museum of African American History and Culture, 211, 216, 223, 364, 443, 444, 682
National Museum of American History, 93, 164, 176–77, 229, 356, 364, 425, 457, 460, 491, 518, 525, 558–59, 579, 599, 655, 672, 674, 686
National Museum of the American Indian, 16, 266, 273, 458, 685
National Museum of Natural History, 518–19, 620, 686, 697, 703
National Origins Act, 408
National Park Service, 416
National Portrait Gallery, 618, 681, 697
National Postal Museum, 324
National Railway Appliance Exhibition, 170
National Research Council, 369
National Weather Service, 184
National Woman's Party, 355, 358
National Zoo, 9, 259, 495, 499
Nation of Islam, 562, 564
Nation of Nations, 633
Native Americans, 28, 31–37, 39–42, 195, 259, 261–62, 696
See also specific Native Americans
NATO, 463
Naturalization Act of 1790, 452
Nauvoo Expositor, 155
Nauvoo Temple Sun Stone, *152,* 153–56
Navajo Indians, 51

NBC. *See* Natioanl Broadcasting
　Company
Neblett, Charles, 558
Nebraska, 159
Necessary Evil, 469
Nelson, Harmon Oscar, 616
Nelson, Willie, 572, 642
Nevada, 186, 354
Nevada, U.S.S., 435
"New Colossus, The" (Lazarus), 300
New Deal, 410, 411, 428, 699
New Lost City Ramblers, 567
New Mexico, 159, 186, 194, 363–64
New Orleans, La., 113, 116, 160, 219,
　373–74
Newport, R.I., 305
Newport Folk Festival, 569, 571
New York, 354
New York, N.Y., 182, 305
New York Fire Department, *670,*
　671–77
New York Journal, 277
New York Life Insurance Building,
　306
New York Shipbuilding Corporation,
　435
New York shirtwaist strike, 408
New York Times, 328, 623
New York World, 277, 299
New York Zoological Society, 264
Niagara, 628, 630
Nicaragua, 277
Night of Terror, 356
1984 (Orwell), 656
Nineteenth Amendment, 357, 358
Nini, Jean-Baptiste, *103*
Nipkow, Paul, 600
Nisei, 456–57
Nixon, Pat, 495, 496
Nixon, Richard, 493, 495, 513,
　535–36, 546, 605
Noa, U.S.S., 485
Noble, David, 647
"Nobody Knows the Trouble I've
　Seen," 417
Noonan, Fred, 390–91
"No Particular Place to Go," 612
Norem Bega, 80
Norman, Jessye, 419
North Carolina, 221, 226
North Conway, N.H., 286

Northern Cheyenne, 269
Northrop, Jack, 390
Northrup, Eva Stewart, 216
North Star, 208
Northwestern Sanitary Fair, 220
Northwest Territory, 141
Norton, Ken, 564
Nova Francia, 80
Nova Granada, 80
Nova Scotia, 200

Oates, Joyce Carol, 569
Obach's, 336
Obama, Barack, 4, 16, 211, 419, 432,
　571, 577
　"Hope" portrait of (Fairey),
　　678–83, *679*
Obama, Michelle, 419
Occoquan Workhouse, 356
Occupy Wall Street, 4
Ochs, Phil, 582
Odetta, 567
O'Farrell, Bridget, 234
O'Farrell, Patrick, 234
Office of Strategic Services (OSS),
　520–21
Of Plimoth Plantation (Bradford), 67
Ohio, 39
Ohio River, 167
Ohm, Georg, 180
O'Keeffe, Georgia, 699
Oklahoma, 159, 263
Oklahoma, U.S.S., *434,* 435–38,
　437, 675
Oklahoma and Woody Show, The,
　426, 428
Olds, Ransom, 312
Olmsted, Frederick Law, 264
Olympics:
　of 1912, 397
　of 1936, 602
　of 1960, 560
　of 1996, 565
Omaha, Neb., 162
"O Mio Fernando," 417
Onassis, Aristotle, 518
Oñate y Salazar, Juan de, 51–53
On Golden Pond, 618
Ontario, 200
On the Beach (Shute), 477

Opabinia, 23–24
Oppenheimer, Robert, 466
Ord, Edward, 234–35
ORDVAC, 654
Oregon, 188, 354, 455
Oregon Trail, 133
Origin of Species, The (Darwin), 380
Ornithological Biography (Audubon),
　200, 201
Ørsted, Hans Christian, 180
Orteig, Raymond, 384
Ortiz, Alfonso, 686
Ory, Kid, 374
Oscars, *614,* 615–19
Oscar statuettes, 9
O'Toole, Peter, 618
Ottoman Turks, 46
Owens, Jesse, 699
Owsley, Doug, 703
Oz, Frank, 640

Pachter, Marc, 109–20
Pacific Railroad, 169
Paik, Nam June, 4, 663–68, *665*
Paine, Thomas, 123
Palm Beach, Fla., 305
Palmer, Bernice, 339–45, *340,*
　342–44
Panama, 277
Panama Canal, 196, 257, 700, 702
pandas, 493–99, *494*
Pangaea, 21
Paris, Treaty of (1783), 103, 141
Paris, Treaty of (1898), 278
Paris Exposition, 298
Parker, Diana, 686
Parker, Dorothy, 617
Parker, Fess, 605
Parkes, Alexander, 325, 327
Parksine, 327
Parsons, William, 466, 468–69
passenger pigeons, *198,* 199–204, 698
Patterson, Floyd, 563, 564
Patterson, Robert, 161
Patuxet, 67
Paul, Alice, 354–56, *356,* 358
Paul Garber facility, 470
Payen, Anselme, 325
Peace Corps, 515
Peacock Gallery, 333, *335,* 336, 337

Peale, Charles Willson, 96, 107
Pearl Harbor, 437, 452, 456, 675
Pennsylvania Abolitionist Society, 102
Pennsylvania Railroad, 293, 301
Pentagon Papers, 700
Percy, George, 60
Perkins, Carl, 607
Perkins School for the Blind, 348
Pernambuco, 81
Perry, Matthew, 189, 334
Pershing, John, 370
Peruvians, 80
Peter, Paul, and Mary, 432, 569
Petersburg, siege of, 231
Phelps, Orson, 147
Philadelphia, Pa., 182, 299
Philadelphia Story, The, 617
Philippines, 151, 277, 278, 439
Phillip II, king of Spain, 51
Phillips, Sam, 607, 609
Phillips, Wendell, 211
phosgene, 368, 369
Pickersgill, Mary, 116
Pickford, Mary, 616
Pilgrim Society, 68
Pill, the, contraceptive, 527–32
Pinchot, Gifford, 417
Pincus, Gregory, 529
Pinta, 47
Pioneer Society of California, 196
Place, Jeff, 432
Plains Indians, 261, 270
Plane Crazy, 595
Planned Parenthood, 527, 617
Platoon, 490
Platt, Charles A., 337
Playboy, 628
Plumbers, 700
Plymouth Rock, 9, *64*, 65–69
Pocahontas, 56–63, *57*, *62*
Pocket camera, 341
Podesta, Heather, 681
Podesta, Mary K., 681
Podesta, Tony, 681
Poland, 504
polio vaccine, *508*, 509–12
Political History of the United States (Laboulaye), 295
Polk, James K., 12, 188, 189, 193–94

Polk State School for the Feeble-Minded, 511
Polo, Marco, 46
Poor Richard's Almanack (Franklin), 99
Popp, Michael, 459, 460
Porter, Cole, 69
Porter, General, 234
Portland, Me., 286
Portrait of a Man, Said to Be Christopher Columbus (del Piombo), *47, 49*
Port Royal, S.C., 222
Post, Jeff, 624
Post, Nathaniel Lyon, 234
postal hand stamps, *434*, 435–38, *437*
Postal Museum, 675
Postal Service, U.S., 324, 437, 463, 625
Poston, 455
Potosí, 81
Powell, Colin, 121
Powers, Pat, 597
Powhatan, 59
Presley, Elvis, 607
Preston, Jimmy, 607
Price, Leontyne, 418
Price of Freedom, 191, 229, 492
Priestley, Joseph, 123
Primrose, Archibald Philip, 108
Prince and the Showgirl, The, 629
Princess from the Land of Porcelain, The (Whistler), 333
Princeton, Battle of, 96
progesterone, 529
Project Mercury, 482
Prospect Hill, 307
Public Art Fund, 676
Pueblo Indians, 51
Puerto Rico, 73, 278
Pulitzer, Joseph, 276, 277, 278, 299–300
Pullman sleeping cars, 301
Pullman strike, 382, 408
Puppeteers of America, 642
Puritans, 65
Purnell, Louis, 443
Putnam, George, 389

Quarry, Jerry, 564
Quebec, 200

Quota Act, 408
Quy, Matthew, 443
Quy, Tina, 443

R2–D2, 644–48, *645*
Railway Union, 408
"Rainbow Connection, The," 642
Ralph Lauren, 120
Ralph Rinzler Folklife Archives, 431
Ramage, John, 96
Randall, Henry, 126
Randolph, Benjamin, 88
Randolph, Carolina, 127
Randolph, Thomas Jefferson, 126
Rankin, Jeannette, 355
Raposo, Joe, 641
Rathbone, Henry, 238
Raulston, John T., 381, 382
RCA, 600–606, *601*
Reagan, Nancy, 63, 519
Reagan, Ronald, 458, 503, 504
Reagon, Cordell, 558
Reconstruction, 361, 364
Red Cloud, 267
Red Cross, 418, 447, 510
Red Horn, 42
Red Horse, 271, *273*
Reed, Ted, 495
Regime Change Starts at Home, 681
Reiniger, Pete, 432
Renwick Gallery, 516
Return of the Jedi, 644, 647
revolver, 172–77, *173, 175*
Reynolds Center for American Art and Portraiture, 676
Rhapsody in Blue, 375
Rhoad, Julie, 592
Rhode Island, 138
rice, 73, 134
Richards, Keith, 612, 613
Richardson-Flory-Kops (RFK), 369
Richmond, David, 555, 559
Richmond, Va., 233
Rico, Vincent, 30
Riis, Jacob, 150
Ring, 563
Rinzler, Ralph, 432, 571, 686
Rio de Janeiro, 81
Ripley, S. Dillon, 15, 204, 521, 525, 686

Roanoake, 56, 80
Roberts, Ed, 350–51, *350*
Robinson, Jackie, 699
Robonauts, 648
Rochambeau, General, 102
Rock, John, 529, 530
"Rock and Roll Music," 609
"Rock Around the Clock," 609
Rockefeller Center, *308*
Rockwell, Norman, 448, *449*
Rockwell International, 548
Rogan, James P., 39
Rogers, John F. W., 504–5
Rolfe, John, 56, 61, 62, 63
Rolfe, Thomas, 63
"Roll on Columbia," 429
Rolling Stone, 570
Rolling Stones, 607, 612
"Roll Over Beethoven," 609
Rombauer, Irma, 520
Romero, Francisco Xavier, 54
Romero, Maias, 191
Ronald McDonald, 635
Roosevelt, Eleanor, 416, 441
Roosevelt, Franklin D., 120, 410,
 411, 435, 454, 465, 467,
 509, 511, 512, 602–3
 Fireside Chats of, 401–5
Roosevelt, Theodore, 14, 176,
 257, 265, 276, 320, 337,
 439, 698
Roots, 605, *606*
Rosebery, earl of, 108
Rosie the Riveter (Rockwell), 448,
 449
Rosing, Boris, 600
Ross, Diana, 641
Ross, Fred, 573
Ross, Robert, 113–14
Rough Riders, 439
Rubenstein, Harry, 127, 164, 243,
 585
Rumble in the Jungle, 565
Running Fence (Christo and
 Jeanne-Claude), 699
Rush, Benjamin, 123
Russia, 203, 366
Russo-Japanese War, 452
Ruth, George Herman "Babe," *392,*
 393–98
Ryan, Fred, 504

Sabin, Albert, 510
Sacagawea, 163
Sackler, Arthur, 15
Sacramento, Calif., 170
Saint Lawrence River, 80
St. Louis, Mo., 161, 196, 305
St. Petersburg, 248
Salem, Mass., 286
Salk, Jonas, *508, 509*–12
Salk vaccine, 9
Sam (eagle), 30
Sam and Friends, 639–40
San Diego Zoological Society, 204
Sandwich, fourth earl of, 252
Sandy (buffalo), 264
San Francisco, Calif., 299
San Francisco Zoo, 495
Sanger, Margaret, 349, 527, 617
Sankey, Ira D., 215
Santa Anita Racetrack, 455
Santa Anna, Antonio López de, 10
 uniform of, 186–91, *187*
Santa Clara, 47
Santa Fe Trail, 174
Santa María, 47
Santo Domingo, 81
sarin gas, 370
Sarnoff, David, 602
Saskatchewan, 200
Saturday Evening Post, 448
Saukett strain, 511
Saunders, Robert, 418
Save America's Treasures, 120
Scandinavia, 354
Schenck, Joseph, 616
Schierbeck, Helen, 686
Schlosser, Eric, 636
Schoenberg, Arnold, 666
Scholder, Fritzer, 687
"School Day (Ring! Ring! Goes the
 Bell)," 610
Scopes, John Thomas, 379–83
Scopes "Monkey Trial," 378, 379–83
Scott, Ridley, 656
Scott, Winfield, 189, 190, 232
Sea of Tranquility, 535
Sears, Roebuck and Company, 150
Second Great Awakening, 153
Seeger, Mike, 567
Seeger, Pete, 429, 432, 558, 569, 572
Seeger, Tony, 572

See It Now, 605
Seinfeld, 605, 606
Selden, George, 311, 312
Selena, 700
Seminole Indians, 139
Semipalatinsk Test Site, 475
Senate Park Commission, 337
Seneca Falls Convention, 353, 358
September 11, 2001, terrorist attacks
 of, 122, 526, 670, 671–77
*September 11: Bearing Witness to
 History*, 677
Serwer, Jacquelyn, 74
Sesame Street, 640–41
Sethi, Rajeev, 518
Seven Days in May (Knebel), 477
Seven Year Itch, The, 629
Seville Cathedral, 48
Sewall-Belmont House, 355
Seward, William, 214, 220
sewing machine, 8, 145–51, *146*
Sewing Machine Combination, 149
Sex and the City, 605, 700
Shanghai Communiqué, 493
Sheehy, Dan, 572
Shepard, Alan, Jr., 482, 483
Sheridan, Philip, 234
Sherman, Roger, 87
Sherman Antitrust Act, 408
Shima Surgical Clinic, 469
Shirra, Wally, Jr., 482
Shortridge, Samuel M., 196
Shuster, Joe, 423
Sibelius, Jean, 414
Siberia, 23
Sicily, 442
Sickler, John T., 316
Siegel, Jerry, 423
Sigsbee, Charles Dwight, 277, 279
Silk Road, 46
Simmons, Russell, 680
Simpson, Alan, 455–56
Sinatra, Frank, 641
Singer, Isaac, 145–51, *146*
Sioux Indians, 269
Sit-In Movement, Inc., 558
Sitting Bull, 270
 drawing book of, 10, 267–73,
 268, 271
60 Minutes, 605
Skolsky, Sidney, 615

Slater, Samuel, 138
slavery, 118, 139, 207–11, 240–41
slave shackles, *70*, 71–77
Slayton, Donald "Deke," 482
Sloanes, 307
Smith, Arthur, 327
Smith, Carleton, 403, 405
Smith, Fred W., 109–10
Smith, Hyrum, 155
Smith, John, 58, 63
Smith, John C., 270
Smith, Joseph, 153–56
Smith, Sachin, 616
Smith, William, 556
Smithson, James, xi, 11–12, 16, *17*
Smithsonian American Art Museum, 667–68
Smithsonian Astrophysical Observatory, 288, 693–94
Smithsonian Castle, 317, 320, 351, 693
Smithsonian Folklife Festival, 76, 558, 591
Smithsonian Institution Archives, 379, 382
Smithsonian Tropical Research Center, 702
SNCC Freedom Singers, 558, 569
Snook, Mary Neta, 389
Snow White and the Seven Dwarfs, 422
Socialist International Workers of the World, 408
Socialist Party, U.S., 349
Soldiers' Home, 220
Solis, Hilda, 579
Solutrean peoples, 36
Some Like It Hot, 629
"Somewhere Over the Rainbow," 421, 642
South Africa, 328
South Carolina, 134, 221
South Dakota, 159, 263
Southeastern Ceremonial Complex, 41
Soviet Union, 377, 409–10, 478, 483, 484, 493, 503, 509
Spacelab, 550
Spacesuits: Fashioning Apollo (de Monchaux), 536
Spain, 23

Spanish-American War, 48, 276–79, 439
Spanish Florida, 214
Spearing, Nathan, 177
Spence School, 307
Spirit of St. Louis, 4, 6, 384–91, *385*
Spirit of Tuskegee, 439–44, *440*
Springsteen, Bruce, 432, 572
Spurlock, Morgan, 636
Sputnik, 480, 694
Sputnik 2, 480
Squier, Ephraim George, 40
Stalling, Carl, 597
Standing Rock Agency, 270, 272
Stanford, Dennis, 36
Stanley, George, 616
Stanley, John Mix, *260,* 261
Stanton, Edwin M., 226, 228, 240
Stanton, Elizabeth Cady, 353
"Stardust," 377
Star-Spangled Banner, 3, 111–22, *112, 119, 121*
Star Trek, 548
Star Wars, 644–48, *645*
State Department, U.S., 91, 92, 104, 220, 377, 495, 521
State of Tennessee v. John Thomas Scopes, 381
Statue of Liberty, 9, 295–300, *296*
Statute of Virginia, 123
Steamboat Willie, 596, 597, 599
Stearman, Lloyd, 441
steel, 304, 406
steel plow, 8, 10, *140,* 141–44
Stephens, Carlene, 703
Stephenson, George, 167
Stephenson, Robert, 167
Steven F. Udvar-Hazy Center, 10, 546, 551
Stevens, Robert, 167
Steward Observatory Mirror Lab, 695
Stewart, Martha, 520
Still, William, 212
Stimson, Henry, 468
Stine, John, 171
Stockhausen, Karlheinz, 666
Stockton & Darlington Railway, 167
Stone, Lucy, 353
Stone, Oliver, 490
Stone, William, *86, 92*

Stonewall riots, 583, 584
Straight Flush, 469
Strait, Kevin, 610, 611
Streep, Meryl, 526
Strug, Kerri, 699
Stuart, Gilbert, 4, 105–10, *106,* 114, 704
Studebaker brothers, 133
Student Nonviolent Coordinating Committee, 557–58, 559
Students for a Democratic Society, 582
Sturgeon, William, 180
"Subterranean Homesick Blues," 570
Suez Canal, 297
suffrage, *352,* 353–59
sugar, 159
sugarcane, 134
Sugimoto, Henry, 452, *453,* 456
Sullivan, Anne, 348–49
Sullivan, John L., 188
Summary View of the Rights of British America (Jefferson), 87
Summers, George, 103
Superman, 423, 698
Super Size Me (Spurlock), 636
Suriname, 76
Susan B. Anthony (Eddy), *357*
Susan Constant, 58
Sutter, John, 193
Sutter's Mill, *192,* 193, 196
Swann, Joseph, 293
"Sweet Georgia Brown," 375
Sweet Honey in the Rock, 558, 572
"Sweet Little Sixteen," 610
Syllabus of an Estimate of the Merit of the Doctrines of Jesus, Compared with Those of Others (Jefferson), 125
Syria, 370

Taft, Helen Herron, 517
Taft, William H., 517
Taino Indians, 73
Tai Shan (panda), 497
Taiwan, 493
Taj Mahal, 572
Takao Ozawa v. U.S., 452, 454
Takayanagi, Kenjiro, 600
Tanana (musk ox), 498

Taney, Roger B., 117
Tanforan Racetrack, 455
Tavernier, Jean Baptiste, 622
Taylor, Elizabeth, 589
Taylor, Zachary, 189
Teage, Walter Dorwin, 329
Teamsters, 577
Tea Party, Boston, 4
Tear, Wallace, 270
Teatro Campesino, El, 577
Technicolor, 422–23, *424*
Tecumseh, 113
telegraph, 12, *178*, 179–85, *180*
telephone, *282*, 283–88, *284*,
 286, 292
television, 9, 600–606, *601*
Temple, Shirley, 423
Tennessee, 39, 200, 219
Terrell, Ernie, 563
Terry, Sonny, 430
Texaco Star Theater, 604
Texas, 54, 159, 186, 188, 200, 263
Texas Air Command Museum, 491
Texas Rangers, 174–75
Tharpe, Sister Rosetta, 607
Theory of the Leisure Class, The
 (Veblen), 305
Theremin, Léon, 602
Thevet, André, 45
Thimonnier, Barthélemy, 145
Thinking of Loved One (Sugimoto),
 452, *453*
Thirteenth Amendment, 213, 439
"This Land Is Your Land," 426–32,
 427, 431
Thoreau, Henry David, 189
Thorpe, Jim, 397, 699
Tian Tian (panda), 497
Tibbets, Robert, 465, 466, 467,
 468–69
Tihanyi, Kalman, 600
Tilden, Bill, 398
Tillstrom, Burr, 639
Timberlake, Justin, 642
Time, 329, 460
"Times They Are A-Changin',
 The," 569
Tioga (eagle), 29–30
Titanic, R.M.S., 10, 343–45
tobacco, 73
Tocqueville, Alexis de, 68, 153

Today show, 109–10
Todd, Mary, 238
To Hell and Back (Murphy), 462
Tojo, Hideki, 445
Tokyo, 370
Tonight Show, The, 640
Toscanini, Arturo, 414
totem poles, 8
Tracy, Spencer, 617–18
Trail of Tears, 139
"Trampin'," 417
Transit Workers' Union, 406
Treatise on Domestic Economy
 (Beecher), 520
Treaty of Amity, Commerce,
 and Navigation, Between
 His Britannic Majesty
 and the United States of
 America, 107
Trevithick, Richard, 167
Triangle Shirtwaist factory, 151
Tribute for the Negro, A (Armistead),
 209
Trinity test, 466, 467
Trollope, Francis, 153
Trout, Robert, 402–3
Truettner, William, 249–51
Truman, Harry S., 229, 442, 467,
 478
Trumbull, John, 107
Truth, Sojourner, 353
Tsimshian totem pole, *684*, 685–90
Tubman, Harriet:
 hymnal of, 4, 212–16, *213*
 shawl of, 16, 212–16, *213*
Tubman, John, 212
Tunisia, 442
Turner, Big Joe, 607
Turner, Ike, 607
Turner, Nat, 16
Turner, Steve, 49
Tuskegee Airmen, 16, 439–44
Tuxedo Brass Band, 374
TV Bra for Living Sculpture (Paik),
 666
TV Buddha (Paik), 666
TV Cello (Paik), 666
Twain, Mark, 300, 349
Twentieth Century-Fox, 627
Twilight Zone, The, 478
2001: A Space Odyssey, 661

U2, 572
Underground Railroad, 212, 214
Underwood & Underwood, 343
UNIMA, 642–43
Union Baptist Church and People's
 Chorus, 414
Union Carbide, 329–30
Union Defense Committee, 220
Union League Club, 234
Union Pacific Railroad, 170
United Auto Workers, 315
United Farm Workers of America,
 573, 577–78
United Farm Workers Organizing
 Committee (UFWOC), 577–78
United Mine Workers of America
 (UMWA), 406, 409, 411
United Nations, 515
*Universalis cosmographia secundum
 Ptholomaei traditionem et Americi
 Vespucii aliorumque lustrationes*
 (Waldseemüller), 82–83
University of Virginia, 123
uranium-235, 466
USO, 447
U.S. Steel, 411
Utah, 186, 354

Vail, Alfred, 179–80, 182, 183, 185
Valdez, Luis, 577
Van de Pass, Simon, *57*
Vanderbilt family, 292, 305
Vanguard TV3 satellite, 480
Vanishing Museum, A, 204
Van Ronck, Dave, 567
Vaquero, 699
Varden, John, 13
Vassos, John, 603
Vatican, 277
Veblen, Thorstein, 305
Vehanen, Kosti, 417
Vennum, Tom, 686
Veracruz, Mexico, 189, 232
Vespucci, Amerigo, 82, 83
Victoria, queen of England, 215, 237
Victor Records, 428
Vietnam, 151
Vietnam Memorial, 492
Vietnam War, 358, 487, 489, 490,
 491, 563, 581, 605, 700

View of the Bombardment of Fort McHenry, A (Bower), *115*
Vigilance Society, 212
Vikings, 80
Vincennes, U.S.S., 254, 256
Vinland, 45–46
Viollet-le-Duc, Eugène, 298
Virginia, 60–61, 80, 219, 226
Virginia Company, 56, 62, 63, 65
Virus Research Labs, 510
Viviparous Quadrupeds of North America, The (Audubon), 200
Volta, Alessandro, 180
Volta Bureau, 346
Volta Laboratory Associates, 287
von Baeyer, Adolf, 327
Voyager, 611
Vrais Pourtaits et Vies des Hommes Illustrés, Les (Thevet), 45

Wagner, David, *528,* 531
Wahunsenacawh Indians, 58
Walcott, Charles D., 21–23, 196, 322–23
Waldseemüller, Martin, 82–83, *82*
Walker, Diana, *661*
Waller, Fats, 375
Walsh, Ed, 490
Walt Disney Company, 598
Wampanoag people, 66, 67
War Department, U.S., 219, 224, 228, 239, 301, 454
Warder, Bushnell, and Glessner, 144
Warhol, Andy, 4, 9, *626,* 627–31, *631,* 680
Warner, Mallory, 544
War of 1812, 91, 111, 113–22, 141, 167
War Relocation Authority (WRA), 455
Warren, Earl, 515, 625
Washington, Booker T., 222, 441
Washington, D.C., 116, 210, 356
Washington, George, 87, 89, 90, 99, 101, 102, 103, 116, 141, 191, 203, 231, 518, 699
portrait of, 105–10, *106,* 114, 704
uniform of, 3–4, *94,* 95–97
Washington, Martha, 203
Washington, Samuel, 97, 103

Washington, Samuel T., 103
Washington Lecture Association, 210
Washington Post, 497, 516, 624
Washington Star, 204
Washington State, 354, 455
Watergate, 700
Waters, Alice, 520
Waters, Muddy, 609
Watkins, Carleton, 251
Watkins, J. Elfreth, 170
Watson, Doc, 572
Watson, James, 543
Watson, Thomas A., 285
Watt, James, 165
Wayne, John, 489
Webster, Daniel, 186, 189
"We Can Do It!" poster (Miller), 445–51, *446*
Weeks, William, 154–55
Welles, Gideon, 227
We're Not Married!, 628
Wescott, W. Burton, 422
"We Shall Overcome," 558
West, Richard, 687
"West End Blues," 375
Western Union, 183, 185
Westinghouse Electric Corporation, 445, 447, 450
Wetmore, Alexander, 31, 197, 229
"What a Wonderful World," 376
Wheat, Chatham Roberdeau, 190
Wheat, Mrs., 191
Wheatley, Phillis, 48
Wheatstone, Charles, 181, 182
"When the Saints Go Marching In," 376
Whipple, Fred Lawrence, 693–94
Whiskey Rebellion, 97
Whistler, James McNeill, *332,* 333–38
Whistler's Mother (Whistler), 334
Whitaker, E.W., 234
White, Ed, 538
White, Elizabeth Boyd, 53–54
White, John, *61*
White, John H., 170, 171
White, Roger, 132
White, Ryan, 588
White, Thomas E., Jr., 674
White, Walter, 416

White House Historical Association, 516
Whiteman, Ridgely, 31, 33, 34
White Star, 343
Whitfield, Louise, 304, 305
Whitman, Walt, 430
Whitney, Eli, 134–39, *135, 172*
Whitney, Eli, Jr., 175
Whitney, Thomas, 159
"Why Don't You Love Me," 450
Wilkes, Charles, 256
Wilkes expedition, 13
Wilkins, Mariline, 217
Williams, Paul, 642
Williams, Samuel, 108
William Wilson & Son, 227
Wills, Bob, 609
Wills, Helen, 398
Wilson, Brian, 572
Wilson, Edith Bolling, 63
Wilson, Pete, 197
Wilson, Woodrow, 349, 355–56, 358, 366, 409, 435
Wings, 615–16
Winiarski, Warren, 526
Winnie the Welder, 448
Winston, Harvey, 620, 622
Wired, 536
Wisconsin, 141
Withuhn, Bill, 171
Wizard of Oz, The, 420, 421–25, 663
Woman's Air Derby, 389
Women Pilots Association, 390
Wonderful Life: The Burgess Shale and Nature of History (Gould), 24
Wonderful Wizard of Oz, The (Baum), 423–24
Wood, John, 156
Wood, Nelson, 203
Woody Guthrie (Grossman), *429*
Woolworth Building, 307
Woolworth's, *554,* 555–59
Works Progress Administration (WPA), 364
World Boxing Association (WBA), 563
World Boxing Council (WBC), 563
World Puppetry Festival, 643
World's Columbian Exposition, 48, 170, 235, 336

World Trade Center, 671, 675, 677

World War I, 328, 356, 371, 384, 439
gas mask from, 366–70, *370*
Richardson-Flory-Kops (RFK)
version, 369

World War II, 7, 9, 10, 92, 97, 324,
358, 364, 404, 418, 429, 438,
459, 476, 487, 575, 604, 651–52

Wozniak, Steve, 658

Wright, Orville, 4, 11, 317–24, *319*,
484, 703

Wright, Wilbur, 4, 11, 317–24, *319*,
484, 703

Wright-Humason School for the
Deaf, 349

Wright Military Flyer, 323

WTOP-Radio, 404

Wyoming, 159, 354, 455

XH-40, 487

Yank, The Army Weekly, 627

Yankee Stadium, 395

Yeingst, Bill, 558, 673

Yohe, May, 622, 623

York, 161

Yorktown, Battle of, 102

"You Never Can Tell," 612

Young, Amanda, 540

Young, Brigham, 156

Ypres, Battle of, 368

Zworykin, Vladimir, 600, 602